THE FIRE STILL BURNS

Music inspired by the post-punk message

By David Gamage

Published by Earth Island Books
Pickforde Lodge
Pickforde Lane
Ticehurst
East Sussex
TN5 7BN

www.earthislandbooks.com

Paperback ISBN: 9781916864382
ebook ISBN: 9781916864399

Printed and bound by Solopress

Dedication

To everyone standing at the bar at the back of the gig, shouting out witticisms,
To the hardcore kids down the front and the punk-rock scene that keeps us going,
And to my wonderful wife, Louise, and superb sons, Carl and Jake.
May you find constant inspiration for your own great adventures.

The Fire Still Burns
Music inspired by the post-punk message

Contents

Foreword

BY IAN GLASPER

It would be a sobering thought - if I drank, that is - to ponder on the fact that, by the time this book is published, it would have been over forty years ago that I played my first gig as a budding young bassist. Of course, it was a punk gig, and no one got paid, and there was a big fight... but back then, I did drink, and there wasn't a sober thought to be had in the house.

The underground punk and hardcore scenes - and the post-punk scene, as this book loosely hones in on - are all veritable schools of hard knocks, and even now, four decades later, with nearly a thousand gigs under my belt, not to mention over a dozen albums (and ten books – yaay! Go, Ian!), it's still a sharp learning curve, with unscrupulous, or incompetent - or both - shysters looking to shaft you, left, right and centre. And it's not an exaggeration, but despite playing some rather large gigs and jetting off to various punk hotspots around the world, I've not made a penny from a single band I've been in. To hang around in this dog-eat-dog arena for forty minutes, let alone forty years, could understandably be regarded as a sign of thick-skinned idiocy or self-flagellating masochism. Or both. Yet here we are.

But there is so much more to it than that. I'm sure many of you - hopelessly addicted to punk music, who keep coming back for more, against all better judgement, just for the sheer love of it, because the punk scene is somewhere we feel complete - will have been told by your elders and 'betters' over the years, 'Oh, you'll grow out of it, you'll see... ' And that's the thing - I never did. I actually grew *into* it, if anything.

As did David Gamage. He's old school through and through, as amply detailed in his last book, 'A Hardcore Heart', but just can't bear to hang up his boots. I first read his BHP fanzine and reviewed his band the Couch Potatoes' EP for Terrorizer magazine, over thirty years ago, if I'm not mistaken, and nowadays he's still releasing music and publishing books (my own included). Still giving back to the scene that has given him so much. And now he brings you 'The Fire Still Burns', a collection of lovingly collated interviews with many of the bands he has released through his prolific Engineer label, some of whom you will have heard, and some of whom you will have not.

But that's the thing – *every* band has a story to tell. Regardless of whether they 'made it' or not... and pray tell, when exactly have you 'made it' anyway? And who's to decide that someone's tale of sleeping under a park bench during a disastrous European tour that virtually cost them their life's savings – not to mention, sanity – is any less important than some huge rock band's debauched recounting of filling hot tubs with champagne and throwing hookers out of hotel windows? I certainly know which one I can relate to more, and to those struggling DIY bands, and their circle of friends who experienced those times with them, these tales were – *are* – an indelible part of their lives, and part of the very fabric that knits the underground punk and hardcore scene together. That's exactly why I started to document the scene in such detail with 'Burning Britain', back in 2003, and exactly why I'm still doing so today, but no one person can ever do this crusade justice, and that's why it's so great to see David throwing his hat into the 'punk historian' ring and honouring all these bands who put their arses on the line for your dubious listening pleasure. It's a dirty job, or so I'm told, but someone's got to do it.

Ian Glasper, September 2024.

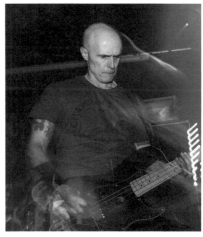

Music Venue Trust is a UK registered charity which acts to protect, secure and improve the UK's grassroots music venue circuit.

Created in January 2014, Music Venue Trust aims to secure the long-term future of iconic GMVs such as Hull Adelphi, Exeter Cavern, Southampton Joiners, The 100 Club, Band on the Wall, King Tut's, Clwb Ifor Bach, Tunbridge Wells Forum etc. These venues play a crucial role in the development of British music, nurturing local talent, providing a platform for artists to build their careers and develop their music and their performance skills. We work to gain recognition of the essential role these venues fulfil, not only for artist development but also for the cultural and music industries, the economy and local communities. We provide advice to the government, the cultural sector and the music industry on issues impacting GMVs and are the nominated representative that speaks on behalf of the Music Venues Alliance, an association of nearly 1000 venues from across the UK.

These grassroots music venues aren't just home to great nights out. From them emerge local scenes of music, styles and fashion that grow to become regionally important, then national trends. Sometimes they even become global movements. But it's when they are first starting in and around their local venue that they create an identity that is unique; special to that place, special to the people who create it. A Hardcore Heart is the history of just one such scene, but it tells the story of literally hundreds if not thousands more.

This book supports the Music Venue Trust and Grassroots Music Venues.

www.musicvenuetrust.com

Music Venue Trust

THE FIRE STILL BURNS

Music inspired by the post-punk message

By David Gamage

The Fire Still Burns
Music inspired by the post-punk message

Introduction

Punk is more than music. If the personal is the political, then post-punk and truly independent alternative rock bands are a perfect medium to carry that message to audiences willing to listen.

The alternative live music scene that I know has a great feeling of inclusion, energy, community and friendship. Apart from giving us brilliant entertainment and a great place to belong, it can help influence change too. Often striving for social justice and standing up wherever possible to dissent against what we all know to be wrong, unfair or corrupt. And unfortunately, with more inequality and authoritarianism seeming to rear its ugly head every day now, the inspiration and encouragement to stand against it is needed constantly.

Granted, you might say, it's just music and lyrics. But that's the point. It's simple, it's primal. It provides a platform that allows you to do your own thing, find your voice, look for new ways to express yourself, to experiment and share a message. The sound might be heavy and angry, but it could also be melodic and catchy, often anthemic and even soothing. Punk is a frame of mind as much as a musical genre, and as such, post-punk bands can be identified by their attitude and beliefs just as much as their powerful sound.

There are already more than enough books about the big rock bands that everyone's heard on the radio, and there's plenty of books about the old '77 punk bands too, some of whom have reformed and continue to play to fans old and new. But it seems that there are relatively few books

singing the praises of the unsung multitude. This is quite probably due to the economic concerns of the publisher or the return on time invested by the author. But nevertheless, the vast number unsung post-punk, hardcore, alternative-rock and indie bands that make up the scene we love and bring us all out to gigs every weekend to share that energy, need to be celebrated too.

That's why this book exists. To honour some of those lesser-known bands from the underground music scene that I would consider post-punk and definitely worthy of your time and interest. Many of them play melodic hardcore and some have strongly political lyrics. More than a few of these bands are on my own label, Engineer Records, so that's partly how I came to meet them and get to know them so well, which in turn made it much easier for me to interview them and have the discussions for the content of this book.

With most of these bands are on my record label of course, so I've seen them play live, many times, and all of them really brought it when they hit the stage, pouring their heart and soul into every show. Even with their undoubted musical talent and burning energy, they have had varying popularity and success within the scene so there's a few here you may not have heard of. With that in mind it's time to get to know them now, so this book is also a document to steer you towards some of their great records and talk about these bands inspirations, motivations, local scenes, adventures on the road and Engineer Records humble part in their releases.

These artists come from all over the world and espouse punk beliefs in many different ways but share important common ideals. Many of these artists are still creating incredible music, releasing records, playing gigs and touring. But inevitably, as this book covers twenty five years of releases, some of the groups I've written about have broken up now. Their music is still available though, lurking in record store bins or readily waiting to be searched online, and the band's reasons for forming in the first place, writing their songs and sharing their releases, is no less important today than it was the first time they stepped into a cramped rehearsal room or onto a sweaty stage.

I wanted to discuss what influences these artists, while sharing their gig stories, in-jokes and opinions on the scene. All of which helps shine a light on what makes them tick and why they go out every weekend to play

2

gigs, often for no or very little financial reward, in small pubs and clubs. I respect that motivation and always find the humorous little human stories interesting. In fact, I'm willing to bet that you'll empathise with most of them, and I'd even state that this determined positivity and punk-rock mentality is needed more now than ever before.

David Gamage, September 2024.

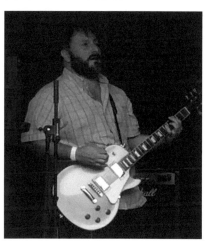

Engineer Records

When I started making notes for this book it was going to be a follow up to 'A Hardcore Heart' looking again at the people and bands that I'd met through the hardcore scene and telling a few of their stories as best I could. Due to my proximity to them through my Engineer Records label and being constantly in touch with certain bands on our roster it's turned into a sort of record label story told through the interviews and discussions I've had with some of my favourite bands. There's a lot in here, as you'll see, but there's also a lot missing and I could have written even more! There are great bands I couldn't get hold of in time or didn't have enough up to date information on, so there may just have to be a second volume of this, if anyone's into it. But either way, I think it's worked out pretty well and the stories these bands have helped create are well worth telling and reading about.

I always find the day-to-day tales behind any creative endeavour interesting and was further incentivised to write this collection by the lead from other, far better, books I've enjoyed such as Beth Lahickey's 'All Ages', Henry Rollins' 'Get in the Van', Eric Grubbs' 'Post' and Ian Glasper's 'The Scene That Would Not Die'. I'm glad to see that there are motivated authors and many more great books like this coming out all the time now, but in my personal opinion, still nowhere near enough covering the inspiration, energy and passion that is the hardcore scene we all love. There's definitely room for many more books on post-punk incitement yet and hopefully they'll continue to emerge from the ether.

With that in mind, a brief synopsis of Engineer Records might be good for some context...

I'd been playing in bands, putting on gigs, running a fanzine and releasing records, working with other small independent labels in the punk and hardcore music scene for a while. Originally, I ran Gotham Tapes, a compilation tape label just spreading the word about new bands through pen pals when I sent out gig flyers or my fanzine, BHP. This was all pre-internet, of course, but it seemed easy enough to just do things for yourself. Next came a short-lived label called Something Cool, (a predecessor to Unlabel) to release a Joeyfat 7", then came Get The Gimp for another 7" EP release, this time for Wact and Couch Potatoes. It was fun making up the logos, creating the cover art and packaging, personalising it all and sending these things out into the world, like punk-rock messages in a bottle.

Next came the slightly more professional and long-lived Scene Police Records, which I worked on with my friends Dennis and Emre, where we created and released around forty records over a few years, working within the punk-rock underground of soaped stamps, fanzines, distros, gig flyers and word of mouth. I wrote about this in more detail in 'A Hardcore Heart' and I'm trying to persuade Dennis, the head honcho of Scene Police, to write his own book about it all. It was fun and fairly easy, especially with us all sharing the work and costs, and the bands joining in on the promotions. We took pride in what we did.

It has always been important to me to be a constructive and contributing member of the punk-rock community so, enabled by that brilliant 'just get up and do it' mentality that pervades our scene, back in 1999, twenty-five years ago now, I decided to start my own record label and give it a go.

Obviously I wanted to treat the bands properly; work with them on regular releases that would be backed by marketing and worldwide distribution, so we'd help create art, PR and merchandise for them, and share any income fairly. It helped that I played in a touring band too, so I'd seen both sides of how record labels dealt with artists and felt that it could be done in a far better, more friendly and equitable manner. Also, being a massive fan of the bands I wanted to work with also helped. We kept up our energy and adhered to the commitment that we'd only put out records for bands we were really into.

Originally the label was called Ignition, hence the IGN catalogue numbers for our releases, but a couple of years in, after an argument with the management company that looked after Oasis amongst others that led to threatened lawsuits, we decided to change the name to Engineer Records. We've been going strong ever since and have released over 400 records working with around 200 great bands.

Everything is more fun with friends, so right from the start there were several of us involved. A like-minded collective from day one. We set up an office, mailorder and shop in Tunbridge Wells and started strong, with initial releases for Hunter Gatherer, Hot Water Music, Rydell and San Geronimo. The feeling I received from those records, all our releases, was the same sort of buzz you get at a good gig.

Through the early years Milo (Miles Booker) worked with me on setting up a distro and running stalls at gigs, these could often be an adventure and a story in themselves, while Syd (Stephen Franklin) corresponded with more bands from all over the world about songs for the Firework Anatomy and Shudder To Think Tribute compilations. Before long Craig (Cirinelli) joined us to set up the Engineer Records USA office in Boonton, New Jersey, to spread the word and our distribution even further. We had help where needed and all worked on it together, finding even more partners, including fanzines, promoters, distros, radios, labels to trade with and like-minded friends, as we went along.

These records soon brought us even more exciting and productive contacts from both near and far, leading to releases for local bands; Urotsukidoji, Winter In June, xCanaanx, Eden Maine, The Babies Three, Nine Days To No One, etc and bands from further afield too; Last Year's Diary, Speedwell, Crosstide, Chamberlain, Planes Mistaken For Stars, Flyswatter, Joshua, Elemae, etc. The styles were mainly melodic hardcore, but all firmly based in the alternative / post-punk genre. We developed things as fast as we could afford to, trading a lot of releases with other indie labels and often paying for ads in fanzines with copies of records. We worked hard to build the label and alongside our vinyl and CD releases started to include digital and videos too, although I'd make sure that bands always had plenty of physical records and merchandise for their tours and gigs.

I could go into exhaustive detail about the hundreds of partners we had in all this, the labels, distributors, promoters, magazines, fanzines, radio

stations, pressing plants and so on. They all helped us support and promote the bands, and it was all done in such an enjoyable, positive, punk, underground D.I.Y. kind of way that even in the occasional moments of hardship, sometimes caused by an unreliable gig promoter or an overly thrifty store, it all seemed like such worthwhile fun to me.

All these superb bands need wider coverage and should be much better known, so it's a great feeling to help them reach a wider audience where I can. This is a fairly hefty book, but still only covers eighty of the labels' bands. There's at least that many more to write about on the label, and hundreds more in their own right, such is the well of talent and energy in this genre. Because of this, I remain positive, passionate and full of energy for the hardcore / post-punk scene and can assure you that the fire still burns!

There are QR code links at the start of every chapter so you can listen to the band while you read about them, if you want to – and you should. Even better, go and buy their records or see them play a gig. You'll be blown away.

It's an absolute honour to support the creativity of so many talented musicians and bands, many of whom are close friends and this, of course, is what led to the conversations that follow in this book, which I hope you enjoy...

3dBs Down

Tage Wood: Guitar and Vocals
Matt Oastler: Guitar and Vocals
Joe Cooper: Drums
Si Fawcett: Bass and Vocals

3dBs Down from Gravesend, UK, combine a unique three-pronged interchangeable lead-vocal attack with frantically paced punk-rock ska-tunes that are catchier than flu in a doctor's waiting room and will kick you in the nuts with the heaviest of riffs when you least expect it.

Having spent much of their teenage years hanging out together in the notorious biker's venue-pub in Gravesend, The Red Lion, Matt, Tage, Mr J and Si formed 3dBs Down back in 2001. The band could most easily be described as ska-punk, but all four of them shared a passion for 90s SoCal punk rock, grunge and even Britrock, so influences from all those genres have also stayed with the band throughout their 23 years together.

Matt Oastler, guitarist and vocalist, told me, "We threw ourselves into it and released two albums ('Bottom of the Learning Curve' and 'Can of Worms') as well as an EP ('Come Get Some') in our first four years as a band. Both full-length records getting a lot of positive reviews and even a KKKK review in Kerrang! magazine for 'Can of Worms', our second album."

Up until 2007 3dBs Down had a policy to take any show offered to them no matter where it was or how much cash, if any, was being offered. It wasn't uncommon for them all to squeeze into a tiny Estate van, two of them with their legs around their ears, on the floor in the back with all the gear and make a ten-hour round-trip to play to about fifteen people. Eight of whom were in the other bands.

They were lucky enough though to get onto the bill at some of the early 'That's Not Skanking' shows in Manchester, that were being put on by Andy Davies, who went on to start TNS Records (along with Tim Bevington) and front the super-fast punk band, Revenge of the Psychotronic Man. Even early on there was a great buzz at the TNS shows and when 3dBs Down were asked to play one they were more than happy to make the four hour drive up from Kent.

Matt continued, "On one occasion, having arrived at the venue we settled in to enjoy some of the opening bands. A couple of lads in the crowd were really getting into their slam dancing and at some point, a nose must have got busted open or something because there was a pretty impressive pool of blood forming on the dance floor right in front of where we were sitting."

"Si is blessed with amazing musical and song writing ability (he is dBs songwriter in chief and all-round musical mastermind.) However, he is also sadly cursed with being terribly accident prone."

"After seeing this slightly unnervingly large pool of blood he headed off to go and be sick in the toilets. Unfortunately, before he could chunder he passed out, hitting his head on a sink on the way down."

"I'd been out having a smoke and when I came back in there was a crowd of people gathered around where I'd been sitting. 'He's gone blind!' someone informed me. We had to cancel our performance and instead head off to A&E where Si was told he had concussion." The irony that 3dBs Down most well-known song at the time was called 'Concussion' wasn't lost on anyone.

In 2005 3dBs Down were lucky enough to be included on the Hidden Talent roster and so got to tour with the likes of Adequate Seven, Sonic Boom Six and Howard's Alias. This meant they had to get their shit together and invest in a new van, an Iveco Turbo Daily.

"A carpenter mate of ours put some bunk beds in, while Mr J took care of wiring it up so we could have a TV and home cinema in the back. That led to back-to-back Red Dwarf and Spaced episodes while we were on the road. Living the Dream!"

The only trouble was that the van had a tendency to break down. A lot. Although Matt assures me never cost them a show. Indeed, at the start of a ten-day tour in '06 it broke down before they'd even left their hometown of Gravesend. The AA came out and made a temporary fix involving a coat hanger, and the guys cracked on with the tour, travelling as far North as Dunoon in Scotland, and as far South as Plymouth in Devon. On completion of that trip the van promptly died on them as they we dropped Si off back home in Gravesend.

From about 2007 onwards 3dBs Down stopped touring. They had put all the time, mileage, and money in that they could, but for whatever reason never seemed to make a mark on the scene nationally, certainly not beyond the advocates of the ska-core scene. So, the band entered a phase of playing just a couple of local shows each year, often at their spiritual home, The Red Lion in Gravesend. There were annual charity events put on by a local promotor, Ant Martin, who always succeeded in dragging them out, even if they only ever got together to practice just before the show.

Another of these rare gigs, this time in Exeter, showcased Si's accident-prone nature. The band opened their set with 'Better Off Alone' which has a big kick-in where the whole band jumps, but somehow Si managed to tangle his feet in the guitar leads and stack it off the stage, crashing onto the floor, with everyone singing, 'You're better off on the floor', rather than the usual, 'You're better off alone' chorus.

However, despite his clumsiness and injuries, Si was constantly writing songs, and the band soon had tracks on various samplers, including Punktastic's 'Un-Scene' compilation CD. This all helped them get good radio airplay, one time seeing Matt calling into Mike Davis Radio 1 Lock Up show, calling himself Geoff, in order to request airplay of their own track!

Even though the band could never seem to get any momentum going for another record and tour, a few good friends kept in touch. One of these was Paul Smith, who sports a colourful 3dBs Down tattoo on his right leg, and in recent years has become one of London's go-to promoters for punk rock shows.

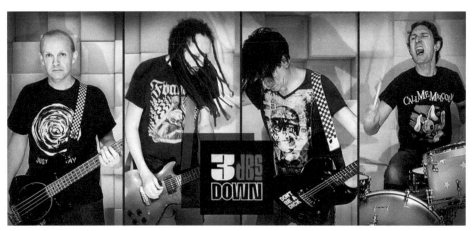

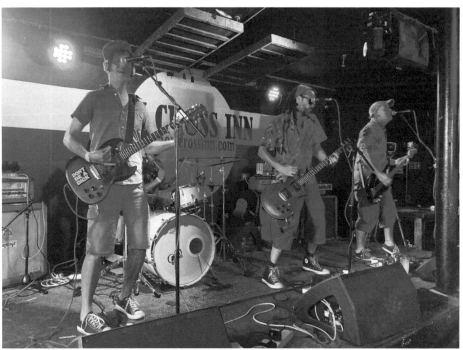

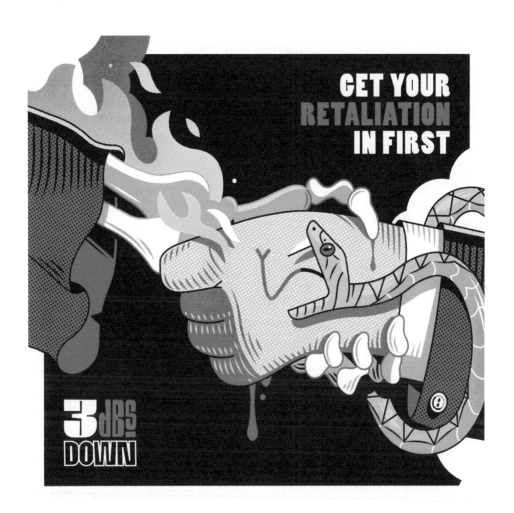

"It gives us a lot of pride - and perhaps a touch of bemusement - that Paul cites coming to see us at our early shows as a driving factor behind his enthusiasm and commitment to the cause." Says Matt. "In recent years he has asked us to play at several his superb B Sharp shows he puts on at The New Cross Inn where the UK ska punk / punk scene is well and truly kicking. The venue is always crammed full of people who simply want to have a good time dancing to good music whilst rubbing shoulders with good people. If it wasn't for Paul inviting us to play at these shows I'm not sure we would still be active at all. It was his enthusiasm for us and for the scene in general that helped give us a new lease of life."

Matt continued, "Around the time of the bands twenty-year anniversary, plans were made to crowdfund a new record. Then, David from Engineer Records got in touch to see if he could lend a hand with the release. Propelled by the likes of Paul and David's enthusiasm, our new album, 'Get Your Retaliation in First' was released on Engineer Records in 2020. Our first record for fifteen years!"

The new album came out in gatefold LP, digipak CD and digital formats with bold and beautiful Jim Billy Wheeler artwork on the cover and posters for supporting videos and digital singles. The band played a handful of gigs to promote the record, including one at Leo's Red Lion again, and even travelled further afield, supporting US, European and UK ska-punk bands. To this day, they still get out and rock, although now they turn up at venues in their own, only slightly more reliable, cars.

I asked Matt what he thought of the current scene and where he saw 3dBs Down within it, and he replied: "There is still such an appetite for punk-rock / ska-punk and it's great seeing bands like Sonic Boom Six and Random Hand tearing up huge audiences 15-20 years in. The creative, energetic and rebellious nature of punk-rock will, I think, ensure it's longevity as younger generations will always want to taste those ingredients."

"The scene has always had a knack of bringing amazing people together; be it band or audience members alike. Although these days going to shows has unfortunately become an ever more infrequent occurrence for me personally - when I do go I know there will always be interesting bands to watch and friendly people to meet, drink and dance with."

"As a band, 3dBs Down have always been a little on the periphery of the scene, but I think that those that have bought into our mixed blend of styles

have bought in pretty heavily and that brings us a lot of satisfaction."

Reviews of 3dBs Down 'Get Your Retaliation in First' album include:

"Buzzsaw riffs and whopping great hooks" **Kerrang**

"Demand and deserve your attention" **Punktastic**

"Thought-provoking and extremely listenable" **Big Cheese Magazine**

"You'll listen to it 100 times and still hear something new that you'll love"

Colins punk rock world

"Dual harmonies on basically every chorus coupled with solid shout interjections. The call-and-response is what defines the 3dBs Down style on this release. 3dBs Down have made one of my favourite albums this year."

Warrington Ska Punk

"A fierce, anthemic ska-punk-rock kick to the teeth that will leave you gloriously satiated. They've been described as 'Less Than Jake on steroids', and we're inclined to agree; with unstoppable tempos and stupidly pit-worthy singalongs, 3dBs Down have created an infectiously joyous album that will charm the socks off of just about any listener."

Bittersweet Press

"Up-tempo ska punk, interchangeable lead vocals, a catchy as hell chorus and crunchy guitars."

The Punk Site

"A varied and enjoyable album from a band who really feel like they're firing on all cylinders."

Nite Songs

https://3dbsdown.bandcamp.com

Abermals

Alberto Abad: Drums
Enrique Alarcón: Bass
Chris Späth: Guitar & Vocals

Abermals is what happens when you put three people in a room that have played in too many bands, listened to too many records and have too much excess energy than is appropriate for their age. Kraut-infused indie punk with nods to post-hardcore and whatever else seems to fit.

From Mallorca, Spain, the band features Engineer Records alumni from the band Tidal, a German screamo band from the early days of the label, who released a split 12" with Acabah Rot when we released records as Ignition. The band also have ex-members of Dog Day Afternoon, and current members of The Distance.

'Reasons to Travel' is the band's latest full-length album, released as part of a split-label agreement between Engineer Records (UK), Memento (Germany), Sell The Heart (USA) and Runaway (Spain), which is a follow up to their self-released 'These Broken Bodies' EP.

"After my old punk/ hardcore band Tidal ended in 2005, I played in a

couple of band projects of various styles and setups, but none really worked out. It wasn't until much later, in the first year of the covid pandemic, that I started playing with a drummer called Alberto Abad, in Mallorca, Spain, where I had recently moved to. We jammed together and soon came back to the punk style of our roots." Christian Späth, guitarist and vocalist of Abermals, told me. "We took Alberto's old buddy Enrique Alarcón into the fold, on bass, and started what would become our new band, Abermals."

"We practiced for a few months in Alberto's apartment but had to be careful to keep it very quiet for a rock band, as his next-door neighbour was incredibly sensitive to noise and would quickly complain." Chris went on, "Alberto had an electronic drumkit set up in a small room. Enrique and I played through a small mixing desk, and we all wore headphones. There were no amps or speakers, to minimise the noise. It was difficult to raise the atmosphere but worked ok because we could hear very clearly what we were playing, and therefore improve our songs and musical skills quickly."

After a few months of this noise-abatement practicing, Abermals moved into a proper rehearsal space where they recorded their first few songs. Seven of these tracks came out in 2021 on their self-released 'These Broken Bodies' CD. When the pandemic lockdowns finally ended, the band started playing live, both locally in Mallorca and all across the Spanish mainland, with several shows in Madrid and Barcelona, helping their D.I.Y. release sell well.

In 2022, Abermals recorded nine brand new songs and Chris got back in touch with Engineer Records, who had originally released the Tidal / Acabah Rot split 12" record under the label's original moniker of Ignition. After some discussion, Engineer Records would co-release this new Abermals album, 'Reasons to Travel, alongside Christian's own label, Memento, on both vinyl and CD formats, supported by digital channels and several video singles.

"I wasn't sure if Engineer was still active, but they were. Apparently, in fact, more than ever, releasing tons of good music from all over Europe and the US." Continued Chris, "I sent them our new recordings and they immediately took a liking to them, so it was decided we'd follow our 2002 footsteps and co-release the Abermals LP / CD 'Reasons to Travel'. David even managed to get California's Sell the Heart Records involved, for

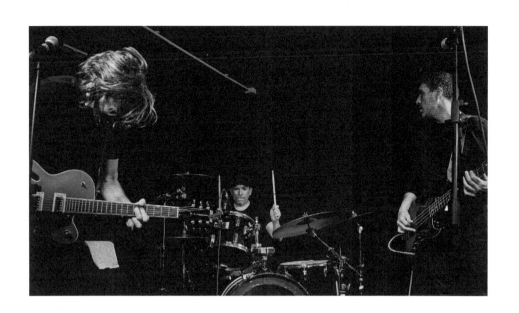

ABERMALS

REASONS TO TRAVEL TOUR 2022

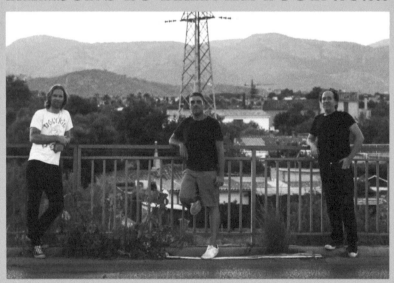

8/12 Barcelona, Sala Vol
9/12 Sant Feliu de Guixols, Atzavara
10/12 Tarragona, Mojo Club
15/12 Magaluf, Zeppelin

linktr.ee/abermalsband

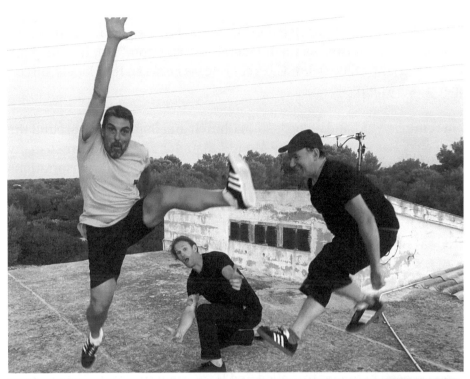

ABERMALS

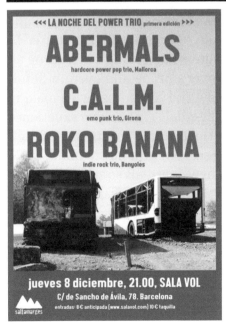

<<< LA NOCHE DEL POWER TRIO primera edición >>>

ABERMALS
hardcore power pop trio, Mallorca

C.A.L.M.
emo punk trio, Girona

ROKO BANANA
indie rock trio, Banyoles

jueves 8 diciembre, 21.00, SALA VOL

C/ de Sancho de Ávila, 78. Barcelona

entradas: 8€ anticipada (www.salavol.com) 10€ taquilla

saltamarges

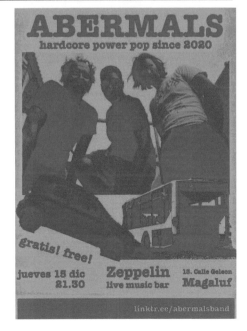

ABERMALS
hardcore power pop since 2020

gratis! free!

jueves 15 dic
21.30

Zeppelin
live music bar

15. Calle Geleon
Magaluf

linktr.ee/abermalsband

18

more US coverage and distribution, and that helped us also secure support from another Spanish label, Runaway, too." So, in true punk scene style, the album would be a co-release between four labels, all co-operating to help.

I'm reminded of bands like Seam, J Church and Superchunk around the 'No Pocky For Kitty' / 'On The Mouth' Matador era, but I hear so many influences in the mix. I asked Chris about his song-writing inspirations and he told me; "As a songwriter I have many influences and quite often a band or song will inspire me to write something of my own, which usually ends up sounding so different that nobody ever recognises the original inspiration, but instead people might say, "*That song really sounds like band XYZ*", whom most often I've never heard before." Adding, "For instance, 'You', the opening track on the 'Reasons to Travel' LP, was my attempt to write a song in the style of German krautrock hero Klaus Dinger, of Neu! and La Düsseldorf. And our fast-paced punk-rocker on the album, 'Segunda Inspección', or 'Second Inspection', was heavily influenced by the energy of a recent DC hardcore band I'd been listening to, called Red Hare. Even the track 'Never Done' was me trying to prove to myself that I could still write a song with the feeling and substance of bands like Shotmaker and Four Hundred Years when in my forties. That said, most songs just come out the way they do, and it's unclear even to me what may have brought them to the forefront of my consciousness."

Touring, or even playing a few live shows outside of their island home isn't easy for smaller bands like Abermals. "Certainly not like it used to be, back when we were young, when there was a strong D.I.Y. scene all over the world and we could tour all over Europe and even in South America, without losing too much money, and sometimes even making enough to cover costs." Added Chris, "The whole gig booking experience can be a bit of a pain these days, but I still love expressing myself through songs and hopefully I'll never stop doing so." So, with that in mind, while you're reading this, there may well be a new Abermals song out there for you to listen and 'Rock out with your socks out' as the band say.

Isaac Kuhlman reviewed the album for **Powered by Rock**, writing, "*Abermals rock out like it's 1999, placing surf rock beside psychedelic rock, then throwing it in a blender and pouring it all over a punk rock waffle. Sonically equivalent to bands like Blind Melon or Sunny Day Real Estate, but with a bit more gravel and grit in the tone. My favourite song on the album is*

'Belong' which runs to about four minutes of pure alternative rock with the catchiest chorus on the album."

Punk-Rocker.com magazine added; "'Reasons to Travel' is a remarkable debut album. The diverse blend of influences, impressive *musicianship, and thought-provoking lyrics make for a captivating listening experience. Whether you're a fan of kraut rock, indie punk, post-hardcore, or simply enjoy music that challenges and inspires, 'Reasons to Travel' is an album that is sure to leave a lasting impression. Abermals' boundless energy and musical prowess shine through in every track, solidifying their position as a band to watch in the contemporary music scene."*

"The album commences with a profoundly melodic track titled 'You', immediately grabbing the listener's attention with its frenetic basslines, moderate rhythmic sequences, and intricate guitar manoeuvres. The band's raw energy is palpable, creating an infectious atmosphere that persists throughout the entire record. One of the standout aspects of 'Reasons to Travel' is Abermals' ability to seamlessly transition between different musical styles within a single song. Tracks such as 'Amadeus' demonstrate their knack for incorporating unexpected tempo changes and shifts in dynamics. It keeps the listener engaged and unsure of what to expect next, making it an exciting and unpredictable listening experience."

https://linktr.ee/abermalsband

About Leaving

Jaime Pizarro: Vocals and Guitar
Martí Ferrer: Guitar
Jordi Erra: Drums
Joan Pérez: Bass
Claudi Dosta: Guitar

About Leaving was formed in early 2015 and is comprised of ex-members from Furguson, Power Burkas, Ohios, and Jilguero. These Barcelona-based Catalan emo-kids delve deep into melodic power-pop and shine their spotlight on 90's stalwarts like The Promise Ring and Texas Is the Reason.

First, there was a band called Ears. Sometime around 2010, Jordi and Jaime met at college while studying Art History in Barcelona and, in sharing their love for music, they became friends and started toying with the idea of forming a band. Jordi was already quite an accomplished drummer in the Catalonian underground music scene with the electronic post-punk band Furguson and Jaime had started playing guitar and writing a few songs along with his long-time friend and neighbour Jab, so when the time came to find a bass player, Jordi

recruited Martí, whom he knew from their hometown of Vic, and the bands' line-up was complete.

Lyricist, vocalist and guitarist, Jaime Pizarro, told me; "To be quite honest, as beloved as the project was to us at the time, Ears was kinda short-lived and lacked focus and direction in terms of both sound and concept. There were a few good songs, though, with the more emotionally charged 'Scars' playing an important role down the musical road, and from the ashes of Ears, that split when Jab moved to Madrid, rose About Leaving."

With Jab leaving, Martí abandoned bass duties, picked up the guitar, and started sharing new ideas with Jaime, which led them both to soon become obsessed with Basement's 'I Wish I Could Stay Here' (2011) and then The Hotelier's recently released second album 'Home, Like No Place Is There', and from this, the new songs flowed in a direction that had only been briefly explored by Ears.

From the few shows that Ears had played, they had befriended Gabo, from the indie folk band Jilguero and although the fledgling outfit already had enough guitarists, they asked him to hop on board to see where they could take the songs. With Jordi still willing to play drums, the band only needed a new bass player, which led to Martí, who also happened to play drums for the indie rock band Ohios suggesting their bassist Joan, who became the final piece in the About Leaving jigsaw.

Maybe it was symbolic of their newfound musical freedom or a declaration of intent about the direction that they wanted to pursue, but whatever the reason, they took the lyrics of 'The Summer Ends', by foundational emo powerhouse band American Football as the name of the band and started translating Martí, Jaime and Gabri's initial ideas into feasible songs for a full band.

"Our focus was emotion, and a lyrical sense of nostalgia combined with the ambivalence of subtle melodic pieces and raw, unhinged musical passages, as we wanted to evoke and create the same sort of intensity and feeling that the bands who inspired us; American Football, Basement, The Hotelier, Mineral, Texas is the Reason, Elliott, The Promise Ring or Penfold, did and make the same sort of impression on the Catalonian scene that the much admired, and by that point much missed, Her Only Presence, had." Continued Jaime.

"That's why it made so much sense that, by the time we had a full-length LP figured out, we sought the aid of our friend Victor Teller, bassist of Her Only Presence, to help us with the production aspects of the recording. Working with him felt right, and he became a sixth member of the band during the summer months of 2015, during which his feedback and know-how helped shape our first album, 'An Echo', into something far better than it would have been without him."

Victor helped out with the release by taking the band under the wing of his own label, Pick Your Twelve, and then getting in touch with his friends at Engineer Records for help when the release was ready. The band finished the recordings and by November 2015 had their first, self-titled EP ready for release and followed it quickly with their debut album, 'An Echo', (IGN230) which was launched on CD jointly by Engineer Records and Pick Your Twelve Records on April 16, 2016, or as it was more commonly known, Record Store Day.

"Victor contacted Engineer Records' master and commander David Gamage. Honestly, we were so excited to be working with them. We had been following their work for some time and it seemed almost impossible that a UK/USA-based label would even consider signing such a small unknown Spanish band. But David really liked the record and soon we were part of the Engineer family."

Then came the gigs. About Leaving spent years trying to make their bones in the scene and spread the word about 'An Echo'. At that time, Catalonia had a couple of bands they could play with, such as Wann, Coherence, Please Wait or L'Hereu Escampa, who'd released a split purple vinyl 10" EP on Engineer Records alongside Her Only Presence back in 2012. But in general, people seemed to go for either a more classical and straightforward punk sound, or a more melodic indie rock vibe, that other bands seemed to encapsulate better, and for a group that consciously tried to walk a line in between those two worlds, About Leaving initially struggled to find their footing. They were, as good friend Luis Benavides, member of the Desert Pearl Union collective and a reputed musical journalist, empathetically put it at the time "Too mild for the punk scene, and too noisy for the indie scene". And at the time, it showed.

"We vividly remember being booked for a hardcore DIY festival, with a lot of passionate and dedicated punk bands. It was maybe only our fifth or sixth show, so we were ecstatic about being included in the line-up,

but when it was our turn to play, the mix of alcohol and euphoric intoxication got the better of us, and our feelings of inadequacy started creeping in when our most gentle and instrumental passages brought down the energy of the room. Or at least that was how we all felt at the time. We played horribly and people seemed to take that as an opportunity to go outside and smoke, drink or whatever, which we took as a sign and rushed through the rest of the set."

Quite soon after releasing the first album, Gabo had decided to move to Belgium to study and work on his art as a comic-book illustrator, so the band were 'one man down', which didn't exactly help their cause. That's not an excuse, but it did reinforce the idea that they had grown a little too fond of, and overly reliant upon, their 'too-many-guitars' line-up. Nevertheless, the band went in search of another guitar player.

Luckily, one of the light bulb moments that Victor Teller had during the recording of 'An Echo' was that he had asked Claudi, a bandmate of Martí and Joan in Ohios, who was visiting us for the day, to record some backing vocals for the end of 'Of Those Things (That I Say And I Shouldn't Say)', so he was already an honorary member of the band, and so his promotion to full-timer felt only natural. Everything seemed to click with Claudi and the definitive five-member line-up started working and sounding better than the band had since Gabo's departure.

A few really good shows followed, including About Leaving's Catalonian mini-tour with Wann, the first show with their now usual companions Coherence, and a particularly memorable gig at Parc de la Linera festival, in which friends and fans climbed up on the stage to sing the same backing vocals Claudi had recorded for the song 'Of Those Things'. It all culminated with a slot at Primavera Sound Festival, which was the fulfilment of the dream of every small band from Barcelona.

From then on, About Leaving continued making appearances at festivals and shows, but mainly focussed on working on new material as a band. The rocky beginnings of the group, with it having been formed from the dissolution of a previous band, and the couple of line-up changes that followed, had contributed to a kind of individual song-writing process, that meant Martí and Jaime would come up with pretty much finished songs and bring them to the band's weekly rehearsals. That changed in the run-up to the next record.

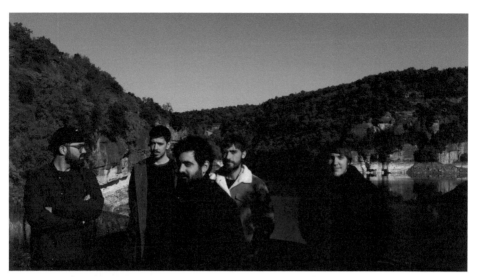

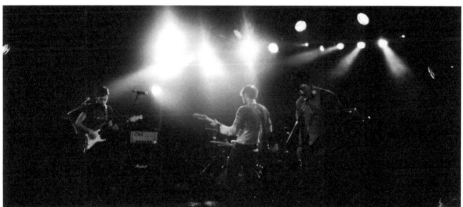

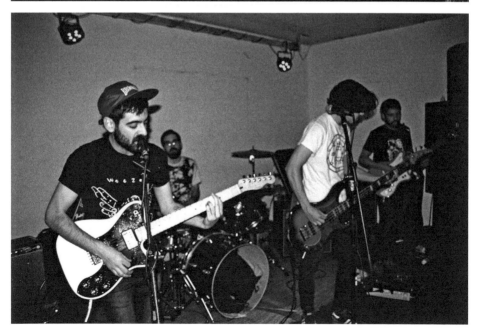

Abrigaries fest

ABOUT LEAVING / ALIMENT
DIEGO ARMANDO DJ / GÈLS
FOTOS DE LA NOVIA
FILLES EUROPEES / NIL NADAL
**DANIEL 2000 + NILE FEE + JOHN HEAVEN
+ JP SUNSHINE (MAINLINE)**
NARA IS NEUS / OMA TOTEM
REMEI DE CA LA FRESCA
ROGER USART I GUILLEM PLANA
ROBOT EMILIO / SABER / T.O.R.D.
TRILITRATE / YAUNEST
ULTRA-LOCAL DJS

4, 5 desembre 2021

**L'ORFEÓ — VIC
GRATUÏT**

ORGANITZA **LA CLOTA** COL·LABORA Els Vespres thalgastats AMB EL SUPORT DE Cassanyi

For the next couple of years, About Leaving bounced ideas off each other and wrote, rewrote, trashed, and recovered songs, lyrics, and melodies. Someone would come up with an initial verse and someone else would provide the chorus. An idea for a riff would arise mid-practice and from there they would all join in and play to see where it would take them. This new organic way of doing things instilled an interest in recording a new album internally, at practices, as a means of keeping things open to the possibility of change. Improving whatever needed it, whenever it needed development, by coming up with different harmonies, melodies, lyrics, and playing to the band's strengths.

This made writing an exhausting but rewarding process, and by the time the ten new songs were recorded, every member had contributed pivotal ideas to the new album and played a much more compositional role than they had on the previous record. Jaime recalled; "We weren't just proud of the record as a band, we ended up feeling much more connected to the material as a whole."

"We enlisted the help of Joan Peirón, from L'Orella Escapçada, to mix the new songs and, knowing that we already had support from Engineer Records for the international release, scouted a few national labels for Spanish publishing. We contacted a lot of labels, but ended up with, and became the first release on, I'm Not Going Anywhere Tonight Records, Navalla Discos, home of our beloved brothers of Coherence, and CGTH Records, a label from Galicia, in the North of Spain, who were known for having Mentah or Llacuna on their roster. They all really came through for us and we finally released our sophomore album, 'Sculptures of Water', on 12" vinyl in the summer of 2021.

The four labels pushed the record hard, it being the culmination of five years growth and new perspective for the band, and it was well worth the wait. Swaying from the gentle indie melody of Promise Ring-centric pop to Touche Amore-style screaming, this release had character and depth required for a must-have for any post-punk aficionado.

Since then, About Leaving have continued to make a name for themselves in the alternative music scene, although mainly in Catalonia and Spain, playing more shows with Coherence, Viva Belgrado, Please Wait, L'hereu Escampa, and Wann, as well as being asked to play infamous Spanish Rock Festivals such as Primavera Club, Primavera Sound, Parc de la Llinera and Il·legal Fred.

Their fellow countryman, Fernando Lamattina, wrote about About Leaving and 'Sculptures of Water' for **DIYtopia Collective magazine**, and his review says it all...

"There's no stopping my pen when I listen to this Fugazi-esque guitar! About Leaving's new stuff is just a massacre wearing an unhinged midwest-hairdo. A raging, armoured, emo assault. The kind I almost had trouble remembering. There are nice Mineral-tasting chords but with cadences that belong to the Sunny Day Real Estate royalty too, all coming together through uncontrollable influences.

'Feigning Colours' spits tears on your face from its very first breath. With the gain set to three at most, I still instantly become a fan of the maps they like to share, of the decomposed geographic lines they trace, of blurred frontiers amongst screams that aspire to be weeping between ochre octave harmonies.

I'd ditch school for 'As light', a song that plays as if part of the best Benton Falls repertoire. A mature emo voice, one so grown that it even starts to taste a bit grunge at the roof of the mouth. A song filled with 90's spirit, midway between Fun People and that evergreen emo from Catalonia with the BCore atmosphere that refuses to leave us. Bless them. I gear up into emo-punk speed and watch desert winged-demons pass by my side.

'Conversations in a car' sounds honest. Sadness overcome by salt-tasting smiles. Algernon Cadwallader arpeggios in Texas is the Reason rhythms. About Leaving has even added an uncomfortable feeling to it, the kind that every good Midwest-emo band should have. The one that can, consciously and beautifully, be faulty, true and carefree all at once. It really shows in the middle of 'Sculptures of Water', with songs such as 'If ever it falls' and 'Background Character' that stroll on landscapes that seem closer to Liverpool than to California. Sheer emo, even beyond their emo influences. A casual kind of emo, created by a recipe that turns About leaving into something truly authentic.

'The Hours, Their Weight' is the masterpiece of the whole sculpture. A song in which water fluctuates between its every state. A dose of incontestable personality. I can well picture some loser like me in the year 2040 saying that some newcomer band sounds like About Leaving. My favourite song of the album. I can't even begin to describe it.

'These walls' blows my head again with its sadness. That pure Mineral school

of thought shows its face again. An authentic harmonic bomb that hits the ground with powerful punch-like drums.

'Dance & Tremble' has a masterful bridge. A playful arpeggio that reminds me of This Town Needs Guns with a voice that feels like Nantes from Heavy Hearts. Each note brings me a new ingredient, forming a feast of emotions soaked with intention.

Rarity becomes banner in 'There, at that place'. Maybe the song that feels most stranded on the album. A good tune that takes me out of the suicidal voyage the rest of the album had put me in. Perhaps I should thank them. Schizophrenic pop that's hard to disentangle, but nonetheless offers true prowess in its last chorus, sodden in the good taste that permeates the record.

'That Girl, you know, the singer' is the perfect soundtrack designed for the album credits. A classy send-off built upon outro-like notes.

This is an album that I will treasure on my shelf, longing to hear again and again. I applaud this Catalan emo group for filling my homeland with long-missed authenticity.
Thanks for a great record; I'm a believer again.

"Barcelona's emo-rock heroes... Swaying from the gentle indie melody of Promise Ring style pop, through to Touche Amore screaming, this release has character and depth and is a must have for any post-punk aficionado."
Punk Rock Vinyl

"Reminiscent of cult bands such as American Football and Mineral."
Rockzone magazine

"The best kind of emo: pop and rock woven with guitars that dream and travel to the nineties and rage like unvaccinated beasts."
Binaural magazine

https://aboutleaving.bandcamp.com/

Adjudgement

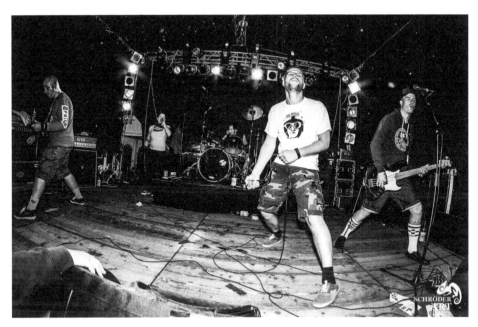

Marc Brodowski : Vocals
Markus Henke : Guitars
Wilko Brodowski : Bass
Ruven Brodowski : Drums

Formed in Hannover in 1993 by brothers Ruven and Marc, their cousin Wilko and close friend Markus, Adjudgement was one of the oldest, continuously active hardcore bands in Germany. Inspired by the likes of Agnostic Front and Sick Of It All, but bringing their own distinctive German additions to that NY Hardcore sound, they toured all over Europe for years and recorded prolifically, releasing four great albums, two EPs and never stagnating.

These four guys had known each other from kindergarten and at some point, in their teens, went to see Leeway, SOIA, Agnostic Front and Sheer Terror shows together. They then decided to form a band and play that same style of angry music with attitude that these bands had introduced them to. They became very good at it, and in a world where even the hardcore punk scene can be invaded by short-lived fashion and musical trends, bands like Adjudgement became increasingly more important.

Musically, Adjudgement has their roots in older-school hardcore, but musical development has always been their godfather. The band had its own sound and style. They had something to say. Their lyrics weren't just accessories and often contained personal impressions on socio-critical and political topics. As the band themselves say, "We'll write about what's important to us. Be it the filthy toilet from last weekend's gig or the overbearing exclusion policy of the Western states."

Adjudgement's discography includes the 'Kiss My Ass' 7" and CD on Lost & Found Records in 1996, 'And A Life To Come' CD in 1999 and 'Hedonistic Movement' 7" in 2000, both on We Bite Records, the 'Information Fallen To Rock Bottom' CD on Vacation House Records in 2002 and the 'At Two O'Clock' CD on PCS Records in 2003, where they brought in Anna as an additional singer to mix things up a bit.

In support of these Adjudgement have toured repeatedly throughout Europe for well over a decade, from Holland in the West to Poland in the East and all over their homeland of Germany, often being invited back by the promoters as they put on such a solid show. This is partly due to the bands line-up remaining constant for years. There have only ever been two line-up changes; Tim, who joined the band as second guitarist in 1997, just as they were playing an open-air show in Finsterwalde at one o'clock in the morning to four drunk punkers leaning on the stage built in the middle of a football pitch. He left the band in 2003. Another guitarist came in and played with Adjudgment at the With Full Force Festival in 2004, but soon left due to musical differences.

By 2006 Adjudgement had returned to their original line-up with Markus back on guitar and thus to their roots. This would see them produce their best album yet. Recording thirteen new tracks in February 2007 with Marc Dorge at Tank Records Studio in Wunsdorf, just outside of Hannover, where he'd already worked with bands such as Pittbull, Ryker's, Miozän and Jingo De Lunch. They created 'Human Fallout' and got in touch with Engineer Records about a UK / US label partnership, having got to know us through the distro selling their previous releases. The band and record producer Marc's own Tank Records would cover the release promotion in Germany and we would promote the album everywhere else.

'Human Fallout' was released on CD (IGN108) via Engineer Records (UK/US) and Tank Records (Germany) in July 2007 and proved massively

ADJUDGEMENT

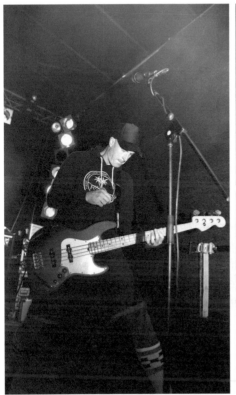

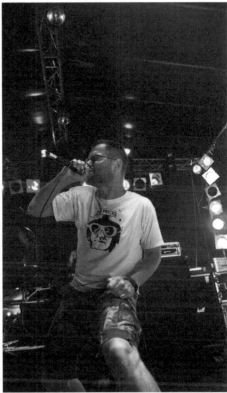

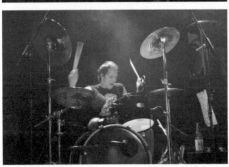

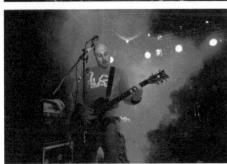

popular with fans of bands like Comeback Kid, Gorilla Biscuits, Bane, Grade, Poison The Well and The Promise. The record proved that Adjudgement would stay true to their hardcore roots.

In September 2013 the band brought in Anna as an additional singer to mix things up a bit and released their final album, entitled 'Bis hierhin... . und weiter', (Up to here... and further) digitally and on CD. Continuing to play gigs until 2017, when three new Brodowski babies were born and needed their attention, the band finally took a break after twenty-five years, but came back in December 2023 to play a final celebration show in Quedlinburg with their friends HC band, Isolated.

Joachim Hiller of **Ox Fanzine**, Germany's biggest HC zine, is a big fan of the band and wrote about 'Human Fallout' in his review; *"Adjudgement succeeds in giving each song its own character, and thus avoids uniformity. The fact that there is now only one guitar at work here is not audible with the best will in the world. Lyrically, too, the group leaves a lasting impression, because their lyrics deal with responsibility, problems of the penal system, growing poverty and one also expresses criticism of capitalism. In this way, they continue to pleasantly stand out from bands that do not consider it necessary to address such topics. They celebrate the fourteenth year of their existence with this new album, 'Human Fallout', to be released by the English label Engineer and the thirty minutes or so sound surprisingly punk-heavy at times but doesn't break with the hardcore roots of the Hanoverians."*

https://adjudgement.bandcamp.com/album/human-fallout

Amalia Bloom

Tommaso Capitello - Vocals
Ettore Pernigotti – Guitar & Backing Vocals
Federico Ceretta - Guitar
Antonio Donà - Bass
Stefano Rigo - Drums

This emotive post-hardcore quintet from Vincenza, Italy has been active since 2018, playing alternative festivals and paving their way through the hardcore scene with a profoundly powerful, melodic, yet delicate approach to the genre.

"Four of us used to play in a pop-punk band called Mr. Day, (named after the muffin brand), and Ettore played bass in a punk-rock band called Frode Alimentare (Food Fraud). Says Tommaso Capitello, the vocalist and lyricist of Amalia Bloom. "We met in our rehearsal space, which was Antonio's basement. His brother Andrea used to play guitar in Frode Alimentare, so we shared the same room for rehearsals."

"I think it was 2013 or 2014 when we first met and our friendship started to bloom, but by 2018 both bands had split up, so we decided to join

forces and Amalia Bloom was born. This band became our very first 'serious' project. We took a year to finish our first record 'Maiden Voyage' and we officially debuted as a band on February 16th, 2019. Six years later we're even more motivated to keep this project going than we ever have been."

Every song on the bands powerful, eight-song, debut album tells a story and in fact, the release could be called a concept album as it weaves a tale throughout. 'Maiden Voyage' is built around the legend of a boy who unintentionally escapes the humdrum confines of reality and explores the infinite possibilities of fantasy through the comfort and security of his dreams. Exploring populist ideas of loneliness and the disassociation that walks hand in hand with it.

Feeling lost and alone, despite being constantly surrounded by people, 'Maiden Voyage' is a beautifully intricate and expressive record that is as emotionally resonant as it is intelligent. In a world plagued by fear, loss and uncertainty, with 'Maiden Voyage' Amalia Bloom tried to offer the one thing that everyone, whether they know it or not, craves: Hope.

The record was released on digital, CD and LP formats in April 2019 jointly by five partnering labels; Engineer Records (UK / USA), Rabat Joie (Spoilsport / Killjoy) (Canada), Missed Out (USA), Non Ti Seguo (You Lost Me) (Italy) and E'Un Brutto Posto Dove Vivere (A Bad Place To Live) (Italy). It has beautiful artwork of a boy staring out the window into space and the vinyl version came with a separate lyric booklet, reading like a short story of the concept.

Tom added, "Right from the start David proved to be one of the most enthusiastic people about the 'Maiden Voyage' record. We produced vinyl and CDs together and did the same for our latest album, 'Picturesque' and throughout this journey, Engineer Records has always been available, even just for advice, and for that, we are immensely grateful."

Making music and playing concerts, are Amalia Bloom's very favourite things to do, and it's clear that nothing else even comes close for them. "We love to spend time together as friends, but when we are together, we tend to work on our music, and even if we are not playing, we talk about it all the time. It's pretty much all we think about most of the time."

Discussing the band's influences, Tom continued, "Musically speaking, I think that, so far, Touché Amoré is the band we are inspired by the most, along with Birds In Row, Poison The Well and Defeater for our heavy side. Brian Fallon and The Gaslight Anthem, Death Cab For Cutie, Elliot Smith, Big Thief, The Menzingers, too. Then lyrically, I guess the artists who influenced me the most are Trophy Eyes' John Floreani, especially the 'Mend, Move On' and 'Chemical Miracle' era, and Enter Shikari's Rou Reynolds. Their lyrics have been an inspiration for years. But now both my tastes and their music are changing, I don't relate in the same way to most of the bands that I listed above anymore."

Heavily affected by the covid lockdowns, the band had several gigs and tours cancelled, but still managed to continue writing and recording, releasing 'At Eternity's Gate' as a digital single in 2020 and 'Alive, A Ballet', a live recording EP, on cassette in 2021. But the big release would be the 'Picturesque' album in 2022, coming out on vinyl LP and CD through Engineer Records (UK), Sell The Heart Records (USA), Fireflies Fall (FR), and Dingleberry Records (DE).

"Our last record, 'Picturesque', was so far our most important one." Continued Tommaso, "Thanks to this record, we were able to understand how a band actually works, and how a recording studio works (we had never been to a professional studio before) which made us become better musicians and a better band. When it comes to references for Picturesque, I think that we can refer to the bands I already talked about earlier. 'Lament' by Touché Amoré, both 'Personal War' and 'We Already Lost The World' by Birds In Row, as well as 'The Blue & You' by our fellow Vicenza band Regarde, were the records that helped us to find the sound and style for our latest release."

For their new songs, Amalia Bloom are approaching the writing process in the same way, but at the same time incorporating more influences from other genres. Tom says that he's now listening to a whole lot of different music, incorporating the elements of various artists in his songwriting such as Ovlov, Viva Belgrado, Italian singer Elisa and Boygenius. Their new music may be a little cleaner, but it remians energetic and powerful. "We don't plan to abandon our harsh, hardcore side by any means, but we do aim to be more versatile."

Knowing they were booking another tour to support 'Picturesque' I asked Tom about the local HC scene in Vicenza, Italy and Europe as a

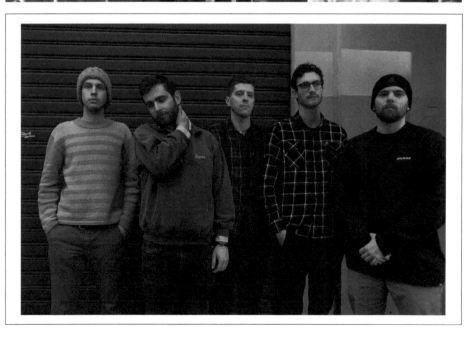

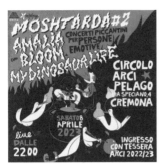

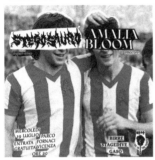

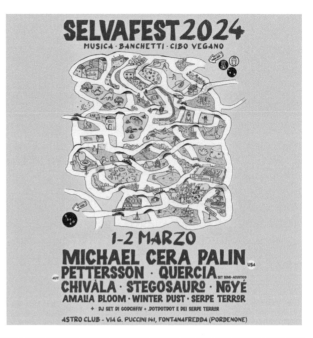

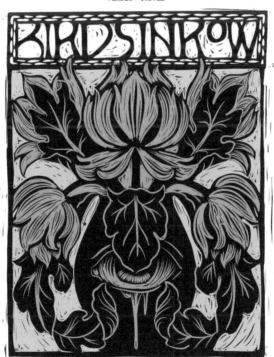

whole: "Our local scene is more vibrant than ever. The problem is that there's a lack of spaces, both DIY and more corporate, where bands can play, and collectives can host concerts. Our province has always been a very active territory for art in general and now, there are a lot of people creating art and making music. Ultrasaturated, Stegosauro, and Norman Bates are just some of the amazing bands that make up our city scene. In 2022 we played three hometown shows and all of them were epic, people were singing along, stagediving everywhere, and our merch sold well."

Tom added, "Our very first international show in Graz, Austria was one of my favourites. We played at SUB, a DIY space dedicated to punk and hardcore. Steven, a friend of our friend Alberto (singer/guitarist for Stegosauro), who was living in Graz at the time, decided to have his birthday party at our concert and fifty or so people showed up and we all had the time of our lives, even if the public wasn't the typical punk/hardcore crowd, they were all dressed in party mode and having a lot of fun. Hands down one of our favourite shows ever."

"I don't think any current bands in our hometown have a similar approach, as we've always tried to make sure our music was heard in foreign countries from the very beginning, while most of the bands that are in the scene right now are dedicated to the Italian scene. This doesn't mean we don't have an interest in the Italian scene, on the contrary, we just never found a good place where we could fit in our home country. Which is why we recently started to work with our dear friends in Grato Cuore (Grateful Heart) booking agency who are going to help us try to play around Italy more."

During Amalia Bloom's first European tour they played in Amsterdam. The venue was an artistic space which was open to musicians, painters and anyone who wanted to support the scene and its initiatives. That night they were the only band booked to play. "We loved the view of the canal and the vibes of the place, and we were proud to have come to play so far from home. At the start of the evening, the venue had organised a rumba dancing lesson. What can I say. We rushed in! Three hours before the show we were all doing crazy group dances and the positive energy that was in the air was something wonderful. We had never had such an experience."

"We strongly believe that this thing we do is much more than music. It's a symbol of unity and mutual respect, as well as a promise we made to

ourselves of always being there for each other as brothers. Musically speaking, we don't like to label ourselves in any way (especially because we genuinely don't know what to say), but we do identify with punk and hardcore. There's no other genre in the world more than punk that strongly clings to, represents, and is represented by values of solidarity, inclusivity, and friendship. If people are feeling alone or hopeless, we believe that this kind of music functions as a shelter for anyone facing hardship or tough times. Punk has a very important duty towards society, in that it encourages critical thinking and social consciousness, so, in my opinion, as long as there's bad in the world, punk will be needed and will thrive, as a means of protest, critical thought and as a point of mediation, as well as a safe harbour for anybody who needs help."

Amalia Bloom published a double single in October 2023, 'Afa' and 'Fatigue', released independently only on streaming platforms. The band says that these songs represent a transition between what was 'Picturesque' and what will be their next album. Tom adds, "Our personal lives are changing fast, we are becoming adults without even having time to realise it and we do not know what this band will be in the future. We only know that we have a sincere desire to find out and we will continue to write music for a long time, trying to make sense of all these changes in our lives through our songs."

"A peculiar mix of punk rock, hardcore and emo through which they search for a personal, overwhelming, and often visceral sound, combined with nostalgic lyrics, screamed or whispered with energy, strength and intimate passion."
Velvet Thunder magazine

"This expansive offering showcases the band's ability to strike a delicate balance between melodic elements and harsher, more aggressive sounds. The album serves as a heartfelt dedication to their beloved yet struggling city, acting as a cathartic medium to express their emotions and respond to the isolation they experienced in recent years."
Punk-Rocker.com

"Amalia Bloom's first album 'Maiden Voyage' brought a profoundly powerful, yet melodic and delicate approach to the genre, and was available on both 12" vinyl and digital CD. Their second release, an EP entitled 'Alive, a Ballet' kept them going through lockdown, and now this beautiful new post-punk gem of an album, 'Picturesque', will rank among your favourites of the year.

'Picturesque', the second studio album by Amalia Bloom, has a layered but direct sound, light and airy in the melodious moments but granite dense in the growing intensity. The band has become self-aware and owns the space of every element on the stage as in the song itself. A must-see band live who are about to take on a tour of Europe."
Frontview Magazine

"An original and great journey for the ears and mind of the listener. I listened to this album on a sunny, quiet Saturday morning. Being home alone, I just closed my eyes and let the music take me to other places. This is a great record, showing how hardcore can be both diverse and original, and that is the beauty of it all."
Kraykulla Webzine

"Relentless energy through dense guitar shreds, massive enough to crush everything in a wide radius. Both heaven and hell through a tremendous polyphonous experience."
Thoughts Words Action

"Floating guitar sound carpets that provide the necessary emotional framework in between spoken word or blast beats. Extremely diverse and entertaining."
Ox Fanzine

https://letamaliabloom.bandcamp.com/music

Antillectual

Willem Heijmans: Vocals and Guitar
Ben Joosten: Bass
Riekus Van Montfort: Drums

Hailing from Nijmegen in the Netherlands, Antillectual play a socially conscious, melodic blend of punk rock that incorporates influences from every sub-genre of the scene in order to create something a little out of the punk ordinary. The powerful three-piece blend stolen riffs and borrowed choruses in a glorious maelstrom of anti-authoritarian fury that they call Antillectual music.

Formed by a bunch of friends who didn't really know how to play, and for the most part hadn't picked up an instrument before they entered the practice room in 1999, the membership of Antillectual remained in a constant state of flux until they played their first show, back in 2001.

They started playing, as most bands do, because they fell in love with music, and wanted to forge their own take on the thing that they adored above everything else. Brought together by a mutual love of 90s skate punk, the Epitaph/Fat Wrecks sound that took the world by storm, and

the faster, more technical bands like Satanic Surfers, No Fun At All, Millencolin and Dutch bands like Undeclinable, Heideroosjes, and I Against I, only to later discover emo and the No Idea/Orgcore sound that was created by Leatherface, Hot Water Music, and their contemporaries. The end result of all of those influences all converging in the same practice room? That is Antillectual music.

None of that should have surprised me, as Antillectual was born and raised in a world-famous enclave of Dutch punk rock. Nijmegen is a city that has always been politically left of the dial and is a haven for students, free thinkers, and intellectuals. Even before Antillectual emerged from its highly charged punk rock scene, Nijmegen was the place that Bambix, The Bips, and later Brat Pack called home.

Antillectual already have more than ten releases to their name. Beginning with the 'Silencing Civilisation' LP on Angry Youth Records in 2005, proceeding through a load of great EP's, including a split with Anti-Flag, and the 'Testimony', 'Start from Scratch!', and 'Perspectives and Objectives' albums, up to their previous collective favourite, 'Engage', released in 2016 on Redfield Records, and summing up everything, musically at least, that the band were at that stage. Since then, the EPs have continued, with the most recent being the excellent 'Covers' 7", released by Engineer Records and others in 2020, and featuring Antillectual versions of songs by The Police, The Ramones, Blondie and The Stooges. These prolific releases have culminated, so far, in their latest record, the 'Together' album.

I've been a fan of the band and in touch with Willem, their singer and guitarist, since their 2011 tour with Static Radio, but the first time we managed to work together on a release was the 'Covers' EP in 2020. I was stoked to be involved in that as I was really into the songs they'd chosen, and sure enough, all the copies we had sold out quickly. So I was even more pleased to be involved again with the band's new 'Together' album launch in 2023.

'Together' was released worldwide on LP, CD and digital formats jointly by over twenty record labels, all friends of the band, including Engineer Records, in a very punk-rock style Do-It-Together co-operation. This ten-track rocker would bring a host of new tracks to the top of the Antillectual live playlist. The theme of togetherness is woven throughout all the songs on the album, capturing the feeling that current day

problems can't be solved unless we all work together to fight them with our combined forces. It's a clear message that Antillectual aren't about to start slowing down anytime soon.

Talking about records naturally led us to chatting about shows, as that's where Antillectual feel they belong, one stage in front of a crowd, doing what they love to do, and do best. Playing Antillectual music. We started talking about gigs, which in turn led to the band telling me about what they think are the best, and worst, shows they've played. Willem, the singer and guitarist, told me, "No specific single show comes to mind. We've played over 1,000 in total now, but album release shows are always very memorable. As was Yvo's farewell show, our original bass player."

"Every year we host Friends First Fest, between Christmas and New Year's Eve, which is the best way for us to end a year, in a sweaty basement with all our hometown friends. We'll also never forget touring with Propagandhi on the same nightliner bus or playing to about 8,000 people supporting Rise Against in Düsseldorf. Manchester Punk Fest in 2018 was also incredible, as was playing Jera on Air, KNRD Fest and PunkRockHoliday. It's a long list."

And the worst gigs? "They're always the ones with a smaller crowd than anticipated, or without a significant audience at all. This is often followed by not having a proper place to sleep, making the show the next day harder as well. But the worst shows are the ones you can't give 100% because you're sick, or you blew your voice out the night before."

As soon as they'd finished telling me about the shows, the Antillectual trio began to discuss another familiar topic, the strange and wonderful stories that they've ended up being part of. With more than twenty years of history to their name there's a lot of stories to tell, so here are just some of them...

"Over ten years ago, June 2010, we played Subversiv in Berlin. A DIY place, supporting a lot of political activism, and a friendly place where we felt at home immediately. We were booked together with a local band called Smile and Burn. We didn't know them, never even heard of them. As I said, we love autonomous venues, but they sometimes come with interesting line ups. For some reason we expected a highly political, raging hardcore, crust, grindcore or powerviolence band that night, and we weren't sure if our melodic punk-rock would fit in well. What would this night bring?"

"Smile and Burn started before us. And when they began, they blew our socks off! Catchy and poppy melodic punk rock with a singer that was jumping around with a huge smile on his face and singing his lungs out. Their set was solid, tight and funny. They were one of the best German bands we had ever played with, seen, or even knew. After they ended their show with a pop-punk cover of the Baywatch theme (yes, the tune of the 90s series!), we weren't sure if we could fill the hole they left on stage. I think we did, and we had a fun night, together with and because of, the people in Smile and Burn."

"A while later they released a new album. The anticipation for it was very high on my end, the impression that they left live had raised my expectations for the recordings. And maybe my expectations were raised a bit too high. I loved the record and the songs on it. But it didn't recreate the energy and the vibe that I experienced in that squatted basement. I'm not even sure if that would have been possible. When a review of that album was posted on AsIce.net (the Netherlands biggest punk/hardcore ezine of that time) I wanted to support our Berlin friends, their album and especially their live show. So, I posted below the review: "Toffe plaat, live nog toffer!" Or something similar. Meaning; "Great album, even better live!". They are some of the funniest yet smartest people in German punk-rock, so I think they got what I did there, and they put that quote, in Dutch, on a sticker and spread it all over Europe."

"The bottom line is expectations, that's what it's all about. Smile and Burn are (still!) a great band, but me expecting something completely different that night at Subversiv made their set extra special. This night made my expectations for their next album unrealistically high. Either way I never expected that my Dutch Compliment made it to a sticker!"

As Antillectual were about to start yet another European tour, supporting an American band, Static Radio, I asked them what they expected of the tour. They told me that next to the shows, visiting new countries and meeting new people, one thing they were really looking forward to was the German Autobahns. "You can go as fast as you like there". When the tour was over, we caught up and I asked them how it went. They really enjoyed the shows, and the people, but didn't get to see much of the racetracks they were expecting. Even after driving from Vienna to Cologne to France, it all seemed like normal motorways to them. Never achieving the mythical status of Formula One racing with cheering audiences standing roadside and checkered flag finishes before the

venues. "Touring Europe is awesome, but the Autobahn isn't what it used to be."

A good way for bands to get around Europe is by 'exchanging' tours. You and your band book a tour for two bands in your region, then the other band returns the favour in their area. Antillectual did that many times and had great tours in far away places they otherwise would never have visited. At one point during a US tour, they were loading out the backline when the bass player of the other band complained about the weight of the bass cab, a 4x10. They warned him that it would be way worse if they come to tour in Europe. "Why is that?" the US bassist asked. Willem added, "We initially meant that we had an 8x10 bass cab, which was obviously heavier to lift. But instead of explaining that those narrow French basement venues can be a pain in the ass when carrying around an 8x10, we ended up telling him that 'Gravity in Europe has way more effect and something of the same weight is definitely heavier in Europe than the US'. Something about being closer to the core of the earth, an explanation we didn't even consider believable ourselves. Unexpectedly it actually took him some days before yelling at us that he didn't believe it and we were full of shit. Ha, a pre-cursor to the 'fake news' that is everywhere now I guess."

Willem continued, "We love playing in Germany. The venues feed us incredibly well. The cooks are usually very friendly too, and there is always seconds if you can speak good enough German to ask for it. More than half of our shows happen in Germany, we love the German scene and its people for supporting the music they like, and the bands they love. People in the scene love bands even after the hype is over, they support them by buying their albums and merchandise, and by giving them attention online. Their dedication persists over a long period of time. So, nothing but love and appreciation for Germany's punk scene. But there's one thing about playing Germany that makes it unique in another special way. The German Compliment. NOFX wrote a song about it, and we've had our fair share of them."

"There are generally two things you will recognise in a German compliment. Obviously, the German accent, but also a very heavy 'BUT' halfway through the sentence. Right in the middle of the actual compliment there will be an honest, yet confronting tip, critique, or suggestion. German philosophy is known for its long sentences, so it's no surprise that the German compliment continues in this tradition.

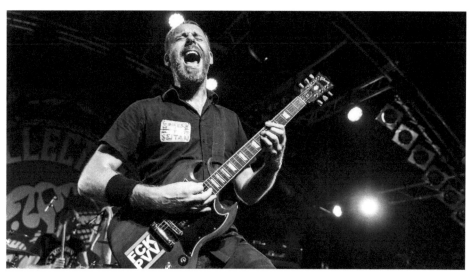

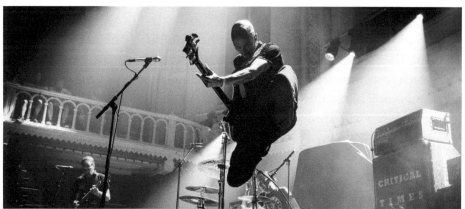

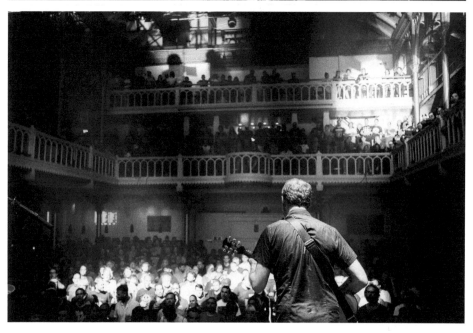

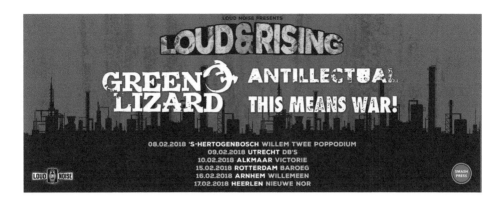

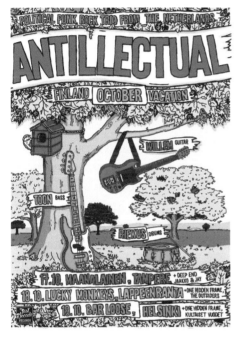

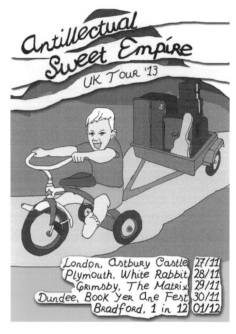

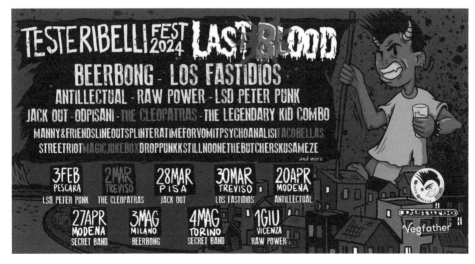

Most recently a compliment that came our way was hidden in some well-meant advice. A big fan of the German band we played with came up to me and said he really liked the show, but, the reason we didn't get the crowd going was because we played a mix of 'Rock, Metal und Paaank'. He ventured that as soon as we make up our mind about what musical genre we wanted to play, the crowd would love us more and go crazy during shows. Another typical compliment was given to us about how tight we played live, but, the person handing us the compliment didn't really like our records, as they sounded too clean."

"There was one occasion when I thought I was one step ahead of a German compliment. Someone told me 'I thought the new single was awesome when I heard it live first, but ...' so that's when I expected the German compliment to begin, but he continued 'but, when I heard the recorded version, I thought it was absolutely incredible!'. So don't be fooled, not all German compliments bear the same caricature."

As our conversation drew to a close, I asked what the band thought about punk-rock and the scene currently, and they were more than happy to share their take on both. "I'd like to say that in an ideal world this band would not exist. But as long as there is stuff happening in our society that suppresses people, and as long as people listen to music and go to shows as an outlet for their daily lives, music / culture is something people can't live without. And when this outlet is not only a way to be distracted and have fun, but also a medium to criticise the way things are going in the world, a means to express opinions, then there will always be a need for punk and hardcore. And in today's day and age with the far right spreading crazy conspiracy theories, with racism, fascism, and populism gaining ground, a climate in distress, and animals still being treated as commodities, counterculture is more important than ever."

Mangorave reviewed the 'Covers' EP saying, "*Antillectual's newest release is a 7" vinyl containing four cover versions. The idea the Dutch band had was to cover four songs that had a strong impact on early day punk-rock. Instead of paying homage to the bands that influenced the Nijmegen-based trio themselves, they preferred going back to the beginnings of Punk Rock Culture. The outcome are four classics reinterpreted in the melodic and somewhat Mod-influenced style of Antillectual.*

The cover arwork by Andy Dahlström of Satanic Surfers shows four pictures of Antillectual based on the four originals. The beautiful thing about this cover

is that you can wrap it around the vinyl record whatever way you want. It will always show two of the artworks.

The first song is 'Truth hits everybody' by The Police. The song released in 1978 by Sting, Andy Summers and Stewart Copeland comes in a dynamic new version that does not deny its original melodic sound. Antillectual perfectly hit the interface between Mod, Pop and Punk Rock.

Next up 'I believe in Miracles' from the Ramones' eleventh studio album 'Brain Drain' (1989). Ramones fans might know that this is not the first time the song was covered. Andy Vedder, Zeke and Pearl Jam love to play that one, too. The tempo and intensity of Antillectual's version are pretty close to the original, but the Dutch trio rewrote the song more melodic and the chorus is way more harmonic.

The B-Side begins with 'Hanging on the Telephone', written by Jack Lee and performed by The Nerves on their self-titled EP in 1976, and later covered by Blondie in 1978. The version by Antillectual is beautifully dynamic Mod Punk. Music for missed calls and canned beers. The Surf Rock impact from The Nerves' version was almost completely abandoned. Instead, Antillectual's 'Hanging on the Telephone' is closer to Blondie's version – even the ringing of the phone was implemented in form of a vibration alarm. But still, Antillectual's version is way more Punk Rock.

Last but not least, one of the biggest classics for early-day or Proto-Punk. 'Search and Destroy' by The Stooges from their third album 'Raw Power' (1973). Not as fuzzy, not as rusty as the original, the Dutch trio reinterprets the Anti-War song. If The Stooges were Mods and they would record the track in contemporary days this might be what it could sound like. Planning a Punk Rock Party soon? The 'Covers' EP should be part of it."

Willem added, in an interview with **Salad Days** magazine, "*When the cover idea surfaced we didn't feel like covering the bands we grew up on. Most of them are still around or reunited. It seemed much more interesting to go back some more generations and find early punk songs with a melodic vibe to them.*"

The cover artwork consists of adaptations of the four original layouts, re-designed by Andy Dahlström (Satanic Surfers). The rhythm section was recorded live by the band's sound engineer Emiel Thoonen. Vocals, guitars and hammond are recorded by legendary Dutch producer Menno Bakker

(NRA, Seein Red, Undeclinable Ambuscade) at Amsterdam Recording Company. Dubs and edits are kept to a minimum, this is as raw/unpolished as Antillectual gets in the studio.

And **Thoughts Words Action** commented about 'Covers', "*This politically charged punk rock trio has been a powerful catalyst for intelligent melodic music for quite a while. The group solely focuses on the importance of being socially aware in the times when mankind easily lacks compass over its actions. Their music serves loads of thoughtfully detailed insights on how to prevail the problems of contemporary society and reach a harmonious outcome for all the participants. Antillectual has provided their thoughts on these topics through numerous full-length records and singles, distributed by loads of great recording labels, so their message has been heard all over the globe. However, this time Antillectual has decided to experiment with a slightly different approach, so they alerted all the possible participants to crowdfund their highly anticipated Cover 7" record. The band has discreetly picked four numbers they grew up listening to and decided to cover some prominent heavyweights such as The Police, Ramones, Blondie, and The Stooges.*

The Covers EP has been backed up by various labels such as Fond Of Life Records, Geenger Records, Guerilla Asso, Lockjaw Records, Engineer Records, Morning Wood Records, NoReason Records, Mud Cake Records, Shield Recordings, Thousand Islands Records, White Russian Records, Keep it a Secret, Lensen Industries, Bad Mood Asso and SBÄM."

When 'Together' came out **Thoughts Words Action** declared, "*Together is Antillectual's mission statement to convert social urgency to catchy punk rock. How can you not be engaged as the world burns?!*"

Punk-Rocker.com added, "*With Together, Antillectual has shown that punk rock can still be relevant, forceful, and inspirational, showcasing that art can make a positive change.*"

And **Dying Scene** volunteered that the album "*Combines four previously released singles with six brand spankin' new songs. The album is out now. Check it out and get a physical copy from one of the 20+ labels who released it worldwide. Thousand Island Records has copies in North America, Black Star Foundation's got our Swedish friends covered, if you're in the Netherlands you can grab a copy from White Russian records. The possibilities are truly endless!*"

There are track by track liner notes with the album written by the band and starting with the opener, 'Together', advising us all that, "Recent events have revived the age-old belief that you can achieve more together than alone. This goes for both global events, the music industry and the way we deal with our band."

"Climate change, #MeToo, Black Lives Matter, the Covid pandemic and the war in Ukraine are the most important issues we've been facing on a global level lately. Each of these can only be solved by taking action together. We can't stop global warming unless a great majority of the people is involved. A dissonant relation between gender types can only be restored if all support a healthy balance. Disadvantaged groups in our population can only get the right amount of respect if people outside those groups recognise the value of treating others with dignity, if both groups decide to tackle this problem together. And only together countries can fight an invasion of another country."

"The current situation in the music industry in general and the punk scene in particular forces people to work together as well. The traditional roles of bands, musicians, labels, distributors, bookers are fading, if they ever were clearly distinguished in the DIY scene at all. Social and personal media have been taking over the role of mainstream media. The democratisation of the musical landscape has created an opportunity that can be both a blessing and a curse. Bands can only spread their word and music together with partners and supporters, instead of via just one major label."

"Since 2018 we have been releasing individual songs as singles. We didn't feel like creating a new album in the traditional way. Now that we have recorded and released a bunch of songs, we feel like putting them together so people can enjoy them the best way possible! We have never really released music the standard way, and this album is probably our most unconventional release to date. We hope to spread this release together with you. Do it Together. Teamwork makes the dream work!"

https://antillectual.com

Argetti

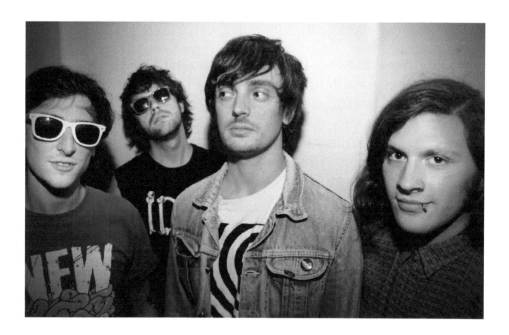

Guido Becchetti : Vocals
Enrico 'Punch' Pancera : Bass and Vocals
Marco Mantovani : Guitar
Enrico Belloni : Drums

Argetti were an Italian punk-rock quartet formed in 2004 by two school friends, Punch and Enri, and two older punkers, Guido and Marco who had made their bones in the scene at a multitude of local shows. They mixed influences from bands like the Ramones and The clash with a 90's emo / melodic hardcore sound and toured Europe with the likes of The Rituals, Settlefish, Dufresne and Forty Winks. Argetti released two albums, 'In My Shoes' on Goodwill Records in 2005, and 'Flags of Karma' on Engineer, No Reason and FastLife Records in 2008. And then a final EP, 'New Seeds' on Engineer and No Reason Records in 2011. They played nearly 300 shows all over Europe before calling it quits in 2012.

I caught up with Punch a while ago and while we were laughing and reminiscing about old times, he shared some of his favourite stories and thoughts about the scene with me.

"We were cool kids discovering Europe with our music. In 2009 we booked a couple of gigs in England with our dear friend Kevin and his band Die Emergency. The first time we toured England we travelled in his car with him as a driver, with no backline at all; we only brought a bass and a guitar with us and were always asking other bands if we could use their equipment."

"The second UK tour was longer", Punch told me, "Our roadie Mich came with us. It would be his first time in England, and he and Kevin decided to rent a van. You can guess what our faces were like when walking outside Leeds airport, we discovered that the van was a commercial one. No windows at the back, not even the little one between the back and the front of the vehicle. The day after we went to pick up Die Emergency, and took the pillows from the bass player's couch to make the back of the tour bus a little more comfortable. We spent an entire week with three people up front with seats, and six in the back, just rolling around with no seats."

"I remember our roadie, asking if he could at least see Sherwood forest, and of course, Guido, our singer was never in the back of the van with the rest of us, but he is kind of posh.
We were touring Greece with a super old and stylish Ford RV from the 80s and after we played the Athens gig Guido was flirting with a Greek girl, so we finished packing all of our stuff in the van and made him say goodbye. We were on our way to the place that we were staying at and out of nowhere the girl Guido had just met started following us, so while we were driving a huge RV through the tiny streets of Athens which was pretty hard, we were also trying to communicate with someone in another car, which was just crazy. Finally, we understood what she wanted and the two swapped their numbers, like in the movie Speed, they did it while we were driving. I still have no clue why we didn't stop to let them swap their numbers in a parking lot."

Touring in Poland, Argetti's third gig was in a little village, close to the German border. "We played in a kind of cultural spot for kids. Afterwards we discovered that all the crowd was sleeping in the building with us, and beds were assigned first come first served basis. We decided to celebrate and party hard with the 'delicious' local wine. When we'd finished all of our newest favourite beverage, the promoter said that there was no problem, he would be back soon with more drinks. Hours later we saw him coming out of one of the most dense fog we've ever seen, riding a

mule, with more goodies in wicker baskets. The party went on with the only food available, raw onions."

"We were promoting our first full-length in Northern Italy, close to the Austrian border. People there speak text-book Italian with a strong German accent, and just this was pretty funny. The support band was an almost unknown band from Verona, it was the first time we met them, but we were getting along super well and after the show, we partied at a village festival close by. It was incredible, there were thousands of people in a huge tent and millions of unattended, unfinished beers. As humble punks from abroad, we thought we'd save a lot of money by drinking their leftovers and ended up asking everyone if they knew the local legend, Adolf Hitler."

"The next day, we were hugely hungover and the night before we'd crashed one of our cars into a tiny wall and had driven back to our hostel on a flat tyre. It was Sunday so no garages were open; we waited for several hours for one of the organizers' friends to come with some tools. When he arrived we couldn't remove a single nut cause they were stuck, so he came back with new tools we managed to change the tyre but then discovered that the spare wheel was flat as well, so the promoter had to come back for a third time with a fixed spare wheel, and to this day, we still hang around with Gabbians, the band from Verona."

"When we were touring Germany for the release of our last EP as a three-piece, Guido, our singer, was no longer with us, and I was still learning how to sing the songs he had written, so we had a pretty short setlist for a headlining tour. Somehow at one show, we were the only band playing at the venue so the promoter asked us to play for two hours (our normal set usually lasted 30/45 minutes) and we ended up playing the same set three times in a row."

"We played in Ostrava, Czech Republic a couple of times, and Stanley, the local promoter, is such a great guy! The second time we arrived there were a lot of people at the venue. Pretty excited we watched the local opening bands and the club kept filling up, but when we got on stage, the place emptied Pretty disappointed, we finished our songs thinking that people had shown up for the other bands, but as we were cooling down and hitting the bar we discovered that everyone was outside fighting a group of Nazis! Luckily the Nazis took flight and the kids said that our set had been the perfect soundtrack for the fight, and they kept telling

us how great our performance had been. We slept at Stanley's place and went to see his band's practice room at his dad's factory the next day. His parents were there, and, after a tour of the factory, Stanley's dad forced us to have lunch with them, and we ended up drinking the strong local spirit, Slivovitz, like water at eleven in the morning."

We had Argetti's 'In My Shoes' CD from Adam at Goodwill Records (he's now running No Plan Records in Berlin) in the Engineer Records distro. We liked the release and it was going pretty well so we made contact with the band via their new label in Italy, No Reason Records, and agreed to co-release the new album, 'Flags of Karma' on CD (IGN122) with them and FastLife Records in Japan. We pushed the album hard and later released Argetti's third and final CD, 'New Seeds' (IGN166) again alongside No Reason in 2011.

There's no doubt that Argetti had some good times touring around Europe. For some of their stories I guess you had to be there. But the band have broken up now and I asked them why. "Nowadays the local punk scene is almost dead, and way fewer people go to concerts or care about live music. It's such a shame, but I guess nothing lasts forever."

Punch still plays in a band called Hearts Apart, Marco played with a band called Trifle for a while, Enri became a promoter and runs Occasional Disaster Booking, and Guido is now a tattooist. If you want to get some ink from the man himself, you can find him at the shop he owns and works in, Ladies and Gentlemen Tattoos in Vicenza.

In a live review **Disagreement.net** said; "Argetti are fond of fast, straightforward songwriting, providing catchy choruses that instantly hook themselves in your brain. Even their harder material retains a solid melodic foundation. They play mostly fast songs and are great fun."

Rockshock.it added that they are; "A good balance between energy in a sunny climate and darker, bitter, suspended content. Strongly influenced by punk and hardcore."

And when Germany's **Ox Fanzine** reviewed 'Flags of Karma' they said: "Argetti deliver well-mannered, melancholic punk-pop with twelve songs that breathe the spirit of the 90s. You'll be reminded of bands like Jawbreaker or At The Drive-In."

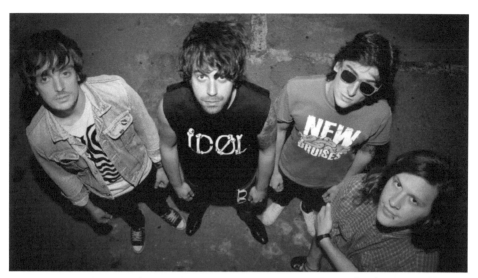

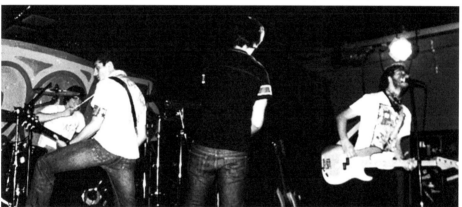

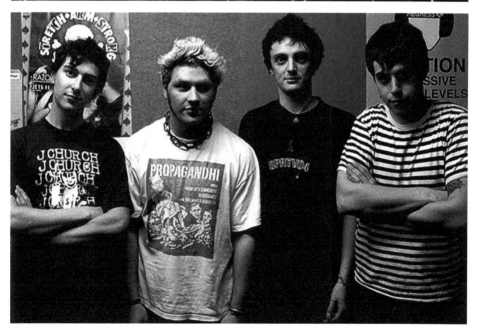

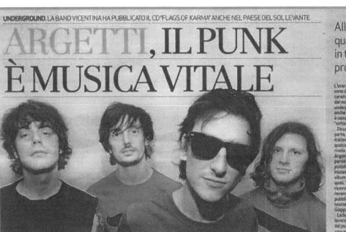

ARGETTI, IL PUNK È MUSICA VITALE

All'inizio di dicembre i quattro musicisti saranno in tournée in Olanda per promuovere la loro musica

L'energia e la voglia di fare sono da sempre una caratteristica fondamentale del mondo della musica underground in tutti i Paesi, anche se in Italia la situazione è sempre stata un po' più "sotterranea" dell'usuale.

Da un po' di tempo a questa parte, invece, nel garage italiano si sta rimescolando qualcosa e anche il Vicentino rivela realtà interessanti. Gli Argetti sono una di queste, partiti nel 2003, hanno pubblicato, finora la parte un iniziale demo di tre brani) due album compiuti. L'ultimo dei quali, "Flags of Karma", ha riscritto ientplasticche recensioni arrivando alla pubblicazione, la primavera scorsa, addirittura in Giappone.

La band vicentina sta lavorando sotto soprattutto dal punto di vista dei concerti suonano anche nelle

prossime settimane un po' in tutte il centro a nord Italia, ma anche in Paesi stranieri, come in Olanda, ai primi di dicembre.

L'occasione per noi per vederli all'opera dal vivo sarà il prossimo sabato 14 novembre all'Younbar MusicLab di Thiene, dove i quattro suoneranno nell'ambito di una tournée chiamata "Rock Your Weekend Tour" assieme a Dulivana (altra bella realtà indipendente vicentina) e Forty Winks, P&G III.

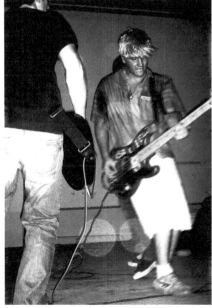

With Italy's **Rock-On** adding; "Twelve tracks of tough and fast hardcore, filled with introspective and sometimes political lyrics. A batch of devastating songs that do not give a moment's respite to the listener, but are marked with such melody that you can't help but wriggle along your bedroom. 'Flags of Karma' is one of those pieces of good news that comes to you when you least expect it. A breath of fresh air among so much mediocrity, which proves how our punk and hardcore scene really has nothing to envy from the American and English ones."

https://www.facebook.com/ARGETTI

A Rocket Sent To You

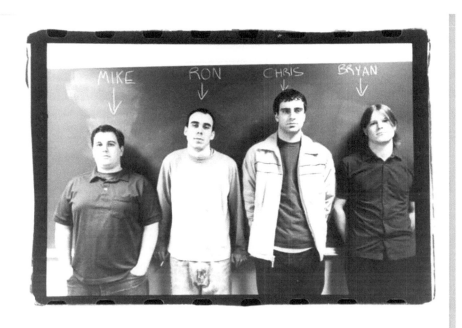

Ron Price : Vocals and Guitar
Dave Forman : Guitar and Vocals
Chris Wetterman : Bass
Mike Borlik : Drums

A Rocket Sent To You was a great post-hardcore / emo band from Baltimore, Maryland. Their eponymous debut album came out on Silverleaf Records in 2000 and was followed by another album, 'Lonely Streets', in 2001 and a split EP release with Rydell and San Geronimo on Ignition / Engineer Records in 2002. Although they were a relatively short-lived band, they left a lasting impression on the scene.

We hadn't spoken for a while, by the time I caught up with Ron Price to discuss notes for this book, but as Jason Sears sang in Seein' You, "Nothing changes but time between good friends." So, when I did catch up with Ron, to chat about A Rocket Sent To You, we picked up right where we left off all those years ago. It turned out that Jason was right,

and maybe Einstein was wrong. But then, I'm not a physicist, I'm an old punk rocker, and so is Ron, which is why it was so easy to talk to him, and a pleasure to while away a couple of hours in his company. I remember being very happy to have ARSTY on the label, but Ron told me, "Engineer found us" so we were both very pleased for that.

Ron Price and Dave Forman met in middle school and bonded over their eclectic taste in music that initially included Iron Maiden, Metallica, Led Zeppelin and Pink Floyd, then later Jawbox, Smashing Pumpkins, Sonic Youth and Fugazi. It was this shared vision and passion that led to Ron and Dave forming a band called Epstein in High School, who played a bunch of shows and gained some local popularity in Washington DC and Baltimore after signing to local label Fowl Records. Which incidentally is owned by Jimi Haha of Jimmie's Chicken Shack, so you can see how the label got its name.

Fowl put out their debut album, 'Permanent Winter Headcold', and then Epstein also released a two track EP on SilverLeaf Record, and one song, 'The Right Hand Rule' on Deep Elm's 'The Emo Diaries, Chapter Three' compilation CD. After Epstein broke up, Ron and Dave had a short stint self-recording a full-length album in a band called The Beta Unit. Despite the fact that the band was rooted in progressive emo-rock, a lot of its material was built around previous ideas and riffs from the Epstein days. It was just a little more developed and drawn out.

The Beta Unit played a few shows before quickly dissolving and reforming as A Rocket Sent To You. This time Ron and Dave were joined by Chris Wetterman on bass and Mike Borlik on drums. Chris played for another small local band, Rosyln, and Mike was playing in a band with (Pre-) Q and Not U's lead guitarist and singer, Chris Richards, called The Tilden Shirtwaist Fire when they signed on the Rocket dotted line.

ARSTY officially formed from the ashes of the previously mentioned bands in the Annapolis, Maryland area in the year 2000 and after several releases and tours, Dave Forman left the band for a few years, and was replaced by guitarist / vocalist Bryan Elliott. Bryan had played guitar for Liars Academy and sadly passed away in 2023. Dave re-joined the band in 2004 and played the band's final show with his brothers-in-arms in Baltimore in 2005.

 All four members were looking for a more serious approach to music. They wanted to tour and utilise small label support to stretch their limbs and see what would become of the band. When I asked Ron why the band

gelled so well, he shrugged and replied "We enjoyed hanging out together, meeting other bands, and we just seemed to click when we started writing songs."

We talked about the band's favourite records, the artists that inspired them and the release that Ron thought epitomised the band, and he told me, "Although the quality was a bit lacklustre; ARSTY's self-titled album was our best work as a band. All of the members have different inspirations but Dave and I would always fall back to 1977, and Pink Floyd's 'Animals' album."

Every band has a home scene, and because ARSTY was a diehard Maryland band, I had to know if Ron thought that ARTSY was a DC or a Baltimore band. With a wry grin plastered all over his face, he answered, "Baltimore and DC had very different scenes. And we fit in a little bit better in the Baltimore scene playing with bands like Liars Academy, Summersett, and more post-punk bands. DC was heavily influenced by Dischord Records bands such as Fugazi and Jawbox. However, we all melded pretty well and all the bands had quite a great time when playing together. Just a little different of a scene, although the cities were only separated by 30 or so miles."

I love to hear stories, because when you draw back the curtain and explore the minutiae of who and what we are, the one thing that connects us as humans is the way that we adhere to and use stories to explore our collective history and culture. So, when I asked Ron about the ARTSY moments, the shows and the tour tales that make him smile or wince whenever he thinks about them, he told me, "We did a good bit of playing on the East Coast. Boston, down to the Carolinas, and one of my favourite memories was playing in a small town in Pennsylvania. The venue was a bowling alley that had a place for bands to play and this became a spot we often frequented. Mike destroyed his drum set during one of our shows and we were all pretty loaded up from drinking all evening."

The largest show A Rocket Sent To You played was probably the Vans Warped Tour in Virginia. That would have been quite a memorable event as Green Day headlined the concert that year.

ARSTY also played a lot with Q and Not U and Liars Academy in the early 2000s. Both those bands had larger label support, by Discord and Equal Vision Records, and all really enjoyed playing together.

A Rocket Sent To You

|01|RedRightReturning|02|Miles|03|GrammaLoreto|04|Cheapeake,America|05|PaperBeatsRock|06|TheAgronomist|07|TheLastTimeI'dEverSeeTheOcean|08|KernIn'79|09|LessTheSound|10|Trainwrecking

Silverleaf Records 003

1	Red Right Returning	The Agronomist	6
2	Miles	The Last Time I'd Ever See The Ocean	7
3	Gramma Loreto	Kern In '79	8
4	Chesapeake, America	Less The Sound	9
5	Paper Beats Rock	Trainwrecking	10

Rydell San Geronimo A Rocket Sent To You

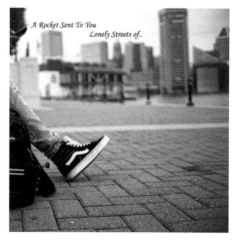

A Rocket Sent To You
Lonely Streets of..

Ron Continued, "I remember pounding three forty ouncers right before taking the stage at Duke University in North Carolina and nearly fell off the stage during a song. Mike B was cracking up, he was definitely the funniest dude in the band and a total nutcase most of the time, always messing with someone, but always in good fun and in a good-natured way."

Unfortunately, ARTSY disbanded in 2005, after recording 'The Last EP', when all of the members moved far away from each other. Mike now lives in New York, Ron in South Carolina, Dave in Iowa, and Chris in Washington DC. Family commitments took over, but most of the band still records and plays. Ron records as Archies Come Back, which is mostly just his acoustic songs, and Dave and Chris have done some work here and there, but nothing that's been formally released.

After promising that we wouldn't leave it so long before we talked again, I asked Ron what he thought about the scene now and whether it was still something that still mattered. He sighed and replied, "Personally, I think that is a loaded question. For me, it exists only as mid-90s to early 2000 nostalgia. The bands that came out following that movement I would refer to as 'mall emo'. You know, the kind of bands like Paramore or Panic at the Disco. You go into a Hot Topic and buy their t-shirts, chains, or necklaces. Those bands sort of killed it for me. I found myself falling back to 80s, country, and electronic music for quite a while. That said, I am excited to see Sunny Day Real Estate in May for their 30th anniversary of the Diary Show in Raleigh, NC. So, do I think it should exist today? Yes, but only as recorded 20-plus years ago. It had its time, but I think that time has expired."

I get Ron's point but am not sure I agree with him on that one. So, to end this chapter positively I'll just take a couple of quotes from A Rocket Sent To You reviews...

"A Rocket Sent to You continue the emo thread with cleverly syncopated rhythms and catchy vocal lines." **Mat Hocking of Drowned In Sound.**

"ARSTY mix rage and delicacy as well as Jamie Oliver whips up a korma... Larrrrrvelleeyyy."
PunkNews.org

"A Rocket Sent To You have a sound steeped in the Deep Elm crew, Garrison and Jawbox. They're emotional and melodic, but with plenty of bite and crunch." **Unfit for Consumption**

"A ROCKET SENT TO YOU are from Maryland and do, musically at least, a very TEXAS IS THE REASON kinda deal. They do it well. They're very able and can create large, post-HC, sweeping soundscapes mixed with subtle melodies." **Scanner**

"Competent, driving emo in the vein of Garrison or Burning Airlines." **Suburban Voice**

https://archiescomeback.bandcamp.com

The Babies Three

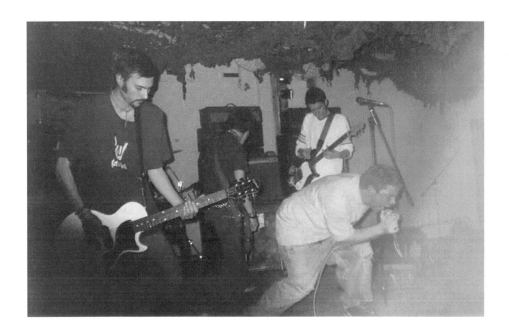

Paul Waller – Vocals
Jim Davies – Guitar, Bass and Drums
Daniel Sargent – Guitar
Steve Jedrik – Bass
Alex Miles – Guitar
Russell Bellingham – Drums

The Babies Three was a post-punk, hardcore band, who called the dilapidated seaside town of Margate in England their home in an era long before its recent revitalisation as an artistic hub. They played some great gigs, recorded and released some decent records, then split up. Then they got back together briefly. Then they split up again.

It's been more than ten years, following their final and "that's it, the band really is over and done this time" split in 2013, since I last spoke much to any of the members of The Babies Three. Or at least it was until I called, and then spoke with guitarist Daniel Sargent, about the band and their time spent playing to the scene's congregation in any and every punk rock-friendly pub and club that would let them turn up and plug in. We discussed their records and our bands many gigs together, as well

as the stories and memories that Dan had accrued during his Babies journey. This is what he had to say…

"We all met in the mid 90's either as schoolmates or people we knew from the Margate music scene. It was a long slow formation. The Babies Three started as a DIY punk band called The Babies (with no three) in the mid-90s, with Paul Waller on Bass and Vocals, Doug on Guitar and Jim on drums, sorry I don't remember their surnames. They released one demo tape with this line-up called Girth. After that for some reason, the drummer Jim was let go or left, and a guy called Jamie Thompson joined the band to replace him on drums and they recorded a demo called 'Barney'. At this point Paul decided he didn't want to play bass anymore, so they enlisted a close friend of mine called Gee (Geoff Moore, who'd later join North By Northwest) and Paul became the vocalist and front man, and they were much better for it."

"Watching those really early Babies shows was as much about watching Paul be funny as it was the awesome punk rock for me. I think this is when they changed the name to The Babies Three, because it was the third line-up of the band. They released a new demo tape called 'Hate Oasis'. I don't remember why, but Paul and Doug fell out, and the band kind of drifted apart for a bit. Paul went and did a band with a guy called Mike from my band at the time, Stain, that was called Karpwaffle, but I don't think they even played a gig."

"Mike and Paul moved in together in a flat in Cliftonville and I became good friends with Paul through Mike, and after they eventually realised Karpwaffle wasn't any good, Paul asked me to kickstart The Babies Three with him. I said yes, as long as Alex Miles, who was also in Stain, could come in on second guitar. So Stain broke up and The Babies Three came back to life with a new line-up that featured Me, Paul, Alex and Jamie, the old drummer."

"Jamie didn't last long though and went on to become a massively successful crypto entrepreneur. He's also in a TV show and I'm very proud of him. Then, we briefly had a drummer called James Barber, who left because he wanted to spend more time riding his bike. Which is fair enough. He did later join a band called I Said Something. But I don't think he was really into the punky sort of stuff we were doing. We recorded our first CD with him playing drums on some of the songs. It was a collection of old demos with some of the songs re-recorded, and

some newer songs that were more indicative of the direction we wanted to go in."

This debut CD was called 'Homosexual Love Ballads' and has a vintage picture of Margate harbour on the front cover. "The name came from a fight we almost had playing in a pub in Whitstable, a local at the bar clearly wasn't impressed with our music and called us gay. Paul came back with 'This is a homosexual love ballad and it's dedicated to you' and pointed at the guy. It all kicked off and the guy threw a few punches but was swiftly chucked out the pub. Anyway, we had 1000 copies printed up that I think we still owe my Dad for thirty-odd years later. Sorry Dad, bung it on the end of the tab of everything else I owe you. After it was released, on Paul's record label, Geek Scene Records, we asked a chap called Russell Bellingham to replace James Barber on the drums. We knew Russell from the local scene, he was in a band called Choke that were a few years older than us, and we idolised them, so we were very chuffed to get him in the band."

Dan continued, "Our first UK tour came about with the release of the split CD with Rydell and Sunfactor. Each band would contribute three songs and then there would be a tour to promote the record. Those guys became some of the closest friends we made as a band, and we played with them many times over the years. Our songs for this release were recorded by Zack Morris at the Liverpool Institute for Performing Arts as part of his degree. The CD was released by Scene Police Records, who had already worked with Rydell before, and where David, the Rydell guitarist, (and now owner of Engineer Records), helped out. There's a whole section about this tour in his 'Hardcore Heart' book. At the very first show of this tour, at the legendary Cardinal's Cap in Canterbury, I accidentally smashed Paul in the face with the headstock of my guitar and broke his nose. There was blood everywhere. Paul ended up in hospital all night, getting out just in time to go to the gig the next day. It was another awesome Babies Three rock and roll moment."

While Daniel paused for a moment to take a sip of his coffee, I mused out loud about the reasons for wanting to play in a band, and he immediately perked up and started talking again...

"For years I always turned that question around and said if you love music why wouldn't you want to be in a band or learn an instrument? I never got all the people who loved music but didn't feel the need or

impulse to pick up an instrument and do it for themselves. As I've got older, I've figured out that it's like the people who love football but would never dream of going to try out for their local team."

"With the Babies getting together it just seemed like the most like-minded people in our scene naturally coming together to play their version of the music that they were into at the time. Which was punk. We were all mates anyway, whether it was from school or meeting at local gigs, so it just made sense."

"I don't think most of us had a goal in mind when we started, other than playing local shows. Paul was the one with the vision and the drive, and he knew exactly what he wanted and had a plan to get there. We never would have done a UK or Euro tour if it wasn't for Paul's enthusiasm, as no band in our local scene had even played outside of Kent. But he was in his room, writing to people, ringing up a huge phone bill, and getting his hands on a van."

"I remember Paul telling me in his flat that we had been asked by Dennis of Scene Police to go out and tour Europe for the release of our second album, 'A Hole Where My Heart Should Be' and thinking there was no way that would ever happen. Scene Police has pressed the album as a vinyl LP with beautiful cover artwork. There were 300 black, but also 150 pink and blue, and 50 custard with a dollop of jam coloured. We were stoked and wanted to get out and play. At this stage, I had never been on holiday by myself, let alone been behind the wheel of a van full of friends traveling the mainland with no adult supervision. Luckily, I didn't have to drive, as Miles from Rydell jumped in and took on the driving responsibilities for that tour."

The Babies Three second full LP was called 'File Under Retaliation' and it was recorded over three different recording sessions at a studio in Monks Horton, right in the middle of nowhere, with sheep wandering around outside. The band had a line-up change after the first recording session, when Alex decided he was off to London to become a thespian. Dan says that, "The attitude of the band seemed to change at this time and it became a lot more serious. At this point Jim the bass player took Alex's place on guitar and our friend Steve took over bass duties. When Steve joined the band took a harder turn, and this can clearly be heard on the songs he played on this LP. Wimpfest and Cartoon Boyfriend being the harsh examples."

This LP was released in 2001 on Year 3000 Records who had other cool UK emo bands of the time, like Sunfactor and Stapleton. The Babies Three were a bit heavier and more aggressive than the other bands, but seemed to fit in ok with them on tours and gigs. Dan continued, "The label was owned by the same guy, Zack, who had recorded us in Liverpool a couple of years back, so we already had a good relationship with him. But the biggest disappointment for me with this LP was that Zack took it upon himself to move the track order about without consulting us. The songs Wimpfest and 050500 were recorded and mixed to slightly overlap as if they were one song. For some reason Zack separated them and it sounded awful, you can hear the end of the song Wimpfest fade out at the start of 050500 two songs later. The artwork was done by a chap called Dave Blanco. It's a crab claw, but looks like a dick at first glance, I don't think any of us really liked that either."

As we're all the collective sum of the people, events, music, books and films that inspire and influence us, I asked Dan about the things that inspired him, the band, and how they played a part in bringing The Babies Three to life...

"Wow, that's a big list, The Babies Three went through three distinct phases during its lifetime. The punk band that they started off as, the emo band they morphed into, and then a more hardcore version of that that, the band became in the end."

"I guess in the early days most of us were into Green Day and Epitaph-style bands, but Paul introduced us to the likes of Black Flag and Fugazi, and got us more into the politics of punk rather than just the great tunes. Then as we grew and met new people, we were introduced to the Emo/Hardcore scene, so we found bands like Sunny Day Real Estate, Get Up Kids, and Jimmy Eat World. We always had a harder edge than most of our contemporary UK-based emo-band friends because we were also listening to the likes of Converge, Coalesce, and the like. It all just seemed to be the same scene to me."

"The most inspirational, and I think best, Babies Three record was the split EP with Rydell and Sunfactor. At this stage I still couldn't believe that someone would pay money to put our music out on a CD, on an actual record label. But Dennis, Emre and David, of Scene Police Records, were keen to help us. We had self-made stuff that we funded ourselves, but this was the first time that someone who wasn't in the band, or

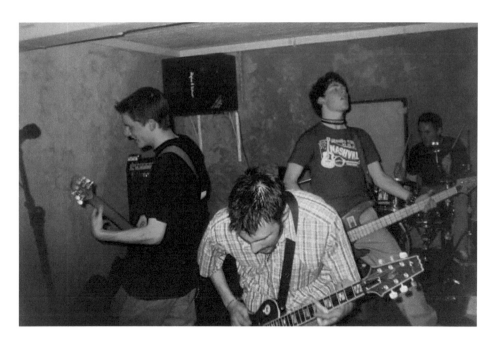

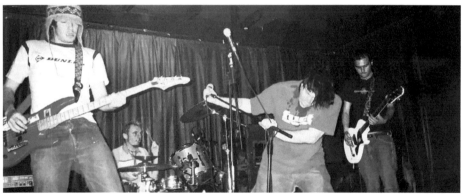

STAIN

THE BABIES 3

Welcome to the Geek Scene

Friday August 16th 1996

Live at the Lido Cliff Bar, Margate

THE BABIES THREE

SUNFACTOR

RYDELL

SUN 28th MARCH 1999

THE RAILWAY INN, ST PAUL'S HILL, WINCHESTER (3 MINS FROM TRAIN STATION)

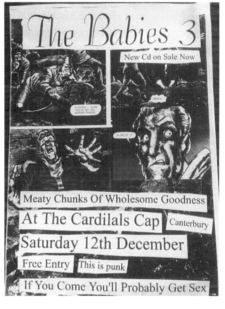

The Babies 3

New Cd on Sale Now

Meaty Chunks Of Wholesome Goodness

At The Cardilals Cap Canterbury

Saturday 12th December

Free Entry This is punk

If You Come You'll Probably Get Sex

XCROSS BONESX
PRESENTS

THE BABIES THREE

UNREAL EMOTIONAL HARDCORE

XCANAANX

CANTERBURY'S STRAIGHT EDGE
MOSH MACHINE

UROTSUKIDOJI

CHAOTIC HARDCORE/METAL

ALL AGES SHOW
SATURDAY MARCH 16TH

JUBILEE HALL, WINCHEAP ROAD

FIRST RIGHT AFTER THE ESSO GARAGE

IF COMING FROM CANTERBURY, 5 MINUTES

CANTERBURY EAST

£3.00 ON THE DOOR

DOORS OPEN AT 7:00

FIRST BAND AT 7:30
SHOW FINISHES AT 10:30

INFO: JENKINS@AOL.COM

TUESDAY 26th SEPTEMBER 2000
Household Name Records presents, the return of:

BØYSETSFIRE

special guests:

Hundred Reasons
and the babies 3

at the underworld
174 Camden High Street, London
Doors 7pm - Advance Tickets 5 pounds - Info 020 7482 1752

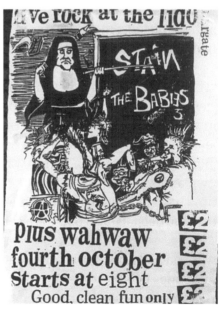

ve rock at the lido argate

STAIN

THE BABIES 3

plus wahwaw
fourth october
starts at eight
Good, clean fun only

72

related to us, saw something in The Babies Three and wanted to invest in it."

"As for other bands' records that had an impact on me, it has to be Iron Maiden's 'Seventh Son of A Seventh Son'. It was my first metal LP, it made me who I am today and before Iron Maiden offered me that first glimpse of the bigger musical picture, I was still into New Kids On The Block!"

Most punk bands owe some sort of debt to the scene that they emerge from, and as such I asked Daniel about how big a role the Margate scene had in making the band what it was, the members who they were, and are, and what it was like to be part of it...

"The Margate scene in the late 90's and early 2000's was amazing! It mostly centred around a place called The Lido Cliff Bar, on the cliffs in Cliftonville, there were other places like The Ship, but that got knocked down to make the Turner Centre. There was also Pisces Cellar Bar, which was shut down for being unsafe. It didn't have a license, so the door was locked after 8 o'clock and the fire escape was too small for a crowd to get out fast."

There were gigs at the Lido every Friday night, and sometimes on a Saturday or weekday too if Paul and Dan were putting on one of their Geek Scene promotions for touring bands. It was a huge place that could hold 300 to 400 people, and in its heyday, it was always packed out with goths, emo kids, metal kids, and hardcore kids. I visited and played their many times and everyone pretty much all got along.

"The three main promoters all had their individual angles. Paul ran Geek Scene Promotions and I helped, DJing and doing the door. We mostly put on hardcore bands, usually touring bands with local support to get the people in. We were the locals, so we weren't treated any differently from anyone else there. The venue was out of the way of the main Margate town and seafront so we didn't really have that much trouble running into chavs or townies, and some of them, when the curiosity bug bit a little too deep, would pop in to see what it was all about."

Every band that's played gigs, sat in a van for far too long, or left their loved ones behind to head out on tour, ends up swapping their creature comforts for a collection of memories. Good and bad, Dan was more than

willing to tell me about the best shows The Babies Three played, and some of their more notable and historic moments...

"Supporting Boy Sets Fire at Camden Underworld, along with Hundred Reasons, was a big milestone for us. Playing a venue that we had seen some of our favourite bands play at was exciting. Loads of friends and fans from the Margate scene came up to support us, which was amazing. We also played there with One Line Drawing and Rydell a little later on, which was ace, but the evening was slightly spoiled when Jonah (Matranga, aka OneLineDrawing) threw a coin at a window to get someone's attention, but it bounced off the wall and hit my car, denting it. Bloke never even said sorry. If I recall, we didn't get paid that night either."

"We never had guitar tuners on tour, someone just decided what E was and we all tuned to that, and we also used harmonics to tune in between songs. It must have sounded awful and looked very unprofessional to the audience."

"The first time we played Germany, Paul didn't realise that most Europeans are fairly fluent in English so asked the crowd if they understood him in that very slow way that old people talk to foreigners in sitcoms."

"We got pulled over by the police on the way back from a show in Hastings very late one night. Our van only had six seats but there were eight of us, so a couple of guys, Russell and Jim, jumped in the back with the equipment. Which was, in hindsight, probably very dangerous. When I realised we were being pulled, I called back and told the guys what was happening and to be quiet. I talked to the police and explained there was nothing dodgy going on and we were just on our way home from a gig. They insisted on looking in the back of the van, in case we were running around with stolen stuff or drugs. So I jumped out, shitting myself, and walked to the back of the van and opened it up. To my surprise, Russell and Jim were nowhere to be seen. It took me a couple of seconds to work out that they had hidden themselves under sleeping bags and pillows. It was in no way convincing, we all burst out laughing within about five seconds and the police were not impressed, but we got away with it by telling the cops that they were asleep, not hiding."

"I was sure they were going to get chucked out of the van and that I

would have to come back and get them later. But as one of the police officers was taking my details, the other was chatting to the guys and it turned out his sister was in a band called Miranda Sex Garden. We told the officer we loved that band, even though we had no idea who they were, so he let us all jump back in the van and drive home, as long as we promised to drive slowly and safely. It proved to me that the populist punk belief that 'all coppers are bastards' may not be entirely true."

"One trip up to Bradford, in the same van, we were trundling along the motorway, maybe doing 60 or 70 miles an hour, as the van couldn't go much faster than that. When all of a sudden there was a huge boom and the van filled with rushing air. Our shit blew everywhere like a hurricane had formed inside the van. I lost control and we veered across the M1, luckily it was the middle of the day and there wasn't much traffic around, so I didn't hit anyone. I managed to get control again and started to slow down, but very soon there was another bang and the wind stopped as quickly as it started. I pulled off onto the hard shoulder and we all jumped out of the van in shock."

"It turned out that the fibreglass roof of our van had detached from the bodywork at the front and peeled backwards. The van looked like we had hit a bridge, and I was sure we were not getting to Bradford. One of the lads jumped on the bonnet of the van with a roll of gaffa tape, pushed the roof back into place and stuck it down. I was apprehensive about carrying on in case the tape gave way and it happened again, so I drove very slowly the rest of the way to Bradford, but the tape never gave out. I was going to look into getting it repaired professionally, but the van was stolen shortly after. Turned out it was the bloke we bought it from, because we never paid him for it. Sorry Trevor."

"Another time, we were on tour in Germany and having a walk around whichever town we were playing that night. It was seriously cold, so Steve and I decided to go back to the venue and grab a beer before the show, as we didn't want to go far in the chilly German night air. When we got back to the venue the promoter welcomed us backstage and sat us down with our rider, which included a huge crate of German beer. Steve and I must have drunk four or five cans each before we realised, we were still stone cold sober. When the other guys finally returned, they pointed out that we had been trying to get pissed on non-alcoholic beer for two hours."

"Later that night, after the show, I did end up getting extremely drunk and fell over in the loo. landing in a load of piss and puke. The area above the venue we were staying in didn't have a shower, running water or lights, as it was basically just a loft space. I had to get changed in the pitch black and scrape the puke off my clothes. In the end, not wishing to salvage them, I threw them out a window and tried to dress myself as best I could in whatever I could find. I passed out halfway through. The hangover I had the next morning was one of the worst I have ever had, so I didn't drink again until at least that evening."

"During the same tour, we played a fairly good gig at a cool venue in Rosswein. The backstage area had a wall that all the bands who had played there had signed. Loads of our favourites were on there, like The Get Up Kids, Jets to Brazil and Boy Sets Fire. Anyway, we were on tour with a friend of ours who had come along as a roadie, but we were all slightly falling out with him because he wasn't helping lift anything and treating it as more of a lads holiday around Europe. As usual, we finished our last song and headed off the side of the stage to the backstage area, where we started to chat about how the gig went, as you do. Our 'friend' came bounding backstage, saying we needed to grab our gear and get back on for an encore, as the crowd were well into us. So, we all cheered, ran back up on stage and grabbed our recently downed instruments to blast into another song. Where it quickly dawned on us that no one had been cheering for an encore and the entire crowd had pretty much filtered out of the room. We were extremely embarrassed but for some reason played another song anyway, feeling very silly with our hilarious friend laughing at us from the side of the stage."

Daniel also reminded me that he spent almost everything he earned with the Engineer Records distro, especially between 2000 and 2002. He already knew me and Milo (Miles Booker, Rydell singer and part of the Eng Recs label) well, so that when they signed with the label they did so because we'd already played shows together and had become friends while out in the punk rock wastelands playing here, there and everywhere together.

There was a brief reformation of The Babies Three, around 2012, also using the name The Luzhin Defence for gigs, with original members sometimes being replaced by Ian Sadler of Call Off The Search on drums and Ross Blair of Urotsukidoji on guitar. But that soon petered out and the conversation became darker as I broached the subject of the band's eventual demise. Dan sighed, and told me...

"I don't think we will ever get back together. Personally, I would do it in a heartbeat, but I don't think the other guys would. I'm still good friends with Paul and Jim, but they always shoot the idea down very quickly if I even joke about playing a gig."

I also asked him if he thought the punk scene was still a vital part of underground culture, and he offered this parting shot...
"Until everyone is happy and equal there will always be a need for punk and hardcore."

After The Babies Three, Paul and Alex formed a new band called The Boss, who had a CD release entitled 'Lay Down Your Firearms' on Engineer Records in 2006. Russell and Steve formed a band called Candy Sniper, who also had a release. 'Low Art' with Running Riot Records and Engineer Records. And most recently Paul, and initially Dan, formed the hard-rock / stoner band, OHHMS, who regularly appear in metal mags like Kerrang with their releases on Holy Roar Records.

When The Babies Three brought out their 'Luzhin Defence' release on Engineer Records in 2004, Ben Gosling wrote in **Punktastic** about it, saying; "*This EP is the last recorded works and a testament to The Babies Three, as they split shortly after this was created. A little confusingly, after two albums and two 7"s, the band changed their name to The Luzhin Defence, the name of this EP, before disbanding shortly after.*
In the accompanying press release they are said to have found their 'true sound' during their second European tour, in 2002, with Song of Zarathustra and Yaphet Kotto. And although they're now all either in other bands, or working as promoters, the decision to split was attributed to 'complete disillusionment with the hardcore punk scene'. This is a shame, as this is a great release, and if it's true that they only found their true sound shortly before recording these songs, the future could have heralded some fantastic output.
I recommend picking up this CD if you like your Punk intelligent musically, provoking lyrically, but still ragged and rough around the edges."

https://babiesthree.bandcamp.com/album/babies-three-houston-split-7

Barbed Wire

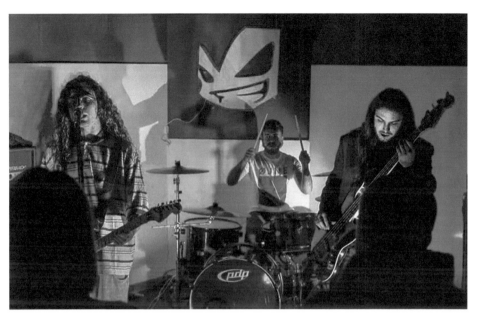

Federico Coni : Drums
Daniele Manno : Bass
Andrea Boiani : Guitar & Vocals

An alt-rock trio hailing from the vibrant city of Rome. Influenced by many emo-core and melodic post-punk bands but with an original style.

"We were originally into the Nu-Metal US scene and thought it was important to bring a beat to Rome, but soon found that was long-dead and people were more into grunge or rap, and just wearing Adidas didn't make you a nu-metal musician," Andrea, Barbed Wire's singer and guitarist told me. "We started playing in clubs in Rome around 2016 and were very young, often getting taken advantage of and rarely being paid for our shows. We just couldn't find 'our scene' and many club owners used to trick younger bands who just wanted to play and exploit them. Often promising a payment for the gig but then never showing up on the night so you go away having nothing in your hands."

"In Italy music isn't really seen as a job and, unless you are famous, it's very hard to make a living from artistic performances. It's rooted in a

cultural sickness that comes from the mid-90's political-economic movement which looked for exploitation of any kind and did not see anything cultural as a job itself. Possibly because they thought culture may unite people, and that union could slow down their division and exploitation of economic and social growth. This began to improve around 2019 when bands started to create their own promoters' collectives in order to organise shows and pay the artists. It was the rise of a new scene, which grew fast on social networks."

By 2019 the D.I.Y. scene which grew around hardcore and post-punk was improving again, even in Rome, where there were bands like Short Fuse and Rejoyce/Rejoice, who became influences for Barbed Wire, seeing them move away from the more mainstream rock / metal music to a quieter, more melodic mid-west emo style.

Andrea continues, "Emo / hardcore music blew our minds: bands like Sunny Day Real Estate, Mineral, The Get Up Kids, Texas is the Reason, they all invaded our twenty-year-old hearts, filling our YouTube chronologies with all those 'mid-west emo mixtapes'. They came from a strong scene and made us want to improve ours."

This motivation, derived from a melancholic and energetic mix of 90's emo-core and darker post-punk sounds, inspired Barbed Wire to record their first album, 'One Last Drive', in November 2020. They would self-release these twelve tracks on CD, alongside a limited-edition cassette version in the US on Foreign Girl Records. Now the band would perform these new songs live on many Italian stages, and despite the pandemic, they'd join other new Italian bands like La Quiete, Verme, and Gazebo Penguins at gigs, and soon made contact with Low Standards, High Fives from Turin, and Amalia Bloom from Vicenza, when asking them for support shows.

"We started playing outside of Rome more and more, but it was difficult as none of us had a car, so we travelled by bus or train where we could. It took time and effort, and we often slept on dirty, cold floors after playing for far too few people. We figured that it was worth it, for the scene and our own personal growth, but we'd often wake up freezing, particularly on our December 2021 tour."

By now Barbed Wire were part of their own gig collective in Rome, called Weird Side, and were fast becoming well-respected around Italy as they

had organised shows for more than 100 bands, treating them like brothers and sisters, and helping develop unity, friendship and collaboration between the bands.

The band had been developing their sound and writing new songs, so that by May 2022 they were ready to head to their producer Andreas Macri's countryside home to record their second album, 'The Sun Sets In The Wrong Place'. These eight tracks told a nostalgic story and were recorded mainly at night, over eight days, then mixed and mastered by Simone Umbaca. The labels co-releasing this CD (IGN359) with Engineer Records would come from all across Italy; È Un Brutto Posto Dove Vivere, Non Ti Seguo Records, Fresh Outbreak Records, Weird Side Records and Dinomite Records, and there would also be another cassette version in the USA on Sleepy Clown Records.

The first single from the album was 'Bedroom Walls', released in September as a digital stream and video, and in support of this the band now increased the number of shows they played, putting on more with Weird Side too, giving them the chance to play with bands like Quercia, Chivala, Radura and Cabrera. And then, in November, going on tour with Short Fuse, both bands piling into a nine-seat van.

With the new album's release Barbed Wire got to play several big summer festivals in Italy through 2023 where they realised that they could receive an even better response singing the songs in Italian than in English, so that will be one of their aims for 2024 as we wait for their next recordings.

Idioteq reviewed the new album, covering every track with the band: *"The Rome-based musical ensemble Barbed Wire embodies the essence of emotive expression through their synergistic blend of 90s emo and alternative rock with the haunting aura of 80s new wave. This remarkable union was showcased on their debut album 'One last Drive', a masterful work that radiates darkness and energy while maintaining an air of intimacy and melancholy. But the refreshed version comes along with their new offering 'The Sun Sets In the Wrong Place', released to the masses via by Engineer Records (UK) È Un Brutto Posto Dove Vivere (IT) Non Ti Seguo Records (IT) Fresh Outbreak Records (IT) Weird Side (IT) Dinomite Records (IT) and Sleepy Clown Records (USA)."*

"The new eight-track album come as a manifestation of the melancholic

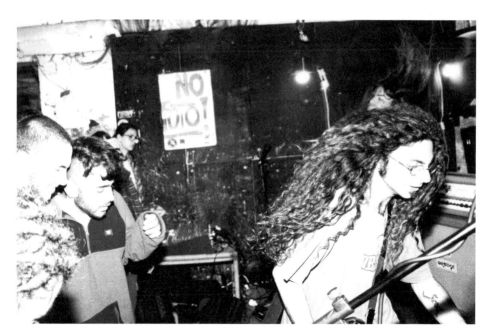

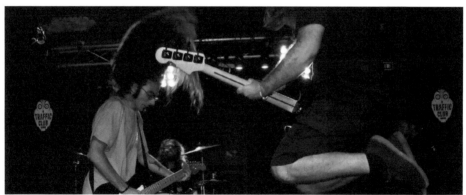

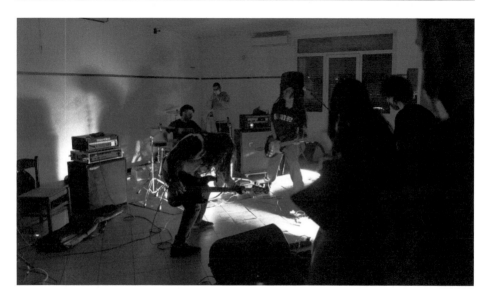

81

reverie that overtook a group of individuals as they retreated to a rustic abode in the countryside. Over the course of eight days, they dedicated themselves to the creation of melodic pieces, capturing their essence in the still of night at the stroke of four."

"We could record at any hour, usually at 4am when inspirations came fluently, despite the need for sleep." commented the band. "We recorded 8 tracks which fixed what we've finally become musically and personally after the three years since our first album. We've grown up and the darkness increased, as you all could listen into the record. We sound still emotive and energetic but with a darker mood."

We're diving deep into each and every track of 'The Sun Sets In The Wrong Place', through the band's first-hand track by track rundown below...

3 A.M
This song is all the frustration of a sleepless night under the sheets overthinking about anything happened to our poor mind during the years of adolescence: lost loves, ended friendships, fear of living.

BEDROOM WALLS
When all the memories can't leave you alone, even in your ordinary place, it means that you're getting nostalgic for everything made you feel sad.

PICTURES
People we met and loved in life, expect you to forget everything about iy and go on living. Unfortunately, this is impossible if you have a heart, so we all became a 'sad generation with happy pictures'.

I WISH EVERYTHING WENT SLOWER
Another about memories and overthinking, so much so that you lose connection with your surroundings and see everything going faster than you can move.

BORN FROM DEAD FEARS
Unfortunately, fears move the world and yet, the fear of being alone moves everything inside you. It often causes negative actions.

GLOOMY NIGHTS
A purple sky or a cold night could be a perfect reminder of all the moments you felt in perfect connection with what surrounded you, but that happened

when you used to be confident with yourself. That feeling does not last forever.

ANGELINE
During the years of adolescence, mistakes seem to be the 90% of what you made. With people, with yourself, with things that deal with your future or present, and for years after that you spend most of the time thinking about what you were and how you could fix those mistakes.

THE SUN SETS IN THE WRONG PLACE
There are times when being sweet and lovely bring to nothing but suffering. You convince yourself that next time will be different, that it will be you driving things your way, but you can't change your nature.

And **Punk-Rocker.com** had this to say: *"This material embraces the finest qualities of several complementary music genres. It carries something for everyone, and it will unquestionably appeal to those listeners looking for melancholic and melodic sonic experience. 'The Sun Sets In The Wrong Place' delves deep into introspective themes, exploring a myriad of emotions and personal journeys. Barbed Wire masterfully weave poignant lyrics and evocative melodies to create a captivating sonic experience. Each track harmoniously paints a vivid picture of the human experience, conveying a sense of longing, melancholy, and raw energy."*

http://linktr.ee/barbedwireroma

Barking Poets

Neil Murray : Guitar and Lead Vocals
Conor Heary : Drums and Backing Vocals
Conor Thomas : Bass
Kaid Miller : Guitar
(Ander Mendia Gutierrez : Bass and Backing Vocals)
(Harvey Springfield : Vocals and Guitar)

Barking Poets are a melodic punk rock band based in London, founded in 2019 by experienced musicians from the London, Bristol and Dublin underground scenes.
Their lyrics echo the concerns of our time such as climate change, racism, austerity and populist politics.

The band's soul-lifting debut single 'Make Me Strong' was released at the start of the pandemic and they donated their merchandise profits to the #SaveOurVenues campaign run by the Music Venue Trust. Their second single 'When I Am King' continued in their style of mixing the anthemic punk rock of The Clash and The Gaslight Anthem with the protest song lineage of Neil Young and Billy Bragg. A captivating video premiered on Facebook Live in September 2020.

In 2021 Barking Poets recorded their debut full-length album 'Back to Abnormal' produced by Paul Tipler (Idlewild, Reuben, Elastica, Placebo) at Stereolab's studio in London. The band's bassist, Ander, got in touch with Engineer Records and sent us a demo. We loved it and soon a CD and limited edition 10" vinyl release (IGN326) would follow, with beautiful cover art designed by illustrator and tattoo-artist, Dan Allen, the front-man of Ducking Punches. This record was supported by videos, radio, digital playlisting and good gigs, ensuring a steady growth in their fanbase.

There was a line-up change in 2022 with Harvey leaving (having to work up in Nottingham) and Neil taking over as the main vocalist. The band steadied themselves and launched videos for 'Part of the problem' and 'We will overcome', soon gaining thousands of views and finding the Barking Poets plenty of new support, just in time for them to head back into the recording studio. This would see them produce their riff-filled sing-along six-song 'Southsea Sounds' EP (IGN375) working with Tim Greaves in the Southsea Studios, hence the EP's name. Released on CD and across all digital channels, these rabble-rousing songs would have you tapping your feet or jumping around in no time.

Barking Poets were going from strength to strength but there have been more line-up changes for the London punkers and bedding-in at gigs for the new members. Now ready to rock again and preparing to get back into the studio to record a new album, I caught up with the band to ask them a few questions...

Conor H: The idea of Barking Poets was born on a dark Autumn evening in London's West End. I met Harvey for the first time in a nondescript pub after I replied to his musician's wanted ad online. I listened to his demos and instantly liked what I heard. The songs were strong, familiar, and had a retro, timeless feel.

After chatting about our previous musical lives, mutual love for the great North American songwriters as well as throwing new and current punk bands at each other to check out, we tried to get a band off the ground but alas we failed! The ceiling started leaking above our table in the pub of our initial meeting and we had to move... A bad omen perhaps?

Harvey had planned on playing lead guitar and backing vocals with me on drums and we had some people come in through the front door

then swiftly exiting via the back. There are, and were numerous reasons for the revolving door membership but total commitment to a band was tough to find in London and after a few months of frustration, we went our separate ways. Harvey joined a folk band called Man the Lifeboats and I recorded some songs and put my own band, The Wake Ups, together.

In the summer of 2019 Harvey arrived back in London after spending some time in Spain and we met for a drink at The Monarch in Camden to catch up. Harvey informed me he had a caseload of new songs and this time he was going to take on frontman duties. He asked if I knew any drummers who would be interested and so offered my services to get the band started and off the ground. Little did I know that four years later, I would still be in the band. We started the search for a bass player and lead guitarist, and as there was no leak through the ceiling this time, fate was seemingly on our side.

Neil: I'd been in some bands before but had been out of the game since I moved to London around 2016. I'd been trying to write songs, though without a band to try them with I'd just been going around in circles. I'd also been accumulating guitars at quite a rate, so by late 2019 I thought "I'd better join a band to justify having all these guitars lying around", so I posted adverts on some 'musicians wanted' sites, looking for a low-pressure gig as a sideman, as I didn't fancy leading a band myself. After a couple of false starts, Harvey got in touch and I arranged to audition, this must've been around October 2019.

That said, I initially advertised myself as a bass player, as there are so many guitarists around, but in the week of the audition, Harvey told me they had loads of bassists auditioning so did I want to play guitar instead? Well yes, I did, because I'm terrible at bass, so that was a lucky escape! As it turns out we continued to have a bit of a revolving door of bassists after I joined, but I'd got my foot in the door as a guitarist and stuck with that, plus I could sing, so naturally, I did backing vocals too.

After we'd learned half a dozen of Harvey's songs I brought in 'When I'm King' to try out and that got added into the set, along with a few more of my songs and as time went on, the set was around 75% Harvey's tunes 25% mine by the time he left the band. Joining Barking Poets was good for my songwriting as left to my own devices I'd try to be too clever, and the songs would end up going nowhere. Following Harvey's lead, I

became less obtuse, and more direct in my lyrics and just put them, and the music out there.

We managed to get our first gig at the Beehive in Bow, then one at the New Cross Inn, then... Lockdown hit. The pandemic had arrived, and everything shut down. So just as we were ready to start getting out there, there was nowhere to play. In between the lockdowns, somehow, we squeezed in a couple of days to record our first single, 'Make Me Strong', and then laid down 'When I'm King' at the same studio. Both were recorded with Paul Tipler, who'd produced Idlewild and Elastica back in the day, at the helm and jt was a stroke of luck to find such an established guy to record us, and it's probably one of the reasons why those songs sound so good. Being punks, we did what we were supposed to do and self-released them, but they didn't really get any attention.

Around the same time we recorded, we played a couple more gigs, so compared to a lot of bands during that first covid year, I think we did pretty well, all things considered. We finished off our first EP, 'Back to Abnormal', with four more songs, and the title of that EP is, obviously, a reference to the craziness of the pandemic. For that whole period, our bassist was a guy called Sergio, but he ended up having to move back to Spain after we'd finished recording the EP, so we were on the hunt for a bassist again. And that was where Ander came in.

Ander: You're probably thinking how I ended up here. Having been a failed guitarist for bands in the past (the prop for any new bassist), I resolved to learn bass to support my wife's solo project. I instantly got hooked on the different techniques and perspective that learning to play bass offers. After a couple of gigs, a few rehearsals, and lots of neo-soul, a recent mortgage in Northampton seemed like the last thing that'd push me to abandon the London scene. Or so I thought.

Out of the blue, I received a message from Harvey, which was his way of trying to gauge my interest as a bassist. I hadn't been out for a bit, band-wise, and wasn't expecting to, but he picked up an old ad of mine and we got talking. Punk rock, eh? I gave the songs a listen while thinking that commuting back to London was probably going to be more of a chore than joy. But boy, was I wrong! The songs had a lot of fire and heart, and punk has always been my first love - those hot summer days in Bilbao, shutters down, playing Tony Hawk's Pro Skater did a number on me and then some.

Much as I tried to play it cool, I was learning a song a day and recording it on my phone to send it across to Harvey. To me, punk rock needs a pick for bass so I went out on a limb and rewrote some of the songs and then met up with the guys for an audition with my strange headless 5 string bass (which would be replaced many times in the coming months) and was offered the job. Some 13 days since we first spoke and 10 tunes later, I had my first gig with the guys at the Black Heart – which was a big tick off my bucket list!

Shortly after that, we recorded a video for 'When the Bands are Gone' and I made it my mission to get as many labels as possible interested in the band, and one of those aforementioned labels was Engineer Records, which had a fantastic roster that we were all excited about. We had a chat with David, who was incredibly enthusiastic and inspiring, so we signed on the proverbial dotted line without a moment's hesitation.

Over the next couple of months, we continued to gel as a band, sharpened our repertoire of silly jokes, and played as many gigs in as many places as possible, around Camden, Bristol, and our first festival appearance for HRH Punk in Sheffield. In between all of that, we shot another video and embarked on road trips up and down the country for gigs and rehearsals.

We released 'Back To Abnormal', our debut mini-album, and to celebrate we hosted a sold-out party in the emblematic Hope And Anchor in London with a bunch of our label buddies and friends, among them The Stayawakes who we fell in love with from the very beginning of our introduction to the Engineer Records roster.

The songs kept rolling in and my excitement about the band continued growing, and then, just when we thought we were sorted, Harvey announced he was relocating to Nottingham! With the distance from London to Nottingham being too much for a regular commute it made it impossible for Harvey to continue in the band so just like that, he was gone.

We bid farewell to our frontman and played our final show at The New Cross Inn in South London in February 2022, wondering what would happen next. I'll happily admit I pushed to keep it to the family and not recruit a new frontman. I was precious about the authenticity and chemistry of the band and we pushed Neil to be our new singer and try things as a trio whilst looking for a lead guitarist... and he, of course, delivered!

Neil's vocals are incredible and gave me a chance to toy around with and work on my backing vocals and with Conor setting the pace that helped us to navigate the change, we leaped into recording new material. Even though we wanted to adhere to our signature sound, we also wanted to try something fresh and new that was in keeping with the new streamlined version of the band, and we trusted the mighty Tim Greaves at Southsea Sound to help us with that and record our next single 'Part of the Problem', then the whole 'Southsea Sounds' mini-album, which we released in late 2023.

Neil: Sadly, just as after the new album came out, Ander's job moved away from London, so he could no longer continue with the band, and gracefully bowed out with hugs and tears all around. Me and Conor braced ourselves for a long round of auditions, but luck struck as the first two men through the rehearsal room door were just what we needed...

Conor T: Enter new challenger, Conor, on bass... I had played bass on and off in bands since I moved to London in 2011, but, as was always the way, these tended to fizzle out or lose momentum, usually due to members leaving London or putting more time into their other bands. I had nearly given up looking to join a band when I by chance happened across my namesake, and fellow Irishman, Conor's add for a bassist for the very punk sounding band named Barking Poets.

I sent Conor a message almost immediately that night, and not really expecting to hear anything back, I was pleased to see he had messaged me 15 minutes later. We arranged for me to have an audition with Conor and Neil where I played 3 songs from the Southsea Sounds EP. Very much guided by Ander's excellent bass playing on this EP, I just tried to give the songs my own little personal touch as well as trying to emulate his memorable and unique backing vocal style. This obviously worked as the next day I was offered the position of bass player.

I was delighted to accept and on the 22nd of September 2023 I became an official Barking Poet. Since then, we have played gigs in the both iconic Dublin Castle and Fiddler's Elbow Camden along with my fellow new recruit, Kaid, on guitar.

We are now working hard on writing material for the next step, the big full length debut album and I am pleased to say my writing, input and

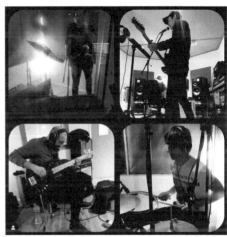

enthusiasm has been encouraged and respected as much as if I was a founding member all those years ago.

Kaid: They say the best place to begin is the beginning so here we go. I've been in bands, out of bands, for the majority of my life, I've done everything from Hardcore to Glam Metal and weirdly enough neither the spandex or air max worked out for me. So I went back to my roots, Punk, the most beautifully simple yet simultaneously complex music of all time. After a rough patch of my life and moving to London, I decided it was time to retire as a bedroom guitarist and get back in the saddle in a band.

Going back to the old familiar forums I've used since I was about 14 I found Barking Poets, went for an audition and it's been manic ever since, gigs, songs and all that good stuff, the wildest, most fun ride of the past few years and I cannot wait to see what our future holds.

Neil: So that's the story so far – with the new boys in the band we're now halfway through writing our next album, and it's sounding better than ever, exciting times all round...

Reviews:
"A very accomplished EP from a 'New Wave' band based in Barking, and often to be seen / heard in and around Camden. Their lyrics echo the concerns of our time such as climate change, racism, austerity or populist politics. They're multi-talented and quite outspoken, with a passion for old-school heroes like the Clash, New Model Army, Ramones and The Who; plus more contemporary influences from the likes of The Gaslight Anthem, Green Day, and they especially remind me of another local crew with the same passions, Stevie Jones and The Wildfires.
The band support and donate to the #saveourvenues campaign run by the Music Venue Trust, and this ongoing venue crisis and gentrification of clubs and pubs is accurately addressed on their track 'When The Bands Are Gone'. The guys are passionate, they have a lot to say and aim to get people to listen, whilst still producing high quality music."
Richard Proctor for **Velvet Thunder**

"Melodic punk rock compositions that will be right up the alley for those who're looking out for a more classic punk rock sound. The group blends classic punk-rock, contemporary melodic pop-punk but also adds smaller chunks of indie rock in the mix. You may notice how the greats

like The Clash, Ramones, The Jam, The Who, The Kinks inspired their classic punk rock side, but also bands like The Gaslight Anthem, Rancid, Green Day, Frank Turner, inspire their contemporary punk rock side. Barking Poets solely rely upon powerful chord progressions, melodies, harmonies, themes, and simplistic but effective solos."
Djordje Miladinovic for **Thoughts Words Action**

"A solid EP, no filler, just lots of great guitar and some tasty garage vocals. There's an old school tone to the guitars, warm and not as intense and high gain as a lot of modern stuff. It reminds me of some of the more melodic early bands, more Buzzcocks or even My Generation era the Who than UK Subs. Would go down with fans of Giant Eagles or even The Hives I reckon. Whatever it is, it got us dancing in the car, and singing along to some classy "Woahs" - and it's always a good sign when you can sing along on the first listen! Some of the twiddly guitar bits are smashing too!"
Chris Lowry for **Warrington Ska Punk**

"Crank the volume up to 11 and listen to a true band breathe energy over their powerful music. A big middle finger up to the current establishment in power, 'When I Am King' is worthy of the throne. Barking Poets echo their concerns of politics and important topics within their music, and 'When I Am King' cements that this experienced band will never go down without a fight. Memorable, historical and unapologetic."
Chloe Mogg for **RGM Magazine**.

"The London punk-rock group Barking Poets sound ready to turn heads on their debut single, 'Make Me Strong'. Their sound feels heavy and meaty, but the melodies in the mix are markedly upbeat. They wrote the track before so many people ended up needing so much encouragement and assistance amidst the COVID-19 pandemic, but it's a timeless message — the lyrics and energetically forward melodies that pop out amidst the heaviness both communicate a strikingly real-feeling idea of rising past what might hold one back." 5/5
Caleb Newton for **Captured Howls**

"When this song hits, it hits hard and perfectly. 'Getting Away With It' has a perfect nostalgic vibe to it but with a very current message. The first track off of Barking Poets' new EP 'Southsea Sounds', this song is a political protest song with lyrics revolving around everything going on right now such as climate change, racism, the list goes on and on. I love

the fact that this song has such a powerful message matched to such a catchy sound. There's a classic rock n' roll vibe throughout this song but there are also clear nods to everything from pop-punk to something more in line with Billy Talent. All in all, this is a powerful and anthemic track that deserves to be heard."
Girl At The Rock Show

"A great blend of alternative rock and punk rock, this 'Southsea Sounds' EP really does reach out to many genres for influence, and this is a band who is not afraid to wear these influences on their sleeves. With six punchy tracks, this is an EP full of upbeat riffs and beats and melodic lyrics that really do get the listener up and bouncing around."
Metal Asylum

"Barking Poets kickstarted 'Southsea Sounds' with 'Getting Away with It', a perfect opener with big melodic riffs laying the foundations of their energetic sound. It has a dominating punk-ish groove with a catchy vocal melody and a smooth flow that promises a mood-boosting EP. 'We Will Overcome' comes next with an engaging sound that I believe would create amazing singalong moments when played live, it sounds like the band are aiming for a more spacious structure with deep bass, and slower riffs, giving more space for the vocals to lead the song's dynamic progression. 'I Could've Been a Contender' steers towards a heavier, faster sound that pushes forward, shaking off the EP's dynamic flow to keep the listeners onboard. It shows another side of Barking Poets writing with its intense flow and insanely good guitar work. All within a solid relentless structure that kept the energy levels at the max and uncompromised. As we reach the middle of the EP, 'Punching Down' welcomes us with warm acoustic guitars and an irresistibly moving vocal melody. It smoothly progresses into a faster flow with mellow engaging vibes, which I believe at this point is one of the bands key elements. I loved its changing structure as its cleverly crafted organic ups and downs kept its sound fresh and super fun. 'Part of the Problem' comes next hitting hard and heavy. Its big powerful sound took me by surprise, while its fluid melodies and pounding sound kept my head banging throughout the whole song. It sounds like a loud blasting statement that's well-written, with the whole band giving their best in a big unified stream of riffs, melodies, beats, and a killer solo. Ending the EP on a high note comes 'Going Back to London Town', a diverse-sounding piece that takes us on a journey through Barking Poets writing styles that were introduced throughout 'Southsea Sound'. It starts as a

chill emotional ballad with warm acoustic guitar and powerful vocals before exploding into their energetic punk-ish sound and adding a deeper melodic layer that breathes life into their structures, all creating a wall of dynamic sound that carries the listeners to the end and probably playing the EP all over again."
Hazem Mahani for **Rock Era Magazine**

https://barkingpoets.bandcamp.com

Bear Away

Jacob Thundercliffe: Vocals & Guitar
Dom Brining: Guitar & Vocals
Lewis Ward: Bass
James Charnock: Drums & Vocals
Josh Booth: Guitar & Vocals

A melodic punk rock band from Scarborough, UK taking influences from Bouncing Souls and Hot Water Music, through to Menzingers and Iron Chic, and adding to them to create their own catchy and powerful brand of melodic hardcore.

"I met Jacob around 2006 when I joined his then-band, To Die In Paris,

who were looking for a replacement drummer. The band continued for a few years, before we all moved on to other projects, but in the years that followed, our paths regularly crossed at gigs in the area, many of which were in a small backroom of The Queens Hotel in Bridlington. This was a favourite place to play for many local bands, as it always seemed to draw a good crowd." James Charnock, Bear Away's drummer, was telling me. "Jacob and Lewis met at around this point too, as the bands they were members of were also regulars at the 'Rock-it Club,' as that tiny room was known. They kept in touch over the years and played about with projects which never really took off."

Jacob Thundercliffe (Vocals & guitar) and Dom Brining (Guitar) first started playing music together at school, and continued to jam over the years that followed, sharing mutual friends and bands until eventually finding the perfect match of musicians to form what has now become Bear Away.

James continued, "We formed in early 2019, after Jacob asked me to start a new band with him, Dom and Lewis Ward (Bass). Our main aim was simple - to make music that we would enjoy listening to, to scratch that punk itch none of our previous bands had quite reached. After much discussion on the matter, we found that we were all wanting the same thing, something none of us had found in a band for quite a while. I think realising what you want from your band comes with age and experience. We all had other commitments (families, jobs, etc) which meant that the band would have to be more easy-going. We would do things at our own pace and allow things to take as long as they needed to. I really do think that this is one of the best things about Bear Away, from a personal perspective - there's no urgency, no pressure, we do things when we can, to fit around life's other priorities."

Using this approach, the four-piece Bear Away would create demos remotely, then meet to practice and develop the songs together. These early tracks would be the first written for the band's debut EP, 'Never In The Same Place'. "Ideas were passed around via email, so that when we eventually met up, we'd have at least a couple of songs to play. To this day, we still write like this. It's very rare that all of us sit down together and 'jam' to write music."

"Whilst writing the first batch of songs, we were drawing influences from a lot of the bands we were listening to at that time: Iron Chic, The

Menzingers, The Bouncing Souls, Spanish Love Songs, The Flatliners, to name just a few. These were all common influences that we initially bonded over and took inspiration from, but we all have our own personal influences that cover a vast range of the musical spectrum. That being said, most of my personal favourite albums come from the melodic punk genre." James continued, "Alkaline Trio played a big part in my musical upbringing. Their album, 'Good Mourning', to me showcases everything they have to offer as a band. It was Derek Grant's first album with them, and I find the way he writes his parts to be absolute perfection. His groove, how he accents certain parts of a song. It's like a masterclass to hear him play."

With their first handful of songs written and recorded, Bear Away were ready to put out their first EP. The title came from a discussion they'd been having whilst trying to arrange practices. It was proving difficult, as someone was always unavailable. They were never in the same place at the same time, hence the title, 'Never In The Same Place.'

The bands next task was to decide whether to self-release the EP, or to get help from someone with a bit more knowledge. Jacob, Lewis, and James had all previously worked with Wayne Hyde at Disillusioned Records in Bridlington, so he was their first port of call. Wayne loved what he heard and was on board immediately, soon suggesting getting Engineer Records involved too. I'd known Wayne since way back and we'd already worked together on several joint releases including Failsafe For Tomorrow's 'Give Up The Ghost' and Red Car Burns 'The Roots & The Ruins' in 2010 and Come The Spring's 'Seven For a Secret' in 2013. Obviously, Engineer was all-in. The band were receiving so much positive feedback from our initial contacts that we all knew they were doing something right.

By June 2019 the CDs and cassettes were ready, t-shirts had been printed and a gig was booked at Indigo Alley, in the band's hometown of Scarborough, with support coming from close friends Misfortune Cookie. The EP was released on 14th June, but the gig was booked for 17th August, to give people plenty of time to get to know the songs before the show. It was the band's first proper gig and the venue was packed for a great night.

For the rest of 2019 and into 2020, Bear Away played shows when they could, mainly around Yorkshire, and then uploaded their song, 'Is There

Any God Up There?' to BBC Introducing. To everyone's surprise, it made Track of the Week on Jericho Keys BBC Radio York Introducing show, giving the band a boost of momentum, just before the world shut down for covid in March 2020.

"Although this was frustrating, the spare time we now had allowed us to write and record more songs." Says James, "We also decided to release another EP, and this time it would be a two track 7". David at Engineer and Wayne at Disillusioned were both on-board again, and the 'East Coast / Old Friends' 7" was released on 26th June 2020 to many positive reviews, selling out almost immediately." Both tracks were accompanied by music videos.

For a while live music was non-existent so more songs were written and new plans were made. This included a split 7" with the legendary Finnish punk band, Custody, released on 15th March 2021 via Brassneck Records and Disillusioned Records. Again, it sold out straight away. That was two consecutive 7" singles, gone, just like that.

Now the band were expected to produce an album, so got down to working on it. The band recorded their parts on their own portable studio, apart from the drums, which were laid down at Hyperbright Studio in Scarborough. When the songs were ready, as a longshot, they contacted Dan Tinkler in Chicago about the mix, as he'd worked with bands including Masked Intruder, The Falcon, Brendan Kelly and the Wandering Birds, and others they were fans of. To their surprise, he was up for it, and within budget. As an added bonus, the record would be mastered at the legendary Boiler Room studios, run by Collin Jordan. So, Bear Away's music would be playing through the same speakers that'd helped mix and master some of the band's favourites; Alkaline Trio, The Lawrence Arms, The Menzingers and Less Than Jake.

The new album, entitled 'A Drastic Tale of Western Living', was released on 21st October 2022, on coloured vinyl LP, CD and digital formats, via Engineer Records and Brassneck Records (UK), Shield Recordings (NL), Sell the Heart Records (US), and Waterslide Records (Japan). (The Japanese version of the CD had a bonus track on it called 'An Oasis of Filth' which the band released as a digital single on 25th January 2023)

By late 2022, Jacob started to develop problems with his hands, causing him a lot of pain and meaning that he was struggling to play the guitar,

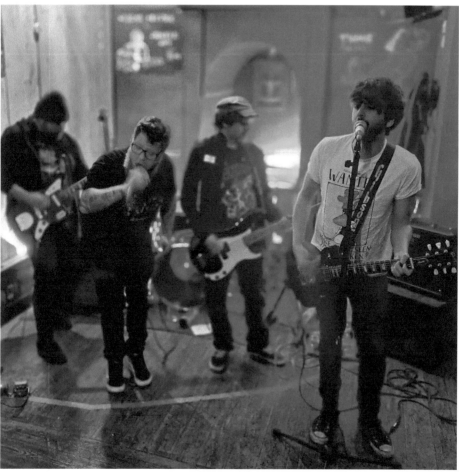

GOOD BYE BLUE MONDAY

BEAR AWAY CHARACTER ACTORS

FRIDAY 30TH JUNE

DOORS 7:30 SANTIAGO BAR, LEEDS, LS1 6PG
£6adv / £8otd TICKETS VIA FATSOMA

A DRASTIC TALE OF WESTERN LIVING

BEAR AWAY

BEAR AWAY
never in the same place

BEAR AWAY
THE LOCK AND KEYS
CALM
CHARACTER ACTORS ACOUSTIC SET

THE PACK HORSE
208 WOODHOUSE LANE
LEEDS, LS2 9DX

SUN 9TH OCT
7:30PM

£5 OTD

Bear away!

ZERO COST
BEAR AWAY
CALM

18TH NOV
7 30PM

FREE ENTRY

so the band made the decision that he would focus on vocal duties, and they would seek out a new guitarist. One man stood out for them as the ideal fit, and this was Josh Booth, from Character Actors. They'd played together before and knew his style would suit Bear Away, so asked him to join, and now rock as a five-piece.

"Josh has re-energised the band and given us a lot of drive to move forward. We aim to play many more shows across the UK, travel over to mainland Europe and hopefully even further afield." Says James, "You never know where these experiences will take you, as our story so far has proven. We have had tremendous luck, working with some of the best in the business, and these people have been so kind and generous with their wisdom and guidance over the years."

James continues, "The punk / hardcore community on the whole is a great place, especially once connections are made. The bands, artists, promoters, and fans you meet on your travels often become life-long allies. Although the scene has declined over the last years, I believe it is as important today as it has ever been. Given the current state of the world, I think punk and hardcore music taps into people's feelings, state of mind and personalities. There's always that sense of unity, whether it's within political punk, straight-edge hardcore, emotional post-hardcore, skate-punk, or any other form of the genre. It will continue to inspire and act on change, just as it has always done. This scene will stay alive and relevant in one way or another, because people need music to survive.

"Strong and interesting twin guitar work plus a really good vocal performance go a long way to making Bear Away a band to keep an eye on."
Razorcake magazine

"Emotive, melodic, punk-rock along the lines of Samiam, Knapsack and Custody. It's the kind of shit I pretty much live for. The lead and backing vocals interplay is soaring and majestic, and glides well atop searing guitar licks."
Apathy & Exhaustion

"The entire album resonates with brilliant ideas and exceptional musicianship. These guys know how to assemble proper bangers decorated with clever arrangements, themes, melodies, harmonies, and other sonic delicacies that define only the best punk rock albums.
The vocal segments are one of Bear Away's heaviest weapons in a sonic

arsenal. Anthemic singalongs and vocal harmonies enhance every song. The guitars continuously duel for dominance. There's no doubt this will become your go-to album every time you need melodic punk-rock music fix."
Thoughts Words Action

Bear Away: http://bearaway.bandcamp.com

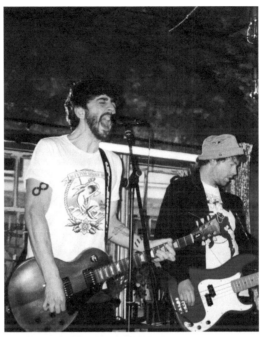

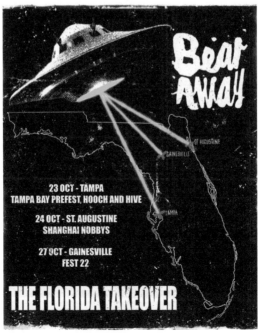

Born Infected

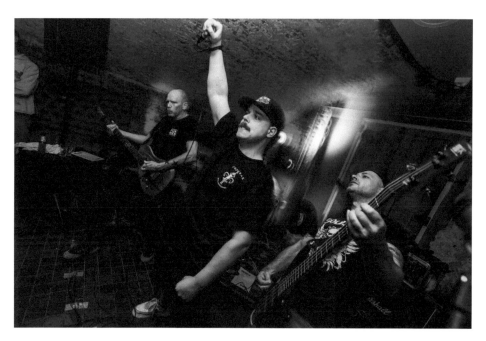

Ken Stassen: Vocals
Patrick van der Beek: Guitar
Ronald Hogeboom: Guitar
Pascal Beskers: Bass
Stan te Loeke: Drums

Born Infected is a Dutch hardcore band founded in 2019 on a singular idea, to make music that stands for something. The original principle was centred on the notion of mutual corporation with other bands in the scene to provide a platform and support for organisations and cooperatives that needed, and still need, both.

Dedicated to the belief that we're 'Stronger Together' Born Infected reached out to charities that they felt best embodied and were aligned with the objectives at the core of the hardcore scene, namely Hardcore Help Foundation, Animal Rights, and Sea Shepherd. Born Infected set out on their mission to wake the world up.

Ronald, Stan and Patrick shared some musical history having played in Past Our Means and Crawfish, but it was only when they added Pascal

(ex-Brickless, Revealed) on bass and Ken (ex-Reverse The Flow) on vocals to the mix, that Born Infected felt complete and ready for battle.

I was honoured that they wanted Engineer Records to be part of their ongoing quest to make the world a better place and released 'Self Reflection', the band's debut EP in December 2020. It had been a while since I'd spoken to the band, and when at long last I managed to have a conversation with Ken about everything going on, I decided to hand the reins over to him and let him do all the talking. After all, it's their mission and their story to tell...

"The story of Born Infected is rather difficult because there was a lot of history before I joined the band. From my perspective, it all started when my partner Amber got a message in the inbox of the Innocent Youth Centre, known for booking shows for hardcore legends and up-and-coming bands."

Patrick van der Beek had formed a new band but it just wasn't working out with the vocalist they had and they were looking for a singer who understood the hardcore mentality and music more than the previous vocalist had. Enter Ken.

"At the time I was living in another part of the country and had just had my first taste of doing vocals by storming the stage at a Malevolence show in Haarlem and grabbing the mic for Andrew Neufeld's (Comeback Kid) part in Severed Ties. That rush of energy left me wanting more. I'd been the drummer in a local hardcore band called Reverse The Flow but they wanted to play old-school hardcore in the vein of No Redeeming Social Value and I wanted to play more mosh-oriented music, which led to us going our separate ways. Still, I want to thank those guys for being my gateway into the modern hardcore scene in Europe. We played some good shows together and it's cool to see them still rocking on! I decided to reply to Patrick, and heard nothing for the next day or so."

"Then I received a message from someone called Stan while teaching, who turned out to be the drummer in Born Infected. He wanted to see if I had what it takes to be their singer and sent me an instrumental song, asked me to write lyrics for it, and then add vocals to the song. So that's exactly what I did and the song 'Two-Faced' was born, which was about a work colleague who talked shit about me behind my back. I was invited to Winterswijk to rehearse with the guys as a full band! And boy was I nervous."

"When I arrived Stan was waiting for me and walked us to what looked like a shed, but it was actually an isolated rehearsal room. That was when I discovered that they weren't a new band, but had all earned their stripes in the scene the hard way and I was the only newbie."

Patrick used to play in a legendary crossover/thrash band called Disabuse as well as Rise Above and Crawfish. Ronald has been playing music for longer than many people been walking the Earth and had been in Winterswijx Chaos Front, Fierce, Rise Above, and Crawfish. Pascal used to play in Revealed and Brickless, and Stan played in Crawfish. All the guys were in Past Our Means with singer Ronny Dorsthorst, who Is now Born Infected's gig merchandise guy and resident beer-connoisseur.

"Together they started a band with a mission, to bring hardcore back to what it used to be and give something back to the community. They told me that all of the profit from any future record and merch sales would be donated to three charities, Hardcore Help Foundation, Sea Shepherd, and Animal Rights, which is exactly how it should be, as Hardcore is more than music."

"Musically you can hear the influences we all bring to the table, as our songs have elements of Discharge, Hatebreed, Merauder, Madball, Kickback, and newer hardcore bands like Get the Shot and Terror. And here's a fun fact for you, the band's name comes from a moshcall in 'Atlas' by Get The Shot."

"I was more than a little impressed, as I was joining a band full of scene veterans with a conscience and hoped that I'd make the cut. The first rehearsal went well, and the songs started to take shape, which eventually led to another first for me, going into a recording studio."

Ken continued, "We recorded 'Self Reflection' in the summer of 2020 and wanted to get it released as quickly as possible. The vocals were recorded in August and, then it was time to find a label. Patrick found Engineer Records, as Antillectual was part of their roster, so I sent David the record demo tracks and he was incredibly enthusiastic about it. After a couple of quick emails back and forth it was clear that Engineer were the label for us, and have been working with us and incredibly positive about Born Infected ever since."

'Self Reflection' was released on CD and across digital channels on 4th December 2020 and the band were ready to get out and play, but COVID had other ideas.

"We decided to write more and concentrate on preparing for the day when we could start playing shows. During the lockdowns we were offered a couple of shows, however, due to the restrictions in the Netherlands, the audience would have to be sitting down, which we weren't happy about, and we didn't want that sort of subdued atmosphere to be our overriding memory of our first show."

"Thank God for social media though, as through Instagram we found out that a band had pulled out of a HC show in Hamm, Germany, so after some deliberation, we took a chance and got in touch with the German band Clubber Lang, who offered us our first show. As far as I remember, the audience was filled with more Dutchies than Germans, the show was fun, the fuse was lit and we wanted more." More soon followed. A lot more.

"When we were finally allowed to play shows we started promoting the record like crazy and the ones that stood out the most were our first weekend ones, which included the legendary Among The Angels festival with Backfire, GetSome!, Demon Joker Junior, Eightball and Hometown Crew. It was around then that Russia invaded Ukraine, and as hardcore is a global movement, we were asked to play a benefit show at Innocent in Hengelo, the venue we call home."

The entry money was donated to the 'Hengelo Helpt' which made sure people in the warzone received stuff to make life liveable; blankets, care supplies, bandages, etc. Born Infected played with No Teacher No Pupil from Rotterdam and local legends Fatesealer (formerly Troops of Doom). "Being able to play a sold-out show like that, with friends and good bands is exactly why we started this band."

"We then started supporting bands like Pro-Pain, First Blood, Dare, Teethgrinder, Stab, and Hoods, but the most awesome shows we've played so far are Pitfest 2023 and our weekender with our buddies in Tigerknife from Rotterdam and Bridge Burner from Germany."
"The weekender would, unbeknown to us, be the last shows we played with Stan (drummer) for a long time. He ended up hurting his back big time and wouldn't be able to drum for nearly a year, but luckily a good friend of ours, Kees, filled in and did an awesome job while Stan was out of action."

"Then Pitfest 2023 was a dream come true for us, playing with Bulldoze, Mindwar, Mayhem, and Phil Campbell (ex-Motorhead Guitarist, now playing in Phil Campbell and the Bastard Sons) was an honour, and sharing a dressing room with black metal band Marduk was a blast! We then started writing songs for our new record, which is going to have a more metal influence than our debut, and we've also started playing with Stan again which is awesome."

"We're grateful to everyone who bought a CD or a shirt, moshed during our sets, sang along, or just watched us from the back of a club. Thank you so much! It's all of you that keep this scene going and seeing new kids become part of it is incredible." Ken added, "Hardcore and post-punk will survive as long as there's injustice in the world, which means that it'll be around forever."

Thoughts Words Action said of the band in their review of 'Self Reflection'; *"Born Infected operates as a platform firmly chained to important causes, which immediately need implementation in contemporary society. The group preaches about the importance of animal rights, veganism and the eco-movement in times when both ignorance of humanity and societal habits are harming the global ecosystem."*

"Their 'Self Reflection' record discusses these crucial issues and reflects on our daily routine as possible causes for ecological downfall, global warming caused by gas emissions, malnutrition in third world countries, global poverty, etc. Still, Born Infected leaves enough room to reflect on the lack of compassion of contemporary society towards all living beings inhabiting the Earth."

"Music wise, Born Infected nurtures a widely recognisable new-school hardcore sound with beatdowns and catchy old-school thrash metal riffs throughout the recording.
You may hear similarities with bands such as Earth Crisis, No Turning Back, Backfire, Death Before Dishonour, Terror and Wisdom In Chains, but despite that, Born Infected are keeping their sonic articulations as unique as possible. One thing is for sure, if you're deeply rooted in hardcore music, you'll fall in love with their intelligent song writing, addictive beatdowns and energetic guitar shreds."

https://www.engineerrecords.com/borninfected

Breaching Vista

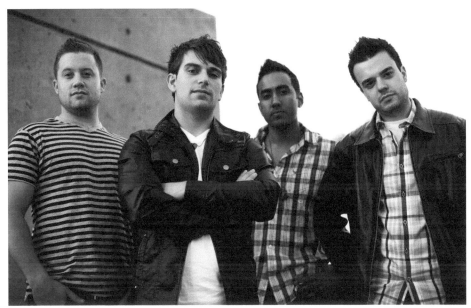

John Maksym : Vocals and Guitar
Al Malnar : Guitar
Mike Chhangur : Bass
Nik Varey : Drums

In 2007 Kitchener, Ontario's Pop Infused Alt-Rock quartet Breaching Vista arrived on the punk scene in a flurry of blazing, buzzsaw guitars and highly infectious hooks and melodies. Breaching Vista played over 200 shows with such notable acts as Theory of a Deadman, Jack's Mannequin, Hedley, The Sheepdogs, Matthew Good, Marianas Trench, Arkells, Finger Eleven, Our Lady Peace, The Reason, and many more throughout their storied, road dog career.

The release of 2008's 'Breaking The View' EP, paired with their rock-solid crowd-pleasing live performance, helped them land the closing ceremonies of the Canada Day Celebration in Waterloo, Ontario, for three consecutive years (2008-2010) and saw them play to audiences of ten thousand plus spectators each year. Their music garnered media attention with print, online, and both college and major radio stations, which led to them signing with Canadian indie label Brightside Records and UK post-punk label Engineer Records.

When the band started, they wanted to achieve the same thing every band looks for in a name; something original that not only stands out from the crowd but also holds substance with a story to tell. If this tagline was going to be what represented them on the front lines of the music industry for as long as they were a band, then it needed to be compelling, resilient, and inspiring, to showcase who they are and what their journey meant to them.

They had a passion for creating music and performing live, but saw the industry as a machine. All of the pieces operating in mechanical unison, but not necessarily in a way that was in their, or anyone else's, best interest. Breaching Vista didn't want to just go through the motions. They wanted to break into the scene, full force like an adrenaline rush, and change their view of how it worked. They intended to breathe some new life into a stagnant rock scene, and they wanted to be the band that was breaking the view.

Once they established this sense of purpose, they needed to phrase it in a way that sounded like a name. 'Breaking The View' seemed like a good description of the message they were attempting to portray, but it wasn't until they turned it into the synonym 'Breaching Vista' that they finally found their identity.

Breaching Vista's sound was often compared to bands of the mid-'90s to early 2000s, and if you asked each member of the band who their biggest influences were you'd hear band names like Green Day, Goo Goo Dolls, Third Eye Blind, Silverchair, Nirvana, Coldplay, Kings of Leon, Bush, Pearl Jam, Foo Fighters, Jimmy Eat World, Brand New, Taking Back Sunday and Yellowcard. Reviewers and journalists would piece together phrases like "Think Johnny Rzeznik of Goo Goo Dolls fronting Jimmy Eat World" or "It sounds like all of the best parts of the '90s without any of the fluff", which were probably the most apt, and accurate descriptions of the band committed to print and the digital realm.

The band always thought that they were fortunate to be in the heart of southern Ontario, Canada. The Canadian music industry is largely based out of Toronto, Ontario, which is just over 100 kms down the highway from their hometown of Kitchener. As more than a third of the country's population also resides in Ontario, it's an incredibly reasonable area to tour around in, with markets only a short distance away from each other. And as they were also very close to the East Coast of the USA, it made

touring fairly straightforward for American bands coming into Canada, even though Canadians always seemed to have more red tape to cut through before crossing the border into the US than their American counterparts did when they headed North.

Breaching Vista always had a very strong presence in their local scene and a few prominent DIY promoters helped build the local scenes in the late '90s and early 2000s, in cities like London, Toronto, Hamilton, Guelph, Kingston, and the band's hometown of Kitchener. And according to the band, some of those promoters are either still actively injecting life into the underground scene, or have passed the torch onto a new generation of rising talent in the industry.

Engineer Records bumped headlong into Breaching Vista when the band sent their demo to us and seemed genuinely surprised when we showed an interest in them, John later telling me that they rarely ever received any responses or feedback from any labels. After doing some research and finding out that we were legitimately doing what we said we would, they decided that we were the perfect partner for them. Even though they knew that we didn't have the financial means to compete with the likes of Vagrant, Fuelled by Ramen, or Hopeless Records, they still felt like they were part of something bigger than themselves and now had genuine support to help them expand their reach. In their words, "That was truly an incredible moment for us."

Working closely with the band, and Siegfried Meier at Beach Road Studios in Toronto, we'd soon release their first four-track EP, 'Breaking the view' on CD (IGN148) and promote it hard. Following it up with the full album, 'Vera City' on CD (IGN159) in 2011 and bringing on board Canadian rock label Brightside Records to help, as they had great distribution through Sonic Unyon.

Breaching Vista were going places, and I spoke with John about some of their more memorable shows and what eventually happened to slow their rapid ascent, and he smiled, took a deep breath and replied...

"What could possibly have been one of the most epic failures for us, turned out to be one of the most memorable days in Breaching Vista's history. But this is a story of how our triumph was very sadly outweighed by another's tragedy. It was the summer of 2012, and probably best described as a rollercoaster of events. We were landing some of the

biggest and best summer festival slots that we ever had, and just as quickly they were dropping like flies."

"We had been booked to play Brantford's Hockeyfest alongside Billboard chart-topping American Geek Rock band Weezer and Canadian Pop Rock charting outfit Hedley, but the festival fell apart and was eventually cancelled hours before the event was to take place. We had an opening slot to Brit-Metal icons Iron Maiden and American Theatrical Shock Rocker Alice Cooper at Sarnia Bayfest, but a week prior to the event Maiden opted to bump their set time an hour earlier than planned which resulted in us being dropped from the bill. There was also a small-town indie folk festival featuring Canadians Hawksley Workman and Serena Ryder that we were to play a significant role at, but it was randomly postponed until 'next summer' which, of course, never happened. And then there was the legendary Vans Warped Tour in Toronto."

John continued, "I'd been a long-time fan of the Warped Tour, having attended just about every summer from the year 2000 onward. On this 12th anniversary I would no longer be a spectator but finally part of the act! We had been invited to play on the Lemmon Stage, and it was definitely one of those childhood dreams come true. Wanting to soak in every ounce of the day and be well prepared for load in at 7am, we decided that we would leave the night before to make the short drive to Toronto and sleep in the big red school bus we used for touring when we got on site. Mike was driving, and as we were taking the ramp to transfer from Hwy 401 E to Hwy 427 S, when he very quickly manoeuvred the bus over to the shoulder. Thankfully there were no other vehicles around us as it was roughly 1.30am. When I asked what happened, he just responded something to the tune of 'We lost power' with a very confused look on his face."

"We tried to start the bus back up but it continuously failed on us. After about 30 minutes of troubleshooting and trying to evaluate the problem, we finally decided to call a mechanic, waking him up at 2am. Being in a fairly desperate position, we needed his help, and he didn't hesitate to jump in his car and meet us on the side of the highway. He arrived somewhere around 4am and spent about 30-45 mins doing his own troubleshooting to finally discover that our fuel injectors had disconnected. Within minutes of that discovery, he had the bus fired up and ready to go. By 5am we were back on the road headed to play Warped."

"After loading in and getting our merch tent set up, we found out that our set time was somewhere around 5.45pm. It was too exciting of a day to try and get any of the sleep that we'd missed out on overnight, so we did some promotion, watched some of the bands on the tour, and hung out with fans at the merch table. About halfway through the day, a fierce storm rolled in, with crashing thunder and bright lightning, forcing the festival to temporarily shut down. Fans were evacuated from the Ontario Place grounds and into the Molson Amphitheatre for shelter."

"I remember thinking to myself 'This is it, we're not gonna get to play Warped after all'. With the way the summer circuit had been going for us, it didn't come as a surprise, and I just kept reminding myself to appreciate that for the first time we were actually part of the Warped family. Somehow, I found comfort in that and was ready to accept our defeat. And then the storm passed us by, the sun returned from behind the clouds, and the festival was back on. Our set time was bumped to around 7 pm, but Breaching Vista were definitely still playing!"

"I'd be lying if I said I could remember the 30 minutes we had on stage. It's pretty much a blur, but I do remember the feeling of pure joy that I had, knowing that against all odds, here we were finally on the big stage doing it. It was completely awesome. By far one of my fondest memories in this band. We finished the night off with the famous Warped after-party BBQ, which took place on the Molson Amphitheatre stage. Just standing on that stage and looking out into the empty seats was a pretty surreal feeling as well, since I'd attended tons of concerts there over the years, but this was my first time getting the perspective from the stage."

"What we didn't know throughout most of the day though, was that in addition to the festival nearly shutting down from the intense storm, there was an even greater tragedy. A teenage girl had collapsed while moshing in front of one of the stages, and very quickly succumbed to her injuries as a result. It was during the set of the second to last band on the main stage that we had caught wind of the news. I remember the singer holding a moment of silence after giving a brief message of being careful and not taking life for granted. Not being fully aware of why he was relaying this message, I eventually learned about a girl passing away mid-afternoon. A mix of emotions; joy, sadness, and disbelief, were felt during the after-party by our entire band."

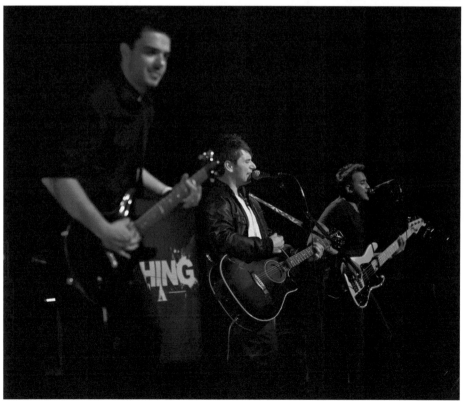

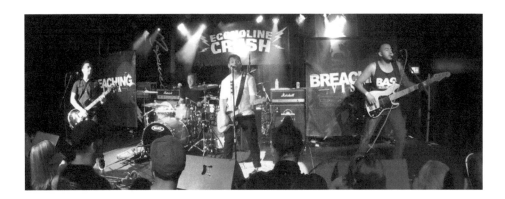

BREACHING VISTA

WEDNESDAY, JULY 25
6:00PM - 6:30PM

"We were grateful to have experienced a successful day for our band, but shared in some of the hurt that was felt throughout the Warped family that night. The next day we were shocked. Our Twitter account seemed to be blowing up with condolence tweets, tweets of gratitude, and general messages that somehow tied us directly into the tragic event of this poor girl's passing. We then learned that this young girl was Taylor Nesseth, not only a fan of Breaching Vista, but whose last tweet was reaching out to us the day before coming to Warped. She tweeted that she was so excited to finally see us play, and I had responded to her saying "Awesome! We can't wait!" sharing in the excitement. I never knew how much of an impact those four words were going to have."

"After seeing her picture posted online, I instantly recognised her. She had never been to one of our shows before, but earlier in the year I had met her outside of a Simple Plan concert at the John Labatt Centre in London, Ontario (now known as Budweiser Gardens). Taylor was there with a group of friends standing in a long line waiting for the doors to open. I was walking up and down the line offering to take the concert goers minds off of the cold weather while they waited, by inviting them to sample some Breaching Vista music via my iPod and a couple of sets of headphones with a splitter."

"This guerrilla marketing technique that is both challenging and rewarding because you not only get to meet many potential new fans, targeting your demographic of fans with similar interests in music, but can also convert potential fans into album sales on the spot when you connect with a fan who's willing to take a risk and support an indie band. Taylor was that fan. Within the first few seconds of listening to our music, she wanted a CD. I remember both her warm personality and the jumbo fuzzy slippers she was wearing. We joked and compared shoes as she bragged that her feet were really comfortable and I complained that mine were completely frozen in my Converse "Chucks", while her friends also listened to the music. Before moving on down the line, I quickly grabbed a photo with Taylor, as a way to show appreciation to our new risk-taking fans. I would take a photo with anyone who bought a CD from me, and then later post it on our Facebook band page as a thank you."

"As more information began to circulate, and friends and family of Taylor shared stories online, I read about how she had saved up all of

her babysitting money in a jar marked 'For the Best Day Ever'. She had been waiting anxiously for this day to come and couldn't wait to attend her first Warped Tour. To this day, I still find it hard to believe that our band was included in the plans of what was to be a young girls 'best day ever'. It's very humbling and I personally feel honoured to have met such a wonderful person, even if only for a few moments."

"Being a sentimental person myself, I couldn't help but pick up a pen and paper with my guitar one night in the late summer of 2012. Reflecting on one of the most emotional shows that I've ever played, I penned a verse and chorus for Taylor. I'm not sure why I never continued to write anything further, or why it never transpired into a full song. Maybe it will in time, but for now, dedicated to Taylor Nesseth is a poem called 'Best Day Ever'.

Best Day Ever

So long as never to forget
Celebrate your life
Though we mourn when you left us
I never really got to know more than your name, You touched well over a thousand lives
I was there first hand for the moment of silence, The Warped Tour it'll never be the same

Counting down the days, Every penny saved, Turning the calendar page,
I still can't believe You would say
We were gonna be part of, Your best day ever

Breaching Vista spent five years from 2007-2011 going from basement band to opening act for some of the biggest alt-rock bands in Canada. They received radio play across many stations and were invited to play at some major festivals. But when Nik Varey left the band, they experienced a revolving door of drummers which seemed to cause identity crisis within the group.

They carried on rocking stages, playing over 200 gigs, until after thirteen years together, they played their farewell show at Maxwell's in Waterloo, Ontario on 27th December 2019. John Maksym continues writing and playing music as a solo artist.

Reviews

"Their CD Release Party was nothing short of an over-the-top splash of talent and excitement when a sold-out crowd turned up" **Velvet Rope Magazine**

"If you're a fan of Alternative Rock, you can't miss out on this band. I know after listening to this, I need to see them live." **Marina Boy**

"A decidedly emo pop aesthetic but tight, dulcet guitars, double-kick and occasional African-folk inspired back-up seem to make good neighbours. Who knew?" **The Portal Magazine**

"Their music is unmistakably rock but it's punchy with a lot of edge. This band's sound is epic, there's just no other way to describe it" **Soul Matters Mag**

"A song like "Nervous" has enormous chart hit potential" **RockFreaks.Net**

"These guys have a great formulaic sound, perfect radio friendly driven rock." **May The Rock Be With You**

"This is one of those under the radar albums that you should not miss." **Melodic Net**

"The overall running vibe of the album is catchiness, something BREACHING VISTA have proven to have plenty of" **My Global Mind**

"All throughout the record; memorable choruses, impressive bass and guitars as well as catchy drums capture the attention of the listener." **VisiONtheNet**

"This album is an example that proves true the old adage of radio music: "It's popular for a reason."" **We Got This Covered**

"It is easy to imagine the music as an outline for a manic rock'n'ro'mantic tragedy to be produced for the theatre or the big screen" **Black Hat Media**

"A thirteen-song debut album that shows a lot of maturity, some great lyrics and an incredible sound. To say that I'm impressed by this band and their debut release is an understatement." **/scribbles**

"A catchy-as-hell slice of pop-rock" **Mass Movement Magazine**

https://breachingvista.bandcamp.com

Break To Broken

Clinton Maher: Vocals & Guitar
Eli Nowak: Drums, Vocals & Guitar
Justin Rauschkolb: Bass, Guitar and backing vocals

Formed in 2020 during a global pandemic which left the world in an isolating lockdown. Aussie Clinton Maher was looking for like-minded collaborators to help bring to life his vision for a new music project. A post on a message board connected him with Eli Nowak and Justin Rauschkolb, both veterans of the late 90's New Jersey punk scene, and the trio was formed. Despite living on opposite sides of the globe, the three forged an instant musical bond and began to collaborate on songs.

Break To Broken's songs range from ripping post punk/hardcore to introspective, almost dreamy indie rock. The individual styles, vocals and lyrics of each member merge throughout the album, creating a unique sonic connection through their virtual collaboration.

The alternative music scene can be anything you want it to be and the worldwide internet allows even more interaction, regardless of geographical limitations, enabling new post-punk inspired bands to

form in original ways, for many different reasons. The recent nightmare of government enforced covid lockdowns, allied with online based possibilities, propelled the seed of an idea to create a new band that Clinton Maher (Vocals & Guitar), Eli Nowak (Vocals, Guitar and Drums) and Justin Rauschkolb (Bass, Guitar and backing vocals) developed and took advantage of to form Break To Broken.

Justin told me when I asked him to reflect back on the band's unique formation.

"Reflecting on the year 2020 is a truly bizarre exercise. Did all of that lockdown stuff really happen? Looking back, it seems like a blip on the radar but in the moment, the isolation we all felt was real. Band practice, writing sessions, and punk shows were all stripped of the main ingredient - physical human presence. It was a time when most musicians found themselves turning inward to focus on solo projects. Then came the Zoom sessions and other technology that showed the world perhaps connection and productivity is still feasible without a face-to-face interaction. Instead of retreating inward, what if this time was viewed as an opportunity to extend outward? What if we leveraged this period to effectively shrink the world and collaborate with individuals we might never have encountered otherwise? Can people who have never been in the same room even create meaningful music together? These were all questions we unknowingly set out to answer by forming our band."

Break to Broken were brought together in October of that year, by way of two of the most polar-opposite things you could probably imagine: Fugazi and Facebook. Australian musician Clinton Maher found himself increasingly frustrated after producing years' worth of demos across different bands, yet with nothing to show for it in terms of actual releases. While fighting the boredom brought on by the pandemic, he received a gentle push from his wife to search for bandmates online in hopes of doing a virtual collaboration. Clint, an avid fan of the band, Fugazi, found a Facebook community, humorously named 'This is not a Fugazi Appreciation Group.' He joined the group and crafted a post that caught the attention of two Americans, Eli Nowak and Justin Rauschkolb.

Clint's Facebook Post from 6th October 2020 simply read: *"New member here… From Australia. Been a fan since about '93. Would any of you guys be interested in doing a collab Fugazi style band? I'm talking an over the internet*

collab. Not a rip-off, just in a similar type vein. I've got some songs going that I think could be cool for an EP."

Neither Eli or Justin had ever really considered doing a virtual collaboration, but Clint's proposition was intriguing, and they both thought the prospect of having Fugazi as a shared musical touchstone was inspiring. Once they all connected, there was a surprising revelation - Eli and Justin learned that they lived only an hour apart in the state of New Jersey. As they began to converse about past musical endeavours, they also uncovered that they had performed at some of the same NJ/NY venues with their previous bands over the years. The fact that they both happened to see and respond to the same post was a truly remarkable coincidence.

Shortly after chatting as a trio, the song ideas began to flow, and they navigated working in this new virtual space. The collaborative process was instantly organic with no one person dominating. They would start with one member sharing a basic track and would then build upon the ideas, listening objectively and evolving them to unexpected places. Communication, mainly text-based, proved surprisingly smooth and as songs took shape the band found it's rhythm—sharing ideas, recording and organising files. Some ideas fell by the wayside, and others transformed from raw demos to fully formed songs. The idea was actually working! Before they knew it Break To Broken had assembled twelve songs that would turn into their first album, 'The War on Sparrows'.

When I asked about the recording process Clint told me, "Recording and mixing a 'virtual' band might seem difficult or counter-intuitive on paper, but in practice it actually worked really well. The tracks were recorded in our various bedrooms, garages and basements, with my parents even providing their garage space for some loud guitar re-amping. Although most of the guitar tracks on the demos were recorded by each member using computer amp simulations, we wanted the final recordings to be of actual amplifiers through microphones. To do this, I utilised the process of re-amping Eli and Justin's guitar tracks. This was accomplished by taking a direct, clean recording of their guitar parts, running them through a mic'ed up amplifier in my studio, and then recording the parts back in real time, one by one. A laborious and painstaking process for sure, but it captured the live sound of the guitars as if Eli and Justin were right there in the studio with me. The songs were

all eventually pieced together track by track until we were happy with each one. Then the mixing process began."

'The Music Room' as it was dubbed by Clint's family (a spare bedroom taken over by guitars, amps and mixing equipment) is where the mixing took place, and the DIY mastering was also done there. Clint had spent many years before the band's formation collecting a bunch of mixing gear and spending countless hours learning mixing techniques and tinkering around.
He'd get each song 'in the ballpark' and then send them over for listening and any notes or changes.

Clint continued, "It was pretty remarkable how we always tended to be in agreement upon the sound and mixes we were looking for. There were rarely any debates or back and forward discussions. It all just fell together quite seamlessly. We were looking for a sound that could potentially sit alongside some of our favourite post-punk music from the 80s, 90s and early 2000s. Something with a DIY ethos shining through, but also polished enough to be able to blend in with other bands in the genre. Through a combination of modern software and external hardware we managed to get something we were all happy with in the end, and the process itself is something we plan on sticking with for the future."

From the start, Break To Broken collectively agreed to pursue a 100% DIY approach, taking charge of every aspect of the music themselves. This ethic was deeply ingrained in each of the band members through their upbringing in the respective punk scenes they emerged from. Their profound admiration for the band Fugazi transcends the fact that they were the catalyst for bringing us together. Their sometimes-unconventional approach to writing, where songs are more assembled from pieces than conventionally written, resonated deeply with the trio. This process played a pivotal role in shaping their distinctive sound, pushing them to venture into uncharted musical territories and leading to untraditional song structures. Consciously or subconsciously, the band adopted a similar ethos in their own creative process.

Each member of Break to Broken is a multi-instrumentalist, contributing various elements to each song, irrespective of the final performance on the recording. Another component of the blueprint that Fugazi created as a band was their natural aim to do the right thing

whenever possible. These things not only inspired Break to Broken as a musical entity, but also resonated deeply with them as individuals.

In 2021 Justin and his family relocated to Richmond, Virginia. This was around the time that the legendary Washington D.C. recording studio, Inner Ear were closing their doors. In November, the studio announced that they would be holding a closing-down sale that was open to the public. Don Zientara, the studio owner and engineer was selling almost every piece of equipment, furniture and artwork from the place. Justin made the short trip up to D.C. to check it out and see if he could snag anything. He was lucky enough to get a short tour of the studio and purchase two microphones from Don himself. The sale soon became chaotic and crowded so he didn't get to ask Don much about the mics, but a few months later he reached out via email to see if Don was willing to share any history. He learned that one of the microphones was a condenser that had been used by Dave Grohl and Scott "Wino" Weinrich (of the Obsessed and Saint Vitus) during a session, and the other had been used in almost every Inner Ear recording, for bands including Swiz, Minor Threat, Dag Nasty, Gray Matter, Government Issue, Verbal Assault, 7 Seconds, Avail, Fugazi, Shudder To Think, Jawbox, Lungfish, Rites of Spring, Discount, Girls Against Boys, The Promise Ring, Dismemberment Plan, Burning Airlines, Against Me!, Shades Apart, Down By Law, Joshua, Speedwell and many more. Break To Broken used both microphones to record parts of their album, inspired by using literal pieces of music history to help capture their sound.

The band was never about big plans or high expectations though. They just wanted to have fun and see where the music took them. Eli recalled when I asked about the decision to release their music on cassette. "Things took an unexpected turn when Charlene Ridley from Ripcord Records, an independent label in Scotland, came across two of our demo songs that were posted on an internet message board. It was a surprise when she reached out and complimented our music. We got to talking and she asked if we'd ever considered working with a label to do an official release. We mutually agreed that it was a good idea, and 'The War on Sparrows 'was released digitally and on cassette tape in August 2022."

Justin added, "Later, we talked about the idea of releasing our music on vinyl, something that we had collectively always wanted to do, but hadn't yet to in our individual careers. We didn't know how to go about it and were warned that making vinyl records could be costly and take a long

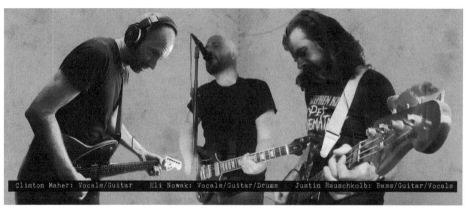

Clinton Maher: Vocals/Guitar Eli Nowak: Vocals/Guitar/Drums Justin Rauschkolb: Bass/Guitar/Vocals

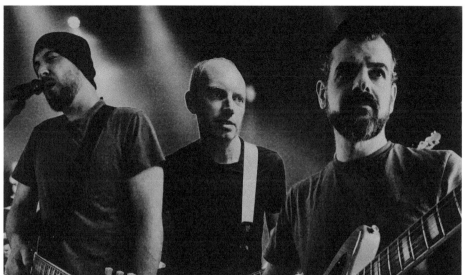

BREAK TO BROKEN

my better half +2

BREAK TO BROKEN

the war on sparrows

limited edition cassette

FFO: fugazi, helmet,
the jesus lizard

PREORDER NOW

128

time to produce. Leveraging past music connections, I got in touch with Craig Cirinelli, a stalwart of the New Jersey punk scene. Craig, who was working on a vinyl release for his own 'virtual' band, The Atlantic Union Project, generously provided advice on how to navigate the process. Ultimately, we decided to self-fund a run of 100 vinyl records, as Clint was able to find a reasonably priced company who could turn the records around fairly quickly."

"Soon after, Craig introduced us to David from Engineer Records which sparked a connection that went beyond our expectations. Through our conversations we were reminded of past ties to Engineer Records calling back memories of ER releases from Merciana and We're All Broken, bands with whom I (Justin) shared a personal connection with. To the delight of the band, David expressed interest in making the vinyl album an official Engineer Records release and offered to help with UK and European distribution. The limited run of records was released in October 2022."

Following the release of 'War on Sparrows' the bands focus shifted to spreading the word and promoting the record to those who might resonate with their music. Since live performances weren't an option due to proximity limitations, they set out to maximise their presence on digital channels.

Justin continued, "Charlene and David played pivotal roles in this effort, linking us with various reviewers and publications such as Idioteq, Thoughts Words Action, and Small Music Scene. These connections resulted in favourable reviews and write-ups, providing a solid foundation for our grassroots promotion. We actively reached out to our contacts and shared the album within punk and hardcore internet groups."

During this promotional phase for the debut album, the band never stopped working on new material. To sustain the positive momentum generated by the reception of 'War on Sparrows', they made the decision to release a digital EP featuring three songs. One of these tracks was a cover of the song 'My Better Half' by One Last Wish (the short-lived Washington DC band which featured members of Rites of Spring, Embrace and Fugazi). Given the bands collective admiration for the 1986 One Last Wish record and the fact that they derived the band name from a OLW song title, attempting a cover felt like a fitting tribute. Break To Broken also included 'Sorry not Sorry', a track from their original writing sessions, and Eli's sombre acoustic version of 'On the Beat' from the first album too.

The EP, entitled 'My Better Half +2', was released digitally in March 2023, and employing a similar grassroots promotional approach, the band managed to secure airtime for their cover of 'My Better Half 'on the Sirius XM radio channel, Faction Punk. Soon after, their original song, 'Safe Space' was added to their rotation as well and this exposure significantly expanded the band's reach within the punk community, for which they are immensely grateful.

"Podcasts also played a significant role in amplifying our presence." Explained Eli. "Jeff from the End on End podcast, a show dedicated to discussing various Dischord Records releases, graciously gave us a shout-out. Brad Nunnery of the Signal Chords podcast also helped to spread the word and provide support. Even a podcast based in France, Broke the Casbah, featured a review. Unfortunately, none of us speak French, prompting us to enlist the translation skills of Justin's brother-in-law, Andrew. These podcast reviews, along with the Sirius XM rotation, contributed to a growing appreciation for our music within various global communities."

While Break To Broken have regular conversations about how great it would be to perform in a live setting as a band at some point, they recognise that geographical logistics reduce the likelihood of this happening in the foreseeable future. But since Eli often performs via his solo project, No Wake, he plays 'On the Beat' in a few live sets. First airing it at a venue in Paterson, New Jersey, marking it as the first Break To Broken song ever to have been performed in a live setting! Not long after this, Craig Cirinelli invited Eli to take part in the first instalment of the great performance series he curates, called 'Legion Halls To Taproom Walls', held at Twin Elephant Brewing Company, NJ. Eli shared the story behind the band's formation at this show, and that led to its proper recording and inclusion on the 'My Better Half +2' EP.

But how do Break to Broken perceive this musical endeavour? Is it merely a response to necessity, a project formed out of convenience, or does it genuinely embody the spirit of a true band? Justin answers, "Without a shadow of doubt, we see Break to Broken as a bona fide band. Even though we've never all met in a physical space, and the prospect of playing our songs in person may remain elusive, the connection we share is undeniably authentic. This collaboration checks all the boxes crucial for a functioning band—a space where ideas flow freely, devoid of judgment, a mutual appreciation for each other's talents, a shared sense

of humour, and a collective passion for creating music that resonates with us on a profound level."

What makes this collaboration truly special is the absence of ego and the refreshing lack of anyone taking themselves too seriously. The band's unique dynamic not only translates into musically satisfying outcomes but also into the genuine friendships that have blossomed.

Clint added, "The pride in the work we've crafted together is magnified by the fact that it's a product of our shared commitment to the DIY ethos—an emblem of the authenticity and camaraderie. Our whole unexpected journey, marked by chance encounters and shared passions, really defines the essence of Break to Broken. It's not about big plans; it's about the genuine connections and the music that leads us down these unforeseen paths."

"These guys burst with impressive ideas and exceptional musicianship. The continuous duels between the two vocalists help this material shine even brighter in its diversity. There is no doubt that this debut is one of the best post-hardcore albums you'll hear this year."
Thoughts Words Action

"Nifty rifts, catchy hooks, and strident lyrics discussing that fear of being easily riled up and triggered by the opinions of others. Energetic and rhythmically riveting, with strong words centred around being foolish to trust such obvious scumbags who manipulate you and eventually stab you in the back to get themselves ahead of the rest of the crowd. It fires you up to stand united and lead a revolution against all the injustice and corruption that collectively holds us."
Small Music Scene

"'The War on Sparrows' delivers twelve songs ranging from ripping post-punk / hardcore to introspective, almost dreamy, indie rock. The individual style, vocals, and lyrics of each member merge throughout the album, creating a unique sonic connection through their virtual collaboration."
Idioteq

http://linktr.ee/breaktobroken

Call Off The Search

Ian Sadler : Vocals and Guitar
Mikee J Reds : Vocals and Guitar
Joe Michael : Bass
Ajay Pepin : Drums

Call Off The Search were a punk-rock outfit from Kent, England who played over three hundred gigs all around the UK in their fairly short existence, pouring their hearts and souls into every show. Supporting bands including Futures, Canterbury, Chunk No Captain Chunk, The Ghost Of A Thousand, The King Blues, Furthest Drive Home, Me Vs Hero, Not Advised, Smudge, So So Modern, Lost Boys, My Awesome Compilation, Patchwork Grace, DissolvedIN, Mimi Soya, Lights Go Blue and many more and likened to such luminaries at Four Year Strong, Paige, Tellison, New Found Glory, Hit The Lights, early Fall Out Boy and The Get Up Kids.

They met in the way band members often do, via the local scene where their original groups ended up on stage together in one form or another and they realised they could and should be doing better. They needed a good drummer though, so lit the metaphorical bat signal through

Myspace bulletins and Ajay came along to a practice. Despite his unique dress sense his powerhouse skills soon silenced any doubts and the band started to click.

Despite having over three years gigging to their name, between 2008 and 2012, Call Off The Search only ever had one official release and that was 'What Doesn't Kill Us... Will Try Again'. Released as a CD (IGN143) by Engineer Records late in 2010 with the first pressing of a thousand CDs selling out in less than six months and leading to a swift repress on Engineer and a US release on Pacific Ridge Records in California.

The nautical cartoons on the CD artwork had sharks, an octopus and a shipwreck on it, designed by Pete Duffield, who now illustrates books, and this theme continued onto some cool t-shirts, printed in neon green and blue, with some in muted brown and gold. They looked great and went like hot cakes too, designed I believe by Will Blood of Chaos Days, fellow South coast pop-punkers. These came in handy on the tours that followed, with Smudge and Mimi Soya, and then on a BBC Introducing tour, which I asked Mikee, of one COTS singers and guitarists about...

"Ever been in a situation where you didn't quite feel like you fit in? Of course you have, we are punk rockers, the outsiders to all the normies. Well, we were the outsiders of the outsiders on a BBC Introducing tour. To say we were unwelcome would be quite the understatement. I am pretty sure we just fell into it, by someone dropping out and our name being alphabetically next on the list. Whatever it was, at this time, it sure wasn't talent or even similar music. We didn't fit. We were a square peg in a round hole. One good thing did come out of it, was that during our performance at The Forum in Tunbridge Wells, our bassist at the time some how fell off the stage on to his arse and bounced back up. He was rather well known for letting the magic of the music take him to places we didn't wish to see, so this was a blessing in a disguise as after that, he was far more still, and in now also in time! Thank you slippery floor."

Despite any setbacks Call Off The Search always seemed to be the witty optimists at the gig and just kept on plugging away. The next thing being a music video for their single 'Train Yourself To Drive Colour' which brought them national television exposure on Kerrang, Rocksound and Lava TV, not to mention an extremely high number of online views through BlankTV and Engineer Records own YouTube channel. The guys shot the music video for 'Train Yourself...' in an extremely dusty and cold

space underneath London's famed Bridge Tunnel. Full of dust, bright lights, hard floors, jumping around and even more dust, the video and song captures the quartet at their filthy and energetic best. "It was a lot of fun," Mikee told me, "But caused a lot of bruises. Converse and uneven concrete floors are not the best pairing."

I asked Mikee about any other stories from COTS gigs and tours and he told me; "I don't care how punk you may think you are. Hell, you could have thrown TVs through windows and set hotel rooms on fire as you shout something about the royal family. But I can pretty much guarantee you that you have never had a full-blown argument mid-set on stage with a waiting crowd about where to park the damn car. Yep, that happened to us. Call Off The Search may not go down in history for what we produced with our thrashing guitars and somewhat in-tune singing, but we shall be remembered for one of the most awkward moments ever on stage in Kent."

Mikee laughed and continued; "We never quite hit the mark or found the crowd we were looking for, but we sure had fun trying. We got called all manner of things when it came to genre; punk-rock, pop-punk, softcore and once beardcore; yep you guessed it, a bunch of white dudes jumping around and getting sweaty on stage whilst having beards. Not a giant leap for the genre, but it seemed to fit us. I think they were trying to say we wanted to be Four Year Strong, which at one point I am pretty sure we were. But remember kids, never chase a trend, because once you have caught up, another one runs past and you are left far, far behind."

I reminded Mike about the successes of the band, including many great gigs and reviews, and tracks on quite a few big compilation releases. And he agreed, saying; "Kerrang wasn't knocking down our door to be their new front cover kings, but they never ripped us a new one either. In fact, our reviews always seemed to be positive, so you can't ask fairer than that. Plus we got to be on some magazine covermount CDs which lead to more gigs and eventually tours. Looking back now, we were lucky to have all the experiences we had. I can't ignore the successes of the band. We were an extremely proud member of the Engineer Records family, always treated well and our CDs seemed to move when they needed to. They even somehow wangled our funny looking mugs to be on the telly, thanks to all the now long-gone heavy music channels. We also had a few tours under our belts, nothing major, but always fun to remember."

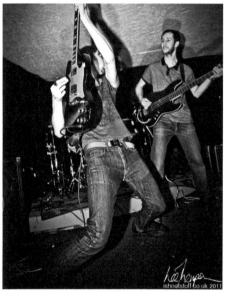

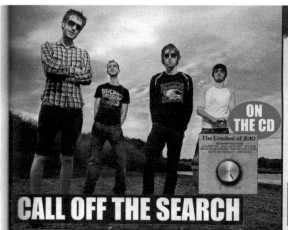

Home-grown pop-punks aspire to greatness.

While this playful UK act are loaded with upbeat, pop punk trappings there's no denying the steely determination that has fuelled their painstaking and passionate efforts from early 2008. Formerly known as The Sketch, the quartet's independently released 'Best Kid In Town' showed obvious potential, but this year's six-track EP sees the band enter increasingly skilled territory. Bursting with infectious hooks and sing-along choruses, 'What Doesn't Kill Us' is drenched in energetic riffs teamed with the melodic warmth of Jimmy Eat World and The Get Up Kids. Led by tender but commanding vocals, the band's accessible anthems have secured airplay on various radio stations, receiving praise from fans and hardened critics alike. Alongside their radio-friendly talent for catchy songwriting, the outfit's deeply personal lyrics lend a well-balanced dash of originality to the mix. Joining a promising roster of punk and alternative acts, Call Off The Search recently signed to Engineer Records in a bid to expand their steadily growing fanbase. Along with support slots with The Ghost Of A Thousand, Patchwork Grace and The Horrors, these young musicians toured with the BBC Introducing Crew, having been handpicked as one of Britain's finest emerging talents.

'What Doesn't Kill Us' is out now on Engineer

ROCKS LIKE:
FALL OUT BOY – From Under The Cork Tree
THE GET UP KIDS – On A Wire
FOUR YEAR STRONG – Rise Or Die Trying
Myspace.com/calloffthesearch

I asked him about some more stories from the COTS gigs and he told me; "It's never the good things that really stick with you. It's more the times where on tour our £200 car came to a screeching halt mid-journey through Piccadilly Circus. And believe me, there aren't many places busier to break down. We were not popular with those on their way home, however we did become friendly with some locals as they tried to sell us recreational goods on the side of the road. I guess they thought we may need a bit of pick-me up after all the wonderful hand gestures and audible comments from passers-by. Good people."

Mikee continued; "They say there is nothing better than a good show, with the crowd singing along and us more or less hitting the right notes at the right time. What could dampen that? I have the answer. On the drive home from said gig as a band member hurls his guts out the window and all across the car, as his head and half his body hangs out the window, zipping through country lanes. That my friends, is bonding. True moments of being a band."

"I am hoping we are not alone on this one, but we have played some from very odd shows. Once where we turned up to be the only band on the bill, due to others bailing. So, of course the smart thing to do is to cancel the show and go home early. But no, youth and stupidity won. Who were we to let down our one screaming fan, so we took to the stage. But, being the punk rockers we were with most songs barely reaching three minutes long, thank you Green Day and NOFX, the show came to a close very quickly, again. Seems like a good time to leave right? It would have been and it should have been. But no, stupidity and probably ego strikes again. Why not play the set again, exact same order, but why not twice as fast? What harm would it do. A lot, it was a wall of noise, and a mess of swinging limbs, that more than likely confused and saddened the 'crowd'. A lesson learned."

"Another time that comes to mind is that during the tour in which the car broke down, we did in fact play a gig to no one, and I mean no one, even the sound guy walked off. After all, who wants levels mixed as you play, what a ludicrous notion. One more, that likes to play on loop in my head as I try to drift off, was where we had finally made it. We had gotten ourselves a manager, full time representations. He was going to make us all stars. First gig. Old Gentleman's Club to a buzzing crowd of, well you guessed it, old gentleman. Maybe not the masses we wanted, but still a good practice opportunity before the runs across

Europe and the US. We were supporting a rising talent on the same management agency, we knew we were in for a show! And yet, our new guide to all things fame and glam, was shouting at this poor kid, 'No, no, no, you can do better than that. What's wrong with you?' It was at this very moment we realised, we had made a huge mistake. In hindsight, we should have known better when were asked to learn 'A Hard Day's Night' by some boys from Liverpool, it was not meant to be. Maybe we just assumed our next step was to conquer Germany much like them."

The next step for Call Of The Search in fact was to record a great punked-up cover version of Katie Perry's 'Teenage Dream' and release it in March 2011. It was meant to be a 7" single but eventually was a digital single (IGN213) with a video. It's hard to believe you're watching a load of hairy punk rockers shouting, "Do you think I'm pretty without any makeup on?" but it happened, a lot. It's a funny old world.

So, I asked Mikee, how did this run-away train to local success come to a screeching holt? "It didn't really. No major bust up or breaks, it just fizzled out. The determination had been demoted to motivation and we all know what happens to that. Eventually there was a phone call and we all agreed to part ways. From that day we never spoke again. No, I'm kidding, we have all very much been part of each other's lives on and off stage, with Ian (who runs his own recording studio, Emeline Studios) always being at the helm of recording our latest venture. I tell you that boy has the patience of a saint. We may have never travelled the seven seas or the lands afar, but some of the shows were truly unforgettable, with crowds jumping on stage to join in our singalongs or to precariously build human pyramids. Sights like that stay with you. After all, what goes up must come down, usually in a loud heap."

Once the COTS train came to an end Mikee continued with his acoustic solo project, Mikee J Reds, including European dates with emo champion Jonah Matranga of OneLineDrawing, Far and others, accompanied by his debut EP and split release with Jonah. But this faded away as a house, family and career came calling. The others re-joined forces to form a punk rock unit called The Reason I Failed History, which gigged on and off for years. From here, several different projects were birthed and came to an end, although Ian still runs his recording studio making many bands sound way better than they actually do.

Big Cheese said; *"Expect to hear a lot more from Call Off The Search, they're playing some of the best and most passionate indie-pop-rock in the country!"*

And **Kerrang** added that COTS were; *"Blending poppy, punky hooks with a dash of earnest Get Up Kids emotion. They are a burst of nervous, heartfelt melody."*

https://calloffthesearch.bandcamp.com
https://www.youtube.com/watch?v=dCIa8Ka65zo

Calm.

Ashley Merritt: Vocals & Guitar
Fred Jones: Guitar
Raphael Amancio: Bass
Jamie Lyons: Drums

Blasting straight out of Harrogate, North Yorkshire, this powerful and original punk-rock four-piece have gone through countless iterations over the past decade playing music together. From Midwest emo to hardcore, through skate-punk, the band has taken all the best flavours from each genre, adding some rock 'n' roll gnarliness and combining it to come up with a massive, anthemic brand of punk-rock that is all their own.

With influences ranging from Samiam, Jawbreaker and Fugazi, to Weezer, The Dirty Nil and My Chemical Romance, there are really no boundaries to the inspiration behind the Calm. sound. As long as it rages, it goes in the mix.

"Music and friendship are intertwined for everyone in the band," states Ash, Calm.'s charismatic singer and guitarist, adding insightfully, "I

know that I personally struggle to make strong bonds with people without that deeper connection that music provides."

Fred and Jamie, Calm.'s guitarist and drummer, met first, at school, playing in a pop-punk band called 'The Transmitters' who were essentially a Blink 182 covers band. While this was going on, on the other side of town, Ash was playing in "a terrible metal band called 'Sacred Poison' which was one step away from a Metallica covers band". Things didn't truly click for either until their worlds collided and confirmed that when the chemistry is right, and you're all weird in the same way, things can be far greater than the sum of their parts.

"I'd meet Fred on nights out, at local shows, or festivals" says Ash, "I found him to be obnoxious, loud, and too much for just about anyone to handle. We got along immediately! We'd talk about music and spend entire nights smoking weed, endlessly chatting about punk and hardcore. This resulted in Fred persuading the guys in NAA, the power-violence band he was now playing in, to give the weird kid in tartan skinny jeans from the posh school a chance at rehearsal with them. It clearly went well because I joined, and we started playing shows. This would be my first look into the equal parts, talented and passionate, yet cliquey and elitist world of local hardcore scenes."

"After some months playing in NAA, I moved from Yorkshire to London and would soon be joined there by Fred, who had a lot of demons to exorcise and time to kill. The songs that he wrote during that period would become the first iteration of Calm in which he played guitar and sang, and I played drums. Eventually we would be joined by Jamie who also moved down south, to Guildford, to study at ACM, and the runway became clear for Calm to truly take shape. Calm was an ever-present throughline that existed as the musical representation of our friendship during our twenties, even when other bands took priority, the feeling of the three of us in the room writing, jamming and fucking around was the best."

Ash continued, "Throughout the latter part of my time in London, I was going off the deep end in two respects: mental health and song writing. One acting as a sort of therapy for the other. Inevitably however, my struggles with my mental health and OCD would grow to the extent that they would put everything in my life in jeopardy unless I made some sizeable changes. A mental health inspired exodus back home to the north and endless therapy occurred, resulting in two things; feeling like

myself for the first time in years, and of course, writing songs! The struggles of that period became incredible fodder for writing and gave me so much to reflect on, including the lives and hardships of the other guys in Calm. Many of the tunes on our singles collection, 'Our Twenties' were inspired by that time."

The final piece of the puzzle for Calm would be finally finding their 'forever' bassist, who would eventually come from an unlikely source. "One day an incredibly good friend of ours, Pat, who'd also been a bassist for a while, was telling us about his cousin's husband Raphael. His bass guitar was broken, and he wanted me to fix it." Ash told me. "It turned out that Raph was not only a sound guy personality-wise, but he loved metal and hardcore, and more to the point, was a shredding bassist!"

The band decided to meet him properly and arranged a get together, showing up at his house one cold Yorkshire day where Raph appeared in his customary football shirt and flip flops combo, complaining about the cold, and going on about some music-man bass he desperately wanted.

"He was weird, but good-weird, so we hung out, talked music, politics, food and just about everything in between. If this guy could play then we might finally be onto something, and oh boy, could he play!" grinned Ash, "Our next band practice was a revelation. The band sounded better than ever. Raph was pointing out all our mistakes (something he still loves to do), but he was in. That was the day the band had truly formed."

Motivated to hang out and make the best music they could, Calm. began in earnest. There was no greater purpose or idea. Previously, they may have been concerned about making sure there was money for practice, weed and hoping they could wake up in time for work the next day. But now it was the music and their friendships first, with the band serving as an incredible outlet for creativeness, a mental health cushion and a shared experience with the people they love.

Calm.'s initial and pivotal influence was Samiam, especially around the Astray album era. It gave the band a mission statement that honesty, simplicity and heart are all they needed to affect people deep within their core. Many other artists have clearly gone into the mix; Jawbreaker, The Menzingers, (older) Fall Out Boy, The Dirty Nil, Superheaven, Alkaline Trio, Green Day, American Football, At the Drive In, Blink 182, Rancid / Operation Ivy, The Cro Mags, Descendents, Trash Talk, My Chemical

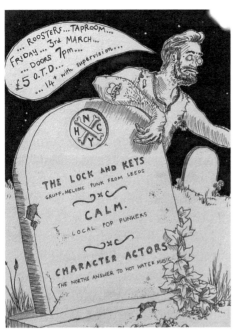

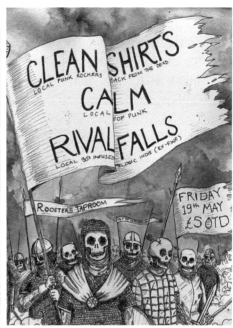

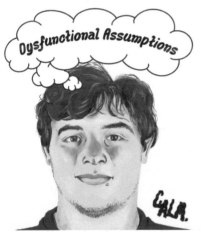

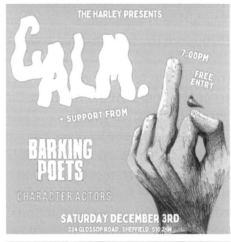

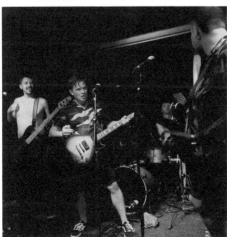

144

Romance, Fugazi, Rites of Spring, Into it. Over it., Iron Chic, John Frusciante, Nirvana, NOFX, PUP, The Smiths, The Strokes, Weezer. They've been playing together for so long and blended all these influences with their own distinctive and individual voices to develop a musical language unique to Calm.

Calm.s first release was a jangly, pretty, Midwest emo style demo EP called 'Help Yourself', which was put out independently and can only be dug out of rarity bins. This led to a series of digital singles, starting with 'Feeling Fly', which caused a major blip on the radar of the hardcore scene. Throughout 2021 and early 2022 the band would visit Homefire studios in their hometown to record a series of five ripping singles, including 'Eat Shit Everyone' (Ash's immediate reaction to the Covid epidemic as it was emerging – personal and powerful from the first second) and 'Reptile Brain' (a totally unrestrained vomit of thoughts blurted out in the white-hot heat of anger), both of which had accompanying video releases, and the latter was the opening track on Devolution magazine's 51st issue covermount CD. These songs introduced the fully formed sound of Calm. to the masses.

Towards the tail end of this process the band heard about Engineer Records through Ander from the Barking Poets. He'd been having guitar lessons with Ash in London and knew the band needed more promotion. "He was singing the labels praises and introduced us to David." Says Ash. "We have been enamoured at the DIY ethos and independent spirit that underpins everything Engineer Records do since. It's incredible to be part of a family that feels the same way we do about art and punk rock." This led to the release of a compilation CD containing all their singles, under the title 'Our Twenties'. The EP would come out with great artwork by their friend Joe Parker, of a giant middle finger flipping everyone the bird decorating the front cover.

The alternative music scene around Harrogate wasn't that warm to post-punk bands initially, even though NAA built some credibility, "there was still some arbitrary hierarchy and superficial cliquey bullshit to be dealt with". But in trying to develop a punk community where everyone gets respect and treated well, their local scene produced some incredible bands. Fuck With Fire, Eric Bana, Valhalla Pacifist, Jimmy Hotrod, Sweet Revenge, Shark Bait, and The Grebs were all brilliant, DIY punk-rock bands who wrote music as good as, if not better than, a lot of the generic skate-punk bands doing the rounds at the time.

They were supported by the band's good friend and local scene daddy, John 'Ozzy' Shepherd, who provided equipment, ran the sound at shows, recorded bands in his attic studio, stumped up cash, let people crash, and did all he could to collaborate and help. Without him, there really was no local scene and he still works closely with Calm. to this day.

The covid-19 pandemic proved fertile ground for song-writing and, like the man possessed he is, Ash continued to write obsessively, compiling the tunes that would comprise the band's next release, 'Dysfunctional Assumptions'. This would be a seven-track mini-album that tells the story of Ash's Twenties, from the murky depths of mental illness to the nostalgic reminiscing of memories created with his best friends. The new EP came out on digipak CD, limited 10" vinyl and digital formats, via Engineer Records again, and their partner labels, Shield Recordings in Europe, Sell The Heart Records in the USA, Fuck It All Music in Brazil and Waterslide Records in Japan.

'Dysfunctional Assumptions' was recorded, mixed and mastered with the help of John Shepherd. He even took the band photos to go with new Joe Parker art on the CD packaging. But initially the recording didn't run smoothly at all. At first the band went into a local studio with "two slimy, over-promising, under-delivering fools" where they were soon ripped-off, falling out and never receiving the tracks, even getting into local mud-slinging matches and legal hassles, with John losing his part of the business. This reminded them all of the importance of the scene's D.I.Y. ethic and they went back to basics for a second attempt at the recording. With the drums going through simple mics in Jamie's living room, combined with no over-dubbing or samples, just authentic, warts 'n' all, honest performances to capture the energy and urgency of the tracks. The result was a beast of an EP, packed with angry songs, powerful riffs, earworm melodies and anthems for today's ripped-off and lied-to generation that tend to stay with you and resonate.

The first video single from the EP was 'Obsessive Compulsive', launching on Friday 13th October 2023, jointly premiered by Punknews in the US, Thoughts Words Action in Europe and Mass Movement in the UK, and gaining over 5000 views in its first month on YouTube. Things were taking off, and more and better gigs would follow now. Calm. had arrived, and immediately started work on their debut full LP.

I asked Ash about a few of Calm.'s memorable gigs, and he told me, "We

have come to realise that our favourite gigs are the independently organised, diverse line-up, old-school punk shows. Essentially, the kind of shows that we grew up attending, that had a huge effect on us. The first time we played The New Adelphi in Hull remains our unanimous favourite. The venue is killer, it has been played by everyone from Radiohead to Green Day to Oasis to My Bloody Valentine, but you would never tell because it is a shithole at the end of a row of council houses."

That being said, there is just something about the place. Hull has a killer scene now, with a new annual punk fest, and great crowds who go absolutely mental. Ash continued, "Fred was in the crowd, throwing people about, surrounded by drunkards turning the floor into a sea of booze and fluids. We were playing with amazing bands like 'ADHD' and 'I Tell Lies', it was one of those shows that felt like home and really set the standard for us."

"We played the Key Club in Leeds with the incredible 'Cold Years', which was a huge moment for us in terms of playing in a place that felt like a legitimate level up. As a punk band we play our fair share of barely attended gigs in absolute dives too. The good example of this was an all-day festival we played in Manchester. We were on early in some pub near the university. We get there, the place is empty, absolutely deserted short of the bar staff and a handful of disinterested local alcoholics. Just our old mate Andy came to cheer us on as a one-man crowd. To add insult to injury, they'd put us on the acoustic stage which made passers-by hate us even more. The only silver lining of all this was that later, downstairs (where we should've played) an insane one-man act, best described as a 'singing, synth magician who played the keytar' was completely redefining what performance was. He even gave out beermat business cards afterwards."

Despite any amount of this, I just can't see Calm. getting down about it. Their band is about friendship first and foremost, and these stories seem to just make them stronger and more determined. With that in mind I asked Ash what he thinks of the scene now.

"Punk rock is music of emotion, disobedience, and protest. As long as those three things and electric guitars exist, there will always be punk, and it will always be relevant. It is fair to say however, that there is a massive difference between popularity and relevance / cultural significance; punk and indeed rock music as a genre is nowhere near its

peak of popularity, that honour would more than likely go to rap and hip-hop. Culturally, rock and punk are still massively healthy, especially in the underground where popularity is so much less important than meaning and passion."

Nicole Mendes at **The Other Side** was asked to review 'Our Twenties' and raved, *"Calm. has a unique way of both calming and provoking a listener. Using loud, brash and bold music, the lads throw a ray of sunshine on the dreariness of Northern England. Following their pop-punk anthem 'Eat Shit Everyone' (reverberates down your spine and makes your ears bleed – but there is something calming in the chaos – as if they are taking my disruptive thoughts and laying them bare for all to see), 'Our Twenties' is a look at the 'general train wreck' of adolescence and young adulthood. There is a sense of hard-hitting power in their unforgettable tunes.*
Everyone knows they make mistakes, deal with breakdowns and land up in the shit, but it is how you deal with these errors that make you stronger."

"I was sitting down to write a tune about one of my closest friends and noticed that at some point we'd all suffered essentially a total mental breakdown, some large and some not so large, but all of them resulted in acting like a total bellend for a while. In layman's terms, the tune is simply about how hard it is to become an adult. You gotta figure out what that means to you, gotta struggle, you gotta screw up and hope that on the other end you still vaguely resemble a human being." – Ashley Merritt on 'Our Twenties'

Punk Rocker.com added that *"You'll never find any close resemblance with any other band. Calm. thought about each segment of their songs. From catchy themes, ear-appealing harmonies, powerful chord progressions and riffs, to beautiful vocal harmonies, singalongs, warm-sounding basslines, and dynamic rhythmic sequences, Calm. thoroughly planned every manoeuvre to satisfy even the pickiest fans of the pop-punk sound. 'Our Twenties' EP is superb material you need to hear."*

Sage Plapp at **Rising Artists** reviewed the 'Our Twenties' CD saying, *"Packed with realism and relatability. It perfectly captures the feeling of being in your 20s and miserable, because the world is harder to get by in than expected, and it's also harder to get by in than it ever has been before. It makes us all feel like we screwed up. A lyric that truly captures this is, "I'm not a fuck up he said / But I'm just fucked up right now / This life has messed with my head / I think I've fucked my life up." It's well written and rings true to those*

in their twenties. A lot of the time it feels like we've fucked our life up when there's still so much ahead of where we're currently at."

And **Indie Dock Music** called 'Our Twenties' *"A hymn to past glory days of a cool youth movement. A track for crazy times when you drive around and tear everything to pieces."*

US music magazine **Bad Copy** reviewed the new 'Dysfunctional Assumptions' CD, saying that Calm. take *"All the best flavours from each genre, add some rock 'n' roll gnarl, and combine it to come out with a massive, anthemic brand of punk-rock that is all their own."*

The long-lived and well-respected UK fanzine **Suspect Device** added, *"This six track CD is good stuff. The first song, 'Obsessive Compulsive' is an ace song to kick things off. A loud, energetic, anthemic tune with great lyrics concerning mental illness, which he explores several times on the EP, which can only be a good thing. Some of the songs and vocals get a bit close to straight up rock in places but that's ok, the vocals actually remind me of Bruce Dickinson of Iron Maiden in a few places, one of those singers that can actually sing properly! Production is good, really full and powerful sounding. So, if you like your Indie-rock, pop-punk really anthemic and tuneful give this a listen."*

And the ever-trusty **Thoughts Words Action** punk rock blog said that *"Calm.'s sophomore EP, 'Dysfunctional Assumptions' thrusts listeners into a maelstrom of raw, unbridled energy that is both refreshing and desperately needed in an era tainted by deception."* Adding, *"The EP is a sonic journey that encapsulates the spirit of punk rock, delivering a potent mix of aggression, introspection, and unapologetic authenticity. As Calm continues to evolve and refine their sound, 'Dysfunctional Assumptions' stands as a formidable statement, a musical manifesto that demands to be heard and felt."*

We're waiting to see what happens next amongst the chaos for Calm. and looking forward to their first full length album in 2024.

http://linktr.ee/Calmfreakingslaps

xCanaanx

Nathan Bean : Vocals
Alan Dargan : Guitar
Darren Hilsdon : Guitar
Charlie Warren : Bass
John : Drums
Richard Shiner : Bass (& Guitar)
(Ross Bones : Drums)
(Daniel Burrows: Bass)

xCanaanx were a straight-edge hardcore unit from South East UK that formed in 1999 and split in 2003. Their explosive live shows and adherence to the straight-edge philosophy ensured that they soon became the stuff of scene legend, and their fame, or infamy depending on your point of view, persists more than two decades after they called it a day.

'Gehenna Made Flesh', their first release on Ignition / Engineer Records, was recorded in 2000, and its raw energy and brutal breakdowns were welcomed with open arms by a scene that craved the intensity that xCanaanx consistently delivered. They are, were, and

probably always will be widely regarded as the most influential straight edge band to have emerged from the UK.

Inspired by Essex heavyweights Above All and formed by members of various established and short-lived bands including Raiden, Slavearc, Bloodgreen, Touchdown and Up In Arms. After a cassette demo recorded by the late great John Hannon (of Understand) released in 2000 on their own short-lived Eden's Burning Communications, and a short run of 'Gehenna Made Flesh' CDs on Manchester's Abstract Communications label, xCanaanx started playing riotous gigs and soon came to the attention of Ignition / Engineer Records.

Ignition re-released and promoted their six-track 'Gehenna Made Flesh' mini-album in 2002, launching with a one-sheet summing up the band for the press like this...

"From the self-styled 'Straight-edge metallic hardcore band from the black heart of South East England', Engineer is proud to release 'Gehenna Made Flesh'. The long-awaited re-release of the awesome xCanaanx's debut record and by far the label's heaviest, most mind-blowing release to date.

Doing the rounds for about two years now as forerunners to the recent surge of straight- edge / metallic hardcore bands, this incredible band have achieved more than most do in double the amount of time. Establishing a formidable fan base across the UK and European scene and turning the heads of tons of hardcore label's, zines and kids everywhere.

With a recent line-up change and an even more hectic touring schedule building, xCanaanx seem to be set for the chance they deserve to devastate the world with their intensely heavy hardcore and perfectly executed straight edge message.

When a band comes along that actually has something to say and can combine that message with accomplished, tight, and focused songs that make you want to slam until it feels like your heart is going to explode and punch the air until your shoulders pop out of joint while you're singing along with them, you sit up and take notice."

xCanaanx (the x's were a declaration of their commitment to the straight-edge lifestyle) left you with no choice other than to stand back

in amazement at their incredibly tight, technical mosh-heavy sound that balanced precariously on the fine line that separates chaos and order.

Their harsh, angst-ridden vocals (Nate, xCanaanx's singer, started coughing blood during the recording) that were fuelled by lyrics confronting religion, corruption, and self-ruin pummelling blast beats that were reminiscent of Slayer and monstrous riffs that could have been written by Hatebreed, made the band a force unto itself that pummelled its way to the top of the scene and earned the band a place at the head of the hardcore table.

'Gehenna Made Flesh' opens with the catchiest track on the record 'Hollow Sky', re-recorded from the demo, and you know you are in for a treat with some of the most exciting music you're going to hear. With it's addictive "On your knees before a hollow sky" chorus building you're only just getting over that when you're blown away by the onslaught of the next song, 'Eighth Day Descent'. A breath-taking track based around verses lead by insanely fast blast beats that give The Swarm a run for their money. The next two tracks 'Immaculate Amongst Betrayers' and 'Vae Victus' display the bands strength in nailing sweeping double bass pedal backed, dark and heavy sections to awesome rhythmic breakdowns. The last two songs are earlier demo tracks, their anthem 'Gehenna Made Flesh' and 'Sworn Vengeance', which could easily be a band slogan. These songs capture an earlier more metal side to the band bringing the likes of Caliban to mind. The record just seems to increase in aggression and power, or that's certainly the way it makes you feel as you progress through each song. xCanaanx are a straight-edger's paradise, with crushing music and a proud and clear self-belief. Overall, their lyrics, repeatedly confronting religion, corruption and self-ruin, will provoke thought in any listener, something that is constantly reinforced as they seem to strike a chord in anyone and everyone that hears them.

xCanaanx toured here, there and everywhere with The Deal, Sworn In, Caliban, Unearth, American Nightmare and Kentish HC comrades Urotsukidoji, and would soon be recording a split 7" with Newcastle's heavy hardcore kids, Thirty Seconds Until Armageddon. Each band providing two tracks, Canaan's powerful 'From Blood To Fire' and anthemic 'Sometimes Death Is Better' which would soon be appearing with bloodied razor blade graphics on their t-shirts. The EP came out on Ignition / Engineer Records as cat no. IGN020 and 1118 were pressed.

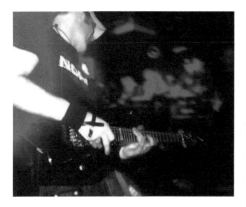
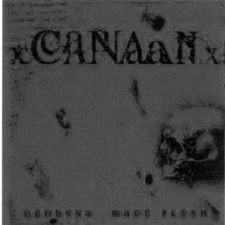

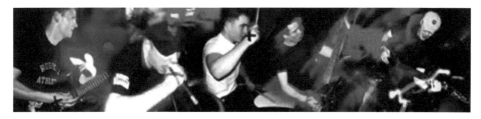

The 7" was launched on 8th June 2002 with a noisy, boiling gig at the Jubilee Hall in Wincheap, Canterbury. This tiny nondescript little venue had never seen so many screaming, sweating, finger pointing hardcore kids packed into it. xCanaanx headlined with Urotsukidoji, Winter in June, Rydell and Jairus (playing their first ever gig) all supporting.

Of the 1118 copies pressed, the first hundred had special straight-edge XXX covers for the release shows. These covers were a spoof on Wide Awake's 'CT Hardcore' 7" on Schism Records and were hand numbered by Milo from Rydell. All the EPs after that had the bright red blood-smeared gatefold artwork designed by Richard Shiner. And for the record

collector nerds out there, a club that I'm a fully paid-up member of, 700 were on black vinyl, 200 transparent yellow, 100 clear and 118 were released on red wax.

The seven-inch should have solidified their reputation and pushed them even further down the path to hardcore fame and fortune, but they'd implode in 2003 before they could benefit from it. xCanaanx did record two more tracks before the end, with Ben Philips at his City of Dis studio in Rainham, Kent which were circulated on CDr in the band's final days. The various members all went on to play in numerous hardcore bands of note, including Nate in On Thin Ice, Age of Kali, Rot in Hell and Eyeteeth. Alan in Tyeburn. Darren in Raiden and Love That Kills. Richard in Lightbringer and Inherit. Ross in November Coming Fire and Dan in The Break In. xCanaanx burned briefly and brightly, and it was one hell of a ride...

One review, in **LouderThanSound**, summed it up; *"The incredibly fertile Kent scene produced many great bands during the early noughties, but the kings of the Kent scene were definitely straight-edge five-piece xCanaanx. A good few years before America decided to kick-start the metalcore revolution, xCanaanx were making hardcore that was cut from a decidedly more metallic cloth. 'Gehenna Made Flesh' is a stunning listen; full of pace, fury and riffs that owed more to Slayer than Agnostic Front. Clocking in at just under eighteen minutes it leaves you gasping for more, and while it's really brilliant, the fact that you won't ever get to experience these songs performed live again is the real tragedy here."*

https://youtu.be/p-5k9ovSbAk?si=xFE4X9GvdGq-VjiL

Come The Spring and The Atlantic Union Project

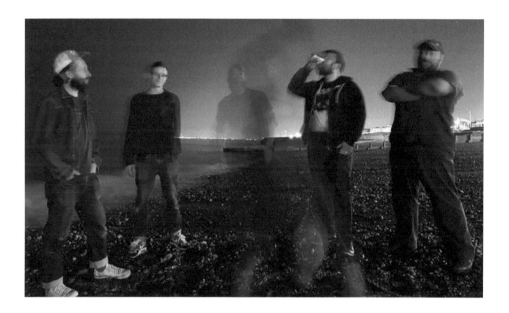

Simon Goodrick : Guitar
David Gamage : Guitar
Mark Wilkinson : Bass
Jamie Donbroski : Drums
Sam Craddock : Vocals (Come The Spring)
(Vic Payne : Vocals (Come The Spring))
Craig Cirinelli : Vocals (The Atlantic Union Project)

Hailing from the rocky coasts of Brighton in the Southeast of England, Come The Spring offered a fresh and uncompromising sound, blasting straight out of their sea-breeze filled lungs. Comprised of hardcore veterans whose previous bands included Rydell and Strength Alone, they'd shared the stage with everyone from Hot Water Music to Green Day, Samiam to No FX, Down By Law to Leatherface, and many more. Those experiences giving them the confidence to hit the touring circuit on a national level, unleashing high-energy performances with a set of emotionally charged and anthemic songs.

It was a chance meeting in a swimming pool in Brighton in December 2011 that proved the catalyst for Come The Spring and The Atlantic Union Project. Macca (ex Rydell, The BBMFs) bumped in to Simon, an old friend he hadn't seen for seventeen years, who both played in the final incarnation of UK SXE legends Strength Alone. Talk immediately turned to getting a band together again and during early 2012, I (David) hooked up with Simon, Macca and another ex-Strength Alon-er, Jamie and we started to jam.

Starting out at Monster studios in Brighton, we intended to get together once a week to write music and then go for a few beers. Four musician friends hanging out and having fun, just for the hell of it. But it all came together so well that we soon felt we should be recording or out playing gigs, but there was a problem - first we needed a singer!

We'd decided to call ourselves Come The Spring and soon had the music sorted for our first five or six songs, but none of our 'backing vocals voices' were quite cutting it. I was in touch with Vic Payne, the singer of a great south coast hardcore band called My So Called Life, who'd pretty much broken up now, and he was just singing solo gigs playing acoustic guitar and I'd been helping him book a few shows. I suggested he joined us at practice and he came along and tried out. It went very well and he was soon penning the lyrics to our first six song EP, entitled 'Seven For A Secret'.

In October 2012, before we'd even played a single gig, we headed into the studios to get these tracks down. We recorded at Emeline Studios in Whitstable with Ian Sadler, a good friend and brilliant engineer, and that would be the home for all our Come The Spring recordings. 'Seven For A Secret' (IGN199) was released in March 2013, initially as a short-run of CDs by Disillusioned Records, a new hardcore label based up in Yorkshire, and then soon as a bigger CD and digital release by Engineer Records, pushing it further afield.

We'd agreed as a band to pace ourselves; all having been here before, only playing the gigs we wanted to and fitting band commitments into our busy lives as best we could. But the bug was always there, and we were bitten again. Soon we were starting to book gigs, first around the southeast supporting friends bands and then slowly further out across the country and steadily we played more often. Most weekends we could be seen bouncing up and down with our guitars on some sweaty stage

with Vic hanging upside down, swinging off of the lighting rig and screaming. It was pretty good fun.

Our first gig was 27th October at the Crown and Anchor in Hastings with Kent pop-punkers The Vindickers. We nearly got to play earlier that day at the Hastings Zombie Walk too, but unfortunately that fell through. Now that would have been a great first gig! Notes from that initial performance included "learn how to count the bars before the start of readbeforeyouwatch" and "enforce the 'no more than two drinks before we play' rule", but otherwise it seemed to go fairly well.

We had a lot of contacts from our previous bands so plenty of gigs quickly followed, including three shows in a week at the end of November, one being a packed Stonegate 'Rock Nite' to raise money for charity, where we debuted our screamo cover of 'Living on a Prayer', and another was our first gig in London, with The Vindickers and These Days up at The Fighting Cocks in Kingston. Always a good venue and a friendly crowd.

March 2013 saw the release of our debut EP 'Seven For A Secret' with posters, t-shirts and much fanfare, and great gigs in Worthing and Brighton followed, before what turned out to be the final gig with our original line-up at the Grand Hotel in Folkstone in April 2012. This was a stripped down, acoustic gig in front of a seated audience. Very different from anything we'd done before, but something we wanted to try. The show went incredibly well and there's a video on YouTube if you can find it. This format seemed to open up new possibilities for the band and our songs, although I remember Jamie ruining his hands with his ferocious thumping of the cajon, and, as it was a fairly mellow event in the Grand Hotel's huge glass conservatory in the clifftop gardens, a pizza was delivered to an audience member during 'Patching the Cracks'.

Unfortunately, playing in a lesser-known post-punk band is hardly lucrative. It is an absolute labour of love and unless you commit 100%, or sign to a big label with lots of money, it can be thankless too. Cracks had been emerging in the band's relationship with our singer Vic for some time. He had other commitments, singing for a wedding band and playing covers in pubs, so discussions over a ten-date tour later that year proved the breaking point and we parted ways, rather acrimoniously, in July.

That was a real shame, but after a few months off, we recruited Sam Craddock, another great guitarist and singer who was playing solo gigs under the moniker of Hands Shaped Like Hearts.

I'd known Sam for a while, seen him at gigs and even discussed a release for his solo acoustic songs on Engineer Records. When we played him the new demos and invited him to write some lyrics for them and join us, he couldn't wait. It was a great match, his angsty bellowed lyrics over the intricate but powerful music. It worked well almost immediately, and the sound became even more hardcore. Repeating the pattern from the first EP, we recorded together before playing any gigs with the new line-up. We went back into Emeline studios with Ian recording our 'Revive' EP over two sessions in January and July 2014.

'Revive' (IGN222) was released on CD in the spring of 2015 by Engineer Records and the launch was supported by airplay on several heavier alternative radio stations. There were also a couple of videos, one for '24' and another for 'Memory and Resonance', both made up from clips of us all just driving or walking around the Brighton area inter-cut with live gig footage. We started gigging again and soon had better tour and support offers coming in.

We played a bunch of shows around this period, at Bar 42 in Worthing, a seedy but fun rock club in Worthing with carpet all over the walls to dull the sound, and both inside and outside at the excellent Help For Heroes Festival, where Simon, Macca and I invited our kids (Ollie, Charlie and Jake) on stage to join in and sing-along. This may have perplexed the audience, but we loved it and so did the kids, and we have some great photos and memories of these shows. We played excellent gigs at the Quadrant in Brighton, where Duncan, the old Rydell drummer, came over from South Korea to see us, and then at the Hope and Ruin, where Sam joined in on third guitar. Macca did his knee in and had to have a brace on it but was still jumping around onstage at our next gig in Hastings.

Despite all life's distractions, by early 2017 we'd written a whole new set and were playing a few sing-along covers live alongside our emo angst songs at gigs too. One of these was 'Swann Street' by an old DC band called Three, formed by the three guys in Gray Matter and Jeff Nelson of Minor Threat. We cranked it up and played a fast, crunchy version, instantly recognised and cheered by the hardcore kids at our gigs.

In July 2017 we went back into the studio and recorded the 'Echoes' EP. Six more original songs and a speedy revamped cover of Don Henley's 'Boys of Summer' as a nod towards Rydell, the previous band of Macca and myself. 'Echoes' was released in the spring of 2018 on CD and digital formats by Engineer Records under IGN240 and had beautiful night-time cover photography taken on Brighton beach by Simon's girlfriend, Sofia Wåhlin. The angst-ridden record, and many of our gigs at the time, kicked off with 'Thirteen Months' and Sam shouting, "I've had trouble sleeping and that's nothing new, I keep waking up in these cold sweats to violent headaches and I regret it all" but soon turned to the more uplifting messages we wanted to portray.

There were videos released of the songs 'For What It's Worth', recorded at our practice studio in Brighton and described by one Rocksound reviewer as 'the perfect three-minute punch of hardcore joy' as well as the more upbeat and positive 'Better now' filmed out of the car window as we drove around New York City. We played more gigs and a few festivals, but less often now, as our singer, Sam, didn't drive and moved back across Kent to look after his parents. Our last gig with this line-up was a sauna-hot sweat-fest at The Harp Restrung in Folkestone with big fans trying to blow us and Red Light Runner off of the stage.

Around the end of 2018 Sam decided to leave the band and the four of us were looking for a new singer again. We soon found one in Sam Calver, another Brighton local, considerably younger than us, but heavily into the New York Hardcore scene bands and desperate to sing and play. We dropped down a key at rehearsals to fit his tone and wrote even faster paced, stripped down, more hardcore songs to bring back the energy. We recorded a couple of them live in the practice studio, just to listen to ourselves, but fun as it was, we never got around to properly gigging or recording these songs with SC singing as Covid intervened.

Nevertheless, soon after, we'd written and recorded another new EP, six more tracks we were pretty pleased with and wanted to release, but again needed a good vocalist to do them justice. We had the idea of asking six different friends from the scene to guest vocal on them, taking one song each. But having first invited our good friend Craig Cirinelli to sing on one and sent him the tracks to choose from, he sent back great sounding demos for all of them! The new songs sounded awesome as he'd nailed the vocals, so we were very happy to go with that. We decided to change the band's name to The Atlantic Union Project as he was based in

Boonton, New Jersey, nearly 3500 miles away across the Atlantic so we knew this record would mainly be a studio project.

Craig is a good buddy of mine and has been involved in Engineer Records almost since its inception. He'd also sung for some great bands, including Elemae, Damn This Desert Air, World Concave and Hidden Cabins so we knew this could work very well. We'd recorded the music at Emeline Studios in Whitstable with Ian Sadler, then sent the tapes over to Craig to work on the lyrics and vocals in New Jersey. He recorded his tracks at home in Boonton and sent them back to us for mixing and mastering here. It worked surprisingly well.

Craig started laying down his vocals towards the last months of 2020 and finished them in January 2021 with 'Stay At Home' which was an old instrumental out-take from the 'Echoes' sessions. The process of Craig adding his vocals to these tracks was an absolute joy. Macca commented on the process, "It's so hard to be objective when you're listening to your own band and this was the first time that I'd ever been close to that experience. Craig would send back files and I'd have no idea how he was going to have interpreted the song, what the melodies would be, what the lyrics were. Needless to say, each sonic package blew me away. It was a huge shame when all of the songs were finished."

Craig told me, "During the height of the Covid 19 pandemic I couldn't venture out to a studio, so set up a less than $100 mic through a USB into my laptop and recorded myself in an attic bedroom at home. I may have blasted out the mic sensitivity on a part here or there." He was receiving mainly positive feedback from all of us over here so kept on it, eventually getting all the tracks in the bag over the course of a few weeks.

"It felt so heart-warming but was also the challenge I needed to help the depressed mental state I was in, with loss of so much around me, along with the confusion that comes with being an over-thinker." Craig continued, "I'd record a full breadth of vocals for each song, one by one, sending them demo-mixed along as I completed each thought. I had four or five songs completed within about three weeks. Then, recalling an old, unused instrumental demo recording I had in my archive from Dave from years before, I committed vocals to the closing track 'Stay Indoors', which to me summed up the times, the anxiety, the fight of my personal self, mirroring the human sentiment globally, in such few words."

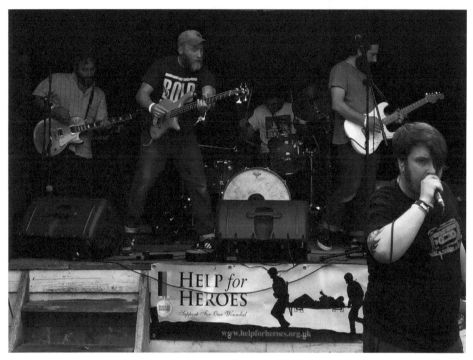
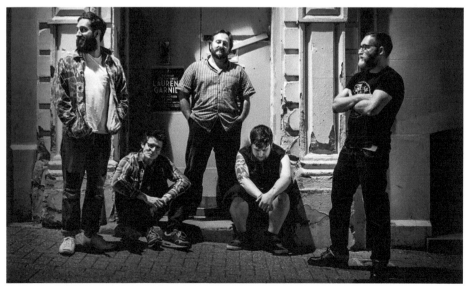

161

COME
THE
SPRING

THE DEBUT
SEVEN FOR A SECRET
OUT 25.03.13

COMETHESPRING COMETHESPRING

ENGINEER
EngineerRecords.com

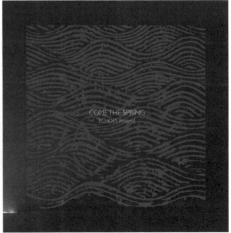

In 2021, while we decided what to do with the new recordings, we released 'Echoes Revived' (IGN310), with the thirteen songs from the last two Come The Spring EPs mastered together as a full album. The CD version quickly had three represses, but this was now well into the Covid lockdowns, so the live shows had long since stopped and things had really broken down. It was frustrating.

Going back to the new tracks, we decided to call this cross-channel collaboration The Atlantic Union Project and would name the release the '3,482 Miles' EP, representing the distance between Brighton, UK and Boonton, NJ. This was straight after Covid and we'd sent a few demos out, so the offers started coming in fast. The record was eventually released in 2022 on Sell The Heart Records in the USA, Shield Recordings in Europe and Engineer Records in the UK. Our latest musical venture would be available on digital, CD and gatefold 12" coloured vinyl formats. This release would be distributed worldwide through these independent labels yielding yet another creative idea brought to fruition through the D.I.Y. alternative scene.

The LP pressing was limited to 300 copies on sea-glass green vinyl and sold out almost immediately. The CD has had three pressings of 1000 each so far. It shows no sign of slowing, supported in part by videos we've gradually released for every track, with premieres on some of the alternative scene's biggest websites. Most of the videos quickly gaining over 20,000 views on YouTube, even with the first single for 'The Actuary' with its simple theme of 'how a life can't be weighed in value' being censored for having imagery about injections, riots, pharmaceuticals and politics, all deemed as 'sensitive' material by the channel.

By now we'd moved over to Brighton Electric for our rehearsals and Craig flew across the pond in May 2022, after the lockdowns, so we could play together properly as a band and record videos for 'Soon to End', a heartfelt song about mental health, the support and positivity that we all need, 'Strings Attached' about the looming sense of being an emotional puppet, and 'Cheap Seats' a rabble-rousing song championing the working class and all the downtrodden. "A real fist in the air from the amassed voices, hoping to rattle the engines of change and bring the conviction it'll take to get us there." It felt good to have such positive vibes flowing and an outpouring of anger against the grinding negative propaganda we were all being surrounded with.

We carried on pushing the Come The Spring and The Atlantic Union Project records throughout 2023 and into 2024, but we haven't been able to gig, despite some great offers, so the future is unclear for the band.

All the members of the band remain positive about the scene and are still contributing to it and playing in various other groups as well as writing. Constantly inspired by the post-punk music and message. And though currently on hiatus, they may be back at any time to give themselves and all of us an energetic kick up the butt.

Small Music Scene reviewed Come The Spring's 'Echoes' saying; *"They dish out the goods with great riffs and a mix of power and passion behind the harmonies."*

Post Punk Press added that *"Come The Spring are emotionally charged in every aspect of their musicality."*

And **Live A Little Bit Louder** joined in, saying, *"I was absolutely blown away. There's so much emotion and passion throughout every part of this record that really made it stand out. It impressed me a lot and honestly may be an early contender for one of my favourites of the year."*

Ox Fanzine said that; *"Come The Spring resurrect old emo heroes like Further Seems Forever and Elliott and spice it all up with a good portion of Gaslight Anthem. It sounds like the perfect emo-rock mix and has great potential. 'Echoes' sounds incredibly honest and authentic. And that means a lot nowadays."*

And **Thoughts Words Action** espoused, *"These experienced musicians purposely blend the essentials; virtuoso guitar licks, basslines operating as a separate life form and a mind-blowing drumming performance. Marvellous music, the quintet includes meaningful lyrics that go hand in hand with an extraordinarily pleasing sound."*

Ringmaster described 'Revive' as, *"A creative bellow which ignites ears and emotions. A tempest of alternative punk-rock, feisty and impassioned, fiery and memorable."*

While **Already Heard** admitted they were, *"A sucker for this type of radio friendly alternative stuff"* and that Come The Spring's 'Seven For A Secret' *"Ticks all the right boxes."*

Moving on to The Atlantic Union Project; "'3,482 Miles' was written and recorded during the pandemic, with audio files being sent across the Atlantic, the resulting EP is a love letter to the hardcore music scene. Inspirations include all the greats, ranging from Minor Threat, Dag Nasty and Descendents to Hot Water Music, Braid, The Promise Ring and Seaweed."

John Gentile of **PunkNews.org** continued, "This band kicks out high-energy, melodic punk-rock. There's soaring vocals. There's heart-on-the-sleeves lyrics. And on 'Soon to End' the band wraps up everything they do in one tight little ditty. This track has a lot of emotion and a lot of punch."

Jen Dan of **Rebel Noise** reported, "New melodic hardcore / post-punk outfit of veteran musicians launch a dynamic and socio-politically relevant anthem. 'The Actuary' is a pumped-up number that charges full-steam ahead with gritty guitar jags, a running bass line and hard-smacked drumbeat. The jagged guitars whirl around Cirinelli's emphatically shouted out vocals as he decries the economic disparity and other ills that plague our society."

And Rich Cocksedge of **Razorcake** added, "This release features half a dozen tracks of heart-on-the-sleeve, melodic punk rock along the lines of A Vulture Wake and Samiam. I enjoy how the rhythm section drives the songs along, whilst the guitars and vocals allow the songs to soar, especially on 'Trustworthy,', my favourite of the six tracks. I hope this trans-Atlantic musical venture offers up more like this in the future."

VinylBlaze described The Atlantic Union Project's music as, "Soaring guitars, big choruses, melodic emo / hardcore with a touch of Sensefield, Shades Apart, Saves The Day, Promise Ring and Praise."

Martijn Welzen at **Never Mind The Hype** noted TAUP are; "Heavily influenced by Hot Water Music, Dag Nasty and The Promise Ring, a mixture is made of emo-worn punk rock from the 80s and the post-punk sounds of the following decade. Six songs of nice up-tempo rock with a message, all underlaid with a wonderful DIY feeling."

And Marv at **Gadgie** said it was, "Anthemic melodic punk, a carry on that was as much in thrall to the likes of Leatherface and Snuff as they were to US HC acts of the 80s like Dag Nasty and Descendents."

Si at **Suspect Device** says '3,482 Miles' is, "An amazing EP! Kind of a blast from the past of fastish melodic driving hardcore reminding me of Sensefield,

Hot Water Music, maybe Seaweed, and others of that ilk. The lyrics are more personal, very well written and poetic, the sound is really powerful and full. The first track, 'The Actuary' is immense and on first hearing it I thought 'Wow, the rest of the ep cannot live up to this!' but I was very wrong, all six tracks are truly excellent. The vinyl comes in a gatefold sleeve on lovely looking sea foam blue vinyl."

And Dennis Merklinghaus wrote in **Punxhcilated**, "I cannot overstate how cool this record is! This transatlantic hyper melodic emo punk band brings powerful riffs, cleverly assembled melodies and harmonies. Punk and emo pioneers, the sound at times it reminds me of Samiam and A Vulture Wake."

The last word goes to Djordje at **TWA PunkRockBlog** warning, "If you aren't familiar with these guys already you should pay attention now. A polyphonous clash between ideas, creativity, experience, and years of performing. Outstanding compositions that span genres. The band distills their love for underground music through fresh ideas, cleverly arranged, performed and produced. An intelligent clash between old-school and contemporary punk-rock music." Adding, "What I adore about The Atlantic Union Project is the duelling between lead and rhythm guitars. There's no way you'll miss those powerful riffs and cleverly assembled melodies, harmonies, and themes. Both guitars are equally present in the mix, so everything sounds even more interesting. Thankfully, the bass guitar is also vividly hearable on each track. Those sharp, clean, almost semi-distorted basslines define the massiveness of these songs. As usual, melodic punk rock music wouldn't sound energetic without dynamic rhythmic manoeuvres, and the drummer knows how to decorate each segment properly. But wait until you hear Craig's voice. This guy is a beast and never ceases to amaze me with his impressive vocal skills. Each member plays a significant role in defining the sound of The Atlantic Union Project. Replace one of them and this EP wouldn't sound the same. I know some readers would like to read comparisons with famous punk rock bands, but The Atlantic Union Project sounds unique to me, and if you pay close attention to their songs, there isn't any other band like this one on the scene."

https://theatlanticunionproject.bandcamp.com

Crosstide

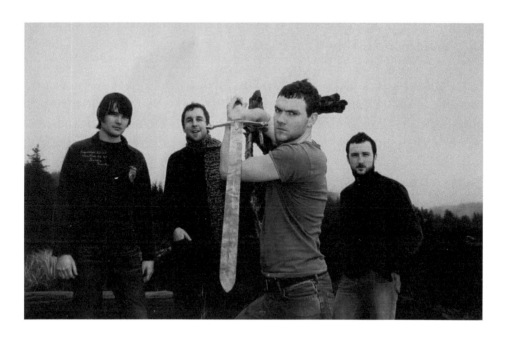

Bret Vogel: Vocals and Guitar
Matt Henderson: Drums
Nick Forde: Bass
Dave Scott: Guitar
Rian Lewis: Guitar

A band with the controlled, beautiful power of Sunny Day Real Estate, Chamberlain and Texas is the Reason, but accompanied with a mainstream accessibility and skilled musicianship that should have seen them scale the billboard heights Radiohead and Muse have achieved.

The formation of Crosstide was more or less an accident. Sometime in the late 90s, Bret Vogel (Vocals / guitar) called to check in on an old Hillsboro High School friend, Scott Preston. Scott was doing well and happened to be finishing up an impromptu jam session at Rian Lewis (Guitar / vocals) place in Lake Oswego, an affluent Portland suburb. He had run into Rian at an early show, and been dropped off at his place, but through a miscommunication, had no ride home. He asked if Bret (then known as Noodles due to his long curly hair) could come hang and give him a ride. Bret agreed.

While he had barely spoken with Rian before, just a brief chat at a Converge gig, he'd played a few gigs with hardcore bands that Rian had been in. So, about an hour later, Bret was sitting on the carpet of a soundproofed practice room listening to his friend and a few other local HC kids smash out some riffs. When the guys decided to take a break, Bret stayed behind to strum some chords and see how they sounded through proper Marshall stacks. A few minutes later, Rian Lewis was standing outside of the practice room wondering what band's chords Bret was playing. It turned out, they were his own. The songs reminded Rian of Texas is the Reason, and it turned out that they shared a favourite record in 'Do You Know Who You Are?' Excited, Rian sat down at the drumkit and started laying down some hardcore influenced beats to Bret's arpeggiated major sevens. They both thought it sounded pretty good. Moreover, they were surprised with each other; Bret knew Rian as a bass player, and Rian only knew Bret as a saxophonist! (A long story that involves Bret being a big Fishbone fan and becoming the sax player for a local ska band called Little Mission Heroes). It was a fun few minutes, but ended shortly as the others soon came back in, Bret handed the guitar over and the hardcore jam resumed.

When it was all done and Bret was leaving, Rian pulled him aside, and in a hushed tone, admitted that he and a couple guys were just starting an 'emo project'. This was somewhat secretive, because this was back around 1997, when the word 'emo' meant Rites of Spring, Texas is the Reason or the Promise Ring. There was no eyeliner or hair-dye involved at this point. These were the bands that sensitive HC kids listened to and were often afraid to admit to their friends. Bret had been writing these sorts of songs for a while, but had no outlet for them, and didn't think he was all that great of a songwriter or singer anyway. But Rian felt differently and it was through his encouragement and enthusiasm that the original incarnation of Crosstide was formed.

They formed a group with high-school acquaintances, Mike Wright and Joseph Neely, from semi-rural Hillsboro and up-market Lake Oswego, and for a while a fifth member, Keegan DeWitt, who booked their first ever gig at a venue called Stage 4, well before they were really ready. The high school students recorded a demo EP and began playing small all-ages clubs around town, between their other bands, Backside Disaster, Little Mission Heroes, and Second Self's gigs. They were immediately embraced by the Portland HC crowd, and while there was a thriving indie scene in Portland at the time, (with bands like Hazel, Slackjaw and Elliott

Smith) Crosstide felt more at home opening for hardcore bands during those days. Crosstide sold out of demo cassettes, played to bigger and bigger audiences, and eventually recorded a self-titled six-track EP for Chapel Hill Records, a small label in the Midwest. But by the time they got the CDs back to sell, the band had already pretty much fallen apart.

And that was almost the end of Crosstide. Rian, who was in many ways the heart and soul of the band then, began his senior year at high school. The multi-talented 17-year-old was singing lead in the school choir, starring in the school play, playing bass in his hardcore band, and eventually even voted 'Prom King'. Drumming in an emo band wasn't his priority, and without Rian's practice space, energy, and leadership, the band became dormant. Bret enrolled at a small Quaker university where he joined the cross-country team and took a part time job as a bike mechanic. He thought his musical days were over.

So, it was a bit of a shock when one day, while working at Hillsboro Bike N Hike, the shop's phone rang, with Matt Henderson, Rian's best friend and well-known Portland hardcore drummer, on the other end. He didn't have a number for Bret, but knew he worked at the shop. Obviously, this was before the days of social media. "Bret," he began. "I heard the EP. Rian left a copy of it in my car. You and I both know he's too busy being Prom King to really do anything with this band, and the songs are just too good, man. You need to let me play drums for you."

Bret told him it wasn't as simple as that; the other guys had gone their separate ways, but Rian was a big part of those songs, and he didn't want to offend him. "Let me deal with Rian. He's one of my oldest friends. He'll be realistic about it. And as far as the other guys, my buddy Nick plays bass, and we can find someone who can play the other guitar. Just let me deal with everything. We can practice at my house. What are you doing tonight?"

Bret had had about one conversation with Matt prior to this, at a Botch show, so he barely knew him. But he was so struck by the audacity of this guy, that he couldn't help but agree.

So, Bret, Matt, and Nick Forde got together and Crosstide was reborn. Despite recording an eight-track demo called the 'Winter' EP, which the band sold and gave away at gigs both on cassette and as a CDr in a paper bag with a Crosstide sticker on it. Rian soon agreed he was too over-

committed and bowed out. They found another guitar player in Dave Scott, another kid from the local scene whom Bret admired as a songwriter. This incarnation of the group really took off and new tracks started flowing.

The crowds grew until they could finally headline a small venue. Crosstide shared the stage with bands like Jimmy Eat World, Elliott, Cave-In, JeJune and The Juliana Theory. It was at a gig with the latter where Bret first met his now-wife, Shelley.

Crosstide were also lucky enough to open for Sense Field, where Bret met their singer Jon Bunch and told me, "After hearing me warm up on some U2 riffs, Jon struck up a conversation with me. He watched our whole set, and afterwards gave me his personal AOL email, offering to give me advice on being a frontman or anything else I wanted. I idolised the guy and had spent many a night blasting Sense Field records whilst I tried to sing along, so this was surreal. I took Jon up on that offer several times and he always wrote back. Seriously, we lost a real treasure in that man."

In 2001 the band released a track entitled 'Backwards' on Ignition's 'Firework Anatomy' compilation CD, and around the same time they signed a deal with Portland based Rise Records. Soon releasing four more tracks on a split EP with One Last Thing on Rise in the US, that was also picked up by Ignition Records (before the name change to Engineer) for distribution in the UK and Europe, later earning them a 4 out of 5 star Kerrang review. International distribution was quite an accomplishment for a group of boys who weren't old enough to drink yet.

Early in 2002 Crosstide released their superb ten-track debut album 'Seventeen Nautical Miles' on Rise Records (RISE016) in the US and Ignition (IGN015) in the UK / Europe. The album's title was a tribute to the long-defunct Portland all-ages club where the band had done a lot of growing up. The jewel-case CD would have beautiful nautical artwork on the cover and a fold out lyric sheet, with blue and white on-body print versions. This would lead to more shows, including support slots with Rival Schools, Sparta, Hot Rod Circuit, Further Seems Forever, Onelinedrawing, and No Knife, as well as completing several minor west coast tours and a full US tour with Divit (Rise / Coldfront / Nitro Records).

In the summer of that year Crosstide had a US tour booked, opening for the short-lived Revelation Records band, Pitch Black. Unfortunately,

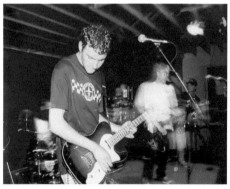

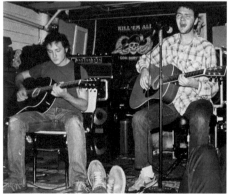

kind of like spitting
montgomery from Tacoma
crosstide

saturday, january 8th
@17 nautical miles
around $5
8pm

CAVE IN
THE ICARUS LINE
CROSSTIDE
MONDAY NOV 5
MEOW MEOW ALL AGES
STIXX

WALL DRUG

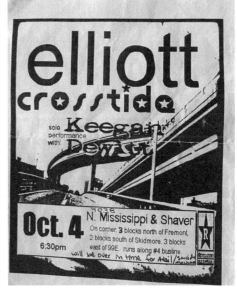

elliott
crosstide
solo
performance
with Keegan
Dewitt

Oct. 4
6:30pm
N. Mississippi & Shaver
On corner. 3 blocks north of Fremont,
2 blocks south of Skidmore. 3 blocks
east of 99E. runs along #4 busline.
will be over in time for Avail/swa

they lacked a guitar player to do it, having now parted ways with Dave. But a collect call from Italy would change all that. Rian, who was just finishing a semester overseas as an exchange student, had just listened to the mp3's Matt had emailed him. He wanted back in the band, but this time on guitar. While Bret wasn't sure how their two egos would operate together, he agreed to give it a try, and while it wasn't without conflict, by the time they hit the road, the band sounded better than ever.

It was on this tour, after playing a gig in Orlando, that Bret managed to get himself banned from Disney for life. He was trying to sleep and rest his throat in the van after the show, when the rest of the guys turned up saying they could stay with some girls who worked at Disney and lived in the apartments nearby. The girls weren't allowed to have members of the opposite sex stay after 10pm, but said that everyone did it, so they could just climb the fence, walk through the trees, and one of them would let the guys in. What could possibly go wrong?

Bret continued the story, "I jumped the fence and hit the ground, to be greeted by a flood of torchlight and a very sternly worded 'Stop right where you are!' Minutes later, I was sitting in a cluttered security guard's shed, full of wall calendars, yellowed ledgers, and squawking walkie talkies. 'Disney Jail' as we came to call it. I had my driver's license photocopied, my photo taken, and received a very thorough questioning. They asked if I realised that I was trespassing on the grounds of a major international corporation who took this sort of thing extremely seriously."

"After threatening to call the cops and just generally giving me a pretty good fright, the guard decided to let me walk out. But left me with the most memorable four words of any tour I've been on since. 'We'll let you go, however, I do want you to know that from this point forward, you are banned from all Disney owned properties, and you need to take this very seriously, because Disney doesn't fuck around'. The girls had to smuggle Rian out in the boot of their car a few hours later after everything had calmed down."

Bret found out about six years ago, when his family went to Disneyland just before hopping on a plane back to Auckland, that Disney doesn't actually keep a list of names and photos at the turnstiles. Space Mountain for the win!

Crosstide continued to tour, record, and evolve their sound, growing disillusioned with the 'emo' label, when the pop-punk guyliner crowd began to take over. They were influenced by their future Slowdance Records label-mates, The Velvet Teen, as well as classic acts like Nick Drake, New Order, REM, Depeche Mode, and The Smashing Pumpkins. They recorded a couple of songs with R. Walt Vincent, of Pete Yorn and Liz Phair fame, that were played on NW US commercial radio, even having two top ten singles in Portland. They shared the stage with Franz Ferdinand, The Killers, Spoon, and many other big names. They were featured at SXSW on the Ferret Records stage, flown to New York and California to showcase for Epic, Atlantic, Columbia and other majors. But this was around the time when Napster was changing the face of the music industry, and the major label thing never worked out for the Portland kids, who never felt all that comfortable with the idea anyway. In 2005 they released their second full-length LP, 'Life as a Spectator' (the title being a nod to an old favourite hardcore band, Silent Majority) and continued to play successful shows throughout the west coast.

This new album earned them another round of label showcases, however none panned out. They improved their live act by adding bassist Erick Alley and keyboardist Bryan Free (Bret's old college room-mate) to the fold, and even got the nod to open a Pearl Jam tour, only to be bumped in favour of Sleater Kinney, who were calling it quits and wanted to go out for one last hurrah with their Seattle friends. It was starting to feel like a never-ending series of disappointments and it wearied them. The band took those emotions into the recording of their swan song LP, 'Walls of Home', with Rian Lewis producing and Jake Portrait (now of Unknown Mortal Orchestra) mixing. While the five members considered it their best work, before it could be released, the group had all but fallen apart. There was no conversation about it. No official break-up, no last show, no press release or social media post. It just ended like it began, by accident. Bret moved to New Zealand (where he lives with Shelley and their two kids), Rian moved to LA, where he still resides (Google him - he's got at least one Grammy, and his name on several platinum records.) Back in Portland, Matt runs a post-modern community centre in Portland called Xhurch, and lectures on VR at the local community college, Erick works for the Portland Timbers, and Bryan is an IT manager.

When reviewing 'Seventeen Nautical Miles' **Collective Zine** exclaimed, *"This is incredible... overwhelmingly gorgeous vocals. I felt whilst listening*

that I couldn't physically do anything else but devote myself entirely to hearing it. The second song 'High Wire' is ace, such a glorious, life-affirming chorus. 'Black Eyes' is probably my favourite track on the album. There are hints of bands such as JEJUNE and SIGUR ROS in the delicate ambience of the mid-sections."

And **Penny Black Music** added *"Crosstide's main strength is their song-writing. The strong melodies and powerful musicianship maintain interest throughout. This is an album you'll go back to time and time again."*

It is speculated that the band may have taken their name from Pablo Neruda's poem, 'Waltz' relating a seaborne plight:
"My mouth is full of night and water. The abiding moon determines what I do not have.
What I have is in the midst of the waves, a ray of water, a day for myself, an iron depth.
There is no cross-tide, there is no shield, no costume, there is no special solution too deep to be sounded."
The metaphorical workings of a crosstide – rough waves surrounding calm water.

https://www.youtube.com/playlist?list=PLD297FD87F92F1984

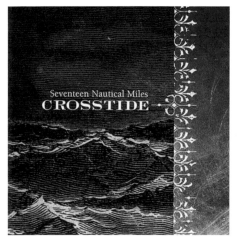

Dead Red Sea

Ryan Shelkett – Vocals & guitar
Charles Cole – Rhodes piano & drums
Alan Randall - Bass
Buck Holck – Drums

Dead Red Sea were a post-punk, emo band from Baltimore that pushed the limits, and the musical boundaries, of the subgenre that they found themselves caught up in. Comprised of Ryan Shelkett (ex-Cross My Heart), Charles Cole, Alan Randall (ex-Wrong Button), and Darron 'Buck' Holck (ex-Third Harmonic Distortion), they recorded their debut album 'Birds' in November 2000 and released it on John Szuch's Deep Elm Records late in 2001.

Engineer Records were working with John as Deep Elm's UK reseller at the time, selling all their releases in our distro and also running the labels amazon UK fulfilment too. We discussed a few local, limited releases and he introduced us to the band, thinking they'd be a good fit for a release on the label. We followed up their album almost immediately with two new tracks for the 'Gone' / 'Brightside' red and black vinyl 7" (IGN007) released at the end of 2001. (Our next partnership like this would be for Planes Mistaken For Stars)

The Deep Elm PR tells us; "A dark and poignant merging of indie rock, hardcore and blues, Dead Red Sea struck with a hushed aggression and a stripped-down exposed, alienated and intense sound that was the perfect instrumental vessel for the candid narratives of frontman Ryan Shelkett which grounded the listener in his musical memoirs about insecurity, mistrust and self-loathing."

After hearing them you couldn't help picturing yourself in Shelkett's place, as the universal themes that made their songs soar were, and are, part and parcel of everyone's everyday life. Taken before their time by the ambiguities of touring fate and scene destiny, Dead Red Sea came, they conquered and disappeared into the emo ether leaving an incredible musical legacy in their wake.

As well as the 'Birds' album and 'Gone' / 'Brightside' 7", Dead Red Sea also appeared on Deep Elm's 'The Silence In My Heart: The Emo Diaries, Chapter Six' with the song, 'Even If There's A Chance In Hell.'

Reviews:
"Dead Red Sea have a sound on Birds that is stripped down, clean and very atmospheric. Dead Red Sea are that time just before the sun comes up, when it's cold and dark and you're drifting into an alcohol induced coma, snug under the duvet and forgetting that you're even alive. October music for sure." **Fracture**

"Very impressive, Birds from Dead Red Sea features clean sparkling guitars coupled with patient rhythms. Laid back emo rock that's well played with nice changes and an overall sound that just oozes class. There's also some jazzy elements that add an extra touch to the already confident songwriting, and Dead Red Sea's quality becomes increasingly apparent with repeated listens." **Mass Movement**

"Birds is a pretty neat disc from Dead Red Sea that falls in the range of heavier emo, with moments of darker, bluesy rock. Featuring the great vocalist Ryan Shelkett from Cross My Heart, Birds is a natural progression in sound and spirit, but with a more open feel. Dead Red Sea are often direct with their song structures, and no wandering guitar parts slow down their pace of venting. After a few spins, I'm growing to like this more and more. Emo for the heavy at heart." **Pastepunk**

"With Birds from Dead Red Sea, moody and caressing waves of lyrical beauty fall over you, inspiring you to sing along before you even know the words. The emotions capture you and steal you away, until you're lost within the music. The sadness, the loss, the angst, are rendered in shades of truth and energy. The songs roll into a dynamic swirl of melodic aggression, with the vocals keeping the music moving forward until, with a soft sigh, you're at the end." **Big Takeover**

"Dead Red Sea's unique blend of melodic indie rock and bluesy beats give the songs on Birds a sort of soothing, melancholy mood, while the music itself is something to lie back, tap your heels and snap your fingers to. The effect floors me more each time I hear it. Birds is full of monumental, awe-inspiring songs that demand to be heard - or rather absorbed - time and again with their hook-filled rhythmic guitars and pacifying vocals. Birds is now one of the most cherished records in my entire collection...another gem stamped with a Deep Elm logo. Songs like Obscene Calls and Somewhere In The Universe are likely to remain among my most-played tracks for a long time." **Punk International**

"Fans of Cross My Heart rejoice, as their most visible characteristic - the strong, rich, and passionate vocals of Ryan Shelkett - are present in Dead Red Sea on Birds. Shelkett has finally found the creative outlet he's been looking for in this new band. His vocals feel at home as there's a sense of melancholy roots-rock underlying most of the songs. It's in these softer melodies and more deliberate structures that Shelkett's vocals are able to really shine. His strong, emotional voice it fits perfectly, and in these quieter, more despondent songs, he and the rest of the band creates some mellow and emotional indie rock." **Delusions Of Adequacy**

"When Cross My Heart decided to call it quits, the kids didn't have to be morose for long; their demise has consequently blessed us with this project, Ryan Shelkett's Dead Red Sea and their debut, Birds. This is Ryan's emo side coming through - spacey arrangements, delicately plucked guitars and whispery vocals are the name of the game, and Dead Red Sea inject more than enough originality to pull it off and keep it interesting. Experimentation with different sonic palettes like the country guitar on It's So Hard To Be Alive or the Agent Orange-esque guitar on the title track make Birds a really fascinating listen. It's impossible to tell what this band is going to do next. I mean, have you ever heard of an emo band being compared to Agent Orange? That in itself should tell you that these guys aren't content to follow the beaten path. As for songwriting, of course this is top notch. Lyrically, Ryan's melancholic obsession on mental illness carries through this record, as Love Is In the Air And Is Floating Away and Nowhere, Nothing give a good impression of the general lyrical tone. Dead Red Sea will have you doing back flips in your bedroom." **Deep Fry Bonanza**

dead red sea

a side : gone 04:15

b side : brightside 02:45

ignition

IGN 007

"Ryan Shelkett of Dead Red Sea is the driving force on Birds, with a somber voice and some almost Neil Young-caliber guitar blues. High compliments are not spoken lightly, and Dead Red Sea nail all that is great with Bad Man, a song as depressing as it is lovely. The band has variance and talent, yanking charms out of their hat such as the instrumental mantra of the title track. Whether musical jams sans vocals, or poetry driven tales and tunes of woe, Dead Red Sea are interesting and endearing. Impressive." **Friction**

"I'm greatly impressed by Dead Red Sea and their debut Birds. With song titles like Love Is In The Air And Is Floating Away and It's So Hard To Be Alive, bouncy, happy pop is clearly not on the agenda. But unlike many singers, Ryan Shelkett knows how to carry a tune, and does so without sounding stuffed up. More importantly, the music on Birds sounds extremely full...a far cry from the simple picking and chord progressions practiced by many bands for whom screaming about broken hearts is a higher priority than musical ability. To my ears, Birds is thing of beauty." **Splendid**

"Deep Elm Records continues to impress with Birds from the Baltimore quartet Dead Red Sea. Like their label mates, front man Ryan Shelkett and company create indie rock that's a cut above the competition. The highlight track, We're Not Kids Anymore is wistful and melancholy...a patient showcase for Shelkett's considerable songwriting talent. The indie rock sound is all in place...strained, sparse and subdued, but it never gets boring and never goes drifting." **Suite 101**

"Dead Red Sea churns out gently rolling emo and duly satisfying songs on Birds. Very deliberate, but that in no way takes away from the joy of these pieces. The song construction is simple and direct...almost in the realm of alt country singer / songwriters, though the sound itself is still emo: Vaguely atonal guitars, less-than-perfect vocals and strident rhythms. All this makes for a good mix. Dead Red Sea veers from influence to influence, depending on the needs of the song. The overall sound is thick and full. I like the way these songs have come together. It's hardly typical, but close enough to be comfortable. I surely would like to hear how these boys develop their ideas in the next couple of years. Will be most interesting." **Aiding And Abetting**

https://deepelmrecords.bandcamp.com/album/birds

Death Of Youth

Rob Horrocks: Vocals & Guitar
Sahib Dhinsa: Bass
Michael Kew: Drums

Dredging their own style of powerful screamo hardcore from the drains of South London, Death of Youth formed as a cathartic protection of the singer's mental health after a relationship break-up. Their music conveys emotions through a combination of melancholic melodies and raw aggression. They have been likened to Touché Amore, Departures, Casey, Counterparts, Defeater, La Dispute, State Faults and Pianos Become The Teeth.

Death of Youth came about in 2018 following the fallout of Rob Horrocks, the bands vocalist, lyricist and guitarist, first real long-term relationship. "My mental health was in pretty bad shape, and I was trying to do whatever I could to make it through this turbulent period." Rob confided in me. "My old band had essentially ground to a halt after our singer moved to Brighton to go to university (he now sings and plays guitar for Windowhead), and our bass player ended up working full-time at Rogue Studios as a producer between touring with two bands (Vega and A New Tomorrow). I really missed playing music live, and I thought that forming a new band would be a great way to cope with the situation."

Rob continued; "I tried starting a hardcore band inspired by what I was listening to at the time, but struggled to find new members, so decided to just write music by myself, hoping to record and release it later. The first release I recorded was 'Between Chapters' in 2018. This was very much the EP where I was finding my feet and working out what I wanted to achieve."

"I had a few guitar parts laying around so a lot of those ended up being used on that EP. It was a mixture of old unused guitar parts (some dating as far back as 2013) and new stuff I wrote specifically for the EP. What's cool about 'Between Chapters' is that it has a real narrative throughout. You can hear all the lyrics relating to my break-up and the emotions I was experiencing at the time." Although Rob adds, "I was very conscious not to fall into the trap that a lot of Warped Tour metalcore or pop-punk bands fall into, writing incredibly derogatory lyrics. Especially since the break-up was pretty civil and amicable. So, I focused more on my emotional state and tried to get myself back to normal."

'Between Chapters' was recorded at home in Thamesmead in July, with Rob singing and playing guitar, and his friend Michael Kew mixing, playing bass and programming the drums. The EP would be digitally self-released in August 2018 as Rob tried to put together a full band for the project but struggled with a lack of commitment from other members, so went back to making music essentially as a one-man project for a while. He did, however, bring in his friend Sahib Dhinsa to help out and play bass on the recordings for the new tracks and things developed from there.

Originally inspired to start a band when he was just fourteen, after listening to Green Day's 'Dookie' album, Rob soon discovered Funeral for a Friend who turned him onto hardcore and post-punk bands like Thrice, Thursday, Boysetsfire, Grade, Snapcase, Alexisonfire, and eventually, bands such as Touché Amore and La Dispute, who were the biggest influences behind Death of Youth.

"One album that inspired me a lot at the time was 'Chapter and Verse' by Funeral for a Friend. FFAF had been my favourite band since I was seventeen and when that album came out it really had a big impact on me. Initially it flew a bit under the radar (much like a lot of the band's discography after 'Tales Don't Tell Themselves' sadly), but I embraced the album. It had the elements that drew me to Funeral for a Friend to

begin with, but also clearly drank from the same well as bands like Touché Amore. It had that great mix of personal and political lyrics and a raw sounding production which gave the album its distinctive sound."

"I've always been a sucker for bands that combine more aggressive music with a sense of melody, and these bands had that in spades, alongside a 'heart-on-your-sleeve', honest approach to their lyrics, which was something I really latched onto; In particular, Jeremy Bolm of Touché Amore's style of writing and vocal delivery. They are probably what I emulated the most in terms of my own writing and performance."

"For the next record I also wanted to bring in some of my influences from outside that circle. I'm a big fan of mid-west emo bands, such as The Get Up Kids, American Football, Texas Is the Reason and Mineral, so that was mixed in with the hardcore and screamo too." You can really hear the Jimmy Eat World vibe in the intro of the track 'Faded Nostalgia', which became the band's first digital single and lyric video.

'Suburban Dystopia' was the follow up EP, recorded at Rouge Studios in February 2020, with Rob on vocals and guitar, Sahib on bass and Michael again programming the drums and producing. The limited edition 10" vinyl release came out jointly on Engineer Records and Wayne Hyde's Bridlington, East Yorkshire based, short-run label Disillusioned Records. The initial pressing sold out in about a week, so we pressed more.

"I wanted to make sure this EP was better than the last one, so was doing a lot of second guessing and throwing stuff away if I didn't feel it was up to scratch. I was a lot more confident now. I'd found my feet and knew exactly what I wanted the songs to sound like."

Whereas 'Between Chapters' was focused on his emotional state, 'Suburban Dystopia' saw Rob tackling more social and political topics with his lyrics. The track 'Cover Feature' is a good example of this, focusing on some women at the time who were coming out about various bands within the scene using their platform to take advantage of and prey upon girls at gigs.

"I was angry that this scene, that's supposed to be a safe haven for all, was being made unsafe due to these bands getting away with a mere slap on the wrist. Their careers were unaffected due to their fanbase being willing to ignore any allegations for the sake of the music. To make it

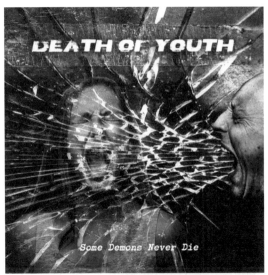

DEATH OF YOUTH

Some Demons Never Die

Death Of Youth
Suburban Dystopia

1//Deconstruction
2//Faded Nostalgia
3//Cover Feature
4//Blind In One Eye
5//You're A Crook, Captain Hook

Disillusionedrecords.co.uk

worse, it seemed that the press was more than happy to ignore this too and plaster these bands all over their magazines." States Rob, adding, "Near the end of the writing process, the December 2019 Election was happening, and my frustration at the result resulted in the lyrics for 'Blind in One Eye' which is about the ignorance of Conservative voters, happy to let the tabloids spoon-feed them lies and propaganda while they turn a blind eye on issues in the country, they feel don't affect them."

'Suburban Dystopia' was definitely a step up for Death of Youth. A perfect melting pot of everything that inspired Rob's music. It has elements of mid-west emo (Faded Nostalgia), straight up hardcore (Cover Feature), and screamo (Blind In One Eye) but combines them all with a melodic hardcore sound that bands like Touché Amore and Departures capture so well, and that Rob was emulating. It has a mixture of personal lyrics, with a song that serves as an epilogue to the mental health message of the previous EP, and also touches upon the more social and political topics that Rob wanted to discuss at the time.

Then in 2021, with the vinyl sold out, 'Some Demons Never Die' was released. Taking its name from Rob's lyrics to 'You're A Crook Captain Hook', this nine-track CD contained both of the Death of Youth EP's. It was released through Engineer Records and Disillusioned Records in the UK again, but also involved Sonic Slap Records in Europe and had a far wider distribution than the previous releases, gaining a lot of positive coverage in fanzines and radio airplay on alternative stations.

"David wanted to release a CD of 'Suburban Dystopia' but felt we needed more songs than the five on the EP." Says Rob, "Since this was while the pandemic was in full swing, I wasn't sure when I'd be able to get any new songs recorded, so suggested including the 'Between Chapters' tracks as well, since that EP never had a physical release. He agreed, and it was cool to have the songs all together in one place. The two EPs flowed pretty well into each other."

Rob still wanted Death of Youth to play these songs live so embarked on another round of painful auditions with potential band members, none of which really worked out. He found some good guitarists, mainly rockers who weren't quite the right fit, and also learnt that decent drummers are rarer than rocking horse shit.

"The scene in my local area is practically non-existent. Just a couple of bands and even fewer venues. Those there are might shoehorn a hardcore band onto a thrash metal set, but opportunities were rare."

Because of all this, Death of Youth is on hold for the time being. Rob is co-hosting a monthly media podcast called Bloobcast and has now joined a band called Minister, (formerly Ivy League Murder Scene) playing guitar and singing backing vocals for them. He's finally getting to rock out at a few gigs. Minister signed with Undead Collective Records and released their heavy-hitting 'Sunbleached' EP, which **PunkRock.blog** described as *"Rapid guitars mixed with fast paced singing, plunges you into an abyss of mayhem you hope to never escape from"*.

I asked Rob what he thought of the post-punk scene now and if it was still important to him, and he told me, "I believe that hardcore, emo, post-punk, whatever you'd call it, very much has a reason to exist, especially given the political climate in the UK and all over the world. People are incredibly angry about the havoc the Tories have been inflicting on the country for over a decade and their complete disregard for those of us struggling to make ends meet while they make themselves comfortable, and punk / hardcore has always provided a voice for those who wish to express that frustration. Likewise, while there is less stigma surrounding mental health now, the mental health services in this country are sadly neglected which leaves many without the help and support they need, and the expressiveness that music allows provides an outlet for those to channel their emotions into something creative. Chiefly, I feel that the post-punk scene allows for everyone to have a space that they can feel safe without fear of getting attacked or discriminated against (or at least, it should). There's a real sense of community and togetherness which is a big reason why I latched onto the underground scene to begin with. I've befriended so many people at shows who I otherwise would not have met."

Thoughts Words Action described 'Some Demons Never Die' as *"Perfectly structured modern hardcore compositions with a touch of contemporary emo added through the meaningful lyrics. Every instrument appears as a wrecking layer that will shake your bones. All blended together in polyphonous harmony."*

https://deathofyouthuk.bandcamp.com/album/some-demons-never-die

The Dreaded Laramie

M.C. Cunningham: Vocals
Zach Anderson: Guitar
Drew Swisher: Bass
Andrew Mankin: Drums

The Dreaded Laramie is a power-pop femme-core band in a long-distance relationship between Lexington, Kentucky and Nashville, Tennessee who are part of a growing chorus of young Southern bands challenging what it is to be normal.

Bassist Drew Swisher explains, "Normalcy defines our dreams and what we think is possible. But everybody's weird, we just try desperately to hide it."

In their songs, The Dreaded Laramie celebrates living authentically with vocalist / guitarist MC Cunningham delivering thoughtful dispatches on gender expectations, insecurity, and a healthy portion of all-consuming crushes. Vitally, this is a band for whom having an emotional heart-to-heart and having fun are not at odds with each other. Their emotive reflections are served up drenched in shimmering sweet melodies, a decadent dose of harmonised guitar interplay, and a power-punching rhythm section.

It all started with a cover of the theme from The Office at local house shows after M.C. Cunningham and Zach Anderson formed The Dreaded Laramie with a rotating cast of their friends while they were students at Belmont University in Nashville. After becoming friends following a Gen ED requirement and a shared love of the Weezer discography, they bounced from show to show until meeting Drew, a self-confessed and not-so-closeted fan of the band, who was studying audio engineering and bonding over indie rock, Nintendo RPG's and a shared sense of absurd humour.

Having been plagued by the bane of every band's existence, finding a drummer who wasn't already in a hundred other bands, they stumbled across Gainesville native and like-minded power-pop devotee, Andrew Mankin, who completed the definitive and current line-up of The Dreaded Laramie.

When I asked them about their motivation to form and play in a band, Andrew told me, "Upon arriving in a new city where I had few connections I searched around for bands to join on social media with little success. The global pandemic hit the US soon after settling in, which stunted my efforts further. Eleven months into this wild goose chase I started a new job and met Zach there. The universe was looking out for me, or I had good karma, because I was in a band drought while Zach and his band were in a drummer drought. We both had the key to each other's doors of fulfilment. The motivation existed as a natural consequence of who we all were at the core, all there was to do was turn the key in the lock."

It could be argued that if it wasn't for Weezer, there would be no Dreaded Laramie. The band owes their existence to a mutual adoration and shared ability to play the Weezer discography. MC and Zach bonded over and solidified their relationship during late-night car rides listening to Pinkerton. Even though other bands and records have played a role in the bands' continual musical evolution, the chunky power chords, and lyrical vulnerability that lie at the heart of everything that the world-famous Rivers Cuomo-led Weezer do, are also integral to everything that the Dreaded Laramie was, is and probably always will be.

The band recorded their first five-song EP, 'The Dreaded Laramie', in November 2018 with the help of producer Adam Meisterhaus and engineer Justin Francis, and freely admit that both played a significant

role in how the record ended up sounding. The producer, Adam, was playing in West Virginia riff-merchants Rozwell Kid at the time, and the record was soon being reviewed in all the right places, being hailed by The Alternative as "Rivalling the royalty of the genre", while Music City taste-makers Lightning 100 branded the band a "must listen", as the EP helped them gain radio rotation from the Rocky Mountains to the British Isles.

This experience of being in the studio made them want to write and record even more. So, after releasing their debut record in August 2019, they planned to enter the studio again in March 2020, to lay down the tracks for their second EP, 'Everything A Girl Could Ask'. But the best-laid plans of power-pop mice and punk-rock men are often waylaid by the vagaries of fate, and as The Dreaded Laramie were about to embark on their sophomore recording adventure in Nashville, the world went into Covid lockdown and the band found themselves quarantined in their respective home states.

Thanks in no small part to the global spread of Covid-19 and getting back into the swing of everything that makes them tick, their second EP was unleashed four years after their debut, and was, and is, a natural progression and continuation of the blueprint they laid down with 'The Dreaded Laramie'. The three new tracks of buzz-in-your-ear, pop-punk goodness came out on 13th May 2022, with 'Archipelago' and 'Tell me' on one side and 'Where do all the hardcore kids go?' on the other side of a beautiful heavy vinyl picture disk 7" jointly released via Engineer Records in the UK and Europe, with Wiretap Records and Sell The Heart Records in the US of A.

All three tracks were supported by music videos, radio airplay and constant gigging by the band, so the vinyl EP soon sold out. Possibly part of the reason a bootleg CD of the first two EPs, with an extra track, 'Don't do it for me' has since appeared.

Up to this point all the Dreaded releases had been digital, with videos on YouTube and songs on spotity, but they'd hooked up with Mike Cubillos at Earshot Media and wanted to promote a proper release on vinyl. Rob Castellon at Wiretap Records and Andy Pohl at Sell The Heart Records, both on the West coast USA, were into it and onboard, but they wanted a UK / European partner for the record. I'd worked with both on co-releases before, most recently The Atlantic Union Project

album and the Tired Radio, Neckscars, American Thrills and Nightmares for a Week split EP. I'd also heard a few of the instantly catchy Dreaded Laramie songs and knew this was a winner, so jumped at the chance to help release their debut 7" on picture disk. It sold out pretty much immediately.

When the subject of the record that they're most proud of came up, Drew headed me off at the pass and quickly responded "I know, I know. Boo. Say something we can actually listen to right now. I'm infinitely proud of our 'Everything A Girl Could Ask' EP. Once the full length is out, I think it'll be clear that the themes we explore on the EP, both musically and conceptually, are a sort of blueprint for the new material we're developing. And getting to release that EP with such a wonderful team of people has been an amazing privilege."

It's hard for the Dreaded Larry's to point to one record from someone else as the most influential for them. "We all bring a unique musical background to the band. Our rotating cast of influences is a huge part of what propels us forward as friends and bandmates."

So, I pressed them about their favourite records, asking about the songs that helped to shape and define their musical voyage. Drew told me "As far as the greatest influence on the band overall, it's probably a tossup between 'Pinkerton' by Weezer and No Doubt's 'Tragic Kingdom'. 'Pinkerton' played a formative role in M.C. and Zach's early musical collaboration. Its 'Trapped in a dark basement' tone and self-effacing lyrics continue to inform our own work. On the flip side, the bouncy summer fun and tongue-in-cheek satire from 'Tragic Kingdom' seems just as significant."

Drew continued, "It may seem like a strange choice, given the type of music we make, but I think my personal greatest influence is 'Our Endless Numbered Days' by Iron & Wine. Sam Beam's bittersweet lyrics and harmonic instincts have infected everything I make. That said, the Animal Crossing Wild World soundtrack is fast on Sam's heels. It might overtake Iron & Wine if we start writing more songs that are less 'Oh, the ennui!' and more 'Boy I love playing on a tire swing!'"

Being part of the Nashville scene, where almost everyone is a professional musician and makes a living from their chosen career, must be tough. But it breeds generation after generation of incredible, insanely

good bands. It has clearly pushed The Dreaded Laramie to become better at what they do, and tighter musically. They'll be the first to tell you that whatever success they've had as a band, they probably owe to Lightning 101, Nashville's premier alternative and indie radio station.

But if you thought the band was all about Nashville, you'd be wrong, as they split their time between there and Lexington, Kentucky since MC started working on her PHD there in 2017. The band feel innately connected to the scene in their adopted home, which thrives on late night local music shows and the familiar faces that make everything happen. In other words, it's an undiscovered punk-rock mecca that's one of the underground's best kept, and most beloved, secrets.

As our conversation progressed, we started talking about playing gigs, and Andrew happily opened up and told me about some of the best, and worst shows, that the band has played. "We've been lucky enough to play a wide range of shows, from the heart-warming to the ridiculous. The one that sticks out most in my memory was our first show back after the pandemic started and our first performance with our current line-up of members."

"It was 22nd May 2021. Vaccines had just started rolling out for vulnerable groups, it was the peak of social distancing, and everyone was trying to adapt to a 'safer' way of interacting in public. We were playing on an outdoor stage in the parking lot of The Basement, a staple of the Nashville music scene. The bill was stacked, with Nordista Freeze, Future Crib, and Chrome Pony, and we opened the show at around 3.30pm. It was the first weekend of what felt like summer weather, and it was hot. Nobody seemed to mind the heat because it felt electric to be in a crowd for the first time in over a year. Every interaction started with some trepidation but ended with overt pent-up joy. It felt as though the sea waters had parted and we could see a way forward after being unsure about the future of live performance. Most people were out of practice socially, which made for an even playing field for us."

In the time before this gig, the band had been through a lot. Andrew had joined the band on drums only several months prior. "I listened to and played along with recordings repetitively for hours to prepare and make this new project as successful as I could. We toiled over three new songs and recorded them, but had yet to play them in front of people. We had added backing vocals during practice in the weeks leading up to the

performance, something that I had never done before. There was so much investment and anticipation leading up to the show. It was a huge rush and release to finally show people what we had worked on, and it went as well as we could have expected. After we played, we were able to unwind and enjoy the other bands' excellent sets. I don't think we will be able to replicate the feeling of this show because of the unique lead-up to it."

Andrew continued, "It's difficult to think of our 'worst' show as almost all of them have some redeeming qualities. Even when things go terribly wrong in some way, it at least gives us a strong memory. One example of this was a gig in Chicago on 11th June 2022. It was the second date of a nine-day run, and the booking process had been a chore, coming right down to the wire. We initially had a great setup at a well-attended venue, just the right size for our draw. In the weeks leading up to the show, we learned through the grapevine that the promoter who had set us up had cut ties with the venue where we were supposed to play and that they had filled that date with another act. We scrambled to find another venue and somehow ended up communicating with the owner of a hot-dog stand on the beach of Lake Michigan. Hosting bands at the hot-dog stand was apparently a new venture for them. Our gig was to be the first of its kind. Tobias, the owner, was a colourful character and assured us that power at the stand wouldn't be a problem by saying 'We will see if it holds' so we were all unsure of what to expect."

"As we approached Chicago, we checked the weather forecast. Rain was expected right around show time. We pulled up to the stand and were disappointed that not only was there no covered area to play under, but the stand was right on the beach and the surrounding ground was all sand. We unloaded our equipment and came up with a stage plot on the fly. We scrounged up as many blankets, towels, and other garments as possible to lay out as a stage. Power came from one extension cable from the hot dog stand, and we daisy-chained power strips across the 'stage.' Equipment slowly trickled in as bands arrived, we all provided a piece to the precarious puzzle. Our ability to put on the show was hanging by a thread, but somehow, we pulled it off. The weather held, the power held, and it turned out to be positioned in a convenient spot for beachgoers so was well attended. As we relaxed and realised, we were going to make it through, we noticed the beautiful sunset behind us. To date, this was one of the most beautiful settings we have all played music in."

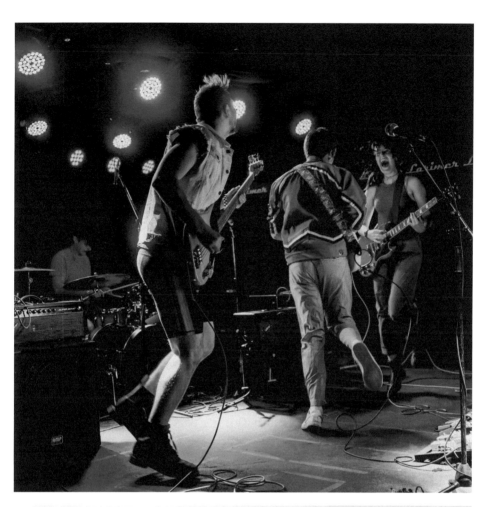

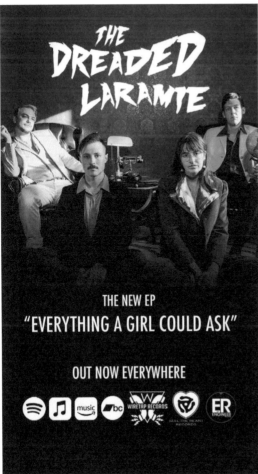

THE NEW EP
"EVERYTHING A GIRL COULD ASK"

OUT NOW EVERYWHERE

M.C. followed Andrew's lead and shared some more of the band's favourite and most memorable stories "I certainly feel that The Dreaded Laramie is still in its nascent stage, but that doesn't mean that we have any shortage of funny or interesting stories. I'll share one of my favourite stories from the band about a memorable festival we played in the summer of 2022."

"On the second of July in the two thousand and twenty-second Year of our Lord, The Dreaded Laramie played the 41st Annual Green River Catfish Festival in Morgantown, Kentucky, USA. I am still unsure what we did to earn the distinct privilege of playing the Catfish Festival, but it was one of the most amazing and strangest events we have attended in our lives. The Green River Catfish Festival is a week-long event in Morgantown that culminates in a county-fair-like party of music, carnival rides, games, food, and competitions on the 4th of July weekend at the Fairgrounds on the banks of the Green River."

M.C. Continued, "This event is exactly what one thinks of when they think of the American South. Maybe even more so. As we drove up in our car, loaded to the brim with gear, we noticed a large crowd of people gathering in the middle of a field. The crowd was so thick, and the ground was so flat, that we couldn't see what they were gathering around. But there was a palpable excitement in the air. People were hooting, hollering, and waving their hats at something. There were people holding their children above their heads, and groups of teenagers climbing up into truck beds to get a better view of the action, like Zaccheus climbing the sycamore. We parked the car, loaded our gear in, and ran over to check out the excitement. We made our way over to the crowd and fought our way through the wall of people like concertgoers arriving late to see their favourite band. When we finally got close enough to see what the fuss was all about, we found we were witnessing something unlike any of us had ever seen before in our lives. They were Catfish wrassling."

"That's right, not catfish wrestling, catfish wrassling. If you are unfamiliar with this, one of the most elegant and extreme sports of the interspecies variety, allow me to paint you a picture. Catfish wrassling is the ultimate face-off between man and fish. It is a battle of endurance of the mind, body, and soul. Two human people and one catfish enter a pool together, and no one leaves until one of the humans captures the catfish with their bare hands and lifts it entirely out of the pool."

"The staging of the wrassling is like so: there are three massive tanks of water on the ground. Essentially above-ground pools. Two smaller pools stand under a tent, and one larger one lies about twenty feet from the tent. The tented pools are the waiting area for the catfish gladiators, and the large pool is their Colosseum."

I was enraptured by this tale, so M.C. forged on, "With this being my only experience with catfish wrassling, I can't speak to the general size and temperament of the catfish one typically wrassles. I can report, however, that these fish were nothing to mess around with. We arrived in the crowd in between wrasslings, soaking in the sight of the massive catfish, one of whom would be awaiting battle. Six catfish, all four feet long or more, moved lugubriously through the green water of the waiting tanks. I was in disbelief that anyone would willingly jump in the water with one of these vestiges of the Pleistocene era, reminders of the fragility of the human constitution. I thought it must be the case that only trained professionals would or could wrassle these monster fish. However, America values its democracy above basically everything else, and the democratic ideal, for better or worse, extends to the selection process for catfish wrassling at the Green River Catfish Festival.

The crowd buzzed with anticipation as the next human-on-catfish contest approached. Onlookers casually discussed strategy. One woman suggested that 'noodling', the practice of catching catfish by sticking one's entire arm down its throat, was the most effective way to get hold of one, comfort be damned."

"We heard a large man shout 'Who's next?' from a lifeguard stand above the showdown pool in a thick western Kentucky drawl, ringing a bell as he yelled. Hands shot into the sky throughout the crowd. The people of Morgantown were ready. Eager even, to put their humanity on the line in the pool. To everyone's surprise, our guitarist, Zach, was among those volunteering to fight. I'm still not sure whether it was dumb luck or the fact that the way we dressed caused us to stick out like sore thumbs in the crowd, but somehow Zach got the big man's attention. He, the Nashville city-slicker, was selected alongside a local high school-aged girl to enter the pool. The girl was prepared. When she was selected, she excitedly stripped down to her bathing suit, put on a pair of pink goggles, and equipped some light safety gear. She quickly made her way into the pool and began preparing for the fight, her father advising her poolside about how to outsmart both the catfish and Zach. Without a bathing suit,

goggles, or protective equipment of any kind, Zach removed his shoes and socks and climbed the small metal ladder into the pool."

"Before we knew it, another man was trapping one of the waiting-pool catfish in a net and carrying it to the larger pool where Zach and the girl waited. Once the catfish hit the water, things were a blur. The next several minutes felt like an eternity where no time passed. It seemed to last forever. Zach's jeans sloshing through the pool, every square inch of denim a metric ton of resistance to the water. The catfish darting around the pool and every so often breaking the surface with its angry tail. The girl moving awkwardly, but still with more facility than Zach, diving down underneath the godforsaken river water, as if to become a catfish and persuade it rather than catch it by force. These images burn in my memory. At some point, the catfish must have tired. Maybe enough water had splashed out of the pool and onto the muddy grass for the fish to start feeling claustrophobic, the swaying of the water and its slow de-oxygenation causing a case of catfish vertigo. Maybe the catfish had just given up. In any case, the girl dove down under the grassy, muddy, fishy water and eventually, after some thrashing and a short pause, came up with the monster in hand. The crowd roared like she was Madonna."

"Zach, laughing, drenched, and traumatised, let out a cheer of relief and scooted back to the flimsy side of the pool to climb the small ladder. The end of the round was not so much a loss as a relief for everyone. The girl, however, wanted to hang onto the moment a little longer. She relished her spoils. Her celebration ritual would have made that of any WWE Champion or professional football player pale in comparison. Her victory reeked of redemption, and I wondered about her previous wrasslings. She moved to the centre of the pool, lifted the catfish entirely out of the water and above her head. A feat of strength worth celebrating in its own right, which the crowd met with a massive cry. And, after spinning around a time or two, spiked the catfish back into the water like a football. Feeling a little sickened by the pungent smell of piss, sweat, and fish in the air, I made my way out of the crowd. I'm not sure how the catfish fared post-spike."

"Zach cleaned up as much as he could with the foot-pump sink outside the port-a-potties and a towel that a kind stranger had lent him. Somehow, in the span of the following forty-five minutes, we secured some carnival food, tuned our instruments, sound-checked, and hit the stage. The wonderful absurdity of the situation had all of us a little

delirious on stage. At times during the set, we were laying down, laughing hysterically, and jumping up on top of the monitors, all while playing our music. It was a sweaty, fishy, mosquito-y, joyful set, and one of my favourites we have played to date. After the set, we enjoyed a nightcap of fried Snickers (a food, we learned, that God did not intend to be fried), said goodbye to our new friends, and hit the road. Morgantown is now one of our favourite towns to play."

The band's relationship with their current labels is born from glorious serendipity and continues to be a wonderful partnership that all parties want to continue for as long as the crazy ride lasts. But ever evolving and broadening their coverage, the latest Dreaded Laramie single, 'Breakup Songs', was self-released digitally, and appeared as a flexi-disc on Smartpunk Records. All of 2023 was busy for the band, who spent much of the year on tour, playing Pouzza Fest in Montreal, The Fest in Gainesville, and headlining their own huge summer jaunt. They've torn-up stages supporting bands like OK Cool, Rozwell Kid, Bad Moves and The Smoking Popes. As well as successfully crowdfunding and then recording their first full length album, with Dave Schiffman at the desk of Soultrain Studios in Nashville. I certainly hope there's no end in sight and that this incredibly original band will continue to rock for a long time to come. That should be assured, as the things that brought them together: a love of music, the friendships that drive the band forward and continue to make it fun, the inspiration of each of the members, all remain strong and continue to burn as brightly as they always have.

Our conversation ended on a high, with Drew's uplifting and inspiring take on punk-rock and hardcore. "To me, hardcore and post-punk embody a spirit that has endured for millennia. The sound is important, but there's much more to a genre than common tropes, rhythms, and chords. Genres are cultures, and every genre is defined only in part by its sound and much more strongly by how its people live. To me, punk is the project of creating a space where you can thrive in a world that wants you dead. Hardcore is a communal slap in the face to a dominant culture that demands submission to the malevolent powers that be (for example, white supremacy, global income inequality, and the many faces of misogyny).

For as long as these powers live, punk will too. The way it looks, and sounds may change. Hell, it may evolve a different name. But people will continue to create their own little utopias in basements, neighbourhoods, and wherever they can."

Eli Enis of **The Alternative** reviewed 'The Dreaded Laramie' debut EP announcing, *"Pick your favourite crunchy power-pop band and The Dreaded Laramie probably have something in common. But the glaring difference is that this band's first ever project, and it genuinely rivals the royalty of the genre. Stuffed with memorable riffs, really acutely and cleverly accentuated basslines, and a pop vet's sense for melody and pacing. These songs are 70-degrees-and-sunny wonderful."*

Rose Eden of **Punknews.org** made the 'Everything A Girl Could Ask For' EP her staff pick, describing the Dreaded Larry's music as, *"Gender bending sound marbled with sickly sweet, hyper feminine vocals encapsulated by indie rock tinged boppy pogo punk and sprinkled with sudden moments of very macho displays of musicianship: duelling guitars, synchronised power ballad style riffs, post hardcore breakdowns, all neatly tied together with that ultra-melodic, 90's dream poppy sound sitting side saddle with the fuzzy, distorted influence of what's quite obviously Rivers Cuomo & Co."*

Adding, *"With such an in-your face macho sort of musicianship contrasting the delicate lyrical style played out in an uber flamboyant way – is this band a proverbial enigma with a stigma? They make me think of some of the incredible queercore bands I grew up listening to like Pansy Division, Limp Wrist, and eventually Le Tigre, Gravytrain, G.L.O.S.S. etc. Don't get me wrong though, the sound is completely different from any of the above-mentioned bands, as they're more Weezer than Huggy Bear by far. After I first heard 'Everything A Girl Could Ask For' I honestly wished there were more tracks for me to hear after it ended, so there's an addictive quality to be picked up on there for sure. The Dreaded Laramie have pulled off a 3 song EP of power bottom power pop fully loaded with ethereal distortion, candy coated vocals, and just enough polarised juxtaposition to keep you wanting more."*

New Noise Magazine agreed that *"The band's sound is perfect for anyone unafraid of embracing an emotional heart-to-heart and having fun, knowing that these two ideas are not at odds with each other."*

Whilst **Sonichits** simply say, *"The Dreaded Laramie is a group of ragamuffin ruffians who bonded over a mutual love of philosophy textbooks and Weezer B-Sides."*

You'll just have to make your own mind up.

http://linktr.ee/thedreadedlaramieband

Eden Maine

Adam Symonds : Vocals
Phil Buch : Guitar
Simon Davis : Guitar
Nick Brown : Bass
Kieran Iles : Drums

Chaotic screamo metalcore band from St Albans in Hertfordshire in the vein of Converge, Cave-In, Botch and Dillinger Escape Plan who created a huge buzz in the underground circuit for a while. A melting-pot of ferocious metal drumming, searing riffs, epic atmospherics and subtle dynamics. They dared to be different and refused to be pigeon-holed, evolving into a short-lived but unique entity.

The original concept for Eden Maine (I believe the name was inspired by Stephen King's home state horror stories and the village of Eden, on Mount Desert Island in Bar Harbor, Maine) came to fruition when Adam Symonds and Nick Brown tagged into the Hardcore ring in 1997. Continually disillusioned with most of the music being made around them, they decided the only way to hear the music they wanted to, was to write it for themselves. Influenced by bands such as Breach and Orange 9MM, the goal was simple; To create heavy, atmospheric, accessible music.

It wasn't until 1999 that they found what would become their trademark sound when Adam took over the vocal spot and Kieran Iles joined the band. For the next two years, guitarists came and went, from all over the U.K. and even as far away as the U.S, and in 2001 when Simon Davis, a

noisecore-crazed guitarist, became part of the ensemble, they found a new aggression as the final piece of the puzzle slotted into place.

Two months later on the eve of recording their debut EP, long-time member Neil left the band because of 'musical differences', which left Eden Maine in an awkward position and meant that they'd have to record the EP as a four-piece. It was a do-or-die moment, as they'd scraped all the money they could find (and borrow) to produce a record with Harvey Birrel (Senseless Things, Culture Shock, Therapy?, Blaggers ITA, Die Cheerleader, Alien Sex Fiend, King Prawn) at Southern Studios in Wood Green. They had to put up or shut up. Luckily, they decided that the former was their only course of action, and the rest is history.

The vocals had to be left to a later date, as Adam's voice was shot following a recent illness. As they waited for Adam's voice to heal, Phil Buch, a hardcore and emo-obsessed guitarist who brought a new melodic counterpoint to Simon's noisier and more aggressive guitar, pushed the quartet to a quintet again.

After finally polishing off the vocals, the reels were sent to Kurt Ballou (Converge guitarist) at Godcity Studios for mixing and were then mastered by Alan Douches at West West Side Music (Converge, Misfits, Electric Frankenstein, Bullet In the Head, Monstermagnet, etc), which was when Ignition / Engineer Records became involved. Eden Maine quickly signed to the fast-rising UK independent labels roster, releasing 'The Treachery Pact' CD EP as IGN024 and joining their new comrades in arms, Planes Mistaken For Stars, xCanaanx, Rydell, Urotsukidoji, Winter in June, and Hunter Gatherer. The CD's cover artwork was supplied by US artist Kevin Llewelyn, aka Puddnhead, who now illustrates Magic the Gathering cards and works with the likes of Nikki Sixx and Kat Von D.

Most of 2002 was spent building a fierce live reputation by playing as many shows as possible, on the back of 'The Treachery Pact' EP's release and the positive reviews that followed the record everywhere it went, including being voted as one of the top 50 albums of 2002 by Rocksound Magazine and achieving 4 K's from Kerrang. At the end of 2002, Eden Maine set out on their first UK tour, in support of Swiss band Knut, and US band 5ive's Continuum Research Project. It was an eye-opening experience for the band, and having now acquired a taste for touring, Eden Maine made plans to set sail for Europe in 2003.

Around this time, we looked at releasing 'The Treachery Pact' as a 10" vinyl picture disc too, but the discussions around artwork became complicated and unfortunately it never happened.

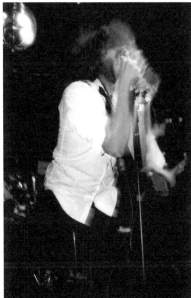

With great press coverage, several larger tours, and decent sales of their debut record, the band were making waves and now wanted to try for bigger things. Initially looking to sign with Fuel Records in Belgium for a vinyl release of 'The Treachery Pact', and then speaking with Julie Weir about working with her Visible Noise label, the home of Lost Prophets at the time. Engineer Records having introduced the band to both labels, but again unfortunately, both deals eventually falling through.

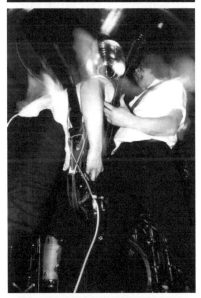

We had discussed it so knew the band wanted to leave Engineer for a larger and / or heavier label, so in mid-2004 they entered Foel Studio in deepest Wales (Hawkwind, Napalm Death, New Model Army, Raging Speedhorn, Spear Of Destiny) as unsigned artists. Working with producer Andrew Schneider (Garrison, Cave-In, Keelhaul, On Broken Wings, The Red Chord) they recorded their debut full album, entitled 'To You the First Star', and touted around a three-track demo CD from it, entitled 'Do not move a muscle, do not breathe a word'.

Their evolving sound and ongoing search eventually brought them to the

attention of Undergroove Records, a heavier metal-core label based in Selby, Yorkshire and developed from Undergroove Fanzine. They already had bands like Johnny Truant, Charger, The Murder of Rosa Luxemburg and Minus The Bear on board, and were keen to release Eden Maine's 'To You the First Star' album, doing so on CD in 2005.

This twelve-track album split opinion amongst Eden Maine's existing fanbase. Many found the direction shift challenging, exciting, and original, while others missed the full-throttled attack of the earlier release. The press, however, were mostly unified in their praise of the album, tipping the band to go on to bigger and better things.

Following the release of the album, the band embarked upon their most intensive touring schedule to date as a headline act and played more cities and countries than ever before and in the process gained a strong following in mainland Europe. They supported Sepultura, The Lost Prophets, The Dillinger Escape Plan and Converge, amongst others and played several prestigious festivals. After three more months of non-stop touring, with Reflux and Lack, the band took a break to regroup and during their downtime, a North American label approached them intending to release 'To You the First Star' in the States, which would mean that the band would have to embark on an extensive tour of the US and Canada.

The proposed schedule was the cause of massive inner turmoil within the band, due to the financial and personal risks involved. The group went through their most difficult period and were unsure of the next step to take. Despite them being at an all-time creative high, they couldn't weather the potential monetary storm that awaited them, and after playing their final show in 2006, Eden Maine went on indefinite hiatus.

Various members of Eden Maine went on to form or join other bands, including Adam and Nick in The Rifle Volunteer, Simon and Phil in Shels and Kieran in Astrohenge.

Drowned in Sound called Eden Maine; *"A Force to be reckoned with."*

And Carolyn Thomas at **Old Time Music** recently wrote about the song 'The Acidic Taste of Betrayal' from 'The Treachery Pact' EP, commenting that it is; *"A powerful track that captures the raw emotions experienced when trust is shattered and betrayal takes hold. This post-*

hardcore and emo blend showcases the band's ability to convey deep emotional pain through their music.

The lyrics of the song delve into the profound impact of betrayal, exploring the bitterness and heartache that accompany such an experience. The title itself, 'The Acidic Taste of Betrayal', alludes to the corrosive nature of betrayal, likening it to a sour and consuming sensation.

The verses paint a vivid portrait of an individual grappling with the aftermath of betrayal. Lines like "Disillusioned and defeated, I search for something pure" depict the emotional exhaustion felt when trust is broken. The lyrics capture the struggle to regain a sense of innocence and purity in the face of such betrayal.

One of the most poignant lines in the song states, "Your actions spoke louder than your empty apologies." This line reflects the heart-wrenching realization that apologies alone cannot heal the wounds caused by betrayal. It highlights the significance of actions in rebuilding trust and the futility of insincere gestures.

Personally, this song holds a special place in my heart as I have experienced betrayal in my own life. The lyrical depth and emotive instrumentals resonated deeply with me during a time when I was grappling with trust issues and the aftermath of being betrayed by someone close to me.

Listening to 'The Acidic Taste of Betrayal' became a cathartic experience, allowing me to confront and process my emotions. The intensity of the music mirrored my own inner turmoil, and the lyrics felt like a mirror, reflecting my pain and validating my emotions.

The song served as a reminder that I was not alone in my experiences. Knowing that others have faced similar betrayals and have channelled their pain into art helped me find solace. It reminded me that healing is a process, and that music can be a powerful tool in navigating through difficult emotions.

As I immersed myself in the music, I found comfort in the fact that Eden Maine had managed to capture the essence of betrayal so effectively. Their ability to put into words and music what can often be an indescribable pain was a testament to their talent as musicians and songwriters."

https://engineerrecords.bandcamp.com

Elemae

Chris Homentosky: Guitar
Craig Cirinelli: Vocals
Dan Nolan: Drums
Mark Cooper: Bass
Mark McKenna (Zullo): Keys
Chris Smith: Guitar
Mike Barbagallo: Bass

Elemae (pronounced 'L-M-A') was composed of New Jersey and Pennsylvania natives who created a band based on their combined love of music and built a friendship that kept them writing, recording, and rehearsing together despite their relatively far-flung geographical locations. Elemae was influenced by Chamberlain, Sense Field, Jawbox and Swervedriver and used the inspiration that they took from their musical heroes to develop their unique sound.

Beginning in 1999 in rural Northwestern New Jersey, the original members of Elemae (Chris Homentosky, Craig Cirinelli, Mark Cooper, and Dan Nolan) fused different genres of the underground and beyond, which was never quite in keeping with the blueprint of any scene.

Taking their lead from their previous post-punk/hardcore groups, Standbye, Threadline, Chander, and Muskalunge, these twenty-somethings were determined to forge a different musical path that was mapped by post-punk, classic rock, no-wave, and alternative jazzy post-rock.

It was a recipe that kept things interesting for the band, despite the member's dietary musical diversity, variety really was the spice of life, and allowed them to fuse their disparate influences and fabricate songs that didn't sound like anything, or anyone else.

The first note they played in public was in a recording studio, recording a single that was dramatically slow and introspective. 'Fret Echo', the aforementioned single, ended up on a compilation of primarily New Jersey & New York bands called 'Stop and Smell the Locals'. A friend of the band, an engineer at the time, brought a mobile recording set-up and they decamped to the suburbs for a few days to get work. The result was the four-song 'Beautiful Things' EP, which the band began gigging to support and added their new name to the New Jersey music landscape and the clubs in New York's lower East Village where they first shared stages, albeit in different bands, years before.

Because of their strong creative chemistry, Elemae decided to embark on their first adventure into a real studio in Central New Jersey to record with Eric Rachel at Trax East in South River and laid down six more songs with producer Peter Horvath (Seething Grey/Greyhouse) who was a greatly admired friend and peer of the band.

These six songs and their previous releases were used to shape their first full-length album, 'A Life to be Defined' (IGN042), which captured them at a transitional point. The album title was fitting in retrospect, as the band consider the record a little too contrived and cobbled together, but it remains a definitive sonic portrait of who they were at that stage of their journey.

Around this time, the band was introduced to keyboardist Mark 'Fingers' McKenna who they quickly hit it off with and ended up joining them in their quest to explore the extraordinary. Elemae phased Mark into their songs, both new and old, and his synths discovered new and alternate melodies in their established musical canon.

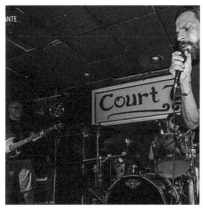

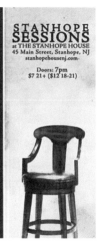

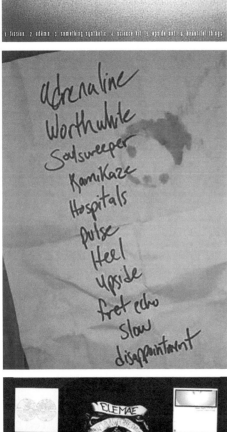

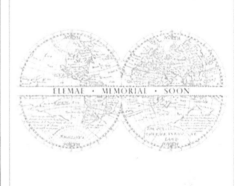

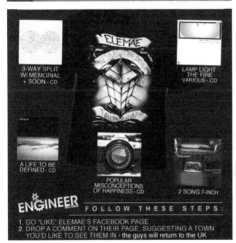

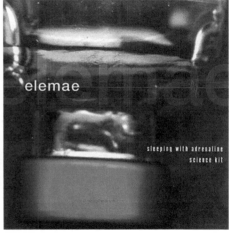

Elemae began mailing out CDs to promoters, fanzines and a few small indie labels, and that was when we discovered each other and Ignition released their debut seven-inch, 'Sleeping with Adrenaline' (IGN012). We also offered them a slot on our 'A Shudder to Think Tribute' (IGN006) which they leaped at and sent us 'X-French Tee Shirt' for the album which was released in 2003.

The label changed its name around then and the newly dubbed Engineer Records and Elemae's relationship blossomed as we released their full-length album entitled 'Popular Misconceptions of Happiness' (IGN053) in 2005. The album did well and we ended up putting some songs from it on cover-mounted magazine comps, local promos and label samplers. What can I say, I'm still an Elemae fan.

Just after we released the album, bassist Mark Cooper relocated and left the band, and they became a two-guitar band for the first time when Chris Smith was added to their ranks, and following the departure of keyboard player Mark Zullo, friend and bassist Mike Barbagallo was brought in, which was the biggest personnel shuffle the band had ever undergone.

Writing slowed down as the band dealt with the wear and tear of life between 2006 and 2008, so it made sense to use Elemae's new songs for a 3-way split CD (IGN109) in 2008 with Belgian band Soon and Memorial from Virginia, which was co-released by Engineer and Embrace Records. Tracks from the release landed on more compilations and additional exposure for Elemae flooded in from overseas with promotions running in fanzines, on distro tables, and more.

Soon after, Elemae recorded its, at the time, final single, a tribute to Northwest indie-punkers Seaweed. 'Magic Mountainman' appeared on 'Hours and Hours: A Tribute to Seaweed' (IGN110) that Engineer released in 2008.

At that point, as their collective focus seemed to be losing steam, the members mutually decided it was time to lay the band to rest. Craig had already been recording, gigging and singing in the band (Damn) This Desert Air which was already on the move with an EP out on Bastardized Recordings (Germany), a 7" on Koi Records (USA), and later moved to both Funtime Records (Belgium) and Engineer for their albums. Both

Dan and Craig were also in a studio-only project called The World Concave (also on Engineer Records) who released two EPs and two singles and in the process had Mark Cooper on bass for a couple of sessions.

In 2011, Chris and Craig reconnected and revised some of the songs in a stripped-down acoustic style, which inspired them to write some more music, re-ignited the old chemistry and pushed them into recording one of the new songs for 'Lamp Light The Fire: A Compilation of Quiet(ER) Songs' (IGN180), the first in a popular series of acoustic compilation CDs on Engineer Records. It also kickstarted their relationship again with us, so we booked an acoustic tour of the UK with labelmate Mikee J Reds in 2011, which they dubbed the 'Lamp Light Tour'.

After they got home, the duo pitched an idea to a few past band members; Mark Cooper, Dan Nolan, and Chris Smith, which led to them rehearsing together, then fleshing out a new EP, 'Tilling the Fallow' (IGN201) which was released on Engineer Records in the Spring of 2013. Is that the end of the Elemae story? Only time will tell, but I certainly hope not.

Erin Jackson of **Punknews**.org described Elemae's 'Popular Misconceptions of Happiness' as, "Full of beautiful and sleepy songs that coax a climax out of an ardent melody. 'Kamikaze's' sweeping melody, emotive lyrics, and crafted percussion make it a standout hit, while 'Soapbox Podium' rocks a little harder than the rest, a change in pace that feels natural and is an appreciated break from the softer emo rock."

While **Interpunk** said the album was, "A strong move forward for an already ambitious group. With the powerful catchiness in the openers 'Sleeping with Adrenaline' and 'Disappointment Book' to the hazy dream-pop of 'Soulsweeper' and 'The Fall of Summer' this disc will instantly attach to your senses and linger in your mind for ages to come."

https://elemae.bandcamp.com

Eretia

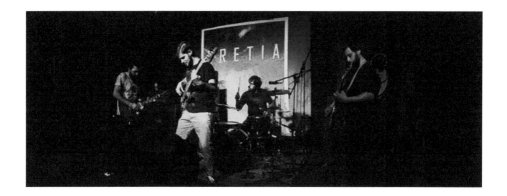

David Fernandez: Guitar and vocals.
Borja Del Hoyo: Guitar.
Rubén Revuelta: Bass.
Carlos Rebolledo: Drums and vocals

Eretia is a four-piece post-everything band from Cantabria in Spain. Featuring ex-members of Témpano, Fürio, and Osoluna, they are, in their own words, "Friends playing the music, and adhering to the DIY values, that we love."

Born from two teenage friends, Borja (guitar) and Carlos (drums), desire to play music together, Eretia dislikes the idea of genre, having been formed from the ashes of a trio of post-rock, screamo and hardcore bands. United by the idea that they needed to push themselves as musicians and explore the genres that their previous bands hadn't allowed them to do, they soon found themselves following a darker more metallic path that drew the final pieces of the musical puzzle, when David (guitar/vocals) and Ruben (bass) joined the Eretia fold in 2018.

Clinging to their DIY values, a staunch rejection of the mainstream music industry ideology, and drawing inspiration from, among others, Cult of Luna, Light Bearer, Isis, Amen Ra, Birds in a Row, Envy and more. Eretia is a collective that thrives on the friendships and unity that lie at its core. Providing escapism from the rat race and a vehicle for individual and collective creativity, Eretia is more than just a band to its members. It's a way of life.

Given their feelings about the music business as a whole, it was a little shocking to find out that the record that had the greatest influence on the band was, and is, 'Smash' by the Offspring. Shocking, but not really surprising, as the record in question, while incredibly commercially successful, is fuelled by lyrical fury and intense, insanely catchy music. Just like Eretia.

The Eretia blueprint was forged in part by their home province of Cantabria, which might be small in size but is nonetheless mighty in stature, and the attitude of the scene that the band grew up in, which encouraged them to play everywhere and anywhere they could, whenever they could.

I asked them about the shows they loved playing, and they told me their favourites were the self-managed, smaller promoters, such as Pista rio and Los Antiguos Almacenes, and their local community venues, En vivo, Pedregal, El Reino, La Oveja / Tortuga, Arena, and especially Rock Beer the New, where they've played many times in its twenty-year tenure. They also play some larger alternative gigs and festivals too, though that doesn't always go as well as planned.

Carlos, their drummer, who also runs the Autoestima DIY distro, label and booking agency, told me, "When we played at the Enfants Terribles Fest in Nancy, France, it was a Sunday with everyone hungover as the festival lasted several days but ended that day. When it was our turn, we played for what seemed like ten people, but it was the most vibrant audience we've ever had, and we later received messages from people saying they thought the concert had been amazing."

"Another unforgettable show was at Kassablanca in Jena, where many more people came than we expected. The dinner was plentiful, and the sound was perfect. The crowd really got into it, and we had an amazing night, which ended with us sleeping in a train carriage."

The bandmates of Eretia have all lived together at some point and try to work closely with the promoters and people who are involved in setting up their concerts, as well as the bands they play concerts with. They like to take the time to talk with the people who come to the merch stall or hang out after the gig. They clearly think nothing of loading their equipment in the van and traveling hundreds of kilometres to play a concert, knowing full well there may five or a hundred people there. Without a doubt, their favourite moments with the band revolve around the friendships they've made through their music.

Eretia started writing songs for what would be 'Quietud', their first album, in 2020, but due to Covid restrictions, its recording was delayed until the summer of 2021 and not finished until March 2022. Recording at Cubil studios in Cantabria with Daniel Papelillo, the album eventually came out on the 15th December 2022, with beautiful cover art by Adrian Alcorta, as an early Christmas present for the bands supporters. Released on cassette, CD, LP and digital formats. With five hundred copies of the album on 180 gram transparent red vinyl, jointly released in true DIY hardcore scene style, by Engineer Records (UK), Urgence Disk Records (Switzerland), Pumpkin Records (Bulgaria), Holy Goat Records (Germany), Dingleberry Records (Germany), Araki Records (France), Bus Stop Press (France), Fresh Outbreak Records (Italy), Salto Mortale Music (Slovakia), Nothing to Harvest Records (Greece), Pasidaryk Pats Records (Lithuania), Producciones Tudancas (Spain), Quebranta Records (Spain), Sound like Sundays Records (Spain), Mise-En-Scène Productions (Spain), Primitive Noise (Spain), Navalla (Spain) and Autoestima DIY distro label booking (Spain).

Carlos reminded me of our early conversations about the records release, reminiscing, "I was a big fan of Ignition, even before it was Engineer Records. For me it was a reference label to find bands of the emo-hardcore style that I liked in the early 2000's. Rydell, Vanilla, Shudder to Think, Hot Water Music, Planes Mistaken For Stars, Joshua. Initially I thought that the sound of Eretia did not fit in with the musical style of the label. It was a surprise to join, but now it's a luxury to have the support of such an important and tireless label in the underground scene. Hopefully the label will be alive for many more references."

Carlos continued, "We are lucky that we all believe in and defend the values of DIY. This is really important for us, we have grown up in the DIY scene, and it is the place where we want to be and develop our activity as a band. It's where we believe that there is coherence with our ideas. The album has a theme within the lyrics, collected over tracks, looking at the influence of today's society on people, the way of life that is imposed and directed towards them, the guidelines that mark the media, politicians, expanding culture in the digital age. Basically, how all of this affects people's behaviour and lives."

Before I finished my conversation with Eretia I asked them about how they saw the post-punk scene right now and the impact that it continues to have on them. Their response, "There are reasons why the scene still

exists. It might be a minority style and genre, but one thing about it is abundantly clear: that hardcore and punk are more than music!"

Jens Kirsch wrote in **Ox Fanzine** that, *"Eretia deliver a thick wall of sound, somewhere between the cornerstones of post-hardcore, post-metal and doom. Wave after powerful wave of unbelievable despair, creating a strong album that has to be listened to loudly."*

France's **Absolute Discovery** called the album, *"A crazy listeners pleasure"*, with fellow countrymen **Core & Co** counselling that, *"With such sincerity of musical intention you can immerse yourself and be guided by these songs. Listen through blasted headphones and you'll move forward without knowing where you'll arrive."*

Germany's **Bierschinken** (Beer n ham) described Quietud as, *"Dark, atmospheric, dignified hardcore with a roaring voice, heavy guitars and whirring bass. A piano even gets brought in at one point and you can tell the band are following their own exuberant, theatrical concept. This is the sort of thing the Per Koro label used to release in the past. It's a beautiful 100% DIY release involving labels all over Europe."*

Headbanger's review would advise us that, *"Eretia has more than enough to scratch an itch that very few bands are able to satisfy."*

Fred Spenner at **Underdog Fanzine** in Germany reviewed the album, saying *"The album is divided into a prologue, six chapters and an epilogue. Quietud is a complex story full of revelations, poetry and dystopian prospects. With dark tones, minor and post metal, the quartet from Cantabria celebrates a sound characterised by daily slogans, where longer instrumental passages and screamo meet relentless guitar-driven apocalyptic emotional worlds."*
"We're anesthetized, we're paralyzed. And the riff sounds like a migraine attack, like a hammer blow on the temple. Life is reflected here as a struggle, presented abstractly, and symbolised as a painful experience. The soul screams and the chords awaken longing and torment. The album is synonymous with a heavy doom rock sound with screamo vibes. Downfall and apocalyptic mood with a lot of groove and instrumental beauties in a minor key."

And our friend Djordje Miladinovic at **Thoughts Words Action** published a comprehensive review of the album, stating, *"Eretia's debut album,*

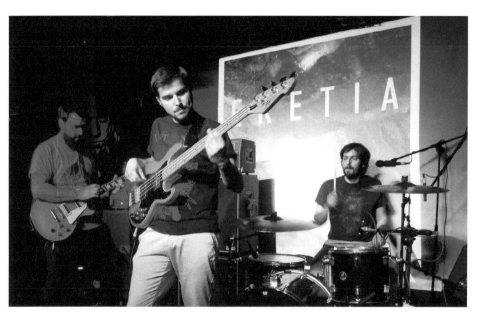

Quietud is a brilliant showcase of the band's incredible ideas, skills, and musicianship. The album begins with the Prologue and Part I, two tracks that set the tone with their raw, intense, and striking passion. From the very first notes, their music pulls the listener into the world of Eretia, a world that's unquestionably melodic, melancholic, and explosive. The band's use of dynamics is impressive, with moments of quiet introspection followed by sudden outbursts of sound that will make the listener's heart race."

"The way this band creates a sense of atmosphere with their music is undoubtedly breath-taking. Tracks like Part II and Part III showcase their ability to create luxurious, complex, textured soundscapes that are simultaneously intense and beautiful. The interplay between the guitar, bass, and drums is flawless, with each instrument working together in shaping a colossal sound that becomes Eretia's signature ambiance. The vocals are another key strength of the album. The singer perfectly captures the pain and disillusionment at the heart of Eretia's music by combining raw and emotional vocal harmonies. He delivers his lyrics with a sense of urgency as he tries to communicate on some profound and significant level."

"The album's production is also worth noting. The sound quality is excellent, with each element of the band's sound captured in a way that highlights its strengths. The mixing is top-notch, with all the instruments equally presented in the mix. Everything is perfectly balanced, creating a cohesive, immersive listening experience. The riffs are equally intricate and memorable, with many melodies, harmonies, and leads included along the way. The jaw-dropping drumming highlights all the orchestrations and keeps the entire band in line. Also, rumbling basslines add an extra layer of depth to the compositions, giving the music extra weight and power. Overall, 'Quietud' by Eretia is an exceptional debut album."

"The band's ability to create a powerful and atmospheric sound that is both heavy and delicate is truly impressive. The musicianship on display is exceptional, with each band member playing an integral role. You should check out Quietud if you are a true fan of neo-crust, dark hardcore, or post-metal. It's an impressive debut that showcases the bands immense potential."

https://eretia.bandcamp.com/album/quietud

Escape Elliott

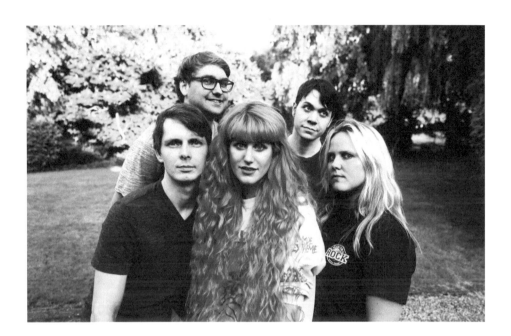

Isaura Flockman: Vocals
Lien Anseele: Guitar
Ward Rosseel: Guitar
Jacob Benoot: Bass
Jorne Tanghe: Drums

Belgian rock outfit Escape Elliott play loud, honest, quirky pop-punk that wears its heart on its sleeve. They combine punk infused melodies with hard-hitting drums and howling, heavy guitars dosed with a touch of ska and reggae. Their ever-evolving sound is a direct result of the divergent influences of the bands core members.

Escape Elliott love to play live and have lit the stage up at every local festival and club they can. They've played major venues in Belgium like Ancienne Belgique and Sportpaleis as opening acts and were the support for US indie band Against the Current at the Belgian show on their last tour.

In January 2019, Escape Elliott recorded their debut album with the help of Canadian engineer and producer Jesse Gander (White Lung, Japandroids, Brutus). Christened 'Everything Here Is Make Believe', their

debut album was built around the idea of escapism and was released on CD (IGN277) by Engineer Records later that year.

Purple haired singer Isaura Flockman is a whirlwind of emotion. You can hear it in the bands lyrics and see it when Escape Elliot play. Led by their energetic frontwoman it's impossible to not be blown away by her and guitarist Ward Rosseel, who are always pushed to their limits by Lien Anseele's mind blowing six-string shredding, powerhouse drummer Jorne Tanghe and quirky bassist Jacob Benoot.

I spoke with Escape Elliott vocalist Isaura, who brought me up to speed... "We usually play small festivals or really small venues with anything from 20 to 200 people, and it's something we love to do. We've played for bigger crowds and to be honest I feel like I belong there. I always envisioned myself being part of bigger shows, but on the other hand it feels like I'm not ready and maybe I'm an imposter trying to run with the big guys.

It's frightening and stressful because we don't want to screw up, so smaller shows are more fun because we're more at ease. The first big show we played was only my 4th gig. It was a private party for Deloitte, a big business our drummer Jorne works for. We signed up for it thinking it would be a small reception and just a bit of fun, but it ended up being in one of the biggest venues in Belgium, the Sportpaleis Antwerp. I had seen Katy Perry there before, and I got all these ideas in my head about what it would be like to play on the same stage. I made my own outfit for it, put it on every night to practice my moves and what I would say in between songs. It was glorious. Although maybe not very punk-rock. I was living on cloud nine before the show, I really thought this would be our big break. Of course it wasn't, but it was a great experience nonetheless. I remember arriving there, wandering around the backstage areas, it really blew my mind, that was what I had always dreamed of.

It really is my biggest dream to play big venues and hang around backstage. I love it so much, I wanna be like Penny Lane and Russell from the movie 'Almost Famous', all wrapped into a single package. I'm often ashamed of speaking about this dream and how I imagine it to be, outfits and all, but in the end it's what makes me me.

Back to the Sportpaleis show. We carried our gear up the stairs trying not to bump our heads on the giant LED screens and while we were on stage

setting up a famous band from Belgium was sound-checking, Black Box Revelation. We were on stage as the second act, but the crowd stood quite far away. A few people stood scattered around the big empty spot at the front and a few were hanging over the front row barrier.

I remember singing and walking to the side of the stage as I saw myself on one of those giant led screens, trying to hide the shock I felt seeing myself looking so big. We didn't play the best show ever, but I think it was alright. I remember my voice shaking sometimes and I absolutely hated how I couldn't control it. But it's a memory we won't forget. This show happened even before our album was released. We had three demo's and we sent those in, and they said we could perform there. How crazy is that? The biggest opportunities often appear from out of nowhere.

Another really cool but scary show was when we opened for Against The Current at the De Kreun in Kortrijk. The promoter knew Lien from years ago and asked if we wanted to play so once again we got lucky. This show was filmed as part a TV program about Lien and that really made us stress out. We had a really small backstage area behind the curtains where the merch was sold. We weren't allowed in the 'real backstage' area where Against The Current was. For dinner we all ate together though. I remember seeing Crissy Costanza sitting in front of the mirror surrounded by all her makeup.

Our soundcheck was interrupted by people coming into the venue for the meet and greet with ATC and that was stressful too as we weren't ready yet. To be honest I often get that feeling that we're not ready for a show, that we're just wingin' it'. Maybe years from now I'll feel like a professional, or maybe I'll always feel like a wannabe.

When we got on there was no barrier and people were almost glued to the stage. They were so close and there were so many of them. I remember trying to be the best performer I could be, but after three songs I was so out of breath from all the jumping and dancing that it was getting hard to sing... It was a struggle to get through the set that night, but we rocked it as best we could. Afterwards Lien and I went to the merch booth and met some fans who wanted photos and autographs. That was strange and unexpected, but we went with it.

It makes you feel important somehow, like you're someone. Fame must be a strange thing. I feel it's mostly superficial but sometimes there's a

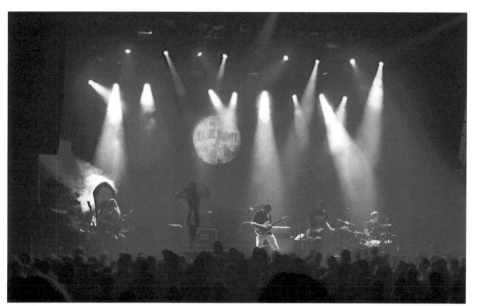

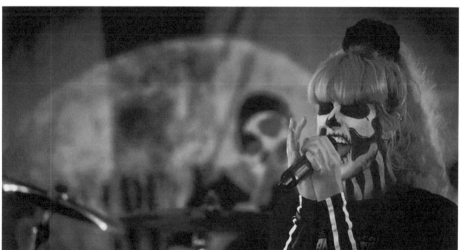

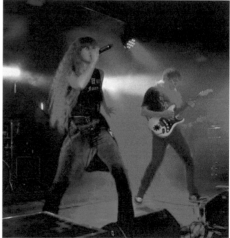

221

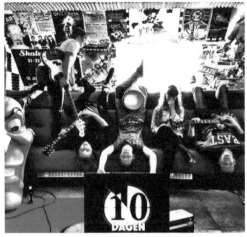

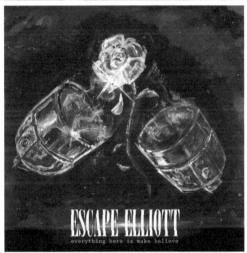

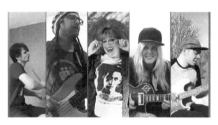

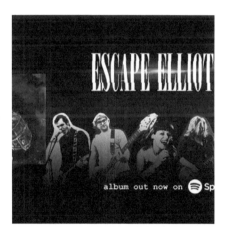

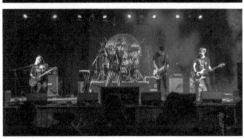

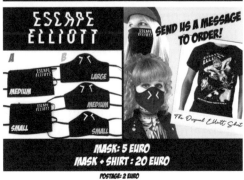

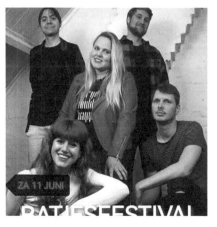

deep connection through music too, those encounters where you feel it's not just about the photo, but about the power of music and the emotional release it gives. That's real magic. Musicians and their fans, it's like the juxtaposition of magic and disillusionment when you realise that they're just people who, just like the rest of us, don't have it all together.

That reminds me of my favourite band 'Brutus', as they have that kind of magic. We've bumped into them a few times and every time I'm so starstruck. I can't talk normally and be my weird self around them. I care too much what they think. Which is kind of terrible. We recorded our first album with Jesse Gander, who recorded Brutus' albums before. He flew over to Belgium for about ten days and we recorded for a week at Closed Session Roeselare, a really cool studio. Before you go in you have to walk through a carnival costume store, it's weird. I hope we'll record our second album there and working with Jesse was cool, he's very professional, works fast and knows what will work and what won't and because of that, we had a great time.

Of course, there were harder moments as well, because our time was limited, I even got in a bit of a fight with Lien about her vocals, and I'm still afraid Jesse might think I'm a bit of a bitch because that happened. Damn, I'm being so honest, I hope I'm not painting an ugly picture of myself, but I just think there's no use candy coating things, and that it's much fairer to tell my truth.

Lien and I have argued and fought about things concerning the band many times, but we've always gotten back together as we both have this dream and I think that's what drives us to keep working together. I'm so grateful to have her in this band and without her it wouldn't be the same. She backs my crazy glitter ideas, we make badass spiked outfits together, heck, we even sold cookies from door to door in the winter to help fund our album. We're a pretty good team. I really hope we'll be able to work together for a long time. She has a muscle disease and is often in her wheelchair which makes things a lot more complicated. It means her time in the band is limited. I hate to think about that. But we're trying to make the best of it.

When we were recording with Jesse we also met Peter and Stefanie from Brutus. We went to a restaurant to eat together and drive there in Peter's beautiful vintage car. All of us piled in so the car was freaking fully loaded and Jesse had to sit in the trunk.

That brings me to another cool gig we played. We got the chance to support Motionless In White at Effenaar (NL). That was a really big deal. I knew who MIW were, but didn't listen to them back then, which made the whole experience less nerve-wracking than it could've been. How did we even land that gig? I mean it's almost impossible to get a slot like that if you aren't a band that's blowing up and if you don't have a booking agency and or big label behind you.

The TV show I mentioned earlier about Lien, Team Scheire, needed one more episode to reveal the system they had been working on. The show focuses on inventing systems for people with disabilities, in this case they'd made a system for Lien so she can use her guitar pedals without having to lift her legs, which was getting harder for her with the muscular disease she suffers from. We had a gig or two planned but the host of the TV show wasn't always available which made it very difficult. They were like "can you make a show happen on one of these days?" so we looked for a gig that was already happening on one of the dates where we could maybe play as extra support.

I went through all the scheduled gigs for the next months and made a list to send to the TV folks then they mailed the venues to ask the promoters and managed to land us the gig with MIW. We rented a van and booked a night in an Airbnb and it was such an adventure. While we were sound-checking Chris Motionless was watching us from the side of the stage. Luckily, we were nailing the song.

After the gig I started listening to their music and watching interviews. I can't believe we got that chance in hindsight, but it's so much better to not know a lot about a band when playing the same show, that way you stress out way less!

Then it was lockdowns and quarantine, and months since we played gigs or even rehearsed. We wanted to record and play live again but for a while were just working on home-made music videos, including one for the song, 'Hey Lorelai' where we had all our lovely friends and the guys from Engineer Records all send it clips of them singing along to appear in the video. It worked really well and was good fun to make. Now we want to write new songs for a second album and I can't wait to see where this goes. Remember, keep dreaming big and never be ashamed to show your love for glitter"

Andy Pearson of **Fear and Loathing** described Escape Elliott as, "A *confident mix of punky, pop-rock fronted by female vocalist Isaura who has*

a powerful but melodic voice that reminds me of Dolores O'Riordan. They bring a lot of different styles together in a totally convincing way. Some moments will remind you of Bad Religion, others will recall Dance Hall Crashers or The Muffs. Great lyrics provide the icing on the cake, making this an album you can think about even while you're dancing to it."

Tim Cundle of **Mass Movement** added, *"I don't believe Escape Elliott comes from the same reality as the rest of us. No band that makes music like this could, because no band from our reality would ever dream of drawing musical inspiration from Muse, Propagandhi and the Lunachicks and write songs that sound this incredible and instantaneous. Part punk prog, part blistering hardcore and part heavy rock crafted in the fading days of the Revolution Summer. Escape Elliott play songs that make your jaw hit the floor while you simultaneously want to sing along with every word."*

And Gemma at **Music of the Future** was singing along too, enjoying the band's; *"Rock sounds that instantly have you in the middle of a concert rocking out, with those punk elements you can't wait to hear. Big sounds and solid performances."*

https://www.youtube.com/watch?v=Z0XSMHc1nBs

Fat Heaven

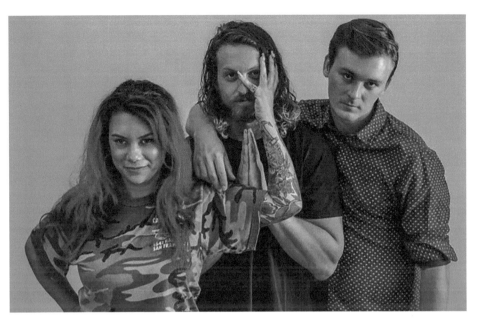

Travis Yablon : Vocals and Guitar
Jack Counce : Bass and Vocals
Gayla Brooks : Drums

Fat Heaven are a noisy pop-punk trio from New York. They've been around a few years and have several releases to show for it but came into 2023 hot with their superbly rabble-rousing new album, 'Trash Life'. The album showcases the band's incredible song craft and worn-on-their-sleeves punk sensibilities.

Fat Heaven is a Brooklyn-based trio consisting of Jack Counce, Travis Yablon and Gayla Brooks that likes to crank out highly melodic pop-punk tunes that harken back to the heydays of Lookout! Records. The band formed in 2014 when Travis and Gayla met at college, hit it off and started jamming. They needed a bassist and a friend of theirs, Sydney, introduced them to Jack.

Their first release was a four song 7" EP, released on red, blue and black vinyl by Chisel Records in 2015. They followed this with their first album, 'Tough Luck', which came out on cassette via Mirror Universe

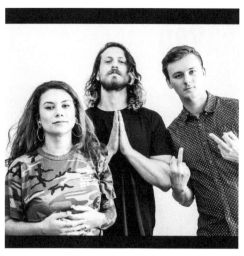

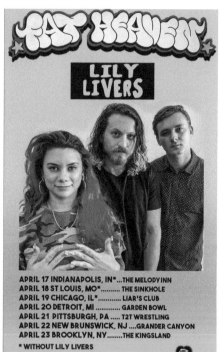

FAT HEAVEN

LILY LIVERS

APRIL 17 INDIANAPOLIS, IN*...THE MELODY INN
APRIL 18 ST LOUIS, MO*.......... THE SINKHOLE
APRIL 19 CHICAGO, IL*............ LIAR'S CLUB
APRIL 20 DETROIT, MI GARDEN BOWL
APRIL 21 PITTSBURGH, PA T2T WRESTLING
APRIL 22 NEW BRUNSWICK, NJGRANDER CANYON
APRIL 23 BROOKLYN, NYTHE KINGSLAND

* WITHOUT LILY LIVERS

FAT HEAVEN

WE'RE FESTING

FEST 22

OCT 25TH, 26TH, 27TH 2024
GAINESVILLE, FL

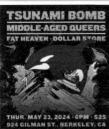

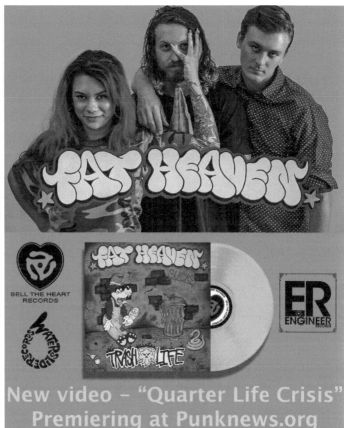

New video – "Quarter Life Crisis"
Premiering at Punknews.org

Tapes back in 2016 and they've been building an underground following ever since.

After ten years Fat Heaven finally have a good list of names to drop, having opened for The Dickies, Night Birds, Pears, Dirty Nil, Leftover Crack, Direct Hit, Mikey Erg, Tsunami Bomb, Days N Daze, Iron Chic, Authority Zero, Surfbort, Thick, Beach Slang, World Inferno Friendship Society, Teenage Halloween, Shellshag, Crazy and the Brains and many more.

"You'd think all that would let us be the attention-seeking, clout-chasey posers we truly are." Joked Travis, their singer and guitarist, adding, "We were also slated to play with the Dead Kennedys and DOA on 15th March 2020. Too bad that the entire world shut down."

They also played the Warped tour one year, which didn't turn out to be a great show, but they'd do it again if they get the chance. I asked Travis about a few gig stories and he told me; 'Our favourite gigs are always the weirder ones. We've had some great and memorable shows, like last year at Pouzza Fest in Montreal and Fest 21 in Gainesville, which were just awesome. But it seems our favourite gigs are when we play Tree Bar in Ohio to about five people. Also, our favourite venue in the world is Skid Row Garage in York, PA. Our buddy MC Hyser runs this incredible venue where every show is just the best fun."

Travis continued; "When it comes to tour stories most are too embarrassing to write. We didn't do anything illegal or harmful, it's just that after 45 minutes of being stuck in a car we seem to lose sense of what it's like to be a normal human being. We've had unsavoury late night karaoke sessions in St Augustine, we had our van break down on the shoulder of I95 in zero degree weather, and once I accidentally found a short cut to our destination by taking a wrong turn resulting in me driving along some train tracks for an undesirable duration of time, but we've survived it all well enough."

"Our favourite stupid tour story has to be credited to our dear friend Jack." Travis told me, "We were starting off a tour from Indiana (where Jack is from) and decided we would get nine hours of driving out of the way the night before, so it'd be just a quick 2-3 hour drive to the gig the next day. After a morning run to Waffle House, Jack decided to pop 'Melody Inn' into the GPS and start driving. Two hours later we're nearing our destination, but Jack doesn't seem to recall his home state

looking this hilly. Indiana is flat. We all check our phones to find out that Jack had put in 'Melody Inn, Ohio' instead of 'Melody Inn, Indiana'. We had now driven four hours away from the venue. Somehow we made it to the show just in time, but this was our first gig on this run so we knew we were off to a bad start."

Luckily, they made it, and their brilliant album 'Trash Life' is available on Sell The Heart Records in the US, Engineer Records in the UK / EU (IGN362) and Waterslide Records in Japan / Far East, with Gunner Records in Germany also helping with distribution and promotions. And while not all of the songs on it are brand new, with the ten-track banger featuring six songs from previously released EPs, it does serve as an excellent introduction to the band and should bring them an army of new fans.

The 'Trash Life' album sounds so powerful, being engineered and mixed by Bouncing Souls guitarist Pete Steinkopf in New York and mastered by Jason Livermore at The Blasting Room in Fort Collins, CO. The LP cover has great graffiti-style artwork too, by Anthony Curla. It's the entire package. Released on 24th February 2023 and available in three 12" vinyl variants: Pink, Green or Purple wax, it features songs from their previously released 'Crybaby' EP, which came out on cassette on Enthrall Records in 2019, and their split release with Trashy, alongside four brand-new cuts. 'Trash Life' finds Fat Heaven bringing us consistently great sing-along punk-rock anthems.

I asked Travis what's next for Fat Heaven? "We've got so many songs in the bank that need to be recorded. We're slow, so who knows when we'll actually finish them, but we have plenty of material. We're about to embark on our first West Coast run with the legendary 924 Gilman as one of our destinations. That should be fun! Luckily, we're more 'mature' as a band these days so we're hoping to have a fun time on this tour with not so much the bad stuff. Overall, we're experienced now and no longer dumb kids. Now we're dumb adults!"

Travis added, "Anyway, we've got much love for everyone who's been part of this journey. We fully intend to keep doing our thing and want to see you all at our gigs!"

Punk Rock Theory's review said; *"They won me over from the opener, 'Quarter-Life Crisis,' a punchy yet melodic tune with a very catchy chorus and*

kept my interest high for the remainder of the album. 'I Am Trash' is a rager from start to finish, 'Miracle' offers plenty of urgency and singalong moments and 'Crybaby' gets to take home the award for most contagious hook, and that's saying a lot if you listen to the rest of the album. If you like your pop-punk catchy, angsty and slightly aggressive, then Fat Heaven is just the band for you."

Powered By Rock compared Fat Heaven to Rancid, The Atari's, Screeching Weasel and The Ramones and added; *"Really catchy pop-punk hooks with vocal melodies and louder gang vocals have the flair to bring energy and emotion to the songs and keep things punchy. I highly recommend you check this album out and play it loud!"*

That's Good Enough For Me called them; *"Possibly the best band that nobody's talking about. Now starting to get the credit they deserve. Fat Heaven are a refreshing throwback to the '90s pop-punk styles associated with Green Day, Operation Ivy and Pansy Division but with a more modern sensibility to their lyrics."*

And **New Noise** magazine added; *"With the same personality as the city they hail from Fat Heaven keep it relentless, fast and dirty, but most of all, fun as hell. Combining '90s pop-punk with New York attitude and deservedly packing out gigs from basements to rooftops."*

http://fatheaven.bandcamp.com

Flyswatter

Current Members -
Florian 'Florry' Kämmerling – Vocals & Guitar
Christoph Neumayer- Bass
Attila Antal - Drums
Former members of the band -
Philipp Seidl - Drums
Marco Kärger - Guitar
Anton Stöckl - Bass

A German hardcore rock band drawing influences from Jimmy Eat World, Get Up Kids, Boy Sets Fire and Foo Fighters. Originally releasing records and touring all over in the nineties and noughties, now reformed and rocking again. Coming back strong and crossing the light years in between like Marty jumping into his Nike pumps and onto his hover-board in Back To The Future.

2024 marks the thirtieth anniversary of Flyswatter. During the last six months, the band has been busy writing new material and has played a couple of shows, and three decades after they first plugged-in, tuned-up, and started jamming, they're finally where they always wanted to be - free to play and do whatever they feel like doing.

At this point, for Flyswatter, it's not just about music. It's about friendship, and their last release, "Togetherness" highlights that. When the band is together good things happen and in the crazy, unpredictable age that we're living in, the most important thing that any of us can do is spend time with the people who matter to us and make the sort of memories that will last a lifetime.

It all started back in the early nineties when a group of high school friends with a burning passion for bands from every corner of the punk, hardcore and metal universe decided to get together and started playing covers from the back catalogues of the artists that they adored, without setting any musical boundaries for themselves. They jammed on tunes by the Rollins Band, Stone Temple Pilots, and Fugazi, and their all-encompassing approach to playing was the beginning of the band that would eventually become Flyswatter.

Fuelled, and inspired, by the eclectic indie and underground playlist of MTV, Flyswatter absorbed the steady diet of music that was ritually offered up to them daily. But for the fledgling band it was about more than the songs that they were exposed to, as they were merely the foundation for the platform on which they built their friendships. And it was those friendships that enabled them to indulge in their other beloved pastime, playing music.

Influenced by a tsunami of disparate genres and everyone from Michael Jackson to Madball, NOFX, Phoebe Bridgers and All, Flyswatter was, and is a band that's far more complicated than the sum of its parts. They are driven, as a collective, as Youth of Today intoned at the start of their musical journey, to 'Break down the walls', and write, and play music that doesn't conform, or adhere, to any established rules.

Having recorded their first demo in their rehearsal room in 1997, the band hit the studio two years later to record their debut album, 'Black and Blue', which came out late in 1999 on Chris Huber's Chiller Lounge Records. This first record secured them good gigs and a band manager, Mike Schurr, who soon introduced them to Engineer Records, a label that they felt an immediate affinity with. This led to the release of their sophomore full-length, 'Repeat in Pattern' in 2002.

Flyswatter's founder member, singer and guitarist, Florry recalled, "I remember the day we received the big news that we'd been signed to

Ignition / Engineer Records for the release of 'Repeat in Pattern'. We were immediately blown away by their roster and the overall awesomeness of the label. They share the same values and love of music. I remember we got so much more recognition and positive feedback in the following years. It helped us a lot along the way and we're forever grateful. After all these years it is just beyond amazing to see that Engineer is still around spreading the same positive vibes."

Following the release of their third, self-titled album by Eat the Beat Music / Roadrunner Records in 2004, Flyswatter started to slow down before eventually calling it quits in 2006 after they found themselves struggling to remember why they were playing and choosing to walk away on their own terms before they irreparably damaged the thing that mattered the most to them, their friendships. And it was those friendships that brought the band back together again in 2020, fourteen years after they initially called it quits. Having realised that their connection to, and with, each other was as strong as it was then they started playing music, Flyswatter recorded and released, entering the digital age with a new EP, '2020'. They followed it with a brace of singles, namely a cover of Bruce Springsteen's 'Dancing In The Dark', and a homage to their good old days and what matters to most to them, friendship, with 'Material'.

Populist wisdom would have us believe that you never forget the first time, and in Flyswatter's case, that's true as they told me that the record that meant the most to them was, and is, their first album, as it's just four friends making music together, living in the moment and that includes all the mistakes that only bands can hear. As for records that helped to shape the band they would eventually become, and set them on the musical path they'd follow, Flyswatter singled out All's 'Pummel', Gorilla Biscuits' first self-titled EP, and Samiam's 'Clumsy', a superb trio of incredible, hard-hitting and emotive releases.

Talk, as it always does with punks and hardcore bands who have spent a huge part of their lives in barely roadworthy vans, traveling from town to crumbling town, and country to country to play shows, moved on to gigs and the local scene. That's when I found out that the band's hometown of Berchtesgaden, is also home to the CBGB's of Bavaria, the Kuckucksnest. Infamous clubs like this are always indicative of a vibrant, healthy scene, a fact that Flyswatter was happy to confirm.

Tour talk led to tour stories, which led to Florry telling me about some of the shows the band played, "Definitely one of the best was Bizarre Festival in 2000. We were part of the Visions Magazine stage and had an amazing show, but more importantly, got to see and share the stage with loads of our favourite bands. We saw the Deftones, Foo Fighters, Mr Bungle. It was crazy! The best show that night was K's Choice. They blew us away. Still to me one of the best bands ever. 'Cocoon Crash' was a mega album. (A platinum selling album by an almost unheard of Belgian band) We still talk about that night all the time."

"In the following years we played a ton of shows, I wanna say around 300. Good and bad. Our first tour was insane. We went on a weekend schedule to Belgium with our friends Baken Beans and Surfers Out. The stories from this tour still go around to this day. Even when you don't expect it. Just recently, a colleague at work who is a mutual friend with some guys in the band asked me about that tour. We had cold floors, nothing to eat but everything to drink, fire extinguisher blowouts on the street, to getting naked pretty much everywhere we went."

"The single worst show was actually the last show we did before we went into our fourteen-year hiatus. Only I was left of the original line-up, and we were already over at that point. Attila and Marco had left the band a couple of years before. It's that moment when you know you don't want to be in the same room, let alone on the same stage, anymore. But eventually, the story has a happy ending. The Original line-up from '94 is back together and here for good. This is not a band; this is a bond."

As these things often seem to, stories about the gigs led directly into the weird and wonderful memories that the band has accrued along the way, with Florry going into great detail and telling me, "One of the best things about playing music for so long is the stories that always go hand in hand with it. First of all, when we started out, we would play everything. And I mean anything. Birthdays, weddings, company parties, high school proms, beer tent events on-grass, outdoor barbecues. You name it. Like I said, we loved playing."

"One of the funniest stories though came with an after-show party that I still remember very vividly. We played a show in Vienna and the promoter said that we're all gonna sleep at his place. That was pretty common, and we were stoked. So, we finished the show and got in the car. He started driving into the Vienna city centre and all of a sudden, we're in the driveway, or rather gateway, of Castle Schönbrunn. (A three-

hundred-year-old 1,441-room baroque palace and main summer residence of the Habsburg rulers). We asked him 'Where are you taking us dude?', and he said, 'No no. It's fine, I live here'. So, we ended up sleeping in a massive, imperial room in one of the world's most famous castles. The next morning when we got up, totally hungover, tourists started snapping at us with their cameras trying to get a good shot of the residents. Ha. I'll never forget that one."

"Also, another evening we'll never forget was when we drove ten hours to play a show with Shelter. It was a hardcore festival with about ten bands playing. We were supposed to go on before Shelter. The evening was a mess, every band played way too long, stage production took a thousand years between sets, and at one point the promoter decided to get totally wasted as he realised that the whole thing was going south. Ray Cappo was warming up playing guitar, and the clock was way after midnight. So, their tour manager said, Shelter is either playing now or not at all. The only right thing to do at that point was to let them go on. Only we were now supposed to play after Shelter. So, we thought, we drove all this way, we might as well hang in there. A couple of people might hang out at the bar afterwards to watch us play. Shelter played the show. The audience got what they came for. Then the audience left. Literally, like all of them within twenty seconds. So, we left too, driving back ten hours through the night. Sometimes things just don't go your way."

Florry continued, "Playing festivals was always fun and we got a ton of 'fanboy' moments. Standing in the catering line with the Chemical Brothers at Rock am Ring, seeing Die Toten Hosen side-stage, and later that year playing an unplugged show with their lead guitarist Kuddel at Musikmesse Frankfurt, touring, and becoming friends with our brothers from BoySetsFire. Especially Robert Ehrenbrand. I must mention him explicitly, being the person who got me into martial arts, which changed my life completely. To this day we train, laugh and play music together. It's always been about the people you meet."

Playing in Flyswatter led to many other musical projects and collaborations. For example, the band's second album, 'Repeat in Pattern', IGN025 for Ignition / Engineer Records was produced by Liquido's Tim Eiermann. To this day Liquido's worldwide hit song 'Narcotic' is one of the most-played radio songs ever. He heard Flyswatter's first record and invited them along as a support act. They

immediately clicked, since he is a big music lover and has a wide range of musical tastes, from hiphop to emo and punk, soul to jazz and grindcore. He even plays drums in the grindcore band Gut. So, it was a great combination and he contributed greatly to Flyswatter's second album, helping make it what it is. He now owns and operates the Audiodrive music studio producing a large variety of bands and musicians.

Florry told me one last story, although not a Flyswatter story, but since this band was the part of everything that happened in-between, he wanted to tell it. "This is by far the biggest 'fanboy' moment of my life. It happened with our Rave-Electro-Funk project 'Team Monster' who played at the Melt Festival, where Oasis played one of their last shows before they split. I will never forget the moment Liam got out of the limousine, strolling to his own backstage area. Just seeing this big rockstar in person. Meanwhile, Noel was casually hanging out at the catering, being super down to earth, greeting and chatting with everyone. And then the show, it was mind-blowing."

It seemed that the Flyswatter guys had enough stories to last a lifetime, and more than enough to fill an entire book. Almost as soon as Florry finished his story, Christoph started telling me his favourite, "My neighbour asked me if I would like to go to his school's summer party. I said sure, why not? It must have been the summer of '94. Green Day and Offspring were always on VIVA and MTV back then. I was about twelve and didn't really have a clue about what was going to happen. But in short, it changed everything! I just switched from metal to punk rock for the evening and for the first time I heard music that I immediately liked and that spoke to me, and that was the first time I saw Flyswatter. I remember Marco playing a Fender Strat with Madball stickers between the single coil pick-ups and Florry playing a Les Paul Gold Top."

"It sounds pretty strange, I know, but this band has been with me all my life, since that night. With Florry and Marco's brothers, Beni and Timo, we played some concerts with our band, Manual, as their opening act. We always met skateboarding, or at parties and gigs. No matter what was 'hot' at the moment, I always listened to Flyswatter. I know it sounds like a cliché, but it was like that. And now I'm writing my own part of the story and I can't thank the boys enough for letting me be a part of it."
After this enjoyable chat with the band, I thought it was apt to let Florry have the last word, "If it wasn't for punk-rock and hardcore none of us would be the people we are today. Hardcore punk will never go away,

because it addresses the core values and principles that help build character and make us all better. It's about freedom, equality, creativity, commitment, and passion."

"I'm thrilled to see HC bands like Turnstile or Gel keeping up the spirit and reaching so many people. For us as 90s kids is also fun to look at their videos and really feel like we're back in the day. The sound, the looks, the vibes. What they do is real. And people will always recognise real. Even though we're not your typical hardcore band, our roots and heart will always be in the hardcore scene."

When Flyswatter's 'Repeat in Pattern' album was released, Germany's **Visions Magazine** wrote, *"Well done songs with a lot of feeling, emotions, fine melodies and enough noise to displease your mother-in-law."*

"The word 'emo' is on everyone's lips, but at the same time no one seems to know where this rampant scene begins or where one leaves the densely cultivated field. It's a good thing that Flyswatter are stylistically within earshot of undisputed genre greats such as Jimmy Eat World and The Get Up Kids. On 'Repeat in Pattern', the Munich-based musicians, firmly rooted in Berchtesgaden, offer emotionally soaked songs, often refined and carried by grandiose melodies."

"Singer Florry Kämmerling balances brilliantly on a multifaceted sound framework, making you sit up and take notice again and again with his harmonious voice. With 'Save Your Heart' and 'New Sensation', Flyswatter are on the threshold of wistful melancholy, but the rough drama of 'Revive the King' or 'Beautiful Customer' make up for it right after. With more pop appeal than Waterdown and more feeling than the Donots, Flyswatter should make the leap out of the hustle and bustle of the national talent pool with their second album."

Now, with the band back in action, **Away From Life** music magazine says that, *"The nineties kids are back, telling stories about the ups and downs of life, but wrapping them up in catchy melodies garnished with gripping singalong moments."*

http://flyswatter.de

Forever Again

Chris Wetterman : Guitar and Bass
Christian Nuckels : Vocals and Programming
Greg Butler : Drums

Forever Again is an American Indie rock band based in the Washington DC area. Beginning as the casual solo project of Chris Wetterman, the duo officially formed when Wetterman joined with vocalist Christian Nuckels to play guitar for Nuckels' solo album, 'Alive and Free'. During that process the two continued together to further evolve Wetterman's material into several indie power-pop anthems in the vein of Saves The Day, Elliott, Braid or Pop Unknown.

I managed to catch up with Chris and Christian to talk about the band, how they met, their debut album 'Resonate' and what lies ahead for them. I sat back and let Christian take the lead as he began to tell me their story...

"Chris and I met at a church in Arlington, VA where I led the music. When he auditioned to be one of our guitarists I knew this was going to be a great partnership, but I never could have known the extent to which we would be able to create together. We bonded instantly over our shared

love of great emo bands like Further Seems Forever and Jimmy Eat World and it was nice to play with someone who shared my lifelong affinity for that kind of music even though we were playing stuff that was quite far from the genre.

"I had gotten my start as the singer for a ska band in the early 2000s and then had done some Dashboard Confessional-type acoustic stuff and played a lot of shows in the indie rock scene in the Dallas, Texas area where I'm from. By the time I met Chris, my punk/indie/emo days were a distant memory. I was writing and recording a lot of Christian worship music (which I love as well just in a different way) but I longed for an outlet that met up with the music I listened to for entertainment and enjoyment.

"I moved to Tulsa in 2018 but Chris and I stayed in touch and he graciously offered to play guitar on a project I was working on. While we were doing that record he sent me some clips of guitar 'sketches' that he had recorded at home over the years. I was blown away. It was exactly what I had been looking for, the perfect musical pallet for all the nostalgic and deeply personal lyrics I had floating around in my head for years. Chris's musical genius combined with my melodies and lyrics really well and thus, Forever Again was born."

Chris added; "It was at that point we started collaborating on what would become our first record, 'Resonate'. We started song by song. Christian would throw down vocals and each tune would come alive. He has a knack for arrangement and writing killer melodies, and that was a challenge as I was used to hearing what I'd written the way it was, sometimes for years one way and then they're given back and everything had changed. I was filled with anxiety about the changes that were to come but that quickly changed to excitement as it was refreshing to hear new life being breathed into these songs that had been dormant for so long."

Christian picked up the thread and told me; "We decided that this music needed to be heard by others. Chris would send me the instrumental ideas and I would write lyrics and melodies for them and put the overall structure of the song together. Most of the songs are just me telling my stories. 'Rearview Mirror' is just me looking back on my life and feeling the need to appreciate the past while moving toward the future. 'Voices' is about my dad's suicide. 'Slowdance on the Ceiling' explores the way

my love for my wife has matured over all these years together, while 'Threads' tells the story of how we first met and fell in love.

"They are all songs that I never could have written on my own and I never had an outlet for them until Forever Again. I had the stories in my heart and mind, but Chris Wetterman gave me a page on which to write them. And Engineer gave us a megaphone. Engineer Records was a label that Chris had been affiliated with in the past and they were kind enough to pick up the album for a distribution deal."

I'd first met Chris Wetterman when he played for A Rocket Sent To You. They had a great album out on Silverleaf Records in 2000 and we brought them to Ignition for an early release, the split CD for Rydell, San Geronimo and ARSTY (IGN005) back in 2002. He'd stayed in touch and dropped me the new demos he and Christian were working on. They asked a friend, Greg Butler (Long Arms, River City High) to play drums on the tracks and he recorded them to tapes at Audio Verite studios with Andreas Magnusson (Light The Fuse And Run, Ann Beretta, Crestfallen). The final recording was mastered by Dan Coutant of Joshua at his Sun Room Audio studios.

We released Forever Again's beautiful nine-song album 'Resonate' (IGN286) in digital and CD formats in 2020, supporting it with radio airplay for the first single, 'Rearview Mirror' on a lot of US college radio stations. The deeply personal songs still shine and stand up to scrutiny, but there were only ever five hundred CDs pressed, keeping this album something of a rare gem. Every now and again I come across a copy in an indie store or record distro.

Chris kindly told me; "Thanks to Engineer this album has been heard all around the world, and we couldn't be more grateful. As for what's next... who knows how long it will take, but we know that this is just the beginning for Forever Again."

Ox Fanzine wrote; *"This makes my emo heart beat faster! From the very first seconds of the opener 'Rearview mirror', the duo lets us take a seat in a time capsule back to the days when Saves The Day were the ultimate, Motion City Soundtrack anthems were written on an assembly line and The Swellers delivered their big hit. Strong, beautiful, perfect for summer in the car. If you like to enjoy new songs from old bands 'Resonate' is ideal for you. The Washington band's lyrics are about feelings. Feelings and self-doubt. An absolute recommendation."*

And **Thoughts Words Action** added; "'Resonate' delivers nine beautiful love songs and bursts with quality. The group deals with themes like love, relationships, friendships, moments, situations and circumstances. Their material also questions mistakes, decisions, acts and what would happen if things were done differently. Forever Again relies upon a contemporary emo / indie rock sound with modern production that highlights all the beautiful moments during the album. Everything sounds like a charm."

https://foreveragain.bandcamp.com/album/resonate

Fugo

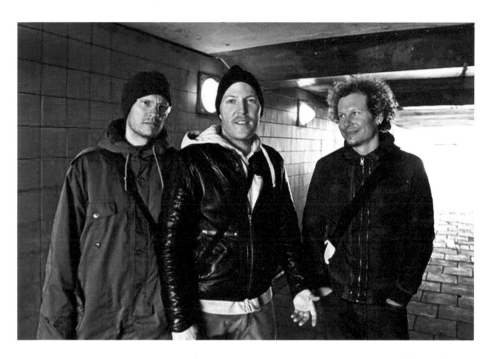

Mich Rothen – Guitar & Vocals
Roman Donzé – Bass & Vocals
Stefan Hell - Drums
Christian Kyburz – Drums (Avant 93:43)

Fugo formed in 2000 and have collaborated with Engineer Records since 2004. The Swiss answer to something in-between Smashing Pumpkins and Fugazi sing in English and French, jumping between the two languages, and tend to name their songs with single letters or numbers. They've shared the stage with the likes of Standstill, Navel, The Delilahs, Darediabolo, Highfish, …And You Will Know Us By The Trail Of Dead, Favez and My Last Sorrow.

Fugo rose from the ashes of Lunazone and Crumb, following the demise of both bands in Aarau, Switzerland in 2000. As the members already knew each other from the hardcore scene and playing shows together, it made sense to Stefan Hell (drums) and Michael Rothen (guitar and primary songwriter) to join forces and create the kind of music that they'd always wanted to make and aspired to. After Roman Donze (bass

player and singer) completed the initial line-up of Fugo, they recorded their first album, 'Aie', (IGN062) which was released by Ignition Records in 2005.

Following the departure of Hell, who left the band to live in Brazil, Christian Kyburz joined Fugo just before they recorded 'Entremets D'Hier' (Yesterday's Desserts) (IGN096) for a split CD EP / mini album with Squarewell, a melodic indie-rock band from Louisville, Kentucky, USA, who also had three releases out on Engineer Records. The partnership went well, and the band kept writing, but took another five years to create their next full-length album. A triple CD work of art entitled 'Avant 93.43' (IGN158) which led to a tour supporting And You Will Know Us by the Trail Of Dead and Rival Schools.

Naming the band after a Japanese blowfish, Fugu, which is widely regarded among foodies as a delicacy but if incorrectly prepared is poisonous and lethal to anyone foolhardy enough to eat it, mirrored the musical mission of the members. They wanted to challenge and push themselves artistically and creatively and make music that would appeal to anyone who shared their vision and yearned to listen to something different. Fugo wanted to write unique songs and that would linger long in the collective imagination of their audience. They took their cues from The Cure, Quicksand, The God Machine, Refused, Fugazi, Standstill, Janes Addiction, Rites of Spring and Helmet.

Before they ventured into the studio to record their debut album, Hell and Rothen laid down the blueprint for what would later become 'Aie' and sent the self-titled demo to Engineer Records, which opened the door to the relationship that would exist throughout the band's career. When I asked Mich about the Fugo records, and those by other bands, that left a lasting impact on him, he told me "I hate to say it, but I love all the albums that we released as Fugo... As for the records that that blew me away, the first and most unexpected, was 'Blood Sugar Sex Magik' by The Red Hot Chili Peppers. Later I guess I was blown away different times by 'Betty' by Helmet, 'Around the Fur' by Deftones, 'Manic Compression' by Quicksand, 'Aenima' by Tool, 'Collapse' by Breach, and 'Worlds Apart' by ...And You Will Know Us By The Trail Of Dead."

When our conversation eventually touched on the band's most memorable shows, and their favorite stories from the time they spent together, Mich reminisced, "For me, our best show was the first of our

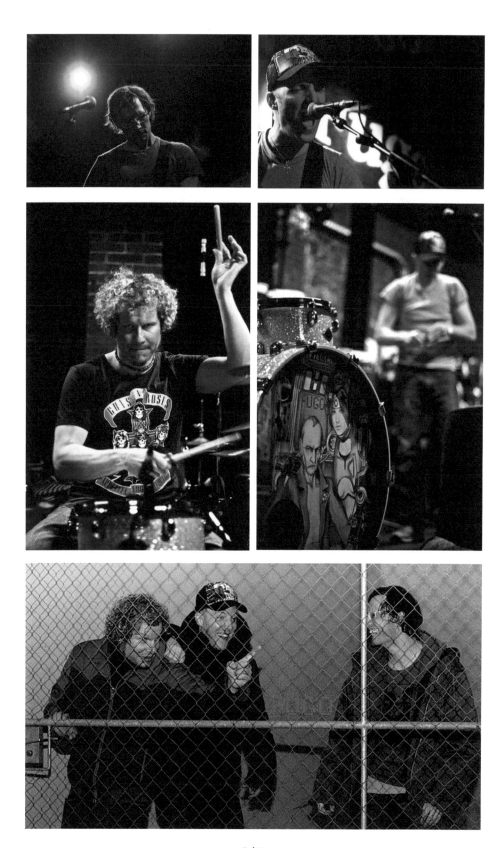

Fugo

European tour in 2011. We opened for ...And you will know us by the trail of dead at ZAKK in Düsseldorf, before Rival Schools joined the tour. I really believe we blew away Trail Of Dead as the opener in front of an 800-capacity crowd. We had a lot of positive feedback after the show and sold a lot of merch. Later on the tour Trail Of Dead became a live show monster and really delivered..."

Their tour with Trail of Dead and Rival Schools saw them travel through and gig in Germany, The Netherlands, France, Belgium, Denmark, Norway and Sweden. Fugo limped along in their own camper van behind the big bands nightliner tour bus, soon finding themselves banned from backstage after their drummer ate most of the other bands food rider at one show. Drinking too much schnapps they broke the camper key in Leipzig, but managed to catch up in time to jump on the ferry from Denmark to Norway, where the ever-friendly customs fellows held them up them for hours, making Fugo late on stage for the next show, despite their best efforts.

Mich laughed and continued, "As for our worst show, that was at an open-air festival in Malta. Nothing worked at all and the song '80:09' on Avant is about this guy from Malta whose name I've since forgotten. A long journey for nothing."

"However, the best memory for me is when Conrad Keely of Trail Of Dead agreed to do the artwork based on my idea (girl stays the same age and boy gets older and older for our triple CD 'Avant') and then he invited us on their European tour in 2011 with Rival Schools. And we got paid for every show."

After finishing the tour there were a lot of letdowns and broken promises, so while writing their third album the band's motivation began to wane. Eventually, as all things do, Fugo came to an end. While Fugo's last drummer Chris is still making music, both Roman and Michael are now content to spend their time with their families, pursuing other personal and professional goals.

That doesn't mean that Michael isn't part of the hardcore scene and doesn't love the music that first made him want to get on the stage. As our time together drew to a close he told me; "Every genre is timeless. They all have a background and history, but in the end it is music, an incredible combination of emotion, feeling, and individual truth. It will

always matter to me, and dependent on how I'm feeling, provides me with whatever I need. Do I want to listen to David Bowie or do I need some Gorilla Biscuits. It's all things to everyone, and that's why it will always be important to me."

Interpunk reviewed the triple CD for their US distro site, saying; *"From deep within the Swiss countryside, Fugo have emerged once more with their second post-hardcore offering, 'Avant 93:43' for Engineer Records. Easily referenced with Fugazi and Quicksand when their debut release, 'AIE', came out way back in 2005, it has taken six years for 'Avant 93:43' to come to fruition and this mammoth three-disc masterpiece is well worth the wait. The growth within the band is clearly audible on 'Avant 93:43', still singing in both English and Swiss-French, the essential Fugo sound is still there but the period spent maturing both musically and as a band has paid off. The development in the band's sound has shown a growth to envelope more than just a modern reconstruction of post-hardcore. Taking more from of a lead from the likes of Rex, At The Drive In, ...Trail of the Dead and Smashing Pumpkins, among others. Considering the gap between releases, 'time' is an appropriate theme running through all eighteen tracks of the record. Yet this is all completed with total simplicity without needing to tread the tenuous ground that is the concept album. Even down to the fuss-free naming of the songs (1.1, 1.2 etc), this is a band who are focusing on the music rather than the trimmings around the sound."*

https://youtu.be/THFPKehj4Lk?si=fhwDWC_JTkA39huG

Her Only Presence

Luis Cifre : Vocals and Guitar
Rafa Rodriguez : Drums
Victor Jimenez : Bass

Her Only Presence was a superbly talented Spanish power trio from the beautiful city of Barcelona who were influenced by mid-90s emo bands like Sunny Day Real Estate, Appleseed Cast, Mineral and Penfold.

Her Only Presence was originally supposed to be Luis Cifre's solo project and came to life after he left his previous band, the post-grunge outfit Emerald Planet. However, things rarely work out the way they're supposed to, and it gradually morphed into an acoustic alternative folk band after he started playing with like-minded musicians.

Moving to Barcelona in 2005, Cifre kept the name and was determined to stick to his solo guns, but ended up shelving the one-man band plan when he discovered that he liked playing with other musicians a little too much to branch out on his own. Even though he'd originally lost his desire to be in a band after trying to deal with the omnipresent difficulty

of playing with other musicians that he'd run headlong into while in Emerald Planet, he soon found that the need to give his songs the room to breathe by expanding the sound of Her Only Presence soon overcame his reservations about being in a band again.

Initially fuelled by an impetus to travel the same musical path as Kevin Devine, Low, Denison Witmer, Rivulets, Leonard Cohen and Kristofer Anstrom, as Her Only Presence added more members their sound changed and began to incorporate elements of bands like Mineral, Appleseed Cast and Penfold, all of which helped them to find their identity and become the band they were always supposed to be.

Influenced more by seeing Standstill, Maine and A Room With A View play intimate shows in Mallorca, the place he originally called home, Cifre moved to Barcelona to escape the non-existent scene that he felt that he, and he alone, was a part of. That move changed his life, as he found what he'd been searching for. A post-hardcore scene filled with like-minded souls.

Her Only Presence released three albums; 'Ghost of the Year' (Dreamville Records 2005), 'The Hurt Process' (Promise! Promise! 2007) and 'A Brand New Start' (Promise! Promise! 2009). Also, a Split CD: 'Dreamville Sampler 002' with the bands L.A, Twin Engine and The Marzipan Man. Luis also played on Primavera Club Festival 2007 and many shows during these initial five years, including opening for Tricky at Bikini Fest in Barcelona '08 and touring Spain with Swedish songwriter Kristofer Astrom.

In August '09 Her Only Presence toured Poland with Setting The Woods On Fire and Chasing the Sunshine, and shared the stage with artists like Declan de Barra, Surrounded, Rivulets, Elephant Micah, Ainara LeGardon and L.A. Then included two songs on the original soundtrack for an Eduard Cortes movie, 'Ingrid', presented at the Sitges Fantastic Film Festival.

Having decided to send their demo to Engineer based solely on the fact that the label released an EP by one of their favourite bands, Penfold, under the name The Moirai, (Bury Yourself CD IGN075) Cifre and Her Only Presence soon established a mutually friendly, open and honest working relationship with the label, leading to the release of their superb 'You're Never Back' album. These ten songs were mastered by Chris

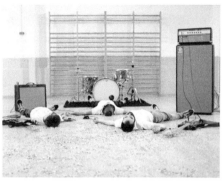
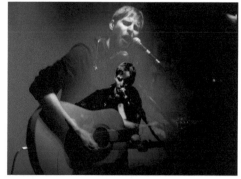

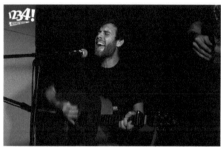
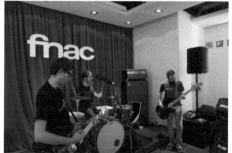

Her Only Presence (Niu, BCN) 11/07/2014

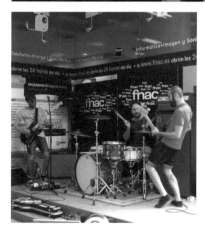

Her Only Presence

"You're Never Back."

Fotografías por: Alberto Foto

her only presence

A brand new start

A VIVA VEU presenta...

Her Only Presence + Atlantic

divendres 20 maig

21:30h - Atlantic
22:30h - Her Only Presence

4 euros general
3 euros socis

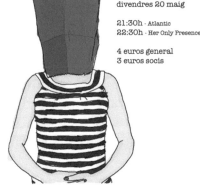

M Miscelanea. Carrer Guàrdia, 10 08001 Barcelona Metro L3 Drassanes

4AP
PRESENTA

HER ONLY PRESENCE

4 NOVEMBRE -22 H- GRATIS
AFORAMENT LIMITAT
ROUGE BAR c/Poeta Cabanyes 21 - BCN
⟨M⟩ PARAL-LEL (L2 I L3)

254

Crisci of The Appleseed Cast & Old Canes and released on CD (IGN162) in the Spring of 2011 by Engineer Records with worldwide distribution.

This would soon lead to Her Only Presence playing at the Mini Cake Music Festival in Barcelona and the Fnac La Maquinista Store to showcase the new album. There were several video singles from the 'You're Never Back' album launched through the Blank TV alternative music channel in the US, with both 'I Wonder If there Will Ever Be A Boy Who Can Swim Faster Than A Shark' and 'A Present' both surpassing 15,000 views.

Soon after, a song by Her Only Presence, 'AWOL', was featured on the first 'Lamp Light The Fire' acoustic compilation (IGN180) and this was followed by a split purple vinyl 10" (IGN198) with fellow Spanish band L'Hereu Escampa on Engineer, Famelic and Desert Pearl Union labels in 2012. More compilation tracks and good gigs ensued.

But as they always do, things eventually came to an end for the band. Frustration seemed to be the main reason, with real life getting in the way of being able to practice, tour and record as often as they'd like. The band had a need to explore different musical, personal, and professional avenues. And while he never left the scene and will always be a lifer, Cifre freely admits that right now, he doesn't really have the time or drive, to play anymore. But that doesn't mean that there won't be a reunion somewhere down the line. After all, the future is unwritten, and who knows what tomorrow may bring?

Before we parted company, I asked Luis if he had any favourite stories from the time he spent in the ranks of Her Only Presence, and whether he thought the scene was still a viable entity. He told me; "After I released the first demo, I remember I got some shows in Spain opening for Elephant Micah. When I got there, I was shocked to find that a musician that I really liked was kinda doing the tour manager job and helping us with everything on these dates. Her name is Ainara LeGardon, a great artist with a discography that's pure gold. That was the beginning of a long-lasting friendship. The funny thing is that I was asking her to sign her record for me during a show in Mallorca not very long ago. She's always been an influence on me and is such a great person and musician."

Luis continued, evoking the alternative scene he knew, "The scene will last forever as there will always be someone digging old records, or new

ones, who feels the need to explore the emotions those records create and pick up a guitar, or bass or learn to play the drums so they can play their guts out. That's what it is and always has been about."

Drifting With The Ice commented that; *"The timing of Her Only Presence's last album makes it tempting to label them an emo revival act, but Cifre's solo efforts predate the movement by a considerable margin, placing him in the company of other prescient acts like Up Up Down Down or Oh My God Elephant. The music itself also eschews the Kinsella influence usually seen in emo revival bands... Her Only Presence qualifies as a forward-thinking outlier."*

And **Ox Fanzine** added; *"If you count Mineral's 'End Serenading' among your favourites you will be more than happy with this Spanish combo. 'You're Never Back' is probably the fourth CD of the band, which has been active since 2005. It's great that something like this still exists, because this fragile emocore, well beyond tough guy clichés, is beautiful and I haven't heard the sound as harmonious as here with Her Only Presence for a long time."*

https://www.youtube.com/watch?v=3nsnSBqAX0Q

Hidden Cabins

Craig Cirinelli – Vocals and Hand Percussion
Brian Hofgesang - Guitars, Synths and Backing Vocals
Jason DelGuidice - Bass
Rich Perry - Drums

Hidden Cabins started life as a two-piece indie-folk group that writes, plays and records melodic songs that are built around simple ideas and possess complex emotional flair. Claiming dual residence in New Jersey & North Carolina, Hidden Cabins earned their live bones on multiple road trips to England, Scotland, Spain and Canada. After releasing several singles and split records as a duo, Brian and Craig brought Rich and Jason on board to record 'The Hidden Cabins Band' mini-album in Autumn 2018 which was jointly released by Engineer Records and Pyrrhic Victory Recordings.

Northern New Jersey's Hidden Cabins formed as a collaborative idea after its core duo started trading home demos in the Winter of 2012. A few songs quickly turned into enough material to fill an entire set before their first rehearsal in January 2013. Hidden Cabins is the brainchild of vocalist

Craig Cirinelli, of Engineer recording artists Elemae, and guitarist Brian Hofgesang, but don't call them a folk act as they turn up the volume, add guts and grit, and bring a healthy dose of melody to their unique take on Americana.

Hidden Cabins recorded their first set of songs at Portrait Recording with John Ferrara in March 2013 and began stamping their name onto US stages near and far, visiting the UK to tour in September 2013, before heading to Canada a month later in support of their split CD release 'Landwater' with Edmonton duo Brother Octopus on Oak Apple Records.

After tracking two more songs at Nada Studios in New York State with John Naclerio (My Chemical Romance, Brand New, Senses Fail, Bayside, Joshua) they subsequently released a split ten-inch record entitled 'Weathered' with fellow NJ group Eyeswan that was released by Engineer Records (IGN211) and Koi Records on olive and grey marbled vinyl.

The next Summer Hidden Cabins hooked up with a promo team from Barcelona called Desert Pearl Union, enabling the band to tour both England and Spain on a jaunt that was co-sponsored by Big Cheese Magazine.

Heading back into the studio in the autumn of 2014, Hidden Cabins recorded a new single, and their first video, 'Suffer The Surge' that was released on a compilation from New Jersey's Combover Records and by the Spring of 2015 they were traveling down the East Coast of the USA with labelmates Sirens & Shelter, playing anywhere and everywhere between New Jersey and North Carolina.

At the end of 2015, two Hidden Cabins EPs arrived, the first of which was a flexi-disc 7-inch, 'We're Not Local', that was made up of two songs recorded at Casa De Ross in Milltown, NJ, and was released in October by Friends+Neighbors label, and then two months later, a split 10-inch, 'Boundaries' that paired them with fellow NJ songwriter Christina Alessi and appeared on Combover Records with two new songs by each artist. All four tracks were recorded at Nada Recording Studio over a weekend.

Hidden Cabins then embarked on another tour of the United Kingdom in the Spring of 2016, booked by Engineer Records, and on this trip they made it as far north as Scotland.

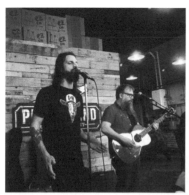
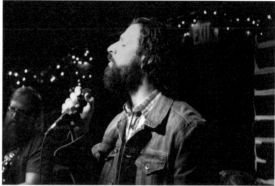

In 2017 the duo began playing as a four-piece when they added Jason DelGuidice on bass and Rich Perry on drums to their ranks. These gigs went so well that they decided to head back into Nada Studios to record 'The Hidden Cabins Band' mini-album (IGN248) that would be released in 2018 by Engineer Records in the UK and Pyrrhic Victory Recordings in the USA.

Hidden Cabins continues to connect to listeners, both live and on record, with their indomitable blue-collar spirit.

Makin Waves made 'The Hidden Cabins Band' EP their record of the week and **Big Takeover** reviewed the heartfelt release saying, *"Their buzzed-about vibrant and energetic gigs have now been captured on record, with their usual effects-laden, split-channel amp tones and resonant combination of rock, folk and Americana gaining a rhythmic backbone. This desire to get to the essence of their big live sound gives listeners a refreshing take on the outfit."*

http://hiddencabins.bandcamp.com

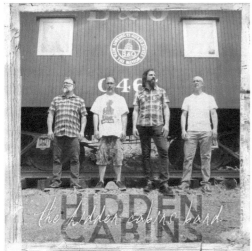

I Like Allie

Renato Treves: Vocals and Guitar
Giovanni Salvati: Drums
Francesco Lodola: Bass
Luca Della Foglia: Guitar and backing vocals

This innovative Milan based melodic indie-punk band have played shows all over Europe, including festivals such as Hamburg's Booze Cruise and Bergamo's Punk Rock Raduno, they even took a tour down the US East Coast to The Fest in Gainsville. The band's sound mixes melody with punk attitude. Some might say the outcome is emo, but with an original style derived from the band's varying musical tastes and the stories found in Renato's spontaneous and honest lyrics addressing issues such as peer pressure, social anxiety and learning to let go of useless negativity.

Renato started I Like Allie back in 2006 mainly because he had a bunch of songs that didn't quite fit with his high school punk band but also because he wanted to play music with his friend Michele Caiati. The project started as an acoustic duo. The first show they played was in September 2006 opening for folk punks Defiance, Ohio, just after they'd

released their 'Great Depression' record through No Idea Records. Little did they know that years later they'd play twice in Gainesville, Florida, the city at the heart of the No Idea Records scene. They released a bunch of songs through MySpace up to 2008 but with university and other commitments, things didn't last.

Between 2011 and 2013 Renato lived in New York and was lucky enough to witness the great resurgence in hardcore punk during those years with new bands such as The Menzingers and Joyce Manor really taking off. He started writing songs again and returned to Milan in September 2013, getting back in touch with an old friend and drummer, Gio Salvati. Their idea was to form the band again and try to record, but filling the line-up and sorting practices was proving tricky, so they stuck with an acoustic format for now.

On the day Italy were eliminated from the 2014 World Cup the No Reason Booking guys put them on a show opening for Garrett Klahn of Texas is The Reason, alongside local band Low Derive. At that show they met Fra of Teenage Gluesniffers who loved the songs and mentioned that if they needed a bass player he was available. For the time being the acoustic shows continued and between 2014 and 2016 I Like Allie opened for more great artists including Rocky Votolato, Rob Moir, PJ Bond, Divided Heaven and Joe Mcmahon from Smoke or Fire, with whom Renato ended up playing a short summer tour.

The project of becoming a full band marched on, with Sandro of Low Derive joining on lead guitar and the full band, with Fra on bass, playing their first gig, supporting Minnie's and Lantern, two important bands from the Italian alternative scene, a great way to rip the band-aid and start playing live and electric. Then they headed into the studio in January 2016 to record five tracks for their debut release, 'The Wounds You Leave'. With five tracks in the can they contacted Will Romeo, then the singer of Gameday Regulars (and now of Neckscars), who put them in touch with the US Paper+Plastick label, who initially agreed to release it digitally as part of their 'Sound of the Skull' series.

They played a release show with New York singer-songwriter Laura Stevenson, but Sandro left the band soon after and they needed to find a new guitar player again. Gio knew Luca from playing together in Sitting The Summer Out and brought him along to rehearsals, with it all coming

together just in time for them to support the legendary punk band Anti Flag at Magnolia, one of Milan's most important live venues.

This all helped them gain a full release with a one-sided vinyl 12" in November 2016, put out jointly by Paper+Plastick, alongside Italian labels, I Buy Records, Neat is Murder and Lonely Raven Records. There was also limited-edition cassette version released in the UK via Real Ghost Records. All of this they promoted with a Spring tour in 2017, hitting cities like Genova, Rome and Turin for the first time.

2017 also saw I Like Allie reach another big milestone: their first US tour. Thanks to contacts gained through Paper+Plastick they were invited to play The Fest in Gainesville and decided to book a tour that would take them from New York down the coast to Florida. Will and Justin from Neckscars helped them out with a backline and every single friend Renato had made living in the US helped them book shows down the East Coast. The first show was a busy night in Brooklyn, then a special gig in Baltimore, put on by Rachel of Feed The Scene at the legendary dive, The Side Bar, with Make War and Good Friend. This was followed by a sixteen-hour drive down to Tallahassee to play a Pre-Fest gig at the Wilbury. The tour finished The Fest in Gainesville, one of the best shows they've ever played.

When 2018 rolled around I Like Allie started working on their first full-length album. They had three new songs, 'Your Superpowers are Stupid', 'Charlie Brown Should Stop Believing' and 'Go Out There, Get Superpowers and Live Your Dreams', which they played live all the time. Luca was growing as a guitar player and Renato was channelling various life changes into his heartfelt lyrics. The next track they'd come up with would be 'Rare Instances of Independent Thinking'. That summer I Like Allie played Hamburg's Booze Cruise and then opened for Pkew Pkew Pkew in Milan, continually developing their full-on post rock bangers. Renato also played a couple of acoustic shows with Laura Stevenson, and the full band rocked the Solidarrock and Punk Rock Raduno Festivals.

The band spent the end of 2019 and the beginning of 2020 in and out of Mobsound Studios, recording with Alessandro Caneva, but before they could finish the new record, the world came to a standstill with the Covid-19 pandemic. This pushed everything back again, but did allow time for adding backing vocals by their friend Laura Stevenson. The tracks were sent off to Jeff Dean (of Noise by Numbers, the Bomb and

many more) to mix the songs, as he'd worked with Samiam and Braid. Jeff suggested they get Dan Coutant, the ex-singer and guitarist of Joshua and now owner of Sun Room Audio, to master the record. The overall result was beautiful and well-worth the wait. I Like Allie had an album at last and decided to call it 'Rare Instances of Independent Thinking' as that song tied the whole record together.

I asked Renato how they found the label partners for this important release, "We had a couple of Italian labels immediately interested in helping us out. No Reason Records and General Soreness. And Paper+Plastick were happy to help out again. These were all labels we had already good relationships with, but we still wanted to have another international label on board that would help us promote the album we so much believed in. After sending a bunch of emails to different labels we received a very sweet and thoughtful reply from David at Engineer Records. We were so much looking forward to his response as the label has a track record of amazing releases and had also worked well on releases for many friends of ours, particularly Low Standards, High Fives, for who they'd released several great records. David let us know that he loved the record and came back with specific comments and compliments to certain aspects in the songs that we were very flattered were noticed. I immediately knew it would be a good fit. All the labels really helped us out in promoting the record, but it was pretty amazing how helpful, insightful and responsive Engineer were in the whole process. We are all pretty old school and would have never made a video if it wasn't for David pushing us to do so. And we would have been completely lost in the digital aspect of the release too if it wasn't for Engineer being super on top of things. They really made us feel at home and part of a great community."

The roll out of the record went like a dream, with the first single, 'Rare Instances of Independent Thinking' launching at the end of July, supported by a video that gained over 34,000 views on YouTube. The album came out in October, and was followed by two more singles, 'A Reaction Paper on Salt' and 'Your Superpowers Are Stupid'. People listened and the album received many plays on all digital outlets as well as being playlisted on the Spotify Rock Italia playlist. 'Reaction Paper' was playlisted on the Spotify New Punk Tracks and 'Your Superpowers Are Stupid' was added to the Apple Music Negative Space playlist. Finally, on release day, 'The Chaser' was added to the Rock Italia playlist.

265

The love for the record was confirmed when the first pressing, on beautiful marbled white vinyl LP, almost sold out at the release show, and then did at gigs over the following weeks. This led to the second and main pressing, featuring a beautifully coloured cover with the goldfish art on it by Emanuela Luzzi.

The band headed back to the US after being invited to play the classic Orlando pre-fest, Foreign Dissent, while the rest of the dates were booked in the months leading up to the Fest. These second tour shows went even better than the first tour and were well attended.

Renato told me, "A set that stuck out and that will remain in my heart was one we played at the Stamp Bar in Vero Beach. We were playing miles away from home with our pals Menagramo, with whom we grew up. The tiny venue was packed and the crowd was dancing and having fun. At the end of our set this kid came up to me and said that he would have really loved to hear 'Charlie Brown Should Stop Believing' and explained to me how much he loved that song, quoting the lyrics and explaining to me that 'the summer is like friends letting you down' was the essence of Vero Beach. I was speechless and sad that we didn't play that song so offered to play it outside on an acoustic guitar."

Renato also mentioned their show at Nobby's in St Augustine, the day after the Vero Beach gig. "Nobby's is a classic dive bar that's been around for years and always has its door open for DIY shows. Charlie usually books them, and that night Charlie played an absolutely mind-blowing set as his alter ego, Canadian Lunch Money. Lots of short songs with funny twists and we were floored. The best local act so far. Or so we thought. After our set there was another local band to go on, called Half My Home. They had been kind enough to lend us all of their gear. Their singer, Steve, was working the door that night, but his voice was amazing. Their songs reminded me of Front Bottoms or Modern Baseball, but more brutal. Needless to say, we listened to their music in our van for the rest of the tour."

He added that after the show they pulled over as the car windscreen had fogged up, almost immediately, like a bad penny, a goddamn cop appeared. "The half Mexican in me kicked in because I am crazy scared of cops and have been all my life. Add to that the disgraceful events that had recently occurred in the US and everyone in the car was nervous. Fortunately, I'd had my last beer abut four hours ago, so my mind was clean as a whistle and I threw the classic, 'I'm the designated driver' line

at him. But that wasn't enough for the pig of course, and he made me get out the car and explain my Italian driver's license. After walking him through it, he still wasn't satisfied and revealed that he smelled drugs and alcohol in the car - a cop with superpowers - and asked if I would consent to take a test to see if I was ok to drive. I agree, even though I was scared that I might not pass the test. Keep in mind at this point there was a second cop now pointing a light in my face, and a third one standing in the dark with his hand on his gun. I took the stupid test and had to follow a red line, with my legs close together, but without losing my balance. I passed, so the three cops let me go back to the car with my band mates."

Since then, guitarist Luca has left the band to focus on his own musical project, and his replacement Fabio, left after a while for another band too. In 2023 I Like Allie got lucky again, finding another super talented musician, Gabriele Turcinovich. A kid from Pavia who'd bummed a ride to one of the Laura Stevenson shows and become a close friend. It turns out he can play too. They still need to figure out what the next steps for I Like Allie will be, and I'm curious to see what these latest changes will bring in terms of arrangements for their new songs. But I know that if they continue it will be because of their genuine enjoyment of it all.

Renato told me in earnest, "It's only worth it if it's fun, and there's no time to waste. The DIY punk world where we come from is a small, almost invisible area of the music scene, but it's kept alive by love and passion."

Lara Roberts, writing for **Colin's Punk Rock World**, described the album as, *"An honest exploration of anxiety, depression, peer pressure, and ultimately trying to let negativity go. 'Opening Number' quietly eases the album open, layering vocals with a slight crescendo, while bleeding nicely into 'Your Superpowers Are Stupid'. This is a pop-punk infused treat, with more defined guitars and faster drums, and a hint of them pushing through the "standard" pop-punk sound. Loss and regret are covered in the short song 'How Weak I Can Be', a sweet little love letter of a tune with lyrics that are easy to relate to. The album sways back and forth between classic melodic pop-punk and incorporating new ideas into the mix, calling on the different musical styles and tastes of each band member. Laura Stevenson lends her vocals at the end of the album, adding a light, ghostly backdrop to Renato's lead. There is a gentle vulnerability in Renato's voice that lends itself very well to that early emo sound, and it really does feel like they've taken on a lot of influence from 90s melodic emo bands, and looked to merge it with their own."*

Matteo Paganelli of **PunkADeka** reviewed 'Rare Instances of Independent Thinking' on its release, saying, *"The emo / punk quartet from Milan comes out with an intense and engaging album, with great production and excellent songwriting. Starting with the intro, 'Opening Number', which acts as a manifesto and forerunner to what you'll be listening to, and ends with the title track, a classic piece with emo sounds."*

And Michael Simeon of **Salad Days Magazine** volunteered, *"If I were to compare the first full length of I Like Allie to anything, my first thoughts go to one of those time capsules that Americans bury after filling them with personal items of the moment, with the purpose of having them unearthed fifty years later. The time capsule of I Like Allie was buried shortly after the transition to the new millennium, when the fear of the millennium bug ended, on mp3.com you found demos of the groups that would then explode, when Kung Fu Records was desperately looking for new bands. The Ataris and Vagrant Records were at the top of their releases. Definitely nostalgic moods and feels for a period that will never return, or at least not with that innocence. And I'm not saying that I Like Allie are a derivative group, on the contrary, it was only to give a minimum of coordinates to those who approach the group for the first time. A highly recommended record if you are nostalgic for the years described, but also because we must consider ourselves lucky that we did not have to wait fifty years to unearth this time capsule."*

https://linktr.ee/ilikealliehc

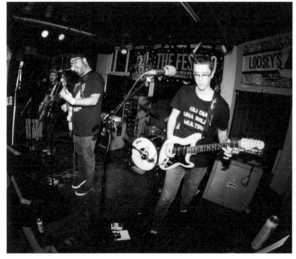

Joshua

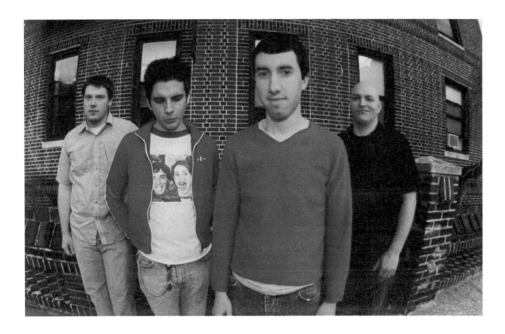

Dan Coutant: Vocals and Guitar
Keith Bogart: Guitar
Sean Hansen: Bass
Shane Chikeles: Drums

Joshua are legendary in emo circles and it's not hard to see why. There are definite nods towards bands like Burning Airlines, Jimmy Eat World and The Get Up Kids, yet they maintain their own identity, doing things their own unique way.

The prototype line-up for Joshua originally formed back in 1994, in Newburgh, New York, when two friends, guitarist Jayson Strickland and bassist Dan Coutant were playing in a half-serious hardcore band called Shunt (with drummer Jay Hall and singer Sean Mesler) but decided to try a more unconventional approach to song-writing and arranging. Over post-practice jams their ideas evolved into a new band, inspired by the emotional intensity of Live (the band), and the pop sensibilities of Weezer, who were two of the bigger bands of the time. Jay was specifically responsible for adding a jazz element on guitar, which would eventually work its way into the bands playing and writing. They placed

an ad in the local newspaper which attracted the attention of a local drummer Chris Cotter. The three of them made up the first incarnation of Joshua, with Strickland on guitar, Cotter on drums and Coutant handling bass and vocals.

Keith Bogart was a guitar player from a local hardcore band called Lost In The System, and a close friend of Chris. He'd attended the early Joshua gigs and become friends with Dan and Jay. When Strickland decided to relocate to Texas in late 1994, Keith joined the band as bassist and Dan moved over to guitar. This restructuring of the line-up coincided with the band's discovery and deep dive into post hardcore and early emo bands. Pivotal records like 'Get Your Goat' by Shudder To Think, 'Grippe' by Jawbox, 'Repeater' by Fugazi, and 'Killed For Less' by Sensefield, along with releases by New York City post hardcore heavyweights Shift and Quicksand, all found their way into the early song-writing DNA of Joshua. As they cultivated their sound, Joshua wrote and recorded their first demo, 'Today We Flew Our Balloons'. This demo attracted the attention of a new local record label, Immigrant Sun, who helped Joshua take the next step in their journey.

Immigrant Sun Records was an independent hardcore record label based in up-state New York and founded early in 1996 by Pat Knight and Sean Mallinson. One of their first releases would be Joshua's self-titled six-track debut EP. The CD came out in suitably emo packaging, brown kraft paperboard with black and white print, and a flyer stuffed inside for their other releases at the time, by Sarin, Hourglass and Morning Again. The CD did well in their local scene, and I asked Dan what that was like; "We had an amazing local scene and community of bands in our area. We played regularly with Lounge, Cooter (who became Autopilot Off), Drowning Room, Clean, Fairchild, and Skiltrip, and were well received in the early days, when the band was a bit heavier musically. That support waned a little when we started writing slower and mellower songs. Heavy and aggressive music was much more coveted where we came from."

The band were on a roll now, next releasing the 'Big Drop' 7" on Struggle Records and then finding their way onto Doghouse Records for their 'Your World Is Over' EP. Dirk Hemsath's Doghouse label was still based in Toledo, Ohio at this time, before they really blew up and moved to New York. They stuck with Joshua to release their first full-length, 'A Whole New Theory' in 1999. The record did well, and the band kept mellowing, adding keyboards for their 'Teardrop Trio' EP release in 2001, then

heading back to Immigrant Sun Records for their second full-length album, 'Singing To Your Subconscious' in 2002. This ten-track album would also come out on CD and LP under license in Germany to Defiance Records, and on CD in Japan through Howling Bull / One Way Recordings too. By late 2003 they'd found their way to Engineer Records through a conversation Dan had with Craig Cirinelli, the vocalist of New Jersey band Elemae who were on the label. So early in 2004 their seven-track Baggage EP (IGN034) came out on blue vinyl 10" and CD through Engineer Records and also Trece Grabaciones in Spain and Discoloration / One Way Recordings in Japan.

The band were lucky and prolific with releases, so I asked Dan if they had a favourite. "For the band, I think 'Singing To Your Subconscious' was our favourite record. It didn't get the same level of attention and acceptance as 'A Whole New Theory', but it's the record where the band ultimately found its sound, and we're still really proud of those songs."

With labels like that behind you, and being based in New York, I imagined gigs must have come pretty easily too, so I asked about that next, "One show that comes to mind is a festival we played in Germany during our European tour in the summer of 2002. Some of the other bands that played that day were The Stereo, Less Than Jake, Solea, and Rival Schools. It was one of the biggest shows we ever played in our career, and we were the first band on stage that day. I just remember it was in an empty airplane hangar, and there were a thousand or so kids outside the building waiting for the gig to start. We took the stage and then the security opened the doors just as we were counting in our first song, and there was this rush of people sprinting towards us. It was a thrilling moment and an exhilarating experience. We had the opportunity to meet some of our heroes that day and it was a true milestone for the band."

Dan went on, "But one of our worst shows happened about year before that in California on a national tour. The first leg of the tour was in Canada, which was the first time the band had played there. Right before we left, our drummer, Shane, decided to leave the band abruptly. It was right after we had finished tracking our second album, 'Singing To Your Subconscious', which was a chaotic and difficult experience. We had to hire a drummer from Canada to fill in, and he was planning to stay on with us through all the dates in the U.S. Aside from some van trouble, which made us miss a handful of shows during the first two weeks of the tour, we also encountered problems at the U.S. Canadian border with an

agent who wouldn't let the drummer into the country because he didn't have a work visa. We coached him beforehand to make sure he didn't mention, under any circumstances, that he was being paid for anything he was doing and was strictly on the tour as a friend and a sightseer. I think he mentioned to the border agent that occasionally he would carry merchandise from the van into the venues and may have mentioned looking after our merch table during the set. That was enough for the border agent to deny his entry into the states. He was sent back to Toronto, where he was from, and we gave him all the money we had earned up to that point on the tour for airfare. It was a total disaster."

"Because we had just lost our drummer and still had four weeks of tour dates in front of us, we asked the drummer of Big Collapse, the band we were on tour with, if he'd fill in for us. His name is Joe Gorelick, (he also played in Bluetip and Garden Variety). The only recording we had with us was a CD of rough mixes of our newly recorded, yet to be released album, which we gave to Joe to learn. In just a few days of listening on a discman in the van, he was ready to give it a go. We got through the first couple of shows OK, and Joe did an amazing job. However, we realised that the kids that were showing up to see us were disappointed that we were only playing new material that they'd never heard. So, we decided to try and learn the band's most notable older song, called 'Your World Is Over'. We were playing in San Jose, California, when we first attempted to play it live. It was one of those shows where Murphy's Law (not the band) was in full effect, and everything was going wrong. Broken strings, problems left and right, you name it. We should have taken a hint from the cosmos not to attempt to try a song we had never played before as a band, but we figured it couldn't get much worse. Ha. I don't even think we made it to the first vocals in the song before it completely fell apart and we just stopped playing. It was humiliating, but luckily the crowd was cool. They applauded and shouted encouragement, which really helped ease a horrible experience."

I love chatting and sharing gig stories with band members, so I asked Dan if he could recall any other incidents on tour. He told me about one that happened in an alleyway in Japan and could well have been the beginning of the end for the band. "This was back on Joshua's first major tour, in 1999, which began with dates on the U.S. west coast opening for The Get Up Kids and At The Drive In. Our debut album for Doghouse Records, 'A Whole New Theory', had just been released, and we were on a positive trajectory. Doghouse records had booked us about eight weeks

of tour dates that included the shows on the West Coast, a week of dates in Japan, followed by six weeks across Europe. Some of us were a bit worried about out on the road for that long. There were financial concerns like rent, leaving our jobs behind, as well as personal concerns. I was in a new relationship back home and felt uneasy about leaving that behind for two straight months. I expressed these concerns to Dirk Hemsath, who owned and operated Doghouse Records, and was accompanying us on the Japan dates. Dirk asked me to meet him outside the hotel where we were all staying and proceeded to walk me into an alleyway where we would have a difficult conversation. Basically, he gave me an ultimatum, which was do the European tour, or we would be dropped from Doghouse. It was an uneasy moment, and I felt a little intimidated, but in retrospect, I can understand his position. He had made an investment in the band, both financially and in time, and he believed in our potential. Ultimately, he had good intentions."

Dan continued the story, "I really didn't appreciate the ultimatum at all, so offered to do three weeks of the European dates as a compromise, which he refused to accept. The rest of the tour became awkward and tense, which sucked. And we didn't know if we would ever make it back over there again. Fortunately, three years later, we did. But this incident really soured our relationship with Doghouse, and that eventually eliminated our entire gig booking infrastructure. We didn't have a booking agent, or a manager, so it was essentially like starting from scratch. If I could go back now, I would have sucked it up and played the dates, just to keep things on an even keel. We ended up doing three weeks of shows, thanks to Burkhard Jünger, who was the promoter of the tour and overrode Dirk. Down the line we repaired our relationship with Doghouse, and almost released our second album with them in 2002."

Another funny story, from the Joshua and Big Collapse tour in the summer of 2001, which we'd dubbed 'The Hell Tour', happened while we were all staying at a motel somewhere in California. A couple of the guys from Big Collapse had gone up to the room ahead of everyone else, while the rest of us gathered up our equipment from the van. Upon entering the motel room, we noticed that the lights were turned off, and the guys were lying on the floor, urging us to be quiet and stay low. We were like WTF? They explained that there was a commotion in the room next door, and somebody in there had a gun. I don't know how they knew, but it freaked us out. We didn't fancy being shot and killed in some random motel room somewhere in California. Somebody in our group got on the

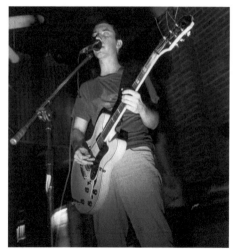

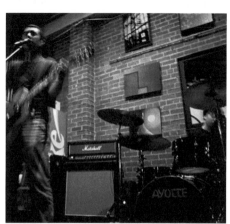

Underground Sounds and the El-N-Gee Present

🐕Doghouse 🐕Doghouse

JOSHUA

🐕Doghouse 🐕Doghouse

Fresh off their U.S. tour with the Get Up Kids! From Kansas City!

Ultimate Fakebook

From Long Island

The Stryder

And

The Weigh Down

(Ex-Thinner, In Vain)

Friday March 31

at the El-N-Gee Club New London, Ct.

Always All Ages! Doors 8pm $7

For info call (860)437-3800 or email drumjsn@aol.com

SCHLACHTHOF FESTIVAL 2002
FINDET DRINNEN STATT

21. JUNI

LESS THAN JAKE
RIVAL SCHOOLS
MUFF POTTER

TURBO ACS PETER PAN SPEEDROCK
SOLEA THE STEREO JOSHUA

SAMHAM & TEXAS is THE REASON LEUTE

DANACH BEATBOX AKA 60IES/BEAT/GARAGE PARTY

22. JUNI

DIE STERNE
ESKOBAR FAVEZ
SENSEFIELD COSMIC CASINO UNWRITTEN LAW

DANACH ALLROUNDER AKA 80IES PARTY

EINLASS JE 18.00UHR - BEGINN PÜNKTLICH UM 18.30UHR
EIN TAG 15€ VVK PLUS GEBÜHREN & 18€ AK / BEIDE 25€ VVK PLUS GEBÜHREN

WWW. TICKETS AN ALLEN VVK STELLEN UND BEI WWW.TICKETONLINE.DE

SCHLACHTHOF-WIESBADEN.DE

phone with the front desk of the motel, whispering a plea to them to call the cops or do something. Some of the guys were seriously worried, others were laughing about it. We were all a bit fried and frazzled from that tour."

Knowing full well that Dan loved and lived for his music, I asked a more positive question about the hardcore / post-punk scene as a while and how he sees it now. "The first thing that comes to mind when I think about underground music is community. This music is more than just something to listen to, it gives people an identity, and something to be inspired by. Looking back, in the late 90s and early 2000s, post-punk and hardcore shows were everything to us. They were the events that defined our lives. It's where we met our friends, our girlfriends, our boyfriends, our heroes, and literally found the soundtracks to our lives. It's where we learned about fashion, language, tolerance, and inclusion, and where we found acceptance. It was our home. It was for everyone, but it ultimately belonged to us. That's what this music means to the people who invest themselves in it, and that's no small thing. It can never be relinquished."

Joshua never officially called it quits, but just sort of faded away. I guess it just seemed that things weren't going to get any better for the band. They had a difficult time keeping a stable line-up together and their creativity started to dry up. As well as falling out of favour with Doghouse there were a few more unfortunate decisions and missed opportunities, like turning down Deep Elm to be part of the first instalment of The Emo Diaries in the late 90s and saying no to being on a split release with Saves The Day in their early days as a band. To an onlooker now it seems like they did everything they possibly could to shoot themselves in the foot.

Sometime in 2003 Dan committed to a new project called Fireworks Go Up and the rest of the band went on to become Park Ranger. Joshua would reform in 2010 to make a third album, entitled 'Choices' for Arctic Rodeo Recordings in Germany. It was primarily an exercise to experience playing music together again and for posterity, but the project was a success and led to some more great shows and a clear vinyl 7" split release with Nightmares For a Week on Arctic Rodeo and Limited Fanfare Records in 2011.

Dan continues his musical life, initially working as a recording engineer at West West Side Music with Alan Douches for a while, before starting

his own Sun Room Audio mastering studios in the Hudson Valley of New York State, where he still strums the strings and twiddles the knobs. He also has a new band called Spoils System. Although, now in the Spring of 2024 as I write this, there's talk of a new collection of re-mixed Joshua songs to be entitled 'Nascent' coming out on their original label, Immigrant Sun. Joshua may just have gone full circle.

Paul from **Punktastic** reviewed the Baggage EP, saying *"Joshua are legendary in emo circles and it's not hard to see why. There are definite nods towards Burning Airlines and early Get Up Kids, yet they definitely maintain their own identity. Complete with driving guitars and very memorable singalong choruses."*

In their review, **Allschools** in Germany commented that, *"Joshua know exactly where to hit. Namely, into the hearts of those in love and those who simply like soft, yet sophisticated music. These songs are hard to beat in terms of harmony and charisma. Influences from well-known bands such as Jawbox, Burning Airlines, Texas Is The Reason or Big Star can be found."*

Rich at **Alt UK** speculated that, *"The band really do have some unique qualities. I don't know how long they've been together, but it sounds like they have some serious experience behind them."*

And Scott Heisel of **Punknews.org** said, *"Every once in a while a true gem falls into my worn, calloused hands and it gives me the high I need to keep up my enthusiasm. The new Joshua record is that shot in the arm that I so desperately needed. Clever lyrics combined with catchy music - it makes you feel like music is alive and well all over again. If you like Jimmy Eat World, No Knife, and bands of that ilk, don't pass up on this."*

https://joshuatheband.bandcamp.com

The Jukebox Romantics

Mike Terry : Vocals and Guitar
Mike Normann : Drums and Vocals
AJ Chiarella : Guitar and Vocals
James Macdonald : Bass and Vocals

Forever JBR Members:
Bobby Edge : Bass and Vocals, 2014-2020
Mike "Bread" Stratton : Bass, 2008-2014
Seth Dellon : Guitar, 2008-2014
Joe Jacobs : Drums, 2008-2012
Chris Schultz : Vocals, 2008-2011

More than fifteen years into the game, The Jukebox Romantics are still the same fun-loving, in your face punk rockers that they have always been. Taking the best elements from bands such as Alkaline Trio, Samiam and The Bouncing Souls, the band excels at writing the kind of songs that are as big on melody as they are on energy. And following a global pandemic, they are even more fired up than they've ever been.

Sometimes bands make it easy, and I soon realised while talking to JBR (that's Mike's shorthand for The Jukebox Romantics) main man Mike

Terry, that this was going to be one of those occasions. I mean, who can tell the band's story better than someone who was there from the very beginning? And as Mike was, and is a natural born storyteller, I thought who better to tell the band's tale than him. So this is The Jukebox Romantics story as told by Mike Terry...

"What is a scene? In the punk world, I feel like it is the punk rock/DIY word for community, and in 2008, the Westchester County, NY alternative/punk/whatever you want to call it scene was more or less dead, and The Jukebox Romantics formed out of the ashes of that once thriving downstate scene.

Of the list of necessary items for a thriving local music scene, I think it's important to have a central hub of 1-3 "venues" where people of all ages, and backgrounds, with similar and different interests alike, can come together to create something, be it music, art or whatever.

From the 90s through to the mid-2000s, our area, which is just above the Bronx and right outside the mecca of New York City, had multiple scenes and multiple places to play for bands from just about every genre and subgenre that you can think of and imagine. Where we lived there was the Scarsdale Teen Centre as a main hub, and then a rotation of church basements, firehouses, and VFW halls, but in or around 2005, many of the area's bands broke up, fizzled out, moved to the city or went to college.

Around the same time, all the venues seemed to either shut down, were repurposed by their owners, or ceased to exist altogether. I also think that it's worth mentioning that this wasn't something that unique to our scene, and in the 914 area code, punks played with metal bands, hip hop, indie, ska, and more outfits and most shows were mixed genres. Our scene was dead, there were no local or new bands forming and no one was taking the lead and building it back up. So, we left too.

That was the beginning before the beginning of JBR. In 2008, I was entering my third year of college on Long Island and was messing around in an indie pop band whilst also working with Chris Schultz (The Vagabonds/Sketchy and future original lead singer of JBR) and a couple of other folks trying to form a band.

My former band, Future Society, was a casualty of the above-mentioned

mid-2000s scene death, along with probably the best local band of my youth, Johnny Giovanni & The Zombie Pit Crew. These guys had swagger, the look, stage names, a charismatic frontman, ability, energy, and most importantly of all, they wrote great songs. They were the band Future Society always wanted to play with and were the measuring stick I used to judge everything band-related against. I wanted to be in that band. But who needed or wanted a third guitarist? The ZPC was always the band voted most likely to make it out of our small scene and go to much bigger and better things.

21st May 2008, 5:41 PM

"Yo, Me Mike, and Joe are starting a new band. Interested in playing guitar and/or singing? Let me know. We're trying some singers out on 7th June, in either Croton or Elmsford. I want you in. Be There!!!" – Seth Dellon

22nd May 2008, 8:33 AM

"I'm down for playing guitar. I'll sing with you guys. I don't know about leads but I'm down. The band I'm doing out here is stagnating and an indie-pop nightmare. I was trying something new, but my heart is in punk. I'm down for some rhythm guitar. Wow, call me man. Stoked" - Me

That Facebook message from Seth Dellon was the beginning of JBR and the Mike and Joe mentioned in the initial message were Mike Stratton & Joe Jacobs of the Zombie Pit Crew. It was basically an invitation to join my favourite local band without their singer in the guise of a new thing. Johnny Giovanni, of the ZPC was the frontman of the band, and Joe's (drummers) younger brother and he'd decided to pursue his acting career while the rest of their old band wanted to start something new.

For the next couple of months, we had a bunch of practices in an old barn that had been converted into a music studio in Croton NY. We were just covering songs from the bands we loved growing up like The Bouncing Souls, Rancid, The Ramones, Against Me!. We were all in our early twenties and were still kids.

Roll On August 2008

We needed a singer. We tried out Seth's friend Matt, who had great energy, but not much of a voice, and he'd eventually end up touring with

us selling merch at our shows. We all wanted this band to be good, and that's when I mentioned Chris, who tried out soon after and by the end of that summer we had a solid line-up, and more importantly, all shared the same goals, which were, in no particular order, write good music, tour a shit ton, get on Warped Tour, tour Europe and make friends and a buttload of memories along the way.

We needed a name, and the truth is no matter what most bands tell you, the name they end up with is the one they all hated the least. That's how we landed with The Jukebox Romantics. At one point I was pushing for the name The Disaster March (after the Lawrence Arms song) but it was taken, and "We are the last, of the jukebox Romeos" is a Gaslight Anthem lyric from their 2007 debut album '*Sink or Swim*'. Before the band blew up a year later with The 59' Sound, they were another little engine that could band like us, and around the time of thinking of a band name I was listening to the song *We Came To Dance,* and hearing that line it clicked but in my mind "we change it to Romantics, like hopeless romantics from the Bouncing Souls." That was it. That was our name.

The next three years were spent crushing our initial goals and we toured a shit ton. You know that bit above about local scenes? The Long Island music scene was always strong where Chris was from, but where we lived between Yonkers and Peekskill, it was still pretty dead. So, we hit the road and lived by the credo that we have to play to people for them to hear us so let's go everywhere; Up and down the East Coast, out West, wherever we could play, we would play. We really didn't know anyone else doing it the way we were and figured we would stand out by using MRR's Book Your Own Fucking Life, websites, forums, fake scam agents, calling venues, and we learned a lot quickly. Some of what we learned was good and a lot of it was bad, but it was all an experience and taught us what to and what not to do.

In 2009 our work ethic got us noticed by Altercation Records. We were playing a show in Connecticut and the infamous Snapper Magee's (RIP) and it was a disaster. Our amps were blown, our guitars were broken but we stuck with it and by the end of the set, all that was left were drums and one amp. We all stood united on stage and turned this disaster into a huge sing-along party with the drunken raucous crowd.

"*Youse boys put on a show. For a minute it was a disaster, but you turned it into a positive.*" Travis Myers, one of the two owners of Altercation

Records said that to us after the show. He was an old-school New York City transplant and a wise guy-sounding owner of the club and we had no idea he owned a label at the time. We knew the bands he worked with and what he could do, and he picked up our first record, *Self-Titled*, and released it with his partner JT Habersaat who ran half the label as a transplant in, and now a native of, Austin, Texas.

Altercation Records taught us the importance of video content before YouTube really blew up and before we got jaded and lazy, we would document everything on Flip camera and if you Google it hard enough, you can find a video from 2011 where we even discover that an iPhone has a camera on it. Yup, I'm 37 right now, which officially makes me old. Altercation was always down for making music videos, just don't read the comments.

I remember one of the said comments on Punknews.org being "*These guys are pretty good. That guy looks like the fat Tim Armstrong.*" Yup, that was me in 2009. A fat Tim Armstrong. Fun times, huh...

That label, at the time we were on it, was what young bands dream about now, and did everything for us. Tour and festival booking, merch printing, manufacturing, promo, publicity, and to this day, Travis & JT do not get enough credit for all the shit they did for bands out of the love of punk rock. The Upstart Fest, BBQ parties with Fat Wreck Bands The Flatliners, Dead to Me, Banner Pilot, and a load more shit like that. It was where we needed to be at the time and they helped us achieve the childhood punk kids dream and by 2010, less than two years after we set the goal, we made it to the Warped Tour. Okay, so it was one week at the end of it, but it was The Warped Tour when that shit still mattered. And we got a song on the CD Compilation that the tour always put out. It was kind of wild.

'*Famous Last Line*' was our 'big' song in that era. We always played it, and it still gets a lot of love because of Warped Tour Nostalgia playlists on streaming platforms, and honestly, it's a good song. We were a party punk band with some politics, a touch of ska and a LOT of drinking songs, and the ever so self-important 'songs about being in a band', that really speaking, only other bands understand and probably enjoy unless they're incredibly well written.

All bands write them, probably because we want the world to really

understand why we do what we do as punk rock musicians, but they won't, and don't get it. They can't understand it. In my opinion at least. Even reading this and other entries in this book, all I can tell you is that it really is a fucked-up life choice, because at the end of the day, all that any of us are rock n roll dreamers.

We never play 'Famous Last Line' anymore. In 2018 we had a tenth anniversary show and played it live for the first, and probably last time since 2012, but it was the first song that caught our audience's imagination, so I don't want to run it down too much. Anyways, back to the Warped Tour, which in 2010, was miserable but awesome. It was gruelling, dirty, joyous, fun and even though we were beyond tired, it was also awesome to share a stage with Cobra Skulls, Flatliners, Menzingers, and other up-and-coming bands. They called it The Kevin Says Stage, and it was the stage that Warped founder, Kevin Lyman got to hand pick the bands he wanted for, regardless of the direction the rest of the festival was going, which became a more metalcore, crab core, something 'core' that we didn't fit in anymore when we returned in 2012. Maybe I'm wearing rose coloured glasses, but those summer tours with Warped were a lot of fun. We had a great bunch of friends with us on those tours and it was a blast. Until we got to...THE FEST.

The Fest

In 2010, we got to play THE FEST, in Gainesville, Florida for the first time and this is what we wanted Warped Tour to be. A utopia of punk rockers, filled with good vibes, and no US Army or Marine recruiter tents next to our booth and no merch cuts. The phrase touted by Warped Tour, 'No Room For Rockstars' was, and is, embodied by the yearly punk rock festival in Gainesville. Over the years we've played The Fest multiple times, first in 2010 and then we returned every year between 2017-2023.

The Fest captures the essence and energy of being at a sweaty basement punk show that's been turned up to 11. We are honoured to be asked to play it every year and another great set memory was playing on the floor of Fest Wrestling. The PA exploded and we had no vocals for most of our set, but the audience surrounded us on the floor, surrounded by a wrestling ring and everyone was screaming our words back to us. It's our home away from home, and if we get asked, we will go without hesitation. That's our motto.

Shows

In the fifteen years that we've been an active band, we've played a lot of shows, and at one point we were doing 100-150 a year for multiple years, and we've played in twenty-eight states and ten countries. We've played some great shows, we've played some good shows and we've played some bad shows. On one of our first tours, we broke down in Benson North Carolina, and were stuck in a motel for a week trying to figure out how to fix the transmission on our pre-owned and pre-loved first van. We problem-solved it, got home, and realised then that if we could get out of that pickle and still have fun, then maybe we really were destined to do this forever. It was a turning point that solidified the path that Seth, Mike, and I thought we were going to follow through life.

I've said it before, and I'll say it again BASEMENT SHOWS ARE THE BEST. The sights, sounds, vibe, and party atmosphere is magical. We've played some insane, insane, insane basement shows, and I remember one in Amherst Massachusetts where the crowd lifted me off the ground during our song rightly named *'THE BASEMENT SONG'*, and pressed me into the ceiling. I was squashed like Charlie Bucket and Grandpa Joe in *Willy Wonka and The Chocolate Factory* and even though I was sure I was dying; I'd never felt more alive. The song was written about the Warped Tour and the DIY scene, and we still play it all the time. In 1997 I saw a live video of Blink 182 playing and watching Tom DeLonge and Mark Hoppus run around on stage having the best time ever, that's all that I wanted to do. That's why I wanted to always be in a band. It looked fun.

Kids & Heroes

In 2012 I became the lead singer of the band, even though I always wanted to just play guitar but after kicking Chris out at the end of 2011 the four of us decided it was best to keep things the way they were and carry on. We wrote an EP called *'Hollywood is Dead'*, which is the record that another fan favourite song *'Bite The Neck'* can be found on. We had moved on from Altercation and self-released it along with Dead to False Hope Records out of Durham, North Carolina, and hosted it on the labels 'pay what you want' model. It was a cool way to do things and lots of amazing bands worked with them, which made me realise that it was going to be a chill way of doing things then in 2013 we recorded a full-length with *The* Pete of The Bouncing Souls.

Our current and long-time drummer Mike Normann was now behind kit as Joe moved to Miami for work, Norm joined in 2012 and has since become the backbone of JBR. He's the silent, angry, vegan, hardcore hockey dude in the band and he's also the silliest and has the biggest heart which he'll show you when he gets to know you. He also hits the drums like they did him wrong, and I'll be the first to admit that there is no Jukebox Romantics without Thomas Michael Normann.

Working with Pete was amazing. That's what I tell myself, and that's not just because they say, "Never meet your heroes." We just met him at a terrible time as Pete was going through a really bad breakup, and although he was mentally not with us for most of the recording, he was a professional and a gentleman, and he made a bunch of Souls fans feel so honoured and stoked to be in there with him bouncing ideas (no pun intended but now that it's there... Alright, you got me, it was intentional) around while got to hang around in Asbury for 2 weeks.

Our buddies in the Handme Downs, another workhorse touring band from Detroit, came down to record with us, as did our long-time merch person and tour driver, Patty Pants. 'Transmissions Down' is one of the most technical records that we've ever written, it was released via Jailhouse Records and was our first record that was available on vinyl. It's actually pretty rad, has lots of good songs and the production is alright on it. I'm always critical of my voice and playing on this album, as everyone was shining and growing as musicians, and I kind of feel like mine were pretty stagnant around that time

But Pete and Asbury natives and our buds Lost in Society sang backups on it and we cemented those fun memories on vinyl. Fourteen-year-old me would never have believed that The Pete would end up producing and engineering one of our records. It's wild, and I love that man and his band because, without The Bouncing Souls, there would be no JBR.

2014 - We Become A Three Piece. We Tour More. We Make New Goals. And We Crush Them.

For six years, Robert Edge III played bass and shared leads with me and to this day is one the most talented musicians I've ever played with and in the summer of 2014, Mike and Seth, played their final shows with JBR. The band they helped build and shape was evolving and their chapter in the JBR had come to an end.

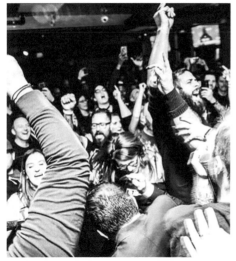

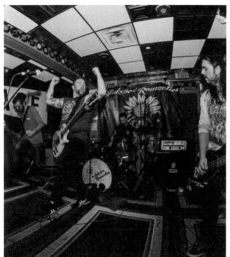
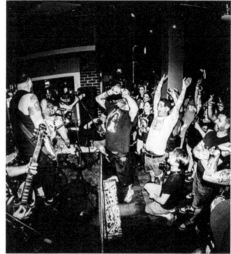

I cried my eyes out at their last show and even though we were still friends, it was just clear that we were sitting on the record we did with Pete was because Mike's job was limiting his availability to tour and promote a record, and Seth was about to become a dad. I got it. They got it. We knew it was right, but it didn't mean it didn't suck then and still sucks now. We're still friends, and we still play in a side band just for fun from time to time. The way we toured from 2008-2014, meant that I spent significantly more time with them or any member of JBR than I did, or had with any member of my family. The thing is, there's more to family than blood and DNA, and JBR is my family. I guess the bard was right when he said 'once a romantic, always a romantic'. Anyway, back to Bobby Edge....

2014-2020: Time To Fly

Bob was a maniac. He had just as much energy and fire as me and always wanted to be in a touring band and do what we did, he'd just never had the motivation because he'd never had the right people around him. Between 2014-2020 Bob, Norm, and I rekindled the JBR road dog touring schedule and did five weeks out, two weeks at home, and three weeks or writing music and rehearsing on repeat. We almost died in the van on numerous occasions during those six years, and the one time we became airborne in a cornfield in Ohio still haunts my dreams, as both the band and were literally flying. We were still one hundred percent DIY and were still gaining steam, and while we and doing this for love and not money, we were making enough to run the machine but personally, we were all broke.

In 2017 we finally crossed off the last original JBR goal, and toured Europe. We went overseas with our Boston buds OC45, who were another road dog band like us and were basically living on the road. Bands like them were popping up more and more and I felt like we were the first wave of bands doing this at the time in the American punk scene. On The Cinder, Voice of Addiction, Taillight Rebellion, OC45, Some Kind of Nightmare, El Escapado, Houston, and The Dirty Rats are just some of the fellow psychos we met along the way doing it the way we did it. Anyway, City Rat Records booked the tour, and it was everything that we had dreamed it would be and more. Our energy, when were sober, was unmatched and as a trio, we were tighter, faster, and way better on stage than when we were a five-piece.

Bob was funny as hell and our shows became a comedy hour with music

in-between and our banter and connection were electric. It was great for a bit until it became tired or too drunk and we rubbed each other the wrong way. I was too business, and Bob was too party, we were a super mullet of punk rock, and our egos, unprofessionalism, alcohol and too much time together ruined the magic we had.

During the beginning and the middle period of the three-piece struggle years, we recorded what I consider our best-sounding record that's home to our best songs, 'Sleepwalk Me Hom'e. It was recorded at Nada Studios by the all-round amazing human and producer, John Naclerio who has worked with everyone from My Chemical Romance to Polar Bear Club, Anthrax, and a list of every pop punk band you can think of. He helped us find our voices. I mean, like our actual voices behind the gravel. The record was picked up by Paper + Plastik Records, the label that's owned and run by Vinnie Fiorella, the founder and drummer of Less Than Jake. He loved the record, had great ideas for promoting it and massive plans for it and... Did nothing with it

SIDEBAR: Before I jump into the abridged and vastly shortened version of our wonderfully miserable experience with Paper + Plastik Records, I want to state that Vinnie is a super nice guy at least on the surface and isn't really malicious, he's just a horrible businessman. Okay back to this part of the story:

"Yes, I would like to send an edible arrangement to Wonderland Tattoo in Gainesville Florida. Please make the note read: Hey staff, please enjoy this lovely edible arrangement, Vinnie, give us a call"

In May 2017, we had just got off tour with Less Than Jake, Face to Face and Direct Hit. The shows were great and so were the bands, and even though some members of all three bands were friendlier than others, for the most part, a good time was had by all.

There was only one major problem: We were on tour with the owner of our label, Vinnie the drummer of the headlining band, and the band that had got us on the tour, It was five months after our album was supposed to be out and we had nothing to sell; no vinyl and no CDs. We ended up bootlegging our own for the tour and they were nicer than the ones P+P eventually made. People who pre-ordered and then ordered the record waited a year for them to finally arrive.

I mean, how are you going to put us on a tour that promotes us as

your new band that's supposed to have a new record out, but no one can actually buy the record because it hasn't actually been released and just kept feeding us one bullshit excuse after another? After the tour finished, Vinnie became a ghost and didn't return texts or calls. We tried everything, and yes, that did include sending a bouquet of shitty fruit to his place of business as a way to try and get his attention.

Let me also go on record, and say that we were warned, but thought it be different for us. And having been in that position, we warned those who signed after us, and while some listened, some didn't. Every year since 2018, we've gone to Gainesville on Tour or for Fest, and Vinnie answers saying he is going to meet me to give us more records because we are out of stock, and then he ghosts us. You'd think we'd have learned our lesson by now, but I guess hope springs eternal. Thanks, Dad.

In 2018, we celebrated ten years of JBR with a giant show in our hometown area, and like I mentioned in the beginning, we still didn't have much of a scene in Westchester County, but we rocked a great show with all of the current and former members of The Jukebox Romantics. It was a magical, sold-out show at Lucy's Garage in Pleasantville, NY, and unbeknownst to us at the time, there was a future member of JBR in the crowd that night. He was intent on returning the scene to its glory, but since we were always on the road and never in the area, at the time, we had no idea who he was or what he was doing.

2020-2022: Heavy Boi

The 2020 pandemic couldn't have come at a better time. We were really trying to make the band work with the three of us but our personal issues were not getting solved even with interventions. I think James Hetfield said, "*If your band isn't always on the verge or breaking up, you aren't trying hard enough.*" The pandemic caused us to separate further, fucked with us mentally, and basically killed the band and any momentum we had. I sold the van, figuring why do we need a van if we can't tour? The world was shut down and just before the global lockdowns were announced, we were flying out for tours or festivals and the Juicebox (our beloved second van, a Dodge Ram 2500) was a broken paperweight, but I still cried when it was towed away, the same way I had when I dropped the first van (the Bro-Haul) off to be crushed in 2011. But in band years, two vans in twelve of them is pretty good.

We were sitting on songs that we had started to write and record but couldn't get it together as a group. When the world started to open back up, Norm and I were trying to get back to work, but Bob wasn't ready. We understood, and we gave him the time we needed, and Norm and I carried on for a bit, just the two of us writing and waiting for Bob. When we finally got back together after months of trying to, we had a terrible writing session that ended in an explosive fight, which was only the second one we'd had in the history of the band, and both of them had been between Bob and M.

That was the second knockdown battle that we'd had, and it was very one-sided, and it was just me that he was exploded on. Either he had to go, or I was going to just end the band, as it just couldn't continue this way. So, by September 2020, Bob was no longer in the band and our friendship was ruined, and I'll freely admit that he's still the most talented person ever to be in this band. We managed to finish, and record the songs we had started working on with Bob and they became the *Fires Forming* EP.

Sell The Heart & Engineer Records

Norm and I went back into Nada studios with John Naclerio and pumped our broken hearts into those 5 songs. *'Hey Nora'* is the stand-out track, the 'single' but there is some magic on there.

This EP was picked up by Andy Pohl of Sell The Heart Records. Andy is a straight shooter. He's communicative, simple, kind, and open, and is the polar opposite of our last label. He was responsible for the bond with Engineer Records in the UK who would carry the *'Fires Forming'* 12-inch EP (IGN319) (Yes, we are psychos and yes, we made a 5-song LP) and adhere to the same DIY, punk ethos and ethics we do so it seemed like a no brainer to work with them on this release as well. After Paper + Plastik and the turmoil that followed Bob's exit, it was a nice place to be in, and the calm and clarity allowed us to breathe new life into the band's lungs and working with both Engineer & STH was wonderfully therapeutic.

At the same time all this was happening we had gained two new members and were a four-piece again. AJ Chiarella and James Macdonald joined JBR in late 2020/early 2021. This is the current line-up, and the band is energized and has a new lease of life. We're hungry and we're going to

eat whatever we can, whenever we can. AJ and James are born leaders, and more importantly, are naturally and incredibly talented. AJ was in the crowd at our 10-year show and has been carrying the torch that we thought burned out in our local scene back in the mid-2000s.

He was putting on shows, running DIY spaces, and rebuilding the scene we left behind when we started in 2008. James' positivity and energy fills every room and stage and there is a level of professionalism, respect, and friendship that feels amazing. We are united. We communicate. Communication is key to any relationship, and we have fun, and this is the happiest Norm has ever been in the band.

I carry the band's history, tours, shows, and music on my shoulders and let explode it out on stage every show. We are still the same band that started in 2008 in that barn and that feeling, that need to smash our goals, that's still us. The JBR spirit is still strong.

At the time of writing this, we've just released a split LP with new songs, (The 'Blood in the water' murky grey swirl vinyl 12" with two songs each by The Jukebox Romantics, American Thrills, Lost in Society and Night Surf released via Wiretap Records in the US, Thousand Island Records in Canada and Gunner Records in Europe) and are starting the process of writing our new full-length. For the first couple of years with the current line-up, we decided to just release single songs and skip the album stress cycle. We know who we are now as the four of us are a collective and always have been. I may be the constant member, but in the four eras of this band, it's always been a collaborative song writing process. AJ is about to start the build-out of a new local music venue within a brewery. The American brewery is currently the workaround to have all-ages shows, but don't tell anyone that I said that...

There's no end to this. See ya at the next show, festival, or better yet, see ya at the next DIY basement punk rock party.

And, in case you thought I'd forgotten...

The beautiful and blasting new 5-song EP from The Jukebox Romantics entitled *Fires Forming* features the tracks *Time to Fly*, *Hey Nora*, 'Dine Fleisch', *You Spin Me* (Right Said Fred) and *Castaway* and rocks in a very agreeable post-punk Deep Elm meets No Idea type of way.

The 12" vinyl comes in three gorgeous colours: Violet, Gold, and Transparent Blue. You can let us know which colour you'd prefer, or just order all three. We picked these colours to align with the beautiful artwork that Mikeala Jane Kennaway provided for us (thank you Mikeala!) Oh, and each variant is limited to 100 units each.

In the late summer of 2019, we returned to Nada Recording Studio in Montgomery, New York, to work once again with the amazing John Naclerio. John produced our 2018 record 'Sleepwalk Me Home', and no one has understood the sound and mood the band was trying to achieve more than John who has a way of smoothing out the rough edges and getting the best out of the musicians he works with

So, we went into the studio in August 2019 with the idea of starting to record a full length. We got all the music done on five songs but with a busy touring schedule, we left the studio with a plan to return in early 2020 to record more music for the release. We wanted to record about 15 songs and pick the best 10-12, but got held up in the writing process as we were looking to really push ourselves, and then boom, pandemic.

With the pandemic and the three of us not living near each other and taking the virus very seriously, we put the recording on hold until it was safe to return. Time passed and it was finally safe to return to the studio in Fall 2020 but we were changed people. As it did with a lot of people, the pandemic made us introspective and changed our priorities, which led to Bobby leaving the band before we went back into the studio. But we had business to attend to and we all wanted to finish what we started together cause these songs fucking rule and we love and respect each other.

So, we got back into Nada and brought the lyrics we had been writing for these songs over the quarantine into the vocal booth and sang our hearts out. Songs about protest, escapism, social change, personal change, and loneliness. For a band that prides itself on writing fun catchy tunes, we feel like we wrote some fun catchy ass tunes that have a ton of depth and meaning behind them. As well as a few drinking songs about punk rock pirate adventuring."

"Insanely catchy and bouncing pop-punk from this trio of New Yorkers" - **Vinnie Fiorello (Less Than Jake/ P+P)**

"...followed by New York City's Jukebox Romantics who always put out a killer performance and this day was no different than the last few times I have seen them, super high energy take no prisoner punk rock." – **Dying Scene (Joe Grimm)**

"One of the most energetic and hard-working new bands on the east coast punk scene...The Jukebox Romantics have quickly gained a rising following of die-hard fans." – **AMP Magazine (Philip Hicks)**

"(The Jukebox Romantics are) on the verge of something big...Creative songwriting, talented performers and lively stage presence." – **Listening Room Blog (jfitzgibbon)**

"Their guitars reverberated in the bar and kids migrated to the front of the stage. Their songs were a pop punk that seems to be slowly disappearing, heavy on the punk not the pop...Their performance was tight, energetic, and full of heart." – **My Crazy Music Blog (Andrea Janov)**

https://www.jukeboxromantics.com

Junior Achiever

Gene Champagne : Guitar and Vocals
Dave Fritz : Guitar and Vocals
Steve Scott : Bass and Vocals
Jeremy Knowles : Drums

Junior Achiever's songs are diverse, but with a unifying sound; poppy, edgy, sunny but not sappy; its summer music that reflects the sparkle of the grass and the warmth of the sun, but with a wry sense of humour and an honest longing for something more. Call it pop-punk if you will, but it sounds more like 'After-School-Special-Core', rock and roll for kids on sugar and too much TV. A scuffle breaking out in the parking lot between The Doughboys, Ramones, All-American Rejects and Fall Out Boy.

Fate can be a fickle mistress, and even though she usually has all manner of curses and threats hurled her way when things don't work out the way that we all hope they will, sometimes she gets it right. When Dave Fritz met Gene Champagne at a Killjoy's show (the latter's band at the time) at a show in Hamilton, Ontario in 1993, he instantly became a fan of the band, who he describes as sounding like "an angsty Teenage Fanclub".

Dave started riding in the bands van to shows and acting as a defacto, unpaid roadie for the band whenever they hit the road and played out of town, and as the Toronto scene was thriving at the time, he found himself at a lot of Killjoys shows. But by the time they hit the 'big time' in their home country, Dave had moved to England and founded the great pop-punk band Wact, so he missed their wild ride on Warner Brothers Records.

A decade later, Dave was back in Toronto, and had stayed in touch with Gene, who used to call him and ask for his opinion on, and about, the songs he was writing. Gene figured that he could trust Dave to tell him the truth, and Dave has always regarded Gene as being an incredible musician and writer, and eventually Dave started making the trek to Gene's house as he knew the songs had to be heard and wanted to work on them with him to make sure that they were. They both still refer to this gestational period, as their "porch days", as they'd spend the time that they weren't jamming, sitting on Gene's porch, watching his neighbours do what people do in suburbia. That is, mow their lawns and wash their cars.

After a year or so of vicariously submerging themselves in the utopia of suburbia, Gene somehow stumbled across a drummer called Jeremy Knowles who was more than a little starstruck about playing with the porch days duo, as he'd been a Killjoys fan when he was younger, Jeremy dragged his friend, and bass player, Steve Scott to Gene's, and the formative version of Junior Achiever started rehearsing in the basement of the man who had, via his old band, brought them all together.

Inspired by a diverse collection of rock and roll underdogs and overachievers, namely The Beatles, The Kinks, ALL, The Jam, Small Faces, Doughboys, The Buzzcocks, and of course, the Killjoys, the band only recorded one album, 'All The Little Letdowns', which was released on CD (IGN115) by Engineer Records in the UK/US and Trust Records in Japan in 2005.

However, they did appear on the soundtrack for the Canadian television series 'Degrassi: The Next Generation', and thanks to one of their songs, 'Suburbs', being used in a less than minute-long montage featuring an, at the time, young actor called Aubrey Graham, their Myspace inbox was flooded with messages from a myriad of besotted American tweens, which was a testament to the power and popularity of Degrassi: The Next

Generation. Oh, and Aubrey? He went on to have a modicum of musical fame after adopting a new identity and performing and recording as Drake.

The 2000s were a strange time for Canadian music. In the wake of the internet was beginning to flex its musical muscle, album sales were down, Napster had cast the first digital stone, iTunes was lurking in the background and getting ready to pick up the baton that Sean Parker had dropped, and a lot of labels were playing the long game and waiting to see how things were going to play out before investing in new artists.

When shows did happen, the scene was staying home, and Dave spent a couple of years trying to figure out how he could make a couple of hundred dollars an evening by spinning other people's songs as a DJ while bands were being paid enough to cover the cost of a tank of petrol and being bought off with beer tokens. Maybe it was due to the geographical anomalies inherent to Canada, where outside of Vancouver, Montreal and Toronto, the population density dips to alarmingly low levels that aren't really able to sustain their own scenes.

When, as it always does when musicians talk to each other for more than ten minutes, the subject of Junior Achiever's most, and least memorable shows came up and Dave, after pausing to think about the question for a moment, said "The worst gig we ever played was at a venue in Toronto called Reverb. It was an amazing club actually. There were three venues in one building called The Big Bop. The Kathedral was on the ground floor. I saw some great shows there, Burning Airlines stands out as a pretty memorable one. On the second level was the Reverb. This was a bigger room, with a larger stage and great sight lines. Holy Joe's was on the top floor. A dark cozy room that was home to quieter acoustic acts. The entire building is unfortunately now a furniture shop."

"I forget how the show came about but I remember that we were headlining and we were all excited to play. There was a huge snowstorm that night, but the show went on anyway. The normally bustling streets outside were empty as the snow began to pile up. The support band loaded their gear right off the stage and left immediately after their set. We ended up playing to the bartender and the two sound guys. There was literally no one there."

"The one amazing thing to come out of this evening however was meeting sound technician Hiro Tabata. He was from Tokyo but was living

in Toronto at the time. We were just starting to work with Trust Records in Japan, so we had all sorts of questions for Hiro. He came onboard as our sound tech and unofficial interpreter on our tour in Japan. The former he volunteered for and the latter he didn't. He made it pretty obvious to that he didn't enjoy translating conversations, contracts, and menus but that didn't stop us from asking."

Junior Achiever's tour with Shakalabbits was reciprocal and part of the agreement was that they would come to Canada a few months later and do a short tour in North America.

Dave continued, "If I remember correctly, it was their first time touring outside of Japan. They brought with them a scaled-down version of their regular crew as well as a filmmaker to document the proceedings. There were about fifteen people including the band and we had agreed to arrange transportation for all of them. Gene's timing was impeccable as he had recently purchased a tour bus. He would eventually run a very successful Coach business with three buses and work on some big North American tours."

Junior Achiever were tasked with booking the Canadian tour themselves. Jeremy did most of the legwork, arranging shows in Toronto, Ottawa, Montreal, and a bonus date in the band's hometown of Hamilton.

"The first show in Toronto was the perfect venue. The well-known club hosted a weekly 'new music' night that was hugely popular at the time and heavily promoted by a local radio presenter. Jeremy contacted the promoter about a week before the gig to finalize some details and was told that we no longer had the night. Apparently, the promoter had given it away to a 'bigger' act that was coming through town."

"We scrambled and found an alternative venue called The Drake Hotel, but we learned via an email that Shakalabbits' management was a little annoyed with us. They had already printed up T-shirts that listing all of the tour dates and clubs and were angry that the venue had changed. Desperate to save the show Jeremy and I poster and flyer every foreign language school and Japanese restaurant in Toronto."

"A couple of hours before the Drake show I go outside and see that there is a queue all the way around the block. I think every Japanese ex-pat in Toronto has heard the news that Shakalabbits is playing this small club.

The venue is completely caught off guard and have to bring in extra staff to deal with the crowd. Our friends See Spot Run open the proceedings. They are well known in Canada having had a number of popular radio singles and quickly win over the audience. We're on next and I'm elated to see that the Drake is packed with an enthusiastic crowd. Shakalabbits hit the stage and are bemused to see so many Japanese fans in attendance."

"During their set, I take a photo from the back of the room of the packed room. The next day I email the photo to the promoter of the club that fucked us over along with a short message; 'I just wanted to let you know that everything worked out okay.'"

On the road a few days later, Junior Achiever were hit with another obstacle when they learned that the venue they were playing in Ottawa had suddenly closed its doors without warning. Jeremy managed to secure a smaller club with the condition that the show ended early because the bar turned into a dance club in the evening. The band spent the remainder of the four-hour journey trying to update their website and Myspace with the new details. This would've been easy today but in 2008 a Blackberry wasn't quite up to the task.

One of the benefits of the venue change would be that it was now an All Ages show. Somehow word got out and a large contingent of teenage punk rockers turned up ready to skank and mosh. The kids would go absolutely bonkers and demand a Shakalabbits' encore. By this time though they'd passed the venue curfew and the promoter was trying to tell the band that it's time to wrap it up. Either lost in translation or intentionally seizing the Punk Rock moment, Shakalabbits continued to play on, with the club eventually cutting the PA system on them.

And if you're wondering how a label from the UK managed to ink a deal with a band from Ontario, well, that's a story in itself. But it all began when I met Dave in 1994 when he was playing in Wact and I was playing in The Couch Potatoes, and while the details will be forever shrouded in the mystery in order to protect the innocent and guilty alike, suffice to say we've stayed in touch ever since and always get together whenever one of us is on the other's side of the Atlantic.

After Junior Achiever arrived home from their Japanese tour, things started to turn sour as it was hard for the band to play home shows to

empty clubs after they'd packed them out abroad. But, as Dave so eloquently puts it, "The Canadians are a funny bunch when it comes to supporting their own. I think we live in the shadow of our neighbours to the south and we don't seem to care about Canadian musicians, actors, or comedians unless they make it big in the States. Then we're quick to point out to every American we meet that 'John Candy was Canadian'".

"Despite our success with Degrassi T.N.G. and Japan the local music press never got behind us. I felt we had an interesting story to tell but Junior Achiever were always just a short blurb in the back of the local Entertainment Paper."

"Our experience in Japan opened our eyes to international opportunities but after five years of pushing hard we were out of steam and our personal lives were making it difficult to keep things going. There was uncertainty and difficulty with the band keeping commitments that was causing me a lot of stress and anxiety. It was with a very heavy heart that I decided to leave Junior Achiever, but at the time I felt like any movement was better than none."

Gene, Jeremy, and Steve continued on for a while after Dave left. They wrote some new songs and demoed them, but I think life eventually got in the way and they didn't pursue it any further.

There was a brief moment before the COVID pandemic that the band discussed getting back together. They didn't have any expectations besides playing through the songs and having some fun, and hoped that it might lead to something more, but unfortunately just before they were meant to get together Steve's career took him to Ottawa. None of them wanted to play if it wasn't with the original line-up, so the reunion never happened.

And now, what have Junior Achiever been up to since the band came to an end? Well, seeing as you asked...

As well as fronting his new band 'Gene Champagne and The Unteens', Gene has returned to duties behind the drum kit with 'The Killjoys' as well as with Canadian Punk Legends Teenage Head. Jeremy has continued playing as a session drummer, runs Dunce Cap Management and is Feist's Tour Manager. Steve has worked in I.T. for many years and moved to British Columbia during the pandemic. The band still fantasise

that he will move back to their side of the country one day so that they can have that JA reunion.

After leaving Junior Achiever, Dave released two records with a new project called Ramona which featured Jeremy on drums. The first of these was the six-song 'Mornington Crescent Now Open' CD EP (IGN145) in 2010 via Engineer Records in the UK, Pacific Ridge Records in the USA and Fixing A Hole Records in Japan. The second was an eight-track CD mini-album entitled 'The Yellow Line' released in 2015 via Fixing A Hole Records. Ramona played a number of shows and had a bit of luck again in Japan, but not to the same degree as Junior Achiever. The birth of his twin boys put that project on hiatus and eventually it ended, when yet another bass player (Matt Trotter) moved across the country.

Dave is currently fronting a three-piece band called Droids Osaka. It began in the same backward way as Ramona did, as an outlet for him to do what he's driven by; a need to make music. He never knows if it's any good or if anyone will like it, but it doesn't matter, as he just needs to get it out of his head and into the world. If it finds an audience, well that's just the icing on the cake as far as he's concerned.

It was only fitting that Dave had the final word, so before we parted he chose to share his view of punk and the scene, saying; "Punk has always been deeply rooted in politics and challenging the status quo, and that's why I think it is as relevant and important today as it ever was."

I love good tour stories so wanted to add this JUNIOR ACHIEVER JAPANESE TOUR DIARY from June 2008...

Day 1 - Tokyo

Toronto, Canada.

A great local band is on stage at the Horseshoe Tavern, but no one seems to notice. Everyone is fighting for space at the bar desperate to get in another drink. People huddle at the back of the room with folded arms, looking sullen and unimpressed.

The band finish their set and quickly load all of their gear out the back door and into the waiting van. Fifteen of the band's closest friends follow. The club is now empty save for the three other bands on the bill tonight. It's only

eleven o'clock but the openers and their entourage are in a hurry to go queue up at a trendy King Street nightclub in the hopes of scoring some Charlie. At the very least there's still time for fighting, it is Saturday night in Toronto after all.

It's my pleasure to learn that Japan is a world away from all of this. Not just in physical distance and culture but also in a passion for live music. It's of no surprise that my band Junior Achiever's first show in Tokyo is to a crowd of over one thousand. We are supporting Shakalabbits who are celebrating their tenth anniversary. Best described as the Japanese No Doubt, Shakalabbits have grown a large following over the past decade.

What is surprising is their fans' unbridled excitement and enthusiasm for a rock band from Canada that most of them have never heard of before. As we walk on stage the audience erupts into a roar. They hang on every word culled from our Japanese phrasebooks, clap in perfect time to our songs, sing in all the right places, and welcome us with open arms.

Japan is second only to the USA for worldwide album sales. In an age of tech-savvy teens who want something for nothing, the Japanese still seem to embrace the concept of paying artists for the work they create. What a novel idea.

Our shows start at 8 pm and wrap by 11 pm giving young rock fans ample time to catch the last train home. It's interesting to note the diminished role that alcohol plays at these clubs. It's rare that I see anyone at the bar which takes up a very small area at the back of the venue. The barmaid passes the time with her nose buried in a book. From my point of view, the kids seem more interested in the music than getting pissed. It's unfortunate that Canadian promoters have to rely so heavily on bar sales to compensate for their patrons' unwillingness to pay a cover charge.

Even rock stars Shakalabbits won't touch a drop of alcohol until several hours later at the after-show party. Earlier in the day we are forced to purchase our own "bi-ru" from a convenience store after discovering there is no alcohol on the rider. The sight of Junior Achiever returning with shopping bags full of beer seems to shock Shakalabbits' management who stare at us dumbfounded as we start putting back cans of Kirin lager. Hiro, our Japanese sound technician, informs us that it's bad etiquette to be seen drinking before you perform. Suffering from a severe case of jet lag we enter into serious negotiations that allow us to bring beer on stage during our set but we are warned, "No smoking."

The after-show party is held at an Izakaya which is essentially a pub where patrons share a Japanese version of Tapas. I manage to wedge myself in between the low table and the floor, trying my best to sit cross-legged, a position that my legs have never really co-operated with. Over the course of the two-hour meal, the muscles in my thighs repeatedly go into spasms. My leg convulsions spill any full drinks that are on the table.

Shakalabbits order up various Japanese delights for us to sample. Raw chicken maki, horse and a plate of giant oysters make their way around the table. I take a bite of deep-fried chicken cartilage and glance over at our vegetarian drummer Jeremy who is feasting on iceberg lettuce and shredded carrots. I had read a bit about chopstick etiquette in a Japanese guidebook. It recommended using the opposite end of your chopsticks when taking food from a shared plate. Trying to impress my hosts with my knowledge of Japanese customs I spin my sticks around and dig into the oysters.

Shakalabbits react in sheer horror. Lead singer Uki frantically types into her "Japanese to English" translator and hands it to me. I look down at the screen and read, "Evil bad luck."

My legs suddenly spasm again, sending two more glasses of beer toppling over on the table. A feeling of nausea overwhelms me. I pull myself up from the floor knocking a picture off the wall behind me. I excuse myself and make my way to the restroom.

Opening the stall door, I'm horrified to discover a traditional Japanese-style toilet. Essentially a small porcelain bowl set into the floor. You are meant to drop your trousers, straddle the bowl, squat down and do your business. I take off my pants for fear of soiling them and squat down over the toilet, my legs still quivering. I'm overcome by a rare case of performance anxiety. I put my trousers back on and return to the dining room.

Standing at the end of the table I survey my companions for the next ten days, hoist my glass of beer into the air and toast, "Rock and Roll!"

Day 2 - Nagoya

The Japanese are very strict when it comes to road safety. They have a zero-tolerance policy when it comes to drinking and driving and enforce a mandatory seatbelt law for all passengers.

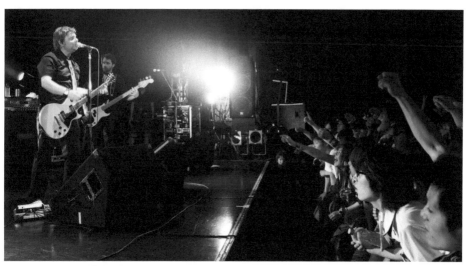

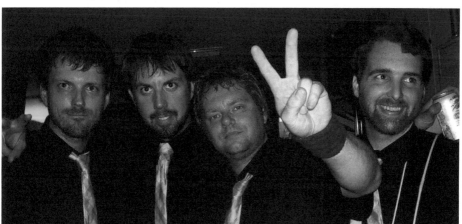

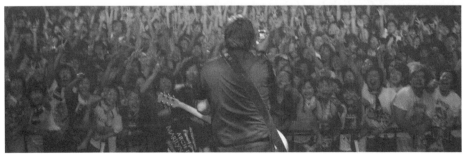

To say our transportation is unsafe is an understatement. Our band van is a late 90's GMC Safari. The seats have been taken out of the back to accommodate our gear and luggage. Our lead singer/guitar player Gene stacks the gear like a kid with Lego. He constructs benches with backrests for us to all sit on. The van is left-hand drive, American style, which seems to confuse our driver / tour manager Wata. He continually hits the curb with the right side of the vehicle and then swerves sharply to the left to try and correct his mistake. His evasive manoeuvres send all of us onto the floor. It is with some irony that every time the van starts the navigation system greets us in an English voice that says, "Please enjoy safe driving."

For our own safety and sanity, we opted to stay in Tokyo after our show at Hiro's mum's house while Wata transported our gear overnight to our next show in Nagoya. After a lovely breakfast of cabbage soup and freshly baked bread, we take an hour-long Shinkansen (bullet train) to Nagoya. We arrive at Diamond Hall by midday and there are already kids waiting outside the venue hopeful to catch a glimpse of their heroes. They seem somewhat satisfied to pose for photos with Junior Achiever instead.

The fans are decked out in a myriad assortment of Shakalabbits shirts, headbands and baseball caps and are hungry for more merchandise. Shakalabbits have about fifteen people working their merch booth and the setup of the display seems as complicated and involved as their staging. Their table dwarves our own, which consists merely of our CD and some flyers printed up by our Japanese label. Shakalabbits have various t-shirt designs, pins, cigarette lighters, stickers, and what I can best describe as a bar towel with their logo on it. At key points during their set fans hold these towels over their heads like football scarves.

Tonight we share a dressing room with Shakalabbits which allows us the opportunity to get to know them a little better. Their English has vastly improved over the last twelve hours. Each of them has purchased English phrasebooks and they've obviously been studying. One book is entitled, "Dictionary of English for Unexpected Situations."

The Nagoya audience is much rowdier than the night before in Tokyo. They are still one hundred percent attentive but are much more vocal in between songs. After our set I change into dry clothes and hurry out to watch Shakalabbits from side stage.

The crowd participation verges on ritualistic. Each part of a song has

seemingly choreographed movements they all perform in unison. If you've ever seen people at a wedding dance to "The Time Warp" or "The Macarena" you have some idea of what I mean. In the verse of "Go" everyone waves their hands in the air from left to right, then in the chorus they all hold their Shakalabbits towels over their heads and sway from side to side until the next verse comes back around and they wave their hands again.

Uki is a ball of energy despite her petite size and quiet off-stage demeanour. She says something in Japanese that prompts the audience to respond, "Groove Shaka Groove! Groove Shaka Groove!" at the top of their lungs. The band kick into the hit single "GSG" from their 2004 album "Clutch".

Despite knowing very little about Shakalabbits or their place in Japanese popular culture, I am completely moved by their performance. It's absolutely incredible to see a thousand people in such unity and four musicians in such command of their audience.

At the after party I'm relieved to discover chairs and western style toilets at the Izakaya. This puts me at great ease I suppose because if I'm being honest, there is very little I remember about the rest of the evening. I drink beer from a magical Japanese glass that never gets empty. At some point in the evening I eat chicken wings (a Nagoya specialty), make a speech that no one understands, and wander off into the rain in search of a pay telephone and some more Asahi lager.

Day 3 - Osaka

The Big Cat club is on the fourth floor of a massive shopping complex in Osaka. The club has a thousand-person capacity, which gives you some idea of the sheer size of the shopping centre itself. My first order of business is to purchase some new guitar plectrums as mine mysteriously went missing the night before. I find the Miki Gakki shop just a short walk from the venue. I usually pay about twenty-five cents a piece for picks in Canada and I am shocked that they're over a dollar each in Japan. I can't really complain though as Marlboros are about seven dollars cheaper here. It's all about balance, I guess.

You can smoke pretty much anywhere in Japan except on the street. On major city streets, there are designated smoking areas. Signs demonstrate how a cigarette in an adult's hand is approximately the same height as a child's face. Apparently, a few children have been blinded by smoking pedestrians. I guess

it's okay for them to inhale secondhand smoke in restaurants as long as you don't take out their little eyes.

After salivating over vintage guitars in Miki Gakki I meet up with the rest of the band across the street at an "American style" restaurant. The place is decked out with vintage Coca-Cola signs, auto parts, surfboards, and other "classic bits" of Americana. The waiter delivers my cheeseburger to me wearing mechanic overalls. My "cheeseburger" is served sans bun on rice with a fried egg on top. I eat it with chopsticks.

After lunch Gene, Hiro and I relax out front of the Big Cat on a bench. A Middle Eastern gentleman with an umbrella and fedora sits down next to us and introduces himself as Rambod. We learn that he is an Iranian carpet dealer who has been living and working in Osaka for ten years. He asks us if we've been to club "Rock Rock". He tells us it's the place to go in Osaka if you're in a rock band. The owner is a good friend of Rambod's and he offers to take us there.

Strolling down the side streets of Osaka Rambod seems to know everyone. He speaks perfect Japanese. He flirts with all the women that we pass and tips his hat to all the men. We arrive at a very nondescript building and Rambod leads us to a lift located in an alcove beside the front entrance. The four of us squeeze into the small elevator and exit on the third floor into Rock Rock. The tiny bar feels a bit familiar. It reminds me of some of the classic rock venues back home. You can tell it hasn't changed much over the years. It is dimly lit and the smell of stale cigarette smoke and sour beer hangs in the air. Huge PA speaker stacks bookend a very small stage. Immediately I'm struck by the tour memorabilia and hundreds of Polaroid pictures that adorn the walls. The photos are of bar owner Seiji posing with countless members of Rock royalty including KISS, Bon Jovi, Metallica, and ACDC to name but a few. We have a couple beers and Seiji invites us back to celebrate after our show that evening. We bid farewell to Rambod and head back to the venue.

We have our own dressing room at the Big Cat. It's a bigger venue than the night before in Nagoya. Apparently, they speak a very different dialect of Japanese in Osaka. Different enough that even Hiro has some difficulty communicating. The crowd tonight is even livelier than the past two nights. They seem more physically into the show, jumping around and pushing each other into the stage barriers.

After our set, I make my way to the balcony through the lobby. It looks like a scene from a war movie. There are dozens of kids nursing bloody noses, cut

faces and twisted ankles. One kid comes up to me holding an ice pack on his head. He removes the pack to reveal a huge bump, gives me the thumbs up, and says, "Good show!"

After Shakalabbits' set we scurry back to our merchandise booth to push CDs. For an hour we sign autographs and pose for photos with very sweaty Japanese rock fans. It's completely manic. I enjoy the experience, but I wish that I could communicate with them. I manage to get by saying, "Thank you", "How are you?", and "Great" in Japanese.

In return, I have no idea what they're trying to say to me. At some point you just give up trying, smile, and embrace their requests for "Hug? Hug?"

It's a surreal moment and after it's all over you're left feeling strangely alone.

We check into a four-star hotel that our bass player Steve has secured for the evening. Tonight we have the luxury of king-size beds as opposed to sleeping on thin futon mattresses like in previous hotels. I'm also excited to find a Japanese "super toilet" that has such features as a seat warmer and both front and rear bidet spray. I discover the former feature after accidentally pressing a button that gives my bollocks a good soaking.

After freshening up we head back to Club Rock Rock. It's quiet on a Monday night but Seiji treats us like rock stars or at least the rock stars that he thinks we are. We drink perfect pints of Guinness, eat delicious pub food and sing along to the DJ's music selections. We have four more club dates in Japan before we go home but none of them will compare to these first three shows with our new friends Shakalabbits. I usually get a bit melancholy when traveling, I'm always conscious that my trip is coming to an end but tonight I feel happy. I am certain this is not the last time I will have a pint in club Rock Rock.

Before we leave Seiji asks us to pose with him for a Polaroid. With this photographic blessing, we become part of Japanese rock history and stumble off into the warm Osaka night.

Press reviews of 'All The Little Letdowns'.

You've got to ask yourself just one question, to quote the inscrutable Inspector Harry Callahan. If you applied this thinking to Junior Achiever's debut the question would have to be "do you like pop/punk - punk?" If the answer is yes and you like the sound of a band who take

their inspiration from mid-period Weezer and pre-serious Blink 182 with a dash of Bowling For Soup's ever present effervescence then step right this way, there is a cracking album in store for you.

Up-tempo and infectious throughout 'All The Little Letdowns' is, quite simply, the best album I've heard this year and the best release in the genre since The Color Fred debut last year, and I include Weezer's 6th album in this comparison, it is that good, really. Over the course of the thirteen slices of pop/punk perfection presented here Gene Champagne wraps some sugar coated vocal and guitar hooks around songs that describe growing up and relationship issues but are never downbeat. Even the piano-led ballad 'How Does It Feel' doesn't bring the mood down that much but, just to make sure you leave the album on a high note, the band romp through an 80 second blast in 'Gutless Wonder' leaving you reaching for the repeat button, something you will find yourself doing time and time again.
John Lewins / Hard Rock House

Each track contains a hefty dollop of 'niceness' but irony is like, so over; it's cool to be kind. With songs like 'Suburbs' and 'Dumb It Down', these guys know their market. "You've got to put things right if you want to keep good company," sings Champagne on 'Underrated', which espouses the value of good old-fashioned manners and self-respect. Summer definitely brings the best out of these childishly enthusiastic pop punkers.
New Noise

Junior Achiever have released their debut album. It is very alternative, and it has a sort of Marianas Trench feel to some of the songs here. Quality songs and a great feel in the playing from the band. The best part is probably the lyrics, they just have so much more than the bland music.
Ontario Rock

Melancholic songs that oscillate between power-pop and pop-punk, although more often than not it's the latter genre that prevails. The CD has been mixed by Ed Krautner who worked in the past with other top Canadians like Sum 41 and Avril Lavigne. 'All The Little Letdowns' has everything an album needs to make it popular with teenagers: catchy melodies, broken heart lyrics, and clean production.
Disagreement.net

Close your eyes and listen for another summer anthem. Junior Achiever will provide.
Let's Sing It

With 'All the Little Letdowns' Junior Achiever have a debut album which sounds like they have years of experience. Sure enough, this experience comes because all members already tested successfully in other bands, in the case of Gene Champagne even attaining a Canadian Juno Award. The other members Dave Fritz, Steve Scott and drummer Jeremy Knowles participate in this new project with full heart and soul. The gentlemen perfectly control their craft and cover emo and pop-punk with a completely different style. They play with joy and great melodies, which compare with Weezer and Jimmy Eat World.
Dosenmusik

Unabashedly in the Fountains of Wayne and Weezer ballpark, this Toronto quartet is rocking some quality hooks and an overall likeability.
Now Magazine

Modern-day pop nuggets worthy of the same attention and airspace lavished upon bands such as All-American Rejects, A Simple Plan and Good Charlotte. Drinking-and-partying anthem Daytona goes from self-deprecating to brutally honest without so much as a bat of an eye.

'Say What You Want Me To Say' stands out by sounding like something Rick Springfield would've recorded in the 80's. Chuckle away, but folks wouldn't turn up car radios and sing along loudly to 'Jesse's Girl' 20+ years later if the song wasn't a damn banger. This is the kind of pop album that more bands should be worrying about dropping to record these days. In two decades, no one listening to this record is going to say, 'Oh man, emo.' More likely, the response will be, 'Damn, what a solid album!' - which is exactly how this review would read in five-word form.
Gary Blackwell - Delusions of Adequacy

It may sound a little bit sappy, but I've always had a soft spot for Indie record label Engineer Records having had the pleasure of reviewing compilation DVD's and CD's from them as well as individual band's albums, and with Junior Achiever they have a great band that pulls together everything that I like. This has a Pop/Punk feel of bouncy catchy Pop/Rock songs, with big riffs and intellectually amusing lyrics giving the proverbial cherry on top.

Naturally for an album that's called, 'All The Little Letdowns' the only one that I can think of is that I have only just discovered them. First song, 'Another Stupid Love Song' sounds like a cross between Everclear at their catchiest, Fountains Of Wayne and Naked Apes. They have the ability of churning out a song that is catchy without sounding like a band that you should be embarrassed about liking. 'Scoot' has a nice little acoustic jig feel in the first verse before the chorus and the guitar riff rips in with all of its head-banging glory. 'Better Than This' is a pure listening pleasure in the vein of Bowling For Soup with a dash of Silver Sun, with chugging guitars and vocal melodies... Great, great, great!

We have the pain of not feeling good enough in, 'Suburbs' with the lyrics of, "I'm a cheater, I'm a loser // I feel like a fallen user // In a world so full of pain // I can sink myself into // I'm ashamed to hear my name next to yours // I'm ashamed to hear my name...". Gene Champagne has a great voice (and name I might add!) that lends itself perfectly for this melodic Pop/Punk so naturally, he must've been humming hooks in the womb... 'Dumb It Down' has some nice harmonies and has a hint of Weezer about it minus the fuzzbox guitars. Then with riffs bigger that King Kong's balls, and hard drumbeats, 'Underrated' is Punk with melodies.

Like early Blink 182 but with better quality, 'Lick Me, Suck Me, Kiss Me, Kill Me' is a sex-fuelled slice of Punk. Stupid, immature, catchy and pure brilliance, sometimes you can leave saving the world to others... then moving on to, 'Say What You Want To Say' which jumps out at you as a anthem that is so catchy that you will swear that you've heard it before. There are elements of Simple Plan, but only splashes as Junior Achiever have a more mature sound and are less throwaway. 'California' is another great song, and it would have to be. Sounding like the band Plunket mixed with Army Of Freshmen but without the keyboards, it's a poppy song with a chorus that reminds me of the theme tune to the TV programme, 'OC'.

'She's So Mean' has cheerleader shouts in the background and sun-kissed vocals like if you took Ben Folds and let him party with Jocks and Cheerleaders whilst Brian Wilson looked on approvingly. We then have electric beats to start with on, 'Daytona' which sounds a little like Wheatus on one of their latest albums (a band that are underrated in my book). It's then interesting to see that it takes a dozen songs before a slow song, which is thoughtfully constructed, before last song, 'Gutless

Wonder' which could've been penned and sung by The Vandals. Great tongue in cheek Punk humour.

Obviously a special mention has to go out in regard to Junior Achiever being featured on, 'Degrassi: The Next Generation', which if you remember was the great Canadian show from the 1980's a bit like Grange Hill but more controversial. However, with their debut album, 'All The Little Letdowns' they have an album that will have you excited as a kid on Christmas Eve with its sound that is a cross between Fountains Of Wayne, Bowling For Soup and Everclear, and so whilst other Pop/Punk albums are becoming watered down and bland, Junior Achiever have one that stands up proud like the contents of a schoolboys' trousers! Great stuff!

Room Thirteen

https://juniorachiever.bandcamp.com/album/all-the-little-letdowns

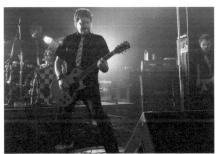

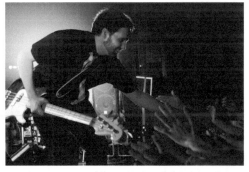

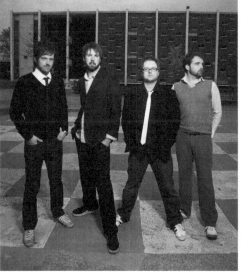

Kid You Not

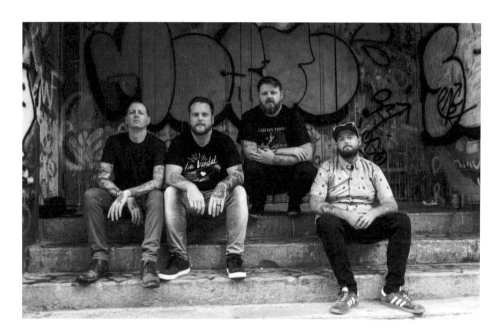

Patrick Drury : Vocals and Guitar
Ben Bennett : Guitar and Backing Vocals
Justin Pritchard : Bass and Backing Vocals
Nick Shoaf : Drums

Kid You Not belt out emotionally driven punk rock in the vein of bands like Neckscars, Tired Radio, Iron Chic, Hot Water Music, Spanish Love Songs and The Menzingers. Hailing from USA's oldest city and gator-haven, Saint Augustine, FL these guys write catchy hooks that stick deep and rock hard. Their most recent album, 'Here's to feelin' good all the time' bursts with ten tracks of powerful positiveness underlined with singalong melodies. It was released on Sell The Heart, Bypolar and Engineer Records on 14th October 2022.

Kid You Not got together in late spring 2015 with a handful of songs they wanted to work on before playing live. They made some rough demos to help them remember the songs as they developed the ideas and a few people heard them. Within three months of their first jam they were offered the support for Face To Face as their first show. Not a bad way to kick off.

Justin, bassist, backing shouter and rabble rouser, told me; "We kicked it into high gear to finish a set because there's no way you can say we're not ready yet to a Face to Face gig." Adding, "It was soon after that a friend of ours passed our demo to Tony at Fest and we were invited to play that too!"

The band had a few line-up changes, although the main three guys remained solid; Patrick, Justin and Ben had started the band in 2015 and brought in Joey Smith on drums and then Chris Johnson on third guitar. In 2016, a week before their first appearance at the Fest, Joey left and was replaced by Jeremy Austin on drums. Chris left after the Fest and in 2018 Jeremy left the band and Victor Joudi took over on drums. Victor stayed until the Summer of 2019 when Nick Shoaf came in and remained the bands drummer.

Kid You Not's first release was a six-song CD EP entitled 'Almost Home' that came out in 2016 on Ron McIntyre's Felony Records, based right across the country in Hermosa Beach, CA. The band's habit of excellent, clever and amusing song titles started right then, with 'Drink your school, stay in drugs and don't do milk' and 'When life gives you lemons, just say Fuck the lemons and bail' amongst others on this record.

This was followed by a five-song EP entitled 'Nothing was beautiful and everything hurt', which also had a limited CD release on Felony Records and then a digital release on Deep Elm Records. This EP included the tracks 'Either get busy living or get busy dying', 'Almost infamous' and 'I'm in a glass case of emotion'.

In 2017 Kid You Not recorded their first full album, 'Never a dull moment' at their own Golden God Recording Studios, a set-up in Patrick's house they'd use for all their recordings. Released digitally by Deep Elm Records and on vinyl LP by Bypolar Records on swamp smoke green wax. It featured ten new songs, including 'Me and dead owls don't give a hoot', 'No shirt, no shoes, no dice' and 'There's no crying in baseball'. They'd also have a track, 'Room to breathe' on a limited-edition lathe cut clear vinyl 10" alongside Teen Agers, You Vandal and Caffiends for the Fest 17 gigs.

"There were only a couple of places to play gigs in St. Augustine. Our favourite hometown venue was Nobby's." Justin told me, "There were a

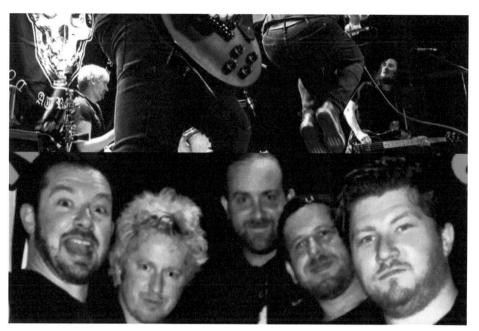

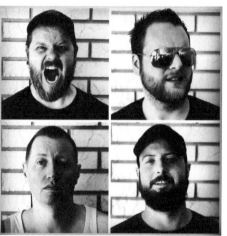

To all of you that have supported us over the last 8 years, thanks for all of the good times and the memories.

Kid You Not
2015-2023

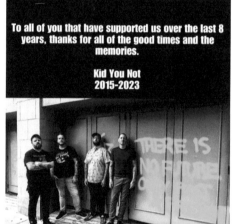

2015 - 2023

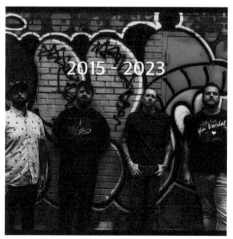

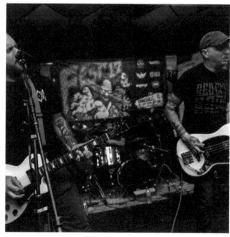

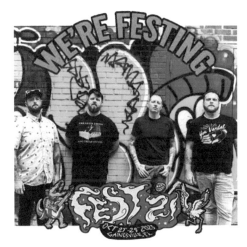

few local bands, Charlie / Mental Boy was one, and we made some good friends in the region to play with. Friendly Fire and Flag on Fire from Jacksonville, Caffiends and Rushmore from Orlando, You Vandal from Gainesville. We played 3-4 day mini tours together with You Vandal for a while and they pretty much become our favourite people in the world." Reflecting on his favourite gig, Justin told me, "The second year we played The Fest was the most fun. All the Fest's are amazing, but that gig really sticks out."

I asked Justin about Kid You Not's musical influences and he told me; "We've always been influenced by the bands we grew up with like Jawbreaker, Hot Water Music, Descendents, Millencolin and Face to Face. But of course, people will hear a lot of our later influences too, like Great Apes, Spraynard, Latterman, Iron Chic and Red City Radio. We were all listening to that stuff a lot more when we first started writing, but we try to take those influences and create our own sound."

The band was developing a very productive and long-term relationship with Damon Workman at Bypolar Records and their great support from this label continued. Initially with their debut album, which was in fact the catalyst for Bypolar records inception, and now with 2018's 'Home Again' album, released on 12" vinyl with eight different wax variants via Bypolar and digitally by Deep Elm. This thirteen-song collection included 'May the bridges I burn light the way', 'E=MC Hammered' and 'Boxers don't have an old timer's day'.

This was followed by 2020's 'Thanks, I Hate It' album, containing eleven more songs, including ''Here's to those who wish us well', 'And those who don't can go to hell', 'Fantastic drugs and how to take them', 'Handbook for the recently deceased' and 'Inside every cynic is a disappointed idealist'. Again, released digitally by Deep Elm and on 12" vinyl via Bypolar Records. There was an emerald wax version with a metallic silver cover and a translucent purple wax version with a metallic gold cover, now long sold out.

Justin says about 2020's covid lockdown influenced 'Thanks, I Hate It'; "The songs on this album resonate with what we believe a lot of people have felt in regard to personal struggles with mental health. 2020 has been a roller coaster of seemingly endless despair which has weighed heavy on a lot of us and has certainly taken a mental toll."

This brings us up to 2022's blistering, passion-filled singalong of an album, 'Here's to feelin' good all the time'. Released on 12" vinyl LP again by Bypolar, but also jointly with Sell The Heart Records in the USA and Engineer Records in the UK and Europe. There were three different vinyl versions, on purple/blue, deep red and turquoise wax with ten new songs including; 'I am who I am and I wish I weren't', 'Last of a lost generation', 'First of a dying breed' and 'I'm not superstitious, but I am a little stitious'. Creatively Kid You Not had reached their apex and the many massively positive reviews for this great album were very well deserved.

They could've and should've been even bigger and better known, but in 2023 the band decided to call it quits and posted this message online; "After eight great years and four albums, the time has come. We have so many mixed emotions about this decision. The ride was incredible. This little band of ours did more than it was ever supposed to do, more than we ever expected it to. We met so many amazing people from all over the world. We felt the love of seeing you sing these songs back to us. We got to release music with a label that we grew up dreaming about. We shared stages with and befriended bands that influenced us. It has been amazing. We want to take a moment to thank those who helped us along the way. John at Deep Elm Records, Damon and everyone at Bypolar Records, Andy at Sell The Heart Records, David at Engineer Records, Tony and every single person that helps with FEST. Jeremy, Victor, Joey, Chris and Andrew - thank you for the time you spent as part of the family. Tyler, Charlie, and Ryan - thank you for your support and for bringing us into the St. Augustine music community. Thank you to all of our friends, family, and every single person that we've shared a stage with. Most importantly thank you to every one of you who ever took the time to listen to our songs and came along on this ride with us."

Punknews.org said; *"Abandoning abrasive angst in the face of melody, intricate guitar work, and a sort of depressive hopefulness. While not shying away from branching into emo and pop-punk, Kid You Not retains all the aggression and rawness you'd expect from a punk-rock band."*

PunkRockTheory agreed *"Uplifting, melancholy-infused punk anthems that make you want to punch a hole in the air with your fist while hugging a bear and whoever has the misfortune of standing close to you."*

Release Wave described Kid You Not as; *"The kind of stuff that goes over*

well in a small club to a bunch of sweaty packed in kids singing along with their fists in the air!"

Scene Point Blank theorised; *"Brimming with coarse, sing-your-throat-raw gang vocals, this isn't circle pit punk rock or sweat-away-your troubles as you pogo punk. It's moody punk that matches words with the tone in an endless search for meaning that cynically gives up and settles for finding identity in a big cathartic chorus instead."*

And **Personal Punk** added; *"These gritty, defiant hymns have their roots in fellow Floridian's Hot Water Music and Against Me! Patient, uplifting anthems of emotional punk. Heart-on-sleeve, fist-waving, blue-collar anthems in flannel shirts. The band's musical legacy is writ large in many of these songs."*

https://kidyounotfl.bandcamp.com

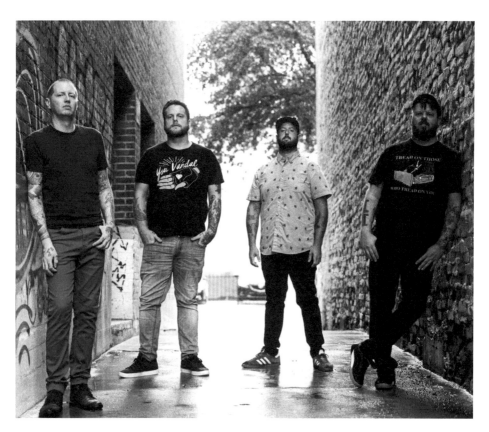

Kover

Ryan Mills : Vocals and Guitar
Jaye Schwarzer : Vocals and Guitar
Neal Lyons : Bass
Greg Lyons : Drums

With members stemming from Canada's beloved Blue Skies At War, Heroes For Sale, Going Nowhere and Hope to Die these four guys from the Greater Toronto area instantly hit us in the heart. Kover juggle just the right amount of classic inspirations. 'Classic' in terms of late 90's post-hardcore, 70's classic rock and great riff-writing. With razor sharp guitars, instantly likeable gruff-yet-melodic vocal harmonies and a tight rhythmic foundation reminiscent of Leatherface, Seaweed, Hot Water Music and Failure, we were stoked to have these guys in the Engineer Records family.

The Kover story started in the basement of Ryan's parent's house in London, Ontario when he and Jaye began swapping riffs. Having decided that music was more important to them than skating, after ironically drafting Ryan's old skating buddy Neal and his brother Greg into the fold, Kover was born. Jaye and Ryan had tried doing the band thing before but

it never worked out until they shifted their focus from spending the majority of their time on four wheels to turning up and cranking out riffs as Kover.

While Neal and Greg leaned towards Fugazi, Minor Threat and Zeppelin, Jaye's eclectic taste spanned stoner rock, metal and punk. Ryan delved into indie realms, and all were influenced by Leatherface, Hot Water Music, Samiam and others. This unified the band in the quest to find their musical identity. Acid, weed and copious amounts of alcohol being the universal fuel of rock'n' roll, also played a major part in helping to drive the band onward.

I asked singer and guitarist, Ryan about Kover and what records inspired and the band's unique sound. He told me; "I-spy's 'Perversity is Spreading', multiple Samiam and almost all Leatherface albums resonated deeply with me. As well as '80s classics like The Cure's 'Disintegration'. Quicksand's 'Slip' and 'Manic Compression', Seaweed's 'Spanaway' and Farside's 'Rigged' held a special place in our hearts. Then later Rival Schools 'United by Fate', Hot Water Music's 'No Division' and 'Caution', Ryan Adams 'Rock and Roll' and many more."

That said, bands are more than just the sum of their musical influences and coming from London and Streetsville, small towns in Ontario, they experienced overwhelming support from their local scene. The sense of camaraderie the band enjoyed went beyond just the venues and encompassed mutual aid, collaborative shows and shared road trips. Thanks in no small part to the foundation that had been laid by the member's previous bands, where they carried over fans from the preceding era.

Kover's unwavering dedication to their cause made them stand out among their peers, and the combination of dynamic live performances, vibrant parties and their own distinctive identity soon propelled Kover into the press spotlight. While there may have occasionally been unchecked rock and roll egos from this, there was a method in the madness as their rockstar cravings energised the audience and kept the band committed to delivering an unforgettable live show. For Kover it was all about the spectacle.

I'm sure that countless nights of debauchery helped shape the band's character and contributed to their unwavering dedication to playing, but

Ryan was reluctant to talk about specific incidents in order to protect the innocent and keep the guilty out of jail. He did though, tell me about a few memorable gigs...

"Adversity at challenging gigs became a valuable character-building experience for us. In one instance, an enthusiastic audience member persistently attempted backflips on stage. Neal, unimpressed, firmly told him to 'Fuck off!' He then set his bass down, executed a flawless backflip off the stage, climbed back and picked up his bass, then seamlessly resumed the gig, proving his point with flair."

Ryan continued; "During our debut performance Jaye made a lasting impression with a memorable stage dive onto a fan's face. That wasn't ideal. Also, for a while in Canadian rock clubs we seemed to encounter gigs shrouded in an excessive amount dry ice. It made visibility on stage practically non-existent. Some gigs became a guessing game as we navigated through the atmospheric haze."

Kover eventually got in touch with Engineer Records through Craig Cirinelli, the singer of Elemae, World Concave and (Damn) This Desert Air, and also the guy running our New Jersey, US office at the time. Kover had a demo EP kicking around, as well as a split CD with fellow Canadians Second To Go, which Craig had a copy of. He'd also seen their shows and wanted to bring them to the label. So in 2006 Kover went into BWC Studios in Brampton, Ontario with Greg Dawson (Moneen, Alexisonfire, Omaha, Choke) to record the twelve songs that would become their 'Assembly' album.

Engineer Records released 'Assembly' on CD (IGN094) and pushed it hard, selling out of the first press quickly with the help of Kover's gigging, radio airplay and plenty of press reviews. Then arranging a second pressing and a re-issue on Italian partner label Chorus Of One in 2007. Kover would also appear on the 'A Tribute to Leatherface' album with the song 'Wax Lyrical'. This forty-one track double CD compilation came out on Rubber Factory Records in 2008.

Things were looking good. But as for why Kover decided to call it quits, it was all down to life weaving its often-strange tapestry. Jaye found a new chapter with Cancer Bats, and then Greg and Ryan delved into fresh projects, Repeller and Pile High, to keep their musical flames burning, while Neal embarked on a venture with his now-wife, crafting a project

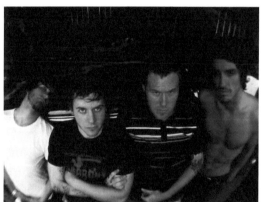

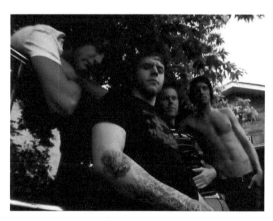

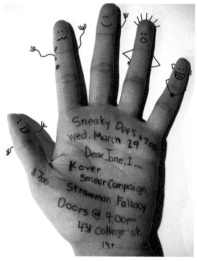

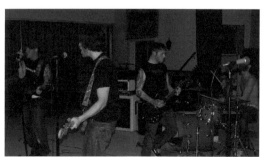

called The North. Later Engineer Records would also release both of Ryan Mills solo records, a split 7" with UK band My So Called Life (IGN111) in 2008, followed by a UK tour and another split record, this time a CD and digital release with Sirens & Shelter (IGN214) in 2014.

The band may have passed into the annals of history now but the members unbridled love of music continues, as Greg and Neal have embraced family life but continue to be mainstays at local shows. Jaye became a member of the Cancer Bats and toured relentlessly and Ryan joined the ranks of Drift Current having dipped his toes into the world of solo acoustic recording and electronic music. The overwhelming sense of creativity, artistic freedom and energy that they shared in Kover continues to flow through each of their lives, reminding them why they did what they did and continue to do, and motivating them to stay the course.

I asked Ryan about the part that punk has played in the lives of the former members of Kover and how relevant he still believes it is. He told me; "Each of us believes in its continued relevance. It's not just a genre. It's a culture that connects generations. The hardcore post-punk scene means the world to us. It's a timeless space where music transcends and friendships endure."

Sonic Rendezvous reviewed Kover's Assembly saying; *"Expect the album to hit your ears with bombast and clarity. Nothing short of inspired performances from these seasoned Canadian post-punks."*

And **Lambgoat** added; *"Kover can be compared to bands like Boysetsfire, Guilt or Hot Water Music, bands that have strayed from hardcore or punk formulae with strong results. They're definitely doing something noteworthy. There's also a bit of a Descendents / Face To Face style influence to what Kover does. They place an emphasis on the strength of their riffs, working well with the gritty and rough vocals. Bottom line: This is a strong debut album from a band that could very well become a powerhouse. They have laid the foundation for great things to come."*

https://www.youtube.com/@EngineerRec

Kyoto Drive

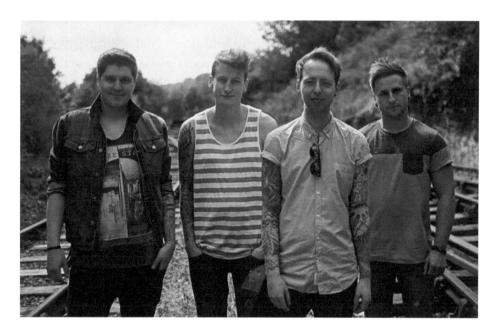

Adam Binder – Vocals & Bass
Mike Levell – Guitar & Vocals
Mark Piper – Guitar & Vocal
Chris Piper – Drums
(Mitch Davis – Drums)

Kyoto Drive were all about big hooks and even bigger choruses. They were a four-piece pop-punk band from the heart of middle England and since forming in 2009 they toured every corner of the UK. After releasing their debut album 'This Is All We Ever Wanted' they never looked back. That was until they eventually handed in their rock n roll marching papers and called it a day...

I'm not going to pretend that when Adam and Mike from Kyoto Drive told me that the band was done and dusted it didn't break my heart, because it did. Sometimes, and by sometimes I mean next to never and hardly ever, you get to work with bands that end up meaning the world to you, whose songs run unbidden through your mind twenty-four hours a day, seven days a week, and every time you hear their name it makes you smile with the wide-eyed wonder of a teenager at their first gig.

When I mentioned this book to Adam and asked him if he wanted Kyoto Drive to be part of it, he said absolutely and five minutes later he was back in touch. We were soon reminiscing about the first demo he'd sent me, some of the Kyoto Drive gigs we'd put on, the hot-tub after-shows, and much more. I was adding some of it, what was decent to print, to my notes. So, ladies and gentlemen, boys and girls, punks, geeks, and poptastic freaks, I give you Mr Adam Binder and the Kyoto Drive story...

"I met brothers Chris and Mark Piper at high school in Wombourne, a village just outside of Wolverhampton in the West Midlands. Around the time we were 16, we started our first band playing Green Day and Blink 182 covers until we graduated to writing our own material.

That band went through a bunch of line-up changes, names, and styles, but there was always the three of us at its core. We ultimately found a post-hardcore sound, a solid line-up and called ourselves Forever Ends Today. We had a couple of releases on Worcester label LockJaw Records and found a home in the underground Birmingham emo scene.

This was the early 2000s era of pop punk, emo, and post-hardcore, and we were heavily influenced by what was coming from across the pond and labels like Drive-Thru records. There was a great community in Birmingham. You could find a show going on most weeks, either a US band touring at one of the Carling Academy rooms, or a UK punk/rock/ska band supported by a local band or two, or an 'all-dayer' at one of the city venues with five to ten local bands, usually starting in the mid-afternoon. All the bands knew each other, and most friendship groups overlapped which helped to create a thriving scene.

By 2008 F.E.T had run its course and we had the itch to return to the poppier sound and we'd met Mike playing in his post-hardcore band Cassettes Lost Meaning who had just split which had given him the chance to start releasing solo acoustic songs. I remember us all listening to Mike's solo stuff at Chris and Mark's parent's house and being blown away by his voice and songwriting. It took a few months of messing around with line-ups and band names, but by Summer 2008 we'd decided that Kyoto Drive was the one, and the line-up of Chris on drums, Mike and Mark on guitars, and myself on bass, with three of us sharing vocal duties became a thing.

We spent a couple of months writing together and came up with four songs for our debut EP. Chris, Mark, and I had all studied music technology together and knew a bit about recording, so we spent some time at Chris and Mark's parent's house laying down the songs that would become our first EP Spotlights and Stars. It was around this time we started speaking with David and Engineer Records. We sent a demo, and he was into it and decided to release it. It was a pretty informal setup, but we loved working with the label, and David had been in touring bands, so we felt in safe hands.

We then spent the next year and a half touring and gigging the snot out of that EP. We still had our van from our old post-hardcore band, a sky-blue Ford Transit minibus we called Cilla Blue. We'd ripped out all the seats except the front and second row, leaving a big open space, in which we built a large chest-height bed creating a sleeping area on top and space for gear underneath.

You could barely sit up in the bed space and we'd drawn all of the ceiling with Sharpies. There wasn't enough room for us all, and whichever friend we'd roped into selling merch, to sleep in the bed area so some unlucky sod would have to sleep across the seats. My mum also made custom curtains for each window, including the windscreen which we then velcro attached so they could be put up or down at a moment's notice. We spent countless nights in truck stop car parks and A-Road laybys sleeping in the van after a show and then finding a service station to shower in the next morning. These were the Myspace heydays, so you could easily put together a tour by messaging a bunch of promoters and mashing together a string of one-off gigs into a week-long tour.

Throughout 2009, we were all working entry-level office jobs, and a few nights a week we would congregate after work at Hockley St Studios in Birmingham where we'd got ourselves a lock-up. and between practicing for odd gigs and Myspace tours, we were writing songs for our debut album. By the time 2010 rolled around we had enough songs to put together 'This Is All We Ever Wanted', and we went into a studio in Worcester with Jim Turner from Tribute To Nothing who was one of the brothers who ran Lockjaw Records. We ended up releasing it with both Engineer Records in UK / Europe and Pacific Ridge Records in the US, but despite the ongoing promotion nothing much changed for us following the release of this record, and we just played more gigs, went on more tours, and wrote more songs.

By the time we came to the end of 2010 we'd refined our songwriting and settled into our sound. We wanted to keep things moving so put two new songs together,' Chapters' and 'So Much Alive'. We teamed up with Matt O'Grady to record them as a double A-side, because at the time he was working with You Me at Six and Deaf Havana and was getting a polished sound out of the bands he was producing and we wanted in on that. This would be another Engineer Records release, coming out on CD as IGN161 in 2011 and supported by a video that gained well over 45,000 views.

We met Matt at a youth club in Guildford to track the drums and did the rest at his studio, which was a converted basement at his mum's house. The place was tiny but he really delivered the goods on the sound we were looking for and helped us craft the songs and make them as good as they could be, especially when it came to the vocal production. Recording in Guildford was also a great excuse to spend some time with David in Kent. During the day we would record with Matt, and at night we'd go back to Engineer Records HQ, drink beer in the hot tub, and sleep in the outhouse with the spiders, much to the terror of some band members. Staying with David and Louise became a regular occurrence for Kyoto Drive and there was always a warm welcome, a hot tub ready, and even an adopted baby barn owl to pet, which would take pleasure in landing on Chris shoulders to terrify him whenever it could, somehow knowing he had a huge owl tattoo on his back from the Rush 'Fly By Night' album.

At this point, the best way to take things up a notch and gain more fans was to have a really slick music video so we put some feelers out and made a great connection with Daniel Peters, an American dude living in Bristol doing excellent work with loads of UK bands. My mum worked at the council and she somehow managed to arrange to have one of the floors of a car park cordoned off for a day so we could shoot a video for 'So Much Alive'.

It was our first time shooting a 'proper' music video, I sweated profusely through the whole thing out of exhaustion and nervousness, if you watch it back now it cuts between scenes of me looking awkwardly at the camera and me wringing wet. We worked with Daniel again a few months later and made another video, this time for 'Chapters', which was filmed on the banks of the River Severn in Bristol.

During the same time, we were working with a booking agent and manager Graham Clews, a straight-talking Scottish guy with a great ear

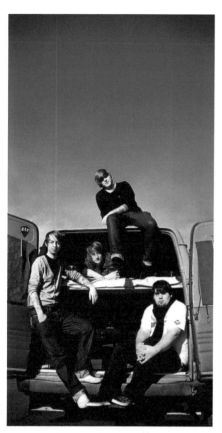

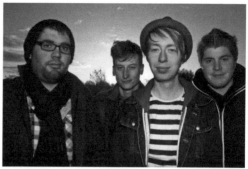

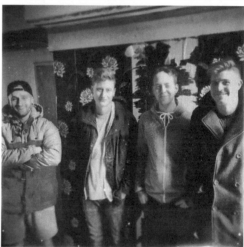

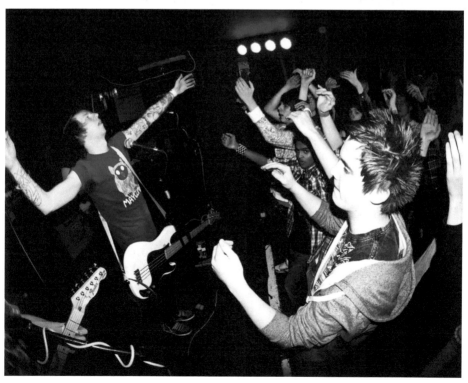

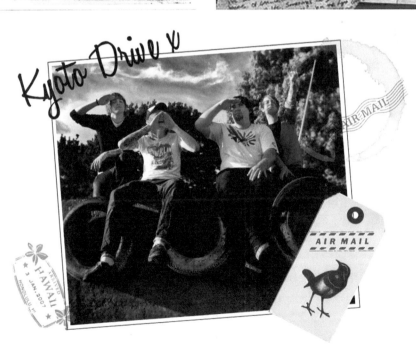

for up-and-coming bands and a habit of booking illogical tour routes. Graham helped us up our game on tour booking and our first proper tour was supporting a great US band called The Morning Of in the Summer of 2011.

This was also going to be our first stint in mainland Europe. If we were going to be able to make it to Poland and back again we'd need a new van, and so we chose Wanda White, a large wheelbase Iveco. We'd learned some lessons on the bed situation with Cilla Blue, this time we had my future father-in-law build us out a full set of bunk beds and a separate compartment for the gear. Wanda wasn't perfect. Wheels came off, the sliding door fell off every few days and we missed a show in Rome because Wanda had stranded us somewhere in Austria. There was even an offer of a festival slot in the Czech Rep with Paramore, but we didn't make that either. She wasn't perfect but she was a massive upgrade.

In the grand rock and roll scheme of things, we were a pretty well-behaved band, took it seriously, and always put the highest importance on being able to play the next show to the best of our ability. That being said this tour saw our first run-in with 'the law'. Due to the previously mentioned bunk beds, we were now able to pull over after a show anywhere quiet and sleep. On a night on The Morning Of tour, we pulled over in a residential neighbourhood with tour mates Paige, found a quiet street, pulled up, and popped open the drinks with the side doors of the vans flung back. Minutes after taking a few chugs of Jack Daniels we were greeted by a police car and they explained that even though we were parked, the two designated drivers were still responsible for being in control of a motor vehicle and so each driver would be breathalysed.

That was me and the guy who was hired to drive Paige's van. Nervous as hell I blew into the little machine and miraculously it came up zero, even after swigging JD literally seconds before, and later I found out that it takes about twenty minutes after drinking for a breathalyser to register anything in your blood, I was let off with a warning and told to leave the neighbourhood.

Paige were not so lucky, though their driver was also not found to be under the influence, there was an issue with the van's documentation and their van was impounded and we watched it being strapped to a flatbed and being taken off somewhere. The good news though was that they sorted it out in time for the next show. We'd get stopped a few times

over the years, had the van searched for drugs as I guess a bunch of dudes in a van kitted out with bunk beds rings PoPo alarm bells. That said, the rest of the tour pretty much went off without a hitch and we enjoyed playing throughout Europe to eager music fans in small clubs and youth clubs.

Early 2012 saw us returning to work with Matt O'Grady, as we loved how he'd taken our sound to the next level and we wanted to turn a double A side into the full EP, that we would go on to name 'The Approach' and released with I Am Mighty Records after we spent more days in Matt's mum's basement and nights with the Gamage family in the hot tub. We had well and truly settled into our sound and had Paul from Paige play a bunch of piano on the record, tambourine on every chorus, and even a key change at the end of 'Breathe'. A key change I could never pull off live. I remember attempting it at a local show supporting I Am The Avalanche, looking out at a good friend, Gav of 'Shapes', and him just shaking his head at me to say "Not quite mate".

Not long after finishing the record we were out touring again with US emo legends Mae. We had grown up listening to their record 'Destination Beautiful' after we heard them on a Blink 182 documentary, so this was a big deal and milestone for us. We 'fan-boyed' a good amount on this tour, watching every night from side stage in awe, but the joy soon evaporated when we got back home and Chris told us that he was leaving the band. This was a massive blow to us, especially Mark who had never really played with another drummer. Chris explained that he didn't enjoy the touring part of being in a band and the way things were headed, there was only going to be more. He wanted to settle down and concentrate on buying a house and having kids.

So, we were in the market for a new drummer and friends in Maycomb suggested we talk to Mitch. We didn't know Mitch very well, but we had the same circle of friends so we must have been in the same place and time on more than one occasion. Mitch was band-less at the time so I met up with him for a drink and chatted and we got on like a house on fire. It turned out that we lived a 30-second walk from each other, so we invited him for practice and I can't remember how we officially asked him to join, it all happened so fast but before long he was a fully-fledged member of the band, and luckily he was also a car mechanic working for a breakdown service, a perfect skill set for a touring band.

The latter half of 2012 was non-stop. It started with a UK tour with another British band called Violet in June followed by a video shoot for 'Breathe' in August. This time we worked with a friend of a friend, Josh Partridge, he worked up a cool little story line and we shot the performance bits in a town hall. In September we then went on a UK tour with emo heavyweights Hawthorne Heights and during this tour we had an incident where the promoter refused to pay the tour package, so three bands with three vans were left severely out of pocket.

Graham Clews tried to have me write up a legally binding contract on the spot, for the promoter, that he would pay the next day. I had no experience in writing contracts, the guy signed it, but we never heard from him again. In October we were back on the road, this time touring with There For Tomorrow across Europe. This is where we had our previously mentioned breakdown in Austria, missed a show in Rome, but played one of our biggest shows ever at a festival in Paris.

When Mitch joined, we added a click track and backing tracks. In the commotion of the breakdown our backing track equipment had gone on the wrong van and TFT were not in Paris on time to hand it over, so we were playing clickless and without a backing track. This would have been fine, but we hadn't practiced for such an incident and there were parts of our set where we would all stop playing and had no clue how to fill the empty space where the piano section on the backing track should be. Oh, and when we played Austria, I shouted 'What's up Germany' to the crowd by mistake. What a miserable few days! Maybe that was why it was our last tour.

Not much happened for the rest of the year, except we wrote and recorded a new song called 'Hurricane' which you can still hear a demo version of on YouTube. Not long after this though, Mike announced his plans to leave Kyoto, and even though we tried to replace him, I don't think any of us had the energy to keep it going.

Post Kyoto Drive, some of us carried on with band life and some of us put our efforts into other endeavours. Mike returned to his acoustic past and he released a few EPs under the name Aesthetics, Chris now plays in cover bands and I started a new emo grunge band called Dearest with long-time merch guy Tucker.

Kyoto Drive was an exciting period in all our lives, it gave us a brotherhood and was the backdrop to us growing into adulthood. Being

in the band gave us all opportunities we'd never have had outside of it and touring sure gives you some good stories - even if sleeping on floors ruins your back"

"A good, solid listen. If you were looking for a comparison I'd suggest 'Clarity'-era Jimmy Eat World — lots of subtle guitar work, driving riffs, and soaring vocals. Catchy but not overly so. I'd much rather listen to a band that's passionate and can play, like Kyoto Drive, than most of the soulless rubbish that's doing the rounds today and it's therefore easy to see (and hear) why Engineer and Pacific Ridge have picked these guys up." **Punktastic**

"A mixture of New Found Glory pop-punk and early Taking Back Sunday emo-rock." **RockFreaks**

"A mix of Jimmy Eat World, Yellowcard, and All Time Low. Kyoto Drive's new album The Approach has some very positive and powerful lyrics. They have the power chords of a pop punk band, but they also have soft vocals that have a calming approach to it." **Josh Raj for Nerds on the Rocks**

"Kyoto Drive are one of those bands that should probably be more well known than they are. Their previous releases have proved to be consistent, feelgood blasts of satisfying pop-rock with a sound that is similar to the likes of You Me At Six." **Already Heard**

"Kyoto Drive are another one of the UK's rising stars and definitely deserve a place alongside Deaf Havana, You Me At Six, Octane OK and Young Guns. The band are supporting Hawthorne Heights on their September tour so make sure you get down early and check them out." **Soundscape Magazine**

"From the start 'This Is All We Ever Wanted' sounds confident, as 'Transitions' is upbeat and fierce and leads nicely into 'I'd Give It All', a song which was first heard on our Autumn/Winter 2009 compilation a few months back and has good blend of light-heavy guitars and strong vocal melodies from Adam Binder, along with occasional 'woah-oh-oh'.

Throughout the bands feel-good factor is consistent and nearly flawless. The band have used pop-punk/pop-rock to the best of their ability, as they show they can write a good hook (see 'Make Up Doesn't Cover Everything').

Whilst 'It's Not About Revenge, Don't Make It Personal' hints at a heavier sound, with thrashing guitars subtly hidden underneath Binder's adrenaline-

filled vocals. Closing track 'Waiting' is an eight-minute wonder, with a slow, passionate acoustic number leading into a strong full band performance, with a chorus that is crying out to be sung along too, before ending in a section filled with electronic beats and vocal loops, which is similar to that of Jimmy Eat World's 'Goodbye Sky Harbour'.” **Sean Reid for AlterThePress**

https://www.youtube.com/kyotodriveuk

Last Year´s Diary

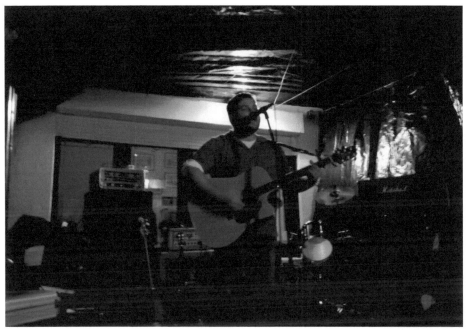

Alex Erich – Vocals and Guitar

Last Year's Diary was originally founded as an acoustic duo, before becoming a band and finally finding its true calling as a one-man-project. LYD may perform and record as a band, but who and what it is will always revolve around the singer and songwriter at its core, Alex Erich.

Bonn-based Alex has always written songs, even though most of his material has never fitted comfortably in the same genre as the punk bands he's played in and been inspired by. But when he found the time to play the songs he'd spent his life working on, they all found a new meaning and purpose as entries in Last Year's Diary.

Having to fill the space on stage that would normally be occupied by a band, Alex's solo shows are far from the introverted, self-reflective model copyrighted and perpetuated by his peers, as he believes in connecting with and helping his audience to find their voices and sing-along with him. Even though he may not fit the populist ideal of what a

LAST YEAR'S DIARY

punk is, Alex has always been, and will always be a punk in mind, spirit and body.

Having been shaped and moulded by the punk and blues bands that he was raised on, Alex's approach to playing and writing is as individual as his songs, and when you see him perform, you'll understand why he covers songs by Counting Crows as well as 'When Rhetoric Dies' by hardcore titans, BoySetsFire.

Last Year's Diary's self-titled 7" came out on Ignition / Engineer Records in the UK and Scene Police in Germany in 2001. Featuring three songs, 'Snapshots', 'Sunday Night', and 'Feels Good To Be At Home', recorded

in a couple of DIY sessions in a friends sauna while their parents were out. Alex sings and plays guitar, bass and harmonica on the 500 copies pressed and epitomises many people's idea of the political protest singer that the likes of Woody Guthrie and Bob Dylan created.

Engineer and Scene Police worked together with UK promoters to bring him over for tour in support of the new release. I saw Last Year's Diary play to a spellbound crowd in a packed cliffside café in the Leas Gardens in Folkestone and it was amazing. He was a one-man acoustic folk-punk song machine who captured the audience's attention and held it in the palm of his hand for the duration of the gig. This was around the time of Dashboard Confessional's 'Swiss Army Romance' and 'Places You Have Come To Fear The Most' and a forerunner of Kevin Devine's incredible 'Circle Gets The Square'. It was new, different, fragile and beautiful at all once, and I felt as though I was watching the start of a strange and wonderful musical revolution.

Initially inspired by the light of the campfires he spent his teens huddled around, Alex would later develop a more mature form of poetry and protest. That's what Last Year's Diary is all about. Big feelings delivered in small stories. Getting back to what really matters musically, using songs, poetry and protest to convey the emotional message that runs through and fuels every single note that Alex plays.

Alex's only vinyl release is a rare find now, the dusty eponym featuring Lasse Paulus on bass and Christian on drums, but if you find a copy, or pick up one of the rare live cassettes, then grab your favourite drink, sit back and lose yourself in the pages of Last Year's Diary.

https://engineerrecords.bandcamp.com

Low Standards, High Fives

Ame : Vocals, Guitar and Alto Saxophone
Luca : Guitar
Endi : Guitars and Vocals
Lore : Bass, Vocals and Banjo
Carlo : Drums

Low Standards, High Fives are a three-guitar indie rock band from Turin, Italy. Their name comes from the very first Ignition / Engineer Records release by the US band Hunter Gatherer and they draw inspiration from the evergreen catalogue of 90's/00's emo acts like Mineral, American Football, Appleseed Cast and The Promise Ring. You can hear them embody that same feeling throughout their records. They've collaborated with artists such as Garrett Klahn (Texas is The Reason, Solea) and opened for the likes of Fine Before You Came, The Penske File, Ratboys, Foxing, Dowsing, Gender Roles, Karl Larsson (Last Days of April) and many more.

Ame and Karl have been friends and playing together since they were fifteen years old. Back in 2012, knowing that the writing was on the wall for the band that they were in at the time and feeling like they were

341

trapped in a creative cage, they decided to start a band that would allow them to do anything they felt like musically and to see how far they could push their artistic limitations.

The rest of the story follows the usual band blueprint. They talked to a couple of friends who shared their vision of what punk rock could be and after signing them up, Low Standards, High Fives started jamming and writing. In 2015 their second guitarist left the band, leaving the door open for two of Ame and Karl's close friends to join their ranks. That is how they ended up with three guitarists and three vocalists, and even though it took them a while to find the right balance, LSHF eventually discovered that they needed to play less and listen to each other more in order to make their unusual line-up work.

That's what they did and what they continue to do. As Ame happily told me; "It works for us. The timing was right. Lorenzo, who I've known since 2012 was looking to join a band that was into the same music as he was. Endi was in a band called Farmer Sea who we're huge fans of and Luca had wanted to play in an emo-style band for about a decade, so luckily for us, everything just came together organically."

I asked Ame about what motivates and inspires Low Standards, High Fives and continues to fuel their collective fire; "All of us have been in bands since we were about fourteen. For us it's a matter of urgency, a primary need. I think all of us would have a hard time trying to imagine a life without playing music. I feel like we had no other choice but to be in a band."

He continued, "We all come from the alternative / indie music and love to listen to all genres of music, new and old alike, but share a deep and abiding love for the '90s and early '00s emo sound. Beyond that, we all love to explore music and are very curious about new genres and styles, even those that aren't part of the indie scene. If it resonates with us, it's something we'll listen to, it's that simple. Also, as we spend hours on the road driving to gigs we have a habit of making incredibly long playlists to which each of us adds songs. The result is always crazily heterogeneous and that's a good way to discover new music, which is a priority for all of us."

Like every band, trying to get LSHF to choose a record from their own discography that means the most to them is nearly impossible, but with

some gentle cajoling Ame admitted, "I would say that 'How Personality Works' was very special because we went into the studio with very clear ideas about what we wanted to do. When we were done with that record we took some time to experiment a little with sounds and try different solutions and that opened all sorts of doors to new possibilities. It was incredibly exciting, finding the key that enabled us to do that."

"Also recording our first album, 'Are We Doing the Best We Can?' was super fun and formative because it was the first time we recorded all of the instruments at the same time, playing together in a room and looking at each other's faces while doing it. We're very used to playing together so that felt way more natural to us than the separate multitrack recordings we did in the past. Once we saw we could record music that way, more or less live, we never went back. A shout out here to Manuel Volpe and Simone Pozzi who manned the board in Ruberdo Recordings (a studio in Turin, Italy) for helping us through this journey and for sharing their huge recording knowledge with us. They made us sound like us."

The story of Low Standards, High Fives home scene is an all too familiar one, as it used to have more venues and bands than it does today, and even though the band don't want to be judgemental and adopt an "it was better back in the day" attitude, when clubs close and things change it's sometimes hard not to see the past as the golden age of the musical culture that you grew up in. These formative early gigs in your local scene are always vitally important in helping you find your identity as a band and as musicians.

But, as LSHF freely admit, the will to promote shows is still there. It's just harder to make things happen with fewer clubs opening their doors to truly indie bands. Which as those of us who have been around since the eighties know, can be a blessing in disguise, as adversity breeds creativity and ingenuity, so maybe their scene's best days have yet to come. Only time will tell.

When punks who've spent weeks on end traveling to play here, there and everywhere in cramped, dirty vans that smell like feet that haven't been washed for three weeks get together, the conversation often gravitates toward the most memorable or horrifying shows that their bands have played, so Ame enthusiastically told me...

"It's so hard to pick one show. We love playing gigs where we connect

with the crowd, with the people organising it and with the other bands. Generally speaking, we love inclusive shows, with good vibes where you can feel the passion flowing through the crowd, bands, and promoters. It's one of the main reasons we do this, as we love to meet people and make new friends."

"The worst shows are without a doubt when we don't enjoy playing, when we feel like we didn't do our best, or when we overthink while playing. But sometimes a bad show for can still be a good show for the audience. It depends on perception and how that can differ between the band and the crowd."

"That said, the best shows are always when the band and the crowd share the same emotional experience, those are precious moments. I would say that's what we aim for when we're on a stage. But if we think about it too much it can disappear, as it all hinges on a very fragile balance which has nothing to do with the size of the stage or the number of people in the crowd. It's about what we feel and what we give during our set."

Ame continued; "Even though we've never been able to tour for long periods, it's something that we love. Spending days on the road together is definitely a highlight of being in a band and as all of us are 'family' we know what each other does and doesn't need. We always look after each other and take good care of every member of the band. We want to enjoy our time together. There is no place for ego or bad attitudes and we're lucky because we really click and create a happy environment. It's something we don't take for granted."

"Before playing gigs we will practice a lot, as we take the time that the audience devotes to us very seriously. They are giving us, a small and unknown band, part of their precious time so we don't want to play a shitty set because we didn't practice. That said, no matter how much time we spend in our practice room, bad shows can still happen. But at least we do all we can to avoid that. It's something we owe to ourselves and to anyone who supports us in any way."

I asked Ame if you he could elaborate on a few of these up and down gigs, and he told me; "Any story involving our drummer, Karl, is always funny. He's always looking for weird situations to put himself in and is the kind of guy that disappears ten minutes before on-stage time or soundcheck. Only for us to discover that he took a stroll around whatever town we

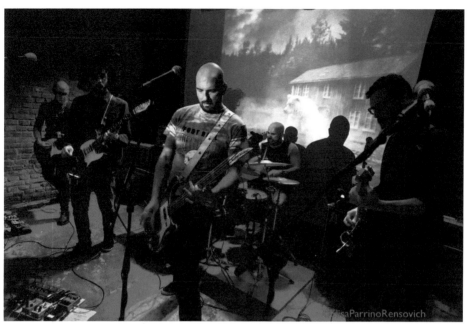

were playing in. It can be concerning but somehow he always gets back and is there in the end."

"One time we were in Rome for a festival and we heard him leaving the room we were all sleeping in, in the middle of the night. When we woke up we had no idea where he was. We checked our phones and saw an Instagram story he'd put online a few hours earlier: a view of the city from the roof of the building we were in. None of us had any idea of how he got up there or what he was doing so we had to go look for him. We finally found him asleep in the green room, behind the stage. He's just that kind of person, but we wouldn't trade him for anyone else."

Low Standards, High Fives first release was the four-song 'Revolushhhh' CD EP on Flying Kids Records in 2014. They followed this with the five-track self-released 'Enough' CD EP in 2015, which we had copies of in the Engineer distro. But the relationship between Low Standards, High Fives and Engineer Records really began when Ame sent me a demo of three new songs from their upcoming debut album, 'Are We Doing The Best We Can?" late in 2017. I was blown away and we started talking. It was the advent of an incredible partnership and friendship that we both cherish and owe to the power of music and the camaraderie of punk rock.

'Are We Doing the Best We Can?' (IGN244) was released as a nine-song CD album via Engineer Records on 31st March 2018. The record did well all across Europe and started to break the band into new areas, leading to more gigs and digital singles and videos for the songs 'Silent Décor', 'Bite Me' and 'Slow dancers in a rush hour'. LSHF worked hard on gigging the record and then started writing more new songs. Early in 2020 they released 'Monumental Lake House' as a digital single and then started recording the 'How Personality Works' four-song EP. This would be released later in 2020 jointly by Engineer Records (IGN306) and the Italian labels Collectivo Dotto, Scatti Vorticosi DIY, Longrail Records and No Reason Records on 12" vinyl. There would also be videos for the tracks 'Teens in the fireroom' and 'Things we won't say too loud' made by Ame himself by his ever-improving Ame Ray Vids company.

'Teens in the fire room' was the lead track with a resounding message and Ame told me about the lyrics; "Growing up is not only about having fun. Growing up also means playing with fire and getting burned a lot, not knowing who you are, wearing a mask and bleeding. So when the time comes, when it all changes, let it go."

It was that same punk rock camaraderie that brought Low Standards, High Fives together in 2012 that has ensured they've stayed the course, through thick and thin, for the last twelve years. Even though they'd all previously played in other bands, none of their former outfits had the same sense of family and connection that they all found in Low Standards, High Fives, which again is a testament to the all-encompassing power of punk-rock. As the band told me; "We never cared about making it or being successful, we just want to make memories and music."

As we drew our conversation to a close, I asked Ame if he still believed that punk, post-punk and the hardcore scene are still relevant and have a place in the rapidly changing and ever-evolving digital age. He reassured me; "Of course it does! A lot of new music has been influenced by punk and I think attitude is one of the most important parts of its legacy. I've enjoyed watching it change and evolve. For example, talking about emo / post-punk, I love how it fuses with totally different genres and in doing so helps to create bands like Nothing, Nowhere and others that found amazing ways to meld it with trap music. As long as there are passionate kids there will be emotional music. I can't wait to see where it goes."

He added; "One thing we hope for in the future is to see more female bands or bands with female members in them, because at least in our country, it is still quite rare in the hardcore scene. Sadly, it is a vicious circle; if no girls are playing on stage, then young girls have no role models to aspire to be like. They need to see that they can do it. Of course, they can be inspired by men too, as much as we can be inspired by women. But I'd like to see the balance change. Again, I'm just talking about our scene and don't want to judge things I don't know. I just hope that things will change and improve. We'll be happy to support any change toward a more inclusive scene, so let's put that into practice."

Thoughts Words Action reviewed LSHF's 'How Personality Works' saying; *"The quintet evolves as time passes and their previous recordings showcase how the group gradually built a more complex sound. 'Are We Doing The Best We Can?' blew us away with its subtle melancholy, unreserved emotions and brilliant musicianship. This time, Low Standards, High Fives are going a step further with their orchestrations and their emotive tendencies. LSHF are showcasing tremendous experience throughout these four compositions and will unquestionably blow away fans of emo, indie rock,*

post-rock and alternative music. Their subtle atmospheric but delicate articulations are unmatchable."

Italy's **Salad Days Magazine** added; *"Low Standards, High Fives are an atypical group in the national underground music scene, because if you put on any of their songs you don't believe for a moment that they are Italian. I'm not talking about wannabes ready to ride the Midwest emo wave that has been so popular in recent years, but about a group that has learned its lesson and reworked it in its own way, letting their emotions flow. The four pieces that make up this new effort show a group increasingly comfortable with their song-writing that is not afraid to experiment with melodies and sound textures with the intertwining of the three guitars (yes like Iron Maiden), emo where it belongs, without jangles and various trappings, and reinforcing the mantra of 'kill them with kindness'. If I had to give some co-ordinates I would say Mineral, Jimmy Eat World pre-commercial success and so on, but it would be unfair to LSHF who really put a lot of their own style into their sound."*

And **Punktastic** simply said; *"LSHF are a five-piece band from Turin, Italy, proving three guitars are better than two. If you like emo stuff like Christie Front Drive, American Football and Mineral then give them a listen."*

https://lshf.bandcamp.com

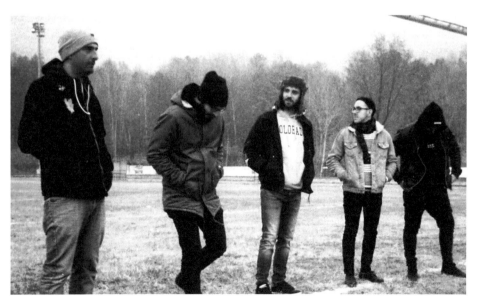

Madeleine

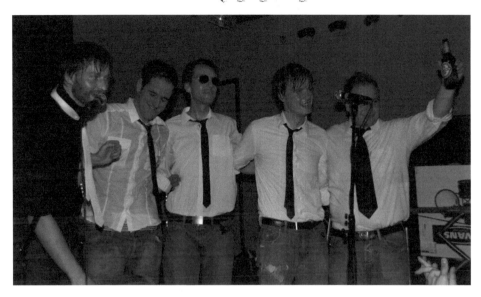

Martin : Vocals and Guitar
Tobbe : Guitar and Vocals
Christian : Bass and Vocals
Folkert : Drums and Synth

Madeleine, from Dusseldorf in Germany, came along to show us all where the melody went. Their catchy 90s-Brit-inspired indie-rock, played by a bunch of friends who grew up listening to Strike Anywhere, Gorilla Biscuits and The Get-Up Kids helped them to get on in a scene that can, at times, be openly hostile to bands that don't fit the blueprint that it's used to embracing. They may not have been around for long, but they managed to pack a lifetime of rock n roll dreams into their band's short life, including supporting R.E.M. And, at the end of the day, how many bands can say they did that?

The four friends in Madeleine were still young when their top-notch song-writing and musicianship beyond their years, accompanied by sheer determination, saw them recording at Downward Studios in Dusseldorf. I was introduced to them by Dennis Merklinghaus of Scene Police Records who sent me their demo and soon enough these seven tracks would form the well-crafted 'Boy=Man' CD and show everyone that they were a band that already knew how to piece together song after beautiful song.

The dynamics of these elegantly played, catchy songs teach us as much about restraint as they do about letting go. From the opening instrumental, 'At First', through all the soaring falsetto vocals and beautiful guitar work, to the mini-album closer, 'How It Goes', there is no filler at all. Madeleine had selected their best to offer us via the 'Boy=Man' CD EP (IGN047) and Engineer Records released it in June of 2005 with worldwide distribution supported by Shellshock in the UK, Road To Ruin & Nail Distribution in the USA and Redfield in Germany.

With a strong gig history already behind them, having shared stages with Wilco, Pale, Last Year's Diary, Red Animal War, Lampshade, Stereophonics and having toured Germany supporting Rilo Kiley in 2005, Madeleine were posed to up the ante and did even more touring, supporting R.E.M. through Germany in the summer of 2006.

For fans of Crosstide, Promise Ring, This Beautiful Mess, Radiohead, Elliott, Camden, The Motorhomes, Brandtson and the like. Madeleine knew how to work hard and play even better. I just wish they'd stuck around a bit longer.

Stewart Mason of **Allmusic** reviewed the record saying; *"German emo-pop outfit Madeleine debuted with the easy-to-like EP 'Boy=Man', something of a throwback to the sound of first-wave emo acts like the Get Up Kids and early Jimmy Eat World. The first thing that's notable about 'Boy=Man' is how agreeably tuneful it all is: after years of tortured metal-derived guitar riffs and anguished high-register squealing from hordes of cookie-cutter bands, it's almost hard to remember how catchy and melodic the style could be. Indeed, much of this record, like the near bossa nova rhythm and winsome vocals of 'By Bus', verges on downright pretty. Other highlights include the gently anthemic first single 'This Town' and the album's power-pop highlight, 'Adolescent Freedom Song'. A most enjoyable find for anyone with fond memories of a musical subgenre that once seemed to have such potential."*

https://open.spotify.com/album/7oOAkbSpt0rtGg2Gx2mfsV

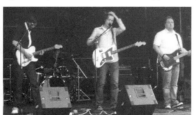

Maker

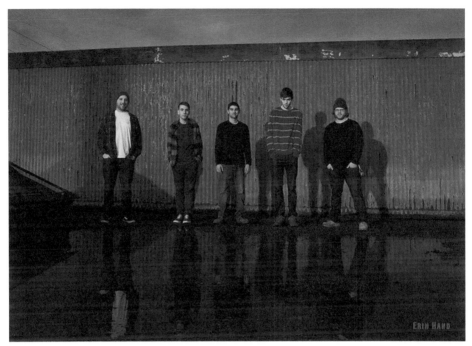

Dave Carter : Vocals
Eric Soucy : Guitar and Vocals
Mickey Lebeidz : Guitar
Mike Coyle : Bass
Raffi Santourian : Drums

Maker was a pop-punk band from Springfield, Massachusetts that lasted from 2007-2013 and toured full-time between 2010-2013. They were likened to Jawbreaker and released several great records, touring all over the US, Canada and the UK in support of them. Arguably known more for their onstage antics than their actual music, the core members of the band, as well as the touring fill-ins, had all been friends since they were teenagers.

Originally formed by Mike, Dave, Raffi and Tyler (their original guitarist), Eric joined on second guitar after the band's fourth show. That line-up lasted until mid-2009 when Mickey joined to fill the spot vacated by Tyler when he bowed out to go to college. Following the addition of Mickey, Maker stepped up a gear and toured with A Loss for Words, Such

Gold, Cruel Hand, Light Years, Hawthorne Heights, State Champs and many more, along the way playing at festivals including Sound and Fury 2011, Warped Tour 2013 and Pouzza Fest 2013.

It was a simple enough idea. After playing in various hardcore bands, Tyler wanted to start a band that had a poppier edge and sound, and after persuading Dave to join him, who he'd met when their previous outfits had shared a stage together, they made it their mission to find the perfect line-up for their new band by trawling through the pages of their little black book that was filled with scene and band friends. Dave suggested Raffi join them when Tyler played him the song that would later become 'Note To Self' and when Raffi said yes, it didn't take them long to find Mike and then Maker started writing and practicing as a full band.

But what about Mickey I hear you ask. Well he was one of the band's original fans, having seen them play one of their first shows (which his previous band had also played as the opening act) after releasing their demo, during which Dave and Raffi, who had known each other since they were five years old and being more like brothers than friends did what brothers always do and nearly came to blows on stage. Being fascinated by Mike's numerous tattoos and having realised that Tyler was one of the nicest and most genuine and open people in the scene, Mickey jumped at the chance to become the missing piece in the Maker puzzle.

Having formed to scratch multiple different itches, namely touring as far as California and getting to smoke some of the good West Coast weed, escaping the traditional confines of the VFW Hardcore circuit, embracing their collective love of the poppier side of punk and maybe reaching a boarder audience while pushing themselves as songwriters, Maker set out to fulfil their multiple ambitions, which wasn't going to be easy. But as a wise man once said, they'd either succeed or die trying, a credo that tragically nearly came true for the band that always seemed to be on tour.

Primarily influenced by East Coast hardcore titans like the Cro-Mags, Gorilla Biscuits and Kid Dynamite, the bands who assumed the roles of the eternal behemoths of pop-punk, namely The Descendents, Saves the Day, Alkaline Trio and Blink 182, and of course weed, Maker had set their sights on scene glory and making the sort of music that could stand on the shoulders of the giants who had inspired them.

Maker touted a demo around in 2008 and then a self-released EP entitled 'A Place To Call Home' in 2009. Their first record label release was the 'I-91' EP on 11th March 2010 via Either/Or Records and Animal Style Records. This was followed by a split 7" with The Story So Far, which was released on 23rd November 2010 with just 500 copies pressed on blue or white vinyl by Pure Noise Records.

The band's debut album, 'Mirrors' was released on clear vinyl LP and CD by LA's 6131 Records on 28th June 2011, and then re-released late in 2011 and early in 2012 by Animal Style Records with three more coloured wax variants.

Trying to pin them down about their own records in an attempt to discover which of them they favoured is an impossible task as none of the band could agree, but the general consensus seems to be 'Mirrors', which is, if you haven't already checked them out, the perfect Maker gateway drug. Trust me, one hit of the record and you'll be hooked for life.

Having been forged in the flames of the Western Massachusetts scene, Maker and its members were used to spending almost of their spare time at shows and being immersed in the DIY ethic from the moment they felt the punk rock call to arms. The scene they called home prepared them for life on the road. Was the West Mass scene the elusive and secretive sixth member of the band? Only the other five know and none of them will either confirm or deny it, but if you ask their contemporaries and fellow scene alumni Such Gold, Transit and A Loss For Words, maybe they'll set the record straight.

While I was reminiscing with Maker about the old days and the time they spent on the road, the subject of what they thought were their best shows reared its head, and rather than attempt to muddy the Maker waters, I thought it best to let everyone share their thoughts on this in their own words...

Dave: "The best was our hometown show in Holyoke at the Waterfront. The entire room was filled with folks singing back 'Stand By Me' to us, an older song. I never knew how many people knew my band until that moment and it was overwhelming. The worst show was any that we played with Kyle Lusty."

Mickey: "My first show with the band always stands out. September 2009, I took Tyler's place in the band when he started college. We played in Burlington, VT with The Stereo State. I think maybe two people paid to get in. The next day at a gas station, some underage kid gave Dave $20 to buy him cigarettes. We didn't know this happened, but Dave hopped in the van yelling drive! The kid ran after the van and did a drop kick into the side of the van at a red light. Turns out the kid never got his cigarettes. I knew this was the start of something interesting. We played a lot of amazing shows with Transit in 2010 all over New England. That summer, I left for my first full US tour on the same day I graduated High School. We played over 300 shows in the four years that we were most active. Sound and Fury and Warped Tour were definitely two stand-out gigs. I can't even think of the worst gig because there are too many of them."

Raffi: "Sound and Fury, Pouza Fest in Canada, the Hawthorne Heights tour in the UK and playing the MA date of Warped Tour. I'd always dreamed about playing the Warped Tour so that was cool."

Mike: "The most memorable show I have ever played was Dez's house in Garden Grove, California with Algernon Cadwallader. It was my first time playing a really choice show. There had to be 500 people in there just hanging off these exposed beams, on the roof, absolutely everywhere. Dave was hilarious that night. He made a Small Brown Bike joke that I was worried wouldn't go over well but everyone loved it and us. He was so spot-on with that crowd it was just magical. That show made me feel alive. Other than that, it's easily Sound And Fury 2011. We played really early but felt like complete rockstars."

Eric: "We played a house show in LA with Algernon Cadwallader it was just so crazy. People were stage diving off the roof, off the ceilings, it goes down in history as one of the most legendary shows I've ever played. It was a dream to get to Los Angeles, and then to just be greeted with hundreds of people that wanted to see your band."

Maker toured a lot, but toward the end of 2012, the band was in a devastating crash on the highway while on tour in Texas, which left one of their friends in critical condition. Luckily, everyone involved in the accident made a full recovery, but after going out for a brief run in the summer of 2013, Maker decided to call it a day. I keep hoping they'll come back, so asked them some more about their road and band tales. The Maker guys told me a few that immediately came to mind…

Mickey: "Maker is a very unique group of individuals. We all shared a passion for writing and playing music together, but we all have strong personalities. We liked to party and fight and everyone in the band has punched someone else in the band at some point. Drinking, smoking and gambling were all usual causes, but not always. Also, we always borrowed gear. We had our own equipment, we just didn't want to bring it on tour. The bands we played with would often catch onto the bullshit stories. Sure, it's okay to share a backline, but you could always count on Maker to want to borrow guitar cables, cymbals and snare, guitar heads, and maybe even a guitar or two."

Mike: "Most of my funny stories are within our band. We were just a bunch of hoodrats with a van. We were always fighting with each other and other people. I remember one time we were playing a show in Pittsburgh and were warned about how PC the venue was and that night, Dave went on stage with a Michael Vick jersey. (NFL quarterback who went to jail for running a dogfighting ring) I remember their faces to this day. Absolute horror. Another funny time (to me) was one night in Toronto we got annihilated and Mickey and Eric were bickering. The next thing I knew, Mickey had kicked the window out in our own van in the middle of winter. It was pretty bad then, but I'm glad I can look back on it now and laugh."

Eric: "We got into a brawl with security one time in South Carolina. We had to leave Dave and Raffi, they were chased on foot by the police and dogs into the woods. We ditched the van at a Waffle House and waited for them to call us. We finally got the call and they worked it out with the cops that the security started to fight, and they pulled up in the cop car in the back, smoking cigarettes. That was a legendary story for us.

"Another major event was on our 2010 tour with Such Gold. Dave lost his mind, and we later learned he was dealing with schizophrenia. He really lost his mind and Tyler quit the band. Dave had serious charges from something at home and went to jail for a short time then was under house arrest. It really changed the band forever, for better or for worse. Dave became even more creative and we all became very close, but we were labelled as a band that had a mentally unstable singer. At the time it wasn't a very PC world and people made fun of him, there were message boards making fun of us. But he was our friend and we did our best to support him.

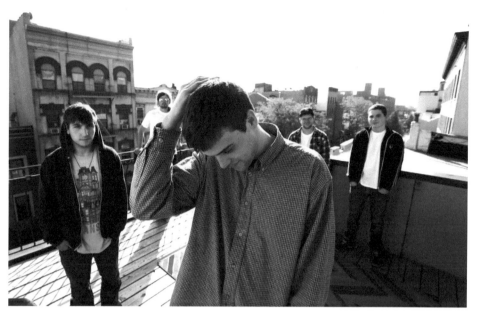

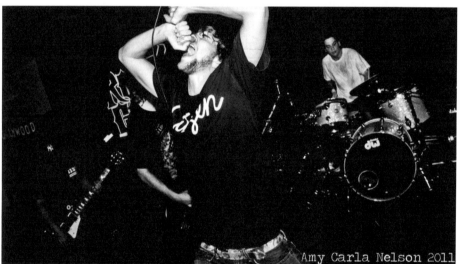

Amy Carla Nelson 2011

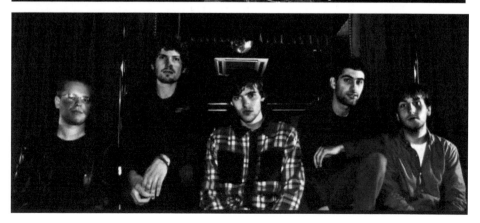

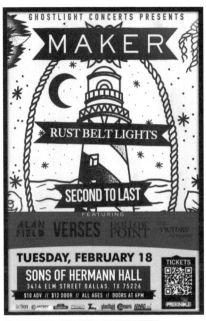

GHOSTLIGHT CONCERTS PRESENTS

MAKER

RUST BELT LIGHTS

SECOND TO LAST

FEATURING

ALAN FIELD **VERSES** HOLLOW POINT

TUESDAY, FEBRUARY 18

SONS OF HERMANN HALL
3414 ELM STREET DALLAS, TX 75226
$10 ADV // $12 DOOR // ALL AGES // DOORS AT 6PM

TICKETS

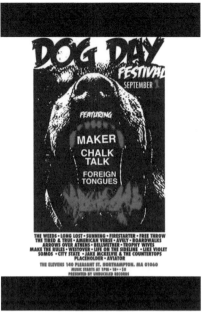

DOG DAY FESTIVAL
September

FEATURING

MAKER
CHALK TALK
FOREIGN TONGUES

THE WEEDS • LONG LOST • SUNNING • FIRESTARTER • FREE THROW
THE TIRED & TRUE • AMERICAN VERSE • AVELY • BOARDWALKS
ARROWS OVER ATHENS • BELLWETHER • TROPHY WIVES
MAKE THE RULES • WESTOVER • LIFE ON THE SIDELINE • LIKE VIOLET
SOMOS • CITY STATE • JAKE MCKELVIE & THE COUNTERTOPS
PLACEHOLDER • AVIATOR

THE ELEVENS 140 PLEASANT ST. NORTHAMPTON, MA 01060
MUSIC STARTS AT 7PM • 18+ • $8
PRESENTED BY UNBUCKLED RECORDS

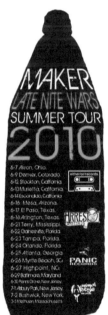

MAKER
LATE NITE WARS
SUMMER TOUR
2010

6-7 Akron, Ohio.
6-9 Denver, Colorado.
6-12 Stockton, California.
6-13 Murietta, California.
6-14 Escondido, California.
6-16 Mesa, Arizona.
6-17 El Paso, Texas.
6-18 Arlington, Texas.
6-21 Terry, Mississippi.
6-22 Gainesville, Florida.
6-23 Tampa, Florida.
6-24 Orlando, Florida.
6-25 Atlanta, Georgia.
6-26 Myrtle Beach, SC.
6-27 Highpoint, NC.
6-29 Baltimore, Maryland.
6-30 Penns Grove, New Jersey.
7-1 Asbury Park, New Jersey.
7-2 Bushwick, New York.
7-3 Nathean, Massachusetts.

MAJOR LEAGUE TURNOVER
CO-HEADLINE TOUR WITH SPECIAL GUESTS:
MAKER

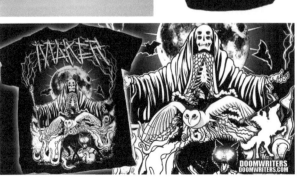

DOOMWRITERS
DOOMWRITERS.COM

358

"I visited him in jail every week and wrote letters every day. You know, when you're on tour with a guy like that it's crazy every night we didn't know what was going to happen. There was a night we all slept in the van in the dead of winter in Colorado and we were scared to sleep next to him. He turned out to be a great person, we just didn't know how big of an issue it could be, being on the road eating so much shitty food, not getting good sleep and partying every day."

Dave: "I stole a bottle of Absinthe in some Welsh town from a fat broad who told me a tale about sucking off all of Mumford & Sons when she met them on tour."

Raffi: "Flipping our vehicle in Texas was one of the craziest experiences of my life."

Given how much time the band spent on the road and the general mayhem that was part and parcel of their day-to-day lives, it's easy to understand how Maker still can't put their fingers on exactly how they became part of the Engineer family, but when pressed on the subject, most of them seem to recall that it had something to do with their previous manager hooking up with us and sending a demo over late in 2011.

In 2012 we released a self-titled five-song CD EP for Maker, working alongside Connecticut based Asbestos Records, and pushed the band all over the UK, Europe and the US. There was a video for the song 'Shadows' too, launched on Blank TV. And maker's singer, Dave, noted, "Engineer is the only label that the band was involved with that doesn't actually owe us money!"

The Maker self-titled CD EP (IGN197) came out in November 2012 jointly on Engineer Records and Asbestos Records, and was also re-issued in 2013 by Black Numbers Records from New Jersey. This was followed, a while later in March 2014, by the split 7" with Such Gold, Ivy League and Turnover via Buffalo, NY's Broken Rim Records. This four-band, four-song EP was pressed on green, bone and black vinyl variants initially with silk screened covers, and then repressed on orange / yellow and white / grey wax when it sold out.

When I finally asked them about why Maker split the guys all had a slightly different perspective and answer, so rather than try to sugarcoat the band's demise, I've included their comments here too...

Dave: "Maker is frozen in time. We'll never break up or have a last show or a reunion show. None of us are really friends anymore but I have a vision of a revival, maybe just a young man's dream I guess."

Mickey: "We threw in the towel at the end of 2013. We were burnt out. We all hated being around each other and were sick of being broke. Sick of sleeping on dirty hardwood floors. We burnt too many bridges with booking agents and promoters. We had a bad history of cancelling shows at the last minute, or showing up late, causing problems with locals or each other and simply making it too much of a chore to book our band. In our defence, we were all young and dumb. We didn't understand the consequences. Maybe we did, but we certainly didn't care. When we decided to call it quits, we all felt a lot of emotions, but they quickly turned into relief. We realised we all felt this huge burden off our shoulders. Once the stress of the band was over, we were able to all become friends again. I still keep in touch with everyone and maybe we'll play again and maybe not."

Eric: "The band broke up because of Dave. We were on tour in Texas and he got into a physical altercation after the show that basically broke the camel's back on top of other issues we were having. We got in the van and just drove home for thirty hours and no one said a word. We all knew it would be the last time that we would be in that situation together. We all knew you can only support something that is failing for so long and it's tough when you love it so much, you hold on a lot longer than you probably should."

On a more positive note, this brought the conversation around to the subject of punk-rock and the hardcore scene and the role they played in the lives of the folks who were part of Maker. This is what they had to say...

Tyler: "There will always be a place for punk and hardcore. It's a reaction to adversity and as long as there is adversity, there will always be punk and hardcore. It's going to look and sound different sometimes, or it will be a mutant combo of something from different ages. Some people hate that, but I think it's cool as hell. It's also inspiring that so many kids are getting into punk and hardcore again now. At its core, it's a youth-driven culture, but also in 2024 there are old heads who could be bringing their kids and grandkids to shows. It's a beautiful thing and something I'm grateful to have been even a little part of."

Mike: "Hardcore and punk are so much more than just music. It's an absolute lifestyle. It's an attitude and it's the way you view the world. I remember seeing Trash Talk going on tour with rappers and I remember thinking to myself "That's punk as fuck". I look at people I went to school with, sports kids, scholars and whatnot and just feel pity towards them like they don't know the feeling I feel. They will never know what it's like to view the world the way I do. I feel really lucky that I discovered punk and hardcore."

Mickey: "I think punk and hardcore is probably bigger than it has ever been. It's a young person's game. There are people like me still booking, attending, and playing shows in my 30's but it's the younger generation who comes out and keeps it alive. If Vinnie Stigma (Agnostic Front guitarist) can still do it, I can still do it."

Eric: "Hardcore and post-punk will exist forever. There's a beautiful subculture in it that you can't get anywhere else. The DIY ethic is so unique to the music scene. I work in NYC now in the fashion scene and the coolest people I work with also came from an underground music scene that taught them how to make something out of nothing. If you want to leave your hometown, you have to try your best and make it happen."

Dave: "Punk rock will always live as long as people make fun of Machine Gun Kelly and shit like that."

As for what the members of the band are currently doing, well they're all living their best lives and following their own paths. Mickey still lives in the Springfield, MA area and has been playing bass with Cruel Hand, keyboards with Matthew Spence and the Churchkey Choir and guitar in Receivers with Tyler. Receivers became Tyler's main musical outlet after leaving Maker. The band doesn't tour but has played more than a few shows throughout New England over the last decade. Mickey and Tyler also work with some friends to host a DIY venue in Holyoke, MA known as Dracula. Eric and his wife currently live in Brooklyn, New York, and own and operate a photography studio. Mike just bought a house in Texas and runs a bar down there. Dave and Raffi are both still in Springfield as well, and Dave still actively performs with his solo hip-hop project under the name Big Wavy Draco and Raffi runs a car wash.

Scene Point Blank described Maker as; *"Playing a style of pop-punk that relies on speed bolstered by breakdowns and gang-vocals."*

Some Will Never Know reviewed 'Mirrors' as; *"Raw yet melodic... full of passion."*

The Punk Site said it was; *"Breakneck post-punk with elements of Crucial Dudes and The Wonder Years and thoughtful collateral circa Brand New and early Taking Back Sunday."*

And **Sputnik Music** added: *"Taking cues from tour-buddies Crucial Dudes and The Story So Far, as well as drawing influence from Jawbreaker and even early Brand New, Maker combine the vitality of passion-driven songwriting with the accessibility of beefed-up choruses, driving their product home with the familiarity and modesty of your favourite local band."*

https://www.youtube.com/watch?v=1smP3K58Zkc

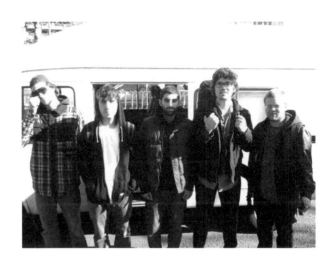

Merciana

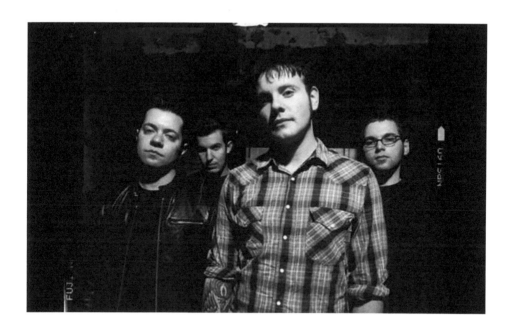

Matt Haick : Vocals and Guitar
Shawn Reams : Guitar
Ryan Roberts : Bass
Chris Walsh : Drums

A New Jersey hardcore band with more hooks than a well-used fishing tackle box. Playing melodic punk-rock somewhere between Lifetime and Alkaline Trio, they burned bright, played some big gigs and should have been huge, but made a few bad decisions and didn't stick it out long enough to see where their music would've taken them.

Merciana started life in 2002 when Matt Haick, who had been playing guitar in Nora, a New Jersey based metalcore band signed to Trustkill Records that had made more than a few ripples in the hardcore pond, wanted to try his hand at writing and playing more melodic music. He recruited three of his friends, namely drummer Chris Walsh, guitarist James Tsaptinos and bass player Mitch, and following the recording of a four-song demo, Merciana was born and began playing shows.

Following their sophomore show, Mitch parted ways with the band and

Ryan Roberts, a long-time friend and former bandmate of Matt's, was given the nod and asked to join Merciana. Ryan had known Matt since they were sixteen years old and had previously shared stages and spent time in rehearsal rooms with him as a member of Four Past Midnight, an emo band formed from a collective love of Falling Forward and Texas Is The Reason, and Nowhere Fast (who were signed to Pinball Records), an established pop punk band who had played shows with, among others, Less Than Jake, Catch 22 and Big Wig.

It was while they were playing in Four Past Midnight that Matt introduced Ryan to a record that would change his life, musically at least. That record, originally given to him on an old Memorex cassette, was Jimmy Eat World's 'Static Prevails'. Put off by the fact that he thought the name was stupid, it wasn't until he gave in and pressed play that he was overwhelmed by the fact that there was another band from way across the country, tuned into the same mindset that he and Matt were. It was a moment of epiphany and an inspirational turning point that Ryan has never forgotten.

Having realised that they wanted to push the punk-rock envelope and explore similar territory to Lifetime and Samiam, Ryan and Matt then formed Carousel Kid, a band that to this day Ryan regrets didn't go further, as it served as a near-perfect amalgam of all the things that they both loved; emo, punk and hardcore. But after a year or so, and in the wake of releasing a demo and playing more than their share of local shows, they called it a day. Matt went on to join Nora, while Ryan spent time in This Life Again, a hardcore band that was a little too much in love with nu-metal for the future Merciana bass player's liking.

Even though he spent way too long trying to subtly transform This Life Again into the next Snapcase, Ryan knew that if Matt was back in the songwriting driving seat with Merciana, then he needed to be part of that band. And when he got the call, before Matt had even finished asking him if he wanted in, he'd already said yes.

Merciana shared the DIY ideals and belief that their home scene in New Jersey had taken to heart, that there was no difference between the people on stage and those who had come to see them play. They wrote music because they wanted to hang out with their friends and play gigs. They didn't have any grand plans and certainly didn't want to be famous; they just wanted to play.

While we're on the subject of scenes, the one that Merciana rose from, New Brunswick, is a pretty legendary scene. In the mid-nineties, New Jersey had a thriving hardcore scene with shows happening almost every weekend at venues such as Middlesex County College, the Manville Elks Lodge and the Princeton Arts Council. By the time the 2000s rolled around the scene had shifted to a post-hardcore style and its hub had moved to New Brunswick. Merciana was lucky to be at the center of this scene along with bands like Ex Number Five, the Low-End Theory and the band that Ryan is adamant was the best to turn it up in the New Brunswick area, The Break.

The Break was formed by two ex-members of the amazing political hardcore band, Endeavor. They put out records on Doghouse Records and Ferret Records and were an incredible live band. Merciana became good friends with their singer, John Waverka, and years after both bands broke up, Matt and Ryan formed a side project with John called Bed of Snakes. They wrote some songs together and recorded them in Matt's bedroom. Timing is everything though, and during the same year that the band started, the three members all got married. Real life got in the way and they never even played a show. But three of the songs they wrote together were released on a self-titled CD (IGN351) in 2022 by Engineer Records.

Speaking with Ryan about his punk-rock journey and when and why he started to follow the same path that so many of us have, he told me; "Hearing Green Day in 1994 as a 13-year-old forever changed my life. This led me to find other bands like Rancid and Bad Religion and I lived in that world for a while until a friend of my older brother's introduced me to hardcore by way of Vision of Disorder's demo tape. He also took me to my first show and after that I was hooked, soaking everything in: hardcore, punk, emo and even death metal. Anything underground was music to my ears."

Despite the fact that the band burned brightly, but briefly, their initial four-track demo impressed Ben Weinman, guitarist of The Dillinger Escape Plan and now Suicidal Tendencies, enough for him to track them down and sign them to his management company, RTS, almost immediately after Your Enemies Friends, making Merciana just the second act on his fledgling roster.

The band then went into the studio again, and recorded another four-track demo, which led to them popping up on Craig Cirinelli's radar. Craig

ran the US chapter of Engineer Records out of Boonton, NJ and helped find great bands for the label and promote them over there. It was conversations between Craig and the band that saw them sign to the label and release their six-song CD EP, 'Let It Begin' (IGN060) in 2005. Their track 'Half-Shut Eyes' also appeared on the Engineer 100 sampler CD.

I asked Ryan about some of Merciana's most memorable gigs and he told me; "We played some good shows during our short existence. Ben and RTS management helped get us on great gigs: a CMJ showcase in NYC, SXSW Fest in Austin, TX in 2003, Hellfest in Syracuse NY, Skate and Surf Festival in Asbury Park, NJ. We also played Rise-Up, HellFest, and toured with The Dillinger Escape Plan too."

"One in particular that sticks out is a gig we played at CBGB's but the memorable event took place before the show even kicked off. As we were loading into the historic venue there were only a few other people inside, members of the other bands and some staff members. But there was one person there who stood out as he wandered around talking to himself.
We thought he was a homeless person who'd just wandered in until our drummer, a massive Lemonheads fan, recognised him and said; "Are you Evan Dando?!" It turns out it was and he proceeded to tell us he was looking for the gold record he had given to CBGB's back in the day as he was hoping to get it back so he could sell it. That left a lasting impression on me and anytime I hear their cover of Mrs. Robinson on the radio it brings me back to that night in NYC."

In my opinion, Merciana suffered from a case of 'too much, too soon'. They received quite a bit of attention early on which, in hindsight, may have been to their detriment. After just their fourth gig they signed with a management company. Then they had interest from both Island and Capital Records and were offered a development contract from producer Lou Giordano (Sunny Day Real Estate, The Ataris) which they were advised to turn down as the percentage he was asking for was too high. After the band passed on Lou's offer he went on to produce Taking Back Sunday's 'Where You Want To Be'. Whoops!

They also had interest from Fueled By Ramen but instead of responding to the label themselves, their manager wrote them back, effectively scaring the label off, never to hear from them again. All of this happened before Merciana ever went on tour or had anything more than a self-released demo out. Too damn much, too damn soon.

It's impossible to talk about Merciana without discussing the band's untimely death, so I pressed Ryan about it and he told me; "Merciana broke up shortly after the release of our Engineer Records debut, 'Let it Begin'. Ha. It's nothing you did, but I think we all got so dejected after fumbling so many of the early opportunities that came our way. In hindsight we should have gotten in a van and headed out on tour. We were getting so much attention but kept putting the cart before the horse, so to speak. We formed our band as a group of friends who wanted to be creative and play some gigs together, but the offers we received early on blinded us and ultimately destroyed us."

With this lesson in mind, I wanted to get Ryan's thoughts about the state of the current punk scene, and what the music behind it means to him today. He replied; "At the risk of sounding melodramatic, this music that has brought us all together, punk, has shaped my entire life. It's not something I'll ever 'grow out of'. The DIY nature of the hardcore and post-punk scene that I cut my teeth in have helped me navigate life. I feel incredibly fortunate to have stumbled into this scene and I trust that it is just as relevant and is in good hands with the youth of today."

Jo Vallance at **Room Thirteen** described *"US purveyors of melodic rock"*, Merciana's 'Let It Begin' as; *"Brimming with aggression that's restrained and pumped through the spasmic guitars and edgy vocals. Like a less hardcore version of Hell Is For Heroes."*

Lambgoat reviewed 'Let It Begin' as; *"A thoroughly listenable and cohesive EP comprised of one strong hook after another. There are some noticeable similarities to other bands who have blended hardcore influences into heavily melodic rock, but the only ones worth mentioning in my mind is a rare slip into newer Underoath territory and Haick's occasional resemblance to Lifetime's Ari Katz. The songs range from mid-tempo poppy rockers like 'Anvil Chorus' to the swaying power balladry of sorts on 'Stagnant'. Each of the six tracks displays another facet of Merciana's abilities, making this an EP worth checking out."*

And **Interpunk** described their sound as; *"Aggressive and heavy-driven yet not lacking in pop sensibility. Much more akin to cascading choruses, mood-inducing intro-pieces and an almost stadium-ready song structure. The songs on 'Let It Begin' are hooky, yet at the same time never fail to challenge the listener."*

https://open.spotify.com/album/5uF9DQo6HlDIsjzRidQTVZ

Minor Planets

Dani 'Flamer' Alonso : Vocals and Guitar
Jaume Pérez Meix : Guitar
Jordi Soteras : Guitar
Álvaro Aguilera : Bass
Carlos Cadena : Drums

When the sun sets over Barcelona's historic streets, you can almost hear the melodies of Minor Planets, a band imbued with a unique blend of Get Up Kids-inspired melodic rock and an underlying punk ethos. They've emerged as a celestial body in the alt-rock universe, their music painting in all the shades of life's highs and lows.

Many times, when you stop and look back, it's impossible not to be amazed by all those little details and random decisions that, by sheer chance, have gradually led you to the point where you are today. It's interesting to see how music, over the years, has shaped absolutely everything around you: how you met your friends, the way you see the world, your hobbies, even some of the most important moments of your life are accompanied by the soundtrack of your favourite songs. And

maybe everything would be different if, on that day, years ago, that song or album that made you shiver wasn't playing exactly in that precise place and moment.

"The band that ignited the spark for us forever was probably The Offspring, with their album 'Smash' says Jordi Soteras, guitarist of Barcelona's Minor Planets. "Back in those days, there was no internet or digital streams like today, so you bought the album and then made dozens of cassette copies for your friends who wore them out in their Walkman's. We were really obsessed, listening to music 24/7. It didn't seem too complex to play, so why couldn't we do it ourselves? We just wanted to get on stage and play fast."

"Carlos Cadena (drums) and I managed to save some money, so went straight to a second-hand store to buy some instruments. With almost no idea what we were doing, we started making noise in the hope that at some point we would manage to play something decent. I must admit that moment took a while to arrive."

But as time went by, through the late '90s, into the early 2000s, there were plenty of punk and hardcore concerts being put on in Barcelona every weekend. So, like many teenagers at the time, Jordi and Carlos tried to attend as many as they could. The gigs were usually in very small venues, social centres and makeshift clubs, so the sound was far from the best, but still, those bands seemed incredible live. They'd also visit specialist record stores in the city and blindly buy any recommendations the guys there gave them to check out.

"At that time, we didn't know Álvaro, Dani, or Jaume. Each of us had our own band trying to make the most of any opportunity, so it was common to run into each other at the same places every week and see each other's bands play live over and over again without exchanging more than a few words for years. We knew each other by sight, by hearsay, through common friends, but everyone was focused on their own projects. Throughout these decades, among us all, we played in a variety of bands such as Undefeated, Still Water To Rain, Torches, Hands of Fate, Red Turning Blue, The Defense, Àncora, Evil-Lynn, Hangman Tree, Shedarsick, Somehow, and Flamsteed."

For a while, Carlos played drums in The Defense, a band where Jaume Pérez Meix also played guitar. Originally the band got Jaume's phone

number to offer him the position of guitarist, but instead decided to play a prank on him and just sent a message with a time and location, as if asking for a fight. Most people on receiving this odd threat maybe wouldn't have shown up. But Jaume did and he got the job.

"Back then, we saw the scene as a good place to meet people and discover great bands. Everyone contributed their little part towards something bigger, bands, concerts, zines, merch, designs. There were more popular bands, but in general, everyone had their chance to take the stage, and usually, the audience responded well." Continued Jordi, "After a while though it became noticeable that things were changing, and many of the people we were used to seeing, no longer appeared. The scene became fractured and hostile for many, raising fewer opportunities to play larger shows with foreign bands, so some people starting organising their own events at new venues."

Around this time (2010), Carlos, Álvaro, and Jordi played in a punk-rock band called Torches and were organising shows to promote their first album, 'Memories and Sick Calls'. (Their second album was entitled 'New Ways, Same Fire' and came out on Western Valley Records). They'd share the stage with Hangman Tree, who Dani played with, and Àncora, who Jaume played with, and that was the start of many concerts together. Jordi fell down a staircase just before one of these gigs in Barcelona, breaking his leg. But gamely still agreed to play the show with a cast on. As it happens, it poured with rain that night, so hardly anyone showed up to see this act of courage and determination. When bands play pretty much just for the other bands, they get talking and the guys soon became fast friends.

In 2021, as everyone emerged from the lockdown caused by the Covid-19 pandemic, the five of them finally got together in a new band. Although based on the punk and hardcore they all loved, Minor Planets would have a calmer sound, with cleaner guitars, even incorporating acoustic elements and more classical song structures. Inspired in part by bands like The Menzingers and The Gaslight Anthem, they soon began to add personal influences and develop their own sound.

"The first thing we did was to create a WhatsApp group, finding an instantaneous connection and good atmosphere, so much so that we had to create a second WhatsApp group to channel the more serious aspects of the band, such as arranging concerts, recordings, rehearsals, etc."

Jordi told me, adding, "The original WhatsApp group is still active every day, and at times can be frenetic. Sharing reviews, opinions, links. It's the busiest one I am on, and I love it."

Coming from a punk-rock, hardcore, and even metal background, one concern the band had in the early days was whether they would fit into any particular scene. All the bands, labels, and promoters they knew were into heavier stuff so perhaps their songs wouldn't be so well-received. So, almost as an experiment, they entered the El Turonet (The Hill) studio with Claudi Arimany and recorded two songs to see how they would be accepted. The result was their self-released digital demo, called 'Outsiders', that soon reached over 1000 listeners online from all around the world.

Satisfied with this interest the band returned to the studio in February 2023 with even clearer ideas of how they wanted to sound and started recording their brilliant 'Neverending Days' EP. Fuelled in the studio by the 'Jaume Menu' where he went off to the supermarket at the start of each session and came back with bags of cookies, donuts, crips and juices, one time just before Jordi had a medical check-up at work, prompting the nurses to kindly recommend that he quickly improved some aspects of his diet.

A couple of weeks later Minor Planets would be playing with SecondBest at La Textil, one of Barcelona's best music venues, a 3,500 square feet craft brewery housed in an old textile warehouse. The bands would play in the basement, marching in with all their amps and equipment, through a busy and rather elegant restaurant. They made it work though, airing the tracks for the first time to a full crowd and selling out of the t-shirts they'd printed for the show.

Now the band wanted to release the EP in a physical format and gain more promotion, so they started contacting record labels and soon found a welcome home at Engineer Records. We discussed the options and agreed on a CD format, with the four new tracks, plus the original two tracks from the first demo, on a six-track release. The CD would come out in the late summer of 2023, both on Engineer Records and Deal With Hate Records from Spain. The launch would be supported by a video for 'Sunsets and Sunrises', jointly premiered and promoted by Mass Movement magazine and Suspect Device fanzine in the UK, as well as Thoughts Words Action and Idioteq blogs in Europe, quickly gaining it over 5000 views.

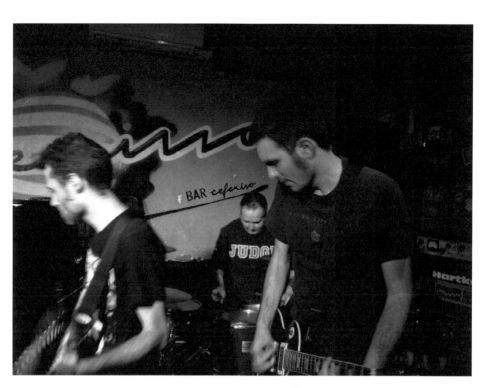

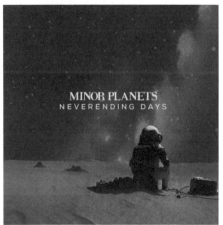

"It was a blast for us." Says Jordi, "Throughout the process we felt very comfortable talking with David and planning how we would release it, where it would be distributed, where it could appear in the media, etc. For us, it was a breath of fresh air and helped us take a step forward as a band, to bring our music and videos to places that would not have been possible otherwise. We cannot be more grateful to him."

Although Minor Planets are a relatively new band, the members are not new to the scene, having spent countless hours on the road, traveling in vans, losing money, enduring poor meals and lack of sleep for days, all for the simple joy of stepping onto a stage. Jordi reminisced, "I remember one time, with the band Still Water to Rain, when we arrived more than two hours late to a gig in northern Spain, due to a misunderstanding with the van rental company. The audience became tired of waiting and headed to another show in a nearby town. So that day, we literally played for the person running the bar at the venue. Throughout that tour we had several dates where we couldn't even find a place to sleep. We took turns deciding who would sleep inside the van with the instruments, while the others opted for sleeping on the street under the stars."

"One of those nights, looking for a quiet place to sleep without drawing too much attention, we ended up parking the van in a residential area on the outskirts of a city in the Basque Country. Without any idea of our location, we unknowingly stayed right in front of the house of a famous Spanish television presenter. I remember waking up, stepping out of the van, and seeing my bandmates stretching their arms outside. On the sidewalk in front of us, this presenter emerged from her house with her children. She looked at us, and I can assure you that I have never seen so much disdain and disgust in someone's eyes. She wasn't used to seeing punk-rockers on her street, so proceeded to notify all her friends in the neighbourhood. We left before they could call the police."

"On another occasion, we had a gig at a venue in Alicante. We arrived there in the afternoon for sound-checking but knew the concert would start later than usual because FC Barcelona were playing Real Madrid at 8pm. What we didn't know though, is that dozens of Real Madrid fans would be in the venue to watch the game and weren't in a particularly friendly mood with us Barcelona fans. We walked in to see an ocean of white shirts, scarfs and jerseys all singing drunkenly about the opposing team. So, we sat at a distant table, trying to watch the game and show

minimal interest, but when Barcelona scored the first goal we couldn't contain our cheers, causing the entire bar to turn and look at us simultaneously. I had the impression that we had just made a serious mistake, immediately thinking about our van, parked right by the door, with a Barcelona license plate. When Barca scored the second goal, we tried to be more subdued, but the damage was already done."

Dani, Minor Planets vocalist and guitarist, joined us with more humorous stories. First, about getting pee'd on by a dog at a squat gig with his band Start Today, and then, about almost being brained by a drunken punk with a chair at a Flamsteed gig in Girona, where he was luckily saved by some members of the audience. "It's all worth it though" Dani confided, "We love playing live and feeling the warmth and energy of the audience, seeing that expression in their eyes that tells you they are enjoying what they are hearing."

There's certainly a great camaraderie within Minor Planets. Just five friends making music, recording songs, and having a great time. Jordi summed it up, "I believe that hardcore or punk still has a very strong reason to exist today. There will always be people who find it as their refuge, their way to express ideas in a community of DIY culture. If it remains underground, it stays stronger and more authentic. There is no better way to express your view of the world then through four chords with your friends. For me and so many people of our generation, it has been one of the best things we have done, and it will undoubtedly endure for new generations."

Idioteq reviewed the Minor Planets CD saying; "*Delving into themes as diverse as personal loss, labour exploitation, the unchecked whims of capitalism, and the aging process. Equally compelling in its commentary on the paradox of alternative music scenes, odes to fleeting moments, and the vitality of living in the present. 'Neverending Days' is more than just an EP. It's a declaration of the band's innovative spirit.*"

https://linktr.ee/minorplanets

Miss Vincent

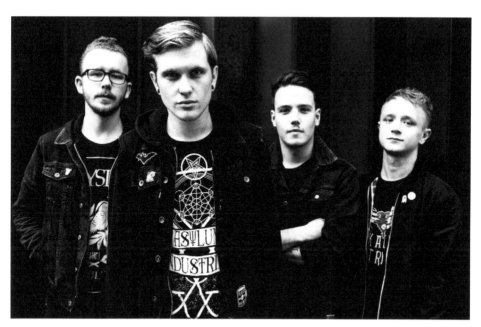

Alex Marshall : Vocals and Guitar
Lawrie Pattison : Guitar and Backing Vocals
Owain Mainwaring : Bass and Backing Vocals
Nate Davenport : Drums and Backing Vocals

Miss Vincent. On the one hand, they're a four-chord punk-rock band from Southampton. On the other, they've got more harmonies than a Saturday Night on the Ed Sullivan Show in the 50s. They worship at the altar of bands like Alkaline Trio, Ramones, Misfits and Bad Religion, but you'll also hear a whole load of other influences, both new and old. Bayside, Danny and the Juniors, Green Day, The Menzingers, The Gaslight Anthem, Against Me!, The Ronettes and more. They're the sum of their melting-pot parts, which is probably why they get compared to so many different bands and why so many people seem to hear something different, which is, as lead singer and guitarist Alex said while grinning, "really cool."

In 2011, Alex was in a weird place. He loved punk-rock, but nobody seemed to be playing it anymore. It was all Neck Deep or New Found Glory style pop-punk bands, and even though he liked some of them, the scene's desire for them pushed it to the point where nobody

wanted to play in the type of band he wanted to be in. So, he did what any self-loathing early twenties musician would do. He posted an advert on a website that served as a portal for scene folks looking to join and form bands.

Most of the people on there were, according to Alex "totally useless", but then he found Lawrie. Lawrie was a gangly dude with straightened hair, a white Stratocaster and a Misfits T-Shirt who couldn't sing (or so he said), but he was studying for a music degree. Alex freely tells everyone he knows that he "fucking sucks at guitar," so he knew the band would need someone really good on lead to hold it down and it became obvious after about an hour of playing together that they were meant to be in the same band.

Alex was also hanging out with a friend called Daisy a lot at that time. She had a killer voice, and owned a bass guitar, even though she could barely play it, but so what? They were gonna be a punk rock band! Dee Dee could barely play when the Ramones started and Alex knew that he wanted to share vocals with her, so she was in.

Finding a drummer was hard. They went through three in about two months, all of whom were either unreliable or couldn't keep time. It was a nightmare. Luckily, they found Jack through Lawrie's uni. He could keep time and was an Alkaline Trio fan, so that was good enough for Daisy, Lawrie, and Alex.

Miss Vincent used to practice in the living room of Alex's flat. Lawrie didn't have an amp yet, so Alex would plug him into a wedge monitor with his Line6 Pod and they'd do it that way. Daisy's bass amp sounded like brown noise half the time, but they didn't care. Alex had a bunch of songs ready for them to learn, so they did what every rock and roll band before them had done. They dived straight in and got on with it.

Their first show was at The Star Inn in Guildford on 4th May 2012. By that point Miss Vincent had demoed some tracks with Daisy's dad, who as it turned out was a songwriter. He'd worked with Westlife and S Club 7, which wasn't exactly the sound they were looking for. But he did have a Brit Award on his desk for his part in writing 'Don't Stop Movin' and it was his voice on the track that says, "Don't stop movin' to the funky wunky beat". Pedigree is pedigree and they didn't exactly have many other options. It also helped that it was free.

Armed with a three-track demo, and with Lawrie sporting a new Marshall stack, they started playing shows. Alex was absolutely desperate to go on tour and as the only one of the band with previous touring experience he was in charge of booking everything. He booked them a tour with a band from Manchester called This is How We Fall, which was due to start in July 2012. Miss Vincent were ecstatic and it was expedient that he was driving an ex-police van complete with Drunk Tank in the back, so they had a touring vehicle ready to go. It was all looking good until Daisy decided to leave about two weeks before they were due to head out. Undeterred, Alex decided to play bass and they carried on as a three-piece.

That tour, and many after it, was on what the band lovingly call the 'toilet circuit'. They started at The Intrepid Fox (where Mick Jagger asked Ronnie Wood to join the Stones), played at a few places around the country, including a place in Sheffield owned by someone called 'Crackhead Keith', and ended in a practice studio in Wigan. Alex also met his wife on that tour, who was the singer of the headline band. Life is weird.

After booking as many shows as possible in 2012 and early 2013, Miss Vincent realised they needed a bass player. Being a three-piece was okay, but it was limiting, so they put out an advert, and Owain, who Alex knew from the South London scene didn't even want to audition, replied. He used to be heavily into drugs and Alex didn't want that to be a part of the band, but the other guys were keen since Owain was the only real option, so he came down to try out. He clicked, and after playing a trial show on Valentine's Day, he was in.

Miss Vincent needed an EP. They knew about a band called Drones and heard their singer Daly recorded bands in his dad's garage, so in May 2013, they recorded their first EP, 'Creepy', which was a no-frills, straight-up punk-rock record that they decided to self-release. Initially on CD, then later in 2014 on limited edition 10" vinyl too. It was met with varying reviews. Rock Sound said that it "rocked with the poise and class of Alkaline Trio", but that the lead single. 'Planning to Fail', sounded like a "stilted high-school pop-punk band". Yay and ouch. Still, at least they had a case full of CDs to sell at shows.

A few Toilet Tours later, Miss Vincent were offered a tour with a band called As It Is. They hadn't heard of them, but looking them up, found out that their singer, Patty, was a semi-well-known YouTuber so they

took the tour, and it turned out to be one of the best decisions they'd ever made. As well as making some great friends, the shows were all full and they picked up a bunch of new fans, some of whom are still coming to see them a decade later, which, as Alex so succinctly puts it; "Is as cool as it is absolutely fucking mental."

Miss Vincent tried to harness the momentum that the tour gave them by booking a few more of their own. After all, DIY was at the core of everything that they did so they didn't even give labels or agents a passing thought at that point. The results were, as they often are, pretty mixed. At some shows, they felt like we were really on to something, like the time in Sheffield, when they flyered the hell out of the skatepark during the day and played a show to a bunch of rabid punk kids who were all singing along by the end of each song. But at others, like one they'd end up playing in Warsop on a Tuesday where there was no support band and just one audience member who went up to the bar and asked if they could stop playing because he wanted to watch the football.

Then there was the time, after a surprisingly great show at a punk pub in Bradford, that they went upstairs to sleep above the pub, as previously agreed with the promoter, and were greeted by a damp room full of stained mattresses, lawnmowers, and cat shit. Such is the life of a DIY punk rock band in the 21st century.

During that time their sound was becoming darker. Alex's mental health was in bad shape which was manifesting itself in all manner of weird ways. He'd always had anger issues, but he started, as he puts it, "beating the shit out of myself" and having random outbursts. This percolated into the band's music and in late 2013 they started demoing their next EP, which was recorded during 2014 and released in 2015. There were gang vocals, faster songs, and dark lyrics. The band used to joke that Alex had just gone through a medical dictionary, because of lyrics like 'my anterior cingulate is almost gone'. He had, at one point, genuinely floated the idea of calling the record Dyspepsia.

Daly had started working at The Ranch in Southampton where the owner was a guy called Neil Kennedy. They loved his production style and decided to go with him for the EP, since Daly would be engineering. It was a real eye-opening experience for the band. They had no idea that bands used things like tambourines and extra layers of instruments, so it was a real learning curve and Daly turned out to be far more dialled into

what they wanted than Neil, who wasn't even there half the time.

Miss Vincent wanted a bit of a step up for the release of 'Reasons Not To Sleep', their newly named six-song EP, so contacted a few labels and eventually signed with Engineer Records. It was a pretty basic deal, but at the time, as Alex says; "we thought it was the coolest thing ever." Just the thought of having their EP on streaming services was amazing. The 'Reasons Not To Sleep' EP (IGN227) was available across all digital channels and on CD from May 2015 and promoted hard across the UK and worldwide.

The band's main focus, as it had been for many years, was still touring. They wanted to play to as many people in as many places as possible. So when 'RNTS' came out they went on a rotating headliner tour. The other bands were garbage and barely brought anyone to gigs, so Miss Vincent did all the heavy lifting. They had a semi-decent following by now, but as ever some of the shows were less busy than others.

From the release of the new EP onwards the band were getting busier and busier so I asked Alex to tell me about anything else that was going on around that time...

"A few other things happened in 2015. In March we played the Takedown Festival. It wasn't a huge occasion, apart from the fact the Fearless Vampire Killers had asked us to open the stage they were curating. That band became a real inspiration for us. They made good music but the coolest thing was that they were a light in the dark. They did everything the right way and are still some of the best people we've come into contact with during our weird journey as a band."

Alex continued, "Something else that happened was the arrival of Creeper, another Southampton band that had seemingly popped up out of nowhere and immediately become the most talked about punk band in the UK. They hadn't popped up out of nowhere, of course. Will and Ian had spent years grinding in Our Time Down Here, who were one of my favourite bands. I was gutted when they broke up and so over the moon when we got to play their reunion show a little while ago that I got a tattoo to commemorate the occasion."

"We initially thought that this would be amazing for us. Another punk band with dark tendencies and they even came from the same place as

us! Surely it was a match made in heaven. We could be the UK version of AFI and Tiger Army. But it wasn't to be. As soon as Creeper arrived we became 'that band that are a bit like Creeper', but with weirdly negative connotations, as if we were ripping them off. It was pretty frustrating. We loved them (and still do, they're great friends of ours and Lawrie has literally joined their band now!), but we didn't understand why their success meant that we couldn't also be a cool punk band from Southampton. It made no sense. It just seemed like laziness on the part of the press."

Speaking of the press, it wasn't all bad. Another thing that happened in 2015 was that Miss Vincent got into Kerrang for the first time. Alex told me, "I'd read it religiously growing up and it was a huge, huge deal to have a feature done on our band. Unfortunately, we accidentally dove into the shit-filled quagmire that was 'New Grave', a term coined by their editor at the time, and one that we've since spent years trying to cast off. New Grave became a dirty term, one that killed bands' careers. There were a few bands in that feature with us but I think we're the only one left playing. It was a mistake, but also, we got to be in the biggest rock publication in the country." Kerrang also premiered the music video for 'Disparate, Desperate' on their website, played it a load on their TV channel, and then Scuzz followed suit.

For the rest of the year and for most of 2016 Miss Vincent toured and toured some more. They were added some great bills, including gigs with Calabrese and Bayside, and kept growing their audience. There is absolutely no doubt that finding out about a band from a gig is a much deeper bond than other methods. They still have many people who come to see them now because of that busy gigging period.

In 2016 they were also offered a tour with Fearless Vampire Killers. Alex reminded me, "I still remember being offered that tour. We were so fucking stoked and with good reason too. We were demoing with our friend Hamish in a warehouse in Mansfield at the time and I got shown the email in the middle of a vocal take."

"In our twelve years of being a band that's still probably my favourite tour we've ever done. Vukovi were also supporting on that tour, and between the three bands and crew, it was like one unit. Everybody was there for the right reasons, there was zero bullshit, and Steve D, the FVK Tour Manager, kept the whole operation running smoother than we

could have imagined. The shows were all full, we made a shitload of new fans, made a bunch of money on merch, and sold out of the remaining copies of the 'Reasons Not To Sleep' CD EP. It's honestly one of the happiest memories of my entire life."

Miss Vincent's van didn't agree, because it broke down twice on that tour. Alex continued, "I can still vividly remember begging a mechanic in Edinburgh to rush order a CV joint on a Friday night so we could carry on to the next show. I decided I'd need a new van after the tour and ended up spending every penny I had on a new one. Aside from that it was great. Sadly, in a really tragic turn of events, Stevie D passed away suddenly soon after the tour. Even though we'd only met him a few months before, we were heartbroken."

In late 2016 Miss Vincent went back to the Ranch to record their third EP. They decided to cut out the middle man and work directly with Daly since he was Producing his own records there by this point. The songs had taken a step up too, with even more harmonies and bigger choruses. Daly had developed his skills as a producer and together they were super proud of the outcome. Their new EP, 'Somewhere Else' was born, with five new songs, two of which they re-recorded acoustically.

Miss Vincent were offered a deal with Uncle M, a punk label based in Germany. Mirko, the owner, was friends with Anti Flag, Hot Water Music and a bunch of other great bands, so understandably the band accepted the offer with open arms, hoping for European tours too. 'Somewhere Else' was released in 2017 on a limited edition 12" vinyl with the five electric tracks on one side and the two acoustic versions on the other. There was a digital download code too so the label stepped up streaming promotions and play-listings. The lead single from that EP, 'The Lovers', received a lot of attention on the Music TV channels as well as a premiere on Kerrang!.

"We also had a bigger feature in the magazine, with Will from Creeper, around the release." Says Alex, "For all the comparisons we'd been getting, we love that band musically and as people, so although it's frustrating to be compared in a negative way, we wanted to prove that we weren't scared of it. They're great people making great music, so who cares if people compare us to them? That was the thought process, anyway."

The release shows for 'Somewhere Else' are some of Alex's favourite memories. He told me, "Up to that point we'd only done one proper headline show in London, in a basement at The Constitution in Camden, so we booked out The Garage upstairs room. We came so close to selling it out and I can still remember the goosebumps I got when we hit the chorus of 'Beauty in Darkness', the first proper slow song we'd ever done. I was totally drowned out by the crowd singing it back to us. Fucking hell, what a moment for any songwriter."

That Summer Miss Vincent toured with Energy, an American horror punk band from Massachusetts. It was a borderline 'toilet tour' but it's another one that sticks out in the band's memories as full of good times. "They were the best people and we spent the whole first day totally nerding out about the Misfits and East Coast horror bands like Blitzkid. But then, sort of out of nowhere, Jack told us he was leaving the band. Replacing a drummer fucking sucks so it was a gut punch."

Alex continued, "When you've spent years traipsing around the country with someone in a tiny van, there's a bond that you don't expect to be broken suddenly. But people want what they want and we set out to find a new drummer, which was actually easier than expected thanks to the Energy tour. Nate's band opened the show in London, and I spied him smashing the shit out of the kit and nailing backing vocals at the same time. He'd actually come to the Nottingham show as a punter too, so we knew he liked our band. He jumped at the chance to try out and about ten minutes in I knew he was gonna join us. He's honestly one of my favourite drummers in the world. He just gets it. We went on a short trial tour with our friends Hrkr (great punk band from Brighton) and he was in."

I asked Alex about what happened with the new line-up and he told me; "2018 was a weird year. We'd started flirting with a manager and I wanted one in the worst way. We needed to take the next step and I didn't know where to go so we needed help. We signed with him and started demoing tracks for an album. We worked on our image as a band, something he said was lacking and started really trying to evolve. Our live show was great and we had a good following, but we weren't big on the internet and he said nothing mattered until we could increase our following there. I fucking hate that's how bands have to be now. I don't want to be an influencer. I want to build bonds through group exorcism in dark, sweaty, sticky-floored rooms. We knew he was right though, if we wanted a bigger label we had to play the game."

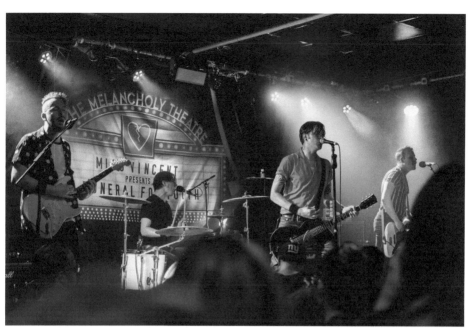

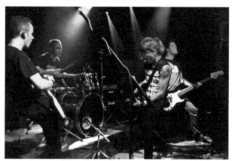

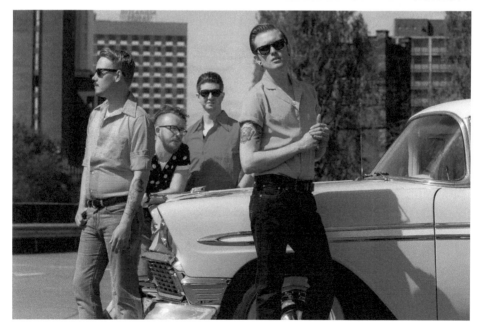

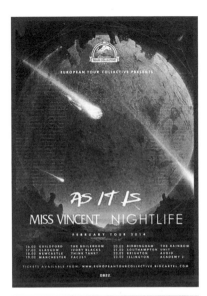

AS IT IS
MISS VINCENT NIGHTLIFE

FEBRUARY TOUR 2014

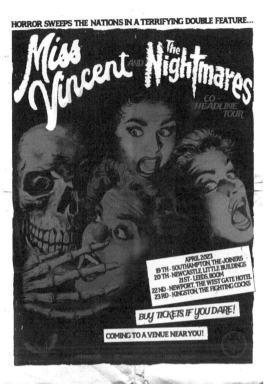

HORROR SWEEPS THE NATIONS IN A TERRIFYING DOUBLE FEATURE...

Miss Vincent AND The Nightmares

CO-HEADLINE TOUR

APRIL 2023
19TH - SOUTHAMPTON, THE JOINERS
20TH - NEWCASTLE LITTLE BUILDINGS
21ST - LEEDS, BOOM
22ND - NEWPORT, THE WEST GATE HOTEL
23RD - KINGSTON, THE FIGHTING COCKS

BUY TICKETS IF YOU DARE!

COMING TO A VENUE NEAR YOU!

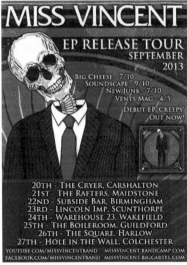

MISS VINCENT
EP RELEASE TOUR
SEPTEMBER 2013

BIG CHEESE - 7/10
SOUNDSCAPE - 9/10
NEW JUNK - 7/10
VENTS MAG - 4/5

DEBUT EP 'CREEPY'
OUT NOW!

20TH - THE CRYER, CARSHALTON
21ST - THE RAFTERS, MAIDSTONE
22ND - SUBSIDE BAR, BIRMINGHAM
23RD - LINCOLN IMP, SCUNTHORPE
24TH - WAREHOUSE 23, WAKEFIELD
25TH - THE BOILEROOM, GUILDFORD
26TH - THE SQUARE, HARLOW
27TH - HOLE IN THE WALL, COLCHESTER

YOUTUBE.COM/MISSVINCENTBAND MISSVINCENT.BANDCAMP.COM
FACEBOOK.COM/MISSVINCENTBAND MISSVINCENT.BIGCARTEL.COM

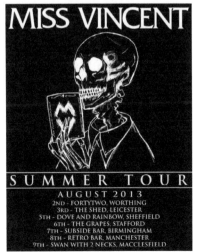

MISS VINCENT

SUMMER TOUR
AUGUST 2013
2ND - FORTYTWO, WORTHING
3RD - THE SHED, LEICESTER
5TH - DOVE AND RAINBOW, SHEFFIELD
6TH - THE GRAPES, STAFFORD
7TH - SUBSIDE BAR, BIRMINGHAM
8TH - RETRO BAR, MANCHESTER
9TH - SWAN WITH 2 NECKS, MACCLESFIELD

MISS VINCENT

[f] [t] MISSVINCENTBAND

Spawned from the same Alkaline-Trio-influenced, Southern England scene that brought you Creeper, Miss Vincent serve up Rise Against-level speed and emotional intensity on their new EP, *Somewhere Else*. The release finds them peering from behind the dark overtones for which they had become known in favor of straight-up punk. As of late, the U.K. has given the world the force that is Neck Deep, but the next best modern punk-rock outfit is certainly Miss Vincent. –@PoisonAndFire

Alex went on; "That Summer we recorded the bulk of an album. He started shopping it to labels and some of the feedback broke my heart. Epitaph got back to him and said they loved it, but they weren't sure 'the kids of today would dig it'. Honestly, what the fuck. Anyway, with the record done and in search of a label, an opportunity came through the grapevine. Creeper wanted us to do a short tour with them. Finally, our great friends wanted us to play with them. We accepted immediately and rushed out a single so that we'd have something new to talk about. 'Melanie' got played on Radio 1 and all the TV Channels. It gained us loads of great press. Daniel P. Carter really got behind it. We played a run of killer shows with Creeper and it felt like all we needed was one lucky break to really start snowballing. We kept touring, including a December run supporting Greywind, so 2019 was shaping up really well."

Throughout 2019 Miss Vincent released all the singles from the album recording without announcing it. "Looking back, it was a terrible strategy from our manager, but at the time we didn't know any better." Says Alex, "They all did well, 'Doctors and Churches' especially, but we'd stopped touring while we were trying to get the album released, so it felt really strange. We'd got a couple of decent shows coming up, like playing with some American bands including Microwave, but we felt frustrated. So, we did what we knew how to do, and booked a tour for the Summer."

"It felt great. People were vibing with the new songs and were asking when the album was going to come out. We'd just released a video for 'My Iron Heart' in which I got to drive a 64 Mustang. It was a real summer anthem. Then, we got asked to play with Masked Intruder, one of my absolute favourite bands. Soon after, As It Is resurfaced and asked us to tour Europe with them. We jumped at the chance and had a real belter of a time. We'd been wanting to go to the mainland for the longest time and it was amazing. People really got it. The best part was that we now had a German agent, who had just booked us a headline tour for February 2020, so we were promoting that while on the As It Is run. Good times like that are the reason I formed the band."

Alex continued, "On a high from the As It Is tour, we smashed the promo for the German headline tour and went out there in February 2020 with our fingers crossed. It was a risk - would people show up? Was it too bold to tour Germany on the back of a few singles and not an album? The answer was clear when we got there. It was a total fucking rager from start to finish."

"We played all sorts of places including a basement where the toilets were behind the stage (some random lady even pushed past Owain to go for a piss during the show), a sex club in Berlin (that does rock nights on Thursdays), and made so many new friends and fans. Our singles were streaming well, our shows were well attended, and that even seemed to be starting to get us some momentum in the UK too. Our manager was sure it was only a matter of time before we got 'the' label for the album."

"I don't need to tell you what happened next. The world fucking collapsed. Covid shut down everything, and like every other band, we were stuck. We had an album but no label and a following but no way of playing to them. All the momentum we'd spent over two years building was immediately lost. I still feel incredibly melancholy thinking about it now, even four years later."

"Somehow, Silent Cult Records (an indie label from London) decided they liked the album enough to sign us, even in the middle of the pandemic. Stef is honestly one of the best people on the planet. She's a true music fan and really understood the record, something that was super obvious from the minute we met her. She initially didn't want to commit to pressing vinyl records but we convinced her that we thought it could be a success. We had no idea if it would, but we wanted records in the worst way. Contract signed, we finally started preparing for the release. Not an easy thing to do when you can't see anyone or go anywhere, but like everyone during The COVID-19 years, we made the best of it that we could. We also enlisted the help of US artist Mark DeSalvo to do the artwork for the record. He's painted the covers of some of the greatest punk records of all time and it was a genuine buzz to be working with him. We loved the end result so much."

'A Funeral For Youth', Miss Vincent's debut album, was announced in the Spring and released in September 2021 with the initial 250 copies on pink and blue splatter vinyl.

"It was almost impossible to tour in support of it that year, because everything that was meant to happen in 2020 got pushed a year, and then pushed again, so any chance of getting on anything good was almost zero. Still, we booked some release shows that were great, and the reception from our friends and fans was incredible. One of the things I had always aspired to growing up was to release a full-length album with a band, and we'd finally done it. It's since been streamed more than 2

million times, and we sold out of vinyl records. That part was especially cool, to make good on our sales pitch to Stef."

I asked Alex about what has happened for the band since their album release, and he told me; "I'm not going to say too much about 2022 because I'll end up slandering our manager. Safe to say it didn't work out and we ended up ceasing to work together. We did release a couple of killer covers in 2022 and early 2023 though, which was enjoyable. (One of these was a great cover of Mud's seasonal hit, 'Lonely This Christmas') As soon as we parted ways, we did what we always do and booked a tour. We arranged to co-headline with The Nightmares and in early 2023 we finally got to tour 'A Funeral For Youth'. It was incredible to be back touring after having to wade through the treacle of the COVID-19 years and we were totally blown away at how much our little band had grown in popularity. Crowded rooms in cities we'd not played in seven or eight years. So many new faces. Such loud singalongs. Getting feedback from people on the record sure hits differently when you're on the road. They'd connected with it so wonderfully. In a lot of ways it made the whole shitstorm of the preceding three years worth it."

Since then, Miss Vincent have been writing songs for a follow-up album. "We did have plans to tour more last year, but unfortunately, now that we're in our 30s, life sometimes gets in the way. My career is taking up a lot of my time and effort, so last year passed in a blur. Lawrie has been playing guitar with Creeper and now joined as a full-time member. The rest of us are so happy for him and for them. He's a great guitarist and an even better person, and they're lucky to have him. It also feels like a win for us, because we've spent so long grinding that it's great to see them have success. Sometimes the good guys do win."

Alex continued; "The next record is taking shape though and we're really looking forward to playing more shows. It's not going to be the same as it was in The Before Times ever again - but we made it through The Covid Years and so for that we're thankful. It does seem like COVID hit at a terrible time for our band though. We had more momentum than ever and it felt like we were finally getting somewhere. Still, we love playing music together and I'm so stoked for some of the new songs. We're not going anywhere anytime soon."

Hit The Floor said of the RNTS EP; *"Southampton based punks Miss Vincent have returned with 'Reasons Not To Sleep' and stake a major claim*

that it is not just American punk bands like Alkaline Trio, AFI, et-al who can deal in good old serious dark punk rock sounds. This punk rock still has meaning, it doesn't have to be horror movies and make up. Catchy melodies, superb structure, perfect use of backing / gang vocals. Excellent work all round here and if you haven't checked these guys out before, then we highly recommend you go out right now and do just that. Impressive."

The Moshville Times added; *"Miss Vincent lock horns with punk-rock on their new EP 'Reasons Not To Sleep'. The fast-paced sound is energetic and infectious, and the act look like they're having fun, pushing their hands up into the thick atmosphere. The band take influence from Chicago dark princes Alkaline Trio. That type of macabre sound is heard throughout the EP, merged together with big riffs and empowering lyrics. Miss Vincent naturally play punk music that swells with pessimism and immense talent."*

Original Rock reviewed the album, saying; *"I love the aesthetic here, nostalgia combined effectively with a modern sound and attitude. The videos are mini films that include old black and white movie clips to increase and maintain the interest. With nods and winks to the horror punk ethic, there is plenty to get excited about, I would even say it's not just song after song here, it is hit after hit, an absolute joy to behold!"*

And **Full Pelt Music** agreed: *"Superbly crafted and elegantly presented, Miss Vincent have captured magic on their debut album. 'A Funeral For Youth' is a sublime collection of upbeat, heartfelt and powerful songs that is bound to be stuck on repeat for the foreseeable future. On the opening track the band sing "...this gravity is keeping me down...", well it's going to take an immense force to hold this band down, because they appear set for the stars!"*

With **Already Heard** simply adding: *"Miss Vincent have Enough hooks to last you all summer and an eye of the poetically romantic, the band have reeled in the creepy, upped the catchy and created a short sharp dose of blooming and affecting punk rock."*

https://missvincent.bandcamp.com/album/reasons-not-to-sleep

Nathaniel Sutton and Hail Taxi

Nathaniel Sutton : Vocals and Guitar

Life has a way of throwing the sort of impossible conundrums at you that make you want to throw your hands in the air and scream "Why?" at the star-filled night sky. Trying to find an answer to the question of who Nathaniel Sutton is and what he does, is one of those eternal problems. Describing himself as a singer and songwriter from Edmonton, Alberta, Canada, Nathaniel has written, recorded and played music under many guises, namely **Making A Monster, Taking Medication, Brother Octopus, Defend the Rhino and Hail Taxi**, as well as forging a solo career using his given name.

It was the aforementioned solo career that was responsible for our paths crossing as he sent me demos that he'd recorded in 2006, which I ended up releasing as his debut album, 'Dramatic Scene', (IGN091) on CD that same year. Yes, the demos really were that good and when I first heard them I had no idea that it was the start of an almost twenty-year

working relationship and friendship that we both hold in high regard and cherish.

Why am I telling you this? Well, I'm hoping that it will explain why I wanted to include Nathaniel in the Engineer Records story, as he was and is a linchpin of the label, while providing some small insight into the previously mentioned dilemma, "Who is Nathaniel Sutton?"

Nate is a capable one-man-band, recording all the instruments and vocals himself, but also working with other musicians as the projects require. He's even played in a few covers bands to earn a crust. He has a style all his own, though not too far distant from Lou Barlow (Folk Implosion, Sebadoh), Eric Bachman (Crooked Fingers, Archers of Loaf) or even Tim Kasher (Cursive, The Good Life) and Isaac Brock (Modest Mouse). Nathaniel is a man with a unique throaty croon and a guitar acting as the paintbrush for his quietly brilliant abstract palette.

Like all stories, the best place to start with Nathaniel's is at the beginning, and when I quizzed him about the beginning of his musical adventure and his motivation for wanting to follow that path, this is what he told me...

"This story dates back to before I started High School. I was signing up for classes to begin my Grade 10 semester and one class that I had originally signed up for was German classes until my mother pointed out that the High School in which I was planning to attend offered guitar classes. It was a no-brainer, I signed up for guitar class instead of German and this ignited my journey into music.

It took some time to fully get used to playing guitar and singing simultaneously, but once I figured it out, I became obsessed with writing original music. I would even stay up all night writing and recording music, finding inspiration from bands I was listening to at the time, from Death Cab for Cutie to Pavement and beyond."

As he'd already mentioned some of the bands that had served as inspiration for his song-writing, I pressed him further about the bands, records and people that influence and impel his creativity. Nate told me...

"A record that left a huge impact on how I write songs is Death Cab for Cutie's 'Plans' album. That album is one that I can keep returning to and

will always love. Ben Gibbard's song-writing flows so well, I feel like in my older age, I've finally reached that level of song-writing. I used to write songs about events based on fiction, scenarios that never happened to me. I've discovered now that music is much more meaningful when writing about personal experiences and factual events. A specific song by Death Cab for Cutie that really speaks to me is 'Brothers on a Hotel Bed'. That song is really emotionally powerful, with the lyrics, "Now we say goodnight from our own separate sides, like brothers on a hotel bed". Like, damn, I feel that. My most recent EP 'A Brighter Sound' is heavily influenced by Death Cab for Cutie, from the production values to the song-writing approach.

However, as far as role models go, I've always looked up to Dave Grohl. How he built his empire from the ground up has always inspired me to keep going. He's actually a huge reason why I kept chasing my dream to pursue music, and I'm sure he's helped so many other musicians. Just being an overall good person, who makes great music that he believes in, isn't that what all musicians should work toward. That, and his luxurious hair."

Having already described himself as a songwriter and singer from Edmonton, I wondered aloud about the scene that he'd emerged from, and Nathaniel was more than happy to finish that thought for me...

"As a musician based in Edmonton, Alberta, Canada, the scene here has always been fairly good to me. The best part of the local scene is the other musicians, we get each other, so I never felt like an outcast. To me, it's important for musicians to support one another, especially locally. Another great part about the local scene is the concertgoers. Edmonton has a lot of music fans that go out to gigs, whether it's the punk scene or the folk scene they're embracing. I remember a show I played in my early years, I was so nervous on stage and I'm pretty sure I messed up a lot of the chords I was supposed to play, but several of the audience came up to me afterwards and told me it was great. They even bought CDs and asked me to sign them. It's those moments that keep you going.

It's not all good though, there are downsides to the scene here of course. My main beef is with some local venues that rely heavily on the artist bringing in the people, which I think should be the venues' job.

There are so many great acts out there that don't get a chance to play at popular venues because they don't have a cult following, but how does

one acquire a strong fanbase without those opportunities. Not all venues are like that though, some do give artists chances to perform, and it's those venues that are the good ones."

The subject of how we first met came up, and Nate wanted to tell it in his own words…"I discovered Deep Elm Records, which quickly became a staple in my music collection, and became a collector of CDs by all the bands from their roster. I was constantly listening to The Appleseed Cast, Benton Falls, Sounds Like Violence and so many other great bands from that era. It made me curious about what other labels were out there, especially as I was also looking for a home for my own music that I was recording at the time. With the help of Google I discovered Engineer Records, a label that even worked with some of the bands from Deep Elm Records' roster. I began looking through the music this label had to offer and quickly decided that I needed all the releases from this label.

So I reached out to Engineer Records, introducing myself and my intention of buying their back catalogue. Craig Cirinelli (Vocalist of Elemae and working for Engineer Records in the US at the time) responded to my inquiry and not long after, I was sent their full catalogue of releases. I became an Engineer Records fanboy and bonded with Craig through many strings of emails, eventually enquiring if Engineer Records might be interested in listening to and even releasing my music. I sent over the original songs that I had been working on and he liked it but had to run it by the label's owner, David. Not too long after that I received the email that I was very much hoping for, they wanted to release my music through their label. I remember being so ecstatic about this, I even ran over to my mom and told her all about it, I couldn't contain my excitement."

'Dramatic Scene' was the debut-album that Engineer Records helped Nathaniel Sutton release in 2006, under his own name, on CD as IGN091. It was his very first offering to the world and contained fifteen songs that were recorded in his bedroom. The sound was a little lo-fi but had a very D.I.Y. personal feel to it.

Nathan continued; "I remember recording the drums in the basement living room in the house where I grew up. I recorded acoustic and electric guitar through a portable Zoom recorder, it was as homemade as you get. Engineer Records helped me get CDs manufactured, distributed and

promoted. It was so surreal to be holding a CD of my own, in my hands, released through a label that I loved."

I'm a firm believer in the idea that we're forged as much by the trials and adversity that we encounter along the way as we are by the victories and triumphs that we claim as our own, and when I asked Nate about the best and worst shows he's played and if he had any stories from his time on the road and in the studio that he could share, he willingly obliged...

"When it comes to playing live, the best shows are often the ones that you think are going to be horrible but turn out great. An example would be when I played in a band called Brother Octopus (yes, it's a silly name for a silly band). We were scheduled to play this show in a very small town. We showed up and there was no one there but we'd travelled all that way so we set up and played anyway. After the first song, people started rolling in, filling up the place and it became one of our best shows. So, you never know what to expect, really.

There's another story I'd like to share, and it involves Craig Cirinelli of Elemae, Hidden Cabins, etc. As I mentioned, I met Craig through Engineer Records and we remain friends. We toyed with the idea of playing shows together so in 2013 I travelled to Boonton, New Jersey to do just that. I performed under the alias, Hail Taxi at the time and Craig performed under the name Hidden Cabins with Brian Rothenbeck on guitar. We played some great shows together. It was my first time playing in the US and it was so refreshing. The gigs that Craig lined up for us were filled with such supportive people and friends, it was such an amazing experience to see what the music scene was like on his side of the world. His family was so inviting too. It was something this Canuck will never forget."

Engineer Records would also release Nathaniel Sutton's next album; The self-titled 'Nathaniel Sutton' CD (IGN170) which contained another fourteen of Nate's original songs, this time recorded at Zounds of Sounds studio and with cover art designed by David S Blanco, who had created the artwork for various Rydell releases a decade earlier. It was released in 2011 on his return to the label after a self-released album entitled 'Starlite' on his own Oak Apple Records in 2009.

Nate was always experimenting with his music and trying out new partnerships and presentations. A few years later he'd settled on recording under the moniker of Hail Taxi and he returned to the label to

release his 'Apart for so long' CD EP (IGN233) in 2016, following it with digital singles for 'Wildrose Country' and 'Magic Spark' and then continuing this more folk and country influenced pop-punk style with his 'A Little Something' CD (IGN256) a year or so later. This was followed by another digital single, 'Oh my heart, it hurts', and then a full digital EP release, entitled 'Fall Apart' (IGN302). He also supplied an exclusive track entitled 'Far More' for chapter twelve (I love you but in the end I will destroy you) of the sought-after compilation series, 'The Emo Diaries', on Deep Elm Records.

He has now returned to writing and recording as Nathaniel Sutton and works on new songs as well as musical scores for film and TV. His latest release is a five-song CD EP via Oak Apple Records in June 2023 entitled 'A Brighter Sound' featuring tracks inspired by his painful divorce. The songs have deeply emotional and hopeful narratives meant to offer solace and sanctuary to the listener.

With the clock counting down on our international digital connection and as our long overdue catch-up drew to a close, I asked Nathaniel about whether he thought post-punk and the scene it calls home were still relevant in the age of AI and auto-tuning. Before we parted he reassured me; "Music is much more than a passion for me, it's a way of life and it all started with an independent record label in the UK. Music is always evolving and so are we as musicians. That said, I do believe that hardcore / post-punk has good reason to exist today. These genres often convey raw and unfiltered emotions, providing a cathartic outlet for both musicians and listeners. The intensity and authenticity found in hardcore and post-punk music resonate with people seeing genuine expressions of frustration, dissent or introspection. These genres are timeless and their influence can be heard in many music styles. I'll always be hardcore at heart."

Cory Jones at **Beatroute Magazine** reviewed Nat's self-titled album, saying; *"Nathaniel Sutton has been a part of the Edmonton arts scene for a number of years now. A one-man band and determined DIYer, Sutton brings forth his most acoustic set with a rightfully self-titled effort. The difference is the wide variety of instrumentation. Cellos, violins, harmonicas, banjos, horns and mandolins all make brief appearances throughout.*

'Nickel Or Dime' is the first real standout track. Here, Sutton starts off with simple acoustic strumming and his distinctive throaty voice before moving

into a pleasant saxophone solo. 'WingTech 3000' balances piano keys and guitar strings with lyrics of society's reliance on technology. 'City Of Dreams' is almost too quick and after a quick, mood-setting interlude, the album moves into the closing duo of 'Zombies Are Everywhere' and 'Bring It On (Godzilla)'. These two tracks show off his unique song writing style as he manages to craft generally catchy tracks relating to zombies and Godzilla, respectfully.

Overall, it's a modest effort as Sutton covers a lot of ground. Metaphors are abundant as references to werewolves, dinosaurs and bumble bees are weaved into themes of day to day human behaviour. Even with the eclectic instrumentation, Sutton's classic and contemporary rock influences can still be heard."

And Txema Maneru at **Staf Magazine** added: "The first thing I like from this Juan Palomo from Alberta, Canada is that it's a one-man band. He plays it, composes it and produces everything. Then, through the 15 tracks of his second disc, after his 'Dramatic Scene' debut 2 years ago, there's no track similar to another one. His lo-fi with lots of electronic and percussion moves among one thousand and one influences. It brings to my mind the most experimental Bob Mould, Chad Vangaalen, Lucky Thirteen's Neil Young, The Faint, Lou Barlow, the most tripping Grandaddy, Eric Bachman, Ed Harcourt or Cursive. In fact, you can find references that only he could imagine, such as the Japanese-like rhythms in 'Fragile', the dance touches in Visage-like '1933' or the syncopated rhythm in Talking Heads-like 'Blow my mind'."

Interpunk simply said of 'Dramatic Scenes'; "Nathaniel Sutton comes at us via Edmonton, Canada and while delivering mostly folk-based indie-rock, you'll find splashes of alt-country, punk and even electronic music weaving throughout his highly ambitious debut. Thoughts of The Folk Implosion or Beck might be a good place to start. He's created nearly 30 tracks, whittled them down to the 15 on his 'Dramatic Scene' debut. Nathaniel Sutton is a noticeable talent for being a self-sustainable one-man-band in writing, recording and producing his own musical vision."

Sonic Bids reviewed 'Apart For So Long saying; "The five-track offering contains vibes of familiarity yet foreignness, and a maturity that can only be heard to understand. With the prospect of good connections, brilliantly written music and strong work ethics, Hail Taxi is a name that is becoming more recognisable by the day; and has hit the ground running with no intentions of stopping anytime soon."

Canadian Beats added; *"Nathaniel's vocals are emotional and heavy-hearted."*

And **Fear N Loathing** suggested that; *"What sets him apart from the masses of dross is that he keeps his melodies simple but is never afraid to indulge in interesting arrangements, bringing out elements of the songs that might otherwise be lost in the background. Elements of folk, Americana and indie-rock are infused into the overall sound and conspire to keep everything intriguing. The production has a genuine warmth that, again, draws you into the music itself. This has a character of its' own and is certainly worth checking out."*

https://hailtaxi.bandcamp.com

Neckscars

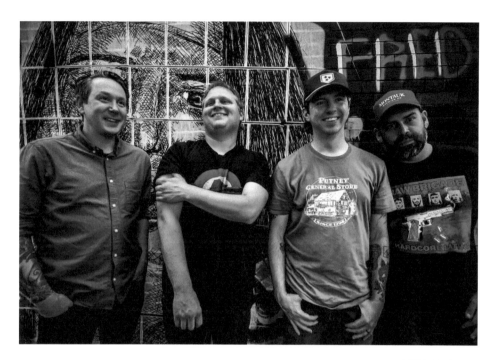

Will Romeo : Vocals and Guitar
Justin Parish : Guitar and Vocals
Colin Harte : Bass, Acoustic and Twelve String Guitar
Lawrence Miller : Drums
(Craig Sala : Drums, Vocals and Keys)

Over the past two decades the members of Neckscars have cut their teeth in the DIY scene and came together to play without any specific stylistic direction in mind but determined to write a diverse collection of songs. The result is a classic punk rock and roll sound that doesn't lean on nostalgia and isn't dependent on formulaic stereotypes, drawing its influences from Seaweed to The Dead Boys and a multitude of other bands, records and scenes.

Justin Parish, Will Romeo and Colin Harte first crossed paths in the early 2000's when their respective bands played a lot of the same shows in the Westchester / Putnam County, New York punk scene. But a lot of road miles, personal and scene drama, along with a whole bunch of years would pass by before they were able to connect again.

The Neckscars story can't be told without talking about the band that preceded it, Gameday Regulars. The idea for the band was to travel the same path as bands like Hot Water Music, Leatherface and Lawrence Arms, and combine melody, grit and energy in a glorious punk rock cacophony.

Originally started by Will and his brother Gino, by the time Justin joined Gameday Regulars on second guitar, they'd already hired and fired numerous bass players. Justin ran into Will at Fest 12 in Gainesville, Florida and it was immediately obvious that he was the missing element that would add a much needed spark to the already established band.

The revolving bass player door would continue for longer than the rest of the band wanted it to, which led to Justin recruiting his long-time pal Colin who had been playing with the guitarist in a skate punk band called Tough Broad. But after numerous tours and a small recorded output, the whole Gameday thing grew stale, more than a little toxic and eventually fizzled out.

Justin and Colin cut their teeth in the Westchester / Putnam County Punk scene that Will, coming up from The Bronx would also become a big part of. It was a thriving scene that many lower to mid-level touring acts would play headline shows with local supports. Unfortunately, as is the case the world over, that scene is now a footnote in punk rock history and Neckscars now consider themselves to be members of a larger, welcoming global hardcore community.

Neckscars rose from the ashes of the road weary Gameday Regulars and was basically the old band with a new drummer. There was talk of a possible Gameday reunion but everyone involved decided that it made more sense to start something completely new. There was a 'vibe' as the kids say, that needed to be harnessed in a more copacetic and positive environment, and in late 2018 this was the genesis of Neckscars.

A lot of the same influences that brought that first band together pushed the new one into being, with a more open-minded approach and a far broader palette. Will recruited his long-time friend Craig Sala to play drums and Colin to play bass. They worked through a couple of songs as a three-piece before Justin came in to round out the sound.

Neckscars first release, in June 2020, was a split with Goddamnit, a great and gravelly hardcore band out of Philadelphia, PA, but it was only ever

a digital release so needed to be quickly followed by a full record to showcase their ever-growing enthusiasm.

In March of 2020, Neckscars entered Nada Studios in Montgomery, New York with Producer John Naclerio and Sean-Paul Pillsworth for their first full-length recording. Ripping through eight songs in just three days, the session came to halt in response to the Covid-19 Global Pandemic. The band returned in the autumn to tie up loose ends and bring another two songs to the table. Completed with a mastering by Jesse Cannon at his studio in Union City, NJ, Neckscars superb debut album 'Don't Panic' was finally released in the summer of 2021.

Jointly released by Sell The Heart Records in the USA and Engineer Records in the UK / Europe, 'Don't Panic' (IGN311) was initially pressed on 12" seafoam green vinyl with a few gold and transparent yellow wax variants. A digipak CD was also distributed and repressed when the first run sold out in 2023, along with a new vinyl pressing on purple and clear vinyl variants.

Of the album's ten tracks, three of them, 'Jarring', 'Not Enough JPM's' and 'First Time, Long Time' (featuring Jon Snodgrass of Armchair Martian, Scorpios and Drag The River), have all had video releases. With 'Jarring', a great song about accepting the flaws of those you love, and a video spliced together from footage of the band performing and goofing off at their beloved Purchase, NY pub The Cobble Stone, gaining nearly forty thousand views on the Engineer Records YouTube channel.

Following their debut LPs release and promotional touring several songs appeared on compilation releases. Neckscars live favourite 'Condor Swoop' was featured on a four-band split 7" picture disk alongside American Thrills, Nightmares for a Week and Tired Radio late in 2021, again through Sell The Heart Records and Engineer Records with Wiretap Records and Rat Terror Records too. This was followed by more compilation tracks and a couple of covers, including their version of 'Vulnerability' by Operation Ivy on the Sell The Heart and Lavasocks Records joint release 'Mooore Than Just Another Comp'.

The band were really starting to make headway but realised that their drummer situation wasn't working out, so Walter Anriquez was brought into the fold. After recording a new single, 'Ray of Pain', they released a split 12" with Moonraker from California, with three more new songs

and a video for 'Level II, Insufferable'. The record was released via Sell the Heart, Bipolar and Engineer Records (IGN371), pressed on peach melba and clear with black smoke vinyl variants and leading to the two bands playing gigs together on each coast.

Neckscars then recorded a Replacements cover, 'Unsatisfied', for a compilation on Creep Records but realised that they still needed to find a drummer who would bring a much-needed punk-rock nitrous injection to their unique and ambitious sound. Lawrence Miller was mentioned as an option by Colin, who had played with him in two previous bands, and after he played a couple of fill-in shows that were essentially an extended audition, he got the gig as his ability, versatility and personality were exactly what Neckscars needed.

With their line-up finally complete Neckscars decamped to an incredible space outside of Ithaca, NY in January 2024 for a long weekender of writing that solidified the majority of the songs that are going to appear on their sophomore full-length, which should, as long as the world doesn't explode, materialise in the next twelve months.

Bearded Gentlemen reviewed 'Don't Panic' on its release, saying; "*I think it's fitting that the debut album from New York's Neckscars is called 'Don't Panic'. After all, they began recording it just as the COVID-19 lockdowns were set in place. Even though they had their recording plans paused as the world dealt with a global pandemic, things worked out the way they were intended to, albeit a tad delayed. When lockdowns were loosened, the band got back together and finished the last few songs. Now, about six months later, Don't Panic has finally seen the light of day. After a few listens, I can confidently say it was well worth the wait.*

"*Clocking in at ten songs in just over half an hour, Neckscars comes at you with a less is more approach. There's no fluff or filler on 'Don't Panic'. Instead, we're treated to an album of classic melodic punk anthems.*

"*Naturally, because of lead singer Will Romeo's gravel-soaked vocals, he will immediately get comparisons to folks like Chuck Ragan, Brendan Kelly and Tim Barry. To be sure, if you like bands like Hot Water Music, The Lawrence Arms and Avail, you are definitely going to like Neckscars. Be careful not to pigeon-hole them into that whole orgcore stereotype though. Sure, they would fit right in, but there's way more going on here. Melodic punk with gruff vocals is about the end of the comparisons. There's also some*

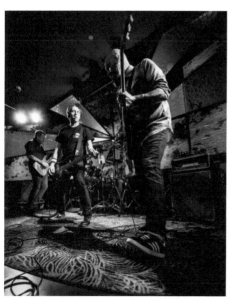

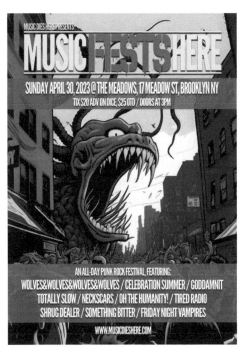

straightforward rock sound coming through ala The Gaslight Anthem and The Menzingers too.

"One of my favourite songs on the album is "Loaded." It's got really clean guitar work on it, and the catchiest anthemic chorus on 'Don't Pani'c. I find myself listening to albums these days with the thought of how the songs will translate live (I miss shows). I can see it now. As the chorus kicks in, the crowd sings along at the top of their lungs. Their hands in a fist, pumping in the air to the beat. It's going to be glorious.

"Another special treat on 'Don't Pani'c is the guest appearance of Jon Snodgrass on the album closer, 'First Time, Long Time'. I've been a big fan of Snodgrass since his days in Drag the River, so it's always a special treat to hear him pop up on other people's music. He has one of those voices that is immediately recognisable. As soon as I heard him, I immediately got a smile on my face.

"Neckscars has only been a band since 2018 and this is their first proper release. They have no business being this good their first time out. It's just not fair! All kidding aside, if this is what their debut effort sounds like, this is a band to keep an eye on. They're just going to keep getting better and better. 'Don't Panic' is the perfect jumping off point. You'll be able to tell your friends that you remember when."

Distorted Sounds described Neckscars as; "A consistently safe pair of hands when it comes to energetic and hook-heavy punk rock."

And **Brooklyn Vegan** added: "Neckscars make rustic, gravelly-voiced punk in the vein of Hot Water Music, Small Brown Bike, The Lawrence Arms, etc and they do a lot of justice to that sound. If you've got a place in your heart for this kinda stuff, Neckscars' nostalgia-inducing anthems should definitely scratch an itch."

https://neckscars.bandcamp.com

One Day Elliott

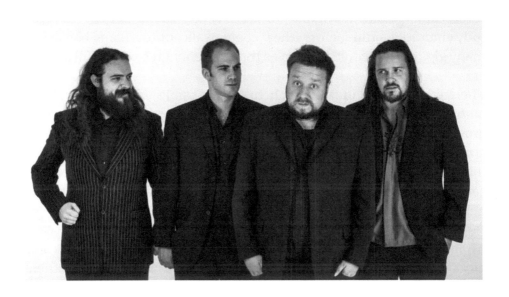

Paul Richards : Lead Vocals and Keys
Richard Crooks : Guitar and Vocals
Pud Greenlees : Bass and Vocals
Dan Purton : Drums and Vocals
(Jamie Greenlees : Drums)
(Leo Blackledge Smith : Guitar)
(Francis Taylor : Guitar)

One Day Elliott is a melodic rock band from Kent in England's southeast. Drawing from a broad repertoire of influences, One Day Elliott's sound is best described as a collection of massive, poppy choruses and thick vocal harmonies wrapped up in guitar-driven anthems that sit somewhere between classic rock, metal, pop-punk and hardcore.

One Day Elliott has toured in the United States and played all over the UK with the likes of The Ataris, Feeder, Ash, Hundred Reasons, The Blackout, Raging Speedhorn, Gary Numan, Capdown, Zebrahead, The Anti Nowhere league, The Fall, The Cooper Temple Clause, Spunge, Allister, Supergrass, Tsar and many others, and have sold about 15,000 albums along the way.

One Day Elliott are so old their first two releases were on cassette. The band started when teenage pals Paul Richards, Jamie Greenlees and his brother Pud decided to stop writing silly songs in their bedrooms and start playing those silly songs to anyone who'd listen, willingly or not. After teaming up with original guitarist Francis Taylor in 1999 the band fully embraced a run-before-they-could-walk approach and booked as many gigs as they could as soon as they had enough songs to fill a set.

Their ethos of having as much fun as possible with no particular ambition or desire to take it too seriously resonated with the younger crowds in their hometown of Maidstone and the band soon amassed a sizeable legion of teenage fans. Much to the justified annoyance of the many other and arguably better local bands on the scene who played carefully crafted grunge and metal songs to increasingly small crowds at the Union Bar.

After the first year or so One Day Elliott parted ways with Francis and guitarists Richard Crooks and Leo Blackledge-Smith joined their ongoing quest to have fun. This saw them begin to write songs that lasted more than a minute and a half.

Heavy touring and their increasingly rigorous schedule became hard to balance with their home and work lives, which meant that the band had to say farewell to Leo and Jamie, which opened the door for Dan Purton to join the final and longest-lasting line-up of One Day Elliott.

Having played more than a thousand live shows the band has continued with the same ethos of having fun and enjoying every performance for the last quarter of a century. Their music may have evolved and matured but their pop-punk roots are as strong as they've ever been. They still write and play songs that make them happy.

I met the band through watching and then playing at a bunch of their gigs in Kent and first got involved with One Day Elliott releases with the 'Medicine' digi-single (IGN220). This led, in 2016, to Engineer Records working with them to release the singalong-fest that is their 'Triple A-Side' CD EP (IGN228) containing three of the catchiest punk-rock tunes you will ever hear. Well, four in fact as there's an extra secret track on the CD, the 'Sound Check Song' with Paul singing, "Check one, check two, we're gonna sing this song for you." It's all wrapped up in the most beautiful cartoon-hero style artwork by Lewis Tillett, with each song

having its own character drawn, that we used for promo posters and postcards as well as on the fold out CD art.

There are few bands that have been involved with Engineer Records that have been around as long as One Day Elliott, so I figured that all of those shows and years on the road must have produced some weird and wonderful stories. Being a curious sort of chap, I thought I'd ask the band to share some of them with me for this book...

Trailer Trash

"On our first tour in the United States, our gigs were concentrated heavily in and around Arizona and California. Our first show was at the Monte Vista Hotel in Flagstaff and it was amazing; completely rammed with enthusiastic American rockers and we were treated so well. We were given hotel rooms as part of the deal and enjoyed the hospitalities of this little town before setting off for our next show the following day.

In true DIY style, we'd organised everything ourselves and had managed to blag, borrow or hire all of our gear from various outlets including a complete backline and a medium-sized trailer we attached to the back of our hired mini-bus. This was mainly to avoid any issues with not having visas to perform.

Flagstaff is situated in the mountains and our driver, Jason (who was a native of Arizona) decided to treat us to the scenic route on our journey to the next town. Thick forest and beautiful mountainous landscapes surrounded us as we twisted through the carved-out highway.

Suddenly, we were startled by our drummer, Dan shouting "Whoah, whoah whoah!" The trailer seemed to be jerking violently from side to side and, as we were cruising along at about 60mph, Jason tried to slow down.

The trailer then came unhitched and overtook us on the highway, hurtling along on the other side of the road. We all stared, mouths open as it eventually ricocheted off the road-side barricade, flipped up into the air, and smashed into a tree.

It was several seconds before we realised what had just happened kicked in and we all dashed over to assess the damage. Our instruments and

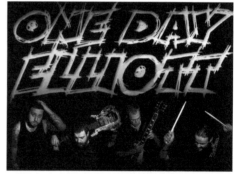

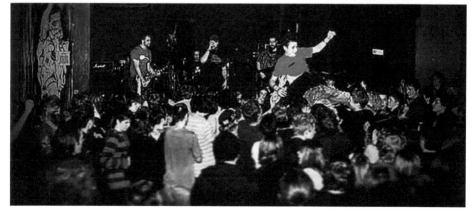

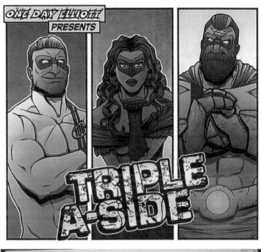

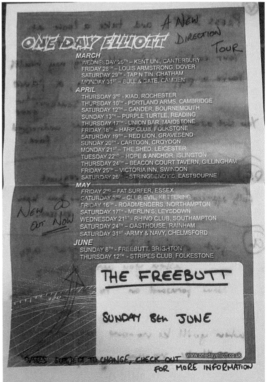

412

amps were scattered across the forest floor, and our merchandise, something like two hundred and fifty CDs, was strewn all over the road.

Miraculously, everything inside the trailer seemed to be okay and aside from being a bit dusty and slightly scratched, no obvious damage had been done to the amps or instruments. Pud's bass was even still in tune.

The trailer, however, was destroyed. Bits of it were all over the place and the base had completely broken in two. Jason yelled at us all to get everything onto the bus quickly, he grabbed a screwdriver and removed the number plate from the back of the trailer so it couldn't be traced to us and we made a swift exit.

The scariest thing was, literally two minutes further down the road, the forest route turned into sheer drops on the side of the road. Had the trailer come off here it would have plummeted into a ravine Roadrunner-style and we'd have lost everything.

Moments later, Jason received a call from the guy who had lent us the trailer, the bass rig, and most of the drum kit. "Hey dude, just to let you know, I'll be coming to see you guys in Phoenix tonight. I want to see the band and I figured you all owe me a beer or two."

We didn't mention at this point that we now owed him a trailer too.

Communication Error.

We had been looking forward to a particular tour for ages and it was taking us all around the country to our favourite venues we were excited to meet up with various bands, fans, and promoters with whom we'd made friends over the years.

Halfway through though, we got the unfortunate news that one of our shows had been cancelled. This is always annoying and leaves a gap in the schedule.

I remembered that I knew a venue that we'd played a bunch of times in the past that might be able to help us out at the last minute. It was in a different area, but it was better than having no gig at all, so I gave the venue owner a call. I explained the situation and asked if there happened to be anything he could do.

He explained that he'd actually hired the venue out to an outside promoter on that particular night and he knew nothing about it apart from that the music was punky, but he said to leave it with him to see if he could wangle anything for us.

He called back after about half an hour with good news. "I basically sweet-talked the guy and bigged you up," he said, "I just said you were perfect for his night, and he's agreed to put you on as long as you're happy to go on first?" Happy days.

We arrived at the venue early and set up our stuff. After heading out for some food, we went back to the venue and decided to just hang there until it was time to play. We were happy having a few beers and chatting between us until something seemed a bit odd. The punters had started to arrive and they certainly looked like a punky crowd; Lots of bomber jackets and big boots and we joked about how we hoped it didn't kick off tonight as pretty much everyone looked like they would be quite comfortable in a brawl.

It was only then that we noticed what the DJ was playing.
We had been accidentally booked to play a private white-power evening.

That was bad. Very bad. Obviously, our political views did not align with those of the horrible people in that room and the whole thing was abhorrent to us. However, there were 10 minutes to go before we were due on stage and our stuff was all set up and ready to go. Explaining how we felt about it and refusing to play was not really a viable option, considering the potential hospitalisation that might ensue if we'd told the nazi morons what we thought of them from the stage.

We decided that the only thing we could do, would be to play, as quickly and for as short a time as possible, and get the fuck out of there. The set was one of the most surreal experiences we've ever had. The nazi-punk arseholes in the venue, all looked confused at our performance of pop-punk tunes about girls and failed relationships, and you could tell they were trying to work out if they were metaphors for something more sinister.

I've never since been part of a quicker pack-down and venue evacuation. We called the owner as we left and let him know exactly who had hired his venue for the night. He was naturally horrified and left immediately to shut it down.

Oddly, though not totally unexpected, we didn't sell any CDs or t-shirts that night.

Bad Hangover

Between parting ways with our original drummer, Jamie, and recruiting Dan, we had a big nationwide tour booked. Luckily, our good friend Ant from the band Morgan's Puff Adder was able to stand in so that we could still play the gigs.

Our first show was in Northampton and it was awesome; rammed to capacity and an amazing atmosphere. The promoter, with whom we had a great relationship had kindly offered to let us crash at his house and also took us out for a late-night all-you-can-eat Chinese buffet followed by a rock club till the early hours. Even though we had two gigs booked the following day, one in the afternoon and another up in Leeds that evening, the excitement of having had such a good first gig and just being on tour meant that it was a pretty messy night.

We woke the following morning to find that Ant had been throwing up all night. From our previous tours with MPA we knew that he was often the life and soul of the party, so this wasn't much of a shock and, despite his protests that he thought he hadn't had that much, we spent most of the morning teasing him about not being able to handle his drink.

Our gig that afternoon was at the Rockingham Speedway in Corby, at a kind of motor racing, extreme sports, and live music festival. Ant was still seriously hanging but a combination of peer pressure from the rest of us and not wanting to let us down meant that he persevered and powered his way through the set. Despite resting his head on the rack toms between songs, I have to admit that he played pretty well.

After the set he went back to the van to have a nap while the rest of us mingled and tried to flog merch. About an hour or so later we wandered back to the van thinking that we'd probably need to leave soon to make it to Leeds in time for the next sound check. Ant wasn't asleep. He was curled up shivering in a load of our T-Shirts.

We found a medical tent nearby and decided to see if there was anything they could give him for his hangover (I can imagine that there was more

teasing and jokes about man-up pills at this stage) and the man there kindly offered to come and have a look at him.

The diagnosis was not what we'd been expecting and despite us explaining that we were on the second day of a two-week tour he was adamant. "Yeah, he's not going to be able to do that, he needs to go home. This guy isn't just hungover; he's really ill!"

Feeling a bit guilty for the teasing and obviously disappointed that we had to cancel our shows, we set off, not for Leeds, but for Kent, calling each venue or promoter one by one to deliver the bad news.

Over the days that followed each one of us developed similar symptoms and found ourselves in an equally compromised, vomiting, shivering state. Turns out we all had Salmonella food poisoning from the buffet and none of us would have been able to continue anyway. Apart from Pud. he was weirdly completely fine.
And before you ask, yes we all apologised to Ant."

One Day Elliott discography:
Three Quarters
Domestic Pet Nightmares
You Must Have Seen The Movie
Readers Wives
A New Direction
Rule Number One
A Vital Something
Mastering The Art of Self Preservation
Triple A side

https://onedayelliott.bandcamp.com/track/medicine

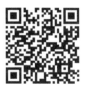

Palm Ghosts

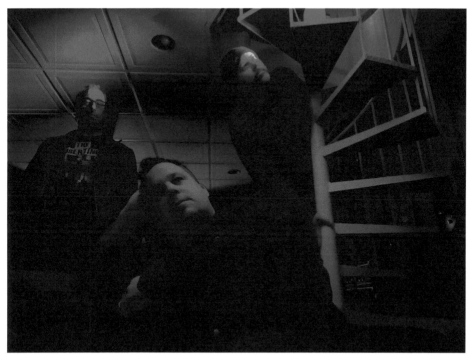

Joseph Lekkas : Vocals and Bass
Benjamin Douglas : Guitar and Vocals
Walt Epting : Drums and Percussion

If an eighties style prom took place in a war zone the band booked to play it would be Palm Ghosts. A million miles removed from the traditional honky-tonks and pedal taverns of their adopted city of Nashville, Palm Ghosts and their amalgam of cinematic dream-pop, new-wave and brooding post-punk sound as though they would be far more at home in rainy Manchester or blustery Berlin rather than the Southern state they call home.

Even though the powers that be regularly remind us that communication has never been easier than it is in the digital age, the perils of modern life being what they are, it took me far longer to sit down and talk with Joseph Lekkas than either he or I envisioned it would. And when we did, before I could ask my first question, he reminded me how we initially met...

"We were introduced by Sweet Cheetah label head and publicist, TIm Anderl. He thought that Engineer would be a great label to help the band break into the UK and EU market. We've only just begun really, but so far, it's been lovely and I'm looking forward to working together in the future."

After exchanging the everyday pleasantries that govern social convention and chatting about the ephemera of our personal and professional lives, Joseph began to tell me the Palm Ghosts story and he started where all good stories do. At the beginning...

"Palm Ghosts started in 2013 in Philadelphia as a studio project. I was suffering from a bout of clinical anxiety and depression and needed a way to focus my energies on something positive, so I locked myself in a rehearsal room in Surreal Sound Studios, a large warehouse in a pretty rough area of the city and worked through the freezing winter months of 2013-2014. The first record, since it was mostly me on every instrument, along with some friends guesting on instruments I can't play, such as drums, cello and pedal steel, feels more like a sparse and acoustic indie folk record."

After Joseph released this debut eight-song record in 2014, self-titled as Palm Ghosts and available on CD via Surreal Soundworks, he put together a group of good friends and local Philadelphia musicians to play some of the songs live. They even managed a very short and ill-attended east coast tour in 2014 before he made the move over to Nashville to continue his musical journey.

Joseph and his wife moved to Nashville in October of 2014 and rented a small house in the Inglewood neighbourhood. They set up a little studio in the guest bedroom and he continued his solo recording adventure with 'Greenland', a fifteen-song album that expanded on the sound of the first record with more electronic and throwback power-pop sounds. It came out on CD via Flour Sack Cape Records in 2017.

"I met Ben Douglas the first weekend I moved to town and we started collaborating on songs and building the relationship that has become the current version of Palm Ghosts."

Joseph told me, "After years of playing in different bands in Philadelphia, I never thought I'd put together a serious touring band again. I think I just wanted to record some new music and play live around Nashville.

The reactions we were getting at our local shows made us think we could take it on the road, and we have, playing over sixty shows per year, consistently since 2018, except the year of the pandemic."

Joseph continued; "The three of us (Ben, Walt and Joseph) truly are best friends and creative partners. Of course, we drive each other nuts occasionally, but that is what good friends do! We know how to spend our downtime during tours making each other laugh and really having a blast playing for people. And regarding our fans, we really have some of the most amazing fans that we've made over our years of touring. They'll put you up in their house for a week, buy you hotel rooms, feed you and just treat you with the utmost respect. Just wonderful people."

In 2018 Palm Ghosts released 'Architecture', (2018, CD, Ice Queen Records) a dark pop record with male and female vocals and their first offering echoing the sound of 4AD and Factory Records' brand of post-punk. Since then, they have built upon that release with a steady stream of songs invigorating the modern era with the '80s youth ethos and paying homage to idols like New Order, The Cure, Echo and The Bunnymen and Peter Gabriel.

During the worldwide pandemic, Palm Ghosts recorded and released 'Lifeboat Candidate' (2021, CD, Ice Queen Records) which received critical acclaim from the US indie press. The record was a giant ear worm on unrest, isolation, and frustration influenced by the jagged art punk of Gang of Four and Wire. The band's next offering, 'The Lost Frequency', (2021, LP, Ice Queen Records) felt more whimsical and celebratory. More nostalgic and less like a war, more like a prom. However, the lyrics still bring confrontation to the forefront and remind us that normalcy can still be devastating.

This was followed by 'Post Preservation' in 2022, another CD on Ice Queen Records, with ten new tracks showing yet another side of Palm Ghosts. There were songs about love with a hint of optimism. If you squint your eyes you'll see a faint light through the cracks, but with plenty of darkness and discontent for balance. Like the soundtrack to a long-lost John Hughes film, 'Post Preservation' twinkles with warm nostalgia for a world that no longer exists, except in our hearts and minds.

Joseph and Palm Ghosts are prolific song-writers and one of the things that I always love to talk to musicians about are the things that

influence them and inspire their records. The answers often tell you more about the person that you're talking to than a multitude of throwaway queries ever could. And Joseph was more than happy to fill in the Palm Ghosts blanks...

"There are so many influences! I personally grew up listening to lots of metal and alternative music. I was also a big fan of early 2000s indie rock which finds its way into our sound. When I was a kid I remember loving Duran Duran, the Thompson Twins and The Romantics, which morphed into Joy Division, The Cure and Echo and the Bunnymen. These sounds have helped form the new-wave vibe of Palm Ghosts. Ben is a big fan of Radiohead, Elvis Costello, Elliot Smith and The Lemonheads. Walt loves Radiohead, Suede, Blur and loads of jazz music. That mix of influences informs the sound of the band."

"Our record, 'Lifeboat Candidate', was a big one that shaped the sound of the band. Recorded during Covid, the drums were all recorded on an iPhone. The band never saw each other during the recording and we all collaborated through file sharing. The result is unique and informs where the band has gone since. I love The Cure's 'Head on The Door' and New Order's 'Low Life' records, the textures of the production and the song-writing are top notch on those two."

I asked him why the band moved to Nashville and he told me; "Nobody really cared about us in Philadelphia until we moved away, started touring and came back to play. I think that is pretty common. Nashville is such an industry town we either play for tourists or other musicians mostly. It keeps you on your toes."

Miles on the road, parking tickets and merchandise sales aren't the only thing that bands collect while touring, and almost every band that has ever packed up a van and set their collective compass for parts unknown have strange stories and a top ten of the best and worst shows that they've played. Palm Ghosts are no exception, and Joseph was more than happy to share his bands war stories with me...

"Opening for our heroes Modern English was amazing. It was so cool to share the stage with such legends. We really love The Mile of Music festival in Wisconsin, there are tons of great music fans at every show of that festival. Our first show in Toronto was pretty amazing too, great bands and a very positive audience. There are lots of bad ones though.

One that comes to mind was a show in Baltimore where we showed up and there was no PA or mics. Someone ran and got a crappy PA for us to use but the audience sat in a separate bar room while we played for the wallpaper."

A few years back we first tried to find a label in Europe. There was a guy who ran a very cool record shop in Germany that liked the band and bought our discography. He mentioned he'd like to reach out to some German labels that might love the band. But instead of enthusiasm, we got the most negative feedback. Stuff like; "This band could never excite anyone," "Songs do not ignite interest," "Please tell them they are not for us or our audience." We just pictured a perturbed German guy, completely taken aback by someone having the nerve to send him our music. It was hilarious to us. I think the guy who liked the band liked us much less after sending our songs to his label friends."

It's a good job now that Palm Ghosts has Sweet Cheetah, Sell The Heart and Poptek Records in the USA and Engineer Records in the UK / Europe all supporting them and their beautiful brilliant album, 'I Love You, Burn In Hell'.

'I Love You, Burn in Hell' (IGN377) is a melodic slab of discontent and disillusionment. Eleven songs about betrayal, exploitation and the hopeless task of navigating the modern world, wrapped up in catchy melodies and propulsive rhythms. If the world is ending, then this record will make you want to get on the dance floor. Recorded and mixed by Joseph at his Greenland Studios in Nashville and then mastered by Dan Coutant at Sun Room Recording in New York State, the album was released in digital, CD and LP formats on 10th November 2023 with the 12" pressed on bright orange vinyl echoing the beautiful if eerie cover art.

Before we went our separate ways, I asked Joseph about the scene, and what, given that his perspective has been tempered by time and touring, he thought about post-punk...

"I think that punk rock is and has always been a DIY art form. Today, laptops and pop music are ubiquitous, but you can't take the place of humans making music together. I think for that reason, it will always exist."

Ghettoblaster Magazine reviewed the new album, saying; *"I'm always reminded of the phrase "If we forget the past, we are doomed to repeat it," not*

because it reverberates with fear and dread but because it's sometimes welcoming. We question a number of things but why some dwell on the past usually isn't one of them. Film and television have a love affair with the past, but so does music. Now while the Nashville by way of Philadelphia's Palm Ghosts has gone through a variety of shifting membership, settling in with its multi-instrumentalist vocalist Joseph Lekkas, drummer Walt Epting, and guitarist/vocalist Benjamin Douglas, the band isn't stuck in the past, it lingers throughout it, grasping at elements, blending it into the sound it creates. Its latest release, 'I Love You, Burn In Hell' marks the fruition of that combination.

Throughout the past decade, the band has honed its skill, combining a wide array of textures into post-punk riffing, wrapped around electronic tones. Through its seventh album, nothing has changed, save for its maturation. Through 'I Love You, Burn In Hell', the band moves in a number of ways, through songs working through the band's strengths. But in all honesty, there's nary a point of weakness. Beginning with keyboard washes, the gloomy 'Tilt' moves with a goth-like intensity, and singer Joseph Lekkas' voice is awash through an array of effects that leads the band through darkness. But there's more than a glimmer of hope through 'Drag', the band's direct approach, brightly lit with possibly its catchiest song yet. The track is sensational in its pop delivery with an infectious melody that's sure to stop everyone in their tracks. Guitars wind around the track while the rhythm allows Lekkas and Douglas to run vocal melodies around it from beginning to end.

There are apparently a number of sexual connotations throughout the album but probably none more obvious than 'She Came Playfully', a forcefully driving number with a playful rhythm that stresses and storms around us. Lekkas' words confuse at first, until I realised he sang "When she came playfully beside me" wasn't "inside me." Its bounciness is hypnotic and changes the outlook on the band itself. But it's 'Machine Language' that offers nostalgic goosebumps, as if it's right out of the soundtrack for Out Of Bounds, you remember, that 1986 Michael Anthony Hall film? Anyone? Anyone? The song moves at a thrilling pace, with loads of kick and keys right across it. It's easy to move around it. But those same feelings lie through 'Catherine Shackles', but I'll spare you the film soundtrack it would be comfortable and fitting within. Musically it's affectionate and unyielding while at the same time keeping its guard up.

Where does Palm Ghosts fall in the grand scheme of things? Well, considering its past few releases were strong, showing continual growth, the band 'I Love You, Burn In Hell' finds the group at its peak."

Spin Magazine says Palm Ghosts are; *"A heat-seeking missile for early alternative rock fans."*

Manchester's **Analogue Trash** describes Palm Ghosts as; *"Achingly beautiful, fragile and majestic music. An intoxicating mix of Shoegaze and Dream-pop, taking from the 80's but not in debt to it."*

And South Africa's **Jangle Pop Hub** said the band has; *"An inimitable 80's style dream-pop that mixes the avaricious swirl of The Cocteau Twins, the atmospherics of The Cure and the grandiosity of Echo and The Bunnymen."*

https://palmghosts.bandcamp.com/album/i-love-you-burn-in-hell

Piledriver

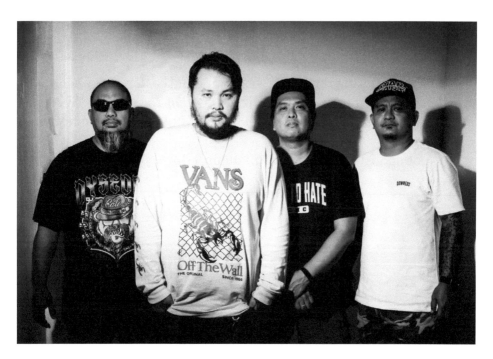

Howell A Casacop : Bass
Gerardo 'Reggie' Bawan : Drums
Rodney 'Boy' Reyes : Guitar
Jayson 'Yuri' Villalobos : Vocals

Hardcore was never about where you're from. Hardcore was, and is, all about energy, a shared spirit of drive and focus, the adrenaline fuelled excitement and intensity of shows, a global network of like-minded individuals and music that makes you want to sing along until your lungs burst, your ears bleed and it feels like you've got nothing left to give. And then getting up and doing it all over again when the next song starts.

Laguna, Philippines favourite hardcore sons, Piledriver have shared the stage with the likes of Youth Of Today, Sick Of It All and Hatebreed, and prove that it doesn't matter where you're from, all that matters is what's in your heart. Hitting like a Brooklyn bound subway train, their music feels as if it was recorded in a previously hidden and unknown basement of CBGB's. It's beat-down riddled savagery, mosh-laden

425

anthems and infectious sing-along choruses make you think of Queens rather than the Philippines and demonstrate that New York is more than just a place, as Nas said; it's a state of mind.

Piledriver started in 1998 as a side project band that found its members in a close circle of scene-based friends in Santa Rosa City, Laguna in the Philippines. In late 1999, while the band was hanging out and skating, they were the victims of a drive-by shooting that took the life of Yap, one of the guitarists from the band's first line-up. It was one of the saddest chapters of the band's life, and they never imagined that something like that could happen to them. They were just spending their days having fun, and in the blink of an eye one of their founding members was gone. After the shooting, the band, understandably, didn't want to do anything for a while. Then Treb, Piledriver's original singer, decided that rather than let the band stagnate and become another victim of that senseless crime, asked Howell to play bass for Piledriver and make it a full-time band. The rest is HC history.

Howell was in a band called Homicide with Reggie, and although Piledriver was just a side project / cover band he asked the drummer to lend his talent to the soon-to-be full-time band. Rodney was in Ammunition, another local band, but knew Howell from college as he used to buy and trade tapes with him. Then Yuri became part of their close-knit circle of friends and eventually joined Piledriver after he met the band at a show. The singer, Yuri, was the secret ingredient that the band had been lacking up until that point and after he joined in 2018 their previously fluctuating line-up finally became the stable tour de force that has stayed strong and remained constant ever since.

United by a love of New York Hardcore and their desire to help stop senseless violence, social injustice and promote a gun-less society, whilst influenced by the bands that inspired them from half a world away, namely Terror, Madball, Strife, Sick Of It All as well as Biofeedback, the gods of Philippine Hardcore, Piledriver found a new focus and drive, and became one of the most lauded, and best known bands in their scene.

Releasing their first four-song demo in 2000, the band didn't rest on their laurels or slow down and soon followed their debut recording with the 'Straight from the Gutter' EP in 2001, then the 'Santa Rosa City' full length in 2006, 'Southside Kings' in 2011, 'Defend Laguna Hardcore' in

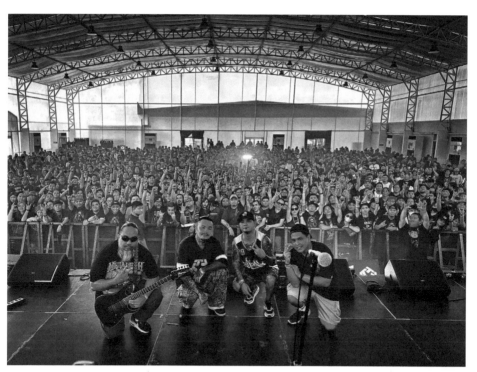

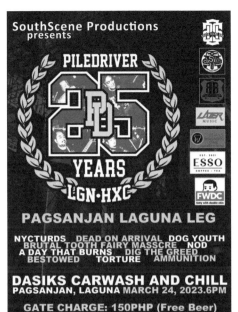

SouthScene Productions presents

PILEDRIVER

25 YEARS

LGN·HXC

PAGSANJAN LAGUNA LEG

NYCTURDS DEAD ON ARRIVAL DOG YOUTH
BRUTAL TOOTH FAIRY MASSCRE NOD
A DAY THAT BURNS DIG THE GREED
BESTOWED TORTURE AMMUNITION

DASIKS CARWASH AND CHILL
PAGSANJAN, LAGUNA MARCH 24, 2023.6PM

GATE CHARGE: 150PHP (Free Beer)

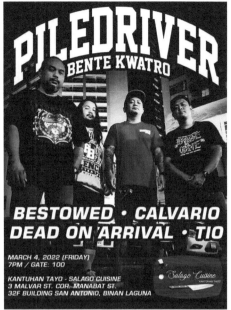

PILEDRIVER
BENTE KWATRO

BESTOWED · CALVARIO
DEAD ON ARRIVAL · TIO

MARCH 4, 2022 (FRIDAY)
7PM / GATE: 100

KANTUHAN TAYO - SALAGO CUISINE
3 MALVAR ST. COR. MANABAT ST.
32F BUILDING SAN ANTONIO, BINAN LAGUNA

PILEDRIVER
1998
SANTA ROSA CITY
HARDCORE

2014 and then their 'Constant Battles' (IGN285), which was released in Digipak CD and 10" clear vinyl format by Engineer Records in 2019.

This prolific output has now been joined by '25 & Live' another CD and vinyl LP release on Engineer Records (IGN387) with support from Crank Music Relief, Lazer Music and Railroad Records. The band's first live record contained sixteen blasting tracks and was released on 11th November 2023 with the ever-busy and constantly touring band celebrating their twenty-five year hallmark with more gigs; in the Lion City, Singapore, at Batam Hardfest and the RakRakan Festival in Paranaque City. The Piledriver gigging steamroller never seems to stop travelling around the Far East.

Collectively the band agrees that 'Southside Kings' is still their favourite record, as it took years to come to fruition for reasons that were, for the most part, out of the band's control. Their original vocalist and up until that point, driving force Treb, was about to leave to live in the USA and they spent a long time coming to terms with his departure and looking for someone to replace him. Luckily for them, they found Gin (Yuri's predecessor) and he was with them until the 'Defend Laguna Hardcore' EP.

The Santa Rosa City scene loves Piledriver, and Piledriver loves the Santa Rosa scene, so playing in their hometown is always a wild and crazy ride for the band. Every city and underground scene they've played in is incredibly welcoming and folks of all ages, young and old, turn out to see the band tear stages apart and raise the roof of every club they hit.

After chatting with Piledriver for an hour or so for this book it felt like I'd known them for years and that I was hanging out with old friends, which is sort of true, as I used to send Howell records to review in his fanzine back in the day. So when he first asked me if I was interested in releasing a record by his band, I said "Sure, I'll give the songs a listen and we'll go from there". He sent them and I was blown away. As I already said, the rest is history.

In between laughing, joking and swapping one-liners with the four hardcore kids from Santa Rosa City, I asked them about the gigs that they'd played and what their favourite Piledriver stories were, they all had different tales to tell...

Howell: "We've played some pretty memorable shows, like playing PULP Summerslam (The biggest Festival in the Philippines) for the first time in front of 30,000 people. It was mind-blowing for me. Also, playing Hong Kong for the first time and meeting lots of great people on that tour was amazing. But along with incredible shows, some aren't so great and I think the worst Piledriver gig for me was in the early days when we had to wait until 3am to play in an already empty club."

Reggie: "My most memorable shows were when we opened for Youth of Today in Singapore, Rise of the Northstar and Sick Of It All in Hong Kong, and Hatebreed here in the Philippines. Every album tour is memorable though and gives us the chance to meet new friends and see old ones around the archipelago."

Rodney: "For me, during the fourteen years of playing in this band, there were and are so many great shows and gigs. But one of the most memorable was this huge music festival where we played on the same stage as Testament, Lamb of God, Darkest Hour, Death Angel and some of the best local bands from the Philippines."

Yuri: "I love all of the shows that we've played, but when a gig is for a cause, that makes it even more incredible because we love to help people whenever we can. Oh, and there was also the Piledriver Philippine tour and the last show of the Backtrack Bad To My World tour which was in Bangkok, Thailand. They were great gigs."

With all the time they've spent on the road and in sweaty clubs they should know, so I also asked the band about why they think the hardcore music scene was, is and always will be important and vital. Their answer was simple, honest and straight to the point...

"Hardcore is always relevant, it's a way of life. There are no frills, no gimmicks, just straight-up real-life struggles, camaraderie and great music. Hardcore still exists today because it's an outlet and escape from the world of stress. It's a perfect way to channel and release negative energy at gigs and provides a medium for us to connect with each other and have a lot of fun along the way."

Unite Asia reviewed 'Constant Battles' and the tour that followed, saying that; *"It's a battle that the band's perseverance and resilience always wins in the end. Because here there are, still touring, still releasing music, still existing*

and now hitting the road again for over 25 dates across the glorious Philippines." **Taiwan Rocks** added; "*The most experienced hardcore OG's from Laguna in the Philippines, Piledriver, came to Taiwan in 2017 and 2019 and are now coming back, releasing the 25th anniversary live album '25 and LIVE!' A mature release sounding a little like West Coast US hardcore kings Terror.*"

And **Thoughts Words Action** wrote about Piledriver's latest live album, '25 and Live', proclaiming, "*It's a straight-up visceral ride through the gritty heart of hardcore. From the first beat to the last scream, this record encapsulates all the unfiltered aggression, raw energy, and sheer power that defines the Piledriver experience. It's not just an auditory assault; it's a 25-year retrospective presented in a sonic package that's bound to resonate with fans of unapologetically intense music. What's immediately apparent is that Piledriver hasn't mellowed with age; if anything, they've harnessed their years of experience to deliver a performance that hits harder and roars louder. The live setting amplifies the authenticity of their sound, capturing the essence of countless hours spent on the road and in the studio.*"

https://piledriverlgn.bandcamp.com/album/constant-battles-ep

Punch Drunk

Gram Black : Vocals and Guitar
Ben Elton : Bass and Vocals
Colette Elton : Drums
(Ryan Murphy : Drums)

Forming in Nottingham in 2016, Punch Drunk are a three-piece melodic punk band with a big guitar sound and tight, inventive rhythms, topped with emotive vocals that recall early Lemonheads, Moving Targets, Jawbreaker, Buffalo Tom and even the UK's own Drive. But although the lion's share of obvious references are American, it's important to note that they don't come across as Americanised in any way, retaining a very evident English manner throughout.

After a fateful evening early in 2018 where Gram Blackwell (Ex-Cape Canaveral) played a few songs on an acoustic guitar at Colette (Ex-The Smears/You Want Fox) and Ben's (Ex-Drag The Lake/King Of Pigs) place (Colette and Ben are married by the way) a rehearsal was booked and the rest is history. The main product of that history being the band's album release 'Sassy'.

The band's ten track debut brings forth tantalising flavours from the likes of Husker Du, Sugar, Jawbreaker, Moving Targets, Lemonheads, Buffalo Tom, Texas Is The Reason and the like to produce some great, melodic and powerful tunes.

As Gram, the band's singer and guitarist says, 'Most of this has been about having a laugh with friends. If the by-product is having a few people enjoy what we do, then that's all the better'.

Cape Canaveral called it a day in 2006 and Gram had no intentions of playing in a band again, in fact he sold all of his kit bar a couple of guitars. Fast forward ten years and he started writing songs again so when the chance to be in a band with close friends came about, he jumped at it.

After some practice time and a handful of gigs the band went into Moot Group Studios in Nottingham with Johnny Carter and Andy Jones at the desk to record a ten-song album in the summer of 2018. The songs were then mastered by Jay Graham at Tenko Studios and the resulting sound is a kick-back to the 90s with an up-to-date spin. The band call themselves pop-punk but there's an emo tinge with a punk edge all the way through.

Punch Drunk's album is called 'Sassy' after the sassy little cat on the cover artwork and it was released on 12th July 2019 in cassette and CD formats jointly by Disillusioned Records, Engineer Records (IGN263) and Just Say No To Government Music Records.

I asked Gram a bit more about how 'Sassy' came about; "Punch Drunk was never meant to happen. I had given up being in bands ten years before with the breakup of Cape Canaveral and had gotten into the groove of attending gigs in Nottingham and further afield and was just enjoying being on the outer spaces of the scene.

I was lucky enough to be surrounded by people who were either in bands, put on gigs/shows, owned studios, did artwork, printed stickers and everything else in the known spectrum of DIY music, and honoured to call them my friends. But as is the case with all friendships, I saw some way more often than others.

Two of those people were also a couple and I'd been friends with Colette for years and we hung out a lot and watched a lot of bands together.

Colette also had a hand in music, having been the drummer for The Smears in the past and the current drummer and singer for You Want Fox. Ben was Colette's husband and we had also become friends. He was also the bassist for King of Pigs, so again, he had a hand in punk music.

A lot of our socialising was based around what their bands were doing in Nottingham and at that point a large group of us went to gigs all the time. All I remember is that the other three King of Pigs members had other bands on the side at the time but Ben didn't and drunkenly approached me at a gig we were all at to ask if I was interested in starting a new band.

I still played the guitar and wrote songs so, as drunk as I was, I agreed to go around their house to play them my songs and as Colette was there, we asked if she would be interested in drumming for the band. At this point, it was just a drunken conversation.

However, a couple of days later I was sitting on their sofa playing some songs, a couple of which ended up on the album. That was February 2016 and we entered the studio to begin practising in March of that year.

Cape Canaveral was an emo band in the Christie Front Drive and Mineral style with a hint of Buffalo Tom. The songs were long and meandering, which was sort of the thing at the time. But immediately with Punch Drunk I knew I wanted to write shorter and punchier songs that wouldn't last more than three minutes and would draw more heavily on the Buffalo Tom and Husker Du sound, both big influences on my musical life.

Stuck on a Name studio became our regular practice space and we hit it weekly for the next six months. There was no agenda or idea behind it as this was both Ben and Colette's side band. Also, in the ten years of not being in a band, I had developed some pretty heavy mental health issues, so I was okay with just practising and never getting on a stage.

Of course, this isn't what a band should be about, so in late 2016 we started looking for our first gig, which didn't come until Easter Sunday of 2017 at an all-dayer at The Maze. The gig itself went exceptionally well. We were relatively high on the list, considering it was our first gig, and for me it put paid to some demons that I had about playing live again.

Without knowing it, we also found a partner label for whatever would be our first release. Litterbug was on the same bill and I was speaking with

Andy Higgins, the guitarist and singer, who was also the main man behind Just Say No To Government Music Records. He likened our sound to that of Liverpool's Drive, so I liked him instantly and we kept in touch.

Throughout the rest of 2017 we played more gigs and our first one outside of Nottingham was in Sheffield with King of Pigs. This was Ben's other band, meaning he had to pull a double shift that day, and bizarrely, we found ourselves on after King of Pigs, which meant Ben had already played.

Let's just say the audience wasn't for us or King of Pigs, as they wanted some of that old-school punk and we could not have been further away from the thing they were all yearning for. All I remember is Ben and Colette glaring at me, telling me not to say anything on the mic between songs while polite ripples of applause preceded deafening silence as I had a reputation for ripping the piss and openly showing my disdain for certain crowds. I kept my gob shut and we got out alive. As we left an Oi band came on stage and everyone got up to watch them. Ah well, we got a few drinks out of it.

2018 started quietly, but then a run of gigs throughout April and May took us to Sheffield again, Derby for the first time and then back to Nottingham to play at The Old Angel, The Salutation Inn and The Maze again (although for the last time as The Maze is now student flats). Later in May we began recording what would become our only album, 'Sassy'.

For me, there was only one place to go; The Moot Group. These guys had been around for some time and initially, it was Johnny Carter of Pitchshifter and Paul Yeadon of Bivouac and The Wireless Stores running the show. But as Paul had moved to the South Coast now, it was Johnny doing it with some help from friends.

The album was recorded and produced over several months, which is what happens when you're being charged mates rates. Colette recorded the drums in one take, much to the surprise of Johnny but not to Ben and me as she was a machine that made very few mistakes. Ben did the same thing with the bass and that left everything else for me to do, or so I thought.

I remember the summer of 2018 being hot so I spent a lot of my free-time sweating in a loft studio recording guitars or vocals. At this stage, Ben was pushed to try to do backing vocals which worked out well and added another dimension to our sound.

We tinkered with the recording until early August. The mixing was complete by the end of the month and we got the mastered version back in September. On listening back to it, it sounded nothing like I expected it to. Our songs were way more poppy and the influences of Husker Du and Buffalo Tom were in every song. Bottom line, we fucking loved it!

And this is where we fucked up! Instead of putting the record on the many streaming services, I refused to use them. I have real issues with Spotify and its ilk, so a song at a time went out on Bandcamp and the album didn't come out until July 2019 and didn't hit the streamers, after I finally gave in, until November of the same year. But I'll come back to this later.

We played many more shows up to the end of 2018. We were playing with bands from the scene we were part of, including gigs with The Murderburgers, City Mouse, Janus Stark, The Atoms, Natterers and You Want Fox. We also played our first Hockley Hustle, a Notts-based mini-festival where most of the bars in Hockley have bands on.

We became friends with the Scary Clown Presents promoters based in Peterborough during this run as we'd played with The Atoms and Janus Stark in late November at the small but perfect Ostrich Inn. They invited us back to play their annual Skate Aid, it was the sixth one and was going to happen in June 2019 and we couldn't wait.

More gigs came and went throughout 2019. We went back to Sheffield and played a few local shows in a bid to get our name out there in our home city and during this time, we had the pleasure of playing to an almost empty JT Soar. We've all done it at some time, but this was a low point.

Behind the scenes, the album was mastered, and the cover was designed and we had an initial release schedule with two different labels. The cassettes would come out on Disillusioned Records thanks to Wayne Hyde, and the CDs would be released by Just Say No To Government Music Records, thanks to Andy Higgins. We were aiming for a July release of both. Wayne had worked with Engineer Records on a few releases and introduced us to them. I spoke with David and he loved the new songs and offered to get involved too. Now we had three decent alternative labels working together with us to push the new album.

While this was happening, we were set to play Skate Aid 6. I return to this

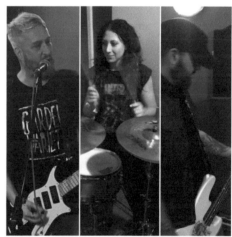
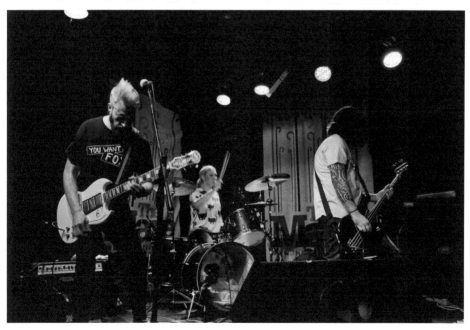

Half-Arsed Promotions Presents...

THE MURDERBURGERS
SCOTLANDS MOST #HFS POP PUNK BAND

£5
OTD

CITY MOUSE
AWESOME POP PUNK FROM THE USA

PUNCH DRUNK
NOTTINGHAMS OWN GRUNGE PUNK COUGARS

DOORS
7 30 PM

ROBOTER
EX SQUIRTGUN USA VIA DERBY

Tuesday 25th September 2018

The Old Salutation, Nottingham.
NG1 6AJ

THE OSTRICH INN AND THE SCARY CLOWN PRESENTS...

FREE ENTRY

SATURDAY 24TH NOVEMBER

JANUS STARK
THE ATOMS
PUNCH DRUNK
PETROL BOYS
THE OSTRICH INN PETERBOROUGH

THE SCARY CLOWN PROUDLY PRESENTS....

SKATE AID 6

SATURDAY
29TH
JUNE 2019
MIDDAY TO MIDNIGHT

ADV TIX
£15
MORE ON DOOR

BBQ BY
RESIST!
VEGAN KITCHEN

ZINES
HUNT SAB STALL
ONE OFF CRAFT BEER

WONK UNIT
THE CRIPPENS
THE MENSTRUAL CRAMPS
THE SIKNOTES SKACIETY
THE MIDWICH CUCKOOS THE DEADLITES
MARK MURPHY THE MIXTAPE SAINTS CHRISTIAN SMITH
PUNCH DRUNK ARMS AND HEARTS
NOT FOR YOU SPRAINER
MAMA LIZS VOODOO LOUNGE STAMFORD PE9 1EL

BEDLAM BOOKINGS PRESENTS

THC DREAMS

PUNCH
PUNCH DRUNK
DRUNK

BLIGHTTOWN

SAINTS BAY

PUPPET
PARANOIA

NOTTINGHAM | ALBERT'S

SUNDAY 13 OCTOBER

6 30PM | £6 ADV | 14+

bedlambookings.ticketline.co.uk

438

because it was the most fun day we ever had with this band and if you've never been privy to the hospitality of Scary Clown, you may not understand this, but there was enough booze and snacks to fuel and feed a small country, let alone the handful of bands they had on that day.

The weather was absolutely stunning, so we did what punks do and scuttled inside to watch band after band while constantly drinking. A strawberry daiquiri or two may have been consumed, but as we were staying over, we didn't stop.

The funny thing about all this is that when we arrived, we were immediately asked if we could go on first and again later, third from the top, due to a band having to pull out. Of course, we said why not. We played our first set to the early gatherers and then went off to drink all the booze and I have no idea how we got back onstage hours later and played again, but it was some of the best fun I've ever had. The one thing I always remember is Bomber down the front bouncing about but asking us to play faster after each song so that set will forever be known as our Drunken Master set.

Soon after this one of our friends bought a bar in Loughborough called the Cask Bah and put us on. It was a great gig and really, I'm only mentioning this because for that night we had a cocktail named after our album, The Sassy Cocktail, or in this case, a rocktail. It was pretty tasty too. This was the first gig where we had all the merch with us and sold a few items but there's an on-going joke in the band because of the amount of times I forget to bring the merch with me to gigs.

After this, we ploughed through a bunch of great hometown gigs. First up was at Stuck on a Name with Distral, Fast Fade and Page 3 Boys and at the time I rocked a Flying V, just like Bob Mould did. However, that guitar had gremlins. Mid-song cut outs, dipping volume and crackling noises. It looked cool but sounded terrible. I loved that guitar but it had to go. Strangely enough, Ben now owns it and plays it regularly without any issues at all.

Another hometown show happened at Alberts (now Ghost) in Nottingham with THC Dreams and Blighttown and it stands out to me because of the sound. The sound guy was a friend of ours, Phil Taylor, and he gave everyone a fantastic sound. I had changed my guitar to an SG, the drums were mic'd up, the bass was booming and that show

reminded why we did this as musicians. The merch sales went well that night too.

November of 2019 saw us close out with a couple of local gigs. One was the worst we've ever played and the other was, yet again, the wrong audience.

First up was Mindfest. A fantastic day of bands in Alberts all for the cause of the Mind Charity. Unfortunately for us, there was also a lot of free booze and it looked like we were the only ones taking advantage of the fact and for me, this was bad. After what happened at Skate Aid I thought I was invincible when drunk and while the Skate Aid set was a success, this one was a drunken mess of my own making.

Strings broke, I played too fast or too hard, and I got angrier and angrier. According to a friend that watched us, we were the most intense he'd ever seen us and even though we went down well, my anger was hard to hide. Nothing is ever perfect but the way I see things now is that I let the band down, I didn't have fun with my friends and I just wanted to get through it. Even now, I still look back and wince at that performance.

As I mentioned, the other gig that month was with another punk band at the Tap n Tumbler and this is where the world of punk confuses me. There are so many genres and a lot of them don't mix very well, and that included us and old school British punk. I have nothing against the people who like this stuff or who play it, but the type of punk we played was oceans apart from that style. The show was packed, and people were standing right in front of us, but only a certain few would engage with us between songs.

It was definitely something that gave me food for thought and after that we wouldn't play just any gig, we would search out those gigs with like-minded people and similar styles of music.

We were meant to play another gig at Rough Trade just before Christmas but we couldn't do it as Ben had gone on the temporary city centre ice rink, fell over and broke his arm. Many jokes about Torvill and Dean later, we realised that our gigging year was over so set about looking for gigs in 2020. That was going to be our year.

During all this, the gigs we could play were mainly determined by Ben's timetable as he was a bus driver for the city and worked shifts that

clashed with gigs. I know this was a bone of contention with Ben but it was his living and neither Colette nor I minded.

The album was out now and doing OK. We sold a few through Bandcamp and at the gigs when I remembered to take the merch, but folks kept asking when it would be on Spotify and the like. I knew at this point I'd messed up by not putting it on the streaming channels and what little excitement there may have been about the album seemed to have passed. So, along with making sure we played the right gigs going forward, we would make more use of the streamers. Remember, 2020 was going to be our year.

Was it hell! January was a write-off due to Ben's arm injury, so Colette and I started to get gigs lined-up from March onward. By the time we had started practicing again in February we had booked ourselves gigs in several cities we hadn't played before and a slot on a new Nottingham Punk all-dayer in June.

Then came COVID-19 and we all said goodbye to any kind of live entertainment for the year. All of our gigs and the window for plugging 'Sassy' was lost. We kept ourselves busy with radio shows and podcast interviews. Pi Records in Pennsylvania loved 'Sassy' and did a big shout out for it, interviewing us for their YouTube Channel. The Punk Bunker in Sheffield showcased 'Sassy' as its Album of the Week and both Local Distortion and Alyx Plays Punk gave the song 'Lane' some airplay. With that, 'Lane' became the unofficial single from 'Sassy' and Ben, using his time as a furloughed Bus Driver, created a video for the single out of live recordings and shots of the open road.

We eventually started practicing again in April 2021, working on new songs and talking about what our next release might be. Gigs were being discussed from sometime in July so we started reaching out again. The first we had booked was with Slackrr on 17th July but our government at the time extended the live entertainment lockdown and that meant all seated gigs with masks on and all the shenanigans that came with it. Slackrr moved their date to later in the summer but we kept the gig and shared the stage with Crosslight and Raging Clue.

Having everyone sat down at tables while playing a gig is one of the most surreal experiences ever for a punk band. It all felt far too civilised so we just got hammered and played our hearts out.

Unfortunately, one of the other side effects of Covid was the amount of relationships that broke up over that time and as it turned out, this came to the home of Punch Drunk too. Ben and Colette's marriage didn't survive. I was stunned to find this out as we had been practicing like normal, arranging gigs, even talking about a gig for my upcoming 50th birthday.

The August gig with Slackrr and Raging Clue went on as planned and was great fun, but also tinged with a hint of sadness. At this moment in time, no one knew. It wasn't anybody's business and after a few conversations Ben and Colette agreed to do one more gig for my birthday in October, but we wouldn't announce anything until weeks afterward.

The final gig with this line-up included a new band called Locals and Colette's other band, You Want Fox. I was wasted beyond words to the point that both Ben and Colette weren't completely sure if I could play. I must admit, I remember very little from that night, but we went out on a high.

All I know is that for most of the night I looked like a version of the Joker. Why? Because someone's female friend found out it was my birthday and gave me a great big snog, which was all very nice apart from the fact she had bright red lipstick on and it was now smeared across both of our faces much to the amusement of everyone there.

A few weeks later, as mentioned, we announced that Colette had left the band and Ben and I set about finding a new drummer. We weren't done yet and losing 2020 made me want to carry on despite starting to look and feel like an old man now.

By February 2022 Ryan Murphy had joined us on drums. Ben and I had decided to drop some songs and write new stuff so the three of us set about practicing. Ryan was also a machine on the drums but also had an amazing memory. It was like he would hear a song once and be able to remember it. This was funny because it began a battle of banter between him and Ben. What was the Battle of the Banter? It was basically Ryan taking the piss out of Ben for forgetting the songs that he had, in some cases, been playing for years and that Ryan had heard once and never got wrong. It got even funnier when Ryan made suggestions to change certain things, especially to songs from 'Sassy', which drove Ben up the wall as we'd have to remind him each week that we had changed it. Despite all this, Ben never forgot them when we played live, but I think

the fear of fucking up got to him. Both Ben and I would need a 'just before going on stage piss'. Are these nerves a normal thing or is it a sign of age?

Punch Drunk version two was relatively short-lived in the end. We practiced most weeks and played our first gig back in June supporting Diaz Brothers and Moving Targets in Nottingham at the now sadly lost Chameleon. That venue could be an endurance test at certain temperatures. I once overheard Colette's older brother leaving the venue during a gig, saying, "I do love my sister but I'm not willing to die of heat exhaustion for her!"

For me though, this was what playing was all about. Like-minded bands, playing together on a bill in front of a like-minded crowd. Moving Targets were one of my favourite bands of all time too and this was what I wanted to carry on doing. Despite the heat, that night I didn't want to stop playing.

Next up was back to the Cask Bah in Loughborough. No rocktail this time, just us on a small stage in front of a handful of people being allowed to play every song we knew. The way we sounded was exactly the sound I had in my head. We were also back to The Ostrich in Peterborough for the Scary Clown Presents guys supporting The Drowns. The show was rammed as usual with an attentive crowd but unfortunately Ben had a few technical issues. What I remember of this night was being soaked through afterward, so going outside to change and it was pissing it down. Cold, pissed off and still wet, we never made it back into the pub and never got to see The Drowns. That was late November 2022.

We played one more gig in late March 2023. Back at The Chameleon. We were headlining what was essentially an acoustic night and it wasn't a perfect situation, what with it being Tuesday night and pissing it down. We were grateful for those that turned up, but it was just a shame that they only turned up to see us and that the other acts played to themselves and us. Something changed in me after this. I wanted a restart. We'd been a band for seven years but still had difficulty in attracting the gigs I really wanted and if I'm honest, I just gave up and settled into a life without a band. I didn't even pick up my guitar for nine months.

I told the others. Ben was ok about it and Ryan already played in another band called Dragster. About a year later I've started playing my guitar again and writing new stuff. So who knows, there may be life in the old dog yet."

Rich Cocksedge reviewed 'Sassy' for **Razorcake magazine**, saying; *"Although the bands used to describe Punch Drunk's sound include Hot Water Music, Hüsker Dü and Jawbreaker I am adding The Doughboys, All Systems Go! and Red Collar to the list. There are some really strong songs here and the highs are much more prevalent than the few lows. Having played this quite a few times now, even some of those lows are beginning to sit nicely in my head. An impressive debut."*

Cian Hynes wrote in **Riot 77 fanzine**; *"Coming across as a combination of The Beltones and Husker Du, Nottingham's Punch Drunk are as likely to glide through sombre or subtle shadings as they are to reach for the power chords. Edgy, tuneful punk that doesn't sound like a carbon copy of anyone else. The music has a potent guitar kick while the lyrics deal with personalised observations on the world. All songs are punctuated by a melodic arrangement, yet there's definitely substance to Punch Drunk and its obvious they've got something going on here."*

And Andy Pearson wrote in his **Fear N Loathing** review; *"With ten songs in less than thirty minutes they're definitely not wasting time and keeping it all within a pop context as well. The whole album is kept pretty much to the point with an approach that really doesn't mess about. They do whip-up a big-sound, but always keep it in check so that it doesn't overpower the underlying melodies or subtle hooks that consistently draw you further into the songs. I'd love to see this band live because I'm sure this set of songs would be blistering in an onstage setting. If you like your music loud and strong, but with plenty of cool tunes to keep you tapping your toes, you really have to hear this!"*

https://punchdrunkrock.bandcamp.com/album/sassy

Red Car Burns

Mone : Guitar and Vocals
Buba : Guitar and Vocals
Ale : Bass and Vocals
Corbe : Drums
Ivan : Guitar and Vocals

Red Car Burns is a punk rock band from Lodi, Italy, that's been hanging around, releasing records, playing shows and touring around Europe and the USA for almost twenty years. The band's unique combination of melodic punk, grunge and post-rock has ensured that Red Car Burns kick ass every time they hit the stage, and has seen them compared to Face to Face, Hot Water Music and Samiam.

Starting out as a punk band called Genitalz, the band soon changed their name to Red Car Burns and released their debut album, 'When Everything Seems To Be In Silence', in 2004 via Engineer Records and NH-N Records. They'd been introduced to us by Francesco Derchi, the owner of the Italian label NH-N, (Now Here, Nowhere) as we were already working together with a couple of his bands (Evolution So Far

445

and Coffee Shower) on co-releases. RCB had a real Jawbreaker / Samiam feel to what they were doing and we were into it right from the start.

As soon as 'When Everything Seems To Be In Silence' came out on CD (IGN064) the band started touring Italy and all over Europe to promote it. They quickly grew in popularity and made new friends and fans everywhere they played. Their songs started appearing on compilations in both Europe and Japan.

They took a while to capitalise on this though and it wasn't until 2010 that they released their second full-length, 'The Roots and the Ruins' on CD jointly through Engineer Records (IGN152), No Reason, Koi, Shattered Thought, Strictly Commercial and Disillusioned Records, and then hit the road again, playing more shows than most of them can remember. Following a line-up change they recorded some new songs for a split 7" with Austrian band Ants! which was released by No Reason Records in 2013 and they got down to the serious business of writing the always-difficult third album.

The aforementioned album, referred to by the band as the self-titled record because... Well, because it's called 'Red Car Burns' was released in 2015, just before their first US tour which ended in, as Short Round so famously said, "fortune and glory" at FEST14 in Gainesville. Following a punk rock moment like that wasn't exactly easy, but RCB was determined that they'd surpass their moment in the Florida sun and having played a bunch of shows in Europe and Italy, the band released the digital DIY EP 'Travellers and Stories' in 2017 to fund and support their second US tour, which funnily enough, finished at FEST16 in Gainesville.

In 2018, they released a split 7" with Seattle, USA based Dead Bars on toxic yellow vinyl via No Reason Records and in 2019 the band toured Europe again just before the pandemic shut the world down, but despite the almost impossible odds that COVID hurled at them and everyone else, RCB survived Lockdown relatively intact. In 2023 the band released a new single, 'Nothing' which marks the official comeback, and with a new 7" in the works, Red Car Burns are ready to do what they do best and hit the road again.

Where did the Red Car Burns story begin? It all started in 1998, when Mone and Buba met each other almost by chance, as members of

different punk bands active in the Milan area. After their bands Segatuva (Buba) and Fumatti (Mone) played a show together, the latter needed a guitarist and Buba looked like the perfect fit for the role. They both shared the same need to escape the small towns of the province they called home and dreamed about becoming musicians like the American bands they listened to. Buba and Mone were young and wanted to have fun, so they recruited a bass player and drummer and became Genitalz.

Despite playing high-energy pop-punk, after their self-titled debut LP it was clear to Mone and Buba that the Genitalz era was over. And that's when, in 2004, Red Car Burns was born. Even though they were part of the same scene, having cut their teeth in vastly different bands, the whole finding their feet in a new band thing was more than a little difficult and it took some time for Red Car Burns to discover who they were, and it was only when Cesco and Carlo, bass player and drummer respectively, joined that things really started to come together.

Their debut album 'When Everything Seems To Be In Silence' saw the band change in their sound, as the songs had a more emo/post-hardcore feel, which according to Mone, was due to him listening to more Vagrant Records and No Idea Records bands, and being exposed to Hot Water Music, Face to Face, Mock Orange, Samiam, Gunmoll and Alkaline Trio. And as those bands used to tour Italy, they helped to feed the dreams of Mone and Buba who wanted to do the same thing with Red Car Burns.

The debut LP also introduced the band to Engineer Records, who they found through Francesco Derchi of N-HN "Since we first met him, we've had a good connection with David" Mone says, "and we received great support from Engineer Records. We could not imagine that 20 years later we would still be in contact and discussing new projects, but I think that says a lot about the respect we still have for him and the label."

When their first album was released, Red Car Burns started touring, both in 2005 and 2006 through Italy and Europe, with the support of N-HN and Mone told me; "We didn't expect it but were asked to play many shows in different cities in Italy, almost every day of the week with very little rest." After bouncing around Northern Italy like pinballs, Red Car Burns embarked on their first European tour that started in March 2005 and was made up of more than 20 shows, which allowed the band to make a name for themselves in the European scene and helped them to tour again the following year.

In 2006 they played 25 shows throughout Europe in August traveling in an RV with their own guardian angel, a pitbull who served as the band's watchdog. One of the most memorable memories, according to Mone, was when Cesco put petrol in the RV water tank, making it unusable right before the last show, or when Buba decided to turn his underwear inside out so that he could get one more day out of his pants before they headed home.

Right after the crazy 2006 tour ended, the band started to work on their second album with the intention of heading out on tour as soon as they could. But it took a while, as Cesco left the band, which forced Carlo to move from drums to bass when they found Friz who picked up the sticks for RCB.

The new line-up was inspiring for the band, as it brought new influences into the fold and supercharged their collective battery, and the fact that Mone and Buba continued to grow as musicians and as individuals, also helped to push the band's songwriting to a whole new level. And somewhere in the middle of all that, Buba somehow managed to find the time to marry his longtime girlfriend Lella and became a father a few weeks before the new album was ready.

All of these huge changes were reflected in 'The Roots and the Ruins', recorded in 2010 in the band's rehearsal room with a mobile studio. Engineer and Italian label NoReason Records joined forces to release the record adventure too, which was celebrated with a party in their hometown, Lodi. But that night was special for all of the wrong reasons, as Carlo decided, all of a sudden, to leave the band. He was replaced in a hurry by Alberto, as the band was about to head out on tour again almost as soon as the party was over.

It was a three-week trek that included Eastern Europe, the Baltics and the UK, none of which RCB had played in before. Mone says, that during that tour, they played a show in London for the first time, which was promoted by Engineer Records. "How could you forget" said Mone, "When Buba took the wrong road and we popped up in front of Buckingham Palace? Or when we finished our last show in Liverpool and he drove straight back home to Milano in sixteen hours as the tour was over and he needed to go on vacation with his family the day after?"

Shortly after getting home in 2010, Alberto left the band and was

replaced, temporarily, by Mone transforming the band into the trio that recorded the songs for the split 7" with the Austrians 'Ants!'.

"We played a few shows as a trio" Mone recalls, "But it was clear that it wasn't going to work out. I remember we played a show in Piacenza in January 2011 in a place called Bullone where we were given just a shitty invisible hot dog for dinner and we ended up playing at 1 AM when we were scheduled to start at 11 PM. That never happened again... anywhere."

Months passed and Mone decided to call Ale, his neighbour and bass player in a local emo band called Venice is for Lovers, who used to cover some Red Car Burns songs during their shows. After a couple of practices, even though he was excited to be part of the project potentially, it was clear that Ale could not manage to play in both bands due to time and family constraints. So he turned the offer to join RCB down.

"But only temporarily" Ale says, "As soon after Venice is for Lovers unexpectedly broke up and after that happened, I thought about calling Mone back and asking if the offer of being Red Car Burns bass player was still valid at least a hundred times. But honestly, I had no courage after having declined the first offer." And then, in the Summer of 2012, Friz decided his time in Red Car Burns had come to an end, and he left the band.

That moment represented a turning point for Mone and Buba, Should they give up on Red Car Burns or try to continue as a duo? The answer was immediately clear to both of them and Mone decided to call Ale again, who having wished that Mone would pick up the phone, immediately said yes.

But they still needed a drummer and through a friend called Ivan (remember his name, as he's important later in the story), Corbe got in touch with Mone and asked if he could fill the vacant spot in Red Car Burns. Corbe was a young but very talented and experienced drummer and together with Ale, in October 2012, he became the missing piece in the Red Car Burns puzzle.

Iron Chic and Young Livers were the first bands that Mone suggested that the new members check out when joined the band, as Iron Chic's 'The Constant One', Hot Water Music's 'Caution' and 'A Flight And A Crash', and Samiam's 'Astray' made up the blueprint for the next chapter in the Red Car Burns story.

In 2013 and 2014, the band was back on stage. "During this period" Mone says, "We played one the most epic shows ever in Graz. The venue was called 'Sub' and we shared the stage with Ants!, as it was the last show of a mini tour we did together with them to promote the 7". The place was so crowded that nobody could get in the venue and the crowd was like 50 centimetres in front of us"

"I was so full of energy that I broke a bass string" Ale remembers, "Which to me was almost impossible. Maybe it happened because of the vegan drink that me and Mone had in the afternoon, which kept me dancing until 5 AM or so, like if I were Gianni Sperti (a famous Italian dancer). And I will never forget the following morning with Buba waking up beside someone he did not know at all, and releasing, poor guy, that he'd just let go of a giant fart."

After touring some more in 2014, the band continued to rehearse intensively, writing new songs and preparing to record their third album, 'Red Car Burns', which was released in 2015. The decision to self-title it was almost like a fresh start for the band. According to Ale, this was the best album the band had written and recorded so far, with songs like 'Summer (Time Off)', 'Ulysses' and 'Devil Is In The Room' laying the foundation for the band's newer sound.

2015 was a landmark year for the band who played larger Festivals in Italy like 'Creature' and 'Tendenze' for the first time and also graced the stage for FEST14 in Gainesville, Florida. That meant that the first US tour was about to happen: Seven shows on the East Coast from New York to Miami. It was like a dream and was most probably the most remarkable tour that the band had undertaken and it was also the tour with one of their worst shows ever; in Trenton, New Jersey.

"We reached the bar where we were supposed to play" Corbe says, "But nothing and no one was there, except for a weird promoter who was sleeping on a table, probably drunk. We waited some 30 minutes but nothing changed and it was clear that there was no show happening that night. And everything was so weird in that place that we decided to run away as fast as we could before the situation got any worse."

"I also remember, in a Gainvesville motel, almost at the end of the tour, on the first day of FEST" Corbe continued, "I collapsed after smoking too much pot and I almost broke my neck. If it wasn't for my

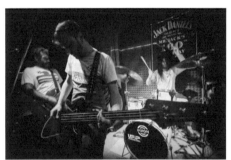

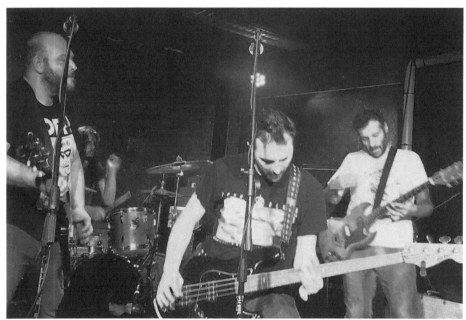

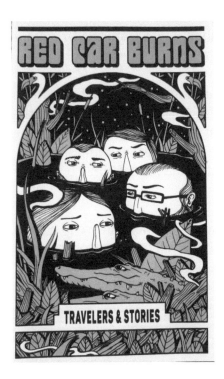

girlfriend Eli, I probably would have fallen down from the first floor killing myself."

In 2016 an Italian tour with Years & Miles helped the band to promote their self-titled record and enabled Red Car Burns to fit France in for the first time. "The show we played in Lyon at Trokson was amazing" Mone recalls, "The first time in France was one of the most exciting shows we have ever played and the crowd was so involved in that small but warm place that we couldn't ask for more."

"A couple of nights after the show in Lyon, I remember we played in Bonn, Germany" Ale continues, "And we had a tall fridge full of beer cans just for us. That was very kind and appreciated. But we were so 'smart' that we decided not to touch any of those and spend all of our rider on Lynchburg Lemonade cocktails. Simply Epic."

2017 was another great year for the band. Mone became a father for the first time, they had a few songs cooking in the oven and it became clear that there was another chance for them to get to the US again. Their next EP 'Travelers and Stories' was almost ready and the second American tour, which would once again end in Gainesville at FEST16 and feature a show at the legendary Loosey's, was all confirmed.

"That show at Loosey's marked one of the craziest nights we ever had." Ale says, "Especially the big unplanned party at the end of our show, at our merch table, with all the folks that stayed behind, including Tony from No Idea Records."

"The second time we hit the US" Mone says, "We also had one of the best shows ever in St. Petersburg, Florida with Days'n'Daze and a bunch of other very good bands, in a cool tattoo shop which hosted the mini-festival. The venue sold out so quickly, it was incredible!"

"Some other 'events' happened during that tour which I'm not sure we should talk about" Ale says "Like when we woke up in a hotel in Gainesville and while having breakfast we realised somebody, one of us who we will not mention, had shit his pants during the night."

But that tour was one to remember because of the great friendship that they forged with Seattle's Dead Bars, with whom Red Car Burns released a split 7" in 2018. The record was limited to just 250 copies so

before you start looking for a copy, don't waste your time. It sold out a long time ago.

"Here I think it's also fair to mention" Ale says, "That one of the most wonderful things we have ever done as a band was the release party show for this 7" in October 2018. We set up some sort of unauthorised gig in Buba's factory with five other local bands we love, like 'Low Standards, High Fives', 'My Dinosaur Life', and 'The Enthused'. More than a hundred people were coming. If we tried to do something like this now in Italy, with the current laws, we would probably get arrested."

2019 saw the band undertake another European tour, to promote the previously mentioned split 7". RCB had a great time in Eastern and Central Europe, despite some ups and downs in Ale's personal life which did not stop the band from releasing a new single, 'Kidult', and playing some great summer festivals like Punk Rock Raduno in Bergamo or Loggiapalllooza in Domodossola.

But then the pandemic hit hard in 2020 and everything came to a stop, and during Lockdown the band had their gear stolen, but then returned, twice! After the pandemic, the band started to think about doing what they love the most again. Playing gigs.

"In 2021, the first show after lockdown" Corbe remembers, "It was probably one of the worst we ever played though. We were totally drunk since 5 PM, we played some 15 minutes and Mone immediately broke a guitar string. No-one wanted to lend us a guitar to continue the show."

2022 arrived and it was a good year as RCB opened for Good Riddance at Low-L Fest in their hometown, and Ivan (remember him from earlier?), a long-time friend of Red Car Burns, joined the band. But 2022 was also a low point, as Buba went on indefinite hiatus for personal reasons. Despite Buba's decision the spirit and the motivation were still there, and Red Car Burns continued to push the pedal to the metal.

Corbe continued; "Even though we are around or over 40, even though we have families, children, we went through marriages, divorces and we have demanding full-time jobs to pay our bills, we would still record new songs and start touring again. And when I say touring, I mean, like leaving tomorrow morning in the van."

"Despite the normal highs and lows of being in a band" Ale added, "We have built a strong friendship which remains solid as the years pass by. That's the glue keeping RCB together."

"Touring played a large part" Corbe says, "In building this friendship and in learning how to accept the flaws of the others when you are in captivity with other human beings for some weeks in a small space like a van or a hotel room."

As 2024 dawns, like it or not, Red Car Burns are approaching their twentieth anniversary and are still part of the scene.

"When it comes to the local scene" Mone said, "We were pretty lucky as it was, and is, really great, full of awesome bands like Rituals, Dufresne and Malemute Kid, to name just a few."

"I remember all of the great local bands playing in many different squats in the Milan area back in the early 00s." Corbe said, "I discovered new bands while I was sixteen or seventeen by getting to Milan with an older friend who already had a driving license, to reach Leoncavallo or Vittoria on a Saturday night. Every time I went, I bought records to bring back home."

"That was a golden age for the local scene. I remember the Fugazi show in Leoncavallo as a blast with great local bands opening the show. Unfortunately, so many things have changed and the pandemic was the finishing blow" adds Mone, and Corbe, with more than a hint of melancholy, agreed with him.

"After many years of Red Car Burns, the local crowd is basically divided in two" Corbe says, "some have great respect, some others just think we should quit playing our shit. The good part of this is that we are not at all like a 'party band', like the folk punk bands for example. The people get sick and tired of so-called 'party bands' quickly. We also are not in any way a political band, even though we might have clear political ideas, but we do not write and sing about politics, despite being a DIY post-hardcore band."

Besides politics, Red Car Burns is fully convinced that hardcore and post-punk still have valid reasons to exist, at least for them. It's still worth sweating, spending energy, time and money, and losing hours and hours

of sleep if the passion for the music still burns. And even though it's in its twentieth year, the Red Car still Burns brightly.

Ox Fanzine says Red Car Burns; *"Good punk-rock with an emo touch. As a comparison, Hot Water Music comes to mind, because of the polyphonic vocals, and Leatherface, because of the musical straightforwardness."*

And **Room Thirteen** added; *"Red Car Burns' sound comprises mainly of catchy yet serious melodies and riffs, heavy use of bass and drums and grating vocals to create a sound that's fresh and mature, while still holding on to that school-band, semi-acoustic appeal. The guitars are very energetic and lively; producing that fresh punk-like rhythm that you just can't help but nod your head and jump around to. Red Car Burns simply enjoy life and their music seems to put across this passion in a feel-good sort of way. There's something that makes Red Car Burns a great deal of fun to listen to."*

https://redcarburns.bandcamp.com

Red Light Runner

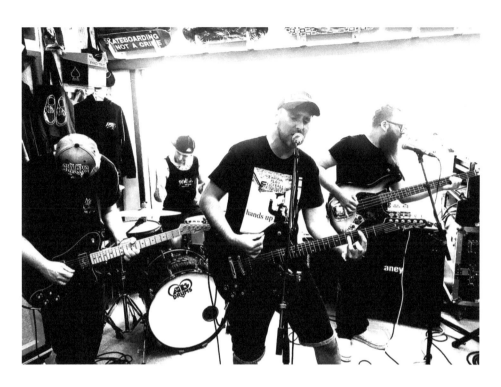

Dan Balsom : Vocals and Guitar
Russ France : Guitar
Lee Vickery : Bass
Dan Corder : Drums
(Joe Michael : Drums)
(Harry Arnold : Drums)

An integral part of the Folkestone alternative music scene, Red Light Runner play a catchy mix of pop-punk and emo-rock drawing comparisons with bands like Jimmy Eat World, The Get Up Kids, Saves The Day and The Gaslight Anthem.

Red Light Runner formed in 2006 off the back of the break up The Chase Scene which included RLR founding members Dan Balsom (vocals guitar), Lee Vickery (Bass, Backing Vocals) Russell France (Lead Guitar), Craig Hammer (Guitar and Vocals) and were joined by Dan Corder on Drums (formerly #1 Defender and 1000 Leagues Below). Craig left RLR not long after to pursue his solo project Fortune Faded Glory.

Dan Balsom and Russell were old school friends who reconnected when he was vocalist for local emo legends Arcaine with mutual friends Damien Sprigg, Phil Huntley, Andy Hucksted and Anthony Flisher (who went on to become One Time Champion). Lee was also a fan of Arcaine and the friendship was formed at their shows. Russell convinced Lee to take up bass when drunk at a house party because he needed a bass player for The Chase Scene.

When The Chase Scene collapsed they initially considered forging on without a drummer after an initial struggle to find someone. Even considering utilising a drum machine and pursuing a more chilled out Death Cab for Cutie inspired direction. Then Dan Corder responded to a call out on Myspace and despite having never played drums before he joined and gave it a go and it was like we'd all been friends forever.

"The name Red Light Runner came from a Rydell song title as we all became huge fans after seeing them support Arcaine at the Mermaid Cafe in Folkestone," Russ, the RLR guitarist told me. "We all loved going to shows and were falling in love with the emo scene finding bands like Jimmy Eat World, The Get Up Kids, Last Days of April, Elliott, Joshua, Camber, Far, Death Cab for Cutie and a lot of these records were coming straight off the Ignition Records distro table. The next thing was to try and do it for ourselves."

The band recorded demos in 2006 and 2007 and then released their self-titled CD EP (IGN219) in 2008. Playing as many shows as possible including a support slot for Last Days of April and sharing a festival stage with Idlewild, Red Light Runner started to find their feet and honed their sound by touring with One Day Elliott, Springtide Cavalry and Hurst Pierpoint. But less than two years in Dan B and Russell left to travel the world and RLR went on hiatus.

Late in 2012 Russ moved back from a short stint in the North West and planned to reform the band but Dan C had moved to London so RLR were without a drummer again. This led to a few acoustic tours with acts including Hidden Cabins, Sirens & Shelter and One Day Elliott.

After a while, Joe Michael, the Call Of The Search bassist, reached out as he was looking to play drums again and RLR got straight back to writing, recording and gigging. RLR were regularly playing Folkestone's legendary punk venue The Harp Restrung and hit the road with bands

including Cardboard Swords, The Young Hearts, Brightr, Tailblock and labelmates Come The Spring, featuring ex-members of Rydell.

In 2014 Red Light Runner released the double A-side CD single 'Lucky Thirteen / Just Might Find' (IGN225) through Engineer Records and then the five-song CD EP 'What Are You Thinking About?' (IGN232) in October 2016 with a riotous hometown release gig.

After another small hiatus, due to Joe having issues with tinnitus, the band recruited Harry Arnold from The Diamond Hope to play drums for them and his high tempo, Travis Barker inspired style gave RLR a new lease of life. This would see 'Breaking Out' released as a single (IGN259) and be followed by another CD EP, entitled 'Under The Weather' (IGN262), a five-song smash and a definite must for fans of The Get Up Kids and Jimmy Eat World.

Russ told me; "'Under the Weather' seemed like a natural choice of title for the new record when you consider the way that the elements are used to convey the moods and emotions that run through it. The EP takes a trip through the eye of a storm and out the other side into the calm that follows, which symbolises the journeys that we sometimes face in our lives. We're really proud of this record and the DIY approach we've taken on it. Our good friend Charles Lancefield at Black Cat Studios was responsible for the whole recording, with most sessions occurring in garages, lounges and spare rooms. The result is an energetic, raw final product which captures the essence of the songs and our live shows perfectly."

Punktastic reviewed 'What Are You Thinking About' and said; "*A rush of unadulterated energy; slick riffs crash down atop of tight drum work. The vocals on this track are reminiscent of early Jimmy Eat World: dynamic, bouncy, and vibrant. With a dollop of feel-good heartiness, Red Light Runner continue onwards with their fun and quirky release. 'Make You Pay' piles on the gang vocals well, without sounding too much like a cliché, and it immediately becomes a track that will see crowds in small rooms put their arms around each other and sing along with enthusiasm and pure joy. 'Right Place Wrong Time' sees the killer vocals make their mark once again; they're strong and steady, refusing to waver whatsoever, whilst closing track 'Be Mine Again' ends this release with a shot of fizzy adrenaline.*"

And **Thoughts Words Action** reviewed 'Under The Weather' saying; "Red Light Runner is profoundly into the emo sound, but the band doesn't

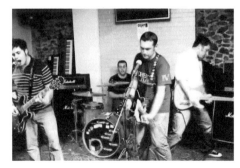

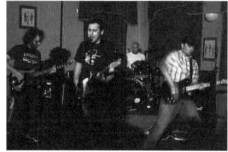

hesitate to include other appropriate ingredients along the way. The compositions are marvellously structured, defined, complex, but easy to listen to at the same time. This is a comprehensive collection of full-hearted songwriting and impressive composing."

With Ox Fanzine adding; "It doesn't get more honest than this. The whole thing smells a bit like a rehearsal room with beer bottles behind the bass amplifier. DIY is in the foreground here and your punk-rocker's heart will beat faster."

https://redlightrunner.bandcamp.com

Rentokill

Bernd "Jack" Unterweger: Guitar and Vocals
Lukas Reichold: Guitar and Vocals
Bernd Plaschka (aka Bertl the turtle): Drums and Vocals
Markus Benesch: Bass and Vocals
Walter Hof: Bass and Vocals

Rentokill is a political Punk / ska-core band from Wiener Neustadt in Austria who've been around since 1996. They play blasting, intense, political punk-rock with a powerful message. They've shared the stage with Rise Against, Anti-Flag, Strike Anywhere, Against Me, NoFX, Propagandhi, The Flatliners, The Loved Ones, Good Riddance, The Unseen, The Real McKenzies and many more.

Their first demo came out in 1999 and their self-released '6 Days' CD EP in 2001. Their powerful debut album 'Back To Convenience' was released in 2004, initially on Rise or Rust Records and Broken Heart Records in Austria, but after the band touring in the UK and Germany, it was re-released in 2005 by Vitaminepillen Records (Germany), In N Out Records (Japan) and Engineer Records (UK and US).

The new CD version of 'Back To Convenience' (IGN055) garnered great reviews and Rentokill continued touring throughout Europe, stopping only to record their sophomore album, 'AntiChorus', at Sideburn Studios in the Spring 2006. This album would be mixed by Alan Douches (Strike Anywhere, Give Up The Ghost, None More Black) at West Side Music in New Jersey and released on CD in May 2007 by Rude Records (Italy), No Reason Records (Italy) and Broken Heart Records (Austria) and was followed by another European tour.

They also released a split 10" vinyl with Red Lights Flash, entitled 'Provokant Wertvoll' in 2006 on their own Rise or Rust Records and Broken Heart Records in Austria, and then later, in 2009, the O.S.E. picture-disk vinyl via Horror Business Records (Germany), No Reason Records (Italy), Shield Recordings (The Netherlands) and Broken Heart Records (Austria).

In early 2009 they toured with Strike Anywhere and Rise Against through several European countries before Union Label Group from Montreal re-released their 'AntiChorus' album in Canada, which finally allowed Rentokill to head to North America and tour with High Five Drive from Winnipeg.

I've always had a soft spot for their high energy, socially conscious ska-flavoured punk, which is why I wanted to release 'Back To Convenience' back in the day, and even though it's been twenty years since we worked together, I wanted to catch up with Bernd, Bertl, and Walter to find out what still makes Rentokill tick. I asked Bernd, or Jack as he's sometimes known to his English-speaking friends, about the bands that influenced Rentokill. He told me; "Strike Anywhere and Propagandhi were and are a huge musical influence on us, and even though we all listen to different music and genres, our hearts, minds and souls belong to the punk scene and the bands it is built around."

Jack continued; "When I heard Bad Religion for the first time I was thirteen. I read their lyrics, with a little help from a dictionary, I was incredibly impressed. I think that moment changed everything for me and it's probably why politically motivated bands have always influenced me, and why politics are so fundamental to punk rock."

With that in mind I asked about his interest in the political undercurrent that keeps the scenes heart beating, and how his overt love of standing

up for what he believes in translates into Rentokill's music and lyrics; "There are so many things to sing about, but honestly, who needs more songs about love, the beach and sunrises? Some folks think that everything has already been said, but certain things are important to me, and that's what I sing about. When I look at the current asylum law situation in Austria, or the results of some climate conferences or the Western ignorance towards the problems of post-colonial Africa, I can't help it. We simply see ourselves as a political band and we want to convey that from the stage. For everyone in the audience who might not want to listen to what we have to say, there could be someone who does, and that one person we connect with, they make it all worthwhile."

Even though Rentokill are an incredibly focused unit, totally committed to its punk rock mission, that doesn't mean they don't know how to have fun, so when I brought up the subject of their favourite gigs and tour-related stories, Bernd told me; ""The Canadian tour in 2009 with the High Five Drive and our first UK tour in 2005 were wonderfully weird and enjoyable road adventures that I can't really talk about without naming names and I can't do that without getting certain people into trouble, so I'd better leave it there…" and Walter laughed and added; "Scary-Mary's house in Brantford, ON, Canada! To be on the safe side, I was on the bus, and even though it was minus ten degrees centigrade, I definitely chose the best place to sleep. Trust me, that was a night that none of us would ever want to live through again."

I asked Bernd if he thought that punk-rock and the scene it spawned were still vital counter-cultural engines that could speed up social change and a means by which to alter the direction of the populist zeitgeist, and he replied; "The line between underground and selling out is blurring in my opinion. I think counterculture is something that everyone lives for themselves and how its interpreted is an incredibly individual thing. Topics such as environmental policy have recently been coming more and more into the public eye, and simply being against it doesn't make much sense in this context, does it? However, when it comes to music, the topic is a bit more difficult, especially since there are so many different ways of perceiving things today when I think of Facebook, YouTube or Spotify. For example, we have always strived to produce our releases in a professional way, and that alone could start a discussion. After all, counterculture could mean putting a microphone in the rehearsal room and blowing the whistle on quality in the traditional sense. But whatever, the interpretation of 'against' is, it

remains free for everyone, and it's clear that it changes for each generation, and what they make of it, and how they utilise and use it."

After nearly a decade away from the glare on the punk-rock spotlight, Rentokill reformed in 2019 with a new bassist. Since then they've shared the stage with NOFX on their (first) Final Show in Austria at the Sbäm Fest in 2023 and supported The Toy Dolls at the RAW Fest and they're still playing now, leaping around stages and bringing their political ska-punk to venues near you.

Kerrang say that; *"Austria's Rentokill follow in the footsteps of Dead Kennedys and modern bands like Strike Anywhere with a strain of socially aware punk rock, aiming to stimulate your brain as much as your limbs."*

PunkNews added; *"If you don't understand why Rentokill are one of the most respected bands in the European scene today, check out their touring schedule and pick up their CD."*

Plastic Bomb reviewed 'Back to Convenience' saying that; *"Rentokill is all about bringing fast-fuelled pumped-up anthemic punk rock with an angry attitude, yet steered in a positive direction. The fifteen songs on display are all very powerful, and come across with a lot of enthusiasm, pretty much in a straight-in-your-face approach. This is a tight, fast-paced but mostly impressive debut full-length from a band who clearly have everything well under control and even find the time to try and get a political and social message across in a very positive and earnest-sounding way."*

I do also have a short tour diary from Jack of the 'Back To Convenience' tour in the UK in 2006 that I wanted to add as it's an interesting insight into the UK scene for European bands at the time...

14.03.06
Met at my place at around midnight. I was still busy printing directions, collecting contacts, packing bags, so we finally left at 2:30 in the morning. We - that´s *johnny (the almighty merchguy, manager and overnight driver), Dominik (the soundguy) and the three of us. Yes, only three of us - Lux had to stay at home, civil service and hernia surgery, and we had decided rather to play as a three-piece than to bring along a spare guitar player. That and the fact the whole tour had been booked by a UK agency made us feel like we were travelling into the unknown.

15.03.06

7am. Bavaria. resting. The police arrive and ask if we have any drugs? No. They put chemicals onto the steering wheel to find out if the driver´s hand had touched prohibition. Fortunately not.

After endless miles we made it to Calais at around 6pm. The next ferry was two hours late. Waiting. Finally boarded, everything overcrowded, first British beer for an unreasonable price.

On British ground at 9:30pm local time, phoned Ed who was supposed to hook us up for that night. Left lane driving felt uncomfortable for about three minutes. Arrived in Brighton two hours later, got lost, phoned Ed again, finally made it to his house. Warm welcome, including a sheisha. participated and fell asleep in a bed. A bed!

16.03.06 - Stoke-on-Trent, the Glebe

Left Brighton after a quite unBritish breakfast (ok, besides the TEA, WE NEED TEA!), and hit the motorway to Stoke-on-Trent. we had no money left and just enough petrol to make it.

Arrived at The Glebe in time, met the promoter Dave who had already put us up the year before. Set up the gear, still very unaware of how the 3-piece would work.

Had some food and Dave said it should be possible to stay upstairs for the night. I was suspicious about that, since that didn´t work out last time.

The other bands arrived, You, Me and the Atom Bomb were up first, Fuck with Fire after them. They had been on tour together for some time and they both did a great show. Finally, after the third band it was our turn, and the 3-piece really worked out. I played guitar lines i had never played before, and Markus and Bertl sang things they had never sung before. People seemed to love it, and we all felt some form of relief.

After we had finished we loaded in, and when everyone else had left Dave told us that it´s NOT possible to sleep upstairs. Thanks, man, you could have told us before.

As there was no-one left to ask we decided to drive back to Brighton, since the show the day after was the same direction, and Ed had offered us to stay at his house at anytime.

I fell asleep while Johnny was driving, and when I woke up again we were in the middle of London, 4:30am. goddamn!

Finally managed to get back onto the motorway, arrived in Brighton at 6am. No sheisha this time.

17.03.06 - Burgess Hill, the Junction

Got up late, breakfast again, and hanging around with Ed´s flatmates,

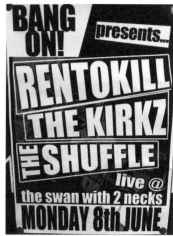

BANG ON! presents...

RENTOKILL
THE KIRKZ
THE SHUFFLE
live @
the swan with 2 necks
MONDAY 8th JUNE

INFECTED RECORDS & ZEROMORK RECS APRESENTA:

RENTOKILL

Viena, Austria - umas das melhores bandas punk/hc da Europa

THEY ARE COMING TO GET YOU!

COM:
ACROMANÍACOS +
lisboa - apresentação do álbum "808"
ALBERT FISH + 50HKUBO
lisboa - punk-rock desde 95

14 SETEMBRO (DOMINGO): 17H30, CASA DE LAFÕES
rua da madalena, n.199, lisboa (metro do rossio)
5€/y's (10€/y's c/ cd de Acromaníacos)

RENTOKILL
PUNK HARDCORE MELODIQUE À LA PROPAGANDHI, RANDY D'AUTRICHE

THE PATRONS
HEAVY PUNK HARDCORE LE HAVRE
MASS CONFUSION
PUNK ROCK LE HAVRE

IF YOU ARE BRAVE ENUF- YOU WIN A DEAD BODY

KINGSTOWN CAFE
RUE GUILLEMARD, LE HAVRE

MARDI 15 JUILLET
20H/5 EUROS

RENTOKILL
AUSTRIAN PUNK ROCK LEGENDS ON TOUR!

SUPPORT FROM:
BANGERS
FAST, CATCHY & LOUD - THINK DILLINGER 4/
HOT WATER MUSIC
A NEW DAY
MELODIC HARDCORE IN THE VEIN OF A WILHELM SCREAM
GUANTANAMO BABES
OLD-SCHOOL INFLUENCED MELODIC PUNK ROCK

£5 THE JUNCTION / STOKES CROFT
TUESDAY 2nd JUNE / 8PM

TIGERBEAR presents...

RENTOKILL
PUNK ROCK from VIENNA, AUSTRIA
plus support from...

VALHALLA
PACIFISTS
Harrogate Party THRASH!
Fast Fast FAAAAAAAAAAST!!

CUTTING CLASS
Ferocious, tight LEEDS Melodic Hardcore

& BURN ALASKA
Poppy LEEDS Hard core

07.06.09 AT THE
PACKHORSE
LEEEEEEEEDS
DOORS 7PM
START 8PM
€4

467

before we left for Burgess Hill, only an hour drive. Arrived there at 5pm, met Christina and Alice, tonight´s promoters. The first show with PMX from Scotland, they had arrived at noon, unloaded and left for sightseeing. as we didn´t know which backline to use, we enjoyed lovingly prepared vegan food, beer and a backstage room.

PMX arrived, welcome, we´re now on tour together! Scottish accents again and soapbars! all lovely people, we set up the backline, they did a soundcheck, and their guitar player Danny managed to have my amplifier case fall off the speaker, right onto his leg! quick check, nothing broken, and yet the amp worked. oh dear!

We taught their 2nd guitar player Chic how to play Olympia W.A., to get back some 4-piece feeling.

First band was Mute66, and then From Plan To Progress, with Christina´s Boyfriend Traut on guitar. Amazing show, very decent music! Finally it was PMX, and then our 3-piece again. Very good response, even more relief for us The Rancid cover song with Chic on 2nd guitar also worked out great. We started to miss Lux, however.

After the show, we loaded in gear, PMX were allowed to stay at Christina´s place, and we took Ed and went back to Brighton. 3rd night in a bed!

18.03.06 – Littlehampton, the Railway Club
Got up a little earlier than the days before, and Ed took us into Brighton. We walked around, visited the PunkerBunker shop, met Buz, the legendary Brighton promoter.

After an "all you can eat for 4pounds" at Bombay Alloo´s we drove along the coast to Littlehampton, found the Railway Club in no time (ok, we had 2 locals in the car this time), unloaded and set up backline. PMX did soundcheck, and after the first band The 1985s I went to sleep in the van. that´s why I missed Ake Hurst (last show!) and I Breathe Spears (with Luke the promoter on vocals), later I was told that I really missed something. damn!

After another great show from PMX, and we also had a great time on stage after them.

loaded in, and went with Luke to the middle of nowhere, where we were allowed to stay in a garden house of his mum´s friend. soft floor, warm food, and beer – all good.

19.03.06 – Coventry, the Jailhouse – *cancelled*
Got woken up by Luke´s mum, trying a few German sentences as the year before.

Went to her house, where Luke had prepared an amazing breakfast, spent some time talking (it was Luke´s birthday!), and finally left the beautiful countryside for the motorway to Coventry. 5 minutes before we arrived a call from Chic - "Hey, we´re at the club, and we´re not on the bill, and you´re not on the bill either!" oh great, there were 8 bands playing, but not us. Promoter´s switched, and our show had been cancelled somehow.

Spent some time on the street, celebrating *Johnny´s birthday as well (at least PMX had brought a birthday card and stuff), had some scottish soapbars, and while PMX decided to find a motor rest we took direction to Leeds, hoping to find somebody to stay overnight.

Candee from Antimaniax texted us the phone number from Chris in Leeds, but since she was unable to hook us up at her place, she texted us more phone numbers, and we finally ended up looking for a pub called The Chemic Tavern where we were supposed to meet Luke who had agreed to let us sleep at his place.

Trouble getting there, finally made it, met Luke and Isabelle, had a few pints, and went to Luke´s flat to end up in a crazy party! All nice people, a very good first impression of Leeds.

20.03.06 - Leeds, the Packhorse

After a short night we woke up, Luke had left already, and we took Isabelle to her place, and then to her College in Bradford. We had decided to visit an exhibition of modern art, but laziness won and we just kept hanging in the van, discussing shit and waiting for Isabelle to come back. Went back to her place, she made us amazing food, and took us to The Packhorse.

Nobody there yet, we unloaded gear, and finally Kim arrived. A warm welcome back, we set up gear and had soundcheck. I experienced troubles with my amp, must have been the crash 3 days before. It worked though and after the Minions Of Jeffrey I was too tired to watch The Infested´s whole set and went to sleep in the van. Woken up by the toughest "drum-smashing-guitar-cranking-i-don´t-look-back-rock´n´rollpunk i ever heard, so i got back in again and managed to see the last few songs from The Dangerfields from Ireland. Left us all mouth opened. It was their last show of a 45-days tour, we traded CDs, and then they went to the ferry home. When we entered the "stage" there were only 20 minutes left for us to play, we made somewhat around 30, before the owner said that he´d cut the power. A decent show after all and after loading out we went back to Luke´s flat. No party this time.

21.03.06 - Bolton, Number 15

Woke up late, Isabelle made a great British breakfast for all of us, we exchanged contacts, and finally left for Bolton. Arrived there an hour later, had again troubles finding the club (i must have messed up something with the directions i had printed...), finally found it. met PMX and Kim again, set up gear, got food and beer, talked to Liza and Matt we had met the year before, and watched Baxter open the show. after them it was the "Minions of Jeoffrey"'s 100th show.

PMX did an amazing set after them, and finally we had a great time on stage. not too many people, but everyone seemed to like it, the way we had experienced Bolton the year before.

After loading in, Kim took us to a recording studio, where we were supposed to stay that night. Plenty of floor for everyone, PMX went to Tesco for bread and kiwi (with the emphasis on kiwi), and we started exchanging Scottish and Austrian phrases (oaschpartie).

22.03.06 - Norwich, the Ferryboat Inn

Long drive without motorway to Norwich, Kim came along, we arrived at the Ferryboat Inn, and Ian the promoter welcomed us with great vegan food and beer. All great. The stage looked more like a cage, but after Lose Learn Karate Win and The First we had a great show with an even greater audience ("fuck the 4-piece, you're fucking awesome!"). This night it was PMX after us, time to cool down and watch their whole set. great!

We all went to Ian's place, again enough space for everyone, we brought food from the van and had a great party playing sega-megadrive, smoking soapbars and drinking 'till we all passed out.

23.03.06 - Manchester, Star & Garter

Woke up late, had some breakfast, waited for Kim who had stayed at a friends place, and went on the way back to Manchester - again 3 hours without a motorway, hence no chance to sleep in the van.

Arrived in Manchester late, with the promoter's girlfriend already a little nervous to get us to eat in time before the show. loaded in, then Kim and her sister Beanie took us to a bar where the promoter James was waiting for us with dinner. "go for it, it's all paid!". veggie lasagne, great stuff! Somehow we couldn't remember we had ever complained about getting no food in the UK...

Went back to the Star & Garter where "Cigarettes & valentines" already had started playing. after them it was "Pendelton" up next, formerly known as "Morning pizza", they played an awesome set of punkrock music how it was meant to be. great!

It was us up next, i had a hard time getting into it, but the show was still fine, and the crowd responded heavily once again. Time to cool down while PMX headlined, again a great show. finally loading in, and heading for Kim's place in Bolton. Got nearly stopped by the police, that was when kim told me that it´s NOT allowed to drink beer while driving in the UK.

24.03.06 – Alton, the Community Centre

Left for Alton in the afternoon, arrived there way before PMX once again (YES!!!), with a whole lot of trouble finding the "community centre". finally found it, but nobody there. after a while sophie arrived, we had met her before in Burgess Hill. She brought a soundguy who set up the PA, while her parents prepared food. great stuff!

It was her band called "Suburbia fears" which played first, then it was PMX after them. when we finally started i encountered heavy troubles with my guitar amp AND the cables, making me drop out almost every song. Horrible. (Well, some people simply call it "unprofessional"). However, that was not my best show. the audience was great, though, and we all had a great time.

After loading in we went to Sophie's friend Bruce, and kept partying ´till the morning (including very nice people, some strange people, a fight, and pasta at 5am).

25.03.06 – Worthing, Leisure Centre

We got up quite early cause Bruce was in a hurry being at the pub in time – Saturday afternoon, what can we say? we went to Brighton once again, met PMX at the pier, ignored the rain and entered the amusement park. Scottish people between cash- and gambling-machines…

We ended up as the only people having only coffee as always, and finally went on to Worthing, a 20-minutes drive along the coast. Why are the last days always rainy?

arrived at the leisure centre, got welcomed by Ed, inside everyone was busy setting up a stage and the PA in an indoor soccer hall. quite a funny place. we had soundcheck, so i had a chance to eliminate the voltage that occurred every time i touched the microphone.

It was 7 bands scheduled for that night, and we were supposed to play 5th. endless waiting once again, watching around 250 kids enjoying the soccer court more than the bands.

we had a good show, my amp worked, the crowd was fine, everything ok for this last evening.

After "once over" with Ed on vocals, Luke on sax and Ben on drums (awesome!) we had enough time to party with everyone, swap

merchandise with PMX and do the usual "oh shit the tour is over back to normal life we 're gonna miss you all so much"-stuff. That was when Chick and i did some "matrix-style--slow-motion"-fighting and both hit our legs accidentally, so you could see the bone. Chick went pale, but medical service arrived within two minutes, Christina bandaged my leg while Trout tried to tell me how irresponsible it is to go on tour without a holiday insurance. So Chick and i both decided not to go to hospital, it´s only a leg, you know?

Last soapbars outside the leisure centre, hugs and kisses, before PMX left for Scotland and we left for Ed's house once again.

Arrived there and got some sleep before our long drive home.

26.03.06

Got up early, we had lost an hour switching to summertime, and we´d lose another going back to the mainland. Decided not to go on the motorway, which was the wrong decision, so we lost another hour. Lesson learned.

Arrived in dover, missed the ferry to Calais, took the ferry to Dunquerque, which would save a few miles on the mainland. Right lane driving again, it somehow feels more uncomfortable than you think. at least for me. went to sleep and woke up at around 10pm in the middle of Luxembourg. Woke up again in a traffic jam near Mannheim in Germany, *johnny was driving, and i agreed to keep him awake by endless conversations about the punk scene in Austria and the meaning of life.

27.03.06

Made it through Bavaria without any police, stopped in Linz where Dominik hopped off, and finally arrived in Vienna at 9.30am. Went home and felt disoriented.

All in all an awesome tour, though playing as a 3-piece, way too short, but prepare, we´ll be back soon!

https://youtu.be/6kGulFd1oPE?si=p-qoxlbcZwwME3SY

Rites

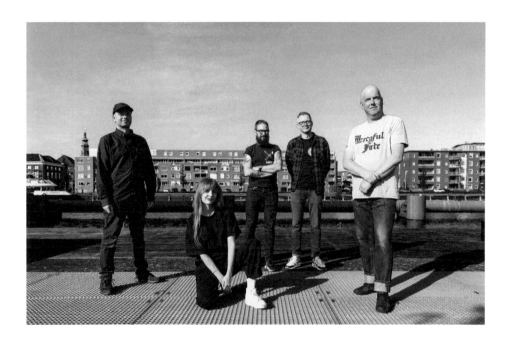

Louisa Steenbakker: Vocals
Chris Marijs: Guitar
Ronald Lokerse: Guitar
Nous Davidse: Bass
Rick Hutjens: Drums

DIY spirit, 80's nostalgia, vinyl records and fast guitars: That's Rites. With five releases including their blistering 2023 record 'No Change Without Me' and over one hundred and fifty international shows to their name, this hardcore-punk outfit is just getting started.
Rites are not afraid to speak up about the current state of the world. Mixing elements of bands like The Distillers, Dag Nasty and Drug Church, and reminiscent of Gorilla Biscuits, Refused, Inside Out, Turnstile or Tsunami Bomb, Rites present high energy hardcore with a punk-rock twist.

It's 2012 and Dutch punk outfit Broken Dentures decide to call it quits after releasing just one record. As with the demise of most punk bands, it ends with a dull bang, some curse words, and a couple of band members storming out of the rehearsal room, never to return. Nothing

special. Only this time three of the band members decided to continue making music together. Ronald would switch from vocals to lead guitar and Chris dropped his drumsticks in exchange for a guitar. Along with Nous on bass, this meant they had no drummer and a silent mic. If you're into experimental stuff I guess that doesn't have to be a problem, but these guys want to play punk.

Fortunately, Nous knew a lot of people within the local hardcore scene. One of them being Rick, a gig promoter and drummer. They talked about his band after an Accept The Change show and Rick mentioned that after some time experimenting with whale sounds in his shoegaze project, I Could Float Here Forever, it was time for him to get back into some high energy stuff. So, then there were four, but that still left the problem of the silent microphone. Nous delved into his HC network again and posted online that they were looking for a vocalist. Louisa showed up for band practice the following Monday and a journey that has lasted over ten years already lurched underway.

Rites hail from the Dutch coastal province of Zeeland, a beautiful but quiet place where even finding a rehearsal space for a punk band amongst all the farmyards was difficult enough, let alone setting up gigs. Nevertheless, and despite a few early setbacks, the band agreed on the name, wrote a few good tracks, including a noisy cover of Strike Anywhere's 'We Amplify' and let the world know that they were now looking for gigs.

By 2013 the Zeeland Hardcore scene was beginning to bloom, with the city of Goes at the centre of it. Rick had already booked some decent gigs there, and even hosted his own mini festival, called Boemtik Fest (his nickname) at a small pub, The Vrijbuiter. He arranged an opening slot for Rites at a pub/restaurant called De Pompe, but it was 3rd August, the hottest day of the year. The crowd was sweaty, the band was nervous, the sound was squeaky, but the room was packed. Rites had arrived and more shows in and around Goes followed, with the tiny pub, The Vrijbuiter, becoming Rites' second home. The band released their first three records there, braved some epic bar dives, busted a lot of gear, and covered the place with stickers. Unfortunately, the venue would close in 2020, but by then the band had far outgrown local shows in their home province.

Since Zeeland is in the south of the Netherlands, gigs in Belgium were never far away, Rites were invited to support Run Like Hell and Ashes

(who decided to cancel on the day of the show) at a rock venue in Eernegem. Playing their first out of town show on a rainy night to a few rockers and a deaf dog, things could only improve from here.

By November 2013 the band were ready to record, and hooked-up with Jasper Wouters at an improvised studio to record their debut four-song EP. Both the guitarists' parts being recorded through amplifiers belonging to the Dutch death-metal band, Gorefest. This eponymous release came out on Rick's DIY label, Brainwreck Records, and started a long list of shows all around The Netherlands, alongside Kids Insane, March, We Ride, The Real Danger and All For Nothing. The band even arranged some merchandise, with their good friend Rosalie coming up with a cool owl design to feature on their artwork, and talented local artist Dennis Menheere designing their first t-shirt, cool graphic art of Wednesday Addams holding a Rites-knife, which is about to have its fifth reprint.

In 2014 Rites played a show in Capelle Aan De Ijssel promoted by Smithsfoodsgroup DIY. This independent Dutch record label had been around for quite some time and set up shows and tours too. It was at one of these gigs, while sharing the stage with Antillectual, that Rites met promoter and label owner Max Buise and a lifelong friendship was formed. Max took a liking to their debut EP and asked the band to give him a call when they had the follow-up ready. In the meantime, he released Rites' self-titled record on cassette, with one version featuring the Wednesday Addams design, and another featuring a Wolf design, also created by artist Dennis Menheere. Alongside the tapes Rites printed the wolf design on t-shirts too, one of the few unique designs they have without a nod to eighties or nineties pop-culture. This partnership between Rites and Smithsfoodsgroup DIY lasted up until 2022, when the record label decided it had run its course.

In January 2015 Rites ventured over to Germany to play at The Wild Rover in Aachen with We Are Dust and soon found how great the scene was there, with large crowds and a crazy amount of merchandise being sold. They'd visit often again. Another good show, back at Cafe de Pompe, was for their friend and promoter, Edmond Spelier's birthday. They'd invited a bunch of bands to play, including a cover act of his favourites, Slapshot (featuring Rick on drums), and on the big day, Edmond was blindfolded and received a lap dance from Jack 'Choke' Kelly. The community had managed to secretly fly in the actual Slapshot from the USA. Needless to say, there were a lot of happy faces and chaos in the bar that night.

While the first record was an introduction, Rites was now on a fast track to developing their own sound. New songs were written, and it didn't take long for a new record to take form. So, in March 2015 Rites entered the studio once again, this time with sound engineer and friend Tanja Jansen behind the mixing desk. Rites were fierier in their sound and more self-reflective in their lyrics, and 'Inner Plagues' turned out a far heavier record than its predecessor. There were guest vocal contributions to this record by Corey Ben Yehuda (Kids Insane vocalist and drummer for Useless ID) on 'Hell' and Jeroen van Moerdijk (vocalist in Run Like Hell) on 'Haddock's Eyes.'

That month Rites played another Belgian show and met promoter Seppe van Ael. Another passionate supporter of heavy music, putting on shows whenever he could, while running two labels and an online magazine to promote the genre. He would soon be responsible for 80% of all Rites' Belgian shows, and foe now wanted to release their second EP on his labels RockXXL and Nosebleed Records.

Later that spring Rites played a weekender alongside When There Is None (containing members of We Are Dust) and Code Blue Coma. First up was Das Blaues Haus in Mönchengladbach, a city and venue that Rites would frequent after that. The venue was small, the stage was almost non-existent, and the entire place smelled of wet paint, but the show went well and was followed up by one at De Vrijbuiter, where for Code Blue Coma, it was their first time playing in the Netherlands.

Next month Rites would play two shows on the same day. First in Genk in Belgium, with War Charge, Adjust, Pulse and Mind War. The British bands Adjust, and War Charge were on tour so supplied the backline, but the stage was slippery, and the drums were moving around. Rick had a hard time keeping his gear in check and didn't notice himself sliding backwards to the edge of the stage. Mid-song there was no more stage left to slide to and he fell over backwards, catching himself in the curtains behind the stage. Leaving the crowd and band members pissing their pants with laughter. The second show in Gemert, back in The Netherlands went a lot smoother.

The release show for 'Inner Plagues' took place in October 2015 at Café de Vrijbuiter, with support from Screw Houston and Tarantino. The CD version was released via Smithsfoodsgroop DIY and Let Them Die Records (UK), and the tape version released by Nosebleed Records (BE).

As Rites sound became heavier, their shows grew bigger. Through 2015 to 2017 Rites shared the stage with No Warning, Cold World, Grade 2, Vitamin X, No Turning Back, Such Gold, Buggin', Spaced, Tusky, Death By Stereo, Angel Du$t, The Real Danger, Clowns, Higher Power, For I Am King, Reagan Youth, Get The Shot, All For Nothing, March and Slow Crush. Next up would be a support with Dutch band John Coffey at a sold-out show at 't Beest venue in Goes, soon followed by a gig at Skatehall Meker in the band's hometown of Middelburg.

In 2017 Rites were asked to play one of the Netherlands most prestigious venues: Paradiso. Located in an old church in Amsterdam city centre, it'd seen David Bowie, Nirvana, Blondie, The Clash, Beastie Boys, Prince, Arctic Monkeys, Iggy Pop grace its stage and a Bad Brains live album was recorded there too. On 7th January Rites would play at a non-stop twenty-four-hour music festival there. With a blizzard blowing outside the place was packed and the band hit the stage just before midnight. The moshpit was sweaty and crazy, and jumping around on the crowded stage Nous managed to hit Louisa with his bass, luckily just bruising her arm.

By now Rites had gathered enough new material to start recording their third EP, 'Misery Is Company'. This time with Jasper van den Broek behind the controls bringing a certain musical genius, having recorded albums for his band, Wasted Bullet, in a converted shed in their drummer's backyard. He'd also worked and played with For I Am King and Call It Off, so was a talented musician and songwriter. So, on a chilly February morning Jasper arrived at Goes train station with his equipment stuffed into a trolly and two large bags. Rick picked him up and took him to the studio, at a small high school theatre where he worked as a teacher. Rick promptly put is back out, unloading the gear on the ice, and then there would be issues with the noise too. Struggling on, two songs were recorded before they decided to break for some pizza and painkillers. To make matters worse, Rick had booked a show for that evening with The Real Danger and Screw Houston at a local pub, so the remaining three tracks were recorded the next day. Still pretty fast work, and Jasper had the EP mixed and mastered in no time. Dutch label Smithsfoodsgroup DIY stepped up for the release, alongside Cult Culture in the UK, and Nosebleed Records in Belgium. With the release of 'Misery Is Company' a lifelong dream of Rites was fulfilled: releasing it on beautiful 7" vinyl with multiple colourways.

In May 2018 Rites ventured across the channel to play a long-weekend tour in the United Kingdom. They'd been invited over by Chris Barling, who played in Group of Man and ran Cult Culture Records. They managed to get through customs, all crammed into an old station wagon borrowed from Rick's dad and drove across to Cardiff for their first show. The venue was an upstairs bar where everyone showed up early to support the bands. Alongside Group of Man and Rites, the line-up was completed by UK band Latchstring. A five-piece who would travel with them from Cardiff to Southampton, then Portsmouth and Brighton.

After a rough first night the bands headed to Southampton, where Ben from Latchstring turned out to be a proper tour guide, treating them to a pint in the sun, and a full English vegan breakfast whilst watching 'The Toys That Made Us' after the show. Portsmouth turned out to be a special gig, taking place on the second floor of a pub where they experienced their first human pyramid, with Latchstring guitarist Catherine forming the top of the pyramid. The crowd was fun, and the vibes were good. To close it off the band went for vegan fish and chips in yet another pub, with a hen-do well under way and a bad dj blasting anything from Britney Spears to Oasis while simultaneously being the mc. The final show of the long weekend was in Brighton, and they sped back to the port to make a tight boat curfew and get home on the night ferry.

Latchstring came over to play a few shows on Rites' side of the North Sea in March 2019, where the final show was marked by a storm that almost blew over the antique statues in the city centre of Antwerp, but fortunately both bands made it safely to an Indian restaurant to enjoy vegan curries. Plans to record a split 7" were made, but sadly this weekender would be one of the last shows Latchstring played as a band.

2019 was once again a busy year for Rites, with multiple shows in Belgium, Germany and of course The Netherlands. Amongst those a support slot for Clowns in Patronaat Haarlem, the Noise Annoys Fest in Astrant Ede with TRAVØLTA, Pressure Pact and many more with a final show in Middelburg's Bar American with I Against I and The Real Danger. The year was closed off with friends in Belgium, at a show that turned out to be the last of the foreseeable future. For reasons now known to mankind, shows in 2020 and 2021 had to be cancelled. Rites had been asked to play a show in Germany on Friday the 13th of March, but with all the news coming from Italy, doubted whether the show would go on. The promoter thought things would not get that bad, but we all know

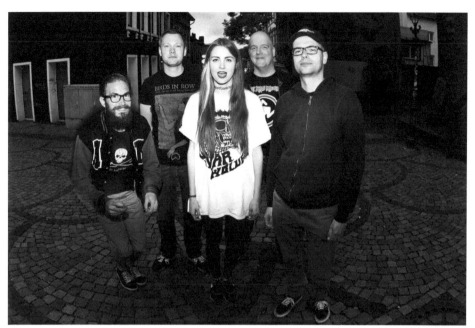

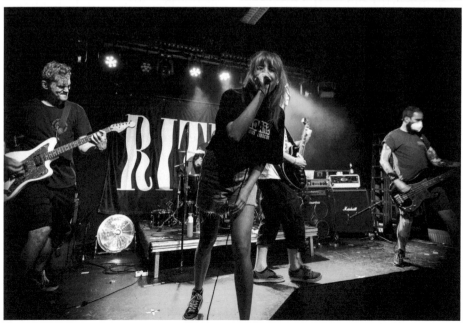

RITES (NL)
LATCHSTRING (UK)
GROUP OF MAN (UK)

THURS 31ST MAY THE BIG TOP CARDIFF FRI 1ST JUNE SHOOTING STAR SOUTHAMPTON **SAT 2ND JUNE BIRDCAGE PORTSMOUTH** SUN 3RD JUNE COWLEY CLUB BRIGHTON

RITES (NL)
MINUTES
NO MATTER WHERE WE GO
KINGS OF FORLORN LANDS

SATURDAY
17-10-2015

DAS BLAUE HAUS
WALDHAUSENER STR 15
MÖNCHENGLADBACH

EINLASS: 21:00
REFUGEES WELCOME!

€4-7

FREE HARDCOREPUNKNIGHT!
FRIDAY NOVEMBER 3TH, 2017

RITES

WRCKG THE UNKNOWN
 CHILDREN

CAFÉ DE VRIJBUITER - SINT JACOBSTRAAT 46, GOES
21.00 - FREE ENTRANCE
WWW.FACEBOOK.COM/BOEMTIKFEST

VRIJDAG
03 APRIL
20:00

BOEM TIKFEST
2015

HONNINGBARNA (NO)
ANTILLECTUAL
OTIS
RITES

M.O.B. & PATRONAAT LOUD! PRESENT
CL☣WNS (AUS)

SWEET
EMPIRE (NL)
+
Rites (NL)

VRIJDAG 26 JULI
PATRONAAT

CODE BLUE COMA
(Hardcore - MG)
WHEN THERE IS NONE
(Punkrock - AC/HS)
RITES
(Hardcorepunk - NL)

29.5.
Einlass: 20Uhr
Eintritt: 5-8Euro
Refugees welcome!

Blaues Haus
Waldhausener Str. 15
Mönchengladbach

BOEMTIKFEST PRESENTS A FREE ENTRANCE PUNKROCK/HARDCOREFRIDAYNIGHT!!
FRIDAY THE 18TH OF APRIL 2014

OTIS
STONER/PUNK/HUSTLERSUPERSTARS BLACK FLAG MEETS WEEDEATER

WHEN THERE IS NONE
PUNKROCK LIKE HOT WATER MUSIC AND JAWBREAKER FROM AACHEN (DE)

RITES
HARDCOREPUNK MOUTHPIECE MEETS STRIKE ANYWHERE WITH FEMALE VOCALS

BE!TIGER
FUGAZI MAKES LOVE TO LEATHERFACE FROM AACHEN/KÖLN (DE)

20:30
FREE
ENTRANCE

ST. JACOBSTRAAT 46. GOES
WWW.FACEBOOK.COM/BOEMTIKFEST

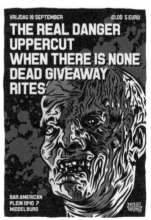

VRIJDAG 18 SEPTEMBER 21.00 5 EURO
THE REAL DANGER
UPPERCUT
WHEN THERE IS NONE
DEAD GIVEAWAY
RITES

BAR AMERICAN
PLEIN 1940 7
MIDDELBURG

how that ended: Covid-19 and long periods of social distancing and lockdowns followed.

Sitting still and staying quiet doesn't suit Rites very well. So of course, the band made use of their time when they got selected to take part in local coaching project 'PopAanZee-Gold'. As part of the project, Rites was hooked up with a knowledgeable coach in the form of Epitaphs Gertjan van Aalst. Together they worked on a plan for the release of the new record and applied for funding to be able to create the best possible product. All the while Rites continued to write songs, with Rick investing in his recording skills so they would be able to record their own demos more professionally. They were writing songs online, not something this 'rehearsal-room-band' was used to, but they made things work and through lockdown thirteen new songs were born.

With restrictions being lifted slightly, the band saw an opportunity to start recording at Tim van Doorn's Big Dog recording studio. Tim is a skilled engineer and producer and had previously worked with the likes of Mayleaf, For I Am, Tim Vantol, Antillectual, Craig's Brother and many more. He's also a notable songwriter, having released multiple projects such as St. Plaster. The co-operation turned out to broaden Rites' horizons, as Tim specialised in producing punk and rock records. His suggestions and input added an extra layer to Rites' bold hardcore influenced riffs. Vocal wise, Tim pushed Louisa to give everything she had in the studio, resulting in songs with dynamic vocal lines where the screams were more intense and the clean vocals more piercing than before. Rick had a tough time in the drum booth, having become a first-time father just a few short weeks before. He was relieved to have played the perfect session, only for Tim to politely ask: 'That was great! Can you do ten more of those?'. Luckily Tim's trusty dog was never too far away for a cuddle and with a Nintendo just around the corner everyone had a great summer.

Rites went into the studio hoping to record at least five songs, but with the help of Tim, ended up with seven solid tracks. Tim suggested a bunch of extra guitar-lines, vocal-ideas and even had Louisa read a passage of Alice in Wonderland for sampling on 'Free'. He pushed the band to create their best record to date, and 'No Change Without Me' was really taking shape.

In the midst of the world shutting down, Rites were selected to take part in the prestigious Popronde concert tour. This traveling festival attends

all major cities in The Netherlands, with shows taking place in strange locations all over the city. Obviously, things were uncertain, but venues were feeling optimistic, and shows were being booked. There were some delays, but eventually Rites was set to play on the opening day of the festival at an old factory in Nijmegen in September '21. It turned out to be an all-seated show with people socially distanced, but banging their heads, nonetheless. Not great, but better than nothing. As you can imagine, the first 'standing' Popronde show was an insane one. Rites closed off the day at a skatepark in Den Bosch, with a crowd that was ready to mosh at literally anything they played. A cover of Minor Threat's self-titled classic was played as an encore.

It was at these Popronde shows that Rites introduced Frank Mastenbroek. Nous isn't always able to play because of health-related reasons so sometimes the band play as a foursome with Chris taking up the bass when needed. That just wasn't really cutting it and Rites knew Frank from his band Charades. He'd also helped the band out when he had to run to the entrance of Vestrock festival as Louisa was stuck in traffic and could only make it to the stage in time if someone else parked her car. She was rushed to the stage in a golf cart. Proper rockstar style. The live registration of this festival was later used as a short clip for the video to the song 'People Are Alike All Over'. But sadly, no golf cart racing footage was available. Needless to say, the union between Frank and Rites is golden, and they continue to play with Frank as an unofficial sixth member to this day.

Soon the band was able to play more real-life shows, one of which was the very last show of the band CLCKWS, where Seppe, the enthusiastic owner of Nosebleed Records played bass and sang. Over the years Rites played a decent amount of shows with this Belgium based outfit and they share an equal amount of unforgettable memories. So of course, when writing about Rites' adventures we have to include the one time they arrived at a venue only to figure out that someone (looking at you, Seppe) forgot to mention that the stage was situated on the second floor of the building and only accessible by some small fire escape stairs which were mounted to the outside of the building. The band had so much fun carrying Nous' 8x10 Gorefest bass-cab (lovingly dubbed 'the coffin') up said stairs. Anyway, they somehow pulled it off and the show was on. CLCKWS made up for it by surprising Rites with a cover of Rites' song The Unloved and as you can imagine, it's pretty unreal and awesome listening to another band playing one of your songs. At other shows, Louisa joined

CLCKWS on stage to sing some of their songs with them and Rick was even supposed to fill in on drums one time, but alas that never happened.

The band were now on the hunt for a new, bigger label to help Rites get their sound out to a broader audience. A tricky task, as most labels had a backlog of records waiting on their shelves to be released because of the lockdowns. And then there were also ridiculously long waiting lists at vinyl pressing factories on top of that. Luckily, Dutch label and distro Shield Recordings were eager to help. The owner, Gert-Jan de Leeuw, having met the band when they frequented his distro at shows and festivals. And so, Shield Recordings became Rites new partner, introducing them to UK based label Engineer Records, and then Sell The Heart Records in the United States. It was a great match, and all three labels got on board, meaning the record was released overseas and introduced to a wide new public. Shield having a bigger reach and network in Europe didn't mean they'd lost the DIY spirit, as Rites and Gert-Jan spent an evening together folding stickers and posters into their brand new 12" sleeves.

So, the time had come and 'No Change Without Me' (IGN346) was here. The band worked hard to make this release their most extensive one to date. Seven songs (nine tracks with the intro and outro) pressed onto one side of a 12" vinyl, with a beautiful etching on the other side of the record, featuring seven tattoo-style illustrations. Each illustration represents one of the songs, with a main illustration bringing it all together on the bright pink cover. The artwork was created by Middelburg based tattoo artist Pim van Loon, photos were taken by Isabel Allaert who also helped design the layout of the record. The record took a long time to produce but eventually came out on coke bottle clear vinyl, black vinyl with silk-screened art, digipak CD and digital formats across all three labels. (Shield EU, Engineer UK and Sell The Heart US). It was well worth the wait.

The first single from the record, entitled 'Overdose', was accompanied by a proper music video, something the band hadn't done before. To create this the band once again locked themselves up in Rick's School theatre, with Jetlag Jenny bass player, Herman, operating the camera and cutest-dog-on-the-planet Mysa, keeping everyone company. You can see the results on YouTube.

On 23rd May 2023 the 'No Change Without Me' release party was held at

De Spot in Middelburg, Rites' hometown. The band invited Dogma, Charades and Tusky to celebrate the occasion with them on stage. Everyone arrived early and shared a big dinner together, with Max of Smithsfoodsgroup DIY and Gert-Jan of Shield Recordings hosting distros. Louisa's former colleague Bart Kuntz travelled to get behind the dj booth and newly founded project Silent Call Collective wanted to capture the entire concert on film. It was a memorable night, with Louisa singing along to a Tusky song, Frank sharing some heartfelt words on stage, and friends and family singing along. There were moshpits all over the place and stagedives left and right. You can see it all on the Silent Call Collective YouTube channel.

Making and releasing 'No Change Without Me' had its challenges, but it brought Rites closer together and now, as for the future, the Rites show calendar is never empty. New songs are being written and new records will undoubtedly follow. The band are hoping to re-visit the UK soon, and maybe add other countries such as Italy, Portugal and even the United States to their long list of gigs. Time will tell, but Rites intend to be here to stay.

Holland's own **Never Mind The Hype** alternative music magazine called Rites *"Lubricated Lightning"* and said of 'No Change Without Me' *"It's just superb! It ingeniously and catchily stomps past you. Hardcore that rubs like Zeeland sand in your swimsuit, with a decent production to top it off."* Quoting vocalist Louisa Steenbakker, saying. *"There is a lot going on in the world. We long for a better future, but are we willing to work on it ourselves? Change is often seen as something for later, it can sometimes even be frightening. But the future and urgency of change is not as far away as is often thought. It's easy to ignore that urgency and wait for others to take action, but the (sometimes uncomfortable) truth is that you can take the first step yourself. There's no change without you, and it starts with your own mindset. In short, 'No Change Without Me' is a wakeup call"*

With **Punk-Rocker.com** adding; *"Rites nurture a specific sound that refuses any categorisation in a singular music genre. Perhaps hardcore-punk comes to mind first, but you'll notice how these skilful musicians combine some of the finest properties borrowed from complementary music genres like melodic-hardcore, punk-rock, and pop-punk. Rites flawlessly levitate between heavier moments where all those robust riffs and powerful beats articulate with tremendous power, and much calmer moments where all the vocal arrangements shine bright alongside catchy melodies, notable during the anthemic choruses."*

Fear N Loathing zine says, *"Their songs are uptempo without getting thrashy, which allows plenty of room for melodic hooks and catchy tunes without losing any of their energy. I'd guess that they have a really broad range of influences and are not interested in sticking to any already-established style or genre, instead opting for their own sound. Whatever the case, it works really well, and this is a really enthralling album."*

And **Thought Words Action** are hoping, *"The tour van of this hardcore-punk outfit is just getting started."*

Skruttmagzine from Sweden expect that, *"These are songs you'll play over and over again."*

While **Rockportaal** added. *"It is immediately noticeable how wonderful Louisa Steenbakker's voice is. It's great to sing screaming and still sound melodious. It's almost impossible not to draw comparisons here with hardcore rising stars Dying Wish and Gel. A song like 'Echo' will certainly appeal to fans of those bands. What distinguishes this band from those is the extra catchy and poppy character in the sense of Paramore and Turnstile as audible on 'People Are Alike All Over', for example. In that sense, there is some of the current Scowl to be found in it. It's those elements that make the band interesting for the less hardcore loving audience as well. Rites clearly dares to go a bit softer as well as loud, which benefits the originality and replay value of the record. A quality album. I'm a fan!"*

And **Idioteq** say, *"Seamlessly bridging the worlds of melodic punk and 80's hardcore, 'No Change Without Me' is a defining record. Rites has achieved more than they ever anticipated, yet their hunger for musical exploration remains unquenched."*

https://www.youtube.com/watch?v=yTwsLrQKUoU

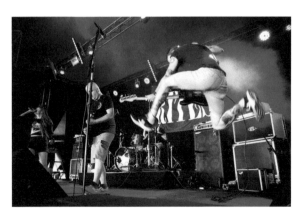

Scary Hours

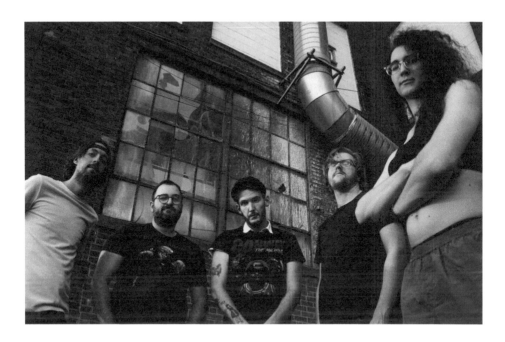

Ryan Struck : Vocals
Mike Greene : Guitar
Nick Andriuolo : Guitar
Maryn Czajkowski : Bass
Joe Billy : Drums

Singer/Songwriter and multi-instrumentalist Ryan Struck grew up in Northern New Jersey, cutting his teeth in various local punk and hardcore bands through his teen years and early 20s. Over time, varied musical interests influenced him to write songs deemed unfit for such an abrasive format, at least initially. The songs blended musical elements of pop, emo revival, and folk, while still propagating the confrontational lyrics and protest-spirit of punk and hardcore.

Scary Hours found its initial home with New Jersey label Pyrrhic Victory Recordings when their debut single Live to Serve/Serve to Live was released to a warm critical response, making Jack Rabid's Big Takeover 'Best of 2018' list. Their first album, 'Live to Serve' was released in early 2019 and picked up some great reviews from the likes of Ghettoblaster, Vinyl District, Big Takeover and others.

In May 2020 Scary Hours released 'Bullet Fairy', a single that served as a rebuttal of right-wing political policy and police brutality on which Struck demonstrates his diversity as he returned to his hardcore roots and utilised the medium to address the political issues he felt compelled to take on

In late 2020, Scary Hours joined the Engineer Records family and gave the world 'Margins', (IGN304) an eight-song CD of blistering hardcore punk attack; full of anger, intensity and an acute awareness and grasp of the reality we live in, their disgust for the mundanity of the social equation that everyone blindly accepts and their desire to be a voice of change.

Struck said "With no shortage of things to write about, the record came together pretty quickly. I thought 'Margins'' was an appropriate title as marginalisation is a heavy theme on this record. For the LBGTQ and BIPOC communities, minorities and those who seek to speak out and denounce their systemic oppression, to merely exist is an act of rebellion. The sentiment is highlighted in the title track and carried through pretty much the whole record."

Ryan Struck, the man behind the Scary Hours curtain, and the band's story is, for all intents and purposes, his story. Growing up just outside of New York City in an area that was a real hub for underground music, Ryan loved all styles of music; his first favourite bands were Green Day, Pearl Jam and the band that first made Ryan want to be a musician, Rage Against the Machine. He wasn't immune to the nu-metal craze of the late nineties but found out about NOFX, Lifetime, MXPX, Operation Ivy, Face to Face, and Millencolin from his best friend, Joe Scardino, who provided a mixtape that would change Ryan's life.

Ryan told me; "I started going to metal shows as a kid, around 2002, even though I was a punk I didn't know how to find punk shows. That sucked because there were a lot of incredible punk and hardcore gigs nearby during the early 2000s. I eventually found ska and emo shows and didn't have to dress like a goth anymore so I wouldn't get my ass kicked."

There was a burgeoning scene in Northern New Jersey. Ryan didn't have to go into NYC to see local punk gigs but was still exposed to a community that was enthusiastic about music.
"We had a lot of great post-hardcore, emo, screamo and pop-punk that would often get billed together. Some of the bands that took off from our

area during this era were Senses Fail, The Number Twelve Looks Like You, Thursday and Midtown. Oh, and this band called My Chemical Romance. While I really enjoyed going to those shows and seeing those bands, my heart was into a different sound. I was really into the Fat Wreck / Epitaph skate sound, and equally obsessed with the hardcore of the '80s after reading Steven Blush's 'American Hardcore' book cover to cover. Through friends and college radio (WSOU and WMSC) I found out about Punkcore Records and bands like A Global Threat and Kill Your Idols who were right across the river putting out some of the best records that I still listen to."

Ryan continued, "I connected with a couple of classmates over punk and metal, one of them was Nick Andriuolo, a great guitarist with an original style. We had similar niche tastes in music and connected on everything from Blink-182 and Foo Fighters to Blood Brothers and At the Drive-in. Nick and I wound up playing in our first band together in high school, a hardcore-influenced skate-punk band, called When Thieves Are About. I learned to play bass as fast and as well as I could. I became a master at EQing out any low end and cranking my treble so I could sound like Fat Mike. I also learned how to play guitar and could fumble around on a drum kit by the time I was 17 or 18 so I could multi-track my own demos and began writing a few songs."

"I played in various incarnations of that band for most of my tenure as a musician and picked up other projects and influences along the way. Nick stayed in the band for several years and we grew very close, but he ultimately left to pursue other projects. We remained good friends and supported each other's projects. I didn't know it then, but over a decade later we'd end up playing together again."

"Eventually I met Mike Greene through mutual friends. We got along really well, often sharing drinks and introducing each other to new music. Mike's guitar playing was impressive and he had a very unconventional sense of melody. I learned a lot from him musically and personally, as he became part of our skate-punk band. We ended up writing a record and playing loads of gigs together."

Despite this early hardcore band, a lot of what I'd heard from Ryan before signing Scary Hours for 'Margins' was fiercely emotive solo work. So, I asked him about how that had come about and developed; "I started playing with other bands in my twenties, most notably The 65s, where I

met Joe Pugsley (65's lead singer and guitarist, who would go on to form Pyrrhic Victory Records). We became fast friends. It was an incredible feeling to take some of the stuff I'd learned from other genres and try them out with a different project and experience a different working-dynamic and a different writing style. Joe taught me, inadvertently, the importance of sonic space and serving the song. I was inspired by those notions and started poking around with the idea of doing something acoustic."

"I felt inhibited by my skate-punk band. I didn't feel I was able to adequately express myself. You can call it pretentious or corny or whatever, but a huge part of song-writing for me is achieving the feeling that I've worked something out in my head, like I've purged a feeling into something tangible. It had been so long since I felt that way. I was constantly being told my lyrics were 'too negative' and my chords were 'too weird'. They probably were. I had undoubtedly become a sad, drunk musician who loved to sing about being sad and drunk and it made people uncomfortable."

"That's when I started writing the first record under the moniker Scary Hours. The name came from the title of a Wu-Tang track that I loved, but given the brazen, uncomfortably vulnerable songs I was writing, I felt the name was appropriate. I would have the kindling for a song and sit down to flesh it out. In doing so I often found the catharsis I had lost over the years. What started as a song about being sad and drunk would help me tie the feelings to a particular issue; sometimes systemic or political, but not always."

"That skate-punk band I was in needed an opening act for a tour after one of our tour mates dropped out. I volunteered and those were some of my first shows as Scary Hours. It was like bringing Charles Bukowski on tour to prime the crowd for Gorilla Biscuits. Overall, the tour was a nightmare and I knew it was time to leave my childhood band for good. Mike and I stuck it out for a year, growing even closer along the way and then we both quit on the same day. Mike and I stayed in touch. He took a much-needed break from music but was very supportive of what I was doing."

"I started recording my acoustic demos and emailing them to Joe, my 65's bandmate and now the PVR owner. I remember him saying, "These...are demos? They sound great. Let's start releasing this shit.""

Before I knew it, I had a full-length record together. The album was largely inspired by my failed tenure as a cook, going through culinary school and winding up in a Michelin Star NYC restaurant. Very few things will teach you more about capitalist alienation, not to mention fuel your addictions, than working twelve-hour days in a kitchen, making $200 tasting menus for $8.75 an hour!"

"Despite having just gotten married to my very supportive wife and pursuing a career some people coveted, I still felt like such a miserable failure and it showed in the songs." Ryan's cry for help was called 'Live to Serve' and was released by Pyrrhic Victory Recordings on 22 May 2018. The eleven-song CD album received a decent response, and the lead track was also released on a limited-edition lathe cut 7" vinyl too.

The Vinyl District reviewed the album, saying, "The band's acoustic pop-punk and filtered lens radiates the confrontational ethos of hardcore. A bit like a Bukowski-esque version of Bright Eyes, or possibly a pissed off Plain White T's high on Ritalin." And Ryan added, about it: "While I was experiencing one of the lowest points of my life, I was happy to have found my voice again."

Ryan continued; "I got sober near the end of 2019, just in time for the Covid-19 pandemic and a summer of civil unrest. This made me miss playing fast punk. Then my wife and I experienced a devastating pregnancy loss and I wasn't sure how we were going to make it. My factory job was making me work mandatory 60-hour weeks, burning out me and my fellow workers in unsafe conditions and putting our health at risk while the company's profits soared. My story was that of the American labourer at the height of the pandemic in Trump's America. I was in a lot of pain thinking about our baby and had no idea how to be useful or supportive to my wife. Everything felt so fucked up, but I knew it would not serve me to adopt a victim-mentality. The last time I tried that I was facing far less ominous circumstances and I still nearly drank myself to death."

"Grappling with anger and anxiety, I felt I needed to vent differently. I set up a basic recording rig at home and multi-tracked a skate-punk version of 'Angeles' by Elliott Smith alone in my basement. Then I tried a couple Dead Kennedys covers and as soon as I managed to get it all sounding about right a barrage of inspiration started coming through."

Ryan wrote 'Bullet Fairy' about the Ahmaud Arbery shooting and released it digitally one week before the George Floyd murder. It was a simple arrangement with a basic rhyme scheme and straightforward lyrics. Due to the sadly serendipitous timing the song picked up a bit of steam and it was around this time that Ryan first made contact with Engineer Records.

I already knew Joe Pugsley through his band, the 65's, as they'd been on a 'Lamp Light The Fire' Engineer Records compilation (Vol 3, IGN275) and then his label, Pyrrhic Victory Recordings, had been one of those that partnered with us in releasing Tired Radio's superb debut LP and CD, 'Patterns' (IGN295), which incidentally Ryan tells me is tied with Maker's self-titled album (IGN197) for his favourite Engineer release of all time. I was stoked to work with Joe again and very impressed with the powerful demos Ryan was sending us.

Ryan told me, "I had a bunch of demos in my pocket that would become the 'Margins' EP. I sent them over to you and your support for the project and solidarity with the working-class message in the songs was overwhelming. I also sent them to Mike and Nick, my old bandmates, who cheered me on from the side-lines. When I sent the final mix to Nick, he texted me back twenty minutes later, in all caps, 'PUNK!' The media outlets seemed to agree with his sentiment."

Engineer Records and Pyrrhic Victory Recordings jointly released 'Margins' in digital and CD formats on 27th November 2020. It was an angry and intense blast of hardcore punk. These eight songs were a far stretch from Ryan's acoustic stuff and even more aggressive than 'Bullet Fairy'. We concentrated on pushing the CD in the UK and Europe and even had a promo video for the EP, which we followed with videos for 'Worthwhile Victims' and then 'Normal's Not New' which gained over thirteen thousand views, with Ryan saying about the song: "Capitalists count on crises, panics, and recessions to regulate the market, exploiting a frantic and competitive working class to siphon profits to political leaders and CEOs. While we are all victims of this cycle, national pride keeps conservatives and liberals alike defending the very authoritarian regimes that keep them working paycheck to paycheck, i.e. the 'Stockholm mob' like the one we saw storming the US capitol on January 6th. They exemplify and uphold the very tyranny they claim to be against. While the actions taken by this mob are unprecedented, the factor remains that these proud white methods of control have been in

place since the Philadelphian Conventions upon which our country was founded. There's nothing new about this 'new normal'."

I asked Ryan what he remembered about the release of 'Margins'; "I felt a little self-conscious about it. The album was different, it was real. You and Joe were so encouraging, and I am grateful for you both believing in it. With such a radical departure in sound, I recall talking to Joe about potentially changing the band name. He said if I like the name, keep it, and fuck everybody. I loved that 'Don't overthink it' mentality. Joe continues to provide invaluable levity both in my personal life and in Scary Hours. Engineer Records helped us reach a lot of ears overseas and we racked up a lot of great press together. Being reviewed by MRR was cool as fuck."

Jack at Big Takeover also showed incredible support. And Djordje at Thoughts Words Action summed it up in a way that I felt represented the record; "Scary Hours vividly depicts the downfall of contemporary society, where the existence of fraudulent democracy became an excuse for imperial occupation, promotion of racial segregation, xenophobia, and nationalism. Each composition includes fragments of old school hardcore punk, modern melodic hardcore, and melodic punk rock."

Ryan told me; "The approach to writing the record was very minimal. I started off vowing to not spend more than thirty minutes or so on the initial arrangement. Sonically, I wanted to blend that '82 DC fury with the Fat Wreck sound, juxtaposing melodic guitar work with neat, punchy, fast drums and mostly shouted / screamed vocals. But I didn't want to write token 'Fuck authority' anthems. I wanted to attempt to engage somewhat more intellectually. I knew after writing two or three songs that I wanted to call the album 'Margins' as I sought to sonically represent the noise marginalised folks were making trying to be heard by anybody. That's the audience I wanted to connect with."

"The title track was inspired after seeing the uprisings in Portland, but it wasn't written specifically about that. I wrote the song as an ode to anybody who was standing up, coming out of hiding: the working-poor, BIPOC, LGBTQ+ and any other individual or group who felt pushed aside but were clearly ready to be seen. It was a rallying call, "These margins will not be contained.""

Ryan continued; "The first single was 'Cost of Living', a song about

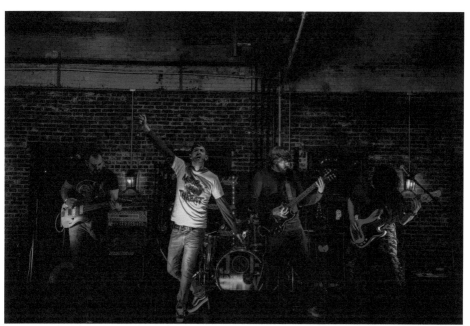

Marxist alienation. When capitalist alienation interferes with your ability to work the machine and fulfil your role, you can become a commodity for the pharmaceutical and other industries. Your unwillingness to comply will leave you economically and socially marginalised. Your servitude will strip you of your identity as you solely exist to produce. Either way, your future's been foreclosed and if you're sad about it, corporate gaslighting will turn a profit from you and keep you quiet while you march to the slaughter with everyone else."

"I had an idea to project images reflecting this sentiment and have my silhouette against it singing the song into a microphone, an idea I'd employ for several other videos. I had commercials for antidepressants spliced with footage of pigs being dropped into industrial grinders spinning behind my shadow. I grabbed my wife's digital camera and rigged it up, nothing fancy, but it turned out to be effective. It's rugged and DIY, but Joe and David seemed hyped on it, and so was I."

"I really wanted to give a full-band aesthetic for the 'Worthwhile Victims' video. I asked my old pal Nick to play guitar, Joe from PVR/65's to play bass, and a friend from another project, Greg, to sit in on drums. I felt the song was a great encapsulation of all the musical tricks the rest of the record had to offer in under ninety seconds, and my buddy Pete Zengerle shot the video in less than two hours. We spliced in some public domain footage and had Hardcore Worldwide do a premier for us. I liked the minimal approach, as we essentially only needed something for people to look at while they listened to the song.

At the time it was written, the ICE sweeps and maltreatment of immigrants interned at the Mexican-American border was being exposed. It wasn't just news coverage or propaganda to me, it touched people we knew. I heard from a friend that his mother was detained. Much of the world was outraged, as was I, but I wanted to also point out the hypocrisy in a particular conservative rhetoric: resources must not be allocated to ensuring human rights and basic dignities to people seeking asylum, but we can afford to fund proxy wars and we care about delivering democracy overseas in the bellies of bomber planes. I aimed to say as much as I could in the least number of words possible: "Babies cry themselves to sleep in their newfound chain-link cribs," fading into a traditional Mexican lullaby played on a nylon classical guitar. Eighty-four seconds, in and out, with samples. It felt concise and effective."

"The artist who did a lot of our cover artwork was John Steinheimer. He was part of the PVR team but also a close friend by that point, who was putting together these wild art pieces that served as extensions to the songs themselves. All the covers and promos we did looked great and worked so well with the message of our songs."

"I did another 'pandemic-style' one-on-one video for another song that my friends told me sounded like it could make a good single, 'Normal's Not New'. At that point, quarantine was in full effect. I taped a bunch of newspapers to my walls and had a projector going with blood droplets and ink spots. I shot it, it was cringy to me, but I also knew that some people might think it's cool and it could be good content to get people engaged either way. If they're slamming it in the comments, they're still bumping me up. 'Fuck everyone'.
For a period of time all the talking heads would use this word 'unprecedented' to describe the social and political conditions of the time. But I felt like, "Really? Policy has never reflected the interest of the working class, this is inherent in this system. There's nothing new about any of this." I know a lot of what was coming through for me was my own frustration and anger, but I honestly felt like, for the first time, I was able to speak about things that other people were experiencing on a systemic level."

"'When e-Thugs are About' was a response to a backhanded interview given by my former skate-punk band mate. I wrote it in the style of our old band, and the outro is missing bass to symbolise my departure from that group. 'Russian Cousin' was about being sober and really missing drinking, my Russian cousin being vodka. I chose to cover 'How Low Can a Punk Get' for no other reason than how good that song is. In retrospect, it was a bad move, as I was unaware at the time of the homophobic rhetoric adopted by Bad Brains in their early career."

"The song I was most proud of was 'Shell Beach', which would be a sort-of prototype for the next record. Shell Beach refers to the fictional seaside city from the film 'Dark City' and served as a metaphor for the constructed reality of pro-capitalist, mostly-conservative Americans. I'll be honest, I also really wanted to write a song that refers to another piece of media. Self-serving artist shit. I felt the lyrics seemed to adequately capture the feelings I was having about the climate in America, and the movements in the song reflected an urgency to act. I wanted the dark, angry musical tone to slowly transform to sadness and

despair, so I threw some violins into the outro. They're barely audible because, as it becomes even clearer in the next release, mixing is not really my strong suit. But you do what you gotta do with what you have. So there it was, my first hardcore EP."

The common thread on 'Margins' was punk-rock. Yes, there was Minor Threat-style hardcore on there, but it was very punk-inspired. Ryan continued toiling in the factory, the police continued shooting unarmed black Americans, the newest incarnation of Reagan was in the White House, and sadly, Marianne and Ryan experienced yet another devastating pregnancy loss. It would be easy to be overwhelmed by all that going on, so I asked Ryan how he coped and what he did next...

"In trying to contend with a world out of my control, I needed to hone in on any small change I could instil in my immediate surroundings so began engaging in philosophical and political literature. Hiding my headphones under my hat for the duration of my 10–12-hour working day, listening to podcasts and audiobooks. I was touched by seminal works from Malcolm-X, Michael Parenti, Richard Wolff, etc learning about historical labour conflicts and how they were resolved (the cover of the next Scary Hours record would be an artist's rendering of the Haymarket Affair). I was exploring nihilism and existentialism on a curricular level."

"Musically, I made a couple of essential discoveries that would go on to shape the way I write. I was inspired by newer bands like Knocked Loose and Vein.fm, but I also rediscovered some essential thrash and metal classics. I committed to not having any melodic vocals on the next record and employed the concept of rap cadence to aid in the crafting of the vocals."

'Symptoms of Modern Hegemony' was released on 29th July 2022 through Pyrrhic Victory. It was recorded solo, just like everything else under the Scary Hours moniker. I asked Ryan about it; "While Engineer Records wasn't part of the release, Joe and I felt honoured to have your support. I spoke about some very specific topics on this record and utilised them as conversation pieces for media outlets to build press around. I knew we wouldn't be the next Rage Against the Machine, but I wanted to try to reach someone, anyone, through music in the same way music reached me."

He continued; "The title of the record speaks for itself. With specific topics in mind, I felt each song was a symptom of a greater systemic issue, whether overtly political or not. I tried to break the album in half and produced a hip-hop interlude to serve as a bridge between the political and personal material. 'Precision Grooming' was the first single, released the week Derek Chauvin was sentenced for murdering George Floyd, exploring the fallacy of trying a racist killer cop in a criminal justice system that was designed to uphold those principles."

"'Western Thirst' was a response to criticisms of the 2021 Cuban protests, tracing the country's unrest back to Western imperialism and resource-pillaging. 'Sackler Street' is about Purdue Pharma and the Sackler family's deadly campaign to get America's working class addicted to OxyContin. 'Suffer Peacefully' explores the intersectionality of worker exploitation and racism, notions Malcolm-X was speaking about before he was conveniently assassinated. Perhaps my personal favourite on the record is 'Secular Grace', written about stigmatisation of the unhoused. The song has a real unhinged quality to it. I had managed to squeeze Converge, The Muffs, Slayer and some weird 8-bit break into a two-minute song. It's also the only song on the album to feature a vocal melody."

"I also shared some vulnerable and personal moments. 'Behind' is about engaging with nostalgia as a form of comfort until you realise you're facing down the fact that the best parts of your life may have already passed. 'Trapped' refers to an identity crisis: whether you're wasting your life away in the bar or wasting your life away in the office, you're still wasting your life away. It's all a big trap."

"'Tiny Tragedies' is about holding the dead foetuses of my would-be children and watching my wife suffer; how it drained the colour from the world and it felt like all I could see was the callous chaos and pointlessness of everything. 'Menace of Proportion', which is a spiritual sequel to that song, explores existentialism and nihilism in the face of tragedy, and how insignificant my problems are in the grand scheme of things, yet how impossible coping can feel."

"I am so incredibly proud of this messy, manic, strange-sounding record. While the reviews were generally positive, MRR said "Tracks reference Leftover Crack, Pantera and Jets To Brazil… confused? There's a lot to unpack here." Distorted Sound said "Symptoms Of Modern

Hegemony is a masterclass in punk music. Covering pretty much every subgenre of punk and throwing in a bit of metalcore as well, the band has shown that this is their scene."

That brings us pretty much up to date with Scary Hours, so I asked Ryan what was next for him; "I've continued writing and now need to perform these songs with a full band. Especially as, at the time of writing, I'm sitting on a new EP that has yet to be released. I knew I had some great friends who were capable and with whom I shared an ethos. It was just a matter of whether they were willing. I brought it up to my old band mates Mike and Nick and played them the new EP."

"We knew what it was like to be in a dysfunctional band, so it was clear from the start that there was an unspoken standard for how we'd operate and interact. I met Maryn through social media after she responded to a post I made seeking a bass player, as I wanted to strictly sing and not be tethered to an instrument on stage. Maryn and I connected through text and I knew she was the one when we sent each other pictures of our copies of the Manifesto."

"Joe Billy is unavoidable in our scene since he plays in so many projects and has his own incredible solo project. His talent and passion is astounding. He subbed in on drums for another project I was involved in and expressed interest in drumming for Scary Hours after I showed him some new songs I was working on during our ride home. We made a set list, set a date and made it happen."

"We played our first show in January of 2024 after releasing a single called 'Muted Mass'. Mike got Covid and we wound up having to play without him, which wasn't optimal. My voice broke halfway through the set, but my bandmates played on and Nick held it down with one guitar like a champion. Our next show was at a popular venue in our area called the Meatlocker. A lot of bands have passed through there over the years, and it was great that we were able to have our full line-up debut there."

I asked Ryan what he thought of the current hardcore and post-punk scene and what might be next for Scary Hours. He told me; "Hardcore and punk are more than an outlet for my own feelings, it is a way to connect to others through their art. For this reason, hardcore will always maintain its relevancy. And What's next? I'm looking forward to the next generation of Scary Hours which now features a full-band, comrades

from other projects playing these songs with me. We're going to trickle out this EP, write more together, and see where the full band iteration of Scary Hours winds up."

The Big Takeover reviewed 'Margins' on its release, writing; *"Ryan Struck, recording under the moniker Scary Hours, is unleashing his raging and socio-politically relevant album, 'Margins'. The eight potent hardcore punk songs on the LP tackle tough issues head-on, from chronicling the abuse against those who are marginalised by society and who are trying to survive to the specific scourges of nationalism, capitalism, alcoholism, and oppression. The record is a blistering hardcore punk attack that is full of anger and intensity, but also an acute awareness and articulation."*

"Struck details the reality that he, and that we all, live in, his disgust for many aspects of it, and his desire to be a voice of positive change. His powerful lyrical missives are matched by his incendiary hardcore punk music, with each song exploding with fierce and fiery truth bombs. Struck's frenetic, end-of-tether exclamations fly by in time with the rapid-fire drum strikes, clanging cymbals hits, scrambling and jagged guitar blaze, and low-end bass line grind on each track."

"Some numbers plough through with an unrelentingly fast 'n' furious pace; The careening 'Worthwhile Victims' and 'Cost of Living', as well as a breakneck cover of Bad Brain's 'How Low Can a Punk Get', while others go for a more melodic hardcore sound; 'When E-Thugs Are About' and 'Russian Cousins'. Some songs alternate between full-bore hardcore and catchier punk sections, like the fervently roaring title track, the galloping 'Normal's Not New', and the album-ending detonation that is 'Shell Beach'."

Jersey Beat chimed in about the local lad, saying; *"Ryan Struck is a one-man hardcore whirlwind on 'Margins', a politically charged assault upon the ugliness and hypocrisy that emerged over the past four years but has been long festering. The opening 'Worthwhile Victims' sings (screams, really) of asylum seekers in cages, babies in cribs made of chainlike fencing, and Bible-thumping bigots over a bed of searing guitar."*

"What I find the most impressive about Struck's work is the sneaky sense of harmony he injects into each track, particular on 'Normal's Not New'. As he roars about economic disparity and free market, the chorus has a hook that is indefinably melodic. There is a boldness to Struck's work as Scary Hours from both a lyrical and musical sense, as he successfully covers 'How Low Can a

Punk Get' from punk godfathers Bad Brains. There is always a risk in covering legends, but this version retains the original fury but is much more than a colour by numbers style homage."

"'Cost of Living' is a rightfully dark blast of angered hardcore with a devastating breakdown and thick guitar riff that channels the best of bands like Cro-Mags and Sick of it All. 'Russian Cousin' shifts gears slightly and returns to a less brusque form of guitar post-punk with a blazingly quick chorus. The closing 'Shell Beach' is nearly twice as long as any of other tracks, clocking in at nearly five minutes. This expanse of time allows Struck to place all of his skills on display, from rumbling bass lines to cleaner vocals, and put forth a song of greater complexity without becoming repetitive. The desperation of the times detailed is heard in the pained nature of Struck's vocals and the eight songs on 'Margins' truly are a soundtrack for the angst and fear that will continue to infest the country, even if the occupant in the White House has changed."

Ghettoblaster said *"Singer-songwriter Ryan Struck, who flies under the moniker of Scary Hours, creates witty and unsettling anti-folk, informed by his past in hardcore punk bands. The confrontational ethos of punk is hard to shake, especially when you live the daily grind of commuting to work from New Jersey to New York City. Struck is keen to vocalise his compelling diatribes on various matters regarding the state of the world, and does so with unbridled, tuneful panache."*

And **Thoughts Words Action** added; *"Scary Hours is a singular punk rock machinery entirely operated by Ryan Struck. Through 'Margins', Scary Hours vividly depicts the downfall of contemporary society, where the existence of fraudulent democracy became an excuse for imperial occupation, promotion of racial segregation, xenophobia, and nationalism. Some compositions are pointing out how the greedy capitalists are using global crisis, recession, and panic to gain more wealth. The remaining portion of this material deals with the Marxist theory of capitalist alienation, working-class heroes, marginalised communities who're uprising against the system, voting, human relations, anxiety and sobriety."*

"Ryan catalyses his emotions through emotive chants that are levitating between ferocious screams and polyphonous vocal articulations. There are even some post-hardcore aesthetics included that will, without any doubt, find potential admirers of this specific sound. On the other hand, the thematics covered in this material contribute an extra layer of ravaging angst pointed

directly towards all the injustices concealed within contemporary society. 'Margins' distributes ultimate dynamics through vigorous hardcore punk songs but also offers moderate polyphonous anthems that suit modern melodic punk rock trends."

Mad Mackerel commented that; *"Scary Hours create unsettling and raw anti-folk, rich with socio-political humour and the confrontational spirit of punk and hardcore... more basement show than coffee shop. Elvis Costello meets Lawrence Arms maybe, or possibly a Bukowski-esque Bright Eyes."*

And **Tattoo** simply said; *"Full of droll humour mirroring the punk attitude of quarrelling with the seemingly irrelevant treadmill of the world, with all its ridiculous flaws. Scary Hours, aka Ryan Struck, comments with stylish flair and clever lyricism on matters sublime and absurd."*

https://scaryhours.bandcamp.com/album/margins

Selflore

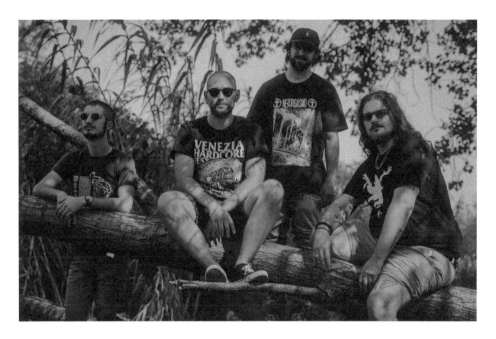

Luca 'Stin' Cristin : Vocals and Guitar
Pietro 'Citt' Citterio : Bass, Synths, Samples and Vocals
Andrea 'Mars' Marsilio : Guitar and Vocals
Filippo 'Flip' Motta : Drums, E-drums and Programming

**A Milanese four-piece creating granite walls of guitar overlaid with
vocal melodies, telling stories of personal growth to exorcise human
anxieties. Selflore have been likened to Husker Du, Dinosaur Jr, Kina,
Modern Color, Title Fight and Hum.**

The post-hardcore scene in Milan around 2017 consisted of bands like
Ojne, FBYC, Radura, Majno and La Siepe weaving a continuous dance
through the cities ever-changing DIY spaces and venues. Amongst this,
the roots of what would become Selflore could be found in two very
different bands, WASA and La Pioggia Su, which both imploded
somewhere around the summer of 2019.

Filippo (Flip) and Pietro (Citt) from WASA were growing out of their raw
garage sound, while Luca (Stin) had given it all with the emo swagger of
La Pioggia Su with their debut album 'Pantone'. The three musicians

came together in late 2019, as the last WASA line-up, playing shows around northern Italy with Walter (from Downhill / Leach) on bass.

The turning point came at the end of February 2020, when WASA finished their last tour through France and Italy. They were traveling with Chiara (Majno / Ojne / Kuroko) on guitar and co-headlining with their long-time friends SAAM, when the first reports of coronavirus made the news in Italy. The homecoming shows were all cancelled, and nothing would be the same again.

Flip, Stin and Citt met again in the summer of 2020 when the lockdowns were lifted, joined by Andrea (Mars) on bass. All the music and media consumed during the long locked-down spring had changed them forever, but they didn't realise how much until they started writing new songs. They carried an emotional heaviness, reminiscent of bands like Narrow Head and Modern Color, filtered through electronic distortion carried over from the endless repeats of Tengil's 'Shouldhavebeens' and The Armed's 'Only Love' constantly blaring through the speakers of Citt's record player.

This creative spurt, together with the forced hiatus from playing live, marked the ultimate end of WASA and the birth of Selflore. The year 2021 was spent between curfews and partial lockdowns and the line-up was reduced to only Stin, Citt and Flip, while Mars took on the role of cameraman / director / editor. With his help the debut singles 'Reykjavik', 'Gent' and 'Kingston' were then released as a series of videos between February and June 2022.

There was a short period before Mars came back as guitarist where Stin played acoustic guitar. But that version of the band did give birth to two tracks, 'Lavanda' and 'Ragnatela', that would later appear on the Selflore album.

After the summer, the full line-up reunited in their current form with Mars on guitar, Citt on bass and synths, Flip on drums and e-drums, and Stin on guitar and main vocals.
Together they recorded Selflore's debut album, 'L'Immagine Che Ho Di Me' (The image I have of myself) at Trai Studio, which was released on 29th September 2023, on pale blue swirl or ice white 12" vinyl via Engineer Records, Fireflies Fall Records, Dancing Rabbit Records, È Un Brutto Posto Dove Vivere Records and Non Ti Seguo Records.

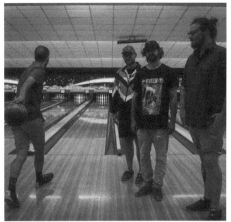
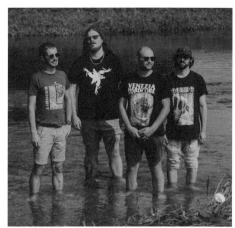

SELFLORE + Winter Dust

01.11 SESTRI LEVANTE @Casette Rosse *
ore 16!
02.11 BOLOGNA @Circolo DEV *
04.11 SIENA @La Corte dei Miracoli

*con BRINA

Poutrasseau
SUMMER 2022

SAM 18/06
CONCRETE MOUNTAIN · TORU · LE CAROGNE
VEN 22/07
GROS ENFANT MORT · SELFLORE · BOURBIER
LUN 08/08
DEATHCHANT · THE BLACK WIZARDS · MANU'S MILK
SAM 03/09
SUPERNAUGHTY · THE SOBERS · SPIRALPARK
SAM 01/10
MESSA · WORMSAND · NAMJERA

NICE
L'ALTHERAX

SUMMERSFALL
MINIFEST

Indisposed
Chicago
flowers&shelters
Bolzano
Selflore
Milano
Leita
Vicenza
Nasser
Milano

Apertura: h 18 Musica: h 20.30
banchetti · merch · musica · aperitivi

Sabato 10 Settembre
Spazio 20092, via Cremona, Cinisello Balsamo (MI)

LIFE IS STRAGE 11
LIFE IS STRAGE 11

FLORAL GRIN STRANGER
SELFLORE

csa arcadia schio

APERTURA PORTE ORE 21 01.04.23 INGRESSO 5$ IN CASSA
VIA LAGO DI TOVEL, 16 CASH/PAYPAL NO CARTE

WET MARY PRODUCTION & FIGLIO
in collaborazione con
ABNORMAL WAVE
presentano:

ABNORMAL SUDORE

MAMBO MELON
SELFLORE
PUT PÜRANA

DJ SET: EL PEDRITO B2B AXIS

GENOVA
SABATO 3 DICEMBRE 2022 h2130

506

The cover artwork is a wooden cabin, or small house, absolutely covered in snow and standing alone in the countryside. It's very much like an arthouse film image. The photo is from a Dakuburu Koinobori film, used in the cover layout by Lorena Palazzolo and helping create the feeling that that the band were after; That we are destined to leave the warmth of home and enter the cold reality. Just trudging along and leaving pieces of ourselves behind, little by little. But at the same time, still being able to sever the threads that bind us to imposed expectations and disappointments.

"We were so grateful for the warm welcome we received from the scene in Italy, with good friends rooting for us right from the very first gigs, and through memorable nights such as our first show with Mars on guitar in Genoa, and the record release show for 'L'Immagine' at the CIQ in Milan, the safe haven for underground culture in an endlessly gentrifying city." Filippo 'Flip' Motta, Selflore's drummer told me.

"It wasn't always easy of course. Every band goes through gigs with cold crowds, crossed arms and bad nights. But a show we played at the Edonè in Bergamo took the cake. A good venue with a decent crowd, but we broke a lot of equipment that night, including the snare-drum, and just couldn't get it together, so really didn't go down so well. It happens."

"Our first show in Bologna was a highlight for sure, we were touring with our good friends, Winterdust and Brina, and playing at the Circolo DEV, a small venue in the city centre run by people from the local scene. The place was packed out with a big crowd of indie / shoegaze fans who were loving what we did. They were all cheering for encores and just didn't want us to stop playing. That's a good evening."

Filippo continued, "Looking back to our 2023, we are very proud of what we have done so far, but our goals are definitely growing, and we want to make the most of the limited time and resources we can allocate to the band as working adults. We want to do more and give back to the scene. As long as people feel an urgency to express difficult emotions and complex feelings through music, there will always be a hardcore scene."

RockIt Magazine says that Selflore create, *"A compression of sound that is born to be seen on a stage, playing music to feed a scene which lives on community and concerts."*

Mescalina reviewed their debut album, 'L'immagine che ho di me', as *"Carving out the boundaries and melting the frost that has been created in human relationships, leading to communication of the deepest sensations of oneself."* Adding a track-by-track report and ending with the album being, *"A story full of hope in human relationships that tries to narrate how much this cold that surrounds us is dividing us all."*

Liberissimo added that their debut LP is *"An album that goes straight to the heart, with genuine alternative rock, and a spirit almost forgotten in today's music."*

And **Sounds Good** webzine described 'L'immagine che ho di me' as *"A short and compact album in which the six tracks tell of an uneven path with which to exorcise anxieties and fears, a path with which to accept the perception that one has of oneself and one's figure without necessarily comparing it to others."* Adding, *"In the glacial landscape evoked by the artwork, a house stands centrally, a wooden hut, a safe place to take refuge, not alone but with all the people we love. The personal journey undertaken thus becomes choral and collective and is therefore only possible when we let relationships warm that layer of frost that we put between ourselves and others to protect ourselves."*

https://selflore.bandcamp.com

Side Project

Ben Pritchard: Lead Vocals
Josh Vale: Rhythm Guitar, Backing Vocals
Phil Robinson: Lead Guitar
Matt West: Bass
Alex Hudson: Drums

Side Project's debut album 'Bittersweet' is a rocking collection of songs written in a conceptual style from a fictional character's point of view, sharing their innermost thoughts, and detailing the demise of a relationship and the conflicts that result from that.

Crafting each song with hooks and sing-along moments whilst staying true to the bittersweet story being told, Leicester's Side Project have created a sound that fits well with modern pop-punk. You'll all have a different favourite track, from the anthemic 'Sad Songs' and punchy 'It's Not A Title, It's A Label' to the emotional 'Macee's Song' and upbeat album closer 'The Thoughts I Have When I Fail To Sleep'. Each song feels unique but ties the record together, ensuring that the band becomes what they were always meant to be; Consummate punk-rock storytellers.

Side Project started life in 2017 when Ben (vocals) and Matt (bass) met in the very rock and roll world of a call centre, where Ben was a manager and Matt worked in his team. After discovering that they had similar tastes in music and were passionate about the same bands, Side Project ventured into the studio and recorded an EP called 'The Shapes & The Colours' featuring three songs that are completely different from how the band sounds today. After their initial adventure in recording, they found themselves having to scratch the 'live' itch and recruited a full band to take their songs and ideas to the next level, and soon started playing shows across the UK.

Having had varying degrees of success in their previous bands and having been bitten and infected by the band bug, Side Project freely admit that they're addicted to writing songs and playing live because, as Ben so eloquently puts it, "Music is in our blood."

Like every musical collective since the dawn of rock'n'roll, Side Project are a sum of their parts and their influences. Sounding to me like a car crash between a punk-rock charabanc and a nu-metal juggernaut, they have a distinctive and individual sound that draws liberally from a varied pool including Sum 41, The Beatles, The Wonder Years and Eminem.

Acknowledging that their debut EP was just a way for the band to find their feet, discover who they were musically, and act as a calling card for the scene, Side Project are far prouder of their debut album, 'Bittersweet'. This eleven-track rocker of a concept album would be released on CD by Engineer Records in 2021 and was written as a way to help vocalist Ben come to terms with the breakdown of his marriage and subsequent divorce. It is, as bass player Matt says, 'the bands baby' and an incredibly emotional and cathartic record.

When I asked him about the Side Project song that he felt was the most reflective of the band, and that was most indicative of the band, Matt replied "The last song on our EP called 'The Shapes & The Colours' which was written about losing a family member and it was finding that emotion and using it in a positive way that struck differently than the rest of our songs. It's easy to talk about relationship issues but when you take something that you remember staying in the pit of your stomach until this very day, I find it more challenging to create something I can listen back to, but with that track, the pride we felt after writing it left a lasting impression on us and inspired us to write more emotional songs."

SIDE PROJECT
BITTERSWEET

NEW EDGE PROMOTIONS PRESENTS...

OCEANS APART

"THE HATE CLUB"
ALBUM RELEASE PARTY
PLUS SUPPORT:

NEON SARC ASTIC

Side Project ROSAIRE

SATURDAY 9TH JULY 2022
THE Y THEATRE
DOORS 7PM
TICKETS £10

HALF HEARTS

ADAM'S PARADE

Side Project

CO-HEADLINE TOUR
JUNE 2022

22	ROTHERHAM	BRIDGE INN
23	YORK	FULFORD ARMS
24	ECCLES	WANGIES
25	WORKINGTON	LOUNGE 41
26	NORTHAMPTON	THE LAB

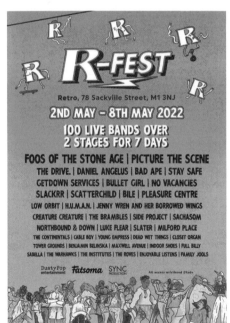

R-FEST

Retro, 78 Sackville Street, M1 3NJ

2ND MAY – 8TH MAY 2022
100 LIVE BANDS OVER
2 STAGES FOR 7 DAYS

FOOS OF THE STONE AGE | PICTURE THE SCENE
THE DRIVE. | DANIEL ANGELUS | BAD APE | STAY SAFE
GETDOWN SERVICES | BULLET GIRL | NO VACANCIES
SLACKRR | SCATTERCHILD | BILE | PLEASURE CENTRE
LOW ORBIT | H.U.M.A.N. | JENNY WREN AND HER BORROWED WINGS
CREATURE CREATURE | THE BRAMBLES | SIDE PROJECT | SACHASOM
NORTHBOUND & DOWN | LUKE FLEAR | SLATER | MILFORD PLACE
THE CONTINENTALS | CABLE BOY | YOUNG EMPRESS | DEAD WET THINGS | CLOSET ORGAN
TOWER GROUNDS | BENJAMIN BELINSKA | MAXWELL AVENUE | INDOOR SHOES | FULL BILLY
SABELLA | THE WARHAWKS | THE INSTITUTES | THE ROVES | ENJOYABLE LISTENS | FAMILY JOOLS

DustyPop entertainment Fatsoma SYNC PRODUCTION All access wristband £15adv

SIDE PROJECT
THE FRESH ✕ START TOUR
FOUNTAIN ISLAND

FUELED BY
Vocalzone
Throat Care

+ LOCAL SUPPORTS TBC

01/09/23 - DERBY, THE HAIRY DOG
02/09/23 - NEWCASTLE, THE CLUNY*
03/09/23 - GLASGOW, IVORY BLACKS*
05/09/23 - CAMDEN, THE BLACK HEART
06/09/23 - LEICESTER, FIREBUG

When I asked Matt about the record that had the greatest impact on him, both as a musician and a fan, he immediately answered, "The Wonder Years 'The Greatest Generation', from start to finish, it's a masterpiece. It unleashes every emotion and deservedly took The Wonder Years to that next level in their career. Dan 'Soupy' Campbell is just the best, literally goals, he has this beautiful, poetic way of explaining things and making those sophisticated lyrics resonate with every listener."

The band's hometown, Leicester, has a scene that music fans from anywhere and everywhere can relate to. It is filled with insanely cool bands, all of whom have a very different take on and approach to playing music that most of the time is popping and bursting with energy and enthusiasm, and at others, enters the inevitable quiet phases and periods. But as anyone who has devoted their life to discovering incredible new bands and going to gigs knows, the exciting part of that is the feeling it's ready to explode again at any moment. And whenever Side Project hits the stage in their hometown, the gig is always going to be packed with familiar faces, wearing their t-shirts and singing along to their songs.

I asked Ben to enlighten me about some of the best and worst shows that they've played, and with a sigh he told me the tale of both, "Out best would have to be a toss-up between our first show as a band, and our album release show. Both were incredible. As a band we were as tight as we could be, we sold them both out and you could barely move in the venue."

"As for the worst, well there's one that really stands out for me. I won't name the venue because that wouldn't be fair, but to give you an idea of the build-up to this show, everything that could go wrong, went wrong. We were on tour, post covid, and tensions between the four of us and our ex-drummer were running high. This guy had been taking us for a ride for a long time and had no business continuing in the band, but we were willing to give him a final chance to show us why we should continue with him in the band. So, a few days into the tour, he bails on us, flat out refuses to play the next few shows as he has hay-fever (most rock and roll drummer ever, right?), and says he will be back for the final show of the tour. We manage to get through the next shows, with the drummer from the band we are on tour with standing in. We were very lucky with his ability to pretty much nail our set from ear."

"On the penultimate night of the tour, after a five-hour drive with everyone tired, and I'd lost my voice, we got to the venue. The load-in was really late for this show but still, the promoter turned-up an hour late. We finally started loading in, up several flights of stairs, into a dodgy looking nightclub. Our merch guy, Bullet, had to do the vocals, but he'd never sung on stage before so the whole thing was a complete shambles. After the show, we were all feeling rough as hell and soon found out we had covid, probably from our disappeared drummer. We had to cancel our last date of the tour."

Despite this nightmare tour the band kept on and now have more stories than they can remember. But Side Project's favourites revolve around the camaraderie that fuels everything they do, like the Cadbury's Heroes tin and broom bass that was a Secret Santa gift and has yet to be played live, and their lead guitarist Phil's train obsession, that has led to them moving photo shoot locations to railway stations so that he could satiate his locomotive desire.

As for why they ended up choosing Engineer Records as their home. Ben says, "It was and is entirely because they understood, and understand what drives Side Project and what we strive to achieve on record. And even though Covid and the fallout from the pandemic threw a spanner in our studio plans we're confident that when our next album is released it'll have the Engineer logo on its cover."

Thriving on a family dynamic and believing that music should have a message, the guys continue to pour their blood, sweat, and tears into Side Project. For them, the future is unwritten and an ever-evolving musical landscape just waiting to be explored.

The **Thoughts Words Action** review of 'Bittersweet' includes, *"Besides the vividly hearable dominance of a contemporary pop-punk sound, you will hear some other popular subgenres, such as melodic punk-rock, post-hardcore, indie-rock, and emo. However, Side Project keeps their tunes within modern pop-punk circles as much as possible, and these other elements are there to highlight particular segments. Side Project easily transit from mellow sounds to more aggressive tones, from calm melodies to more dynamic riffs, but it seems that the group leans towards more polyphonic waters while the aggressive moments serve to give a bit of diversity."*

"Each composition offers pleasant, soothing, ear-appealing melodies, harmonies, chord progressions, and riffs. Side Project transform from mellow

verses to cathartic, singalong choruses with such ease, and these are the moments where the group showcases its full potential. The group pays a lot of attention to every detail. From flawlessly performed rhythm and lead guitar parts, over thoughtfully assembled basslines, to excellent drumming performance and profoundly melodic lead vocals, Side Project possesses everything you ever need from a pop-punk band."

And **Punk Rock Theory** simply applauded the *"Fast riffs and choruses that will have audiences around the country chanting back."*

https://linktr.ee/sideprojectuk

Singing Lungs

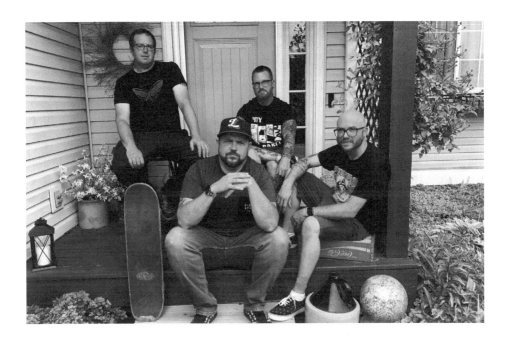

Jason Kotarski: Guitar and Vocals
Ben Graham: Drums and Vocals
Sean Murphy: Bass
Jack Robidoux: Guitar

Singing Lungs is what you get when a board game publisher, a touring punk rock veteran, and a zookeeper are united by their love of music and a history of growing up in the Michigan DIY music scene. Together they are crafting their own brand of 90's influenced pop-punk with nods to the alternative/grunge scene of their youth. They play catchy as hell, old school style pop-punk, straight from the heart.

Singing Lungs was born in 2014 in Flint, Michigan, USA when Jason Kotarski, (guitar/vocals) had the urge to write new songs and perform live again after several years of taking a break from music to go back to school. Having started a board game publishing company, the need for the immediacy of creating music started to work its way to the surface as a necessary outlet. Jason had played in bands for years, spending many weekends on the road with pop-punkers South Bay Bessie going from dive bars to DIY spaces all over Michigan and the

Midwest until it started to feel a bit too much like a chore. But now he wanted to get back to it.

"After finishing school and starting a game company, I was writing a ton of songs just for fun. But soon I wanted to share that creativity with others and play some shows." Jason told me, "I decided to keep things light by asking local friends who I knew from helping out at our local all ages DIY space, Flint Local 432, to join me for occasional gigs. They already had their own bands but had a little spare time. Travis Branvendar was in one of my favourite bands from the Flint area called Lawnmower, and since it was unlikely that he was going to let me be in his band I asked him to play with me whenever he could. Then I reached out to another friend, John Guynn, who had been playing in a band called Hawk and Son, to join us on drums."

Jason continued, "John and Travis were great to play with, picking things up easily. They had great attitudes and were on board with only playing when we felt like it. We called ourselves The Singing Lungs and only played three shows over the next year or two, but it was fun. At the beginning of 2016 my family packed up and moved across state to Grand Rapids, following a new work opportunity for my wife. I was certain this change of pace would be the end of the band, as I had lived in the Flint area my whole life and didn't really know anyone in Grand Rapids."

Once in Grand Rapids though Jason kept on writing songs. He'd grown up listening to punk in the 90's. Lookout Records and No Idea Records were favourites, but also a lot of folk and Americana. He got back into punk again thanks in part to new DIY labels like Salinas and It's Alive, and finding bands like City Mouse for the first time. They reminded him of what drew him to punk in the first place.

"The urgency, energy, and lay-it-all-out-there spirit had recaptured my attention. I dove back in and discovered lots of other new-to-me music that I'd missed out on before due to being a little too young when it first came out; Husker Du, The Replacements, Doughboys. Also, early Goo Goo Dolls, Gin Blossoms, Buffalo Tom and The Magnolias. Coming across all this stuff made me feel at home again." Says Jason.

It was around this time that an old friend, Ben Graham, posted online about how his band, Cheap Girls, had broken up and he had a drum set sitting in his basement that needed to be used. This was the catalyst and

the guys got together to jam where Ben lived, in Lansing, about an hour away. They roped in Sean Murphy to play bass; another old friend from the Michigan punk scene and were soon having a blast.

Not having recorded the first iteration of the band, Jason wanted to record the songs now and have something to show for all the creativity and effort they were putting in. So, before they'd even played any shows, the new line-up reached out to Rick Johnson, a guy they'd known for years from playing in bands like Wack Trucks and Mustard Plug. He had a recording studio in Grand Rapids, Cold War Studios, and had recorded a bunch of great sounding stuff. They booked some time and cranked out fifteen songs over just three days.

Now it was time to play some shows. Starting out in punk bars in Grand Rapids, Lansing and Flint, The Singing Lungs made more contacts and were soon playing regularly, heading out to places further afield like Detroit, Dayton and Chicago.

The band decided to release their first album themselves. It would be entitled 'Groan' and come out on digital, CD and cassette formats, with a busy hometown release show at The Loft in Lansing on 29th September 2018, supporting Laura Stevenson and Mustard Plug. Originally, they'd considered calling the album 'Mutter and Groan' and have all fifteen songs on the release, but later decided to have ten songs on the album and hold the other five back for an EP. This worked well as the Groan songs flowed from their alt-rock / grunge influences while the songs for Mutter were a little more punk-rock. The 'Mutter' EP would come out later on Count Your Lucky Stars Records in 2019.

I asked Jason about the gigs they were playing around that time, and he recalled, "We did a weekend tour in November playing with The Apology Tour in Chicago. We played a basement show in Naperville where all the punk kids with mohawks ignored us until I started playing Operation Ivy's Knowledge and they all came barrelling down the steps to start a pit and scream along. It was also on this trip that we watched Sean chat with some random ladies at a rest area on the highway about ethics and creation. He will talk to anyone about anything. That day, he made friends with some Jehovah's Witnesses, not noticing the cart of Bibles behind them. We'd visit all the toy shops and record stores we could find. We played with Scotland's Murderburgers and Get Married in a DIY space that had a halfpipe that Noelle from Rational Anthem skated while we

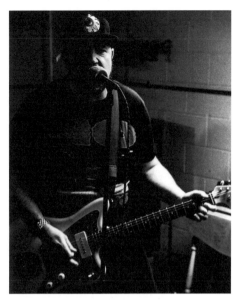
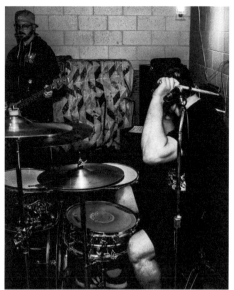

CHILD BITE

WITH COLD JOYS, SINGING LUNGS AND STRANGE WITCH

FLINT CITY HARD CIDER 1111 MLK FLINT, MI SATURDAY AUGUST 13, 2022 8 PM

DISTANTS SINGING LUNGS
SNAKEOUT THEM TEETH
THE MOLLUSKS

LIVE AT THE CREDIT UNION
MUSKEGON
4.16.23 7PM
$7.00
DM FOR ADDRESS

MIKE REED
SMALL BROWN BIKE / ABLE BAKER FOX / LASALLE

SINGING LUNGS
CYNIC LIXIE

FRIDAY, AUGUST 27, 2021
8:00 PM
FLINT HARD CIDER CO.
610 MARTIN LUTHER KING AVE
FLINT, MI

SINGING LUNGS
LANSING ALBUM RELEASE FOR "COMING AROUND"

CAVALCADE
LANSING METAL SWEETHEARTS

COLD JOYS
EX-KID BROTHER COLLECTIVE, DWNRS, ETC.

MT. ORIANDER
SOLO SET, EX-EMPIRE! EMPIRE! (I WAS A LONELY ESTATE)

@ Avenue Cafe SAT, MARCH 4
9PM NO COVER

MUSTARD PLUG

WITH SPECIAL GUESTS
LAURA STEVENSON
GREY MATTER
SINGING LUNGS

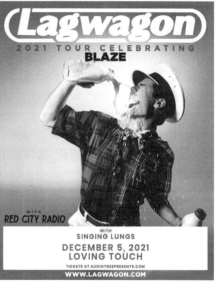

Lagwagon
2021 TOUR CELEBRATING
BLAZE

WITH
RED CITY RADIO

WITH
SINGING LUNGS
DECEMBER 5, 2021
LOVING TOUCH
TICKETS AT AUDIOTREEPRESENTS.COM
WWW.LAGWAGON.COM

played. We played with Turnspit in a 110-degree art space, and we opened for the J Robbins band, after which the legendary producer / Jawbox frontman told me our harmonies sounded great."

Halfway through 2019 The Singing Lungs connected with Keith and Cathy Latinen's Fenton, Michigan based label, Count Your Lucky Stars Records, to release their 'Mutter' EP. This led to many more shows, with the band opening for Devon Kay and the Solutions and Rational Anthem in Chicago. They also played the local Lansing punk fest, called GTG Fest, with City Mouse, and the first Houseghost show in Dayton. They'd also open for New York Ska legends The Toasters, in Grand Rapids, which led to the addition of Jack Robidoux to The Singing Lungs line-up.

"We'd been asked to play with The Toasters but Sean realised he a zoo benefit he was supposed to running on the same night. He told us that Jack, a Lansing native who was coming to all our shows, already knew all our songs and that we should ask him to fill in on bass. I was reluctant," said Jason, "But Sean had already mentioned Jack before, suggesting we'd sound great live with a second guitarist. But I loved the simplicity of not having to manage too many busy grown-up schedules. We really wanted to play The Toasters gig, so asked Jack to fill-in. He showed up to one rehearsal beforehand and really did know all our songs. We played the show and soon afterwards asked Jack to join the band on guitar."

A couple weeks later, Jack played his first show with The Singing Lungs on guitar, kicking off the Bernie Sanders presidential rally in Grand Rapids on 8th March 2020. I asked how the hell a post-punk band booked a gig like that. "Well, we'd heard Bernie was coming to town and that alternative / indie bands were sometimes playing at his rallies. Ben remembered that his friend Max, who played in Lemuria, was working on the Bernie Sanders campaign and called him up. A few minutes later, we were on the bill and getting paperwork for background checks sent to our emails. The show was like nothing else we've ever played. A sea of people holding blue Bernie signs. The energy and excitement of like-minded people making a stand for equity, justice and hope in a mostly conservative city." Jason added, "I was close enough to sweat on the Reverend Jesse Jackson before he came out to speak on behalf of Bernie Sanders. When we got to meet Bernie after the show, we were arguing about who would shake his hand in the picture, while he walked right past us and shook Ben's wife Erica's hand instead. What a classy revolutionary!"

While the Bernie rally gig must've been a special day, a few people in the audience were wearing face masks and these were the first rumblings about a new virus going around. Sure enough, a few days later the entire country shutdown and we all learned a whole new way of life for the next couple of years.

"Just when it started feeling like we were building some momentum all our plans got turned upside down. I'd been in writing mode again and started recording demos on my iPhone using a multitracking app called Spire so I could share the ideas with the rest of the band in-between binge-watching true crime shows and wiping down groceries." Continued Jason, "We started learning to use the recording app through lockdown, sending parts back and forth and building on one another's ideas. After a month or two we had about fifteen to twenty demos. We were so proud of them we considered releasing the lo-fi records as our second full length. The creative excitement pushed us along a little faster than we needed to be moving. We remembered we weren't in a hurry, with no end of the pandemic in sight, so instead of putting out an album of super raw phone recordings we opted to release a limited-edition lathe cut 7" of four of the better songs. They came out on Count Your Lucky Stars Records under the name of the 'Phone From Car' EP in July 2020.

By this time Keith from Count Your Lucky Stars Records had become a good friend, with a shared love of board games, and growing up in the same DIY scene. The guys bonded over similarities found between running an indie label and running an indie tabletop game company. Keith was a huge supporter of the band, often coaching them on how to get more people to listen and direct them to their releases.

It was time to get back into the studio and record the second album, and Rick Johnson had time in his schedule, since his tours running live sound for Jeff Rosenstock, AJJ and Streetlight Manifesto were all on hold. The mechanics of recording during a pandemic were unique, with limits on the number of people in the studio at once, but the band's remote iPhone recording experience had served them well. Ben and Jason recorded drums and rhythm guitar tracks one day, while wearing masks at opposite ends of the live room at Cold War Studios, and without ever stepping into the control room to listen back to takes with Rick. The next day, Jack and Sean would come in and record their parts. Jason headed back to record he vocals a week or two later and it all came together as Rick sent them rough mixes by email. Home recording gear was set up

in Jack's living room so Ben and Jack could record backing vocals to be mixed in later.

"I think one of the biggest lessons we learned about being in a band during the pandemic lockdown era was how much work could be done remotely with a little knowledge of basic technology and patience. The basic tracking went smoothly, so we had time to make the record fun. We asked some special guests to offer their talents and soon had Miski from City Mouse singing and playing guitar on a song. Jack asked Jamie Woolford from The Stereo to lend vocals to a track as they'd met a few times watching his old punk/ska band Animal Chin. Ben reached out to Laura Stevenson, who he'd toured with, and we'd met at the release show for 'Groan', to sing on a song as well. We even made Rick Johnson pull out his old theremin to add some weirdness to a track."

When all the recording and mixing was done the band asked another old friend, Justin Perkins, to master the record at Mystery Room Mastering. Jason had met Justin when his old band, South Bay Bessie, invited Justin's band, Yesterday's Kids, on their first tour. They were on Lookout Records at the time. After Yesterday's Kids, Justin played with Screeching Weasel, The Riverdales, and Tommy Stinson's Bash and Pop, but now spends all his time mastering records. He added the last little bit of shine onto this batch of new songs.

Jason's Lookout Records fan-worship even led him to reach out to Chris 'Applecore' Appelgren, the former Lookout Records owner, who'd bought the label from Larry Livermore and Patrick Hynes in 1997. Chris was well-known for his album cover artwork and had worked with Green Day, The Queers, Blatz, Screeching Weasel and The Donnas. He agreed to do the artwork for the record.

Count Your Lucky Stars had already offered to put the album out on cassette, but the band were hoping for a vinyl release and wider promotion for their second album. This was no small request for a band without a huge following, so label partners were needed, to split the cost and spread the coverage of the new record. The band started chasing other labels.

It was Jeff Dean, from Heavy Seas and Cleon's Down, who pointed them towards Sell The Heart Records, run by Andy Pohl out of Berkeley, California. Andy plays guitar in Tsunami Bomb and had started his killer post-punk label on the West Coast back in 2010. Andy and STH work with

Engineer Records in Europe, so he passed on the bands contact details. We started talking and the band sent songs over, soon gaining them another supporter.

"Engineer has a long history of putting out amazing punk, emo and hardcore releases and it gave us a new-found sense of confidence in our record to know that they were into it," said Jason, adding, "The last piece of the puzzle was Kazu Onigiri and his Waterslide Records label in Japan. Kazu had sold some of our first album through his distro thanks to Keith's connections. When Kazu compared us to Mega City 4 and the Doughboys, I knew we were in good hands."

It took a while for the pieces to fall into place, with pressing plant delays and various shipping obstacles to overcome, but The Singing Lungs second album, 'Coming Around' was released worldwide on 24th February 2023 on 12" LP, in both deep purple and magenta pink vinyl versions, jointly by Count Your Lucky Stars, Sell The Heart, Waterslide and Engineer Records (IGN327).

Between the covid lockdown and the record's release Jack had a kid, Sean had a kid, and Jason went to grad school to become a librarian. Not long after that, Jack moved across the country to Spokane, Washington to accommodate his wife's military service, so the band went back to playing as a three-piece again. They did, however, get to play The Fest though. At Fest 20 in Gainesville, Florida you could find them casually chatting with the likes of Chris Wollard from Hot Water Music about growing up in Flint and eating pizza in the parking lot after watching their favourite bands.

They write songs. They play shows. They even make plans sometimes. The Singing Lungs next plans revolve around a split release with UK band Bedford Falls, again coming out on CD via Engineer Records (IGN403) in the UK and this time on cassette too via Setterwind Records in the US.

Jason concluded our conversation ever-positively, by sharing with me, "Having met Ben many years ago when we were barely teenagers, putting on punk shows and inviting each other's bands to visit each other's towns, I love seeing how much it's influenced the direction of our lives. We came from scenes that taught us to go after the things we loved and make a lot of friends along the way. That's the goal and I hope we keep it that way for years to come."

Singing Lungs 'Coming Around' album was announced in **Razorcake** zine as *"Really great heart-on-a-sleeve punk here. Sounds Midwestern, which makes sense since they're from Michigan. Earnest stuff with one foot unabashedly and unflinchingly in mid-tempo alternative rock. Great guitar tones and gritty vocal melodies. My closest launch point would be early Goo Goo Dolls."*

With **Punk Rock Theory** suggesting, *"Fans of Lagwagon, Lemonheads, and old-school Green Day will find a lot to like here. Gruff but singy vocals, distorted guitars that crunch along to a driving rhythm section. Think 90s punk rock, when punk rock was still underground but primed to break through."*

And **Punknews.org** reporting, *"For fans of Smoking Popes, Samiam, Superchunk, Lemonheads and Gin Blossoms. While that may be true, I hear more of an '80s Minneapolis sound. Specifically, songs and guitar tones heavily influenced by The Replacements and Hüsker Dü. There are also clearly elements of grunge and pop-punk."*

Isaac Kuhlman at **Powered By Rock** called 'Coming Around' an *"11-song straight up rock album that is tied in punk roots, but it comes out more like a Bruce Springsteen-inspired sound. Solid rock songs with thought-provoking lyrics."*

I Don't Hear A Single added, *"The Singing Lungs are like Smoking Popes with a power-pop beat and noisy enough to appear on Rum Bar. But their second album feels even more melodic and at times steps into the territory of The Lemonheads, maybe even Husker Du.*
They just don't come up for air, and that rowdiness seems more focused, largely due to the riffs which grip you to the core. A shake-your-fist and sing-along affair like this needs and deserves greater attention."

And **Rockfreaks.net** reviewed the album saying, *"Some bands carry themselves with an aura of warmth, encompassing their expression and making them easily lovable. The sophomore album 'Coming Around' by The Singing Lungs personifies that statement through its charming, folksy singing style and the great American rock song style song-writing. It's an indie-flavoured form of punk that fits perfectly alongside the Bruce Springsteen and Gaslight Anthem's of the world, just as much as it feels like a band that could and should play FEST. It's punk enough to appeal to the latter, yet draws from anthemic, expansive melodies that ooze tender kindness throughout."*

linktr.ee/singinglungs

Sirens & Shelter

Scott Mallard : Vocals and Guitar

Blood, sweat & broken guitars are the order of the day for Sirens & Shelter. Full of passion, honesty and heart, Scott Mallard leaves everything on stage whilst on tour, giving relentless live performances and captivating audiences wherever he goes.

Formed in the summer of 2012, and having shared the stage with artists such as Matt Pryor (The Get Up Kids), Allison Weiss, Dave McPherson, Luke Jackson, Hidden Cabins (USA), Ryan Mills (CAN), Giants (UK), The Satellite Year (GER), Hildamay, White Clouds & Gunfire, Sean De Burca, T // Alan, Swallow & The Wolf, 8 Foot Felix (AUS), Nizlopi and Her Only Presence (SPA), Sirens & Shelter offer up a wealth of original, incredible, emotionally charged songs, at once singalong catchy and heart-rendingly powerful.

"My teenage years were spent listening to, and playing, heavy metal music, learning riffs and grooves from Metallica's back catalogue, slowly delving deeper into heavier and more chaotic sub-genres, exploring bands like Poison The Well and Black Dahlia Murder." Says Scott, "It

made total sense at this time to turn my hand to writing my own riffs and songs, and forming my first band, Life Sentence. But being my own worst critic and not having the ability to actually record my guitar parts, it was only the catchy ones I could remember the next day that made the cut. I suppose it was there that I found an ear for melody. We submitted our full-length demo effort, 'Dr. Death' to Engineer Records, but it didn't make it through A&R."

Years later Scott, and close friend Dan Mackey, (ex-Life Sentence singer and bass player) had grown tired of constantly smashing china cymbals and yelling, so formed a pop-punk band, called The Startover. This would be a fresh start for both of them and saw Scott start singing and writing more melodic songs. After a while this brought them back to Engineer Records, this time making the cut, initially for the release of their self-titled 'The Startover' debut CD EP in 2009 (IGN127), and then for their superb 'Survivors Guide' CD EP in 2010 (IGN141), which soon saw Scott become close friends with label head-honchos, David and Craig, and then later led to a licensed release on Pacific Ridge Records in the US too.

After years of pop-punking all over the place, The Startover came to a natural halt after a couple of line-up changes. They'd be much-missed, and I asked Scott if he felt the same way about having a full band line-up to play in, "Those years were such fun. I got to play upbeat music with some of my best friends, Matt, Joe, Pete, and Dan. We made many life-long friends in this period and it's a chapter that will always stay with me. Our 'Survivor's Guide' EP was the most professional release I've ever been involved with, and I hold fond memories of recording it with Ian Sadler in Kent." (In 2023 The Startover would rekindle friendships and reform for a superb and packed gig, raising money for charity at Leo's Red Lion in Gravesend).

"I found it tiring trying to write songs, expensive trying to record them, and sometimes demoralising trying to reach people with them. So, after a while, I decided to take a break and play covers in a functions band, which served me well for a few years, and paid ok too." Scott continued, "I can't remember exactly how it came to be, but over time I'd managed to write a few acoustic songs and got chatting with good friends Chris Baxter (of Call Me Malcolm) and Matt Cahill. Chris had an old caravan he kept a drum set in and these songs became Sirens & Shelter's first release, 'The Midnight Arrangement' in 2012."

'The Midnight Arrangement' CD (IGN192) was Scott's first EP, with eight classic tracks, demanded by fans after many great gigs. There were two superb, understated videos for 'The Deep End' and 'Socially Awkward' from this EP, as well as a third video for 'Two Left Feet', performed in a toilet.

"Sirens & Shelter was born out of my desire to sharpen my fingerstyle acoustic guitar playing. I was also hooked on slower Jimmy Eat World songs at the time, and I developed an unhealthy addiction to Florida based emo band, Copeland. It was around this time that I also discovered Mike Kinsella's midwest emo project, Owen, and Evan Weiss's project, Into It. Over it., both of which eventually became my biggest influences." Says Scott.

But as Chris became busier with Call Me Malcolm, the Sirens & Shelter trio gradually became a solo project, with Scott nuturing a desire to play the songs more often, without conflicting with anyone else's schedules. By this stage Scott had realised he'd gathered support from many friends made in bands gone by and was picking up song-writing momentum again. His old friend Dan, from Life Sentence and The Startover, offered to record and produce his first full length album and this would become 'Through The War'.

Released in 2013 through Engineer Records, 'Through The War' (IGN206) would see Scott collaborate with the likes of AJ Perdomo of The Dangerous Summer and Paul Richards of One Day Elliott, amongst others, to create a ten-track album that was rightly reviewed as 'A rare masterpiece'. Promo copies went out all over with 'People need to hear this album to be saved from life' written on the press sheets. Very soon Tanglewood Guitars were in touch to endorse Scott, and Sirens & Shelter were also taken on by Desert Pearl Union Records in Barcelona, supporting Engineer Records and leading to two versions of the album, with purple and red covers. The album helped Sirens & Shelter build a dedicated fan base all over the world and through a relentless work ethic, a video and digital single for 'Landing Lights', and playing an unhealthy number of shows, the first press of 1000 CDs were sold out within the first ten months of release. 2013 would also see Sirens & Shelter touring around the UK, Germany and Spain with label mates, Hidden Cabins.

Back on tour again in 2014 Scott needed more CDs for sale at shows and worked on a split CD EP for him and Canadian artist Ryan Mills. The

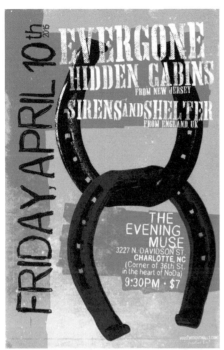

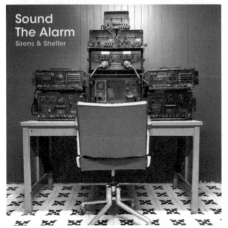

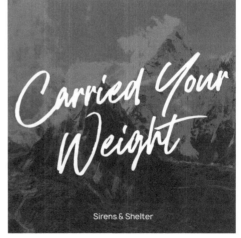

530

record came out as the 'Nine Days' EP (IGN214) in April for their UK tour and featured the tracks 'Breathe' and 'See You Soon' from Scott and 'Overflow' and 'She Takes Me' from Ryan.

Scott also jumped on a UK tour with German emo / electro-pop band The Satellite Year in 2014. Engineer Records was releasing their new album, 'Mission: Polarlights', and had booked the tour, adding Sirens & Shelter as support for the UK dates. Scott recalled, "On the bus between St. Albans and Sheffield we decided to watch an awful zombie movie called Osombie, where the American special forces are drafted in to tackle a zombie apocalypse, and every zombie was Osama bin Laden. In Sheffield, the first person we interacted with was a sound engineer at a huge, noisy, sticky-floored venue called Corporation, whose accent was so thick I had trouble deciphering it. My six new German friends had no chance as they had only just become attuned with my southern accent, and had not long since adjusted their ears from the zombie fighting American military. It's not the funniest account, but a moment I won't forget, given that I first had to decode my own language spoken by this guy before relaying information to The Satellite Year. The gig was a strange experience with the night ending with a round of the venue's top seller, Quad-vods, (four shots of vodka with something sweet to numb the pain) which, as I understand, are no longer on the menu for obvious reasons."

Scott was playing gigs constantly at this stage and beginning to feel it, he told me, "I played as much as I could whilst managing my personal and work life, and eventually it took its toll. My next full-length album, 'Maybe You Should', would be the product of total burnout. I wrote it in about three weeks and recorded it in just two days, with Dan Lucas (of Jairus) at the Joplin House 'Anchorbaby' studios in Ashford, Kent. This record was incredibly therapeutic for me, and houses some of my proudest song-writing moments. I was lucky enough to tour this album with Hidden Cabins in the U.S. too."

Sirens & Shelter's ten-track 'Maybe You Should' CD (IGN226) came out early in 2015, again on Engineer Records but this time with support from Desert Pearl Union in Spain and Oak Apple Records in the USA for even broader coverage of this beautiful album. Although a little less complex in its instrumentation, this album reveals an extra level of honesty and depth to each song. Touching on some sensitive subject matter, including the realities of balancing family, friends, relationships, too many shows, secrets, illness, social pressure and expectations.

With a couple of Tanglewood guitars to hand, Scott experimented with alternative tunings and developed a more progressive, yet intricate guitar technique to help communicate the feelings on each track. Scott and Dan Lucas used more traditional recording techniques during production in an attempt to capture a mix of studio sound and live performance to ensure the integrity of each song was kept intact.

In 2016 Scott put Sirens & Shelter on hiatus and I moved to the Bahamas for two years to work as a guitar teacher. He later moved to Malaysia, continuing is work as a music teacher. The time and space away from everyone and everything allowed him creative freedom and space, and he continued to write songs, albeit with a far more relaxed attitude. 2019 saw the release of a three track EP entitled 'Sound The Alarm', with two of the tracks, 'Carried Your Weight' and 'Sound The Alarm' supported by videos promoted on the Engineer Records youtube channel. Then 2021 saw the release of a double A-side entitled 'Undefeated', featuring the tracks, 'Calling Card' and 'On My Darkest Days'. Both of these digital releases feature a full band and are a loud, melodic and angsty return to form.

Scott said that 'Sound The Alarm' was written after reading an article in the Nassau Guardian of rising crime statistics in the Bahamian capital, and how the government weren't doing enough to tackle poverty. "I kept thinking about how difficult it must be for those in difficult socio-economic situations to find the strength and resources to make positive changes, and so this song acts as a short internal monologue of someone who might not believe they can. The guitar solo played over a 7/4-time signature represents internal struggle and release. As a guitarist, I'm not a huge fan of guitar solos, so deciding to include, and then trying to write and play one proved somewhat difficult."

Ever keen to have the power-poptastic, singalong melody masters tracks available on physical release too, Engineer hope for a five track CD version, making it an absolute must for fans of Copeland, GetCapeWearCapeFly, Owen, City and Colour, Anthony Green, My First Tooth, Kevin Devine, Into It. Over It, Dashboard Confessional, Last Years Diary, Books, Northcote, Death Cab for Cutie and the like.

Scott plays guitar, bass and sings on all the tracks, with Paul West drumming and Dave Irving adding additional guitar and vocals. There are extra backing vocals by Dan Mackey, Pete Clarke, Toby Hawkins and

Lauren Tovey, now Scott's wife. I asked Scott what he thought of these most recent full-band tracks, and he told me "I love these songs, and loved recording them with my good friend Paul West, and some of my best friends in the UK. I've never played these songs live yet, but never say never." Adding, "Throughout my Sirens & Shelter journey Pete Clarke has arranged all the artwork for every release, and very I'm grateful for his time and creativity. He's one of the best."

"If this music does not claw its way into your soul, you better check to see if you have a pulse. Scott has a voice that conveys incredible emotion without overdoing it, whether the words are breathlessly plaintive, or loud and pleading. The musical backdrop is for the most part bare-bones and organic, but his prowess on acoustic guitar often mirrors the vocal intensity and augments it, really driving home the vibe of the music. Such a lush, soul-bearing but subtle intensity that you know the music was written with utmost honesty and passion." Says **Music Morsels**.

In his review of the tracks, Tim Cundle of **Mass Movement** magazine, said *"While their roots may lie in the punk rock scene, Sirens & Shelter have grown way beyond its boundaries. They push and challenge themselves and their audience, and the end result of their progression and experimentation is the gloriously catchy 'Carried Your Weight', which seems influenced by Dischord Records and the DC scene."*

Sonic Hits simply call Sirens & Shelter, *"Honest and emotional song writing, incorporating intricate guitar work."*

Whilst **Already Heard** says that 'Through The War' is a *"Fantastic acoustic album that showcases Scott's talent and promises a bright future. The record features unique vocals, powerful prevailing riffs and splendid melodies."*

And Sarah Quinn of **Gigglepics** reviewed a live gig, announcing, *"Sirens & Shelter is one of the most animated, passionate acts I've seen. He has a unique voice that has an almost tortured thread to it. Within minutes he was bleeding everywhere from his zealous guitar playing and his stage presence cannot be ignored."*

https://www.youtube.com/@sirensandshelter

Sleave

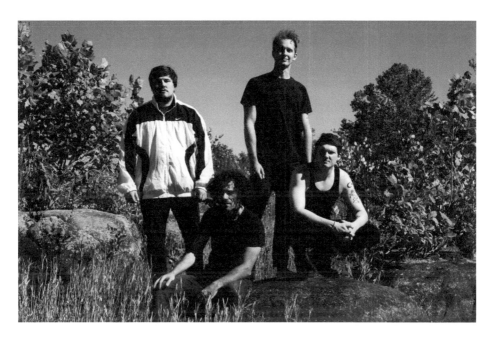

Charlie Bowen : Vocals and Guitar
Daniel Salinas : Guitar
Seth Toney : Bass
Julien Robert : Drums

Sleave is a dynamic alt-rock four-piece from Richmond, Virginia who fuse punk, indie and hardcore with healthy doses of grunge and emo. Imagine a head-on collision between The Smiths, Seaweed and Dag Nasty and you'll have a pretty good idea of where these guys are coming from.

Sleave came into being when Julien Robert and Charlie Bowen met at a party, where they quickly bonded over a shared interest in punk and alternative music. A series of impromptu jam sessions at Julien's parent's house during the autumn of 2015 led to Sleave becoming a full-time band. Around this time Sam Mclelland joined the band on bass and in January 2016 Sleave officially entered the punk-rock fray and became a part of their local, and soon after, global scene.

One of the newer bands to trust their fate to Engineer Records thanks to

a recommendation from Fabi at Homebound Records, as soon as we started talking to each other I knew that we were destined to work together. Sleave and I share the same vision, one that we instantly bonded over, and it was a pleasure to catch up and chat with Charlie and Julien about the band, punk-rock, life on the road, gigs, the scene and everything in between.

As it often does, the subject of influences and inspiration, and how they drove Sleave's guitarist and vocalist, Charlie, came up first. He told me; "Just a lot of punk music. I first got into a lot of the drunk punk stuff coming out of California and Florida when I was in High School. Against Me!, Hot Water Music, NOFX, Jawbreaker and Less Than Jake. By the time I got to college I was branching out into a lot of emo music from the 90s with Sunny Day Real Estate, The Promise Ring and their contemporaries.

"Finally, by the time I finished college, I started listening to and going to a lot of hardcore shows, so I guess you could say I was a late bloomer. That's when I decided to start my own punk band. I was listening to a ton of hardcore at the time and figured if I couldn't sing then maybe I could scream. Richmond also has an exceptional hardcore scene." But more on that later...

I brought up the subject of Sleave's earliest days and what it was like to be part of a fledgling band and writing, recording, and playing in a world-famous scene, the aforementioned Richmond, which gave us, among others; Avail, Strike Anywhere, Ann Beretta, 4 Walls Falling, Count Me Out, Break Away, GWAR, Denali and Municipal Waste. Charlie filled in the blanks: "Julien, Sam and I recorded our first EP in 2016 which was partially comprised of songs I brought to the band but mostly came out of us jamming. Man, that EP is a whirlwind. Completely out of time and fast as hell. It was fun to make but definitely a learning experience for us. As was our follow-up single (an A and B side) that we approached similarly but had finally got our BPMs under control before recording, and as such had a bit more melody and kind of informed the early 'Sleave' sound.

"Our biggest project, of course, unfolded over the next two years which we spent writing and recording our debut album, 'Don't Expect Anything' (CD IGN273) for Engineer Records. This was a great time for us. As we weren't exactly popular, there was no pressure or rush to deliver a result. So we were able to just take our time and get everything

polished, ready and right. We didn't hold back and used tons of samples / post-production / overdubs / group vocal sessions. At times it was tedious, but ultimately, it was a blast. This is also where I switched from screaming to singing.

"It was funny. Julien and Sam were out of town when I first began recording vocals. When they came back they heard all these melodic songs with my (at the time) signature gruff vocal style over the top of them and it just didn't work. Thank God they realised that and Julien pushed me to try to open up and sing more. If not I have no idea where we would have ended up. It was the scariest thing I've ever done but re-recording the album with clean vocals ended up being one of my proudest moments.

"We've just wrapped our second album, 'How To Get Over', (CD & LP, IGN397) and in some ways, it's similar to the first one, 'Don't Expect Anything', but we've pushed everything to the limit and I can't wait for everyone to hear it!"

While we were talking about the band's songs and records, I thought it was an opportune moment to ask Charlie and Julien about which releases they think capture the essence of Sleave, and the records that played a part in helping the band discover their identity...

"For me it's our newest record" said Charlie, "But then again, we only have two records. This new one just ramps up from where we left off with 'Don't Expect Anything' and I'm so proud of it. In some ways we tried to push our limits but in other ways I really tried to strip it down and keep it straightforward. The new album, 'How To Get Over' is a heavy collection of ten punk-rock songs."

"A record that informs my idea of Sleave, particularly when we shifted from hardcore leanings to more straightforward rock songs, would probably be the Weakerthans 'Left and Leaving'. I fucking love that record and was listening to it a ton in our early days leading up to the writing of 'Don't Expect Anything'. The lyrics are abstract but conscientious and dreadfully sad. I can't sing like John K Samson, but I certainly took a lot of inspiration from him and his lyrical style."

Charlie went on to talk about the way Sleave were perceived in their local scene, how they found their place within it, and how and why that changed...

"Sleave is an interesting case, as we were basically nobodies when we came on the scene and most people would have known our name from seeing us play college house shows and bar gigs around town. It wasn't until we put out our first record that we got enough interest to tour and get a decent turnout at our hometown shows. Now we fit in more with the pop-punk crowd, but we'll never give up on trying to get on some of the hardcore shows.

"That said, Richmond has an incredible scene for heavy music. Metal and hardcore are huge here and that's the main reason I moved here right after school. The scene is very supportive and while a lot of venues shut down during COVID it's still one of the best scenes in the country."

Seeing as Charlie raised the subject of gigs, I wanted to explore Sleave's on-stage history a little more, so asked about some of the more memorable shows the band has played. Julien stepped up to the plate and told me...

"This answer may be different for everyone, but I have a feeling we'd all say the same thing for the best and the worst as they're part of the same story. After releasing our first record 'Don't Expect Anything', our first single and video 'Homebound' got us some international attention. I remember being in my apartment and getting an email from a guy in India who was organising a music festival and he wanted us to be a part of it. It was a bizarre opportunity, but our band has never shied away from unconventional shows. With some guidance from David at Engineer, we asked the promoter if he could help us book more shows since flying to India for one gig wasn't ideal.

"Sure enough, the promoter booked us on two other college festivals in different Indian cities and offered to lodge us and feed us at each location, leaving only the plane tickets for us to cover. The India trip will no doubt be documented in depth one day but regarding the shows; The first gig we played was shocking (and will be covered in a later question), the second show was probably the worst show we've ever played, and the third was our best. So, without further ado... We were riding high after our first Indian gig and the subsequent shenanigans and made it to our second location which was a university situated in the North-eastern Indian city of Guwahati.

"A big problem with touring in a country that's not used to having

touring rock bands is finding decent equipment. Each venue offered to provide drums, microphones and amps. The first venue had technical issues that were ultimately unavoidable, but the second venue had an entirely different issue. We arrived at the university and were immediately put off by the lack of organisation and the general confusion. We managed to practice our songs in a school music room and we passed the time strolling around the school after we'd finished.

"We made our way to the stage area an hour or two before we were supposed to go on and it was completely empty. Ok we thought, maybe they'd bring the equipment closer to our show. We're now thirty minutes out from the gig and the stage is still empty. We asked the indifferent sound guy where the drum kit was and he said that there wasn't one (which was funny because I'd played one earlier in the practice room). Not only was there no drum set but there was an issue with the power. So now the crowd of close to a thousand students who'd started showing up were made to wait for two hours before we were able to get on stage.

"During this two hour period we were scrambling trying to find equipment and keep the crowd in place. When we looked at the sound guy he was asleep on the soundboard. I'm not making this up. We went to wake him up and this man could not be bothered, shooed us away and promptly fell back asleep. The crowd eventually started trickling away before the drum set arrived, which was probably for the best because when I finally laid eyes on the kit, I couldn't believe it. One of the festival's staff members found a drum set, yes, but it was a child's drum kit. Anyone who's seen me play before knows I'm a pretty heavy-handed drummer, so as you can imagine, I showed that kit no mercy.

"Halfway through the set parts had broken off, pieces were missing and I'm sure it was quite fun for the crowd to watch. In hindsight, I was a bit of an asshole for almost destroying this drum kit that was given to me by a member of staff who was only trying to help us. But the frustration of the indifference, the delay and the major lack of communication from the organisers had all added fuel to the fire. Not to mention the narcoleptic sound guy. I also found out right before going on that there was a beautiful pearl custom kit on an empty stage about a quarter of a mile from us the entire time!"

Julien continued; "The whole band was pretty peeved for a variety of reasons, so after two sets with pretty major technical difficulties, we

were not looking forward to the third location. After an incredibly long travel day we finally made it to the third festival in Bangalore. The university was a beautiful urban campus that felt more like a botanical garden than a school. The promoter met us when we got there and asked if we wanted to see the stage. We 'eagerly' said yes. We talked to the promoter about our issues at the previous festivals, he assured us that their setup was completely different.

"We got to the stage which was in a beautiful courtyard that had an amphitheatre built into it. There was a top-of-the-line drum set, big amp stacks, all we had to do was plug in and play. When show time came around we walked into the courtyard to find it filled to the brim with students. There were so many people that some students were forced to stand on the surrounding roofs to watch us. We played our best set of the tour and walked away with the unbeatable high of playing a great set to a big, receptive crowd."

For a US band that usually plays local HC scene gigs an Indian tour is pretty exotic and brave I'd say, so I asked Julien about the other tour tales that had become the stuff of Sleave legend, and he continued...

"Well, I hinted at it a minute ago, but our funniest story also comes from the Indian tour (big surprise right). To put it lightly, when we first landed in India, we had no idea what to expect from the coming weeks. Getting to the first university became an adventure in and of itself and we had a full day before the festival fully started. Strolling around the university there was evidence that the festival was going to be massive, the schedule suggested the same.

"Listed was everything from bands to beatboxing competitions, to dance-offs, to sumo wrestling, to dirt bike races, to video game competitions, the list went on and on. Talking to students it became evident that this was more or less the only time each year where they were given a complete break to enjoy themselves. The Indian university system seems to be pretty rigorous and the students we talked to had no time for hobbies, much less passions outside of their studies. When the day of our first show arrived there was a lot of anticipation. We went to spy out the stage an hour or so before the performance and there were already tons of kids showing up expecting a show. Talking to the promoter, he assured us that we'd have a large audience and said that he'd been heavily advertising the 'American rock band' around the school.

539

"Shortly before we made our way to the stage for our set, we were visited by the festival's chief sponsor, Winkies, an Indian Twinkie knockoff brand. The sponsor came to us along with the promoters with a small request. She asked that halfway through our set, we stop playing, and turn our attention to the coffee machine that would be on stage. She wanted us to go to the machine, make a couple of coffees, and have a casual discussion about how Winkies were the perfect snack cake to pair with a fresh cup of coffee. Needless to say, we were flabbergasted. We agreed to say a few words about Winkies, but didn't specify whether or not we would act out their skit.

"We had a few technical issues that delayed our show but it didn't impact the crowd. We had over a thousand students show up for our set, it was by far the biggest show we ever played and the scale energised us. We played a great set, albeit the fact that our lead guitarist at the time, Danny, couldn't be heard and ended up being our hype man for the entirety of the show. Towards the end of our set, I looked to my right and saw the expectant face of the Winkies rep.

"Somehow Charlie became aware of her presence as well and before going into the next song, gave a fervent speech about how Winkies were the greatest snack cake to ever grace the planet. In that moment Charlie channelled the fervour of a firebrand priest at a Pentacostle snake church (look that one up kids). I swear the speech could've started a riot; a riot over the most delicate and sweet cake ever produced by our clumsy monkey hands. After the show we got off the stage and were greeted by the beaming smile of our local Winkies rep who showered us in praise as well as boxes of Winkies. We spent the next hour or so taking pictures, signing autographs and handing out Winkies.

"The promoters asked us to judge a 'battle of the bands' contest the next day that led to even more shenanigans, but I'm convinced that all of the praise and opportunities would've eluded us had it not been for our 'near cult leader' singer Charlie's speech about our new favourite snack cake.

Julien graciously added; "I know I'm going off-topic, but I figured if I don't say it now, I never will. We learned so much from David and the guys at Engineer Records. They were instrumental in getting our first record the attention it deserved. To work with someone so kind, passionate and knowledgeable on our first go-around was incredibly lucky. We're getting ready to release our second record 'How to Get Over'

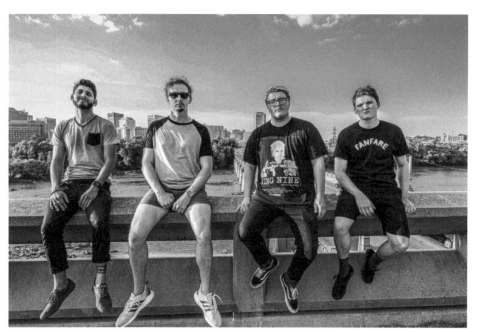

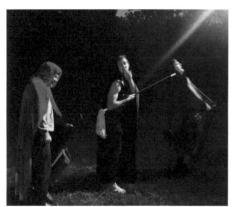

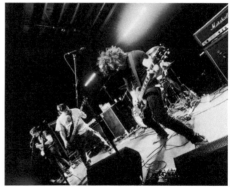

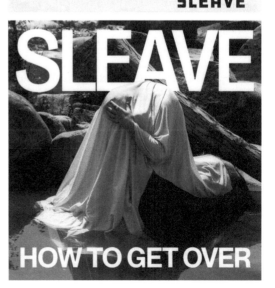

with Engineer as well and I do not doubt that this album will unlock a whole new world of possibilities, and it's largely due to your undying and unwavering support."

That is very kind of Julien to say, but I would add here that Sleave's new album, 'How To Get Over' is out now, it's absolutely brilliant and is a joint label release on coloured vinyl LP, CD and digital by Engineer (UK), Sell The Heart (USA), FIA Records (Brazil), Gunner Records (Germany) and Sleepy Dog Records (France). It follows hard on the heels of their superb 'All These Songs Are About You' digital EP and has several video singles from it currently being premiered worldwide.

Given the number of shows and the volume of recording and touring that Sleave has packed into their relatively short existence, I wondered if the pressure of trying to stay on top of everything had ever made them re-examine their commitment to the band, and what they thought the reasons for the band managing to weather every storm sent their way were. Basically, what it was that binds them together like brothers, keeps them on the road and makes them hungry to keep on writing and playing gigs. Julien told me...

"Well, we haven't broken up yet, but have had a few member changes over the years. As I've mentioned before, Sleave is a strange beast that has not been immune to disagreement and threats of ending; none of which have been particularly serious, but still present. I'm sure this is an old adage but bands are composed of pretty intimate relationships, second only to a romantic partner I'd say. The emotions you show to each other on a regular basis while playing can leave you vulnerable, especially if one hasn't addressed certain insecurities or traumas on their own.

"In my opinion, music is a medium to express emotions that words can't always capture. These emotions can be shocking and part of a cascade of thoughts and feelings that come when you're in touch with your instrument, especially while on stage. As I've realised the impact playing music has had on my life, the therapeutic aspect has not been lost on me. It's been such an important tool and form of expression, and I know it has been for everyone else in the band. I think everyone's level of emotiveness is different, but when it does show its face, it can lead to some interesting and important interactions. All of that is to say, being open and communicative is an incredibly important part of any kind of relationship, certainly, but it's especially important for a band.

"We all have our own ideas on how to move forward, for what a part a song needs, for set orders, for merch designs, for our dreams and visions of the future. Sleave hasn't always been great at communicating these ideas and we've always been a band full of big personalities. We've never had a band member who hasn't had strong opinions, and generally speaking, most 'big' decisions take a lot of effort before we come to a consensus or compromise. What's helped us in recent years has been communicating a lot more. We try to spend as much time having conversations and talking about the administrative aspects or 'vision' for the band as we do playing. We do it not because the 'office' work is particularly enjoyable, but I think we're all (subconsciously at least) seeing the importance of taking the time to get on the same page. What's helped me personally has been to work through my own shit. I, like every human on this earth, have a fair share of traumas and music has been one of the tools to work through them.

"Two years ago my mom suddenly passed away and I was forced to look at myself and ask 'Do I want to keep ignoring these traumas that are impacting my every thought and action, or am I going to face them and move forward.' Fortunately I chose the latter and found that the fear I had in facing the past was way worse than the reality and its issues. Working through my own shit helped me give my band members more patience. This comes in handy when inevitably, a seemingly trivial choice becomes a deep debate that really represents a much deeper insecurity. Instead of taking things personally, I've recognised that our band has become an outlet for expression, growth and certainly healing. Giving everyone involved the space, understanding and respect to express themselves has helped us all get a lot closer and has given our at times tumultuous project some more stability. The aim and hope of the project has two parts and I'll spare you another one of my long-winded responses.

"First, I hope that our project can continue developing that sense of expression, growth and healing. As a musician, it's becoming increasingly important to me, and I know Charlie as well, to make our live performance as expressive as possible. I don't want to hold anything back and want to create an environment where we, as well as our fans, can allow ourselves to feel things that they/we may not know how to address in our daily lives. Our second goal, that certainly goes along with the first, is longevity. I want to play music for the rest of my life.

"Although it would be amazing to reach the point as a band where we tour the world and are showered in riches, praise and fame, it's not something we can count on. Instead, my focus is to help this project grow naturally while finding new experiences that keep it interesting. The key for me is playing shows to good crowds, using the band as a tool to see more of the world and to not get burnt out in the process. Easier said than done but again, there's no rule book here. I would rather this project be different, weird, and slightly less successful, if it means we have the autonomy to do what resonates with us."

Having willingly immersed myself in Sleave's world for a couple of hours with two of the most open, talented and motivated souls that I've crossed paths with, our conversation drew to a close. But before I let the guys return to their practice room, I asked Julien how pertinent he thinks the digital age punk scene is...

"Hardcore, post-punk, or really any genre of music has plenty of reason to exist today. All humans are pretty unique; although we fall into cultural norms in our respective countries, regions and cities, we're more complex than we sometimes give ourselves credit for. I see music as an expression of our deeper selves when we allow it to reach the depths of our emotions. Music is like a painting that colours our lives through distinct moments. It accents our joy during the good times, it helps us process and feel emotions at our lowest moments, it's a source of resilience when we decide to grow, it's a source of motivation when we don't want to do what needs to be done.

"For me post-punk, art rock and some variations of hardcore have been the best companions in my life. But for someone else it could be pop, country, eastern European techno, whatever. The point of all of this is to say that every genre has its place. Every genre has its purpose. Every genre, every band, every song, affects everyone differently, every time they listen to it. Post-punk in particular is an incredibly emotive genre that does such a beautiful job playing on what I call the 'dark and light' in music and life.

"What is in one moment a heavy, pummeling, dark melody can all of the sudden open into a beautiful, bright and resilient reprieve. To me signifying the human condition; our constant strive for balance. When I was a young kid my dad introduced me to Radiohead, Joy Division, New Order, the Strokes, Coldplay (their first three albums thank you

very much), these bands in particular really led me down the path of falling in love with what can be categorised as post-punk.

"It's all relevant because it's all a representation of humanity. I hope that genre continues evolving, continues splintering, becoming more and more vague. The more variety we have, the more it signifies a move towards freedom of thought, a connection with emotion, and trust in the self."

Reviews

"*Richmond, VA's Sleave brings together elements of alternative rock, punk and American hardcore while also being reminiscent of the American grunge and emo movements of the 90's...constantly shifts your expectations and impressions... manages to simultaneously remind you of artists that you wouldn't normally put together, shifting between indie and punk rock and resembling a collision between Editors, Gaslight Anthem and the Smoking Popes. The melodic and introspective side of indie is artfully blended with punk and hardcore aggression, something that surfaces in the tracks without warning.*" **The Punk Site**

"*A set of vocals that pour out with emotions, guitars weep with melodies — Sleave know how to tie their emotions into their art. Blending multiple genres in their glimmer, the group infuses a weight into their music that lifts upon being heard. Sleave open the lid to a swirling catharsis of harsh vocals and swelling melodies.*" **New Noise Magazine**

"*There's something about groups who merge alternative rock with melodic punk music. The vast portion of these groups incorporates exact measurements of each ingredient to highlight particular moments in their music, but eventually, these examinations grow into something more monolithic. Sleave is one of the before-mentioned bands that possess the common sense and knowledge about proper composing and song-writing.*"

"*'Don't Expect Anything' is their marvellous debut album, comprised of twelve emotive compositions. Previously, Sleave released debut single 'Better Now' in 2017 and the 'Gold' EP in 2018. Later on, the group announced this new material by releasing a slew of singles such as 'Homebound', 'Check Myself' and 'Swept'. Judging by these songs, those who followed their activities from the start witnessed the remarkable progress of this Richmond, Virginia based band. Sleave incorporates the precision of alternative indie*"

music, melodies of punk rock, and the massive dynamics of post-hardcore. But they don't stop there and include the dirtiness of the nineties grunge scene saturated by the notable emotiveness of an emo scene of the same era."

"Each song includes a gracious dosage of melancholy that saturates the atmosphere with defined emotive moments, mainly showcased through structured harmonisations and appealing vocal segments. Another layer of compelling guitars empowers these melodies with arpeggiated themes, octaves and other virtuosities. The bass guitar surrenders magnificent low-end tones somewhere beneath the guitar works, but these basslines are recognisable throughout the entire album. These basslines also fill the gaps between guitar and exceptional drumming performances."

"Sleave demonstrate impressive musicianship and tremendous song-writing skills throughout these twelve marvellously composed numbers. The group have whipped up a personal recipe that works pretty well and makes the album memorable for a long time afterwards. Treat yourself to this mind-blowing masterpiece." **Thoughts Words Action**

https://sleaverva.bandcamp.com/music

Son Of The Mourning

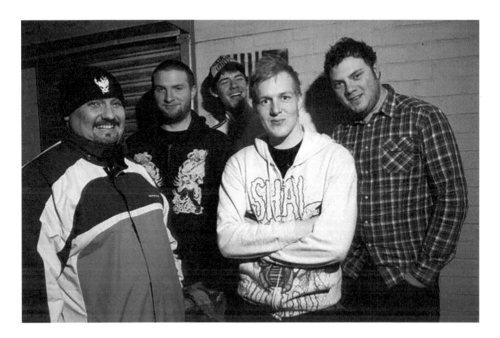

Paul Jackson : Vocals
Garron Dodd : Guitar
Gavin Brady : Guitar and Vocals
Richard Glover : Bass
Scott Gabriel : Drums

Son Of The Mourning were a progressive melodic metalcore band from Salford in Manchester that started in 2001, split in 2008, and regrouped in 2017. They released powerful records and shared the stage with plenty of great hardcore bands despite several line-up changes. Like any fierce monster or ultra-villain, they just won't be stopped or held down.

Formed in the summer of 2001 after a series of phone calls between Scott and Al McElroy as Scott was preparing to leave the Army, Son of the Mourning came into being after the core members met at a local hardcore show at the legendary Manchester Piccadilly pub The Star and Garter.

Inspired and influenced by bands such as BoySetsFire, Poison The Well and Darkest Hour, Scott, Al, Danny Connell, Kyle Greenhalgh and Wez started jamming and writing songs that were forged by passion, built

around melody, and combined thrash, hardcore and metalcore. Their debut recording, 'Reclaim the Streets' showcased a variety of influences and included 'Now Infinity', 'In Merit' and the track that the demo took its name from. The session paved the way for gigs which SOTM used to fine-tune their raw enthusiasm and potential.

Danny soon decided to spread his wings and go travelling and was replaced by local lad John Simpson. The personnel change allowed the band to experiment with different guitar tunings and upped their riffage and shredding, vocal melodies and insane drum patterns, pushing themselves even harder during their next recording session which birthed the song that would go on to become one of the bands' most well-known tunes, 'The Way Laura Won't'.

That recording session was the band's first time in Studio Studio in Rochdale with Phil Collins look-alike Pete as Producer/Engineer. With their new tighter and brighter edge, the release did more to push SOTM into the realm of serious scene contenders. Dubbed 'The Lambton Road' EP, the band used it as a calling card to encourage promoters to add them to shows and hit a rich writing vein thanks to the addition of John, which SOTM capitalised on, and recorded the five tracks that made up their most mature work to date, the 'Forest Bank' CD EP, (IGN046) which helped SOTM sign their first independent recording deal in 2004 and join the Engineer Records roster.

The band quickly got back into the groove of rehearsing and played with anyone who would share a stage with them. This included Beecher, Number One Son, Aconite Thrill, Shaped By Fate, labelmates Eden Maine and a support slot with scene godfathers Converge, after which Scott, Son Of The Mourning's drummer, told me, "There's nothing quite as humbling as having the one and only Jacob Bannon scrawling 'Thank You' on all your CDs after you've just smashed through a set that warmed up the Converge crowd."

Engineer Records then offered the band a split release with New Jersey, USA labelmates My Shining One and rubbing their collective hands together in excitement, Son Of The Mourning wrote and recorded three frenetic and furious new hardcore anthems for the record. Released in 2005, the split CD EP (IGN059) spawned the band's first music video, 'August 29th', which launched on Blank TV in the USA and appeared on Engineer Records new 'Building on sight and sound' sampler DVD

helping them to spread their message of musical insanity to an even larger audience.

During 2005 the band hit a creative high, but as Isaac Newton found out when sitting under an apple tree, what goes up, always comes down. John and Wez felt they had gone as far as they could within Son of the Mourning and made the decision to step away and immerse themselves into other musical ventures and Al followed their lead shortly after.

Facing a possible implosion, Scott and Dave made the no-brainer decision to dig deep and reinvent themselves in order to carry the metallic hardcore flag forward. Local budding sound engineer, Camorra guitarist and long-standing friend Gav Brady signed on the dotted line and added his chunky riffing to the silky-smooth leads of Gaz Dodd, while new bassist Pete Runcie brought the low-end rumble to life.

This new line-up locked themselves away in the back room of Gav's gym where a makeshift rehearsal/recording studio was put together. After months of blood, sweat and no tears, the band re-emerged with an album's worth of brand-new material including the first track the new look SOTM had written as a band, 'Red Brick Epidemic'. The process wasn't all smiles and high fives as Dave Moon later walked away to be replaced by the raw energy of Paul Jackson.

The new look Son Of The Mourning, now more often known as SOTM, was desperate to record some new material so a tentatively titled EP 'The Mimetic Theories' was thrashed out, but failed to hit the bar that the band had set for themselves. The only track that survived the doomed session was 'Constellation of Souls', which unfortunately never saw the light of day.

Deciding to work with Pete the Phil Collins doppelganger at Studio Studio in Rochdale again, SOTM started recording pre-production demos for their first full album's worth of material. Armed with a brand-new arsenal of molten material that could comfortably sit alongside older fan favourites, the band started playing gigs again with anyone they could. Stage mates during this period included scene heavy hitters like hardcore stalwarts Stampin' Ground, tech metal wonders Biomechanical and Scottish terrors Mendeed.

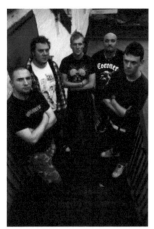
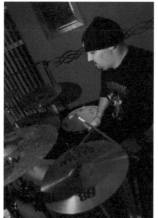
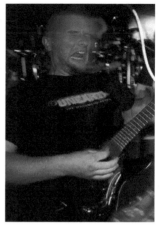
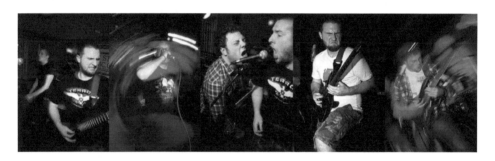

In early 2007, after Pete had moved on to pastures new and Rich had stepped in to replace him, the band set up the mics and started recording their debut album but for some reason things just didn't click. Scott started slowing down after the birth of his daughter, Gaz and Pete were heavily immersed in their individual Uni work and Gav had devoted himself to his studio. The last major outing for Son of the Mourning was a headlining set at the Vale Earth Fair Festival in Guernsey 2007. After a weekend of madness and music the curtain came down on the band and the amps were turned off, for what SOTM assumed was the final time.

Bass player Rich headed out to Perth, guitarist Gaz formally emigrated to Melbourne to carry on his high-level bio work, Gav continued to grow his recording studio dream, Jacko disappeared into the wilderness travelling the world and Scott stayed home and concentrated on his family.

Fast forward to 2017. After keeping in touch throughout the band's wilderness years, Gav mentioned to Scott that Engineer Records had approached him about the possibility of a new release from the band. Could the fire be reignited after all these years? Damn right it could. Gav immediately grabbed the opportunity by the scruff of the neck and using his newly acquired wealth of recording and engineering experience, took charge of the new project in his Rain City Studios in Manchester. Scott's drums were laid down and Gav then set about painstakingly layering all rhythm guitar and bass parts on his own in between recording a wide variety of other bands in his day job at Rain City.

Gaz agreed to remotely provide his slick lead playing on the project from his home in sun-drenched Melbourne, but Jacko amicably stepped away after a few meetings with Gav which left the project, tentatively titled 'Eulogy' without vocals. The search was on for someone who could do the business on the mic. After what seemed like an eternity of searching, Gav decided to step into the vocal booth and give it his all with Scott's newly penned lyrics. The recording finished at long last, Gav then set about mixing and mastering the material for 'Eulogy' and sent the masters to Engineer Records.

SOTM's mini-album 'Eulogy' (IGN237) was released in digital and CD formats by Engineer Records on 10th May 2019 with the seven-song metal-core rifferama being played and reviewed all over.

Punktastic compared the release to Converge and Poison The Well and **Metal Temple** mag announced; *"These seven tracks just never let you catch your breath and the fierce and uncompromising mixes will go down very well with SOTM's original fans and anyone akin to bands such Alexis On Fire, Black Dahlia Murder, Cave-In, Dillinger Escape Plan, Botch, Darkest Hour, Boy Sets Fire, Poison the Well, Killswitch Engage, Hopesfall, Skycamefalling and labelmates Eden Maine and Nine Days to No One."*

Nik Young reviewed 'Eulogy' for **Metal Hammer** magazine. saying; *"'Eulogy' is the first release since this Manchester bands break up a decade ago and deserves to be welcomed with open arms. There is almost no metal subgenre that Son Of The Mourning don't pay homage to here and yet it somehow produces an exciting and inexplicably uplifting and spiritedly feisty ride. 'Carpe Diem' gives a nod to System of a down and the gloriously spiralling fretwork of 'Glowing Orionid' reveals glimpses of Primus and Tool. Taking melodic metal at its base, with slices of death, strident hardcore and sudden introspective calms, this seven-track is as geeky as it is bursting with butch riffs. 'The Way Laura Won't' is particularly special, but the weird pace an intoxicating groove of 'Skinbox' makes it the album's most magical track. For fans of Eden Maine, Poison The Well and Pantera."*

https://www.youtube.com/watch?v=fUfIlTKR8LY

Speedwell

Meredith Bragg : Vocals and Guitar
Troy Farmer : Guitar and Vocals
Brian Minter : Bass and Vocals
Cheryl Huber : Keyboards and Vocals
Jonathan Roth : Drums

Speedwell was an indie rock band that started life in Harrisonburg in 1996. They played extensively in the post-punk scene, released an EP 'My Life is a Series of Vacations' on Engineer Records, appeared on several compilation albums including 'Emo Diaries 3', and toured with Engine Down and Metropolitan. In 2003 an album collecting all their recorded output together entitled 'Start to Finish' was released by Pittsburgh's Coolidge Records label just before the band split up for good.

Normally, for most bands, that would be the end of their story, but Speedwell was far too good to just be a footnote in the index of a final-year sociology student from the University of Richmond's dissertation about the cultural impact of the post-emo scene on the evolution of underground music in Virginia.

That's why I wanted to reach out again and speak with their drummer, Jonathan, about his band as I thought they never reached their potential, and even though they were only around for a brief moment in the cosmic punk-rock scale of things, they were, and are, an important part of the history of Engineer. So, this is the Speedwell story...

"The roots of Speedwell begin in the Fall of 1996. I was a Junior in college and had been looking to start a band from the moment I started college. I had been in some bands in high school and jammed with some college friends over my Freshman and Sophomore years but hadn't found anyone I clicked with enough to start a band. In my circle of friends was a guy named Meredith Bragg. I don't remember exactly when we first met, but we had hung out occasionally and I think we had a class together at some point.

"Regardless, Meredith, who played guitar and sang, had heard that I played drums. One day when he ran into me on campus, he asked if I wanted to start a band. I said yes, and soon after, we started jamming in the basement of a house our friends rented. I loved the songs that Meredith was bringing to practice, but it was hard to get any momentum going with just guitar and drums.

"Finally, our friend Troy Farmer, who lived in the house and had heard us practicing, offered to join us, to help us get things going. Troy played guitar in another band (Daytime Television) but switched to bass to play with us and complete the band line-up. Finally, we were able to get some traction and write songs as a unit. One day, driving around town, the three of us were discussing band names. It was either Meredith or Troy who suggested the name Speedwell, after one of the rabbits in Watership Down, and we immediately agreed that should be our name.

"By the winter of 1996-97, we were ready to play our first show, which we did on 21st February 1997, with Sleepytime Trio, 400 Years, and the VSS. Looking back now, that's an insane line-up of bands for us to play with for our debut. We played more shows in our college town of Harrisonburg, VA the rest of winter and spring '97. In May of '97 we travelled to WGNS Studios in Washington, D.C. to record with Geoff Turner (formerly of the D.C. band Gray Matter) and recorded the four songs that became our first demo.

"I gave one of these demos to my friend Andre Khalil, who was starting

555

a record label called Sport and he told me that he wanted to release two of the songs as a seven-inch. We said hell yes and the 'Pacifique / Smoke to Smother' seven-inch was eventually released in January 1998.

"We went on a bit of a hiatus during the summer of 1997, but we reconvened that August when Troy's other band, Daytime Television, was breaking up. The bassist in that band, Brian Minter, was a friend of ours and suddenly had free time on his hands. Troy suggested that Brian join us on bass, allowing Troy to return to guitar, his instrument of choice. We were all on board with that idea, so Speedwell became a quartet.

"We played our first show as a quartet on 24th August 1997, with Ted Leo, the Jazz June, and the Van Pelt at the Syrian Society in Catasaqua, PA (another insane line-up of bands) and over the next four months, we played some incredible shows: with the Get Up Kids, Jejune, and Mineral at a skate shop in Wilmington, NC; with the Sorts and the Van Pelt at the Artful Dodger in Harrisonburg, VA; with Squatweiler in Roanoke, VA; with the Get Up Kids and Jimmy Eat World at the Next Decade in Pittsburgh, PA; and with Emma, Kerosene 454, and The Wicked Farleys at the Small Intestine in Baltimore, MD.

"Then, in January 1998, we went out on a nine-day south-eastern US tour, from Virginia to Florida, with our band buddies Engine Down. We played with some great bands on that tour, such as the Passenger Train Proposal, 12 Hour Turn, Strikeforce Diablo, His Hero Is Gone and Milemarker. After that, we played more gigs up and down the mid-Atlantic coast with more great bands like Glenmont Sound System, Frodus, Epstein, Jejune, the Blacktop Cadence, the Encyclopaedia of American Traitors, Boy Sets Fire and Algebra One.

"As we approached May of 1998 however, we were all getting ready to graduate college and Troy was going to leave for the Peace Corps. As such, it looked like Speedwell's days were numbered and on 1st May 1998 we played what we thought was our final show with Union of a Man and a Woman, Rural Earl, and Engine Down at the 401 House in Harrisonburg."

Before they broke up, Speedwell sent a demo to Deep Elm Records. They liked it and wanted a song to be included on their Emo Diaries series of compilations. In February 1999, Deep Elm's 'The Emo Diaries Chapter Three: The Moment of Truth' compilation was released, which included Speedwell's song 'Pacifique', alongside some great bands including

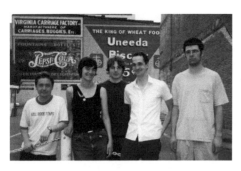

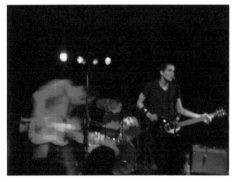

Sunday, August 24th 6:00-11:00PM
at the american amarian
SYRIAN SOCIETY

THE VAN PELT
(emo on Gern from New York)

THE JAZZ JUNE

Teddy Leo (local wonders!)
(ex frontman of the now defunct CHISEL)

Speedwell
(emo from Virginia...7"release show! The next big thing, promise.)

The last Syrian Society show until late 1998!

FOR MORE INFO, CALL ANDRE' at 610 266 1778. Directions: Take Route 22 to the Macarthur Road/7th St. exit NORTH. Get off on the exit. Go north on macarthur until you come to MICKLEY RD (there is a Sears on your left). Turn RIGHT onto Mickley. Go straight until you come to an intersection w/a Bible bookstore on your left. Go a little past the light here, and veer left (do NOT make the sharp left at the light). Go across the bridge. At the end of the bridge, look to your right. You will see a sign for the Syrian Society. However, it is a one way street, so you must go up a block or so and come back around. There is parking in the back and across the street. If you get lost, just ask how to get to FRONT street in catosauqua (the street the club is on.)

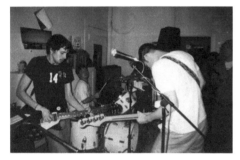

12 hour turn
the Engine Down
SPEEDWELL

show starts at 8:00

at the Stripmine
Wednesday, jan. 7th 1998
313 Laura st.
Downtown Jax
355-8869

speedwell
sleepytime trio
four hundred years
THE VSS

FRIDAY, FEB. 21st
@ the funkhouse
(478 S. Mason St.— Harrisonburg, VA)
9pm please Don't announce! $3

557

Starmarket, Planes Mistaken For Stars, Penfold, Cross My Heart, Epstein, Sweep The Leg Johnny, Sweden's Last Days of April and the UK's own Schema. That was the band's highest profile release up to that point, but unfortunately, it came out after they'd broken up.

About two years later, Troy left the Peace Corps and moved to Washington, D.C., where Meredith and Brian already lived. Just for fun, the three of them started jamming again and found that they could still write some good tunes and have fun playing together. At the time, Jonathan was living in Allentown, PA, but they asked him to come down to jam with them, and not wanting to miss a chance to get the band back together, he agreed and started driving down on weekends to play with the guys again.

Jonathan continued the story, "Eventually we decided it was too good not to continue, so I moved down to Washington, D.C. to join them and Speedwell was a going concern again. We had our first reunion show on 17th February 2001, with Sound of Reverse, Up Up Down Down Left Right Left Right B A Start and The William Tell Routine at the Egypt Fire Hall in Egypt, PA, and around that time I also saw something online about a label from the UK that was looking for bands for a compilation called 'Firework Anatomy'.

"At the time the label was known as Ignition Records, although it would later be called Engineer Records. I reached out to the label, letting them know that Speedwell would like to be included on the compilation, first speaking with Syd, and then David. They agreed to include us. In early 2001, we recorded 'Oceans are Armlengths' with Dan McKinney at Dan's House Studio in Bethlehem, PA and it was included on that compilation, one of the twenty tracks by San Geronimo (Ex-Lifetime), A Rocket Sent To You, Grade, Rydell, Red Animal War, Penfold, Crosstide, Hunter Gatherer, The Casket Lottery, and others. It had a crazy drawing of wolves jumping over fireworks on the cover and was released later in 2001 on Ignition and distributed worldwide by Cargo.

"In May of 2001 we recorded four new songs with Chad Clark (formerly of Smart Went Crazy and currently in the Beauty Pill) at the legendary Inner Ear Studios in Arlington. These songs would appear on our 'My Life is A Series of Vacations' EP released on CD by Ignition / Engineer Records early in 2002 with a beautifully foil printed translucent paper cover."

The first pressing of this CD had a glitch on it with one of the tracks skipping, so I remember giving away about a thousand CDs at gigs in London and Brighton over the next month or so while the pressing plant reprinted the CDs properly for us. Some of them also went into a big box of junk we dropped off at a solicitor's office during the argument over our label's name. But they found plenty of good homes and we even had a call from Radio One evening session DJ Steve Lamacq telling us he loved the CD and was going to play the first song on his show, glitch and all, giving Speedwell a shout out. It all helped the band become better known on this side of the pond.

"For the 'My Life is A Series of Vacations' recording, we brought in our friend Cheryl Huber to lend vocals on a few tracks and liked the addition so much that Cheryl became a full-time member of the band, making Speedwell a quintet. Through the rest of that year, we played shows mainly in D.C. and around Virginia with Darkest Hour, Silver Scooter, the Others, Charming, the Apes and the Carlsonics.

"In early 2002 we continued playing shows from New York to North Carolina with bands like the Secret History, Ostinato and the Washington Social Club. In May 2002 our 'My Life is A Series of Vacations' EP was released by Ignition Records (later called Engineer Records). On 22nd June 2002, we had what has to be the best show of our career: along with our friends Metropolitan, we opened for the Dismemberment Plan at a sold-out gig at the Black Cat in Washington, D.C.

"This was soon after their album 'Change' came out (easily my favourite Dismemberment Plan album) and they were huge, so being able to open for them at a hometown show was incredible. Soon after, we played what is probably my second-favourite Speedwell show, with the Most Secret Method and the Others at Fort Reno in Washington, D.C. on 18th July 2002. The Most Secret Method is one of my favourite D.C. bands, so being able to open for them was amazing.

"We also played some other great shows that year, with Mates of State, Dead Meadow and our friends Disband. Then, in November 2002, we did a week-long south-eastern U.S. tour with our buddies and fellow D.C. rockers Metropolitan, from Virginia to Mississippi, to Florida and back. Also in 2002, we appeared on the Underadar/Coolidge Records compilation 'Empower: Exercising the Human Spirit' with our song 'Fighting Sleep'."

As 2003 was starting both Troy and Meredith were getting married, and Troy was planning to move to New York with his wife. As such, Speedwell's time was coming to an end. The band played their final show on 28th February 2003, with Superdrag and Kicking Howard at the Tavern at American University in Washington, D.C. Not a bad last show to go out on!

Personally, I would put Speedwell in the late 1990s second wave of emo, or Midwest emo, along with bands like Braid, American Football, the Promise Ring, Knapsack, Elliott and the Get Up Kids, although they were never quite as popular as those bands. Speedwell were heavily inspired by Sunny Day Real Estate and Fugazi, as many of those bands were.

Of course, that lineage traces back to the origins of punk and hardcore. Jonathan remarked, "While we were playing a less intense style of music than the original punk and hardcore bands, those punk ideals carried through to what we were doing. More recently, those same values are still present in emo's fourth wave, or the emo revival, that has been going on since around 2010. More recent and current bands like Snowing, Title Fight, The World Is a Beautiful Place & I Am No Longer Afraid to Die, Touché Amoré, Into It. Over It., Joie De Vivre and Crash of Rhinos are carrying through the post-punk values and style of what our contemporaries were doing in the late 1990s. I love the fact that those bands have picked up the mantle and I'm glad that younger kids still enjoy the type of music that we were playing back then. I think it shows the staying power of what we were into."

Even before Speedwell broke up, Meredith Bragg began playing solo and eventually both Brian and Jonathan were in his back-up band, called Meredith Bragg and the Terminals. This project lasted from 2002 to 2009 and allowed them to tour and record more, playing gigs and festivals such as SXSW. Meredith also appears on Ignition's Shudder To Think tribute CD covering 'Funeral At The Movies'. Jonathan also played in other D.C. area bands, including Secret Agent, who eventually became History Repeated! with the legendary John Stabb, formerly of Government Issue.

In 2011, Troy was interviewed about Speedwell for the Washed Up Emo podcast. It's a great listen and delivers Speedwell's history from his perspective. Then, in 2013, Coolidge Records approached Jonathan about a digital release of the Speedwell discography. They collected all of the

recorded material that Speedwell had and it was released digitally as 'Start To Finish' on 16th July 2013, along with a limited edition run of CDs, which are available on Speedwell's Bandcamp page or through the Engineer Records distro.

Jonathan eventually moved back to Pennsylvania and has recently started a new band with friends there called Ghost Wounds. He told me, "Even though I'm well into middle age, I just can't seem to get over the joy of creating music with people I gel with and enjoy working with. Maybe I never will." Let's hope not.

Speedwell's 'Start to Finish' discography was premiered at **Surviving The Golden Age**.com and **The Fire Note**.com likened them to Jawbreaker, Sunny Day Real Estate, The Dismemberment Plan and an 'East Coast Death Cab For Cutie' saying in their review of the posthumous release from this unheralded DC band, *"It is easy to see the direction Speedwell were heading and one can speculate as to how good this band could have been. Coming from the DC area and the birthplace of emo it is to be expected that Fugazi and Rites Of Spring were their initial guide posts. It is also commendable that they showed much growth and promise that obviously will never be fully realised."*

https://speedwell.bandcamp.com/

Squarewell

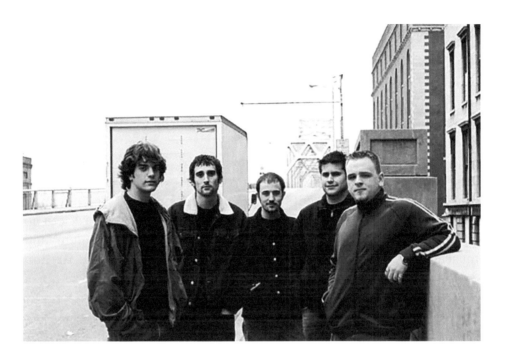

Jeff Drake : Vocals and Guitar
Matt Jagger : Guitar
Bryan Jones : Bass
Martin Kehl : Drums

Squarewell were an emo hardcore band From Lousiville, Kentucky who worked with us across four releases and became big favourites with all the people who are into bands like Thursday, Elliott, Boysetsfire, Quicksand and Taking Back Sunday.

Louisville, Kentucky is one of the many cities in the United States with a strong alternative music scene. It has brought us labels like Slamdek and Initial Records and was the home of ground-breaking bands like Endpoint, Elliott, Christiansen and Boysetsfire, all of whom have contributed immensely to the post-punk landscape. It's not surprising then that Squarewell originated from this active and vivid underground music scene.

Founded in 2002 when Jeff and Martin's previous band, My Life Denial, broke up, they brought in Paul Dailey on bass and Matt Jagger and

Brandon Duggins on guitar. The band aimed to create a sound that was clearly fuelled by the spirit of the aforementioned bands from their scene but still retained their own individuality.

After about a year Paul left and was replaced by Bryan on bass, then Brandon left, leaving the guitar duties to Matt and Jeff. This line-up of Squarewell held together and were soon fusing melodic indie rock to no frills punk and emotional post-hardcore, creating a turbulent and musical experience. Jeff's passionate vocals mixed over a tight rhythm section and intricate, powerful guitars created a base for their complex song structures and in 2003 they started to gig non-stop.

After playing every venue within reach in the eastern USA they consistently increased their fan base and sold out their early demos and self-titled CD EP, supporting bands like Glasseater, Christiansen and Spitalfield. This led to them entering Nada studios in New York State in early 2004 to record their debut full length album, entitled Two Toy Model, (IGN070) with producer John Naclerio, whose credentials include Midtown, Joshua, Matchbook Romance, Hot Rod Circuit and Autopilot Off. This was about the time the band got in touch with us, through Craig in our New Jersey office, after he saw them play a blinding gig.

Released on CD in 2005, Squarewell's 'Two Toy Model' album contained eleven driving tracks that will put you in mind of Elliott's 'US Songs', BoySetsFire's 'The Day the Sun Went Out' or Thursday's 'Full Collapse'. Initially released on their own Shrodinger record label, it was soon picked up by Millipede Records in Germany and Engineer Records in the UK for further distribution and promotion, putting the band on track for well-deserved widespread coverage. This led to more extensive US tours and a trip to Europe supporting La Par Force.

In quick succession we worked with them on more records. Bringing in our friends at Koi Records to help release the 'Synthetic Sensations'

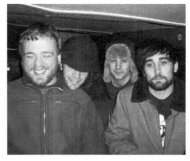

picture disk 7" (IGN073), which was a limited edition of 500 for the European tour late in 2005. Then in June 2006 we worked with their Shrodinger label again to release the self-titled Squarewell CD EP, (IGN095) recorded at Black Lodge studios in Kansas, the infamous home of bands like The Get Up Kids, Appleseed Cast, Brandtson and Limbeck.

Some of the tracks from this Black Lodge recording session also went onto a split CD with the Swiss band Fugo, entitled 'Entremets D'Hier', and this would be released later in 2006 on CD EP (IGN096) containing five tracks from Squarewell alongside four more from Fugo. With the big German punk fanzine Ox describing the release as "Inspiring, high-level entertainment for anyone who wants to put the post before hardcore, and in the vein of Standstill."

The band were taking on a more DC influenced style with the vocalist / guitarist Jeff Drake telling me, "The new stuff changed the way we were writing. We were going for a more Discord-ish sound, like Fugazi and Q And Not U. You could pretty much describe our older stuff as straight indie-rock, but now we're a little heavier and more disjointed."

These four releases all sold out and were all superb, although criminally under-rated to the point of being unknown compared to the legendary scene status that many of their contemporaries achieved. Squarewell wore their hearts on their sleeves and were genuinely good guys and great musicians. I'm proud to have worked with them and will always be a fan of their music. I think, like most of the Engineer Records releases, it changed my life in some way and has undoubtedly impacted the lives of many other disenfranchised and directionless punks for the better.

https://www.youtube.com/@EngineerRec

Stubborn Will

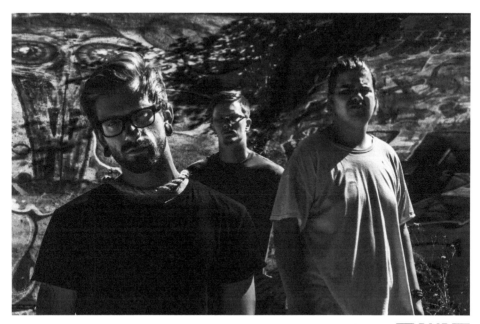

Alek Browning: Guitar and Vocals
Ashton Adams: Drums
Cade Brown: Bass

Stubborn Will are a powerful melodic hardcore band from the deep forests surrounding Spokane, Washington. Formed late in 2018, Stubborn Will was born from a convergence of melodic hardcore and new wave punk and have created a musical hybrid that incorporates the aggressive, poetic energy of the former, and the in-your face attitude of the latter. Stubborn Will are intent on spreading a message of resilience towards life's unpredictable and ruthless nature, and fate's unswerving dedication to kicking us when we're down. The band are long-time friends whose paths originally crossed when the bands they used to play in played the same shows.

The band began its journey as a two-piece passion project that was meant to be a cure for the boredom of life in the sleepy hollow of Spokane. Guitarist and vocalist Alek Browning and drummer Ashton Adams built the foundation of what would soon become Stubborn Will in the winter of 2018. They both came from the post hardcore scene and

wanted to incorporate the aggression and raw emotion of the genre with a fresh sound and new creativity.

After several name changes and a very awkward first show, Alek and Ashton realised they needed a third member to improve and fill out the sound they were striving for. They knew just the guy. A phone call and a practice later, long-time friend and bassist par excellence Cade Brown joined Stubborn Will and added the missing ingredient that helped the band realise their potential and start to craft the pop-punk melodic hardcore crossover they were striving to fashion and would later become known for. Ambitious and ready to conquer the scene, Stubborn Will started working on their five-song 'Contempt' CD EP (IGN321) that was released by Engineer Records on 5th May 2019. The CD promotions were soon accompanied by a video for the blasting title track which quickly racked up over 25,000 views on the Engineer Records YouTube channel.

The band booked gigs and started planning a tour, but their momentum was curtailed by the pandemic that brought the world to a grinding halt in 2020. Fast-forward a couple years and Stubborn Will was more fired up than ever. They re-launched 'Contempt' again in 2022 and supported it with more videos on Hardcore Worldwide, Blank TV and the Engineer Records YouTube channel again. This was followed by two brand new songs; 'Grieved' pursued a more traditional melodic hardcore path, while 'Indignation' seamlessly combined hardcore with pop-punk. These were followed by the digital release of another new single, 'Agape'.

Stubborn Will realised they needed to get out of their hometown and play more shows, so teamed up with national touring act Not.GreenDay and took the first four months of 2023 off to tour. Their time on the road was filled with misfortune and woe though and saw them run out of petrol in the middle of nowhere with no cell phone reception, their vans transmission locking up, a New Years Eve shindig that could have come straight out of the Hangover movies, losing their inebriated bassist Cade in Hayley, Idaho, Alek having to stop their guitar tech having a fist-fight with a disgruntled audience member at a show, and last but not least, playing a set with food poisoning.

They did all of that and more in an attempt to promote their new single 'Never Here', which deviated from the melodic hardcore sound they'd made their own in order to chase a more digestible indie / pop-punk

aesthetic and tone. Stubborn Will are now working on a new release, entitled 'Worth Your Time'.

'Contempt' celebrates its fifth birthday in May 2024 so Stubborn Will and Engineer have been talking about re-releasing an updated version the EP again, which would give the band the opportunity to play the revised editions of all of their classic songs.

Mark Bestford of **Devolution Magazine** reviewed 'Contempt' saying; *"With only five tracks this is really an EP but the songs are good enough to make it feel more like an album. It doesnt sound like there are only three band members with some quite intricate sound structures. If shouty lyrics are your thing then this is for you with what sounds like a cross between Bring Me The Horizon and Funeral For A Friend. Each song stands on their own well but listen through in order and don't hit shuffle as the songs flow together to tell a story"*

And Djordje Miladinovic of **Thoughts Words Action** added; *"Energetic melodic hardcore compositions that will suit even the pickiest fans of modern hardcore. Each song offers countless sonic delicacies, melodies, harmonies, themes, chord progressions, powerful shreds and it's mind-blowing how the trio stacked up all these ideas within just five songs. The screaming lead vocals add even more aggression over the top, but you'll notice emotiveness punching somewhere from beneath. Stubborn Will embraces every single subgenre of hardcore music under its branch, and the group does it pretty damn well."*

https://linktr.ee/Stubbornwill

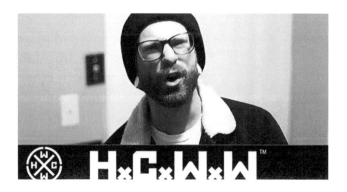

The Moirai

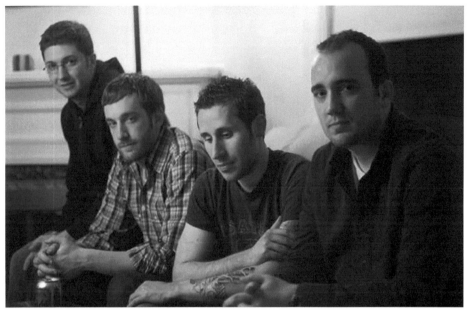

Brian Carley : Guitar, Vocals and Keyboards
Rich Stewart : Guitar
Mark Wojcik: Bass and Vocals
Michael Jones : Drums and Keyboards

The Moirai were a short-lived band from New Jersey that rose from the ashes of the beloved emo heroes Penfold. With a remarkably similar sound to their previous band, The Moirai play in the vein of genre greats like Mineral, The Gloria Record, Christie Front Drive and Sunny Day Real Estate.

The Moirai's only record was the 'Bury Yourself' album, released on CD (IGN075) via Engineer Records in 2005. Mixed by Jason Marcucci (Last Burning Embers, Seize The Day) and mastered by Alan Douches (Lifetime, Joan of Arc, The Promise Ring, Jets to Brazil, Elliott). Several of the band knew Craig Cirinelli, the singer of Elemae, who was running the US office of Engineer Records at the time and sent the masters to him to check out. We immediately agreed to release it and I'm certainly glad we did as this is a fine album that recalls emo's glory days. This is what emo sounded like before it became a dirty word.

Unfortunately, the band broke up later that same year and we were left with many copies of their CD still to move, which of course we found creative ways to find homes for. Later, in the wake of the band's breakup, they released a series of nearly twenty previously-unheard demos through their website. Their dissolution was caused by the idea of a Penfold reunion, which happened the same year. There's even a live DVD of the reunion show, called 'Elf Pond: The Secret Penfold Show', filmed as it took place in a friend's basement in New Brunswick, New Jersey, in front of a few close friends.

There were only ever two Penfold albums, 'Amateurs and Professionals' in 1999 and 'Our First Taste of Escape' in 2001, both on New Jersey label, Milligram Records, and The Moirai carried on from where they left off, with mellow post-punk music and vocals front and centre in the emotive mix. Lead singer Brian Corley's vocals float from soft to passionate and are accompanied by gorgeous instrumentation. This type of music really gets to me. It's one of the genres that I grew up on and still go to in more mellow moments. But this musically beautiful, complicated and ethereal band from New Jersey have seemingly disappeared from the face of the Earth, and despite my numerous attempts to contact and reconnect with them, in the hope that they'd want to talk about the band, the scene and more, every message has unfortunately been met with radio silence.

Like all stubborn old scenesters, I refuse to be beaten by the intervention of fate or the fact that some punks don't want to be found and have less than no interest in reminiscing about the old days, especially when the punks in question were in a band that I adored. The Moirai were part of the Engineer Records story and I wanted their tale to be told, but for now I've deferred to the wisdom of **Sputnik Music**

and their great review of 'Bury Yourself', which tells the story of The Moirai and this release well enough...

"Simply put, Penfold were one of the best bands of all time. They perfected the quiet-loud technique first introduced by genre pioneers Christie Front Drive and Mineral. They had the short, succinct, and poetic lyrics that elevated them beyond their contemporaries. They were everything wonderful and meaningful about 90's midwestern emo wrapped up in a beautiful bow. All good things eventually come to an end, and like most bands from the era, they were just a two-album flash in the pan.

Bury Yourself picks up right where Penfold left off. The Moirai were Penfold minus original bassist Stephan Jones so it's easy to see why. It has everything you want in a midwestern emo album in a time the genre was fading headfirst into obscurity. The glorious and emotion-soaked builds and artful lyrics were still there and done masterfully. There is real craftsmanship here. Vocalist Brian Carley is one of the best of the genre and he continues to showcase his talents here. He is what makes these bands all click together, and had he been a lesser vocalist, I'm not sure how good these bands could have been. He has the ability and range to make you feel his heartfelt lyrics. You experience the sweeping emotion he pours into every word, rivalling even the legend that is Chris Simpson of Mineral.

These are some of the best lyrics ever penned on an emo album, a genre that can often come across as cheesy and on the nose. Not many have the ability to write about love, loss and relationships the way Carley does. "Last Year for Halloween I was a Ghost" is a gut-wrenching track about a past relationship where his lyrics shine through. On it, Carley cries out, "If you're still in love is it criminal to let our ghosts dance in the park alone", an artful and thoughtful line about his past love. He has a tremendous range for an emo vocalist which fluctuates a lot depending on where the song goes. This is where the magic happens. He goes from his soft, delicate crooning to impassioned yells when the builds start to peak and that is where he shines. Carley also has a soothing falsetto, which shouldn't really work on this, but it absolutely hits the mark. It's a mesmerising, virtuosic performance that will leave you speechless, a landmark of the genre.

The vocals are definitely not all that's special on this album though, with the layered, complex guitarwork that is also up to the lofty standards

Penfold set. This is a band absolutely firing on all cylinders and features some of the best songwriting they've ever done. The same haunting, atmospheric and melancholic melodies are executed beautifully like true masters of their craft; the ones that lull you to sleep only to later explode into dazzling and gratifying crescendos. It's an incredibly potent combination when paired with Carley's vocal performance. The guitarwork couldn't matchup better and help create an emotional atmosphere. On the closer "Empathy for the Enemy/Hostile to the Helpless" is where this is most apparent and the guitar does most of the talking. The first four minutes are a sprawling post-rock-esque epic with a slow-moving build erupting into cascading drums and gorgeous melodies topped off with a scream. The last four minutes smoothly transition into a more traditional emo song capped off with Carley's passionate wailing of a lost love. The perfect end to a near perfect album as it slowly fades to black.

This was the last we heard from the guys from Penfold. Bury Yourself was one of the last breathes of a dying genre that would regroup years later but never sound quite the same as it once was. It was the passing of the torch that never shined as bright: the end of an era."

https://youtu.be/nLeJThlyU7M?si=W_2jjCg4kld0yW_r

The Morning Of

Jessica Leplon-Darrow : Vocals
Justin Wiley : Vocals
Chris Petrosino : Guitar and Piano
Rob McCurdy : Guitar
Abir Hossain : Bass
Dan Celikoyar : Drums
(Ryan Jernigan : Bass)
(Jimmi Kane : Drums)

Perhaps more pop than punk, but part of the radio-friendly emo college scene of the mid noughties that seemed to work well for indie / alt-rock bands, especially in the US, and breed the likes of Copeland, Dashboard Confessional, Mayday Parade, Yellowcard, Paige (UK), A Day To Remember, Panic At The Disco and My Chemical Romance. We met them when they came over to the UK to tour with Kyoto Drive and hang out in the Eng Recs hot tub. They were good guys with songs packed full of youthful sensibilities and we ended up putting a record out for the tour.

The original members of The Morning Of, Chris, Rob and Abir, met through playing together in their high school jazz band in Newburgh,

New York, and retained a kind of preppy high school / John Hughes film college feel to their music throughout, with the band's records even being likened to "High School Musical for emo kids" in some reviews.

They tried a few line-ups and had some false starts until things eventually solidified with Jessica and Justin joining on vocals and Dan on drums. This led to a lot of local gigs and the recording of their debut EP, 'Welcome Change. Goodbye Gravity' for Tragic Hero Records in 2005. This six track CD EP would be pushed hard by the North Carolina alt-rock label, seeing an eight song version of the CD re-released by the label in 2007 and a thirteen song expanded collection released by Inya Face Records and CR Japan.

Abir, their bassist, who was affectionately known as 'Peaches', told me, "We were fortunate to grow up in the very solid Hudson Valley, New York music scene. That scene produced bands like Matchbook Romance, Just Surrender, Anadivine, Thieves and Villains, With The Punches and We are the in crowd. We grew up around these bands and saw that they were always touring. We wanted to do the same. Our proximity to the New Jersey scene also helped, where we would exchange gigs with bands such as Houston Calls and Madison. This closeness of bands helping each other, taking each other on tour and trying to bring everyone up with them, that was very important and something we still hold dear in anything we do."

With this in mind, in 2006, Tragic Hero Records signed a deal with the band, backed by support from East West, a subsidiary of Warner Music, and The Morning Of started recording their debut album, 'The World As We Know It', working with Alex Goot and John Naclerio at Nada Studios in Montgomery, New York. It was while writing and recording this album that they'd really hit the road, going on tour with the likes of The Wonder Years, Wheatus, House of Fools, Alesana and Drop Dead Gorgeous. 'The World As We Know It' came out in 2008, on CD in the US through Tragic Hero and in Japan through Inya Face, and there's now a limited edition coloured vinyl version too on Tragic Hero Records.

I met the band through Kyoto Drive when we were working on their third record with us and helping set up UK tours for them. They'd gotten onto a few support slots with The Morning Of and become friends, both now speaking with and starting to work with a Manchester, UK based label called LAB Records. In 2010 Tragic Hero would release the new CD album,

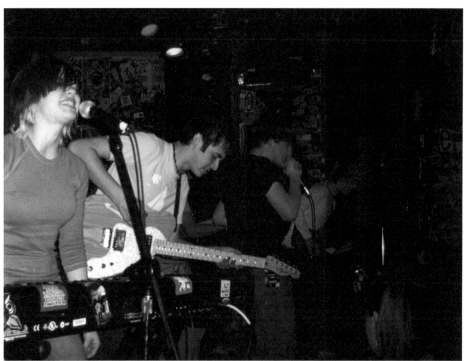

'The Way I Fell In' in the US and LAB Records would release it in the UK, with Engineer Records promoting a tour split CD (IGN140) for Kyoto Drive and The Morning Of, featuring two tracks from each band, ('Tell Me I'm Wrong' and 'Heaven Or Hell' by The Morning Of and 'So Much Alive' and 'Chapters' by Kyoto Drive) with the song 'Tell Me I'm Wrong' from the new album having a very successful video launch with over 92,000 views. The band collected over 1,000,000 plays on PureVolume.com and chalked up over 2,000,000 on MySpace.com. There's also a limited edition colour vinyl LP of 'The Way I Fell In' now on LAB Records too.

The success of the band's second album led to even bigger gigs and more touring for The Morning Of, including trips to the UK and Europe, and several larger festival shows. Abir told me about several great gigs when we met at their show with Kyoto Drive in London, with his favourites being the Bamboozle Fest with Jimmy Eat World and Paramore, and the band's New York dates with Just Surrender.

Time passes and things eventually came to a close for the band without them ever receiving the pop-punk accolades of some of their peers, but Rob and Chris stayed on with Warner Chappell as the production duo Noise Club, still making music in their respective projects Mosss and Rosi. Abir still works in the music industry too as an A&R manager for bands such as Weezer, Fall Out Boy, American Football, San Holo, Wyclef Jean, Martin Garrix and Zedd.

Jessica is now the proud owner of a cool bar in Philadelphia, called Next of Kin, with her partner Kyle. And Justin, Dan and Ryan all work in tech adjacent fields, I'm sure occasionally throwing on these records and reminiscing.

Sputnik Music commented on 'The World As We Know It'; *"You'll notice how bizarrely similar the vocalists (Jessica Leplon and Justin Wiley) sound to the High School Musical leads (Zac Efron and Vanessa Anne Hudgens). I recall bumping into their myspace and listening to the song 'Let You Spirit Soar'. I was literally laughing because no matter how much they sounded alike, the song was really catchy, the band was solid, and those harmonies were just awesome."*

"So to put it bluntly, The Morning Of is nothing more than taking the vocalists of High School Musical and backing it (ironically) with a piano-rock-progressive band. The fun begins however right at the next song 'Let Your

Spirit Soar'. The listener gets wacked with a dense deep and surprisingly heavy riff, they do tickle your ears with the rhythm because honestly when you first listen to it you don't see it coming. Then we get to the first line "3 AM a boy sits outside his house lonely with his guitar." From there on in your going to either hate or love the lyrics for the rest of the trip. There are points that the lyrics are absolutely cheesy, but you can't deny how fun they can be."

And **PunkNews.org** added; *"The Morning Of's youthful spark and overwhelmingly positive cadence make them sound like the younger, more playful siblings of bands like Mae, Copeland and the Anniversary."*

Alterthepress.com continued the story with; *"The New York five-piece make their return with 'The Way I Fell In', a record that is 12 songs consisting of sweet piano-based harmonies and all-round growth. One of the many positives of The Morning Of, is their passionate, positive energy that is resonated throughout. Leplon and Wiley complement each other well and are backed by the band's thriving, tight sound."*

https://youtu.be/LYpheUk5CrQ?si=kgUtpFoo9khpl_KW

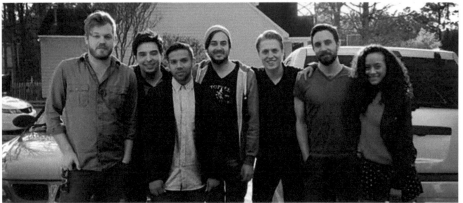

The Nutcutters

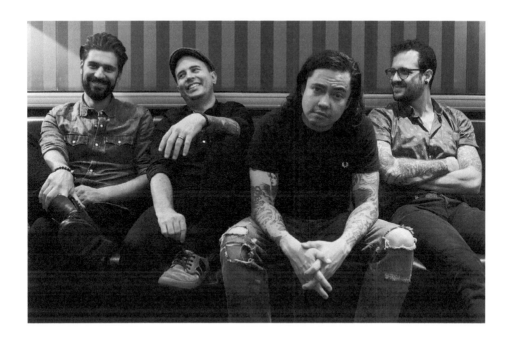

Christian Herren : Guitar and Vocals
Jake Hurni : Bass and Vocals
Normen Zutter : Drums

Hailing from Bern, the federal city of Switzerland, pop-punk stalwarts The Nutcutters have been an integral part of the melodic side of the scene for more than two decades. Influenced by MxPx and Face to Face, they write songs that you can sing along with and dance your heart out to, and their sophomore album 'Clyde' is a testament to their devotion to capturing the fast, witty, and catchy punk rock credo that they lived by.

Once upon a time, two chaps named Chris and Normen were elected to the positions of class representatives at their high school, where they met and became friends at a buffet event thanks to wearing NOFX and Bad Religion t-shirts and Converse and Vans trainers. The Nutcutters are the exception to the old adage about not judging a book by its cover, as Chris and Normen instantly bonded over their mutual love of punk-rock.

As luck would have it, Chris worked at a local music shop so all of the instrumental weapons of punk rock destruction that they needed were readily available to them and an initial jam session rapidly turned into many more, and before anyone could stop them they'd mastered a bunch of cover songs by the likes of Green Day, The Offspring, Blink 182, The Ataris and The Vandals.

Just as Chris and Normen were starting to turn the heat up a Filipino who could barely speak any German but knew how to play bass called Jake turned up and after hearing them jam informed the dynamic pop-punk duo that he was the missing piece of the puzzle that they'd been looking for. And he was right.

The Nutcutters really came into being during the Summer of 2002, thanks to long nights filled with endless practice sessions, which in turn led to them recording their first self-released EP, 'Bad Influences' in a studio near Bern, and playing a seemingly endless succession of shows all over the country. They didn't have a plan and had no idea what the future might hold, but reasoned that as long as they were having fun they'd keep on doing what they were doing.

All they wanted was to play the music that they were passionate about, gig with each other, meet and make new friends, write songs influenced by Bad Religion, Pennywise and MxPx, and drink as much free beer as they could get their hands on. When you listen to them, if you know your pop-punk ABCs, it's immediately apparent that Blink 182's 'Enema of the State' played a significant role in helping them to discover their musical identity.

Their next release, the twelve-song 'Smashin Stereo' CD, saw the light of day in 2005 and kept them on the pop-punk track but it was their 2010 album, 'Clyde' that really put them on the map in the European punk scene. Recorded at Pressluftpark in their hometown of Bern then produced and mastered by The Nutcutters and Dan Precision at his Bombshelter Recording Studios in Chicago, USA. 'Clyde' would be released on CD on 12th May 2010 jointly by Engineer Records (IGN151), Koi Records (US) and Sums Records (Swiss), this nine track album put them on a par with some of the far bigger US bands playing the same style.

Switzerland may not be the first country that springs to mind when the average punk rocker is asked to name the most vibrant scenes in the

world, mainly due to the reserved and sceptical nature of the majority of the populace which doesn't exactly endear bands trying to find their feet to their hometown audiences, but things are changing. Rome wasn't built in a day, and the Swiss scene took nearly a century to lay the foundations that future generations could start to create something special from. Having said that some great bands have appeared from out of the Swiss ether, including Snitch from Zurich, Slimboy from Basel and the incredible Masterblender.

When we talked about the history of The Nutcutters, Chris, their lead singer and guitarist, was also eager to tell me about some of the band's best and worst shows and share some of their stories from life on the road...

"We've had some memorable gigs over the years, as well as some less-than-ideal experiences. While we weren't able to tour abroad extensively due to personal reasons, we focused on our region and had some standout moments. One highlight was when we were invited by a shoe and clothing brand, Macbeth, to play at the Groezrock Festival in Belgium in 2010. Our travelling party of twelve was supposed to fly to Brussels together, but we were delayed due to the Eyjafjallajökull volcano eruption causing air traffic disruption across Europe. We made the most of the delay at the airport bar and were lucky enough to take off a few hours later, arriving at the gig properly drunk."

"In the same year we were booked to play at a massive festival in New Delhi, India. The famous Eastwind Festival contacted us directly, offering a full engagement and covering all travel costs and accommodation. We were thrilled and had already prepared intensively, including getting all necessary visas and vaccinations for diphtheria, tetanus, polio, hepatitis A, typhoid and MMR. However, we were shocked to find out through the media that the entire festival had been cancelled without any prior notice to us. We later found out that all contracts had been cancelled and the festival has never taken place since."

Chris continued, telling me; "We've had many other interesting experiences over the years. For instance, Normen once had to steal back his stolen cymbal stands at a festival. A crew member accidentally set himself on fire during a show. We spent a night in an air-raid shelter with a cute spider family. Ricardo once took off his shirt on stage and accidentally got caught on the ceiling chandelier while throwing it away. We once shared a huge family pizza with Chris Burney from Bowling for

Soup and ended up with only a small slice each. We had to change our rehearsal room three times in just one year. We learned that vodka with apple juice only tastes like apple juice. Chris once had his electricity cut off after only twenty minutes during an after-show DJ set and Normen almost knocked out a bouncer while energetically pushing open the backstage door. We have many more details and adventures to share, and we'd be happy to do so over a drink at a random bar."

Good times don't always last though and after Paul Anthony joined the band as their lead guitarist in 2011, which took their song-writing to a whole new level on 'A Decade of Change', their thirteen-song, 2013 TNC Records album, when he moved to Milan in 2013, it made life as a Nutcutter all but impossible for him, and Ricardo Krenger replaced him on guitar from the then recently disbanded Goodbye Fairbanks. Paul wasn't the only member of the band to leave as Normen also handed in his Nutcutter stripes in 2016 for personal reasons and was, in turn, replaced by Marco Schindler on drums.

It took the band some time to adjust to the changes that they'd undergone, but in 2019 they charged out of the gates again with a triumvirate of singles, 'Runaway', 'Island' and 'We've Got Nothing' before they played and sold out their biggest show to date in Bern, the place they call home, on 4th January 2020. Even though they didn't know it at the time, their biggest triumph would become The Nutcutters last hurrah, as a few months later, the global pandemic changed everything, forever.

The pandemic threw a spanner in the works of the personal lives of the band too, making them realise that they were no longer on the same wavelength and The Nutcutters went on indefinite hiatus.

All was not lost though, as during the lockdown period, Chris and Jake continued to work on music in their home studios, but they soon discovered that their sound had evolved significantly. The pop-punk humorous lyrics and simple song structures that defined The Nutcutters were gone, and realising that they had entered a new era, when restrictions began to lift, they reunited with Marco and wrote twenty-one new songs in their rehearsal room.

This led to the formation of a new band, and after recruiting Sandro in April 2021 as their new bass player, they spent 2023 in the studio,

recording music under their new name: Blackest Heart. Their debut record is due to be released in 2024 on Engineer Records.

Until then Normen had these final words of wisdom to share with me, you, and everyone else; "The fire of punk rock will never extinguish! With each new generation comes a fresh wave of punk rockers who blaze their own trail. Just take a peek at the pop-punk scene today where the likes of MGK, Avril Lavigne and even Will Smith's kids have discovered their rebellious spirit and embraced their inner punk."

Pitfire magazine reviewed the 'Clyde' album as follows; *"For almost 10 years the trio from Bern has been playing the Swiss punk scene and has made a good name for itself over the years. After their 2005 album 'Smashin' Stereo' the guys have finally pulled themselves together again and recorded the long-awaited follow-up album 'Clyde'. Over nine tracks you get melodic punk à la Blink 182, New Found Glory and MXPX on a level that you rarely hear from Swiss bands. Sure, it's not new, but it's still fun! Songs like 'iBro', 'Don't Leave' and 'Wannabe Poser' don't have to shy away from the comparison to the above-mentioned groups and crash in decently with the volume knob turned up. Another highlight is the original booklet with its B-movie-like presentation. All in all, a short but good disc and a real treat for fans of pop-punk."*

And **Ox Fanzine** added; *"I really like the mid-nineties style pop-punk of the guys from Bern, somewhere between late Screeching Weasel and early Blink-182."*

https://thenutcutters.bandcamp.com/album/clyde

The Satellite Year

Daniel Rimedio : Vocals
Andreas Klemens : Guitar
Jens Kreuter : Guitar
André Hofer : Bass
Andreas Fischer : Synthesiser & Vocals
Julian Lorson : Drums
(Christian Detzler : Guitar)
(Björn Mertz : Drums)

The Satellite Year was a unique melodic post-hardcore electro band led by dual vocals that was based in Saarbrücken, Germany. Formed in 2008, they shared the stage with bands like The Get Up Kids, NOFX, Bullet for My Valentine, The Ataris, Hawthorne Heights, Road To Kansas, Sirens & Shelter, Silbermond, Die Fantastischen Vier, The Subways, The Rasmus, Die Happy, Frittenbude, Bosse and Dropkick Murphys. They created several albums of beautiful, powerful music but disbanded in 2017 with some of the members forming the new band, Atlanta Arrival.

I've always had a soft spot for The Satellite Year as they were unlike any other band I'd ever heard. Their individuality and single-minded creative

focus ensured that they stood out from the scene pack and helped them carve their name in the annals of punk-rock history. They were, and still are, one of the few bands that I always ask strangers and friends alike to spend some time listening to, and I implore all of you reading this to do the same. Trust me, you won't be disappointed.

On a windswept, blustery evening in January I spoke with my old friend Andreas Klemens again about The Satellite Year, the band that meant so much to so many of us and drank deep of their wonderful history. So, let's get into it...

"The Satellite Year rose from the remains of a band called Not For Real. Jens and I played guitar and tried to sing, which wasn't going great at first. Another Andreas played bass and sang and Julian played drums. After we toured through Germany for a week the desire to develop further as a band was growing and we knew we wanted to refine our emo-rock with synthetic sounds and solid two-part vocals. We placed an advertisement in a musicians forum saying that we were looking for a singer and/or keyboard player and a few days later Daniel Rimedio was stood in our rehearsal room and The Satellite Year was born."

In May 2008 The Satellite Year would release their six-song debut EP, 'This Is Voltaire' with Andreas Fischer playing bass, synthesiser and singing alongside Daniel. This was followed by a track on Midsummer Records 'Listen Up Kids, Vol 4' compilation and their relationship with Tim Masson's excellent German indie record label began. The band's next release would be the 'Could You Try to Speak in a Higher Register' single in October 2009 and more compilation album tracks, including Midsummer's 'Listen Up Kids Vol 6', and Tim introducing the band to us for songs on Big Cheese magazine's September 2011 sampler and Engineer Records 'Lamp Light The Fire, Vol 1' and 'Unity : Benefit for Children in Japan' after the earthquake and tsunami there.

This all led to The Satellite Year's superb thirteen-song debut full-length, 'Mission: Polarlights' (IGN164) which was jointly released on CD late in 2011 by Midsummer Records in Germany, Engineer Records in the UK and Radtone Records in Japan. The album spawned several digital singles and videos with the lead three earworm songs, 'Jelly, Jelly, How to survive such a trip?', 'A Campus, a Heart, a Star' and 'Citizens, Districts, Telescopes' gaining over 58,000 YouTube views between them. This led to the band getting very busy with gigs and tours.

Andreas pulled triple duty on vocals, bass and synth for a good year or so, but as the songs became more complex and the synthesiser parts increased, TSY began looking for a standalone bass player. Initially they played great shows with Sandro and Sascha on the bass, but finally found their sixth band member in Andre, just in time for the 'Mission: Polarlights' album. They played with this line-up until 2013 and the 'Universe' single release, but then Julian and Andre left the band and Dominik took over on the drums.

In 2015 The Satellite Year would release their second album, 'Brooklyn, I Am'. This record had twelve more melodic, intricate and powerful tracks and would come out on CD again via Engineer Records (IGN224) but also Misteltoe Records in Germany and Go With Me Records in Japan. There would be more high-end videos working with their movie director friend Thorsten Hary and a digital-single release for a cover of Jay-Z's 'Empire State of Mind'.

Shortly after the release of the album Dominik left and Björn Mertz became TSY's drummer, he was followed by Matthias joining as the new bass player and the band went out on tour again, playing awesome support shows with The Ataris and Hawthorne Heights.

The band started writing songs for a third album, 'Orbit' in 2017, but never finished them as founding member Jens decided to leave the band and after nine years, they decided enough was enough. Most of the remaining members of The Satellite Year started a follow-up project called Atlanta Arrival, (with an early single, 'Misfits' released as a video by Engineer Records on YouTube) but even though the end of TSY was heart-breaking for all of them, it was nothing compared to what happened just a year later when their drummer, Björn, died of a brain tumour in May 2018.

Despite remembering that tragedy and I wanted to remain positive and asked Andreas more about his formative band years and the inspirations that made him want to play music. He told me;

"When Andreas, Julian and I founded our first band, we were only thirteen. It was a punk band called Inzest, and even then making music together gave us a lot back and was more than just a hobby. After we played our first gigs and recorded for the first time we were completely hooked. It was the same with Daniel. He started singing in bands at a very early age and just wanted to play and make music."

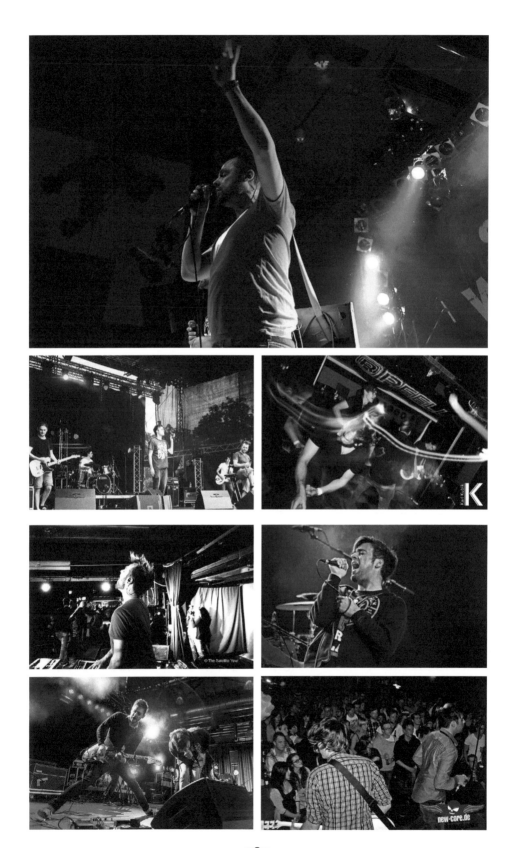

THE·SATELLITE·YEAR
MISSION:POLARLIGHTS

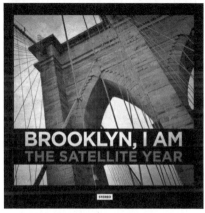

BROOKLYN, I AM
THE SATELLITE YEAR

STEREO

DRINK COFFEE
AND DESTROY

THE SATELLITE YEAR

FROM FALL TO SPRING
OHPORT
SINS'N'RISE
DAYS OF OWNAGE

28.11.2015
AB 18.30 UHR
JUGENDZENTRUM SCHIFFWEILER

COMENIHSSTR. 1 - 66578 SCHIFFWEILER

midsummer
X-MAS FEST 2015

CITY LIGHT THIEF
THE SATELLITE YEAR
AN EARLY CASCADE
GHOST OF A CHANCE
KEFKA PALAZZO
TREES

SA. 12.12.2015
JUZ ILLINGEN

Poststr. 5, PLZ: 66557 | Einlass: 18:00 Uhr | Beginn: 18:30 Uhr
Nur AK (5 €-10 €, pay what you want)

WWW.MIDSUMMER-RECORDS.DE

Andreas continued, "There are many great bands and albums that have shaped who I and the rest of the band are; 'Clarity' by Jimmy Eat World, 'Tell All Your Friends' by Taking Back Sunday, 'Something To Write Home About' by The Get Up Kids and 'This Is War' by 30 Seconds To Mars. Also bands like Senses Fail, Saosin, Underoath and Moving Mountains had a huge influence on our songs. There is just so much great music out there."

I also asked Andreas about his favourite TSY record and their local scene... "Personally, the TSY album that I like most is 'Brooklyn', because of the more complex song-writing, and the album that personally inspired me the most when writing TSY songs was 'Futures' by Jimmy Eat World."

"In the first few years of the band there was a huge scene in our area that revolved around bands like Flares, Road To Kansas, Everment, Traeos, Parachutes, His Statue Falls, Quatropop and No One Knows. Almost every weekend there was a show somewhere with a great line-up and a cool crowd. That was an outstanding time. We are very grateful to have been there."

As usual, I asked Andreas about the best and worst shows he could remember The Satellite Year playing, he chuckled and said...
"We were very lucky to play a lot of great shows, but one that was burned into my memory was in 2012 in a club in Mönchengladbach. That evening I consciously experienced for the first time that we had come to this club to play as headliners in front of a sold-out house and loads of people were singing along to all of our songs. And that happened several hundred kilometres from our home scene. It was crazy."

"Of course," he continued, "we also played many shows that weren't so great. In 2010 we played this festival near Pirmasens. It was at a great location near an airfield, but it wasn't well attended and the headliner didn't feel like playing their late headliner stage time, so their managers somehow arranged that we had to swap slots. Anyway, we played at midnight to about thirty people on this huge festival site, while the headliners left it in their nightliner. But we still had a lot of fun and laugh about it today. It was our first headlining slot at a festival... And it was also our last one."

"We played this weekender with gigs in Hamburg and Cologne, but our bassist Andre left his keys behind and spent the night and all of our money on petrol driving back between venues to get them."

I reminded Andreas of their UK tours, when they'd stay with us after gigs at Engineer Records HQ and hang out, drinking beers and blasting music in the hot tub. He remembered a story from the UK tour in 2012; "On the second evening we played this great concert in a pub in Maidstone and met a guy named Scott. It was none other than Scott Mallard from Sirens & Shelter, so after a few beers we simply packed him into our van and took him on the rest of that tour. At each gig we'd ask the organisers if he could open the show with his acoustic guitar and that worked out great."

"During the recording of 'Mission: Polarlights' near Turin we had a great time. We went to a Melody Fall gig and enjoyed the local nightlife. Our singer Daniel organised a German barbeque evening for the family of our producer, Andrea Fusini, and the Melody Falls boys and during a studio break we organised a football match, TSY & friends against Melody Fall & friends. Anyway, none of us are gifted footballers but we all scored at least one goal and there were no injuries. Of course we lost to the Italian ball artists."

As our conversation came to an end, I asked Andreas why The Satellite Year split up. He sighed, shrugged and said; "As I already mentioned, we decided to end TSY in 2017 when Jens left the band for professional reasons. In addition to Julian, he was the second founding member of the band and without him, it no longer felt like TSY. So we split, but because we can't live without music, we decided to start a new band. Atlanta Arrival was born and we wrote our debut album, 'A Tale Of Two Cities', in just four months. Shortly after we'd recorded it Björn died. Of course, we stopped to mourn him. After a while we finished producing the album, released a tribute single, 'Colliding Stars' and donated all the profits to cancer aid. We decided to continue the band in Björn's memory and found an old buddy of his, Dave, to be our new drummer."

'Then Christian took over on second guitar and brought a breath of fresh air into the band. After the release of 'A Tale of Two Cities' we played a few gigs but then COVID arrived. That stopped everything again. Now we're currently finishing our second album and are very excited to finally be able to play live again."

Andreas final words in this conversation were about the scene and how he feels about it. He told me; "As long as there are people who celebrate, listen to or make this music, there is no need to worry about the scene. It is up to us to pass on the love for this music to our children and to

promote young musicians. Early musical education is key, and so all punk rock or heavy metal parents out there: Heavysaurus is the perfect beginner's band for the little ones."

Interpunk reviewed 'Mission: Polarlights' describing it as: *"An astonishingly grown-up debut album. The Satellite Year attain a new and individual level between pop, electro and melodic post-punk with their debut album. There's just one possibility to create something initial and unique in one and the same thing. It's art."*

Totally Vivid said; *"The Satellite Year's debut album might be entitled 'Mission: Polarlights', but in reality, the sound is far more that of sun-drenched American cityscapes and open highways. This is an album with scope and ambition. One that sounds confident in its consistency, projecting a real solid, robust quality from start to finish. Where The Satellite Year really shine is their keen ear for melody, coming on like a younger cousin of Jimmy Eat World. 'Mission: Polarlights', for all its rock bulk, remains at heart a pop album and everything, right down to the crystalline guitar hooks, resound with clarity. There are big choruses everywhere, the band showing off a good awareness of packing emotion and drama into their tracks. They're well-paced, leaping and colliding in bursts of energy.*
These tracks shine like a bell hit at the sweetest spot. Bang on the money moments that help anchor the album in its own quality. A clear boast of musicianship that, on this occasion at least, feels justified. A highly impressive debut."

And **Sonic Visions** added: *"An expressive and euphonic voice that tells you about a generation, a nation or just one boy's experience of what it means to grow up. The sextet succeed in accompanying the audience to highest euphoria. Meanwhile they bring you down to your knees to hold a melodramatic gun barrel to your head. Based on a mixture of playful sounds paired with the rough edges of life The Satellite Year presents emotionality and ambition."*

https://www.youtube.com/@THESATELLITEYEAR

The Stayawakes

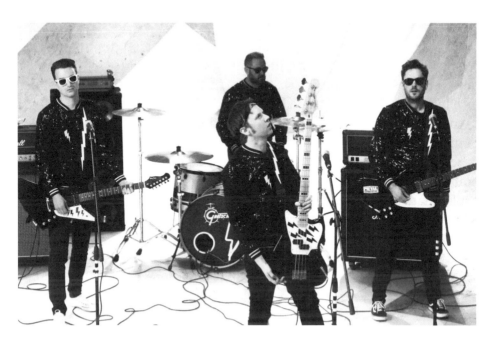

Andrew Ricks : Vocals and Guitar
Jimmy Cooper : Vocals and Bass
Peter Foulk : Guitar
Steven Hart : Drums
David Pryce : Keyboards

A south-coast UK power-pop quartet who specialise in serving up big hearted jams and sweet harmonies with a visceral live energy and both feet on the loud pedal. The Stayawakes are made up of members of Day of the Fight and Awkward Silence, and have put in more than their fair share of miles on the road. When they eventually met in a practice room and turned everything up to eleven, they made power-pop punk rock magic.

Some bands do all the hard work for you, and when I sat down to talk to Andrew Ricks, the singer and guitarist with The Stayawakes, all I had to do was press record, sit back and listen as he told me the bands story from their humble beginnings to the dizzying heights of becoming one of the UK's best kept pop-punk secrets...

"I was working in a project recording studio financed and run by Portsmouth City Council in Buckland. I recorded and worked with at least two or three young bands a week who came to get a demo down, rehearse and just hang out playing music. Whatever, it was their space.

My then partner and now wife also worked at the studio, mentoring young women and girls who had an interest in music. Most of the bands I met when I started working there were inspired by what was happening by bands like The Strokes and later Arctic Monkeys. A few of them clung to the folkier sounds of Laura Marling and the pre-Vaccines solo project of Justin Young; Jay Jay Pistoletme or were switched onto the more emo/ hardcore scenes by UK bands like Hundred Reasons and Reuben. My point being there were bands/artists around that the young people I met could relate to who were exciting and relevant and there was also a space where they could come together and make music for free five nights a week and on Saturday mornings.

We'd recorded the Day of the Fight album 'Modern Rock Hall of Fame' at the studio so I was able to do little demos when it was quiet, one of which was 'Keepsakes' which was probably the first song we played in a Stayawakes rehearsal. I'd also recorded an acoustic version of the song 'No Shame' with Dave Snocken producing who later filmed three music videos for us.

Our only motivation was to hang out a bit more and make some music together again, and if it sounded good (which we hoped it would) then maybe we'd record it or even play live, but hanging out was the thing. I'd been rediscovering The Posies albums and mid-nineties era Superchunk. In fact two of the songs we jammed in rehearsal were 'Daily Mutilation' by The Posies and Superchunk's 'Hyper Enough' and we played the latter at all of our early shows before we had enough material to fill out a set list.

We're from Southsea which had a great punk scene and where we really learned to play was a pub called the Horseshoe, which was the centre of the scene. The Horseshoe had an upstairs room where The Lawrence Arms, Blocko, Scarper, Rydell, The Milwaukees as well as legendary local acts like Pintsize, Plan B, Jets Vs Sharks and many more all played to rabid, eager audiences. Bigger venues like The Wedgewood Rooms also provided great support opportunities which as kids we embraced and learned from and helped to give our scene profile a leg up.

With The Stayawakes we wanted to start from scratch and build slowly, so we spent time in rehearsal, writing together until Pete booked us a gig at the RMA Tavern in Eastney. We were playing too fast and some of the songs definitely needed shaping up (Beezewax's Kenneth Ishak would later lecture us in pre-production about both these points!) but it was good to play the new songs in front of people at last.

Initially people seemed excited about the band. A demo featuring 'Keepsakes' and 'Overdue' was aired on local radio and we played a headliner at The Wedgewood Rooms' smaller venue on the back of this. Our next single 'Summer Suicide / Don't Have to Live Thru This' got played on more radio stations and word started to spread. We had a live review in the local press and started working on a full length album, 'Dogs & Cats / Living Together', which was recorded at Southsea Sound with our friend Tim Greaves and named after Bill Murray's speech to the Mayor in 'Ghostbusters'.

Tim had been the founding member of seminal Portsmouth bands Bulletproof Cupid, When All Else Fails and Jets Vs Sharks. Tim and his partner El Morgan had recently opened their own studio after being long-time defenders of Southsea DIY, putting on some legendary gigs as well as curating their stage at the much-missed Southsea Fest.

Prior to this we'd been over to the Isle of Wight and Red Squirrel studio to work on new songs with Kenneth from Beezewax. That session acted as pre-production for the album we were to make. Tracking was pretty swift, we raced through bass and drums as was typical of that era of the band, guitars took much longer but vocals were only first or second takes. Tim mixed the record, and then we went on tour with Harker from Brighton.

At the end of that tour our bassist left (or rather threw himself out) and we immediately asked Jimmy to jump in on bass. We needed a fresh look for the record so after recording all the moog of Pete's House, at my suggestion we set about re-recording the bass, as my feeling was that by doing so, we'd help Jimmy to feel like he was actually, invested in, and seen as being a vital part of the band by the rest of us.

After hearing Rozwell Kid's LP, Pete suggested we ask Nashville producer Justin Francis to re-mix 'Jake' which was going to be the first single off the new record. The version you hear (which we love) on the

VINYL PRE-ORDERS SHIPPING FROM
MONDAY 19TH APRIL

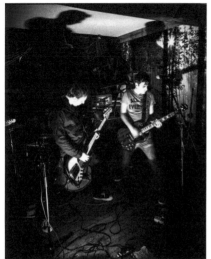

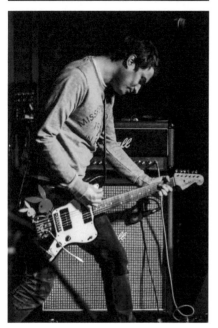

music video is Tim's original mix, but later on, Justin brought elements out of that song that we hadn't considered before, and it became more and more apparent that he should mix the whole record which is of course what happened.

We shopped the record around a few independent labels in the UK most of whom liked it but ultimately passed, partly as their release schedules didn't fit with what we had in mind. I noticed our friend Ellis and his partner Holly had started a label called Bad Horror. Being a horror nut and given that The Stayawakes was named as an homage to slasher movies I sent the record to Ellis asking for his opinion.

After a few messages back and forth, we had a cool new label dedicated to putting out our album, initially on tape and CD and we would self-release the vinyl edition. Once we'd found a label, we went out on another few UK tours with Ellis's band Strange Planes and Harker, and also played a handful of gigs with Beezewax.

The record officially had a release show on the evening of 7th July 2018, after playing an outdoor matinee with Pompey legends Emptifish on Southsea seafront. This was followed by a memorable Bad Horror takeover night at the Monarch in Camden where we celebrated the release with labelmates Good Good Things and Strange Planes.

We followed up 'Jake' with our next single 'Inevitable Truth', the first song to feature backing vocals from Jimmy. Then we made another video which got played around a bit and at this point we started to get a bit of recognition in the US, which ultimately led to our second record 'Pop Dreamz' getting reviewed and played on independent radio both in the US and all over Europe.

A favourite gig of mine was when we played a rammed Cavern pub as part of the International Pop Overthrow Festival in 2022, which was reviewed on a prominent US website. Of course, there's another side, I'd booked us to play a Chilli festival in Swindon as the promoter had offered us a nice guarantee and we followed a chilli eating competition where contestants vomited in front of the inflatable stage we were playing on.

The summer wind blew the terrible stench right onto the stage and we couldn't wait to get to the end of the set. Another time we had been booked to play a few dates with a band from Dewsbury who had

conveniently split up just before we were due to go out. A band from Scotland had been hastily drafted in to play the dates but none of the venues seemed to have been informed. Thankfully our friends in Brighton's Skinny Milk bumped us on a couple of their tour dates to fill in for some cancellations and we tagged these onto the remaining dates that we had been booked on.

One original gig I remember was at The Parish in Huddersfield. We had been pulled over by the police just before we arrived at the venue, as unbeknownst to us, our rental van had no MOT or insurance. I was also convinced that our hosts for the night had spiked our curry with something more than a little spicy and had an uncontrollable laughing fit just as the police flagged us down. I was also positive that I had heard the voice of Zippy from Rainbow coming from the front of the van. I know, it sounds insane, but we were on tour and strange things happen out there on the road...

The Rainbow references would continue after the show with us freaking out at the other bands with impressions of George and Zippy which went on until the early hours. Somewhere down the line it was decided it would be good to find a place to sleep and Steve and Jimmy opted for a night in the van whilst I convinced Pete and Dave to return to the scene of the spiked curry. When the cab pulled up the shutters of the shop front/flat were down and despite banging on them for ten minutes we could not gain entry. Pete and Dave had brought sleeping bags with them, I hadn't.

We took refuge in a churchyard/graveyard in the centre of the town and the next day we had a drive to the last gig of the tour. Had it not been for Pete, I doubt we'd have made it. Pete had rung around local spa facilities to try and blag us some free membership trials and crazily one place bought our crap and we got a two hour session in a Bannatyne Spa (thank you Duncan) where we chilled in the hot tub and tried to forget the discomfort of the previous night.

When we eventually arrived at the legendary Adelphi in Hull I did something I've never done before or since, I fell asleep on stage. I know this happened because I distinctly remember drifting off in one song and waking up in a completely different one. Jimmy drove us back to Southsea that night and I rode up front keeping the podcasts coming until we reached the sails of the South.

One band we played with often was the now defunct Horseflies featuring long-time friend and supporter Joe Watson (of Jets Vs Sharks fame) on vocals. We played some fun Southsea shows together and had a great time hanging out at the excellent Washed-Out festival in Brighton where we played along with Camcorder. Camcorder had recently made a record 'Suck' with Leeds based producer and engineer Bob Cooper and knew we wanted to work together on something.

Bob was into our first record which helped things along. We met Bob at the much missed (and wonderfully monikered) Sticky Mike's Frog Bar and liked him instantly. It would be a while until Bob would mix 'Pop Dreamz' at The Chairworks for us but it was probably this chance meeting that prompted us to ask. We'd play again with Camcorder on our first album tour.

Our friend Wayne (Disillusioned Records) who we knew from the Isle of Wight days and was a big fan of Day of the Fight introduced us to David and Engineer Records. David was pushing our first album in his distro and invited us to provide a track, 'Oh, Telephone' for one of the label's 'Lamp Light The Fire' acoustic compilations. From memory 'Pop Dreamz' was originally going to be a split release with both labels but eventually it came out solely on Engineer (IGN271) but in both 12" vinyl LP and digipak CD formats, which worked out great for us, and hopefully for you as well!"

'Pop Dreamz' is a superb slice of punk-pop power and the bright pink vinyl and CD are still available, having been followed up by several ultra-catchy digital-singles and videos, including 'Lovestruck', 'Please Steve, Just Drive', 'Power-Pop Massacre' and their superb Christmas jingle, 'Let's Stayawake This Christmas Eve'. They're a band you want to drive off into the sunset blasting on your car stereo.

Spill Magazine describe The Stayawakes as; *"Full of harmonious melodies and punchy riffs. The entire album is endlessly-playable."*

Crash Doubt added that; *"The Stayawakes sound like exceedingly well crafted college rock ala Norway's Beezewax or Motion City Soundtrack. Successfully hooky and nostalgic for the early oo's indie kids, and easy to imagine supporting The Get Up Kids or sound-tracking a dance in a high school movie. If you've made it through the second series of Stranger Things without Facebook ranting about the death of Barb then I'll bet you've owned*

at least one album that sounds a bit like this. And if you haven't sang along to it in a kitchen drinking wine from a Tupperware container then you were probably dead inside to start with and there's no saving you."

Already Heard said: *"The Stayawakes deliver an energetic, indie-punk sound twinned with infectious pop melodies and an overall hook that's pretty hard to dislike. There's a sentimental, feel-good factor that's evident on almost every track. A sense that the Stayawakes have managed to recreate a sound that has long been untouched."*

And **Post-Punk Press** commented that; *"One of the charming things about The Stayawakes are their nostalgic throwback to the early noughties, scrolling through MySpace band pages until you stumble across a track that really sticks in your head. You'd probably tell all your friends about them, comment on their pictures, message them to say you're a big fan and stick them in this weeks top 6. Featuring eleven tracks, 'Pop Dreamz' toys with various melodies, offering that oh-so-nostalgic sound with a sense of urgent delivery of a modern pop-punk world. If there is one thing that's obviously clear from this album, it's that The Stayawakes are able to create an incredibly anthemic chorus for their tracks – it's almost like The Stayawakes purposefully created a summer road-trip anthem as I can quite clearly picture myself sitting in the passenger's side seat of a car, sunglasses on and the windows rolled down. Displaying a talent for high energy and spot on harmonics, The Stayawakes are yet again showing their dedication, determination and passion for their work and their music."*

https://thestayawakes.bandcamp.com/album/pop-dreamz

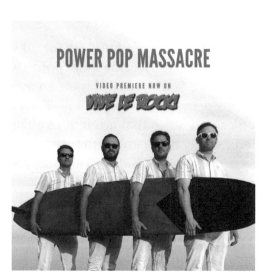

POWER POP MASSACRE

VIDEO PREMIERE NOW ON
VIVE LE ROCK!

THE STROOKAS and TONOTA 80

David Bloomfield : Guitar and Backing Vocals
John Edwards : Drums and Lead Vocals)
Tony O'Rourke : Bass (The Strookas)
Richard Pronger : Bass, Keyboards and Backing Vocals
(Tonota 80)

Sometimes music can be the perfect antidote for all that is bad in the world. Amidst a backdrop of world-wide political upheaval The Strookas, and then Tonota 80 channelled their energy, anger and love into writing perfect, crunchy, power-pop-punk. Their songs are riddled with sweet harmonies and lyrics that attempt to alleviate the banality of living in the increasingly bleak doldrums created by solitary digital escapism and governments who don't give a shit about anyone who doesn't have a ten-figure bank account.

Did they succeed? I think so, but you'll have to judge for yourselves, and in order to do so, I'm going to hand you over to Dave Bloomfield, one of the two main architects of The Strookas and Tonota 80, and let him tell

you the story of one of the best bands you've probably never heard of and the scene they sprung from...

"I was 15 years old when I got the urge to play in a band. When I was 13, I'd become a fan of the Stranglers, the Adverts, Generation X, Buzzcocks, and most of the other punk rock groups I'd see on Top of the Pops. I loved the overdriven buzz of their guitars, I needed to make that sound for myself. When I was 14, I asked my parents for an electric guitar for my 15th birthday, so that I could be a punk rock guitarist by the time I was 16. All loosely went to plan, I was given a Kays catalogue guitar for my 15th birthday, it sounded nothing like Pete Shelley's guitar, and I had to plug it into an old mono record player and turn the volume right up to get any distortion at all, and then it sounded horrible. I had no social life, so at least I was able to spend plenty of time learning to play, and by the time I was 16, I was just competent enough to search for a band to play with. The trouble was, no-one I knew liked the same kind of music as me.

"I heard through the school grapevine that a couple of boys in another class were looking for a guitarist, I 'applied' and got the position, mainly because I knew some barre chords. I'd also acquired a 100 watt, Fal Kestrel combo, which was loud enough to use at a rehearsal, or even a gig. It was very basic and weighed a ton, but by using my exotically named Harmonic Energizer foot pedal I could coax a half decent noise from it.

"Those boys in the other class were John Edwards and Stuart Ellis, and at the time it didn't occur to me that both would become life-long (so far) friends. Stuart's one of those people that work quietly at the back, holding things together (he is a bassist), more comfortable not being the centre of attention. I also consider Stuart to be an honorary member of The Strookas and Tonota 80, being present before, during and after, acting as a catalyst and song contributor. John's more of an extrovert (he is a drummer), he has a great sense of humour and has deep held opinions, especially on politics and music.

"We rehearsed at a community hall in Larkfield near Maidstone, with various other people on extra guitars and vocals, including for several rehearsals, the gravelly voiced, enigmatic Johnny Tucker. We called ourselves Quakerstate, which wasn't even the worst name suggested. John and Stuart's taste in music was more hard rock and blues, styles that I wasn't very capable of, and still aren't, but I was playing with other

people, and it was a start. Nothing much came of our band and it broke up. John and Stuart then started another band with a couple of high achieving guitarists, neither of them being me. We remained friends though and I even helped with lugging equipment around for their new band, Mavis Cruet.

"Meanwhile, through a mutual friend, I'd met Cliff Bailey on the bus to Loose; the village near to where we lived. We were both into the Ramones and Buzzcocks and had soon formed our first band together, Instant Vicar. Two of Cliff's college friends completed the line-up, Ray on vocals and Jazz on drums, Cliff played bass, one that he'd bought from Stuart Ellis. We played our first gig to 20 or 30 friends at Harrietsham village hall on 29th August 1982. It was exhilarating to play on stage to an audience, although I don't know what our audience of friends thought about it, but they clapped and stayed until the end, or at least until their parents came to pick them up. I'm sure it didn't sound great, we were all novices on our instruments, but we made up for our lack of skill by turning everything up really loud.

"After one more gig at Harrietsham, we played our third and last gig at Maidstone College on 30th June 1983. We had a new drummer, John Dean, who could play pretty much in time, which helped. John Edwards and Stuart Ellis were in the audience that night, John remembers Instant Vicar as being painfully loud, or just painful. Then just as we were starting to sound better, amateurish even, if I'm being bold, it all stopped, we broke up. I can't even remember why, but I needed to find another band.

"A few weeks later, a chance meeting with John Edwards in Maidstone town centre led to us and Stuart Ellis getting together for a jam. Soon we had a short set of pub type songs, but with the novelty of both Stuart and me on lead guitars, no bass. In this form we played at John's 20th birthday bash at an events room in The Bull Inn at East Farleigh, near Maidstone. Stuart took up the bass again soon after this and, gradually we started to write material as The Andy Pandys, the name taken from the BBC children's television series.

"The Andy Pandys were a kind of prototype Strookas, our songs also showed an obsession with TV, films and anything ridiculous, but whereas prototypes are usually more basic and unrefined than the finished article, The Andy Pandy's music was more complex, which

kept the songs interesting to play, but made us prone to forgetting where all the various parts should go. From November 1984 to March 1986, we played nineteen gigs, either in Maidstone (including the prison), the Medway Towns and London, there was even some vague possibility that we'd have a gig at Dingwalls in Camden. Then Stuart fell in love and went to a kibbutz in Israel with his girlfriend, and that was it for The Andy Pandys. Our last gig was on March 5th '86 at Churchills in Chatham.

"Not ones to be downhearted, John and I searched around for a new bassist, not having a band to play in was unthinkable, besides being a lot of fun, the urge to make music was irresistible, almost a primal instinct. Our search was short, Cliff Bailey, who I'd been in Instant Vicar with, was available, so we asked him to take over on bass, he said OK, and we started writing some new tunes.

"Our new band was christened The Strookas, which appears in a pulp sci-fi book, by Tully Zetford. Originally The Striking Sex-Crazed Strookas, the name was shortened for what now seem obvious reasons, but at the time it was just too much of a mouthful. What should we aim for as a band? We made a conscious decision to keep the songs simple at first, The Ramones and The Undertones were obvious influences, and when we discovered Husker Du, we veered in that direction. We'd keep the songs short and easy to play, they'd be quick to knock out, and foolproof to play live (that didn't always work out). Most of the early songs were, we thought, humorous songs about indigestion, the size of a horse, broken cars, a Chatham barmaid, doing the washing up, bus rides to Loose, everyday concerns for men in their early twenties. We played our first gig in May 86, at Churchills in Chatham (where we'd left off with The Andy Pandys), and by Autumn of that year we were so delighted with our daft little songs we thought we'd better record some of them.

"We'd found a newly set-up recording studio, Red Studios, just a few miles away at Wouldham (a little village in Kent, England), Graham Semark was the owner/operator, and we instantly got on well with his no farting around approach. Going into a proper studio was a revelation for me, I found it fascinating, so many microphones and leads, inputs and outputs, and Graham somehow knew what to do with it all.

"The way we recorded was always the same at Red Studios, we played all the songs live, drums, bass and guitar, and then added vocals and

extra guitar bits, it was a fairly quick process. Our first demo in October 86 was completed a little too quickly, we'd only recorded four songs (that's the usual amount, I thought) in two days and we had time to spare. In January 87 we came back again and recorded nine more songs in the same amount of time. By the summer of that year we had decided to make an E.P. We'd already sold a semi -official cassette album at gigs, with the unwieldy title 'Bathe in Plankton for a Lifetime of Beautiful Skin', comprising our first two demos spliced together, 13 tracks over 31 minutes, but it was the thought of a vinyl release that really appealed to us.

"In June we spent another weekend recording and mixing four tracks for the E.P. Looking through the music papers we found SRT Records and Tapes, they gave us a quote of £373.75 for 500 7-inch records. We were fine with that price and on October 12th, Cliff and I drove to a factory in Dagenham to pick up our pieces of vinyl (SRT7KS1277, if anyone's interested). In the end there were only 483 records in the boxes we collected, I guess record production is not an exact science. I think we got a discount for the 17 records we didn't receive.

"If you're old enough, you may remember that the U.K. endured a destructive extratropical cyclone on the 15th/16th October, otherwise known as a hurricane. 15 million trees were blown over, people died, and I slept like a baby throughout the night, probably with a copy of our E.P. by my pillow, or nearby, that's what it's like when your band's made their first record. I didn't even hear the tree come down in the road just outside our house.

"On Sunday 18th October, John and I were interviewed by resident DJ Mike Brill, on BBC Radio Kent's, Kent Rocks show, where we excitedly plugged our E.P. We'd been played on Kent Rocks a few times, and whenever we produced a new demo, we'd drop it into reception at Canary Wharf in Chatham and hope to hear it on the airwaves as soon as possible. Cliff and I and our girlfriends would sit in my front room on Sunday evenings, with a drink or two and wait to hear our newly recorded songs, sometimes we even rang the show and requested them. Cliff, John and I had all been interviewed by Mike Brill when we'd had our 'Bathe in Plankton' cassette album produced, thinking we were some mischievous punks, Mike checked with us beforehand that we would behave, he didn't want to go the way of Bill Grundy. We were no trouble of course, we had all been brought up reasonably well.

"Our E.P. had two songs and around six minutes of content on each side, we were told it should play at 33 rpm for best possible sound quality, unfortunately the only pub that accepted it for their jukebox (The Royal Albion in our hometown Maidstone), played everything at 45rpm, making us sound like a punk Pinky and Perky (Punky and Perky?). One thing that I regret about the single's label was having my name as sole writer under three of the tracks, we should have just had "The Strookas" there, it's a group thing after all, and now of course, I can't blame anyone else for those songs.

"As I'd been an avid listener to the John Peel Show on late night BBC Radio 1 since the Autumn of 1977, I thought it would be a good idea to send a copy of our record to my favourite DJ and trust in his good taste (or lack of it) to play it, and on November 17th, John played the slowest track on the E.P. 'What am I Doing Here on My Own', right after Extreme Noise Terror, which must have made us sound like the Nolans in comparison. A friend of ours, Skidge, allowed us to use his short address (a very easy one to remember, as JP noted) for people to buy the record from, and at least a handful of people did.

"A few years later I was in Oxford Street in London and as I was crossing the road to the HMV side, John Peel passed by with a pile of records under his arm. I regret now not chasing after him and telling him how much being played on his show meant to us, but it would have entailed breaking into a trot and I didn't want to alarm him (he may have thought I was going to have a go at him for not playing our record).

"Weeks after the E.P. was released I decided to bodge up some sort of picture sleeve for it, slightly regretting not having had one properly produced in the first place. Loads of my favourite singles had eye-catching artwork, Buzzcocks records come to mind, but our record sleeve would be a more modest effort. With some A4 paper and a lot of cutting and pasting I managed to come up with something that would suffice, a black and white image of three alien beings standing in a desert, one holding a guitar and a flying saucer in the sky. You could read something into the cover, I suppose, I was just pleased that it didn't look too bad, from a distance. That was my first and last attempt at record sleeve art.

"We would go on to make a couple more demos at Red Studios in the 80s and in 1990 we recorded five songs, three of which appeared on our

'Summer to Fall' single. Graham Semark sorted out the production of the record through Red Studios, it made things simpler for us. John designed the cover this time, we were going to have a proper picture sleeve, no cut and paste nonsense. We also realised that the bloke who would master the record was the same one who inscribed "a porky prime cut" on the run-out area of loads of records that I owned. I thought it would be a nice idea to have the same phrase on ours, as I always checked that piece of the record between the song and the label for mysterious inscriptions. We also asked for "horrible old troll" and "well that's enough it" to be inscribed, I don't know what the first one was about, but the second was something Kent Rocks DJ, Mike Brill said to us on our first interview for the show, it just made us laugh for some reason. We asked Graham to ask Porky (not his real name) to fulfil our wish, and he did, although "well that's enough it" got changed to "well that's enough", the original probably sounding too much like nonsense, which was the point. We'd ordered 500 copies of our record, 550 were delivered, I can't remember if we had to pay for the extra 50, I imagine we did.

"Unfortunately, by the time 'Summer to Fall' was ready to pick up from Graham, the band in its original line-up was no more. I'm not sure of the reason why Cliff left, I think he'd been losing interest for a while, and now we had a record that wouldn't be easy to promote or sell at non-existent gigs. I can't even remember sending 'Summer to Fall' off to any radio stations. I did find a few record distros to sell it through, but I wasn't very good at chasing up the sales figures, or was too embarrassed to ask, in case there weren't any. I must have sent some records off for review, as I don't know who else would have, and in Andy Peart's feature on new guitar bands in Spiral Scratch, 'Summer to Fall' was deemed as "a diamond of a single – very second album Mega City 4 and Husker Du influenced". Although in UK Resist, Tom Woolford's opinion was that it's "a bit on the banal side-especially the wishy-washy lyrics which, like the actual music, seem very vague and insubstantial." Fair enough.

"After Cliff left the band, John and I started to look around for another bass player. We didn't have to look far, he was in the pub (The Minstrel Wine Bar) that we frequented. Tony O'Rourke was a few years younger than us, fresher faced, and rumour had it, better looking. Tony also had a bass, an amp and his own transport, so despite his initial overindulgence with light blue denim, he was in.

"Tony was a big Who fan, especially the 'Quadrophenia' soundtrack, perhaps we'd got ourselves the new John Entwistle. It wasn't long before Tony changed his Westbury for a Rickenbacker bass, which seemed to inspire him to develop his own powerful style, reminiscent of Lou Barlow's from Dinosaur Jr. with a bit of Lemmy thrown in. Best heard on 'Cumagutza' Tony's bass is powerful and prominent in the mix, it jostles with my guitar for attention, and sometimes beats the crap out of it.

"After a few rehearsals and gigs, we started to, unintentionally, develop a slightly harder sound. I'd been getting into Jawbreaker, Samiam and Jawbox, and it must have rubbed off on my playing, along with the influence of dozens of other guitar bands that I listened to. Thankfully, John and Tony liked this slightly harder edge, and we were always listening to other bands for inspiration, among them, Dinosaur Jr. Husker Du, Pixies, The New Christs, Bad Religion, and this would naturally bleed over.

"The next Strookas release would be an album, and on the weekend of 14th and 15th of September 1991 we bundled into Red Studios and cranked out ten brand spanking new songs we'd written with Tony. Fuelled with veggie quiche and various snacks, our blood was pumping, and the whole recording has a distinct flow and energy to it. I suggested calling the L.P. 'Deaf by Dawn', due to the high level of volume that we'd insist on hearing everything in the studio. 'Deaf By Dawn' was also a play on the film, Evil Dead 2: Dead by Dawn, which I took John to see one quiet weekday evening in Maidstone. John sorted out the cover for the L.P. and it features our friend Jo Cranfield, sporting one of our t-shirts, the same one her daughter still wears on nights out, decades later.

"After a long wait for a promised release on Vice Records, we were feeling messed about, and decided to have the vinyl L.P. made (thanks to a loan from my parents, partially paid back from our French tour profits) through Graham at the studio. He dealt with the mastering and production, and a few weeks later in January 1993, we drove over to the studio to pick up boxes and boxes of L.P.s. Of course, we hadn't got much of an idea what to do with our 1000 L.P.s, apart from selling them at gigs, and we weren't exactly prolific giggers.

"We did at least send some copies to radio stations, and to our delight, Mark Radcliffe (Radio 1 DJ) played the opening track 'Between the Eyes' on the eve of our French Tour. I'd also sent a copy to John Peel, but by

the early 1990s I'd gotten out of the habit of listening to his show in the evenings, it had become very hit and miss for me. Ten minute techno tracks were challenging to say the least, and it was only a few years ago, and thanks to the internet that I discovered that John Peel had indeed played a few tracks from the L.P. during 1993/4. I'd also sent a copy of 'Deaf by Dawn' to one of the biggest underground publications in the U.S. Maximum Rock n' Rock, where it got a "Potential, but not quite there", citing the singing as flat and too high in the mix. I still need to have that review framed for John.

"More demos followed, in 1992 we recorded nine songs over two days at Red Studios. Late on the first day, John was informed that his mother had died, he went to the studio the next day to record his vocals. I'm not quite sure how he did that. We would usually give our demos names and make tape covers for them (I'm sure other bands do this too). The 1992 session was called 'Sharron' after Sharron Macready from The Champions tv show. The tape cover featured a photo of Alexandra Bastedo behind an old-style microphone, virtually the same picture we would use on our French tour posters. I don't know if we'd intended the 'Sharron' demo as our next L.P. if we had, I think it would have been considered the "difficult second album", as not all the songs are up to scratch, and feel a tad hurried.

"1993's seven song recording was our loudest yet, guitars were double, triple and quadruple tracked, Tony's bass was overdriven to the point of sounding like a power tool and playing it back at volume in the studio sounded like Armageddon. We didn't get round to producing a cover for this one, but it was given the name 'Piece of Cheese' (a twist on "piece of cake"), a phrase that our French tour organiser, Patrick Foulhoux had used to describe the ease which we would (not) drive to the next gig.

"In February 1999, John and I got together again with Stuart Ellis and recorded 6 Andy Pandy's tunes at Red Studios, the only time we'd used a professional recording studio together. This was long overdue, we'd talked about recording some stuff on and off over many years, but it just never seemed to happen. The only other Andy Pandy recordings made were on mono cassette recorders and one session that Richard Pronger (future Tonota 80 member) made of us on a Tascam 244 cassette four-track in his bedroom in 1985.

"A short run of 50 CDRs were made of the Andy Pandy's session, named "halftermlullabies". John designed the cover, featuring an image of

Superman from Max Fleischer's excellent 1940s cartoon series. Lyrics were reproduced and for the last time we adopted our silly alter ego band names, a tradition from the punk era, Bombshell Thompson - guitar/vocals, Hessian Bligh - drums/vocals, Blochin Tackle – bass. On a whim, I sent a copy of the CDR to Fracture fanzine, an excellent publication from Wales, a sort of Maximum Rock n Roll of the Valleys. The review by Dave Taylor was spot on, "I always wondered what Superman was getting up to in that phone box. Andy Pandy's are here dishing the dirt on Superman and his sexual exploits, as well as singing about Dudley Moore's fat arse and all kinds of other silly shit. I get the impression these guys are totally obsessed with bad tv. This band have a camp Britishness about them that reminds me of bands like the Undertones and the Buzzcocks rather than the pop punk bands of today."

"Most of The Strookas 1995 session, 13 of the 17 tracks recorded, plus two more from a 1997 demo, saw a limited release on CDR, sorted out by David Gamage through Scene Police records where he was working at the time. I don't know when it was released, there's no date on the cover, I'd guess around 2000. On the CDs back cover to the bottom right, it states MCRCD004 movingchange records. The previous Andy Pandy's CDR was mcr-cd003, so at least I know this 'Cumagutza' CDR is in its correct chronological order. 'Cumagutza', was a phrase used by one of John's brothers to warn of disaster, as in "If you keep doing that, you're gonna cumagutza." The cover of the CD had a photo of Evel Knievel (one of John's childhood heroes) performing a stunt bike trick.

"In 2000, The Strookas recorded another eleven tracks at Red Studios. This would be our last time there as the band had nearly run its course. Tony was married and would be living in Cornwall in three or four years, the practicalities of playing as a band were apparent to us all. In truth, the band had already been winding down, gigs were few and far between, but at least we had a chance to record some of our latest and last tunes for posterity. After our usual two-day session at Red Studios, we took our tapes away and did very little with them. Looking back, perhaps we could have put out a mini album on cd, 6 or 7 of the tracks would have worked well in this format, but without an ongoing band there didn't seem much point. The songs would not go to waste, though.

"Around 2005, John and I were talking about releasing a compilation of Tony era Strookas material on CD. There had been an ongoing very low-level interest in the band from the odd place in the world. We'd had a

track on a Japanese compilation CD 'The Best Punk Rock in England, My Son', alongside songs by China Drum, Midway Still, Shutdown, Couch Potatoes, Goober Patrol, Funbug, Guns N Wankers, and more, on Snuffy Smile Records. And some of our records were being sold on Ebay for ridiculous money. The time seemed right to put out another Strookas record, it would also give three middle-aged men something to look forward to, apart from receding gums and varicose veins.

"At the time, 'Deaf by Dawn' had only been available on vinyl, so we decided to take a handful of tracks from that record and fill the rest of the CD with the best of the rest of our three 1990s demos and our last one in 2000. I believe this was when I spoke with David again at Engineer Records and he agreed to put the CD out jointly with our own Moving Change Records. We'd had Moving Change Records as our record label name since 'Summer to Fall' in 1990. It had a nice ring to it and is borrowed from the song 'Do the Moving Change' by Aussie rock band Radio Birdman, who we are big fans of.

"John suggested the CD title should be 'What You Want to Hear', a line taken from the track 'Syrup'. Tony, John and I listed our top tracks that we wanted included on the CD, some were obvious choices that we could all agree on, and some we had to 'discuss'. Twenty tracks were chosen and the next job was to compile all the songs for the CD.

"The process of mastering all our old DATs (digital audio tape) and quarter inch master tapes went to our old friend, Graham Semark. Tired of polishing other people's turds in the recording studio, Graham had now set up Cyclone Music, concentrating on cd and record production, mastering, etc at his new premises in a Medway business park.

"John and I sat in with Graham for the mastering session, we'd bought our snacks of course. What followed were many hours of intense, hardcore listening from Graham, sat at his monitoring desk, mouse in hand, occasionally turning round to us to comment, or ask for our clueless opinions. John and I would try, and sometimes succeed (so we thought) in detecting the subtle nuances in sound that Graham would point out, sometimes we'd just agree, not really knowing what was going on. We did enjoy looking at the computer screen though, it was bright and colourful and there was the visual display of "the shape of the sound", looking like a swarm of white digital bees, constantly moving

and dancing to our tunes. Eventually, all 20 tracks were mastered and put in their running order. Graham was also handling the cd production, we decided 500 would be enough, for what, I don't know.

"John was handling all the artwork for the cd and brought up the idea of having Alexandra Bastedo on the cover; she'd already adorned one L.P. - The Smith's live album, 'Rank'. She'd first come to my attention starring in The Champions, an adventure series from the late 1960s that John and I loved. The Champions were secret agents who were given mild, non-budget breaking superpowers by a race of highly advanced monk types, who saved them after their plane crashed in the Himalayas. Along with the lovely Alexandra Bastedo as Sharron Macready there was the smooth good looking American, Stuart Damon (as Craig Sterling) and the more, quirky looking Englishman, William Gaunt (as Richard Barrett). John found an image of Alexandra that he could use for the cover but thought it would be polite to ask for her permission, which he eventually got round to four years later in 2010! I don't imagine Alexandra ever played the cd (she wouldn't have got past the first paradiddle, I suspect) but she was flattered to be our cover icon and even autographed three cd covers, for a small donation to her animal sanctuary that she ran in West Sussex until her passing in 2014.

"Once all the artwork was completed, Graham took over and in a couple of weeks or so, we were able to pick up our boxes of cellophane wrapped CDs. Now we had time to sit back and listen to 'What You Want to Hear' (IGN098) but after all the effort to produce it, were we happy with it? Yes, I was anyway, but I tend not to listen to it all the way through, it is 71 minutes long, and I can rarely listen to any cd all the way through, especially not a double albums' worth. We all have our favourite tracks of course, I'm partial to 'Different Sound', 'Nothing Happens Here' and 'Hey You', all incidentally from our last recording sessions in 2000, and 'Hey You' being the only track from the CD that I've heard played on a U.S. radio show (Signal to Noise). John and Tony's top track on the cd and from the whole of our 14 years' worth (just under 100 songs) of recording, is 'Syrup' (the one stand out track from the 'Sharron' demo), a song without a chorus, but with two guitar solos, a ton of power chords and some highly propulsive drumming. I sang on 'Syrup', but my voice was a bit too shrill, I don't enjoy the song so much because of it, and if we ever re-recorded it, I'd ask John to take charge of the vocals, his are easier on the ear.

"Quite a few copies were sent out for review by Engineer Records, where the CD received reasonably good coverage from fanzines like Suspect Device fanzine. One review, from Japan's Waterslide Records, that after translation, sums up the cd nicely, "The HUSKER DU sound as usual is the most astringent to the melancholy guitar work that seems to be a UK band that pierced the acupoints!"

"'What You Want to Hear' was released 4th January 2006 and as far as we knew that would be the last Strookas CD. Little did we know that faraway, in a distant land, someone that we didn't even know existed was soon to make us very happy middle-aged men.

"Kei Doh runs Fixing a Hole Records, "a small record label in Japan" as it says on the Facebook page, and although I've never met Kei, and only had limited communications on FB, I can feel his enthusiasm and passion for what he does. Which is releasing CDs from the bands that he enjoys. Kei is into punk, he's undoubtedly into lots of other music, but his label mainly releases punk type music, new and old, a good deal of it from the U.K.

"Kei first heard The Strookas on 'The Best Rock in England, Son' compilation cd, on Japan's Snuffy Smile records. Sean Forbes of Rugger Bugger Records and the bands, Wat Tyler and Hard Skin, had invited us to contribute a track to the CD he was compiling. Midway Still (also on the cd) had pointed Sean in our direction after we'd supported them a few times. We were in good company on the CD, other bands included were China Drum, Couch Potatoes (one of Dave Gamage's bands), Scarfo, Venus Beads, Shutdown, and loads more from the UK. We chose the track 'It Makes Me' from our 1993 'Piece of Cheese' demo, it wasn't particularly well mixed, my fault, never ask a guitarist if he wants his guitar louder. We probably could have chosen a punkier song, one that was a bit shorter and minus a lengthy (for me) guitar solo may have been more suitable, but there it was, and it got Kei Doh interested.

"Kei's search for other Strookas music proved difficult though, not only was it hard to find, when he could find it, it was costly. The CDR version of 'Cumagutza', from an auction site in Japan, cost Kei 30 000 JPY! (£180!). It was fortunate for us that Kei was prepared to pay such high prices, as on the cd booklet was John's email, enabling Kei to contact him and find out about more unreleased Strookas tracks, waiting to see the light of day.

"During 2007 Kei got in touch with John and expressed a desire to release some Strookas material on CD. As a fan of the band, Kei's motivation was to share the music and make it more accessible, making a good chunk of our back catalogue available for the first time as properly mastered CDs. In Japan our previously available records and CDR were still very hard to find and expensive, and Kei believed there was a (small) market for Strookas CDs. In November 2007 Kei clarified that he would release three CDs, oh joy! You can't imagine how excited we were that someone was going to resurrect a load of our old recordings, would we be big in Japan?

"Again, John designed the artwork, the first release would be 'Cumagutza', our mid-90s recordings, with some of the 15 songs running at over 5 minutes! There are even a few slower, subtler songs. For the cover, John used an image of the back end of a drag racer, it suggests power and speed, and with the album title, the potential for accidents, and possible disaster. Each CD release would come with lyrics on the booklet/sleeves, more than 40 songs (minus instrumentals) for John to type out and arrange. More CD releases meant digging out master tapes and DATs and a few more trips to Cyclone Music where Graham Semark would work his magic and make everything sound better than ever.

The sound on 'Cumagutza' is quite compressed, it sounds close and powerful, that's the best I can do to describe it. I remember at the original recording, Graham saying that adding compression would suit the songs. I didn't really know what that meant at the time, I expect Graham explained it all, I was most likely too giddy with excitement to soak up all the technical details. I've Googled it now, and I'm still none the wiser, apparently using compression, "narrows the softest and loudest parts of a song, so that it's more consistent in level", that's the explanation for dummies, I think I've got it now.

"'Deaf by Dawn' also got a good mastering. I hadn't listened to it for, I don't know how long, but sitting there in the mastering suite, hearing it blasting out of the speakers, it sounded fresh and full of energy. John used the artwork for the original vinyl release, although zoomed in on the picture of Jo Cranfield a little more, so without "t h e s t r o o k a s" emblazoned across the bottom of the cover, as on the L.P. and due to the jaunty angle of Jo's t-shirt, you get the impression that the band is called The Trookas, only being made aware of the band name if you look on the cd spine. The inside cover features a picture of the band, and we look like

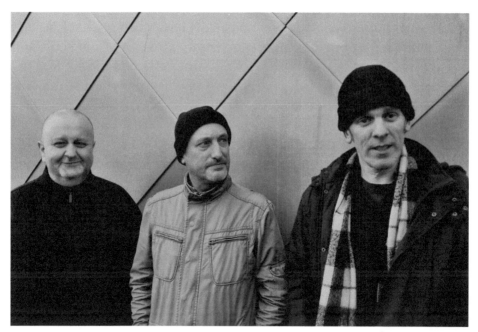

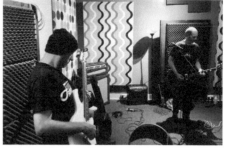

a right bunch of Charlies'. Tony comes off best, with his boyish good looks, blast him! John looks like over eager extra from Only Fools and Horses. I just look too serious, probably ruminating on the state of my hair, and my future days of male pattern baldness. Any future releases were devoid of band photos.

"The last release in the Fixing a Hole Strookas trilogy was 'Summer to Fall', a compilation of our two 7 inches, and our first two demos recorded at Red Studios in October 1986 and January 1987. The 1986 demo was Graham's first job at the Studio, although I don't remember him telling us at the time, probably using the same logic that you wouldn't want your brain surgeon telling you that you're his first job. The sources for most of these old recordings was Ampex Precision Magnetic Tape, those big round spools of tape that I associate with massive whirring computers in sci-fi films and TV shows like Gerry Anderson's UFO (another obsession of John's and mine). I always thought those reel-to-reel tapes looked rather fragile and prone to getting chewed up like their little brother cassettes that you used to see unspooled by the roadside after being spat out by a car's tape player. In fact, when Graham said he would bake the tapes (he had a tiny oven at Cyclone), John and I thought he was joking. Apparently, baking these old tapes makes them playable again, or something like that, Google it, someone else can explain it. Of course, you really need to know what you are doing if you are going to bake your tapes, don't just stick them in at gas mark 6 with your McCains oven chips.

"For the 'Summer to Fall' CD cover John chose an image of the Coney Island Cyclone roller coaster, "roller coaster ride and I'm sinking slowly", being lyrics from title track, John had put some thought into his use of imagery, it's not just thrown together randomly you know. It's a great picture, and it wasn't the first time it had appeared on an album cover, The Red House Painters also used the image to good effect on a 1993 L.P. In fact, there are tons of albums with roller coasters on the cover. The Cyclone seems to be a popular one to use, and somehow it seemed familiar to me from my distant childhood, but it took a while for me to realise that's it's the same one (well, a model of it) that "The Beast from 20 000 Fathoms" rips up in a stop motion frenzy in the film of the same name, one that I'd loved from a young age.

"One by one each of the CDs was released, 'Cumagutza' on December 31st 2008, 'Deaf By Dawn' on January 31st 2009, and 'Summer to Fall' on

February 26th 2009. With these releases and the 'What You Want to Hear' CD, a listener could get a good overview of our fourteen years as a band, and I suppose the music reflects how we were as people at the time, from our chirpy early twenties to our slightly less chirpy mid-thirties, still extracting some fun from being in a band.

"Around 2007, and for a few years after, John and I would meet up with our old mate, Stuart Ellis, when he came to London for work, a long drive from where he lived in Cornwall with his family. Naturally, we got together with our instruments, sometimes at The Premises in London, or NSP rehearsals near Maidstone. We gave ourselves a name, Macready, another reference to Sharron Macready from our beloved 1960s TV series, The Champions. Over the course of just a few, very spread-out rehearsals, we managed to knock together a couple of dozen songs. We talked about recording some material, but it never happened, and our musical meetings dried up, although we still saw each other socially, as time and distance allowed. Some of the tunes we produced were pretty good and luckily, weren't easily forgotten.

Moving on from The Strookas to Tonota 80...

"Good things can happen through the internet, and it was two lovely ladies who unwittingly instigated the next chapter of John's and my musical odyssey. Through Facebook, my wife had been contacted by Marion Bush, the partner of a very old friend from the 80s, Rick Pronger, who was in the process of remastering some old recordings that he'd made of my first band, Instant Vicar. Rick was one of those people, and there are others, who I just lost contact with for no reason that I can recall. I used to hang around with Rick at Sharon Music, a musical instrument shop in Maidstone where he worked. It was a good place to drool over expensive guitars and dream of owning a decent amplifier. Rick is a multi-talented musician, who could still appreciate a bit of musical roughness, and it was high time I connected with him again.

"I met up with Rick at his little studio in Boughton Monchelsea, a nicely fitted out shed/ outhouse, next to his mum's house, a few hundred yards from where he lived with Marion. It was great to see him again, we caught up on our history and soon the conversation turned to recording. Rick's recording equipment and experience in using it had improved greatly and he wanted to record our band, but in 2014 there was no band. I contacted Cliff (the original Strookas bassist, and still local) to tell him

that we had the opportunity to do a some recording, for free, he agreed to be a part of it, and we arranged some rehearsals to get up to speed, we even wrote a new song, 'Daylight', which was one of the four (the others being 'Put it on the Shelf', 'Just As I Thought', 'Is There Any Reason') we recorded.

"The recording was fun to do, the first time for me in 14 years, we even played a one-off gig in Sheerness. After the dust had settled on this episode the thought occurred to John and me, that perhaps Rick would like to find his inner punk and play in a band with us, after all we were more in the Glen Matlock camp of punk, enjoying catchy tunes and playing "wanky Beatles chords", as Steve Jones said about his ex-bandmate. Rick was more into rock/prog/pop, all manner of styles, punk wasn't really his cup of tea, but he did warm to some of the bands that found themselves labelled as 'New Wave'. Martha and the Muffins were one of these bands, 'Echo Beach' being a very influential song for Rick. We understood where Rick was coming from, his input could guide us into new musical areas, the possibilities were exciting, and when Rick agreed to play bass with us, we were delighted, and looked forward to getting started.

"We need a name though, and I went back to pulp sci-fi novel by Tully Zetford, that I took The Strookas from. Tully Zetford, real name Kenneth Bulmer, was a prolific writer, and lived for a time, until his death in 2005, in Tunbridge Wells, where The Strookas had played on several occasions in the 1990s, and I'm wondering if he ever saw a poster or flyer for a gig with our name on, and thought it sounded familiar. The name chosen was Tonota 80, a futuristic weapon, also a town in Botswana.

"Rehearsals began at NSP in Boughton Monchelsea, just round the corner from Rick. With the dynamic of a new bassist, we took a little time to work out how we would sound, but as I was still the guitarist and John was still the drummer/vocalist, we didn't sound a million miles away from The Strookas, but with the influence of every piece of music that we'd enjoyed and absorbed over the last few years.

"The inclusion of Rick as a musician and producer/sound engineer/pianist/bassist/backing vocalist, brought a raft of possibilities floating our way that we'd not previously been able to access. Due to our usual, strict "two days and that's your lot" in the studio, way of doing things, the vocals had never reached their full potential, it was the

element that we should have worked on more when recording (and live, for that matter), but time and money was limited, and it was a case of just standing in front of the mic, and banging it out, usually in one take. With Rick taking charge of the recording, time was not such an issue, we could take some care with the vocals, even create layers of harmony, we could go the full Beach Boys!

"We decided to record five songs for our first CD, four of the best that we'd written with Stuart in Macready, and one new one, 'Can't Buy an Emotion', that I'd worked out some chords for (John later wrote the lyrics) and we'd only played as an instrumental at our last ever get together with Tony.

"Recording took place from April–May 2015 in Rick's small studio in Boughton Monchelsea, a pretty area, you can feel like you're in the country, although the busy county town of Kent, Maidstone, is only a short drive away. The place always bought back happy memories for me, I would play in the nearby Boughton quarry as a nipper in the 70s, having paid no attention to any of the dark, disturbing public information films warning children not to play in such areas, in case they drowned in pool of cow faeces or were impaled with farmyard machinery, luckily, none of this happened to me, or I wouldn't have had been able to appreciate Rick's mum's gorgeous garden, which helped us all to unwind during breaks in recording.

"The drums needed to be recorded first, but just fitting them in the tiny space available caused a few problems, and a trip to the toilet involved some tricky manoeuvres past the hi-hat. With John installed, Rick and I played along as a guide and something for John to listen to, to hopefully get his excitement levels soaring, and of course, John rose to the occasion, he never gives much less than 100% on anything we've ever recorded together. Space was a minor problem for my Marshall combo too, and my amp had to sit on its side in the toilet, with just enough room to relieve ourselves, if we made it past the drums.

"With the drum parts recorded and John packed off back to London, Rick and I picked a day for recording my guitar tracks. Rick used a Korg D3200 to record all Tonota 80 stuff, he has two, as they can be temperamental and even overheat. I used my Epiphone Wilshire for most of the guitar parts on 'Jonesing for Chips', played through a Marshall combo and double tracked, which I reckon, gives more depth than just the one track

panned either side of the speakers. I think Rick's bass parts happened next, he uses a five-string bass, and the lowest note he can play is almost bowel loosening, I wouldn't want to hear it through a massive P.A. - it could be messy. Rick's parts were all done and dusted when I came back to add even more guitar parts, solos and odd twiddly bits. Rick has the patience of a saint, which is good, because I'm not the most precise guitarist, and some parts were made up on the spot, with me having to practice them repeatedly before they were good enough to record.

"I'd sung the main vocals on the four Macready tracks when playing with Macready, and that's what I'd intended to do here, but John wanted to try singing lead on 'Out of Days', which was fine by me, maybe it would have worked even better if John had performed all the vocals, but in the end, I did three, and John did two. My vocals are more erratic, higher pitched, John's are more measured, almost operatic, sometimes he sounds a little like Bob Mould of Sugar and Husker Du. Rick would sometimes double track the vocals, and then painstakingly pick out the best performed lines for the finished song. After John and I had completed all our parts, Rick added his backing vocals, which John and I always looked forward to hearing. Finally for the last song on the CD, 'Rabbits', Rick added some keyboards.

"Unfortunately, there are no divas or complete bastards in Tonota 80, we're just three balding men, getting along nicely with each, co-operating to produce music for our own pleasure. I'd love to report fights and fallouts, it would make for a spicier read. Rick forgot to put sugar in my tea once, and I had to ask him for some, that's all the drama I can offer. Sorry.

"After everything was recorded, Rick went through the long process of equalisation, the twiddling of knobs to make it all sound lovely. Mixes were made and approved by everyone after some adjustments in levels, I expect my guitar would need to be turned up, and finally we're ready to master our new baby, so it's off to Graham at Cyclone Music, more snacks, some daft humour and another chance to watch the sound bees swarming.

"John produced the artwork, the front cover being a photo of the view through a window, of possibly, a derelict house, the bright sun penetrating past the leafless trees. Looking at the same image on the reverse of the lyric sheet, you realise that the front cover is only half of

the photo, the extra information shows the bottom half of the window, looking worse for wear, and outside, what looks like rail tracks, the small branches across the rails suggesting it's not in regular use. The whole thing reeks of alienation and decay.

"If mid/late periods Strookas lyrics gave the impression that we were growing up a little, then Tonota 80 lyrics, subject matter and imagery confirmed that. Songs about alienation, terrorism, death and alcohol all feature on 'Jonesing for Chips'. The record title doesn't really have any relevance to its content, it's just an appealing phrase used by a friend, Emma Griffiths, who moved to the U.S. many years ago. Substitute "I have a craving" for "Jonesing" and you get the meaning. Emma is also a brilliant artist and produced a splendid tape cover for our 1988 demo 'Nothing Happens Here', she works as a tattoo artist in upstate New York.

"Kei Doh of Fixing a Hole Records had the CD pressed in Taiwan. Unfortunately, any information on the cover and cd that Fixing a Hole Records were involved was omitted, so the batch of CDs that were sent to us looked a little sparse. More CD covers were printed up for fix-70 and David Gamage at Engineer Records also kindly agreed to have the CD available in the UK through his label and distro.

"We sent off a few copies of the CD to radio stations and were delighted when Steve Lamacq played 'Can't Buy an Emotion' on his Radio 6 Music show, and the following week gave 'Out of Days' an airing too. This sort of exposure really makes your day, you feel like you're doing something right, but all it really means is that by chance, someone who can play records on the radio, chose to play one of yours.

"It still felt good, though, and I was pleased that 'Can't Buy an Emotion' got played. It's possibly the best song that we've recorded, and the only song of ours that has been covered and recorded by another band, Catalina, from Japan, who have made it their own. On Soundcloud, it's had more plays than our version on YouTube! Now I'm thinking, do we owe some of our views to Catalina fans checking out our original?

"During the rest of 2015 and most of 2016 we spent some of our spare time writing new material for an album. I'd recorded lots of ideas for songs on my Zoom 4 track recorder, and sent them by email to John and Rick, if the consensus was that they "had legs" as Rick would put it,

we'd bash them out at rehearsals and refine them as we went. Sometimes I'd just perform a guitar part or complete a song at the rehearsal and see if anyone approved, if not, we'd just move on to the next set of chords. John wrote most of the lyrics, I managed four and a half songs' worth, the half being the chorus on 'She Let Go'. Amongst the varied song subjects, cultural references, in the form of film and tv crept back in.

"The WW2 desert based British film 'Ice Cold in Alex' (1958) was inspiration for 'She Let Go', particularly a scene where Sylvia Simms character lets go of, or doesn't secure a crank type thing, enabling a truck, that has been gruellingly manhandled to the top of the hill, to roll back down again. It's a quietly devastating scene, (considering the desperate situation the small group of travellers is in, low on everything, and menaced by the German Army) it always gets me teary, almost as teary as Sylvia's character. To top it all, Sylvia's fellow travellers make no recriminations against her, and John Mills' (her love interest) reaction is wonderful, "Let's get a little exercise, shall we?" he says, and off they go, up the hill again.

"The first line of the chorus was taken for the album title 'Killer Sands and Beating Hearts', and an image of Sylvia Simms from the film is used for the album cover. I love the expression on Sylvia's face, there's a lot going on there. I'd advise watching the film to understand most of it but be aware that you may feel the desire to drink Carlsberg lager during the final scenes (something the marketing men exploited), better get some cold ones in the fridge.

"It's funny, the odd things you notice when staring at photos for extended periods. While examining the CD cover, John got a little distracted by Sylvia's second and third fingers of her right hand, the very end segments seem to veer off at a 90-degree angle, holding onto her water canister, when the rest of the fingers are straight. It does look a little odd.

"John's favourite film 'Eternal Sunshine of the Spotless Mind' also gets a song dedicated to it, 'Montauk'. Montauk is a village on the end of the Long Island peninsula, New York, it's well known for its beaches. It's also a pivotal location in 'Eternal Sunshine...', which inspired John's love for the place and the road trip he and friend, Lizzie Black took from Manhattan to visit, while on one of his regularly holidays in New York,

another place he fell in love with, this time through U.S. films and TV from the 70s.

"'During the War' is a song about warfare, and how most people in the western world experience it through television, in the comfort of their homes. At the time of writing the song (2016), I was thinking more of the war on terrorism, but now that there is an ongoing war in Ukraine, there is even more content available through news outlets, online, YouTube etc, and I find myself watching it too, becoming one of the spectators in the song, sitting around watching TV and eating pizza. My line of thought took me all over the place with this song, from 'The Sound of Music' to the many war films shown on TV in the 70s, on BBC1 on Saturday nights, or BBC2 on Saturday afternoons, to an episode of 'Dad's Army' and hideously iconic adverts for shampoo and cosmetics. Not bad for a sub two-minute song.

"With twelve songs ready to go, recording followed in the summer of 2016. It took John less than a day to perform the drum tracks, by now we were becoming quite adept at squeezing ourselves past the kit and into the toilet. My guitar sound was different again, a bit more fuzzed out, after 37 years of playing, I still hadn't found a sound that I could stick with. Listening back, the album has a very distinct flavour, due to the white-hot guitars, maybe too hot sometimes. Rick comes up with some more, rather lovely backing vocals on most tracks, I supply a couple of lead vocals, and John takes on the rest. Rick also performs keyboards on several tracks, plus a gorgeous, complimentary, extended piano piece on 'No Good', the last old Macready song we would record.

"When Rick had recorded and mixed everything, we took yet another trip to Graham Semark's mastering suite. We kind of jumped the gun in respect to getting the CDs produced and just went our own way, getting Graham to deal with pressing, and it was only a little while later that the CD was available through Fixing a Hole Records (fix-84) and Engineer Records (IGN239). We always seemed to have doubts that anyone would really be interested in what we did, and a little surprised when they were.

"A big "doh!" moment came when John got the CDs. Two tracks were in the wrong running order on the back cover, oops, we'd all had the opportunity to check it, and I guess in our scrutiny of the tiny details, the bleeding obvious had escaped us. Another batch of sleeves were ordered,

giving John the fun job of inserting CDs and lyric sheets into every one of them.

"Over a few weeks, we picked three tracks for digital singles, used in the same way as seven-inch singles were to promote vinyl albums. In order of release, they were, 'Could do Better' (Rick cites this as his favourite song of ours), 'She Let Go' and 'Montauk'. Videos for each of the songs were uploaded by John to YouTube.

"Our chosen singles were sent out to radio stations and podcasts, David at Engineer did a lot of work on this, Dave is another of those enthusiastic music lovers (also a fine guitarist, having played in many bands) who have a real passion for what they do. John and I have known him since we met him at The Rumble club, Tunbridge Wells in the early 90s and we have great respect and love for the man.

"I didn't realise just how many small independent radio stations there are, it's a lot, and I have no idea how many people listen to them, tens, hundreds or thousands? No matter, we were just happy that someone could be bothered to play our songs, and that Engineer Records had promoted them for us.

"'Killer Sands and Beating Hearts' was released in January 2017, it took us three years to release the next album. At the time there was no certainty that there would be another album, we were not young men, and we've all got our various ailments, but once we'd got it into our heads that we could squeeze out another record, we became a well-oiled, slightly rickety machine. We must have gone through a couple of dozen songs in rehearsals to finally whittle it down to the 14 that we'd record. Some of the tunes we discarded weren't bad at all, but there would be some element to them that we weren't satisfied with, so out they went.

"Recording took place between May and July 2019. Rick's studio (shed) had been sold with his mum's house when she passed away, so we had to find somewhere else to record John's drums. Rick suggested that we use the room that Rick's partner, Marion, had used for her dog grooming business; it was more of a utility room attached to their house, Rustling Cottage. Rustling Cottage is not a big place by any means, but it had an attic room that could be used for recording everything but the drums. After checking out the ex-dog room, and with a bit of clearance, it was deemed suitable, and just big enough to host John's kit, which sits in my

shed, gathering cobwebs. Only the cymbals, high-hat and snare gets used for rehearsing, we hire the rest, as we wouldn't be able to load it all into my car.

"It took two trips to take John's kit round to Rick's place, I was huffing and puffing, carrying the drums from my shed, down the garden and round the front to the car. I'd just got an asthma diagnosis and my medication wasn't properly ironed out yet, and when it was there were side effects which would diminish my input to the recording.

"John only plays drums at rehearsals and recordings, he never gets to practice on his own, which makes him a remarkable drummer in my book, even more remarkable is the fact that he has MS, which gives him various symptoms, sometimes his legs literally let him down. You'd never guess this though when you've witnessed the man going full pelt on the drums.

"John, who is the youngest sibling of eight, only started playing drums because his older (by eight years) brother Graham, had a kit in the house, and played in a pub/club band called One for the Road. John would play along to the current hits of the day, mainly from the glam rock era, although with five brothers and two sisters, he would be exposed to a wide variety of music, including Mantovani, Elvis Presley, Abba, Curved Air, Frank Sinatra and The Carpenters. Sadly, Graham Edwards passed away in June 2022, and I doubt whether John and I would have played music together without Graham's influence, and drum kit, of course.

"We'd virtually sealed ourselves into the dog room to prevent sound leakage, the sound of a drum kit at full throttle is obviously very loud and can carry a long way. Rick sourced and sorted out some soundproofing material for the walls and an old piece of carpet was slung over the loose-fitting door. When Rick turned on his recording desk there was some buzzing from the lights, so a lamp was brought in from the house and the session carried on in the dimness. Again, our guitars were used to give John a guide, but even at full volume, the headphones couldn't compete with drums at such close quarters, so all we got was a distorted mess in our ears, which was still better than nothing.

"It took a day, not even a whole day for John to record the 14 drum tracks. Some of the songs sounded too fast to me, I was wrong though, they worked fine at the tempo John went with, although they would be a

challenge to keep up with when recording my guitar. John drummed exuberantly, thoroughly enjoying the experience, Rick and I were impressed, it was very loud though. We hoped we didn't annoy the neighbours, some noise would have got out, but Rick's neighbours were very understanding, perhaps he'd promised them a copy of our future CD.

"With the drums safely recorded, Rick and I could get on with our bits and pieces. I was recording my guitar parts using pre-set effects on a multi effects machine, the sounds I could produce were equal or better than anything I could achieve through my amp. I'd been at Rick's weeks before the actual recording, checking out all the various guitar sounds and eating Eccles cakes. I wanted to find the right sounds for the songs we would record, there were dozens to choose from, I tried every one of them and I narrowed it down to a handful that I could use, I even made notes on a sheet of A4.

"Recording the guitar happened at any time it was convenient for Rick and me, usually in two or three, hour sessions, any more than that and my levels of concentration would dip. The main rhythm guitars, mostly double-tracked, were easiest to perform, it's all the fiddly bits that challenge me, and as on the last record, some parts were made up on the spot, under Rick's patient gaze. Rick, as usual, completed his bass parts in private. I've never witnessed Rick recording his bass, or his backing vocals, I've never even heard him sing, only on the recordings we've made. Rick's playing is so precise and tight, and to think that guitar was only his third choice of instrument to take up (making bass guitar his fourth, I presume), after drums, and second choice, keyboards.

"I was on my asthma medication properly now, and as I was getting used to it, one of the side effects was to make my voice hoarse and croaky, especially on the higher notes. I decided not to try and sing any lead vocals, which was a shame as I'd written lyrics to six of the songs, and even though I was never going to sing all six, I kind of fancied trying a couple of them, as I had my own ideas for melodies. John did a sterling job on the vocals though, he has a powerful voice, and when it came to the backing vocals, my voice had improved a little and I was able to contribute a few low frequency lines, and a bit of "ooing" on 'Back to the Sea'.

"Most of the tracks feature Rick's keyboards, never flooding the songs, just effectively placed, of course we would have preferred to have Jools Holland playing some boogie woogie piano throughout the album, but

627

you can't have everything. We had to accept that one track wasn't quite working, it was one of the two songs that John had worked out words and music for 'This Summer' (the other being 'Caramel'), a few mixes were made, one with the drums coming in halfway through, and a couple of other variations. I think it was John who suggested scrapping the drums altogether and doing the whole song from scratch with a sparser acoustic guitar backing. This was a revolutionary move for us, I felt like we'd moved over into the easy listening section, rubbing cardiganed shoulders with Perry Como. It's the quietest, slowest song we've ever recorded, and you'd barely know it was us, if it wasn't for John's vocals. Rick performed the acoustic guitar on 'This Summer' with precision, I've dabbled with an acoustic, but not it's my forte, I might get it right eventually, but the dead and fluffed notes would be painful for anyone listening in. I do supply a couple of quiet subtle parts and a wibbly wobbly sounding solo on an electric guitar, but I could put my feet up for the first half of the song.

"Subject wise the songs are a mix of the personal, 'Apples' a song about the childhood John missed out on, because of his dad's relatively old age. 'Caramel' and 'This Summer' and 'You Still Mean Something to Me', make up John's 'Eternal Sunshine/Atlantic themed trilogy, about an unsuccessful attempt at a long-distance overseas relationship.

"There are a few current affairs themed songs, 'Shake up the World' and 'Pigs Will Fly', where we sound like we're singing "f+++ing booze", on the chorus, but it's actually "fags and booze", which still wouldn't go down well in America, fags meaning cigarettes in the U.K. 'Everybody's Famous' is a rant on the fleeting nature of fame, it's very lyrically driven, and packs in a lot into its two minutes and 16 seconds running time. Things get a little surreal with 'Draper's Cool' inspired by a 1960s based dream that John had about the TV series 'Mad Men'. I've not seen the programme, but the lyrics are very evocative, I'm just not sure what of. My guitar was taken out for the first verse, so there's a nice bit of what could technically be called, drum n' bass, with John grooving on an odd drum pattern (it sounds odd to me).

"Things get a little more bizarre with 'Cold Skin', a song inspired by a horror film. I enjoy a good horror film, and plenty of bad ones too, and even though it's not well known, 'Cold Skin' (2017) just struck a chord with me. It's basically about the relationship between two men and a semi- aquatic female, living on a lighthouse on a barren island around

the time of WW1, they are also being regularly attacked from the sea by more semi-aquatic creatures. It's all a bit 'Assault on Precinct 13' with a helping of 'The Shape of Water' thrown in, it's delightfully gory. The strange, aquatic female is quite appealing, and mute apart from a high-pitched prolonged warbling cry that Rick emulates with his backing vocals. Alberto Sanchez Pinol's novel 'Cold Skin' is gripping and wonderful. I read it on holiday, by the sea in Weymouth, Dorset.

"Another water-based song is 'Back to the Sea', a slower track, packed with harmonies, some wonderful ethereal keyboards, and John's best vocals on the album (in my opinion). I have a thing about the sea, I need to be by it every now and then, I find it very calming, and it takes you away from worldly worries. In the song, our couple, walking along the beach, admiring the stars one night, enter the sea and de-evolve into aquatic creatures for a simpler life. It sounds like the sort of life you'd be fine with for a week or two, but you'd soon get fed up with being wet all the time. The sound of the waves gently rolling up the beach were recorded in Sidmouth, Dorset, you can just hear the distant cry of a seagull, before it attempts to steal my sandwich.

"Two rockers on the CD, 'It's Been a Day' and 'Coffee in My Veins' are our state of mind and body songs, and musically, two of my favourites. '(I Will be Your) Astronaut' is a love song and John's take on the Powell/Pressburger film 'A Matter of Life and Death' (1946), titled 'Stairway to Heaven' in the U.S. Rick's bass line is the best on the album, it's all over the place.

"'Remember Me', is superficially an unrequited love song, but with sinister undertones of stalking, inspired partly by the 1965 film 'The Collector' based on John Fowles novel. Rick thought we'd got the mix just right on this one. The clicking at the start of the song was from a genuine old-fashioned camera (Rick just appeared with it), and it alludes to the first line of the song "Just one click and you're there, caught in the frame".

"John produced the artwork, using an image of an old tv set on a chair, in a blue room, in John's words. "The idea behind the cover was that as a kid, 'fame' to me was watching famous people on TV and as I got older, I admired those people cos they worked hard and were predominantly entertainers who had worked for fuck all for years in variety shows, etc. Now, fame isn't really something to aspire to. Reality TV was the last

straw. It makes me feel empty inside, so I wanted the TV to be turned off in an empty soulless room to depict that feeling. It was also the type of TV my parents had. It also does have that Americana 60s look which I'm obsessed with."

"Again, Graham Semark got the cd production job, were we so uncertain of ourselves that we had to go the DIY route again? Kei, at Fixing a Hole Records, was unable to release it at the time, and why we didn't approach David at Engineer in the first place? I don't know, although 'Everybody's Famous' (IGN282) is now available. Perhaps we were like excited toddlers desperate to get what we wanted in the quickest possible way. The boxes of CDs were delivered to John in time for a 1st January 2020 release, just as some bat/human interaction was about to disrupt nearly every aspect of human life.

"Thanks to Dave Gamage mailing out CDs, 'Everybody's Famous' got some decent reviews, in English too, which made a change from the mainly Japanese reviews we'd been given for previous Strookas and Tonota 80 releases. Japanese doesn't always translate well using Google translate, but you can usually get the gist. Our first four reviews were rather good, perhaps there are some bad ones that I haven't seen yet, I'm in no hurry. Husker Du, Descendents and Moving Targets were among the bands we got compared to in Razorcake, Thoughts Words Actions and Fear n Loathing, and I particularly liked Tim Cundle's remarks in Mass Movement "Every single time I play 'Everybody's Famous' I inevitably find myself thinking "Oh, so that's what Snuff would sound like if they played Smiths songs…".

"As far as airplay went, I contacted many of the stations (online, regional, podcasts) that had played us before, and a few new ones. I always checked out the station first, to hear some of the content, there would be no point trying to interest a gospel music station. Usually, a polite, short, friendly email and an MP3 song attachment is enough for a play on most shows, it's also good form to follow and 'like' the station if they have a Facebook page. This probably sounds obvious and kind of quaint, but it was all new to me. I was quite astonished by the quality of music played on independent stations, there's a real underground feel to most of them, and loads of punk, pop punk, hardcore, post punk being played.

"I think 'Everybody's Famous' is probably our best record to date, we all seem to agree on that, and I guess it must be a good sign that John, Rick

and I can play the CD, two years on, and still enjoy it. Rick's production is also rather incredible for someone who had to learn on the job. I sometimes message John and Rick to tell them I've recently played it, and we give ourselves a little, virtual pat on the back, sounds pathetic I know, but when you've been given another chance to do something you love, you got to celebrate it occasionally.

As you can see, when Dave gets going he can talk the hind legs off a donkey, but I love all this sort of thing, so like a glutton for punishment, I asked him to tell me about his favourite gigs and venues...

"The Strookas played around 130 gigs over 14 years, not exactly the hardest working band in show business, plenty of bands play more gigs in a year than we did in our band's lifetime. To be a little fairer to ourselves, there wasn't any music scene to speak of in our hometown of Maidstone. When I was a little younger in the early 80s, I went to a lot of local gigs and saw a wide variety of blues, rock, punk and new wave type bands. From 1986 to 2000, when The Strookas were actively gigging, I wasn't aware of any network of bands beavering away, improving the lot of local groups, or maybe there was and nobody wanted us involved. There were a few pubs that we played at in the mid to late 80s, John and I already had experience of some, playing in The Andy Pandys. There was The Star Tap (bikers pub), The London Tavern (bikers pub), The Royal Albion (bikers pub), those bikers were a thirsty bunch, must have been all that dehydrating leather they wore.

"A few indie clubs sprang up in pubs here and there in Maidstone in the early 90s, like Trader Jacks, Trotters and Trotters 2 (the last two sounding like a pig-based horror film franchise), but all our gigs there were on Sundays, Mondays and Tuesdays and weren't well attended, understandably. At the weekends, the clubs mainly hosted discos, for people wanting somewhere to go after the pubs had closed.

"An early gig at The Royal Albion led to the landlord ordering us to stop playing. Cliff, thinking on the spot, said we had a coach load of fans coming down from London, the landlord reconsidered and let us carry on, probably regretting it immediately when our guest singer Ray (a.k.a. Hedley Sidewinder) from Instant Vicar, came on in his usual outfit (for stage, not work) of flashers mac, flippers, green y-fronts, black wide brimmed hat and a vicar's collar. Ray also brandished his new vibrator at the bemused audience, in a rather demented fashion. It wasn't long

before we'd exhausted all the Maidstone venues that would have us and playing our hometown became a rare occurrence.

"Churchills, in nearby Chatham, was a venue we ended up playing a lot, twenty times in all, including twice with The Andy Pandys. Churchill's is a largish pub in Whiffen's Avenue, near the town centre, you either played upstairs or downstairs in the basement, the main pub area being the ground floor area. I preferred playing in the basement, as there were fewer steps, the sound was better too, having a low ceiling, and best of all was the groovy zebra skin pattern carpet.

"Our earliest gigs were a bit unsteady, we'd probably had around eight rehearsals to write and learn our new songs, and being brief, we needed a lot of them to fill a set, that's plenty of chances to make a bollocks of them. From May '86 to December '89 we played Churchill's 18 times, all with Cliff on bass. I'd like to take the opportunity to apologise to anyone who saw us those 18 times, I presume it was just the bar staff, who had little choice.

"The gigs kind of blur into one for me, some must have been better than others. Only a few memories stick in my mind; the dog that ran around us when we were playing one night (we attracted a wide audience); the time I nearly got my teeth knocked out by the microphone when some moshing punks accidentally (?) shoved the stand my way; the soundman for another, more pro sounding band, calling us "that shitty punk band" when he thought we couldn't hear; the time we appropriated a Milkshakes song 'Pretty Baby', not knowing that Bruce, their drummer was in the audience, although, true to their non-serious attitude, he only shook his fist at us in mock anger, as he left. I loved the Milkshakes, a 60s garage punk outfit with Wild Billy Childish, they were a big influence on me in the early days, performance wise. It may have been that same night that renowned vocalist and harmonicist, Jim Riley, jammed with us on 'Pretty Baby' with his harmonica, which I presume he always had about his person, just in case.

"In the Medway Towns and especially at Churchills, there were bands we played with more than once, gigs nights at Churchills usually had at least two bands playing, and there wasn't a limited pool of them. The Love Family played melodic, grungy garage music that we all enjoyed (Cliff ended up on bass with them), their songs were less up tempo than ours and their intent more serious, we seemed to get on with them though.

Somersault were an excellent band we played with a few times, they blended elements of Swervedriver and Teenage Fanclub with their own identity, they should have been better known.

"I'm not sure if I could call the people in the bands we played with 'like-minded', we quite often liked similar sorts of music, and our motivation to play in bands was born out of the love of doing it. Perhaps other bands were more ambitious, but at the time, it just seemed that we all wanted to do was have fun and live in the moment. One of the nice things about Churchills was that at any gig, you would see plenty of other band members in the audience, and not just ones that were playing that night, it was a very friendly, social atmosphere.

"There was already a strong music scene in Chatham by the mid-80s, bands like the Milkshakes, the Prisoners, the Dentists and the Claim being the main players that stood out to me. Mark Matthews of the Dentists also helped run The Medway Band Music Co-op, which organised gigs and events for member bands, one of those being The Strookas. There were even a couple of cassettes released by the music co-op, Blabbermouth Vol.1 and Vol.2 (which we appeared on) showcasing the bands music. Maybe I'm a little naive but I don't remember there being a lot of rivalry between the bands, just support, and even though we weren't a 'Medway Band'' as such, (a narrow stretch of the River Medway does run through Maidstone), we felt welcome enough, and seemed to find an audience in front of us when we played (mostly).

"Sometime in 1987, we met punk guitarist F (a.k.a. Martin Vaughn), it was either at a gig we played at Churchills, or a gig we shared with F's band, (All Flags Burn, the Isle of Sheppey's premier punk outfit) at Club Musique, in Maidstone. F's and my memory differ on this, I suppose I need to trust my memory, if not, then everything I've written is suspect. I particularly recall the Club Musique gig, as the barmaid let us know in no uncertain terms, that she thought we were the shittiest band she'd ever seen there, and that I was of the ugliest people she'd ever come across, bless her. It was a Tuesday, Eastenders was on telly, and she had to put up with my ugly face and shitty band. As far as I know she was fine with All Flags Burn's sharp set, being a discerning music lover, she would have enjoyed their original brand of political post-punk.

"We played lots more gigs with AFB, they were good lads, and even though our styles contrasted, we could share a punk double bill and

633

satisfy most spikey haired audiences. We even got asked to play on THE ISLAND, we were happy to, we'd only got as far as Bethersden (17 miles from Maidstone) at a friend's dad's pub, where we didn't go down well with the unimpressed bikers. Perhaps we'd fare better on the Isle of Sheppey (19 miles from Maidstone), virtually another country, and to get there you had to drive over the Kingsferry bridge, it wasn't exactly the Dartford Crossing, but who doesn't like a bridge?

"It turned out that the Isle of Sheppey was the last bastion of punk in the county of Kent. That was the feel of the music scene there in the late '80s, plenty of old school punks, still in bands and influencing newer bands. Lead singer of AFB, Ron Millichamp, also helped set up the Syndikate, Sheppey's own music co-op, with basically the same aims as the Medway Co-op. A few groups even joined both co-ops, such as AFB, The Uninvited Guests, The Infinity Corporation and The Strookas. The Syndikate also released a couple of cassettes, with fewer bands, but with more songs each, we got to contribute four tracks from our 'Bathe in Plankton' tape, which got favourably compared to Sham 69 in a local paper's review column, I don't mind a bit of early Sham, but I couldn't really see the comparison.

"After Cliff left the band in early 1990, and Tony O'Rourke took over on bass, we found ourselves playing in places we'd never played before. In September 1991 we went to the seaside town of Margate, on the Kent coast, where we played at the Jamaica Bar by the Lido. We and another band (Red Rag) were supporting Blaggers ITA, who were an anti-fascist, skinhead, political, oi, rock band. I'd read about them in a fanzine and they were really into direct action and were quite full on and slightly intimidating in a friendly way, if that's possible. They'd bought a few fans along, who all seemed to be skinheads, and even though they were fine, it still bought back a few unpleasant memories of being mildly duffed up by skins when I was 16/17, and when the band and their fans advanced on me with their latest single, how could I refuse, I was the first to get my money out.

"On 20th September 1991 we got our first taste of the Tunbridge Wells music scene. The Rumble Club was an indie rock club in a pub, The Winchester, at the bottom end of Royal Tunbridge Wells, around 17 miles from Maidstone. Tunbridge Wells has a bit of a reputation for being posh and 'well to do', but none of the young people at the Rumble Club were wearing boaters or plus fours, so the posh thing was probably a

misconception, we decided. We were there to support Midway Still, an up and coming, indie, grungy rock band, who had some indie chart action with the track 'I Won't Try'. We were all a little excited about the gig, and for a change, this one lived up to our expectations. We played well, we were pretty tight as we'd only just finished recording what would be our first L.P. and were as note perfect as we'd ever get. The audience seemed to like us, and so did Midway Still, who said we were the best band they'd seen in ages, which was nice of them, we'd not had a reaction quite like that before, it was a new experience for us. Of course, even though we may have been good, Midway Still were better, and went down a treat with the crowd. I think it was also this night that we got to meet Dave Gamage and some Couch Potatoes, which would be the start of our long association with each other, and later, Dave's Engineer Records.

"In late November 1991 we got invited to support Midway Still again at the Camden Underworld, a good London venue where I'd seen bands before and had daydreamed about playing at. Unfortunately, the memory that comes back to me of the night is of my grey Toyota Corolla estate overheating on the trip from John's flat in Bethnal Green to Camden.

"I don't like cars, they always seem to let you down, or give the impression that they will at any moment. All the vehicles I've ever owned have given me grief when I least needed it, maybe I should have had them serviced more often, but I'd just had one done at Halfords for an eye watering amount of money, so I had some confidence that we'd complete our journey without mechanical problems. On this occasion, we (me, my girlfriend Melanie, and John) set out in plenty of time to reach the Underworld, but it wasn't long before steam started billowing from under the bonnet, a passer-by helpfully pointed this out as we crawled along London's roads.

"The engine was overheating badly, I could see the temperature rising second by second, this was not good for my nerves. After a quick visit to a convenience shop where Melanie bought up half their stock of bottled water, we parked up, and wrapping my hand in a spare t-shirt, I unscrewed the radiator cap (another helpful passer-by Londoner warned me not to, due to spurting boiling water or something), and topped-up the radiator. We continued our journey and of course, the car started overheating again, but being so close to our destination, we carried on, and finally, and probably going the wrong way a few times as I always did in London (I love driving in London), we reached the Underworld.

"I can't remember much about the gig, I think it was ok, and I did get one of those Riverman 'crew' stickers that you'd get if you were part of the night's entertainment. I'm afraid I worried too much about the journey back to really enjoy the experience, and predictably my mind games playing vehicle behaved perfectly for that trip.

"We supported Midway Still one more time, at The Venue in New Cross, London, on 1st August 1992. This time my amp broke down and I overheated. John had to jog my memory about the best part of the evening, which was when Midway Still sound checked and played part of one of our tunes, 'Wish You Were Here' from 'Deaf by Dawn'. We were rather flattered that they'd do this and it sounded very powerful blasting out through the massive P.A. It was during our sound check that my new Marshall combo conked out. Paul from Midway Still let me use his Marshall stack for our set, the first and last time I'd ever used one, thanks Paul. Unfortunately, after our set I started to feel very hot and a bit ill. On my girlfriend Melanie's suggestion, I went into the toilets and held my wrists under the cold tap for a few minutes. The cold water cooled my blood, and I felt better in a short while and went to sit with Melanie to watch the rest of the show, (a band called Bowlfish were also supporting Midway Still). A young lad from the audience came up to me and said they'd really enjoyed our set, I love it when people can't be bothered to do that, I've done it myself, it's a very pleasing connection to make.

"On 4th November we played one of several gigs we had at the Stick o' Rock in Bethnal Green, a large East End pub that hosted strippers at lunchtimes, on 14th November we played there again, in the evening, no naked ladies for us. Sandwiched in between these two gigs was our one and only support slot for Mega City Four, at the Clapham Grand. Wiz, singer/ guitarist of MC4, had heard The Strookas from a tape that we'd given Midway Still (the bands were touring together), of our yet to be released L.P. 'Deaf by Dawn'. He'd liked it so much that he rang me at home one Spring evening, my dad coming into my bedroom, handing me the phone and saying, "it's someone called Wiz?" We talked about recording for a bit, and I found out that proper bands use a click track, literally a track you'd hear while recording that went 'click, click, click etc' to keep your timing accurate and from speeding up, which some of our records were guilty of. In June we were offered the support slot at the Grand, this would be our biggest gig so far.

"The Clapham Grand was certainly a big venue, and somewhere underneath, or behind it (I'd totally lost my bearings) was our dressing room, quite a novelty for us, we even had a rider, which was our one and only that we experienced in the U.K. It consisted of a few bottled beers and soft drinks in a wicker basket (I'm not 100% on the wicker basket, it may have just been a bucket, or a wicker bucket). Our friend Gary Weston came along with us as a roadie, he would hand me my spare guitar if I broke a string, it would look better than if I had to pick it up myself, and as I always say, if it's good enough for The Edge. It was a bit of a hike getting to the stage, it seemed like we were going up some stairs, then down some others and up some more, and then suddenly you're on stage in front of a far more popular band's adoring fans, our adoring fan was somewhere out there too.

"We played a short set, shorter than we expected, as John left out part of one song in his excitement. This was par for the course for The Strookas, at least one of us would manage to cock up a song at every nearly every gig we played. The important thing was to carry on with confidence like professionals, which we weren't, so things would often fall apart, and we'd have to start the song again, after making a joke about our incompetence.

"Gig over for us and everyone in the room finally got the band they'd paid their money to see, The Mega City Four, a band that could play more gigs in a day than we could in a year, they really were one of the hardest working bands in show business, deserving of their legion of devoted fans. Wiz was a true gentleman, a very decent human being, we kept in touch by post for years after the gig, swapping news and sometimes cassettes of our latest music, and even when MC4 had split, he'd write of his new bands, Serpico and then Ipanema. From what information I've gleaned from Facebook and other sources, Wiz corresponded with many fans and people in bands, with genuine interest too, not just from a sense of duty. I went to see Ipanema play in Canterbury, sometime earlier this century, and even though I'd cut my thinning hair and the place was pretty dark, he recognised me, and we had a good chat, and that was the last time I saw him, as he died in December 2006 of a blood clot on the brain.

"One of London's better known smaller venues is The Rock Garden in Covent Garden and I was looking forward to playing there, in December 1992, but sometimes the expectation of a gig is more enjoyable than the

gig itself, which was just okay, so why mention it? It's the peripheral details that make certain gigs interesting. The Rock Garden was one of the first dates that Radio Birdman played on their 1978 UK tour. Aussie band, Radio Birdman are one my favourite bands, their L.P. 'Radios Appear' (overseas version) is possibly my favourite record, my love for it gradually growing since I bought it in 1980. John and Tony are also Birdman fans, perhaps we could tap into some of that Birdman energy and intensity, and channel it through the 14 years separating our performances, both of our gigs were on a Wednesday, would that help? No, not really, the sound in the venue was poor, we were less than incendiary, and according to Mick Wall's review in Sounds music paper, so were Radio Birdman, "They play loud (too damn loud) but they say nothing", so perhaps we did tap into Radio Birdman after all. Two more things stick out from that evening, first, the very helpful lady traffic warden who reassured me to my relief that where I'd parked my van would be fine and it wouldn't get towed away or clamped, and second, I saw the actor, John Woodvine purchasing booze in an off licence further down into Covent Garden. London's always good for actor spotting.

The Strookas French Tour...

"The French Tour was undoubtedly our biggest adventure. Three young men (ok, John and I were approaching our 30s), travelling around France in a red Toyota Hiace with our trusty roadie/driver, Frank Bass (with his blue beret, to blend in with the locals). Also travelling with us would be Frenchman and tour organiser, Patrick Foulhoux.

"Lovely Frenchman Patrick had organised the tour, his first time as a tour organiser, but not his last. He'd written to me after buying a copy of 'Summer to Fall', and our snail mail correspondence kept on going, we had a lot in common musically, and with the bands we enjoyed. When Patrick offered to set up a tour of France after a slot at the St. Amant Rock Ca Vibre festival didn't come off, we just couldn't say no, although the whole thing seemed a little surreal at the time, I mean, The Strookas playing a whole tour, in another country? I'd only been to France on a school day trip to Boulogne when I was 13, the memory of a bald, leather clad French punk spitting on one of my shoes still lingered, hopefully he would have settled down by now and be making cheese.

"Piece by piece the plan of the tour took shape, dates were added, and some changed. We sent 30 Strookas cassettes for Patrick to interest

venues with, and Melanie and I photocopied hundreds of A3 gig posters (with space to add the gig venue and date) to send over. Alexandra Bastedo from The Champions featured on these, speaking into an old fashion microphone, as if announcing the gig herself. Patrick gave us an idea how much we would be paid for each gig, which was usually in excess of £100, which surprised us, £20-30, being what we'd usually expect to get in the U.K. for small gigs. Finally, the tour was on, Patrick had booked us for 11 dates, in 10 venues, all in February 1993 and well spread out round the country.

Wednesday 10th, Lille.

Thursday 11th, Amiens.

Friday 12th and Saturday 13th, Tours.

Sunday 14th, Montargis.

Monday 15th, Rouen.

Tuesday 16th, Perigueux.

Wednesday 17th, Clermont Ferrand

Thursday 18th, St. Etienne

Friday 19th, Annecy.

Saturday 20th, Besancon.

"Two days before our first date I stayed over at John's flat in Bethnal Green. That evening, BBC1 DJ, Mark Radcliffe played a song from our L.P. 'Deaf by Dawn', a good omen, we thought. The next day we left early to pick up Frank, five minutes away and then on to Waderslade (near Chatham) for Tony. Frank drove and I told him which exits and roads to take, but I got confused as I was coming from London, which was a different direction than I would usually travel from, and I got us a little lost. I'm a hopeless navigator, but eventually we found our bearings and managed to catch our Sally Line ferry at Ramsgate, with a few minutes to spare. Not the best start for our tour, thankfully I wouldn't be relied upon to navigate in France, none of us were worried though, we were young and full of unreasoned optimism.

"Once we'd arrived in a damp France, Frank carried on with the driving, he had experience on the other side of the road. I was willing to drive, but only on the easier parts of the route. We had planned to go to Paris the night before our first gig, in Lille. I expected we wanted to take in the sights and buy some of those little plastic Eiffel Towers, but Paris would have to wait, because being so budget conscious we'd thought we'd avoid the toll roads and take the scenic route, which barely took us halfway. We were all so tuckered out by then that we decided to stay at Saint-Quentin, and enjoy the experience of a French hotel, and French plumbing.

"Our hotel was run by a blonde, rather motherly middle-aged lady. She put me in a room with Tony, and John in with Frank, this would be our sleep pairings for most of the tour. After all that travelling, I needed the loo, and after "dropping some friends off at sea", I had to work out how to give them a proper send off, but it took me a while to realise that instead of a handle or chain to flush, there was a plunger like set up, which I pulled up too hard, causing something to fall off in the cistern. I'm a reasonably practical person and managed to put the matter right, but on hearing a bubbling sound coming from somewhere in the room, I turned and to my horror, saw my "friends" returning via the bidet; a suspect device that I have never used. An evening in some local bars drinking Chimay Bleue, helped blur out l'experience de toilette.

"The next day we met up with Patrick in Lille, just a few hours before our first gig. It was great to see Patrick in the flesh, he's a very easy person to get on with, even with a slight language barrier. Patrick's also a very busy chap, helping run Spliff records, being involved with the music fanzine, Violence, and playing guitar in a couple of bands, Waterguns and Shit for Brains.

"The gig that night was in a venue (Rock Hut?) a few minutes' walk from the town centre, and it all went fine, we played well, the audience seemed to enjoy it, and we even sold a few records. I think we even signed one or two. We had no idea where we'd be sleeping after any of the gigs, we'd half expected to kip in the van, so we'd all brought along sleeping bags. We needn't have worried though, as there was always a plan to bed us down somewhere, we just didn't know the plan, but through a mixture of squats, hotels and Patrick's contacts letting us stay at their flat etc, we always had somewhere to crash.

"Our second gig in Amiens was probably my favourite of the tour. We

played at a really cool bar called The Grand Wazoo, named after the Frank Zappa and the Mothers of Invention L.P. I presume. The place was packed, and the audience really seemed to enjoy us. I think we finished our set with the Neil Young song "Rockin' in the Free World", played a little faster than the original, it got the barman /owner down the front dancing, he was another lovely French bloke, I think his name was Pascale.

"Our next two gigs were at the same venue, Le Minimum, in Tours, also in the centre of the middle of nowhere, so it seemed. To drum up the punters we gave a rather silly interview on local radio, and as we couldn't speak much French, the interviewer had to translate whatever nonsense we spouted, which included John's faux pas of slagging off techno music when the interviewer had a techno t-shirt on.

"Both gigs at Le Minimum were kind of average, we shared the bill with a covers band, we weren't a good match and didn't have much to do with each other. On the second night, it was noted that my van's exhaust pipe was just about to come off, I can't remember what happened to it, whether we just yanked it all the way off, or Frank disposed of it somehow, but it didn't make it back to England.

"The gig organiser, Lionel Fahy offered me his white Gibson SG to use on the second night at Le Minimum, which I was very grateful for, he probably felt sorry for me. I had bought an Encore Stratocaster copy a few months earlier, it sounded decent enough through my Marshall combo, but it was a very low budget guitar. I decided to modify it by cutting out the Kellogg's logo from a packet of Corn Flakes and sticking it over the Encore logo. All I can say in my defence, is that it seemed a good idea at the time, and seen at a distance, you could entertain the idea that Kellogg's had branched out from breakfast cereals to musical instruments.

"Next day and we're on the road to Rouen heading north from Tours. It was a Monday, a notoriously difficult day for a band to play in France (or anywhere, I suspect), a situation that only got worse after we left. I hope there was no connection. We were playing an afternoon gig in a café, I imagined us turning the camembert and shattering the clientele's croquembouches with our wall of sound, but I needn't have feared as this was a punk café, well it was full of punks.

"We played with a local band called the Budz, who I thought were great, fast and noisy, the way I like it. The Budz played first, they were a hard

act to follow, but we tried, and it seemed to go fine (I am full of doubts, if John had written this, it would have been far more upbeat).

"After the bands had performed, the most punk thing to ever happen to one of us occurred. Tony came ambling up to me and John from the direction of the toilets, laughing, and said "I've just pissed on the Budz guitarist's head!". We were shocked, Tony wasn't the sort of person to maliciously urinate on anyone. It was fine though, and to be fair to Tony, he was just relieving himself when the Budz guitarist rushed in, worse for drink, and was sick down the toilet that Tony was using, and I imagine when someone has their head down your toilet it doesn't leave much room round the sides to aim for, so our French friend got his hair rinsed for free and spent a while stinking of eau de Tony's piss. Later we were invited to eat with a load of lovely punk types at a large squat, and I ate the best veggie quiche I'd ever had. Tony and I were put up in one of the punk girl's flat, she stayed away and left us to sleep, I remember staring at a luminous 3d dinosaur, until I dropped off.

"Montargis was our next stop, but we had to take an extreme detour so that Frank could drive sedately round a stretch of the Le Mans circuit, where we found out, to our surprise, that Le Mans is twinned with Bolton. There had been hints of fog, or brouillard when playing in Tours, but now it was coming on like a pea souper, in fact I couldn't really say much about Montargis itself, because it wasn't visible.

"We were playing in a largish building somewhere in town, supporting Jeff Dahl and his band. Jeff Dahl had played in the Angry Samoans and had recorded and played with members of the Dead Boys and the Adolescents, so he had a bit of punk rock history to his name. I'd had an L.P. of Jeff's, 'Scratch up Some Action', it was alright, a blind buy after reading a revue, always a little risky but it pays off occasionally, Jawbreaker's "Unfun" being my best punt. Anyway, Jeff was on a big tour, there were five in his band, including him and they were meant to be paid £500 for their performance, and if the takings from the gig were good enough, we might get paid a small fee. I didn't mind, we were being fed, the beer was free, and we had a place to stay with a local contact Jean-Luc who, like us, was really into Radio Birdman, we even sound checked with their song 'Breaks my Heart', it got approval from Jeff, being a Birdman fan too.

"The gig lacked atmosphere; any ambience provided by fluorescent strip

lighting. All was fine though, I wouldn't need to drive later, as I would in England, so I could indulge in some French beers. We were told (maybe by Patrick) that before playing a gig, Jeff liked to meditate in his tour van, so we all shuffled out into the fog to check out this centre of meditation. I don't know what we expected to see or hear, maybe Jeff going "om", it was a good size vehicle though and if I were Jeff, I'd have had it fitted out with a toilet and be meditating on that. We got our set over under the harsh strip lighting and grabbed some more beers in preparation for listening to Jeff and his band. Near the start of their set the bass player announced to the audience (of no more than 30) that his fender jazz bass was going to fuck with us, and before I could work out if it was an ironic statement, they were on their fourth encore, and then it was all over.

"Soon after this, Tony reached his lowest point of the tour, when Jeff kindly told him that he enjoyed our music, and Tony replied, "I enjoyed yours too, Maaan". Tony redeemed himself later in the tour with a comment he made in jest to Patrick, "Manage a tour? You couldn't menage a trois!" Still makes me chuckle.

"Our next stop took us in a more southerly direction to Perigueux, and our first meeting with the Revs, the band we would share the rest of the tour with. The Revs were a good bunch, a young London band, full of energy and confidence, and decent company too. The gig in Perigueux was filmed for local TV, but I don't remember much about it, apart from performing on a small stage and noticing a cameraman in the audience. It was an afternoon affair, so after both bands had played we had the whole evening to enjoy. Everyone retired to a large back room where we were fed and watered. Frank, our trusty roadie, driver and responsible adult, got very drunk and planted his face right into his food, after lifting his head from his plate, it took him a while to realise what had happened. Hats off to Frank though, there he was, several years our senior, and he'd just one-upped us in the debauchery department, and the night was still young.

"Later, I must admit, I caught a mild case of tour van envy when I saw the Rev's vehicle. A comfy, wide Transit with a row of seats at the back for the band, and windows down the sides, some thought had gone into it. My van came up short in comparison, it lacked windows for a start, the dimness creating a dungeon like atmosphere, not aided by the combined gas output from the five of us, although Tony could take most of the credit there.

"Next stop was Patrick's hometown of Clermont Ferrand. The Revs, The Strookas, Patrick, roadies and whoever else was there all sat down for a tasty meal before the gig at a large, local disco venue. Our performance is on video, but just before we play there's a scene which I particularly enjoy, where the camera follows the Revs down a small flight of steps into the venue where one of the doormen asks, "have you paid?!" in a very deep accented voice, and when the opportunity arises, I still use those words in that tone of voice, I've heard John do it too, thirty years on. I'm sure everyone has phrases from their past that still tickle them but mean nothing to anyone else. Also, indelibly etched in my memory is the lone, drunken shape of Tony, stumbling around, trying to dance to Buffalo Tom at the after bands disco, a site to behold, and over the years it's probably gotten worse (or better) in my mind's eye. Great sounds from the disco too, Pegboy, Jawbreaker, Celibate Rifles, MC4, MC5, all provided by another Jean-Luc.

"It was John who had suggested we hire the video camera to take to France and record our adventures. We're not talking a nice little compact thing, this was a breezeblock sized machine, you'd rest it on your shoulder for support, and it recorded straight onto VHS cassettes. The camera nearly didn't make it back from France. Frank suggested that I hold the thing out of the passenger side window as we were speeding along, to get some close to the road action footage. I trusted Frank, he's eleven years older than me, so his judgement should be better (but then again, he was wearing a blue beret), but the camera was heavy and nearly got ripped out of my hand with the g-force as we drove round a bend. I thought it was about to disintegrate, and I think it lost a screw. I didn't do that again.

"I recently checked out our tour film again, to glean as much information for this writing, it's amusing in places, but it's weird and not always comfortable observing yourself half your lifetime ago, and although it's not exactly Spinal Tap, there are elements of it that make me cringe, especially when I'm being filmed after having a drink or two and trying to think of something witty to say.

"On to St. Etienne and a pre-gig nosh up in someone's flat, where I tasted some very fine local cheese, and John chatted to a girl named Elsa who told him that she was looking forward to seeing us as she liked to 'spring', and that she had been a kangaroo in a previous life. The gig at the Himalayan bar was good too, I seem to remember a

lively audience and us playing reasonably well, perhaps we didn't even muck up any songs, although I did break a string, and our roadie, Frank did an excellent job of getting Bob, the Revs roadie to put a new one on. The Revs were great, tight and melodious, they played first, we had been taking it in turns. I had worn my green on purple Strookas t-shirt, John had his one-off Strookas base cap on, and the women running the bar was determined to have both items, but that wasn't going to happen.

"Heading east, and up a bit, our next destination was Annecy, via a quick lunch break in Lyon, and a chance to further the spirit of Entente Cordiale with a game of pool with some locals in a café by the Loire. Tony played the winning shot and I bought (with gig earnings) everyone in the bar a drink, all four people, including a wizened old chap, who I included in the round with my perfect French "un bier pour le monsieur". After a quick whizz round town and a chance meeting with a member of the French punk band, the Burning Heads, who Patrick knew of course, and we were back in the van and on the road again.

"Annecy is a town by the impressive Lake Annecy, a short drive from the borders of Switzerland and Italy. Before pulling into the town, we decided to treat Patrick to a meal, at a restaurant of his choice, there wasn't much choice though, so it was just a restaurant. Stuffed, we drove to the venue to meet our contacts for the gig and were taken to eat another full meal. Eating, out of politeness, on a full stomach is a very uncomfortable experience, but I did it anyway, and would regret it later.

"The venue for the gig was near to Lake Annecy itself, which on the day we arrived was shrouded in mist, obscuring the impressive and beautiful mountains of the Northern French Alps. I know they were impressive and beautiful because we returned the next morning, when our view was crystal clear.

"I can't recall much about the venue; 52nd Avenue, Les Marquis, according to the flyer I have. Inside were a few connecting rooms and another band playing at the same time as us in one of them, which was a bit off putting, as every time we ended a song, we could hear them playing quite clearly, and I presume they could hear us too, in their quieter moments. We played a little shambolically that night, as John put it, not long after the tour had ended, "I made zillions of cock ups and Tony forgot where the strings were on his bass".

"We stayed with a lovely fellow called Marco and his girlfriend Marine, neither of whom could speak much English, and seeing as we couldn't speak much French we had to improvise a sign language consisting of pointing at things and exaggerated facial expressions, it worked just fine. I was starting to feel a bit rough that evening, about time too, cheap red wine and two full meals were fighting it out in my guts, and I didn't get much sleep, not helped by John's elite level snoring (caught on camera and played back to him, of course). The next day I still felt gassy and a bit squitty. After an early morning visit to Lake Annecy with Marco, we bid farewell after exchanging records, (Marco being the drummer of Blue Blitz). Our next stop was Besancon, and due to terrible traffic and bad guts, it was a long, unpleasant journey.

"Besancon is north of Annecy, close to the Swiss border and not far from Germany's. The venue was underneath the bar, down the stairs via the front of a vintage car's chassis. It was our last gig and we played fine, but the atmosphere took a downturn when a group Nazi skinhead/punks arrived. It's a shame we didn't know how to play that Dead Kennedys song (watch 'Green Room' to see how that pans out). Perhaps they took the Strookas for the Stukas, and it piqued their interest. Out of interest, or maybe not, there was a new wave/ punk band called the Stukas way back in 1977, they had a single called 'I Like Sport' which I heard on the John Peel show, and when we supported Mega City Four, one music paper billed us as The Stukas - after a phone call from John, it was amended for the next issue. Thankfully there was no aggravation that night, as I'm not sure how many of our group of players, roadies, tour organisers were fighting men, very few I suspect, although, Bob, the Revs roadie on seeing a Nazis punk's t-shirt, said that he thought Skrewdriver were a shit band.

"Everyone stayed in a Formula 1 hotel that night, a cheap, clean chain hotel, where the only limit on people per room was your imagination. John and Patrick were banished to one room and traded snores and body odours throughout the night, while I was in another with everybody else, or so it seemed. Somewhere along the road we'd also picked up Tapi, a friend of Patrick's.

"The next morning, we had to bid au revoir to all our new friends, as we were heading back to England. We traded Strookas L.P.s for Revs t-shirts and handed a box of L.P.s to Patrick for him to do with as he wished (why didn't we do this when we'd visited his flat in Clermont Ferrand?), I hope

he used them as a footrest on the train home. We were a bit worn out to be honest, after only eleven gigs. What a bunch of lightweights! How do bands spend weeks or months on the road? It was a lot of fun, but I was looking forward to getting home again.

"We passed through Paris on our way back to the ferry, and managed to park the van near the Eiffel Tower, a short walk later and we were looking up at France's most iconic structure, which had some green tarpaulin covering part of it, John was still impressed, I thought it would be taller, and Tony said something like "pig iron ugly". That was it for Paris, getting out of the city was an assault course of Parisian drivers, pulling out without warning, perhaps it's a requirement in the French Highway Code, it certainly kept us on our toes.

"The weather started to deteriorate the closer we got to the Ferry at Dunkerque, it was dark now and snowing, driving conditions were poor, it started to worry me. A long winding road led to the ferry terminal and to our left we noticed a car overturned in a ditch. We slowed down a little to see if anyone was inside, it didn't seem so, perhaps one of us should have got out to make a closer inspection. Instead, we pushed on, and at the terminal I ran up to a woman at a desk and informed her about the overturned car in my perfect French "La voiture.... crash, bang!", a bit of pointing towards the road and I felt that I'd performed my duty as a human being.

"The ferry crossing was quite an experience, talk about rock n roll! Yes, it was very rough, but I'd taken the precaution of swallowing two ginger capsules before we 'sailed', and every old wife knows that ginger will settle a tummy, so as the ferry went up and down, crashing over wave after wave, I was smugly not being sick, unlike nearly everybody else. Poor John, he just sat at a table with his head in his hands, trying not to bring up his pan au fromage.

"Eventually we reached Ramsgate, and as Frank had done most of the driving in France, I'd agreed to drive to London, where I planned to drop Frank off first, near to John's flat, and then Tony and I would crash at John's after reflecting on our French adventure, with a very late beer or two. Everybody was knackered though, and soon I was the only person awake in the van, and only by pinching, slapping and punching myself in the face, was I able to stay awake and drive the seventy odd miles to John's place, where we did have our late beer and tour debrief.

"Touring in France was a great experience, perhaps made even more memorable for being our only tour. The French people we met were lovely, very warm and friendly to us 'Roast Beefs', I hope we came across the same way.

"Two gigs later and on Monday 3rd April we played at a former public toilet, the Forum, in Tunbridge Wells with the excellent Joeyfat (another band Dave Gamage played in) and Green Day. I don't recall much about the gig itself now, but before any punters arrived, Tre Cool, Green Day drummer came over from his little band table to see us at our little band table, he needed to ask John how to use his new-fangled drum stool, which went up and down with the use of some technology (I wasn't paying attention and don't know why Tre wanted to use the thing), John explained, and Tre was very pleasant, but in the end he chose to sit on beer crates to play his drums. Billy Joe and the other one sat at their band table, and apart from the odd shy glance from us, no contact was made. I don't remember us being very good that night on stage, or at least it didn't sound good from where I was standing, which can make all the difference. So that was the night we supported Green Day, before they were mega famous, I should add. I should really bring it up in conversation more, I might save it for when I'm in a care home, if I can remember anything at all by then.

"Playing with proper bands and playing in big venues was fine, and I'm grateful for having the chance to do it, but for me, I kind of enjoyed the smaller gigs more, I like to see the weary eyes of the audience, and individual expressions of disapproval on their faces. One gig that I unexpectedly enjoyed happened a month after our Green Day support slot (did I mention that?), in Sittingbourne at the Muscletone Sports Centre. The name of the venue led me to imagine that we'd be playing to a sweaty, musclebound audience watching us from their low-impact treadmills and stationary bicycles, that would have been novel, but sadly it wasn't to be. The room we played in did have the feel of a small sports hall, though I can't recall how I got that impression, any sports equipment didn't register with me, perhaps there was a waft of sweat and body oils.

"We were playing with local band, Eskimo, who had organised the gig, they were quite a bit younger than us, and seemed to think that we were a proper band. The Eskimo guitarist and bass player had quite

small looking amps, we were afraid that the drums might drown them out, and offered our slightly bigger, but very loud combos for them to use, but they declined, and they sounded just fine, what do we know? I think I enjoyed playing, things sounded good, the reasonably sized audience liked it, there's not that much to say about a good gig (one of ours, anyway). Alright, I might be playing it down a bit, perhaps we were fantastic, you'd have to ask an audience member. We'd quite often have someone come up to us after a gig to tell us that they enjoyed it (you'd hope so, wouldn't you, just occasionally?). Perhaps I should have taken these people's names and addresses so that years down the line I could pester them for sworn statements, testifying to our brilliance. I don't think ahead, that's my trouble. Anyway, nothing out of the ordinary happened, as far as my diminishing brain cells are aware of, it was just good clean, slightly sweaty fun. I think we were paid £50, maybe £60, which was a nice surprise, we never demanded any fee or rider (if we had, we'd have played even less), travel and petrol money was always welcome and I always seemed to be the one to share out any earnings, must be my honest face.

"From 1994 onwards The Strookas only played a handful of gigs each year, or at least, that's all I have evidence for. For all his life my dad would keep a diary, mainly factual stuff about dentist appointments, TV repairs, who mowed the garden (usually my dad), JFK's assassination gets a mention too, and thankfully, gig dates and venues for whatever band I was playing in at the time. I keep the diaries in a box in a bedroom cupboard and they are invaluable for me to trace where I was, and what I was doing, from my birth in 1964 (apart from filling my nappy, a slow year for me) to 1993, when I moved out, and that's when things start to get really vague. For instance, did The Strookas play just three gigs in the whole of 1995? The only evidence I have is flyers and posters, and as nothing out of the ordinary happened at those gigs, there's not a sausage to jog my memory, and I can only assume that 1995 was a very slow year for the band on the gig front.

"Sometime in the mid-90s, The Strookas added an extra member, Nick, on lead vocals. Nick was a mate of Tony's, also of Shaun Williamson (Barry from Eastenders, also a singer), whom he knew from his job as a postman. It seemed like a good idea at the time, having a vocalist would allow John to concentrate on the drums, bung in an extra flam fill or something. To tell the truth, I don't know how many gigs we played with Nick, a handful I reckon, he was a nice bloke, we all liked him, and he

could sing, but sometimes he was a little flat, which didn't get noticed at first, and it's not like John or I had perfect voices.

"An indication that perhaps Nick wasn't quite right for the band came at a London gig at St. John's Tavern. I think we may have been playing with the Couch Potatoes, one of them had the nerve to say that it was about time we had someone in the band with a decent haircut, referring to Nick. That's a fair enough comment if it was only aimed at me, I'm having a bad hair life, but John and Tony, they spend good money on their hair! The superior barnet issue wasn't the problem though, that came during the gig, when Nick, sensing the time was right for an audience pleaser, took his t-shirt off!!

"In The Strookas, t-shirts stay firmly on, at gigs anyway, we're not that type of band, (our physiques don't stand up to scrutiny) it's an unwritten rule, but perhaps we should have written it down for Nick. We had to let Nick go, it wasn't just the shirt thing, the voice just wasn't quite right, although we did record eight songs with Nick on vocals at Red Studios. All the songs were from 'Cumagutza', I listened to the session recently and some of Nick's vocals weren't bad at all. I don't suppose Nick was too bothered, not being a Strooka anymore, he seemed like the sort of person that had other things to do, I wish him well, perhaps I should have asked him if his mate Shaun was available.

"On 31st October 1996, we got to play at a book launch event in London, not on our own merit, of course, but you know the saying, "it's not what you know, it's who you know", well, we just happened to know someone. I don't know the ins and outs of how it happened, but "The Rough Guide to Rock" book was having a launch gig/event thing at The Rhythmic in Islington, London and three bands were required. John's old mate, Johnny Tucker, the gravelly voiced one from the oddly named Quakerstate, well his wife Jo, was one the editors of the book, and of course, John would have told her how brilliant we were over wine and truffles, and some sort of understanding would have been arrived at. It may not have happened like that, but, knowing John, it's quite possible.

"The Rhythmic was a big place, as I remember, with lots of fixed seating, which no-one would be ripping up in excitement at seeing us play. There was a rumour going round that John Peel was coming along, he was invited, but you can invite anyone to anything, it doesn't mean they'll turn up, you might as well have invited the Duke of Kent.

"Before our slot, we travelled with our small group of friends and well-wishers along the road a little to a curry house, where there was a buffet meal deal on, it was brilliant, the highlight of the evening, in fact. I can't remember if we played first out of the three acts that night, I would have liked to always have played first, to get it over with, not because I didn't enjoy playing, but my nerves would reach fever pitch if we were last on, and I'd need a nervous piss, preferably inside a securely locked cubicle, and if you need to attempt that sort of thing later in the evening, any available toilets would be in a woeful state, as drunk music fans and toilet hygiene don't go hand in hand, in my experience. I have a vague memory that the toilets in The Rhythmic were a cut above average, the place had the air of an establishment with regularly cleaned toilets and lockable cubicles, so I'd imagine my fight or flight response was under control that evening.

"After we'd played, to a reasonable response from the seated audience, a man approached John and said something to him about recording The Strookas, when I asked John about this recently, he said "yeah, but I can't remember anything about what he said", which is pretty much what he told me after the gig that night. We were paid a handsome sum for our services that night, £350 between the three of us. Normally I'd have bought another crap guitar with my share, but I'd recently got myself a Gordon Smith, a proper guitar that Matt, the lead singer of Joeyfat sold me in a Tunbridge Wells music shop. It didn't mean I wouldn't occasionally buy another rubbish guitar, but at least I had one good one, and still have. £350 was not what we were used to being paid, it was well above our pay grade, it seemed too much, we probably didn't think we deserved it for doing something we enjoyed, but when you consider what we'd spend on rehearsals, petrol, cake and sundries, £350 would soon evaporate.

"On 15th August 1998 we played at Tony's wedding, in his parents in law's garden. They had a house too, in a quiet lane with big houses, in which resided folk who would not enjoy The Strookas, especially at high volume. We weren't the only ones to test the locals noise tolerances that day, The Andy Pandys (John, me and old pal, Stuart Ellis) were coming to play, plus our friend and one- time Mega City 4 gig roadie, Gary Weston and his band (Yogi).

"It was a sunny day and the large detached white pebble dashed cottage was gleaming, it should do, I'd just painted it. A gazebo, to the side of the

house and facing down the long garden was set up for the bands to play under, tables and chairs littered the garden, and guests in their finery were drinking, laughing and strolling into the house to enjoy the buffet.

"Tony, John and I had learnt several cover songs to play on the day, bit of Beatles, bit of Kinks, as we reckoned it would be more party guest friendly than our usual racket. I don't honestly know what we played first, I'd like to believe it was the MC5 song 'Kick out the Jams', I know for sure that we played it (going with "Kick out the Jams, Mothers and Fathers!" for the intro), it can be heard quite clearly in one of the guest's videos that I saw later.

"Of course, it didn't take long for the locals to grab their pitchforks and burning torches, and soon a party from the nearest chapter of the Neighbourhood Watch turned up, and they weren't happy, wanting the music to stop or decrease significantly in volume. We had stopped playing by then and were explaining that you can't really turn the drums down, and that the guitars and vocals had to be loud, so as not to be overwhelmed by the drums. This concept seemed to be a little difficult to grasp by Tony's father-in-law, a lovely man who reminded me of the 1970s Dr. Who villain, The Master, but on his day off. To his credit though he did offer our spoil sports a fiver to go away, and after several minutes of negotiations and explaining what a big day it was, (a wedding for goodness' sake), they did go away, minus the fiver but with our promise that we'd try to play a little quieter.

"When we were first asked to play at the wedding my first thought was, "will I have to drive the gear there, and not be able to drink?" I dropped it off the day before and picked it up the day after, and my second thought was "what a hair-brained idea, the neighbours will complain", and I was right there, but despite that, it was a great day, and obviously not because I was playing music with my friends, and it just happened to be the biggest audience we'd had for a while. A few days later, the people who turned up to complain apologised for their interruption, which was gracious of them

"I'm afraid there was no sex or violence at any of our gigs. We obviously didn't inspire hanky-panky and hostility; Danny Boyle wouldn't be producing a mini-series based on my suspect memories any time soon. I sometimes wish there had been a few bar fights, or someone had thrown their knickers at us, on stage that is, you'd be reading far meatier

anecdotes if they had. The best I can do for you occurred around at a gig we played sometime in the mid/late 1990s at the Orange Club (aka The Orange) in West Kensington, London. It was quite an upmarket place inside, I still have an image of it in my mind, but it's too hazy to describe.

"Before the gig, Tony, John and I decided to get some chips. We were health-conscious young men and knew that our bodies could use the carbs during our high energy performance, and we liked chips. We hung around outside the chip shop scoffing away (that would have made a great album cover if anyone had taken the picture, it would have really summed us up), and out of the blue, a large white limo slowly rolled passed, with a group of young ladies inside, possibly on a hen night, then up through the open sunroof popped a young woman with large breasts, she fixed us with her gaze, and I suspect on a dare from her friends, lifted her top and flashed us. Admittedly, she still had a bra on, so it doesn't really count in my book, and it was probably just meant for Tony's eyes anyway, him being the band hunk.

"That night, another band were on with us, they would be playing first, I can't recall who they were, but the drummer had one of those ridiculously large kits that are attached to a type of scaffolding poles. John's not a fan of this sort of thing for a start, and when he broke through his bass drum during a song, and the other drummer was less than willing to help by lending his bass drum, we had to cut the gig short, which was a shame, although on the plus side, I probably got to bed earlier.

"John wasn't a happy bunny though and this led to him shouting at the scaffold drummer in the toilets, while the poor chap was trying to have a piss, all he could do was stare back at this imposing, miffed figure, as John puts it "I thanked him for being such an unhelpful fucker and slagged off his drumkit". I'm sorry I didn't witness this outburst; I'd liked to have seen the look on the scaffold drummer's face. John's a big man, but he's not in bad shape, if I didn't know him, I'd find him quite intimidating, especially if he shouted at me in a toilet.

"I don't even remember the last gig we played with Tony, our last recording together was in 2000, things just fizzled out, no falling outs, no bust ups. A few years later Tony moved to Cornwall with his family, I'd had a son with Melanie in 2003, and was settling into being a dad. In 2014, John and I joined up with Cliff for the first time in 24 years for a

one-off gig at a punk night at the Castle Tavern. It was also a very late 50th birthday request from our friend F, former All Flags Burn guitarist. I enjoyed the night, we played the sort of set we hadn't unleashed since 1988, silly songs about bus fares, a Chatham barmaid and Richie Benaud were rolled out for a final farewell. It went down reasonably well, but I haven't played live since.

"There aren't any Tonota 80 gig anecdotes to be told, because we've never played live. Due to various reasons and excuses, it's just not happened, and if you thought that Strookas anecdotes weren't very rock n roll, I imagine if Tonota 80 ever got round to gigging, the best we could hope for would be stories of soiling ourselves on stage or putting a hip out.

"I don't listen to very much punk rock/ hardcore/ post punk music nowadays, if I do I tend to go right back to the early years of my love for it and play The Adverts, The Saints, Penetration, The Clash, or into the 80s with The Sound and later that decade and into the 90s with Samiam and Jawbox. I still follow J. Robbins and his latest music, he's a genius guitarist and songwriter. I like to investigate what I've missed from the 60s and 70s, YouTube is great for this, there's so much music that a lot of people would enjoy, it's just tucked away in relative obscurity. I also subscribe to some YouTube channels that post material from new bands, which makes me very aware that punk and all its' offshoots is alive and kicking. I'm glad of that, even though a lot of it doesn't move me. I'm afraid I've become musically difficult to please, although every now and then I'll come across a punky tune that gets my foot tapping. I've obviously not got my finger on the pulse of modern punk, hardcore, post-punk etc, but with what's happening in the world, and to the world, punk should be thriving, it's an outlet to vent frustrations, fears and any other emotions and ideas you may have, or perhaps it's just a chance to get together with friends to make some noise on your instruments. It's all fine.

"I'm glad I chose playing guitar as my hobby though, if you can call it a hobby, it seems a little more significant than that. I believe that playing in bands with friends and creating original songs is one of the most rewarding things a person can do, and when you've made a record or CD you've got a small piece of yourself that will probably outlast your physical body, especially at my age. You also get to meet some great people when you're in a band, one or two idiots as well (perhaps those people thought I was the idiot), but mostly great people. That's all."

Andy at **Fear n Loathing** reviewed a copy of 'Everybody's Famous' that I sent him, describing Tonota 80 as a: *"Kent-based band playing a melodic form of punk rock with input from styles as diverse as indie-punks Mega City Four and the Senseless Things through to harder-edged American bands like Husker Du and Moving Targets. For a three-piece, they whip-up a pretty big sound and the album gives you a real sense of a band that has a strong musical direction. They're not afraid to vary the tempos, include vocal harmonies or add different instrumentation where it's appropriate and the overall production is both inventive and convincing. 'This Summer' might be the slowest track on the album, with only acoustic guitar and keyboard accompaniment, but it stands out really well and also sets the mood perfectly for the following track, 'Coffee in My Veins', one of the liveliest and most instantly likeable songs on the whole record. This is an album that draws you in from start to finish, but with repeated listens it just gets better and better. With the right radio coverage, this could prove to be a very popular album indeed. Good luck to 'em!*

And Tim's full review in **Mass Movement** magazine read; *"For one reason or another, mainly publishing deadlines and the other incredibly boring humdrum everyday minutiae that fills my waking moments, this record has been sitting on my desk for a while. Sitting there, staring at me, begging to be played and this morning I finally relented and it's been on repeat for the last, oh six hours or so. And during those six hours, I've been singing along and getting down with my not so bad self. There might also have been some middle-aged dad dancing going on, but as there were no witnesses, you can't prove anything."*

"To be honest, I'd never heard of these chaps before 'Everybody's Famous' unexpectedly turned up and it's a darn shame that the chances of actually catching them at a show in the next twelve months are probably slim to zero, as they're almost certainly a blast live. Tonota 80 are all about massive power pop hooks and melodies and frantic, energetic delivery and without fail, every single time I play Everybody's Famous I inevitably find myself thinking "Oh, so that's what Snuff would sound like if they played Smiths songs..." . Don't be like me, don't be a moron and sit there staring at this record. Buy Everybody's Famous, play it, sing-a-long and maybe, when no-one's watching, bust out a groovy move or two. Go on, you know you want to."

Djordje at **Thoughts Words Action** compared the album to; *"Husker Du, Descendents and Leatherface. Tonota 80 transmits delightful harmonies*

through recognisable dirty crunch distortion, so characteristic of British guitar amps."

And **Razorcake** added: *"Well, well, well, this is one of those albums that comes from nowhere and which you end up falling in love with. At least that's what happened to me. The result was me quickly getting hooked on the late-'80s, early-'90s indie rock vibe which occasionally brought to mind Hüsker Dü as well as Moving Targets. The recording even has a quality that harkens back to those times, which adds to the quality of the release. If, like me, you enjoy music from that era—which is well written and performed, sounds good, and has strong, catchy melodies—then this trio should be for you."*

https://tonota80.bandcamp.com/album/everybodys-famous

The Wolf Howls When I Scream Your Name

Matthew Awbery : Guitar and Vocals
Harry Woodrow : Bass
Sam Johnson : Drums and Backing Vocals

The Wolf Howls When I Scream Your Name were a three-piece alternative rock/emo band from Cheshire, UK that musically travelled the same path as Mineral, Appleseed Cast, The Moirai, Death Cab For Cutie and Last Days Of April.

Bands often become more than the sum of their parts and take on a life of their own. They evolve into a living, breathing entity that begins to shape and mould itself. The Wolf Howls When I Scream Your Name underwent that transition and in doing so, became synonymous with Matty Awberry who originally came up with the concept for the musical

vessel. And as such, I soon came to the realisation that the only way to actually get to grips with the story of The Wolf Howls was through Matty and by letting him tell it in his own words...

"I was fronting a grunge band called Plastic, that had gradually, due to our separate issues, slowed down after four years together. I began The Wolf Howls When I Scream Your Name as a solo project to fill my schedule, as I was listening to a lot of Julien Baker & The National at the time, who had a very different approach to music and existed on a creative plane that was far from the one that Plastic inhabited.

"The Wolf Howls When I Scream Your Name is a concept where I write the songs but other people can come and go and contribute to it. That said, Sam Johnson and Harry Woodrow were solid in the band for three years. I met Sam whilst studying a foundation degree and knew Harry from the local scene. Last year they both decided to leave and I've been playing shows as a solo artist ever since.

"My last band was very aggressive sonically and lyrically, a lot of it was based around my drug use at the time and I wanted to express a more delicate side of myself now, so after slowly watching my old band fall apart TWHWISYN became my main focus.

"The sound has incorporated a lot of different things over the years, stylistically beginning as Julien Baker & The National kind of thing, then it went in a more rock direction were I was just listening to Thrice, Radiohead and others, and on our Engineer Records release 'Grief Songs', it veered between both ends of that spectrum."

The Wolf Howls When I Scream Your Name's eight song mini-album, 'Grief Songs' (IGN317) was recorded and mixed at Lower Lane Studios in Stoke-on-Trent with Sam Bloor. It was released on digipak CD and across all digital channels by Engineer Records in 2021. The album's promotion was supported by digi-singles and videos for the tracks 'Wilting', 'Doreen', 'Grief Song' and 'Clover', with the second single, 'Doreen' in particular receiving thousands of views on YouTube.

Matty continued; "I started the project with a release called 'The Slow Burn / The Outcome' and the name of the band basically came from self-pity after splitting up with a girl I couldn't get over for years, which was the reason I started spiralling into drug use.

"We made an experimental EP called 'Where Flies Will Reign', which is a nod to Layne Staley from Alice In Chains, after listening to a lot of 'Jar of Flies'. We didn't play this live very often as I went mad in the studio and did whatever I wanted to while Sam played drums.

"Then it was on to our Engineer Records release 'Grief Songs'. This was written and recorded during Lockdown when I moved in with my girlfriend's parents. Due to my partner's mum's addiction issues and a stale relationship, she decided instead of living in a middle-class household, it would be better to become homeless and give into her demons and file for a divorce.

"Ultimately the record was about how I witnessed a day to day grieving process from my partner's father, who I related to, and even though I didn't set out to do that, it just kind of happened over a period of about a year.

"This record was really well rehearsed before we recorded it though, so it came across great live and I can't thank David enough for supporting the release. The CDs went all over and we launched great videos for some of the songs too. Now I'm releasing a new single for the first time in two years called 'Fold' which is a return to the project's roots and draws its inspiration from Mark Lanegan and Leonard Cohen."

I was really into the 'Grief Songs' release and could hear all those emo bands I like in it, but as you can see, Matty's range of influences are pretty wide, so I asked him some more about his inspirations; "I guess it's easy to tell that my favourite record of all time is 'Fantastic Planet' by Failure, as it set the foundation for everything I went on to do and taught me everything I know about song structure. It has always been my muse, despite the fact that I come from the hardcore scene, where we were basically public enemy number one surrounded by death metal bands. Looking back, I think the hardcore band I was in at the time, Bison, was fucking terrible."

The Wolf Howls When I Scream Your Name has always been lucky with landing great support slots and have supported Crywank, Petrol Girls, Nervus, Onlinedrawing (Jonah Matranga from Far) and many more, but locally for them crowds seemed to come out more for the indie bands. Matty told me, as he lives in Northwich, that they often play in a great little pub called The Salty Dog as it's owned by Chris Mundie who used to be in a punk band, The Business.

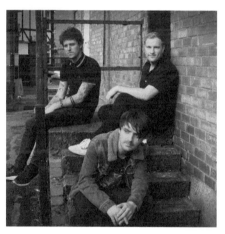

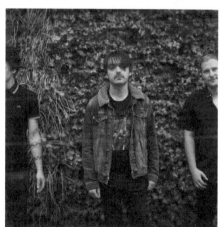

Matty continued, "While we're on the subject of great gigs, my favourite show I've ever played with The Wolf Howls When I Scream Your Name was actually with fellow Engineer Records band Bear Away in Scarborough. The band was in a really good place at the time, we sold a load of copies of 'Grief Song's and the crowd loved us." Which led us into the inevitable band stories that TWHWISYN has collected.

"When the other two guys were in the band there was usually no chaos. I would always have a drink before we played but at our last show I split my head open when I slipped over and hit it against the corner of a monitor. I had to go to A & E where they cleaned the wound and told me I had to stay in hospital. This was in Liverpool and we were meant to be going to Ireland at six the next morning. After about an hour or so, with my partner and Sam and his now wife all waiting for me in reception, I decided to fuck it off and leave. We went to Ireland but I believe that may well have been the final straw for Sam.

"I was a lot wilder in Plastic and was into just about every substance I could get my hands on in my early twenties. I'd started on bar staff, kicked a couple's pizza off a table, threw a drink over someone who was complimenting me. A real dick. None of which I am proud of but I was in a really awful place back then. Now I'm twenty-eight and looking back at my twenty-year-old self is like looking at a different person.

"I regret Harry and Sam leaving but it's made me more self-sufficient as I have to sort my own shit out now. I hope to play in Europe this year and arrange weekenders or tours with friends bands in the UK. I just want to keep creating and won't stop The Wolf Howls When I Scream Your Name. I want to keep releasing music."

Thoughts Words Action described 'Grief Songs' as; "*Eight profoundly emotive compositions. Some of these tunes were promoted as singles, like 'Wilting', 'Doreen' and 'Grief Song'. The remainder of the material represents new compositions paired to match these singles. The Wolf Howls When I Scream Your Name nurtures quite an interesting sound, so close to Midwest emo, but with even more sonic delicacies included along the way. Keeping their music soothing, calmy, relaxing until the raw emotions kick in. Then the group infuses generous servings of aggression, energy, and dynamics into their music.*"

Frontview Magazine said that; *"'Grief songs' is packed with beautiful guitars and heartfelt vocals that will take you on a journey."*

And Azra Pathan at **OriginalRock.net** observed that; *"This collection of emotionally uninhibited, fearless tunes called 'Grief Songs,' the title in itself is observant and blatant, gives us an overview and insight of this difficult subject. There is a lot of talk about mental health and how we all need to dig deeper, not just for ourselves but for those around us. I find music says what I can't or don't want to and these songs are the hand to hold while we sort our lives out.*

For me the influences range from REM and The National on 'Fryin' Brains' and the crashing and thrashing tones of The Jesus And Mary Chain in' Clover' an eight minute Indie tinged number. The songs sweep and soar, way above and then fall just within reach, for us to hold close and cherish. Another trait we have is 'Guilt' it is draining to the point that the inner voice insists that the baggage you carry cannot be set down. The words here are unafraid; 'and I'll hate myself in ways I can't even describe' you don't need a mirror when you can analyse yourself like this. Harnessing the potential and competence of personal trauma the band bring us 'Doreen' a bespoke piece that can apply to anyone who listens to it.

Raw yet accomplished, whole-hearted yet unfinished, but altogether inspiring and enigmatic."

https://thewolfhowlswheniscreamyourname.bandcamp.com

Verse, Chorus, Inferno.

Gabriele Cucinella : Vocals and Guitar
Mattia Cimadoro : Vocals and Guitar
Luca Bologna : Bass
William Tessaro : Drums

Verse, Chorus, Inferno. are a punk-rock band from Como, Italy who formed back in 2007 and toured all around Europe. Now they are back with a bang and a new album, 'Flying a DeLorean to 2007', which bursts with energy and purpose whilst looking back and celebrating.

I spoke with singer and guitarist Gabriele 'Cuc' Cucinella about what fuels their fire; "Verse, Chorus, Inferno. formed by accident. We've known each other since we were about sixteen. Como, our hometown, had a vibrant punk scene at the end of the nineties and beginning of the millennium with more than eighty bands and a number of venues, all of which was held together by a real community feeling. All of the members

663

of VCI had played in different bands that had gigged together many times, but none of us had ever been in the same band before.

"It was a Tuesday night in December 2007, and I was at the bar with Willy (drums), where we usually hung out. InHead had booked an eight-show tour through Switzerland, Germany, Belgium and the Netherlands, and they were supposed to leave in ten days, right after Christmas, but Willy told me they needed to cancel the shows as their guitar player had found a new job and couldn't leave his office for that long. I asked him "Why don't we just form another band and fill in the shows?" And so, we did.

"We asked some of our friends and overnight, we put a band together that included me (Cuc, ex-Staly Fish) on vocals and guitar, Willy (drums, ex-Pankina/InHead), Bolo (who was playing bass in InHead) on guitar, and Otto (ex-New Martini) on bass. I had a few songs in my pocket, we added a couple of covers and rehearsed every day for just over a week before hopping in our van.

"The tour was a blast, we played shows every one of the ten days we were out and drove 1500 miles or so. It was a great time and we decided to keep playing together. A year later Cima (guitar, ex-Pankina) joined us, and we wrote some more songs and played more gigs, many abroad, for three or four years. After that a couple of us moved to Milan, most got full-time jobs and we progressively played less and less. There wasn't a moment when we decided to stop being a band, but life just got in the way. We didn't play between 2010 and 2020. Then during the pandemic, we got back together again and recorded our new album.

"As I've previously mentioned, the band came together more or less by accident and our name reflects that idea. We just wanted to play simple punk rock music and 'Verse, Chorus, Inferno' is basically the structure of our first songs. However, we always wanted to be in a band together, we're best friends and we've known each other for so long that we were sure it would be great fun to play together. And we were right!

"We all grew up with Fat Wreck style punk rock and melodic hardcore. I'm a big fan of Lagwagon, NOFX, Millencolin, Rancid. Cima was pretty much on the same page and we were also influenced by some great local bands such as Mad Clowns, Crazy Dogs, The Leeches and the other groups that we used to play with. Bolo had many different influences, he's the only 'real musician' in the band (in fact he's a professional

session bassist) and listens to everything from jazz to crossover hardcore, and Willy had many different influences, from Incubus to Propagandhi. Our music was faster back in the day, but during the last few years, we've been influenced more by bands like Bouncing Souls, Alkaline Trio and The Menzingers.

"Even though we've been together for more than 15 years, 'Flying A DeLorean' is the only record that we've released. We were born as a live band and never really cared all that much about releasing a record in a pre-social media scene. We'd all released a ton of records with our previous bands, but never got around to doing it with VCI."

While we were on the subject of records, I asked Gab about those that had the biggest impact on them as individuals and as a band. "There's one that everyone agrees was a cornerstone in our musical influence: Lagwagon's 'Trashed'. I remember the first time I put it on in my stereo and I was literally blown away by it. But there are many records that have been important for us. Millencolin's 'Pennybridge Pioneers', NOFX's 'Punk in Drublic' (and 'Ribbed' and 'So Long and Thanks For All The Shoes'), The Get Up Kids' 'Something to Write Home About' and many more.

Gab continued, "Just talking about these bands has reminded me how great the scene was back in the day. Como is a small city (around 80,000 people) but as I said there were so many bands, almost one for every thousand people, which is a pretty good ratio." I agreed that was an incredible number of bands for such a small town and we discussed the local scene around Como. "There were some great bands before our generation, from Temporal Sluts to Thee STP, and the end of the nineties saw the birth of some of the bands we started seeing live who inspired us to start playing. Mad Clowns, Class '78, Crazy Dogs, Succo Marcio and Atarassia Grop were all scene stalwarts. There were so many bands in the scene, there was a compilation from the city, 'ComoCityPunkers' that was released to document what was going on. It was great, and there was also a second volume. That should give you an idea of what it was like back then."

The first Como City Punkers compilation album was called 'Unitigridiamopiùforte' (United, Let's Shout Louder) It was released by Broom Recordz on CD in 2001 and featured thirty local bands. The second Como City Punkers compilation album Gab mentioned was called 'Uniti Un'Altra Volta' (United Once More) and came out via the local punk

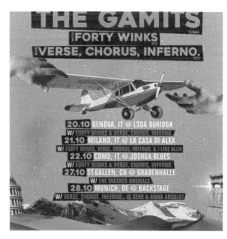

collective, this time featuring forty more local punk and hardcore bands on a double CD. That's one hell of a prolific local scene and must have been great fun.

Gab continued, "The spiritual home of the Como Punk Rock Scene was Rock Club 52, a cultural centre where bands could rehearse and play small shows. Many of the Como bands came out of there and it was the cornerstone of our scene. Unfortunately, Rock Club 52 shut down but its legacy goes on with Joshua Blues Club, a great venue that opened a few years back that hosts great punk rock shows and helped the scene rediscover some of its former glory."

These local gigs sound fun, but I asked Cuc about some of the tour dates they sing about; "Like any band, we've had our share of good and bad shows, and it's always fun to share war stories, so I'll start with the best show we didn't play. It was the second day of our first tour. We had played in Zurich the night before and we were playing in Den Haag that night in a decent venue. But it was a very long drive, something like nine hours.

"We left Zurich early to make sure we had time to get to the club, soundcheck and get everything ready for the show. Then we thought "Fuck it, we have time. We're in the Netherlands, let's go to a coffee shop!" And so we did.

"The problem of course was that we got so smashed we couldn't find our way back to the club. After hours wandering around the canals, we finally stopped a taxi and gave him the name of the club but we arrived back there after midnight. The club was already shutting down, and they'd piled our gear up outside. I don't remember them being particularly upset, but it was too late and we just couldn't play. Anyway, some punks who came for the show were still hanging around and we had a couple of acoustic guitars so we improvised an acoustic set on the street. A few people brought some beers and we played till very late. In the end it was a great night, but we were kinda dumb, missing the show after driving for nine hours. That particular story is what the first single on the album, 'Fast Times in Den Haag' is all about."

I asked about gigs they did make; "There was one near Antwerp in Belgium. We played at a venue called JC Salamander. The stage time was early because of the neighbourhood the club was in, so we played at around 9pm. The gig was good, but there weren't many people there,

probably only 30. But after the show, word spread around the little town and more people showed up, so we played again around midnight, when the venue was full and we were a little drunk. As we were about to finish our set the police turned up at the venue and forced us to stop. I remember me and Bolo playing 'Don't Worry, Be Happy' to them while they were asking everyone to leave."

"Another great but weird show was in French-speaking Switzerland. We'd played at a festival in a forest but there were so many bands and the organisation was so chaotic that we ended up playing at 3am. But even at that time people filled the stage and kept bringing us beers. Really good fun."

More recently, Verse, Chorus, Inferno opened for Snuff at Bloom in Mezzago near Milan. Bloom is a historic venue and many big alternative bands have played there, including Nirvana and many of VCI's Engineer Records labelmates. Cuc told me, "Opening the show for Snuff there was a dream come true. We hung around with them in the backstage area all night and they were super nice people."

"We also played in Gaussplatz, Altona, Hamburg. It's an institution in Hamburg's punk community and it was an incredible experience just to be there." Continued Cuc, "and another time in Belgium, we were trying to get some sleep in a dormitory after a gig when our manager, Luca, came in and sprayed us all with a fire extinguisher. Willy chased after him for ages, I think he might have killed him if he caught him!"

Touring and playing is great, but one of the things that every band eventually needs to tour is an album, it's like a calling card that opens the live door, and VCI had been introduced to Engineer Records through our mutual friend Renato from I Like Allie. They'd recently released their 'Rare Instance of Independent Thinking' record (IGN313) with us. So when VCI recorded their album we were the first label they sent it to. Cuc told me, "I love many of the bands on Engineer and I was really hoping we could join the family. We did and we couldn't be happier."

Verse, Chorus, Inferno have released their album, 'Flying a DeLorean to 2007' LP (IGN353) and two singles, both with videos, and things are going really well so far. The video release for VCI's cover of Fleetwood Mac's 'Dreams' has over 10,000 views. They're back after a ten-year hiatus so it can't have been easy to get back on track. The record is

getting a lot of positive feedback and the band are booking plenty of gigs, which was the main objective of releasing it. Engineer Records cooperate with other labels whenever we can, so the VCI album was co-released with Eternalis Records (FR), Pasidaryk Pats Records (LT) and High End Denim Records (CAN) and we all work together to help spread the word.

I finished our conversation by asking Gab why it took them so long to release an album? "Even though we never really broke up, life took us down different paths for a while, so this is basically a reunion for us. It's great being back together doing what we love, even if we're in our 40s now. I have kids and we all have full-time jobs, but it's great to spend weekends playing gigs with your best friends. Now that we're back, we want to keep touring around as much as possible. We're planning UK and US tours for 2024 and writing new songs for a new record."

"Right now is the perfect time to get out there. Punk is seeing a resurgence with a mix of older punks like us getting back on stage and some newer bands bringing the energy. There are big festivals that we didn't have before and many European bands are touring the world. I think our sense of community in punk rock is needed now more than ever. No matter what, punk rock will always be a connection between people, bonded by their shared experiences. I don't think that'll change."

Punk-Rocker.com said that; *"'Flying a DeLorean to 2007' is an emotional and introspective exploration of the band's experiences during their 2007 tour, their life on the road, the challenges of the lockdown, the importance of friendship, and their unyielding passion to come together and make music once more. A captivating collection of eleven tracks, each telling a unique story and it's evident from the very beginning that Verse, Chorus, Inferno. has poured their hearts and souls into this album. With its powerful lyrics, captivating melodies and impressive production, this album is a must-listen for punk rock enthusiasts and music lovers alike. It invites listeners on a musical journey and leaves an indelible impression that will resonate long after the final chord fades away."*

https://vcipunk.bandcamp.com/album/flying-a-delorean-to-2007

Wake The Dead

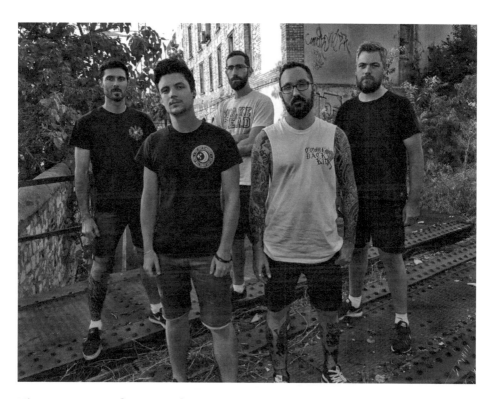

Vincent Fernandez : Vocals
Guillaume Indaburu : Guitar
Nicolas Rege : Guitar
Yvan Turpinian : Bass
Leo Rolland : Drums

Wake The Dead is a modern hardcore band from Marseille, France. Formed in 2010 and living the DIY post-punk touring life ever since with the motto "Driving hours to play half an hour." Musically, the band play heavy, heartfelt and passionate hardcore using as many melodic keys as possible and over the last decade have played more then 300 gigs across Europe and into Asia, sharing stages with bands including Sick Of It All, Birds In A Row, Propagandhi, No Use For A Name, Death By Stereo and A Wilhelm Scream.

Passion, integrity and energy lie at the core of everything that Wake the Dead do, and each and every song that they write about their collective

experiences and the highs and lows of everyday life is bursting with the kind of sing-along choruses that make believers out of hardcore kids and fire up mosh-pits the world over.

I spoke with Vincent Fernandez, the singer of Wake The Dead, about the history and inspirations of one of France's best hardcore bands.
"Our guitarists Guillaume and Nicolas have known each other for years. Everyone was involved in the same scene and came from the same city. One played in bands and another organised a lot of cool shows, for A Wilhelm Scream, Sick Of It All, H2O and more. As the two of them got to know each other they became friends and after a while the idea of starting a band came up. A bass player, singer and drummer later, Wake The Dead was born.

"The original idea was to form a band in the mould of all the bands that inspire us and from 2010 onward Wake the Dead has been playing passionate, sincere Hardcore. We're just kids who grew up loving this music and going to shows, and we just want to play the music that we love.

"The bands and music that made us want to do what we do would be Comeback Kid, Have Heart, Bane, Miles Away and many more. I come from the punk-rock skate-punk scene, so also bands like Pennywise, Satanic Surfers and more extreme stuff like Converge also inspire me. Our drummer is into the metal scene and bands like Gojira, Thy Art Is Murder and Mastodon. Yvan, our bass player, is a total New York Hardcore devotee and bands like Madball and Agnostic Front mean the world to him. We throw all of those influences into one big musical melting pot and make songs that sound like us.

Wake The Dead's debut album, 'The Things We Can't Forget', was released in 2011 by a collective of nine European HC record labels. This was followed by a six-track mini-album entitled 'Meaningless Expectations' in 2012, again working with five European HC labels to get the release out to as wide an audience as possible. But then it took the band until 2016 and a new line-up to get around to their second full album. Entitled 'Under The Mask' it was recorded with the guitarist of Landmvrks, Nicolas Exposito, and released on LP and CD formats by Demons Run Amok Entertainment in Germany.

Then in 2020, with another new line-up, Wake The Dead recorded eight new tracks for the 'Still Burning' album and got in touch with Engineer

Records. The songs were recorded by long-time friend Florent Salfati, the lead singer of Landmvrks, and jointly released on 12" vinyl LP and CD by Engineer Records (IGN279) in partnership with six other European labels; Shield Recordings from the Netherlands, and Burdigala Records, Sleepy Dog Records, We Are Sharks Records, APB Records and Eternalis Records, all based in France.

Vincent continued; "'Still Burning' is probably the album we are most proud of. It was a turning point for us in terms of the heaviness and sound of what we were trying to achieve. I hope the next album will be a logical continuation of this one. I'm stoked with every new Comeback Kid record (especially the last one 'Heavy Steps') and also Turnstile's album 'Glow On' and these two albums are the best of both worlds, they're both old-school and creative, and that's what we're trying to achieve."

I asked Vincent what the hardcore scene was like in Marseille and how that influenced them. He told me; "Like all bands, our home scene has had a massive impact on us, and Marseille's has always been active, energetic, and welcoming. Marseille is a big city and WTD has shared stages with local bands like Disturbed, Landmvrks, Cheat X Death, Odyssey and many more. These bands are friends, and everyone supports each other and comes to see each other's shows. WTD has succeeded in finding its place in the musical landscape of the city and making our mark. Our audience always pushes us, so we like to give back as much as we receive. It's always a pleasure to play in our home scene."

With that in mind I asked if any gigs stuck out for him. "Even though it's impossible to say what our best show from the well over three hundred we've played is, our trips to China and Cuba are still great memories. That was a once-in-a-lifetime opportunity! We also played in a huge skate-park festival a few months ago, with a lot of friends there. Everything was perfect. How could it not be with moshers, beers and teenagers skating around during our set. There was even a tattoo parlour near the stage especially for the occasion, it was really cool."

Marseille has always been a city in musical development. Probably better known for rap and other styles of music, it's been constantly evolving with bands from the hardcore, punk and metal scene recently. Vincent tells me, "There are bands similar to what we do, such as Odyssey, Disturbed, Happy Fist, Try to Win, Where Eagles Dare and Landmvrks, who have entered a whole new level. We stay close to each other and have

a bond with the other bands in the scene. It's what gives us our strength and helps us to keep going."

As with any band though, Wake The Dead have collected their fair share of tour stories. When the COVID-19 pandemic started they were in Porto, waking up to breaking news flashes on the TV screen of the bar they'd been staying in saying that several cities had started their quarantines. It must have felt like a disaster movie. Vincent told me, "Yes, as a result, a part of the tour was cancelled and we received calls from the organisers telling us to stay away from Madrid, where we were supposed to play, because the city was quarantined and there'd be no way to leave. Half an hour later and we realised we were probably not going to get home either. The last date of that tour was in Lisbon and we left the city at 6am and made it home twenty hours later."

He continued, "Eastern Europe is a place where we've played some of our best shows as the crowds are always sick. But it's not safe and you have to remember you're not at home there. In Romania in 2012, it was late at night and we were driving to the next city for a gig, we were stopped by the police for no real reason and, after an almost naked body search of our bassist, had to leave a 'tip' to be able to continue on our way. Also, in Serbia in 2014 after a show there was a huge fight between Antifas and fascists/racists, and while no one in the band got hurt, it always sucks to get caught in the middle of a fight."

Vincent added, "It's been a while since we played in the UK, maybe ten years or so, even though we're on a UK label. I still can't remember how that happened but know that we're extremely lucky that it did. Hopefully, we'll be back soon because we always love playing in the UK."

"Wake The Dead are still doing it, fifteen years after we started, even though it's more difficult as we get older. Some of us are parents and have families and jobs, but thanks to the love that we have for each other, we've been able to play some of the craziest places. Yes, it's more difficult to do it in the post Pandemic world, but we always book shows through friends and do things the DIY way, so we intend to keep doing this for as long as we possibly can and just enjoy the adventure."

"This is about music from the streets. It isn't about money or fame, it's about finding family and friends where you had none, and making the most out of, and enjoying, life in an ethical way that allows people to be

who they are and embrace their passion. And as long as we can do that, there will always be a WTD."

As I write this, midway through 2024, and after five years on the road and two great releases with WTD, 'Still Burning' and 'You and Me against the world', Vincent has departed the band and Wake The Dead have found a new singer in Aleksandra. Their first new single with the new line-up will be 'With No Regrets', launching in September with a powerful video.

Away From Life magazine reviewed 'Still Burning' and said; *"You may recognise the role models, such as Comeback Kid, with their brutal but melodic hardcore that gave the band their name, but nevertheless Wake The Dead have developed their own style. A bit more European, a little rougher. Angry, energetic, sometimes reproachful, but always dashing forward."*

Thoughts Words Action said; *"'Still Burning' blasts with remorseless energy, which has been saturated with multiple sonic wonderments, mainly composed of thoughtful arrangements and exceptional musicianship. The group relies on compelling guitar shredding, which has been precisely submerged under magnificent melodic sequences. The guitar dualities create such an energetic atmosphere, bursting with dynamics without losing elements of greatness along the way. 'Still Burning' comes with an astonishing artwork of lionesses biting a giant griffin, while flames approach from all the sides. This piece of art is an awesome addition to a brilliant recording that should certainly place this great French hardcore punk band on the top of the scene."*

And **Mangorave** added; *"This powerload contains twenty minutes of intense, melodic and emotional sounds. As much as music-wise 'Still Burning' is clearly a hardcore album, the contents are just so punk-rock. The musical motifs remind me of bands such as Comeback Kid, BoySetsFire and Strike Anywhere. From time to time, the dark hardcore of artists like Hang the Bastard shines through, too. By any account this album is powerful output. Melodic, intelligent, intense and emotional. What a brutally beautiful call for action!"*

https://wakethedeadhardcore.bandcamp.com/music

WLOTS

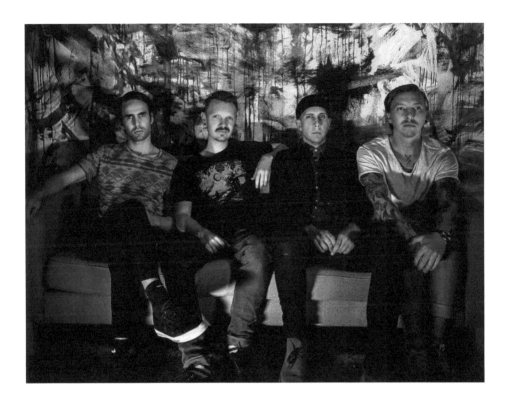

Hannes Wijk : Vocals and Guitar
Robert William-Olsson : Guitar
Alexander Reinthal : Vocals and Bass
Jesper Sundell : Drums

WLOTS are a screamo band from Gothenburg, Sweden. Their name is pronounced Vu-Lots and they will go down well with fans of Thursday, Thrice, La Dispute, Pianos Become The Teeth and Touche Amore.

The legend of WLOTS began when Robert met Hannes in school, when they were both in the seventh grade. Convinced that they'd only been admitted to the illustrious bastion of learning because of their sister's previous academic achievements, the future bandmates immediately clicked due to their mutual love of videogames and skate-punk. As Robert had started learning to play guitar a year before, it wasn't long before he started showing Hannes the basics and taking advantage of the

fact that their decidedly middle-class school had extensive musical resources and offered students two hours of independent study time a week. They soon started using that time to rehearse, and less than twelve months later they found themselves on stage in the school's talent show playing covers of Electric Six's 'Gay Bar' and Sum 41's 'The Hell Song'.

The band originally formed as What's Left of the Sun in 2013 after Robert, who was studying Audio for Video Games and Hannes, whose previous band The Delirium Case had gone their separate ways, decided that they wanted to play music together again. Even though they'd both played in a ska-punk band called Go Smokin' while they were in high school, ska was the last thing on their minds now. They wanted to go heavy and moody, and create a perfect collision of Raein, Thrice, Circle Takes The Square, William Bonney and La Dispute.

Their first EP 'Life Rewinder' was written and recorded by Hannes and Robert in the latter's bedroom. When they started putting a 'real' band together they brought in Alex, who Hannes knew from The Delirium Case, to fill the vacant bass spot. As Hannes wanted to front the band as the singer they turned to another friend, Calle, who laid down a guitar solo or two and was a guitarists guitarist (jazz, blues and more) with a love of pop punk. The drums were programmed for the EP but Hannes also knew a guy named Felix through his girlfriend and he was given the tough job of learning all the overly complicated drum parts that Robert had written.

Calle was the first member of the band to quit, leaving in the summer of 2016. After another EP, entitled 'The Flickering of Day and Night' and two singles. His heart wasn't really in the music anymore and he didn't feel that he was making a positive contribution to the band. Hannes picked up his guitar again and WLOTS kept going as a four-piece. Shortly after that Felix went on a year-long trip to New Zealand and hadn't booked a return ticket, so the rest of the band had a conversation with him before he left and promised they wouldn't replace him while he was halfway around the world.

As a way to pass the time and beat the Winter blues while their drummer was in New Zealand, WLOTS recorded some acoustic demos of songs that they were in the process of writing but soon realised that they needed to start practicing with a drummer again to ensure the band's survival. They knew a guy named Philip who had filled in for three shows for them

in 2015, and after a few incredible rehearsals he gave them an ultimatum: either bring him in as a full-time member or he wasn't interested in rehearsing and practicing with them anymore. It was a no-brainer, they could wait at least another six months, or carry on playing as WLOTS. Hannes was given the unenviable task of delivering the bad news to Felix over the phone.

What's Left of the Sun never really felt like they found their sound, so in 2019 changed their name to WLOTS in the run-up to releasing their debut album, 'Sempre Più', as a way of forcing a soft reboot of the band. Sempre Più is Italian and means ever increasing, or more and more, in relation to turning up music. They signed to Deep Elm for a digital release and went on a week-long tour through Poland and Germany with Kid Feral in the fall of 2019 to support the album's launch. (Deep Elm Records is a label run by ex-EMI executive John Szuch, originally based out of Charlotte, NC with many great vinyl and CD releases to their name, but now holidaying in Hawaii and concentrating mainly on digital releases and licensing).

This led to vinyl and CD releases of the WLOTS album too. The Sempre Più LP came out on Tim Keller's Dingleberry Records in Germany, supported by Disillusioned Records (UK), Callous Records (UK) and Friend of Mine Records (Japan). They printed 300 copies on black vinyl at the band's local Swedish Spinroad Vinyl Factory and taking inspiration from Kid Feral's 'Live and Let's Die!' release, hand-wrote the lyrics and drew the illustrations for the insert themselves. The eleven-song Sempre Più CD was released by Engineer Records (IGN264) in October 2019, with 500 copies packaged in sustainable card-sleeve envelopes with alternate backside art. This would be traded with indie labels worldwide and taken out on more tours and gigs by WLOTS.

There was talk of a limited-edition cassette release for Sempre Più too, and this turned into a planned 'Sempre Più acoustic demos' cassette, slated as IGN267 with several partner labels, but it never seemed to happen. The tracks are just as beautiful played acoustically, so that idea may have to be rekindled.

After realising their big dream of touring, WLOTS fulfilled another ambition and recorded a new album in a secluded cabin in the woods. When the pandemic hit in 2020 they seized their opportunity and spent part of that Summer in the forest. Philip had left the band after the 2019

tour so they asked Kid Feral's drummer, Jesper if he wanted to play on the new album. He joined them in the cabin and nailed all the drum parts in two days. They'd only booked the cabin for a week and by the time those seven days were up they were only half finished.

Then Robert broke his left elbow while making a last-ditch effort to skateboard before getting too old in August 2020, and as he was the band's recording engineer, it pushed the album back again while he was recovering. WLOTS recorded the album themselves, following the blueprint that they'd laid down with 'Sempre Più' but asked Taylor Barrow, who had mixed Terry Green's self-titled LP, to add a touch of his magic to the mix and finish the record. This second album would be entitled 'Paperking'.

WLOTS 'Paperking' album was initially released in the fall of 2021, digitally by Deep Elm Records and as a cassette by the UK's Callous Records. The pandemic had created a huge backlog at pressing plants around the world so the record didn't actually make its vinyl debut until fifteen months later, on Germany's Thirty Something Records, based out of Berlin and often involved in older Deep Elm and emo re-releases.

By this time Alex was taking more of a lead role on vocals and as Kid Feral had been on hiatus for a while the band had persuaded Jesper to join them full time. With Covid touring was still in doubt so they spent a weekend recording a live set built around songs from their new album and premiered it during the final Social Distance Fest (#4). It was the first time they had played the songs together as a full band.

After we'd talked for a while about the history of WLOTS I asked Robert to share a few of the bands more memorable stories, including their best and worst shows, and he told me; "On our Euro tour with Young Mountain in 2022 we had managed to book a show in Paris with three other bands, making it a busy five band bill. The stage was stacked but everyone was excited to play what should be the biggest show of the tour, central Paris on a Saturday night.

"We'd been in luck and found an Airbnb about a thirty-minute walk from the venue. Both bands could sleep there and we crammed in a third, Young Mountain, joining us too. On the way to the venue we were talking about how crazy Paris is to drive in and being the only one who had done it before, our stand-in drummer Leo volunteered. It was pretty hectic

sempre più

LISTENER
supporting acts *wlots* + I LOVE YOUR LIFESTYLE
Friday
9 november
at Sekten

YOUNG MOUNTAIN
HARDCORE/POSTPUNK (SWEDEN)
WLO
TS
POSTHARDCORE/EMO (SWEDEN)
08.08. - SCHAUBUDE - 20 UHR

YOUNG MOUNTAIN / WLOTS

4/8	COLOGNE	NIEHLER FREIHEIT E.V
5/8	TOURNAI	AU BOUT DE NOS RÊVES
6/8	PARIS	L'INTERNATIONAL
7/8	TRIER	VILLAWULLER
8/8	KIEL	KIELER SCHAUBUDE
9/8	COPENHAGEN	UNDERWERKET

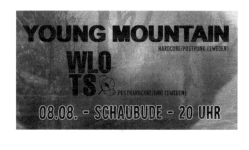

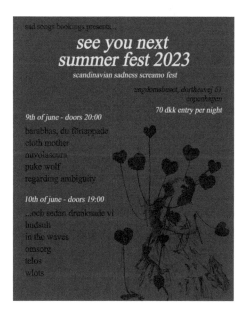

sad songs bookings presents...
see you next summer fest 2023
scandinavian sadness screamo fest

ungdomshuset, dortheavej 61
copenhagen
70 dkk entry per night

9th of june - doors 20:00
barabbas, du förtappade
cloth mother
nuvolascura
puke wolf
regarding ambiguity

10th of june - doors 19:00
...och sedan dränknade vi
hudsuh
in the waves
orosorg
telos
wlots

traffic but everything was going smoothly until Leo managed to scrape the van against another car while parking.

"We were the first band on stage that night and never really hit our stride. Even the headlining band, Fear of Tomorrow, had to cut their set short. Everything was running late and it was all a bit stressful. When we finally loaded out Alex asked drunkenly from the back of the van, "Robert can you give me the key to the apartment?" and I replied "What do you mean? You have it. You never gave it to me". Oh shit, Alex had lost the keys to the place we were staying.

"At about 1am we were standing in solemn silence outside the apartment, considering if we could all somehow fit in the van to sleep, when someone tried the door. We'd forgotten to lock it! We shifted the gear inside and finally got some sleep, them made Alex call the guy we'd rented it from to explain he'd lost their keys in the morning."

Robert continued; "In 2015 we were invited to play the beShore Festival in Sopot, Poland with a bunch of other emo-adjacent bands. There was a guy taking photos of us there, standing under some nooses, looking up. This middle-aged guy was wearing cowboy boots and a big Stetson hat and stood out amongst the younger staff emo crowd hanging around. When I asked about him I was told he had a recording studio and had helped record some of the bands playing that night, so people knew him in the local scene.

"After soundcheck we started off towards the city centre to get some lunch. We were walking along the beach when we noticed we were being followed by the Cowboy. He was acting nonchalant but came over and said, "Oh hey guys, are you going for lunch too? Let me take you to my favourite place, it's called the Pudel. It was the Nazi headquarters during the war and one of Hitler's favourite vacation spots."

"The Pudel was a small bistro close to the central square in Sopot. The food was good, but everyone was tired from the night ferry and not talking very much. It was then that the cowboy guy asked us, "So who in the band is gay?" We all jerked awake and shared looks around the table, replying, "Uh, no one is." He seemed disappointed and told us, "It's no problem being gay you know. You don't have to be gay though, to love a man. You can even fuck a man in the ass and not be gay." We went back to the gig soon after that.

I wrapped things up asking Robert what he thought about the current state of the hardcore scene in Sweden and he told me; "In 2013 when we started, post-hardcore had gone from emo and turned into an offshoot of metalcore. There was a slew of bands like No Omega and Adept. But unfortunately, the current post-hardcore/emo scene in Sweden is pretty non-existent. We have a handful of bands from the last wave that are still playing, like Young Mountain, Barabbas du förtappade (Barabbas You Reprobate), Vi som älskade varandra så mycket (We Who Loved Each Other So Much) and Kid Feral, but there are very few new bands. Maybe Setsuko, Och sen så drunknade vi (And Then We Drowned) and Hudsult, but I'm not sure there will be a big revival anytime soon."

He continued, "That said though, the hardcore scene is taking off big time thanks to Moral Panic Records & Bookings and the GBG Hardcore guys. After Covid they started putting on all-ages shows every month at the Fängelset with free entry for kids under twenty. A group of teens found out about it and basically brought the rest of their school and when those kids started going to different high schools it just exploded. They went from the same twenty people at each show in a fifty-capacity room to now selling out the bigger 200+ capacity rooms at every show. The music hasn't changed much. They're still playing the same hardcore with the same people in different bands, but the time was just right for the next wave of kids to pick it up. Although, Speedway from Stockholm (on Revelation Records) was a breath of fresh air that opened the gates a bit more."

Hopefully, though, history will repeat itself and some of the hardcore kids will spill over into emo. I've already seen a few scene kids pop up at shows and I bet that in a few years we might be getting some more..."

Rich Cocksedge of **Razorcake magazine** described WLOTS sound in a review of 'Sempre Piu' as; "*A bit screamo and a touch post-hardcore, hitting the quiet and loud ends of the musical spectrum, offering an extremely atmospheric collection of songs.*" Adding, "*I do prefer the more energetic tracks, with 'Bitter Lemon' standing out from the crowd and being the song I find most appealing. However, there is something about the dreamlike 'My Morii' which soothes me to my core over its five minutes, so I guess I do swing both ways with this quiet/loud malarkey.*"

Punk Rocker went further, saying; "*Sempre Piu contains eleven screamo compositions fully charged with sincere emotions, relentless dynamics,*

raw energy, anxieties, hysteria, and everything else you ever needed from a screamo band. The way how WLOTS balance between emotionally charged aggression and calmy melancholic segments goes beyond comprehension so many times throughout the album. The group continuously levitates between powerful, aggressive, energetic, screamo/post-hardcore segments and soothing, polished, calmy moments."

And **Sound The Sirens** went into depth on the entire album, stating; "'Sempre Piu' is quite the fitting name for this album, as it is the build-ups and breaks-downs of this album that are amazing! Most if not all songs evolve and progress and are indeed, ever increasing. This is an impressive collection of songs, particularly because of the introductions. Each song carries an intro of anticipation and this is what impressed me the most. This album covers a lot of ground. It is structured so well as individual songs and as a whole. You're interested throughout the album because you can really feel the emotion pouring from the band. 'Sempre Piu' takes you on a journey of musical rage."

Crossed Letters gave 'Siempre Piu' 9/10 in their album review and said; "Completely out of nowhere the Swedish band WLOTS appears with their debut album and blows me totally out of my socks. Twirling guitars play in ecstasy, stormy drum rolls announce that this is to be expected with passion upon passion. Which is underlined by the suffering and high-pitched voice of the singer. The band moves between the pillars post-hardcore, emotive screamo and emocore, influences of black metal, hardcore, punk and post-rock are also there. In terms of intensity, I'm reminded of bands like Thursday, La Dispute or By A Thread. Imagine the song structure simply by building blocks: first, everything is lovingly constructed with a lot of playful imagination, then comes the evil playmate and rips all the walls with roaring roar again."

"And as you quickly notice when studying the lyrics, this title also seems to be the central theme of the album. All of the lyrics tell stories about different people who have to deal with personal problems, psychic states of emergency, depression and mental fatigue and thereby distancing themselves more and more from their social environment and completely isolating themselves. And once you get into such a whirlpool, then more and more goes wrong. The fact that the texts deal with such topics probably has tragic reasons from the personal environment of the band. As I said, an intense album, musically as well as lyrically."

And Joachim Hiller at Germany's biggest punk zine, **Ox Fanzine**, summed it up by writing; *"Post-hardcore bands don't have it easy these days. The genre seems to have been played through and everyone just wants to see the bands who have dared to step into the mainstream – or in some cases deservedly made it – or who want to improve their pension fund on another reunion tour. You accept that there is nothing new to offer, just copycats and other fruitless experiments. So it is all the more extraordinary that WLOTS from Gothenburg knock my socks off with a potpourri that could have been a best-of of the past twenty years of post-hardcore. The extraordinarily artistic to theatrical achievement of the new album is not diminished by its influence from Pianos Become The Teeth, Break Even, The Hotelier, La Dispute and Elliott Smith. Coupled with a convincing depth in lyrics and performance, each chapter of the story of 'Sempre Piu' displays an impressive framework."*

There were plenty of good reviews for the new album, 'Paperking' too, with **Crossed Letters** describing it as; *"Angry, withdrawn, with a keen view of the environment and disgust with authoritarian power structures. That's how punk works! And then these wonderful guitars that will twist your brain! I am absolutely thrilled with this album."*

Rockfreaks enjoyed the; *"Crackling screams that sound like the microphone is about to disintegrate from the sheer violence of their vocalist's razor-sharp delivery, breakneck speed tempo that borders powerviolence in the vein of United Nations, and enough urgency and immediacy to grab your attention no matter what else you might be doing while listening to the record."*

And **Fatal Noise** added; *"Some great emo reminiscent of bands like La Dispute and Old Gray. Emotive, aggressive and cathartic. Some of the best I've heard this year."*

https://wlots.bandcamp.com/album/sempre-pi

Worlds Between Us

Andreas : Vocals
Nikolaus Preglau : Guitar
Dominik Uhl : Guitar
Jochen Brandhuber : Bass
Michael Marlovics : Drums

Worlds Between Us was a melodic metalcore band in the vein of Refused, Converge and Poison The Well. They hailed from Austria and gigged, toured and recorded prolifically for about five years but couldn't seem to hang on to a regular vocalist.

The band formed in 2002 when Michael and Dominik started jamming after their former groups had broken up. A few weeks later Nikolaus threw his lot in with them and soon introduced bassist Jochen to the party. Their first shows were booked in the Summer of 2003 after vocalist Harald joined them the previous Winter.

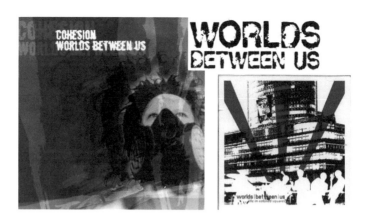

It wasn't long before they recorded their first demo, 'Faded Beauty, Faded Hearts' at Elephantwest with their friend Hanibal and started sending out tapes to promoters to get more gigs booked. But by the of the band's first Summer, Harald left to join Viennese metalcore outfit Forever Ends Tonight. Andreas then lent his voice to the band for the next two years, and almost as soon as he was added to their ranks, Worlds Between Us recorded their next demo, a self-titled four song CDr, which brought them to Engineer Record's attention.

Having signed on the dotted line, the band went back into Red Room Studios with Johannes Cap to record the eight songs (although only six are mentioned on the cover artwork) for 'Life In Coloured Squares', which was released on CD under cat. no. IGN058 in January 2005. Promotion for the band stepped into overdrive and that was the catalyst for Worlds Between Us hitting the road for a ten-day tour across Europe to the UK in support of their debut CD.

This led to various songs being featured on hardcore compilation LPs, including the 'Schubumkehr 2' (Thrust Reverser) album on Rise Or Rust Records and the 'Scream For Help' animals welfare benefit album on Koi Records. Then there was a split 7" with fellow Austrian's The Plague Mass in February 2006 on Noise Appeal Records, followed by Engineer Records releasing a clear vinyl split 7" (IGN087) in March 2006, featuring two tracks each from Italy's Cohesion and Worlds Between Us, supplying the brand new songs; 'Red Eyed Figures Follow Black Cats' and 'Commercial Breaks and Endless Fights'.

The band toured hard, playing shows all across Europe with bands including Himsa, Three Inches of Blood, Endstand, Squarewell,

Converge, Liar, Rentokill, Darkest Hour, Terror, Lack, Bounz the Ball, The Plague Mass, Zao, Most Precious Blood, A Traitor Like Judas, Death Before Disco, Many Men Have Tried, 100 Demons, Hope Dies last and Heaven Shall Burn, as well as an appearance at the Awaken Rock Festival in Malta, alongside Engineer labelmates Nine Days To No One, Fugo, Cohesion and NeverTheMore.

Things were taking off, but Andreas decided that the touring life wasn't for him and handed over microphone duties to Phillip, whose first show would be the Burning Season Festival that summer. The band continued to do what they did best; playing shows, writing music and meeting whatever the scene and life threw at them head-on with passion, energy, and zeal. Worlds Between Us supplied a song, 'Metronom Heartbeats (Are Fashionable)' for the Engineer 100 sampler CD (IGN100) in 2007 and another, 'Card Tricks' for the 'Hours and Hours Seaweed Tribute' album (IGN110) released in 2008, and eventually recorded another five-song EP, entitled 'Downsides' which was released on Noise Appeal Records in August 2007, before they broke up.

World Between Us gained many accolades and garnered positive reviews, with **Lambgoat.com** saying; "*I am reminded of older Hopesfall and Poison The Well. Every song has very melodic guitar work and heavy breakdowns. There is a prevalent rock and roll influence throughout the album and it sounds like these guys also dig the Foo Fighters. There's a lot of riffs jammed in during a short period of time.*"

Glow In The Dark magazine adding; "*Imagine bands like Poison The Well and Grade. These Austrian guys are really, really good at this style. If you like that whole Most Precious Blood sound, then this is most definitely worth checking out.*

SmokingBeagle.com said that; "*This is the latest release from quality UK rock and hardcore label Engineer Records. In a nugget 'Life in Coloured Squares' is an assured melodic metalcore release with plenty of changes in pace and powerful riffs strung together in an intelligent and satisfying manner. I'd name check such varied luminaries as Converge, At The Drive In, Botch and Thin Lizzy. The result is a thoroughly modern brew that keeps the power of metal (there's a fair bit of Iron Maiden in here!) but surgically removes any pomposity and takes the primal energy of thrashy punk but drags it through university.*"

The Communion added; *"It's Hardcore Jim, but not as we know it. Worlds Between Us are five young men from Vienna with an innovative take on the Hardcore formula. The band's sound is a tricky one to pin down, sounding akin to Bane or xCanaanx with the melodic sassiness of JR Ewing and guitar virtuosity of Iron Maiden."*

Planet Loud called it; *"A promising debut of chaotic hardcore."*
Hardcore Music.com said; *"You can hear some Thrice, Poison The Well, Darkest Hour and Converge, and most of all, Refused."*
And **Dance Of Days** celebrated; *"Finally an Austrian band on the British Engineer label. The music has elements of upbeat old school hardcore as well as moshy metal stuff. I especially like the guitar work. Worlds Between Us play highly melodic parts with some chaotic, almost Converge like parts."*

https://www.youtube.com/watch?v=29JeDk8AO94

Zero Again

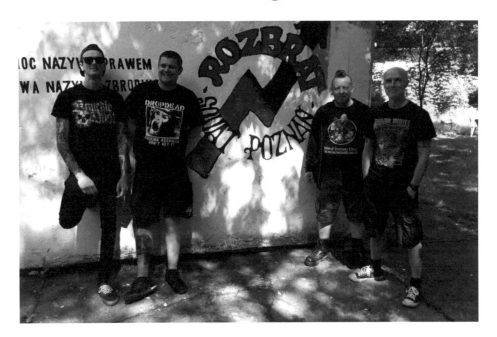

Dean Evans: Vocals
Paul Payne: Guitar
Ian Glasper: Bass
Glenn Tew: Drums

Powered by plants and fuelled by indignation, Zero Again formed during the chaos of the pandemic and while they might appear to be a relatively new band, appearances, as the age-old adage so succinctly puts it, can be deceptive. The truth is, Zero Again are older than dirt. All four members have spent decades in the trenches of the punk-rock wars as members of Regret, Grand Collapse, Warwound, In The Shit, Stampin' Ground, Four Letter Word, Ephemeral Foetus, Decadence Within, Bring To Ruin and a hundred other long forgotten bands. Past glories and history aside, Zero Again are firm believers in the doctrine that you're only as good as your last song and their dark, twisted odes to the malignant society in which they were forged encapsulates the end-of-days zeitgeist dictating our collective destiny.

Often graciously compared to Rudimentary Peni, early Neurosis, the Dead Kennedys, Killing Joke and Lard, Zero Again, as their name

suggests, tore up the punk-rock rule book when they first butted heads in a Bristol rehearsal room and turned their backs on expectations. They unanimously voted to go wherever their muse took them and Zero Again found themselves hurtling down the path to underground renown, one show at a time.

Having already seen them play their hundredth gig and with no sign of things slowing down, that brings us to here and now, and the conversation I had with the band's bassist, author par excellence and scene stalwart, Ian Glasper about Zero Again's relatively brief, but detailed history and what the future holds in store for these hardcore heroes.

First, I asked Ian how Zero Again came to be; "Zero Again formed during the 2020 COVID lockdown, but the idea of the band came about just before that. Our drummer Glenn and I were chatting at a Subhumans gig in Cardiff; I was still in Warwound, but that was winding down and we'd been talking to Glenn, who was in Grand Collapse then, about standing in on drums for a tour in Brazil, which never happened in the end because the band split.
Anyway, we were talking and I mentioned wanting to do something slower and darker than Warwound. Glenn said he'd love to jam some slower stuff, because obviously he didn't have much chance to play at less than Mach 10 in Grand Collapse. So, aptly enough, the idea for Zero Again was hatched at a Subhumans gig."

Ian and Glenn kept in touch and soon enough Dean's name came up as a potential singer. They sent him some home demos to put vocals onto them and it came back sounding great, so they knew they had their singer. Of course, it helped that Dean and Glenn were already mates. But they still needed a guitarist...

Ian continued, "We had a few ideas about who we wanted to play guitar; Baz from Ripcord, Pete Rose from Icons of Filth, maybe a few others, but for various reasons, none of them were able to do it. So, I asked Payney if he knew anyone. The only reason we hadn't already put Payney at the top of our list was because he was in two other bands, but he fancied giving it a go and said that he didn't mind being in three! Ultimately, he was the magic ingredient that brought the whole thing together. I started sneaking down to his place during those relentless COVID lockdowns. We jammed constantly and by the time we were able to get together in a room and rehearse as a band, we already had a dozen songs written."

Motivation and the forces that drive bands have always fascinated me, so next I asked Ian what guided and directed Zero Again, he replied, "The only aim was - and still is - to make interesting music that challenges us and those who listen to us. We've kind of agreed, without really sitting down and talking about it, that there are no preconceived restrictions on where we want to take it musically. The same goes for the lyrics too; we definitely have something to say, and don't want to waste this opportunity to say it."

Given their abrasive and haunting approach to writing and playing, I wondered who and what had served as the band's inspiration and Ian was happy to fill in the blanks...

"Between us we listen to a vast spectrum of music, but for Zero Again we're really drawing on our punk, post-punk, hardcore and metal influences. Some of the bands that are very important to the band members, and I'm sure it comes through in certain parts of certain songs, include Rudimentary Peni, Voivod, Dead Kennedys, Neurosis, Celtic Frost, TSOL, Icons of Filth, Subhumans, Killing Joke, Crass, Bad Brains, Lard, the Banshees, Conflict, early Adam and the Ants, Discharge, Nuclear Assault... the list goes on and on."

Zero Again put their own original spin on all those influences and bring a certain polished power and stage presence to their veteran live act. They been fairly prolific recording artists already too, so who better to ask about a band's releases, than the band themselves and Ian once again stepped up to the plate and responded with a full, up to now, discography...

"Well, at the time of writing, Engineer has released all of it... on CD, that is. But we did two 7"s in 2021, 'Out of the Crooked Timber of Humanity' on Sanctus Propaganda and 'Revert to Nothing' on Kibou Records (James Domestic's label), as well as a split 7" with Attestor on TNS Records in 2022, and then we did the 'A Deep Appreciation of Suffering' vinyl LP on the Polish anarcho-punk label, Sanctus Propaganda, in 2023."

All of that, plus an unreleased track from the first studio session, was then bundled onto the thirty-song 'A Deep Appreciation of Suffering' CD (IGN370) with a twelve-page lyrics and artwork booklet that came out in June '23 on Engineer Records.

Also, as of May '24, Zero Again have just finished writing their second

LP, fourteen new songs, which they'll record over the summer, and that should be out by the end of the year with the CD on Engineer and the vinyl coming through Sanctus Propaganda again."

There's a lot of creativity backed-up by hard work springing from Mr Glasper, so next I asked him about the records that had the greatest influence and impact on him personally and after some careful deliberation he answered...

"I've always maintained that the punk record that changed my life was 'Decontrol' by Discharge, because hearing that totally altered the trajectory of my musical tastes and aspirations. But equally as important was the 'Neu Smell' EP by Flux of Pink Indians, which was what prompted me to go vegetarian way back in 1981, a moral stance I've maintained ever since... so that really was a life-changer. However, if you asked me for my all-time favourite record, that would be 'Dirk Wears White Sox' by Adam and the Ants."

Scenes shape bands and leave a lasting impression on them, and with that in mind, I questioned Ian about the impact that the scene they emerged from had on Zero Again...

"Well, two of the band are from Bristol, one from South Wales and one from Herefordshire, but we rehearse in Bristol, and play Bristol more often than other places, so I guess we're a 'Bristol band'? That's not a bad thing, as Bristol has one of the best scenes in the UK. Full of really enthusiastic, openminded and supportive people, not to mention 'loud, political and uncompromising', as one of the best bands out of Bristol once put it so succinctly. So many great new bands coming through too."

Good 'local' scene or not, Zero Again get out and gig plenty, and not just in the UK, so I had to ask Ian about the best and worst shows they've played...

"We've not really played a bad gig from our perspective, but we've had a few where the turnouts have been poor. Yeovil and South Shields spring to mind. You just have to get on with it though and play the same gig you would if the place was full. We're still a relatively new band, so we're not so egotistical to assume people are just going to turn out for us when we play, far from it. So, the few that did come to those gigs, we are very grateful – just bring your friends next time!

"We also just played the very last 0161 Festival in Manchester and it was obviously an honour to play for that collective, because of all the sterling

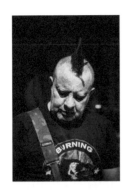
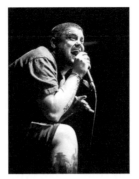
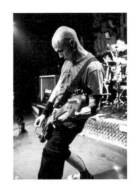

work they've done over the years to thwart fascism in its many guises. However, we were playing in a room with the worst acoustics in the history of live music – the sound man was tearing his hair out – so we sounded fucking terrible and that was kind of hard work.

"We've been very fortunate though and most of our gigs have been great; the Kopi in Berlin, the Ada in Warsaw, and supporting Subhumans at the Dark Horse in Birmingham would all be contenders, but every gig in Bristol is a hoot, and supporting Voivod was a dream come true... for at least two of the band anyway! Mustn't forget the gigs at the New Cross Inn for the South London Scum Collective, and the Mayday Fest in Sofia, Boom in Leeds... As I said, we've been fortunate and we're very grateful for these opportunities."

That's a lot of gigs and a lot of travelling so I pushed Ian for any unusual or funny Zero Again road stories that he'd care to share...

"I'm kind of miserable and serious when it comes to music these days, which probably shines through in the music, so amusing anecdotes are few and far between, but one springs to mind that still makes me smile to this day.

We were doing a gig in Worcester with Diaz Bros, Funbug and The Human Error... the latter are a great little band, three really young guys, and it was their first gig. Anyway, their fourteen-year-old (at the time) drummer turned anxiously to his dad (John Welsh, the old External Menace singer) when we were playing, and said in shocked tones, 'Dad, who's the drunk guy causing trouble at the front of the stage?' Er, that was our singer, Dean, doing 'his thing...'"

I've known Ian for a while, from gigs way back in the day, but Zero Again are fairly new to the Engineer Records story and he reminded me of how they came to join the roster...

"Obviously I know you through my books, and older gigs even before that, but you came along to see us supporting Subhumans in Lewes, to hand over test prints of the Subhumans book I'd just finished at that point, and our frantic, no-nonsense approach seemed to strike a chord with you.

I wasn't convinced that we were a good fit for the label, given the rest of the roster at that time, but it was apparent you genuinely dug the band

and were prepared to put your money where your mouth was and do a 'discography up until that point' CD, and who are we to stop him? Hopefully, Engineer can do the second volume of the discography when it's time to compile it…"

I wanted to wrap things up by asking Ian what he thought about punk and hardcore in the digital age as opposed to the analogue beast we'd both grown up with…

"Punk is always going to be relevant if it prompts people to question what they're told on a day-to-day basis, by the government, their teachers, their parents, the media… and social media, of course. As long as good bands keep coming through, that excite people musically and challenge them lyrically, punk is a vital subculture that helps offset so much of the other bullshit we're force-fed."

Tom Chapman of **Mass Movement magazine** reviewed the album, saying; *"This is very listenable, aggressive hardcore-punk that has been on repeat ever since I got hold of it."*

Djordje Miladovic at **Thoughts Words Action** described it as; *"A powerful and intense offering that showcases the band's relentless energy and unique sound."*

Anarchist Federation described the record as *"A unique brand of violent anarcho-punk with atmospheric deathrock/goth-punk elements and a modern approach to songwriting."*

And **Sanctus Propaganda** simply said; *"From the very start of punk, there have been albums that have defined an era (pick your favourite), and this is one for the 2020s."*

https://zeroagain.bandcamp.com/album/a-deep-appreciation-of-suffering

Engineer Records release list

IGN001 HUNTER GATHERER - Low Standards for High Fives CD
IGN002 HOT WATER MUSIC / RYDELL - Split 7"
IGN003 V/A - FIREWORK ANATOMY - Compilation CD
IGN004 SAN GERONIMO - 'SG' CDEP
IGN005 RYDELL / SAN GERONIMO /A ROCKET SENT TO YOU - Split CD
IGN006 SHUDDER TO THINK – Tribute CD
IGN007 DEAD RED SEA – Self Titled 7" EP
IGN008 ONE LAST THING / CROSSTIDE - Split CD
IGN009 LAST YEAR'S DIARY – Self Titled 7"
IGN010 SPEEDWELL - My life is A Series of Vacations CD
IGN012 ELEMAE – Sleeping With Adrenaline 7"
IGN013 THAT VERY TIME I SAW... – Observing Life Through...CD
IGN015 CROSSTIDE - Seventeen Nautical Miles CD
IGN016 CHAMBERLAIN - Exit 263 CD & LP
IGN017 PLANES MISTAKEN FOR STARS - Fucking Fight CD
IGN019 UROTSUKIDOJI / WINTER IN JUNE – Split CDEP
IGN020 xCANAANx / THIRTY SECONDS UNTIL ARMAGEDDON – Split 7"
IGN021 TIDAL / ACABAH ROT – Split 12"
IGN022 xCANAANx – Gehenna Made Flesh CD
IGN024 EDEN MAINE – The Treachery Pact CDEP
IGN025 FLYSWATTER – Repeat In Pattern CD
IGN026 CHAMBERLAIN – Five Year Diary - Double CD & LP
IGN027 WINTER IN JUNE / STEEL RULES DIE – Split CD
IGN029 RYDELL – Always Remember Everything CD
IGN030 SOMETIMES WHY – To: All Loose Ends CD
IGN034 JOSHUA – Baggage CD & 10"
IGN035 RYDELL – Hard on the trail CD
IGN036 THE BABIES THREE - Luzhin Defence – CD
IGN041 NINE DAYS TO NO ONE – Disrecordings CD
IGN042 ELEMAE – A Life To Be Defined CD
IGN043 CORNFLAMES – The Farewell Drive CD
IGN044 THE BONDS – Not A Phase CD
IGN045 #1 DEFENDER – The Diary Truthful CD
IGN046 SON OF THE MOURNING – Forest Bank CD
IGN047 MADELEINE – Boy = Man CD
IGN048 EVOLUTION SO FAR – Armies Of Bitterness CD
IGN049 COFFEE SHOWER / DEPENDENT – Side By Side - Split CD

IGN050 V/A – Engineer Fifty – Compilation CD (Sampler)
IGN051 COHESION – Lovely Hate CD
IGN053 ELEMAE – Popular Misconceptions of Happiness CD
IGN054 ARAMEUS – Is your revolution merely for display? CD
IGN055 RENTOKILL – Back to convenience CD
IGN057 STRIVING HIGHER – Striving Higher CD
IGN058 WORLDS BETWEEN US – Life in coloured squares CD
IGN059 MY SHINING ONE / SON OF THE MOURNING – Split CD
IGN060 MERCIANA – Let it begin CD
IGN062 FUGO – 'Aie' CD
IGN064 RED CAR BURNS – When everything seems to be in silence CD
IGN065 SOMETIMES WHY – Keepsake CD
IGN066 VANILLA SKY – Waiting For Something CD
IGN067 LANDMINE SPRING – Call Girl 7" pic disk
IGN068 SKIRMISH – The crooked and the cavalier CD
IGN069 NEVERTHEMORE – NeverTheMore CD
IGN070 SQUAREWELL – Two Toy Model CD
IGN071 CATALYST / CALM MURDER – two sides of the suicide king CD
IGN072 SIX SECOND HERO – Recent History CD
IGN073 SQUAREWELL – Synthetic Sensations 7" pic disk
IGN074 THE FIRE STILL BURNS – TFSB 7"
IGN075 THE MOIRAI – Bury Yourself CD
IGN077 SPEAK YOUR HEART – Under These lights we are transparent CD
IGN079 CASHLESS – Kisses and Lies CD
IGN080 WE'RE ALL BROKEN – 7"
IGN081 NINE DAYS TO NO ONE – Ark CD
IGN082 CORNFLAMES – 197666 CD
IGN083 LOSING SIX SECONDS – CD
IGN084 THE NO ONE – Blue Day Way CD
IGN085 FOR THOSE LOST – This is our fight CD
IGN086 ANDTHEWINNERIS – The Punch and Judy show CD
IGN087 COHESION / WORLDS BETWEEN US – Split 7"
IGN088 HSD / MISCONDUCT – Split CD
IGN089 THE BOSS – CD
IGN090 APPLE OF DISCHORD – You're not the answer CD
IGN091 NATHANIEL SUTTON – Dramatic Scene CD
IGN092 BODIES – Hurricane Bodies CD
IGN093 SUNDAE MILK – After a plain sweetness CD
IGN094 KOVER – Assembly CD
IGN095 SQUAREWELL – Self Titled CD
IGN096 SQUAREWELL / FUGO – Entremets D'Hier split CD

IGN097 THE BLACKOUT ARGUMENT – Munich Angst CD
IGN098 THE STROOKAS – What You Want To Hear CD
IGN099 SABOTEUR / THE MOCKINGBIRD NIGHTMARE / RLGL split CD
IGN100 V/A – Engineer One Hundred – Compilation CD (Sampler)
IGN101 V/A – Building on sight and sound - Engineer DVD
IGN102 RYDELL – Per ardua ad astra CD
IGN103 STANDBYE – From the family tree CD
IGN104 HSD – Trapped in lunacy city CD
IGN105 EYESIGHT – Simplify our life CD
IGN106 MY SO CALLED LIFE – On phonelines and letterheads CD
IGN107 AYIN – Fear of tigers CD
IGN108 ADJUDGEMENT – Human Fallout CD
IGN109 ELEMAE / MEMORIAL / SOON – Split CD
IGN110 SEAWEED TRIBUTE – Hours and hours CD
IGN111 MY SO CALLED LIFE / RYAN MILLS – Split 7"
IGN113 LIGHTNING DAZE – Caught in a frame CD
IGN114 FRANKLIN LAKES – Rush hour 7"
IGN115 JUNIOR ACHIEVER – All the little letdowns CD
IGN116 SPEAKYOURHEART – This is how we communicate CD
IGN117 MY SO CALLED LIFE – Lost at sea / Heath was a dead good actor
IGN118 THE SKETCH – Best kid in town CD
IGN119 (DAMN) THIS DESERT AIR – EP1 CD (digi added later by CC)
IGN120 MADELEINE – The city is a story about people CD
IGN121 SEMMI KOMOLY – Loss fills the air we are breathing CD
IGN122 ARGETTI – Flags of karma CD
IGN123 KYOTO DRIVE – Spotlights & Stars CDep
IGN124 SOUND & SHAPE – The Love Electric CD
IGN125 EXETER – Grey noise, white lies CD
IGN127 THE STARTOVER – The Startover CDep
IGN128 COUCH POTATOES – 8 Songs / Wash CD
IGN129 COUCH POTATOES – Excess All Areas CD
IGN130 COUCH POTATOES – Mans Greatest Friend CD
IGN131 COUCH POTATOES – Outweighed CD
IGN133 ONE HUNDRED STEPS – Human Clouds CD
IGN134 THE SEPARATION – Retire your engines CD
IGN135 FAILSAFE FOR TOMORROW – Give up your ghost CD
IGN136 KYOTO DRIVE – This is all we ever wanted CD
IGN137 SUNDAE MILK – My toys kill your existence CD
IGN139 DESPITE THE RAVEN – Hereinafter CD (Digi added later by CC)
IGN140 KYOTO DRIVE / THE MORNING OF – Split CD
IGN141 THE STARTOVER – Survivors Guide CD

IGN142 ROAD TO KANSAS – The contract with the ghosts CD
IGN143 CALL OFF THE SEARCH – What doesn't kill us CD
IGN144 RYDELL – Finale, Live CD
IGN145 RAMONA – Mornington crescent now open CD
IGN146 BLAKE – I was young in the 90's CD
IGN147 RED LIGHT GREEN LIGHT – Everything has gone wrong CD
IGN148 BREACHING VISTA – Breaking the view CD
IGN149 DANCE KARATE – Rich in mind CD
IGN150 V/A – Engineer One Fifty – Compilation CD (Sampler)
IGN151 THE NUTCUTTERS – Clyde CD
IGN152 RED CAR BURNS – The roots and the ruins CD
IGN153 EYESIGHT – Wir Bleiben CD
IGN154 THE WORLD CONCAVE – Harbor CD
IGN155 THANKS FOR ALL THE SHOES – Celebrating Falsity CD
IGN156 NIKSON – Preachers go to hell CD
IGN157 ALL THAT'S LEFT – As time passes CD
IGN158 FUGO – Avant 93:43 3xCD
IGN159 BREACHING VISTA - Vera City CD
IGN160 THE SEPARATION – Our lives in cinema CD
IGN161 KYOTO DRIVE – So much alive / Chapters
IGN162 HER ONLY PRESENCE – You're never back CD
IGN163 THE BLACKOUT ARGUMENT – Detention CD
IGN164 THE SATELLITE YEAR – Mission: Polarlights CD
IGN165 SAME OLD STORY – A Great Disgrace CD
IGN166 ARGETTI – New Seeds CD
IGN167 Hidden Cabins/Brother Octopus – Landwater (split)
(was ARCHIVES – Dakota Skyline CD)
IGN168 MIKEE J REDS / JONAH MATRANGA – Countrysides
IGN169 SETTING THE WOODS ON FIRE – Ruins CD
IGN170 NATHANIEL SUTTON – Nathaniel Sutton CD
IGN171 HOLD THE FIGHT – Hold the fight
IGN172 ARCHIE'S COMEBACK – The Pendolino
IGN173 THE LION AND THE WOLF – The lion and the wolf
IGN174 V/A – From the underground - Amazon sampler comp CD
IGN175 PICK YOUR WEAPON – Everywhere we go, things fall down CD
IGN176 SOUND & SHAPE – Now comes the mystery CD
IGN177 OUT FOR TOMORROW – World on your side
IGN178 V/A – UNITY, A benefit for children in Japan
IGN179 THE WORLD CONCAVE – Loom
IGN180 V/A – Lamp light the fire - Compilation CD
IGN181 TAKE COVER – The dreamer and the realist CD

IGN182 FAILSAFE FOR TOMORROW – The End CD
IGN183 REMEMBER PARIS – But a boy can dream CD
IGN184 SOUTHERLY – Youth CD & LP
IGN185 ARTHUR WALWIN – For one more night – EP CD
IGN186 KYOTO DRIVE – The Approach CD
IGN187 IRIS – Out of fiction CD
IGN188 THE AFTERPARTY – Restless CD
IGN189 FACE THE FRONT – Modern Values CD
IGN190 THESE DAYS – Souls CD
IGN191 WE CAME FROM WOLVES – Cope - EP CD
IGN192 ERAS – Glory Glory CD
IGN193 SIRENS & SHELTER – The Midnight Arrangement CD
IGN194 THUNDERHAWKS – Tongues CD
IGN195 V/A – ENGINEER Sampler
IGN196 V/A – ENGINEER Amazon Sampler
IGN197 MAKER – Maker – EP CD
IGN198 HER ONLY PRESENCE & L'Hereu Escampa – 10" vinyl split
IGN199 COME THE SPRING – Seven For A Secret – EP CD
IGN200 V/A – ENGINEER TWO HUNDRED – Compilation CD (Sampler)
IGN201 ELEMAE – Tilling The Fallow – EP CD
IGN202 THE SATELLITE YEAR – Universe – Digital single
IGN203 WE CAME FROM WOLVES – Crosses – CD ep
IGN204 NO TIDE – Meridian – CD
IGN205 (DAMN) THIS DESERT AIR – Pyramids – CD
IGN206 SIRENS & SHELTER – Through The War – CD
IGN207 SIRENS & SHELTER – Landing Lights – Digital ep
IGN208 HOT PEACH – Hot Peach – CD
IGN209 ZIMT – Tube Killers - CD
IGN210 V/A - Lamp Light The Fire, Volume 2: A Compilation of Quiet(ER)
Songs
IGN211 HIDDEN CABINS & EYESWAN – Weathered – 10" split vinyl
IGN212 THE WORLD CONCAVE – Feed The Current To The Ground – EP CD
IGN213 CALL OFF THE SEARCH – Teenage Dream digi single
IGN214 RYAN MILLS & SIRENS & SHELTER – Split Digital EP
IGN215 SPEEDWELL – Start to finish CD
IGN216 KATE WINTIE – Kate Wintie - Digital single (2 songs)
IGN217 COME THE SPRING – Memory & Resonance - Digital single (2 songs)
IGN218 BAND TOGETHER – Various Artists – Digital dbl album (41 songs)
IGN219 RED LIGHT RUNNER – Red Light Runner CD
IGN220 ONE DAY ELLIOTT – Medicine – Digi single
IGN221 IRIS – Something to live for CD

IGN222 COME THE SPRING – Revive CD

IGN223 WE CAME FROM WOLVES – Am I Useful? CD (sarasoto)

IGN224 THE SATELLITE YEAR – Brooklyn, I am CD

IGN225 RED LIGHT RUNNER – Lucky 13 / Just Might Find - CD

IGN226 SIRENS & SHELTER – Maybe You Should CD

IGN227 MISS VINCENT – Reasons not to sleep CD

IGN228 ONE DAY ELLIOTT – Triple A side CD

IGN229 MONSTERS AS HUMANS – New album tba CD

IGN230 ABOUT LEAVING – An Echo CD

IGN231 WHITE CROSSES – Anchorless CD

IGN232 RED LIGHT RUNNER – What are you thinking about? CD

IGN233 HAIL TAXI (Nathaniel Sutton) – Apart for so long CD

IGN234 THE SATELLITE YEAR – Orbit CD

IGN235 YEARS BEFORE - Hometown Zeros CD

IGN236 HAIL TAXI – Wildrose Country digi single

IGN237 SON OF THE MOURNING – Eulogy CD

IGN238 LOW STANDARDS, HIGH FIVES – Silent Decor digi single

IGN239 TONOTA 80 – Killer Sands and Beating Hearts CD

IGN240 COME THE SPRING – Echoes CD

IGN241 STEVE HEWITT – Pushing Me Away digi single

IGN242 COME THE SPRING – For What It's Worth digi single

IGN243 HAIL TAXI – Magic Spark digi single

IGN244 LOW STANDARDS, HIGH FIVES – Are we doing the best we can? CD

IGN245 ELEMAE – Fiction CD

IGN246 TONOTA 80 – Could do better digi single

IGN247 YEARS BEFORE – A fork in the road CD

IGN248 HIDDEN CABINS – The Hidden Cabins Band CD

IGN249 STEVE HEWITT – Life Stories CD

IGN250 V/A – ENGINEER TWO FIFTY – Compilation CD (Sampler)

IGN251 COME THE SPRING – Better now digi single

IGN252 LOW STANDARDS, HIGH FIVES – Bite me digi single

IGN253 HIDDEN CABINS – Boundaries CD/LP

IGN254 COME THE SPRING – Brighton and the blues digi single

IGN255 STEVE HEWITT – Bigger than words CD

IGN256 HAIL TAXI – A little something CD

IGN257 LOW STANDARDS, HIGH FIVES – Slow dancers in rush hour digi single

IGN258 TONOTA 80 – Montauk digi single

IGN259 RED LIGHT RUNNER – Breaking out digi single

IGN260 SIRENS AND SHELTER – Carried your weight digi single

IGN261 BEAR AWAY – Never in the same place CD /cassette

IGN262 RED LIGHT RUNNER – Under the weather CD

IGN263 PUNCH DRUNK – Sassy cassette
IGN264 WLOTS – Siempre Piu CD / cassette
IGN265 SIRENS AND SHELTER – Sound the alarm CD
IGN266 SLEAVE – Homebound digi single
IGN267 WLOTS – Siempre Piu acoustic demos cassette
IGN268 SLEAVE – Check myself digi single
IGN269 AMALIA BLOOM – Maiden voyage vinyl CD/LP
IGN270 TONOTA 80 – What people say digi single
IGN271 THE STAYAWAKES – Pop dreamz CD/LP
IGN272 PARK AVENUE – CD
IGN273 SLEAVE – Don't Expect Anything CD
IGN274 HOLLER AND THE HAND – Together digi single
IGN275 V/A - Lamp Light The Fire, Volume 3: A Compilation of Quiet(ER)
Songs
IGN276 SLEAVE – Swept digi single
IGN277 ESCAPE ELLIOTT – Everything here is make believe CD
IGN278 JACK AND SALLY – Who we become CD
IGN279 WAKE THE DEAD – Still Burning CD/LP
IGN280 HAIL TAXI – Oh my heart it hurts digi single
IGN281 SIRENS & SHELTER – Sound the alarm digi single
IGN282 TONOTA 80 – Everybody's famous CD
IGN283 SLEAVE – All this time digi single
IGN284 ANTILLECTUAL – Covers vinyl 7" EP
IGN285 PILEDRIVER – Constant Battles CD/10"
IGN286 FOREVER AGAIN – Resonate CD/LP
IGN287 DEATH OF YOUTH – Suburban Dystopia 10" vinyl
IGN288 BEAR AWAY – Old friends / East Coast 7"
IGN289 ABOUT LEAVING – Sculptures of water CD/LP
IGN290 (DAMN) THIS DESERT AIR – Nebulosity CD
IGN291 SIRENS & SHELTER – Darkest Days / Calling Card 7"
IGN292 RYDELL – Per Ardua Ad Astra LP (20 year anniversary)
IGN293 RYDELL – Hard on the trail LP (20 year anniversary)
IGN294 3DBS DOWN – Get your retaliation in first CD/LP
IGN295 TIRED RADIO – Patterns CD/LP
IGN296 LOW STANDARDS HIGH FIVES – Teens in the fireroom digi single
IGN297 FOREVER AGAIN – Rear view mirror digi single
IGN298 TIRED RADIO – Making plans digi single
IGN299 ARCTIC SLEEP – Made of gold digi single
IGN300 V/A – ENGINEER THREE HUNDRED – Compilation CD (Sampler)
IGN301 TIRED RADIO – Send for a hospital digi single
IGN302 HAIL TAXI – Fall apart EP digi

IGN303 INCOMPLETE STRANGER – Let's get lost digital EP (was SCOTT REYNOLDS – Chihuahua in Buffalo LP)

IGN304 SCARY HOURS – Margins CD

IGN305 BORN INFECTED – Self reflection CD

IGN306 LOW STANDARDS HIGH FIVES – How personality works 12" EP

IGN307 DEATH OF YOUTH – Some demons never die CD

IGN308 ALL ABOARD! – The rules of distraction CD/LP

IGN309 V/A – The Scene that would not die – Compilation, Double CD

IGN310 COME THE SPRING – Echoes Revived CD/LP

IGN311 NECKSCARS – Don't panic CD &LP

IGN312 TWHWISYN – Wilting digi single

IGN313 I LIKE ALLIE – Rare instances of independent thinking LP

IGN314 HELL CAN WAIT – Love Loss Hope Fear CD

IGN315 PAM RISOURIE – So be it, eternity 12" EP

IGN316 SIDE PROJECT – Bittersweet CD

IGN317 THE WOLF HOWLS WHEN I SCREAM YOUR NAME – Grief songs CD

IGN318 STATES OF NATURE – Songs to sway LP

IGN319 JUKEBOX ROMANTICS – Fires forming LP

IGN320 V/A – TIRED RADIO, NECKSCARS, AMERICAN THRILLS & NIGHTMARES FOR A WEEK – split 7" picture disk

IGN321 STUBBORN WILL – Contempt CD

IGN322 BARKING POETS – When the bands are gone digi single

IGN323 BEAR AWAY – A Drastic Tale of Western Living CD/LP

IGN324 TWHWISYN – Doreen digi single

IGN325 I LIKE ALLIE – Rare instances digi single

IGN326 BARKING POETS – Back to abnormal CD & 10" vinyl

IGN327 SINGING LUNGS – Coming around LP

IGN328 I LIKE ALLIE – A reaction paper on salt digi single

IGN329 TWHWISYN – Grief Song - digi single

IGN330 I LIKE ALLIE – Your Superpowers Are Stupid - digi single

IGN331 THE ATLANTIC UNION PROJECT - The Actuary - digi single

IGN332 TWHWISYN – Clover - digi single

IGN333 OLD CURRENTS – The Glory, The Defeat CD

IGN334 KID YOU NOT – Here's to feelin' good all the time LP

IGN335 3DBS DOWN – Picking Sides digi single

IGN336 THE ATLANTIC UNION PROJECT – 3482 miles CD / LP

IGN337 THE DREADED LARAMIE Everything a girl could ask 7" EP

IGN338 COVERT STATIONS - Love My Way (Psychedelic Furs) digi-single

IGN339 STUBBORN WILL – Agape digi single

IGN340 THE ATLANTIC UNION PROJECT - Trustworthy - digi single

IGN341 BEAR AWAY – Wake up and smell the floor digi single

IGN342 THE STRATEGIES – S/T 4 song 12" EP (Digi only?)

IGN343 VERSE, CHORUS, INFERNO – Fast times in Den Haag digi-single

IGN344 COVERT STATIONS – She Sells Sanctuary (The Cult) digi-single

IGN345 AMALIA BLOOM – Picturesque LP & CD

IGN346 RITES – No Change Without Me CD & 12" (one sided)

IGN347 ERETIA - Quietud LP (seven tracks)

IGN348 ABERMALS – Reasons to travel LP & CD (nine tracks)

IGN349 BARKING POETS – Part of the problem digi single

IGN350 V/A – ENGINEER THREE FIFTY – Compilation CD (Sampler)

IGN351 BED OF SNAKES – Self titled CD EP

IGN352 THE 1984 DRAFT – Best Friends Forever LP

IGN353 VERSE, CHORUS, INFERNO – Flying a DeLorean to 2007 LP

IGN354 3DBS DOWN – Idiot Ignorant Evil digi-single

IGN355 THE ATLANTIC UNION PROJECT – Soon to end - digi single

IGN356 3DBS DOWN – Unconvinced digi-single

IGN357 COVERT STATIONS - I Melt with You (Modern English) digi-single

IGN358 BREAK TO BROKEN – The war on sparrows

IGN359 BARBED WIRE – The sun sets in the wrong place CD

IGN360 CALM. – Our Twenties CD EP

IGN361 RAISED ON TV – Strangers in pictures LP

IGN362 FAT HEAVEN – Trash Life LP

IGN363 VERSE, CHORUS, INFERNO – Dreams digi-single

IGN364 COVERT STATIONS – The One I Love (R.E.M.) digi-single

IGN365 BARKING POETS – We will overcome digi-single

IGN366 COVERT STATIONS – It must have been love (Roxette) digi-single

IGN367 THE ATLANTIC UNION PROJECT – Cheap Seats - digi single

IGN368 STUBBORN WILL – Never Here digi single

IGN369 ANTILLECTUAL – Together LP & CD

IGN370 ZERO AGAIN – A Deep Appreciation Of Suffering CD

IGN371 NECKSCARS & MOONRAKER – Split 12" EP

IGN372 SELFLORE – L'Immagine Che Ho Di Me LP

IGN373 COVERT STATIONS – Never tear us apart (INXS) digi-single

IGN374 THE STARTOVER – Turning Circles digi-single

IGN375 BARKING POETS – Southsea Sounds CD EP

IGN376 CALM. – Dysfunctional Assumptions CD & 12" EP

IGN377 PALM GHOSTS – I Love You, Burn In Hell LP & CD

IGN378 MINOR PLANETS – Neverending Days CD

IGN379 FLAMSTEED – Truths on Demand CD

IGN380 TESS & THE DETAILS – Runaway LP

IGN381 LETTERBOMBS – The World Is Cursed... LP

IGN382 SLEAVE – All These Songs Are About You digi EP

IGN383 FLAMSTEED – Gentrifica digi single

IGN384 CALM. – Obsessive Compulsive digi single

IGN385 SIRENS & SHELTER – Undefeated digi EP

IGN386 HELL CAN WAIT – 2023 CD EP

IGN387 PILEDRIVER – 25 & Live CD

IGN388 R.C. SULLIVAN – Masquerade 7" EP

IGN389 THE DISTANCE - LP

IGN390 PAINTED FICTION – Dusk EP

IGN391 SHREDS - Step Back CD & LP

IGN392 SLEAVE – Birthday digi single

IGN393 SLEAVE – Clean digi single

IGN394 RAD OWL – Rage Gracefully LP

IGN395 SLEAVE – Our Golden Rule digi single

IGN396 SAMMY KAY – July 1960 LP

IGN397 SLEAVE – How To Get Over LP & CD

IGN398 OH! THE HUMANITY – LP

IGN399 BLACKEST HEART - There Will Be Light CD EP

IGN400 V/A – ENGINEER FOUR HUNDRED – Compilation CD (Sampler)

IGN401 FULL FULL FULL - Camping Paradise digi EP

IGN402 NECKHOLE – Angry Day CD EP

IGN403 SINGING LUNGS & BEDFORD FALLS – Split CD & Cassette

IGN404 UNCLE DAN – Failed to Fade CD EP

IGN405 BREAK TO BROKEN – White & Gray + 2 7" EP

IGN406 ZERO COST – Mouths To Feed CD EP

IGN407 GHOST WOUNDS – Slow Apocalypse 7" EP

IGN408 KING OF PIGS – After Victory Comes Defeat CD

IGN409 MEANT – Self titled 7" EP

IGN410 BEDFORD FALLS – Pleasureland LP & CD

IGN411 POSITIVE REACTION – Dreaming of Violence CD EP

IGN412 ABERMALS – Middle Aged and Underpaid digi single & video

IGN413 AMALIA BLOOM – Remedy digital single

IGN414 POSITIVE REACTION – Dreaming of Violence digi single

IGN415 ABERMALS – Vertigo digi single & video

IGN416 RAINCHECK – Turning Point digital single

IGN417 RAINCHECK – Highbro Lowbro LP

IGN418 AMALIA BLOOM – Compressed Remedies cassette

IGN419 BROTHER OCTOPUS - Stick Up (feat. Hidden Cabins) digi single

IGN420 ABERMALS – Believe CD

With thanks

Thanks of course go to all my friends in the bands who spent time chatting with me for this book, reminiscing about gigs and records, and answering all my inane questions, but mainly for creating this amazing and inspiring music.

Thanks to Craig Cirinelli for working with me on the excellent cover design and Steve Crawley for the superb interior design and layout. Designers par excellence.

Big Thanks to Miles Booker for helping me with the proof reading again, and Massive Thanks to Tim Cundle for even more proof reading and enabling me by sorting my meandering peregrinations into something a little bit more readable.

Thanks, of course, to you, Dear Reader, for bothering to read about these bands.
My apologies for creating yet another hefty book for you to weight train with. I may yet have to go again as I still have many bands and much to write about.

And, Thanks most of all to the post-punk, hardcore scene and it's superb community that has helped raise us all and keeps me inspired to be creative.

About the author

David is a musician and author. He's played in bands since his teens, including Couch Potatoes, Joeyfat, Rydell, Come The Spring and The Atlantic Union Project, and is an active part of the alternative music scene, having promoted gigs, edited a fanzine and run a record label.

He established his current label, Engineer Records, back in 1999 and continues releasing great records to this day, with well over 400 releases and counting.

His first two books were, 'Punk Faction', a collection of BHP fanzine excerpts that cover a range of subjects important to the youth of the '90s and still relevant to the alternative scene of today, and 'A Hardcore Heart', a semi-autobiographical account of the UKHC scene in the '90s focusing on the artists, promoters, venues, and labels involved.

David lives with his wife and two sons in East Sussex, and when he's not playing with his family and their four cats, or writing, he enjoys travelling, strangling his guitar and introducing others to obscure rock bands.

Adventures in a D.I.Y. scene

David is a 'lifer' - he's been around the block and earnt his stripes – and 'A Hardcore Heart' is not only a fascinating insight into the reality of touring with an underground hardcore band, but an invigorating time capsule of a punk scene before Instagram, Facebook and MySpace, even before mobile phones, sat navs and Google Maps. It's a veritable ode to being in the wrong place at the wrong time, an underdog story with (spoiler alert!) no happy ending, yet that won't stop its bittersweet narrative from putting a wry smile on your face.

Ian Glasper- Down For Life (and author of 'The Scene That Would Not Die' +)

Want to know what it was really like to submerge yourself in the nineties Hardcore scene? To live, eat, breathe, and be consumed by punk rock? Or what the reality of being in a touring band that lived hand to mouth and played more shows than the author cares to, or probably can remember, for the sheer joy of playing and not a whole lot else? Then you need to read 'A Hardcore Heart', a book that's a love letter to the intoxicating joy of music, the enduring power of friendship, loyalty, and the overwhelming desire to create something from nothing and forge a better tomorrow. Thoroughly recommended.

Tim Cundle – Mass Movement (and author of 'What Would Gary Gygax Do?'

Available now at

www.earthislandbooks.com

PUNK FACTION
BHP '91 to '95

Punk Faction BHP '91 to '95 is a 280 page collection of BHP fanzines that cover a range of subjects that were important to the youth of the 1990s and are still relevant to the alternative scene of today. Containing short stories and reviews, as well as interviews with Green Day, Rancid, Jawbreaker, Quicksand, Sugar, Samiam, All Down By Law, and many more as well as articles about issues such as equality, the environment, animal cruelty and politics, this is a look back to 90s youth culture and the UK hardcore music scene.

'BHP was one of the many voices reaching out of the UK Hardcore scene during the '90s but it always did so with passion and purpose' Tim Cundle

'Much of my knowledge of music and view of the world is still influenced by those words' Frank Turner

'Infused each issue with enthusiasm, dedication and a love for the scene' Tony Suspect

AVAILABLE NOW AT WWW.EARTHISLANDBOOKS.COM

A COUNTRY FIT FOR HEROES :
DIY PUNK IN EIGHTIES BRITAIN BY IAN GLASPER

Primarily collecting the stories of over 140 UK punk bands from the eighties who only released EPs and demos, or only appeared on compilation LPs, 'A Country Fit for Heroes: DIY punk in eighties Britain' is a celebration of the obscure, a love letter to the UK's punk underground.

'A Country Fit For Heroes' plugs the gaps in Ian Glasper's first three books on UK punk in the eighties, performing a truly deep dive into that volatile subculture to create a more complete historical document of a most turbulent time.

With a foreword by Chris Berry, co-founder of No Future Records, this is an essential read for anyone with more than a passing interest in the UK's grass roots punk scene.

AVAILABLE NOW AT: WWW.EARTHISLANDBOOKS.COM